# 帶路
# Belt and Road

通過鏡頭探索一帶一路的商機、風貌、人情

Exploring the market, sceneries and people along the belt and road through lenses

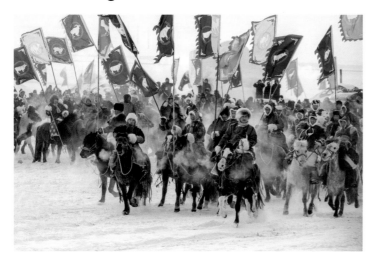

## 李秀恒　著
## Eddy Li

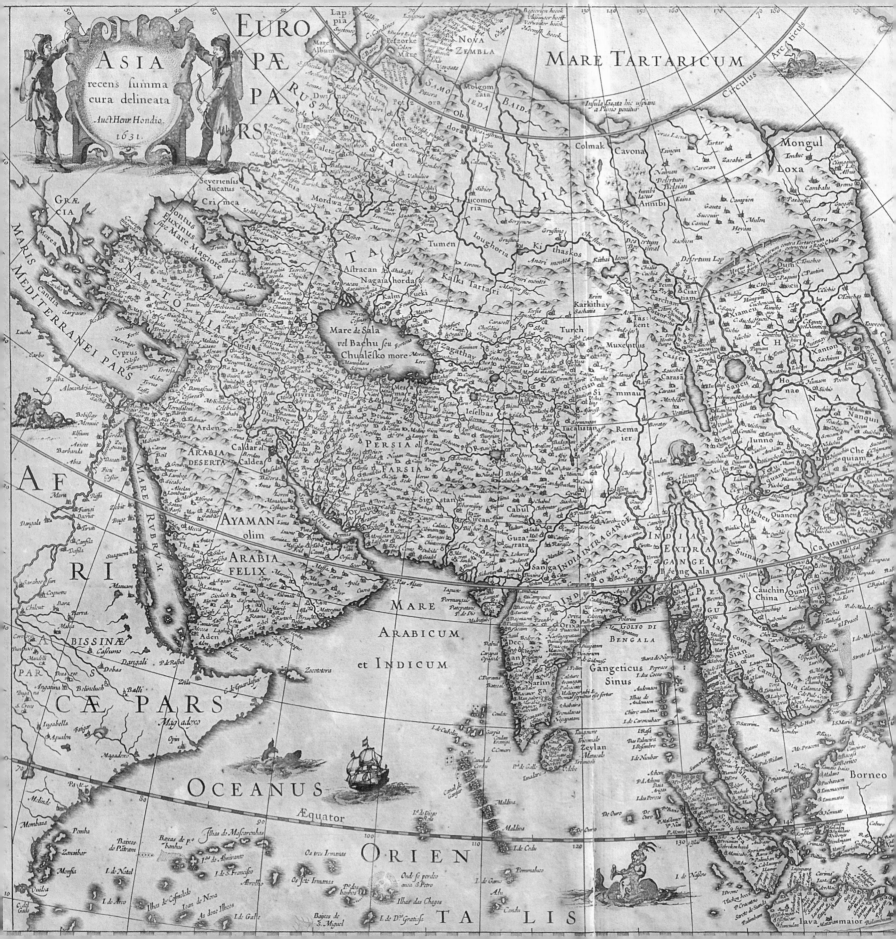

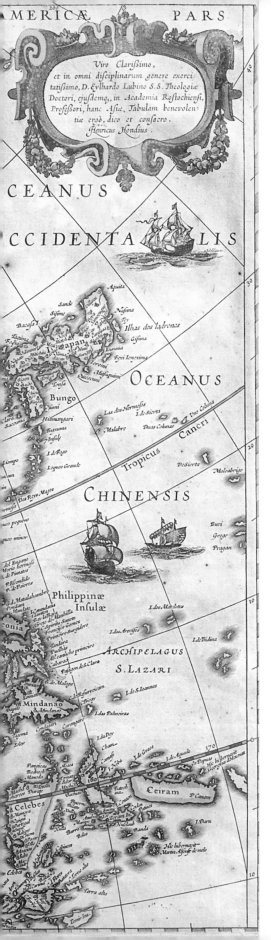

# 帶 路 Belt and Road

## 通過鏡頭探索一帶一路的商機、風貌、人情

Exploring the market, sceneries and people along
the belt and road through lenses

| | |
|---|---|
| 作者 Author | 李秀恒 Eddy Li |
| 翻譯 Translation | 李佳燁 Natalie Li |
| 責任編輯 Managing Editor | 吳家駿 Alvis Ng |
| 文字編輯 Text Writer | 李佳燁 Natalie Li |
| 美術主任 Art Director | 駿二 Zimman Shunji |
| 美術編輯 Designer | 何仲文 Tommy Ho |
| | 譚晞文 Heyman Tam |
| | 梁鳳恩 Joanne Leung |
| | |
| 發行人 Publisher | 熊曉鴿 Hugo Shong |
| 總編輯 Editor in Chief | 李永適 Yungshih Lee |
| 策 劃 Acquisitions Editor | 蔡耀明 Ivan Tsoi |

| | |
|---|---|
| 出版社 Publishing House | 大石國際文化有限公司<br>Boulder Media Inc |
| 地址 Address | 台北市內湖區堤頂大道二段 181 號 3 樓<br>3F, No.181, Sec 2, Tiding Blvd.,<br>Neihu Dist., Taipei City, Taiwan |
| 電話 Tel no | +886 (02) 8797-1758 |
| 傳真 Fax | +886 (02) 8797-1756 |
| | |
| 台灣總代理 | 大和書報圖書股份有限公司 |
| 港澳總代理 | 泛華發行代理有限公司 |

2018 年 7 月初版

定價 Price：NT$1200 / HK$400
ISBN：978-957-8722-22-4（精裝）

國家圖書館出版品預行編目（CIP）資料

帶路：通過鏡頭探索一帶一路的商機、風貌、
人情／李秀恆著；李佳燁翻譯 .
-- 初版 -- 臺北市：大石國際文化，2018.06
504 頁 ；25×25 公分
中英對照
ISBN 978-957-8722-22-4（精裝）
1. 攝影集
958.33　　　　　　　　　　　107006978

# 帶 路 Belt and Road

# 目錄 Index

歐洲（波羅的地區）
Europe (Baltics)

歐洲
Europe

中亞
Central Asia

西亞
Western Asia

南亞
Southern Asia

中國
China

香港
Hong Kong

非洲
Africa

東南亞
Southeast
Asia

絲綢之路經濟帶（一帶）
Silk Road Economic Belt

21世紀海上絲綢之路（一路）
21st-Century Maritime Silk Road

# 前言

公元前 2 世紀，奉漢武帝之命，使臣張騫從長安出發，將中原文明傳至西域（現新疆及中亞地區），並與當地進行了貨物貿易，正式開拓了由中原地區通往西域諸國的道路。這條道路逐漸延伸至西亞、地中海各國，形成了一條東西方文明交流的重要通道。由於這條通道的最初作用是運輸古代中國出產的絲綢，後被命名為「絲綢之路」。

隨著古代中國對外貿易的發展，原本只在陸上進行的絲綢之路，逐漸延伸至海上，形成了「海上絲綢之路」。雖然海上絲路在秦漢時期已經有雛形，但在宋元兩代才達到了真正的鼎盛時期，在這個時期，瓷器漸成主要出口貨物，因此海上絲綢之路又有一個別稱——「海上陶瓷之路」。福建省的泉州被普遍認為是海上絲綢之路的起點。

古代絲綢之路及海上絲綢之路是古時貿易及文明交流的重要通道。以此為歷史背景，在 2013 年，習近平主席在出訪中亞及東南亞期間，先後提出共建「絲綢之路經濟帶」（一帶）和「21 世紀海上絲綢之路」（一路）的重大倡議，得到國際社會的高度關注。到了 2015 年，國家發改委、外交部、商務部聯合發佈了《推動攻堅絲綢之路經濟帶和 21 世紀海上絲綢之路的願景與行動》。

中國經過 40 年的改革開放，逐漸成長為世界第二大經濟體。而隨著世界經濟的轉型，中國在近年的崛起有目共睹，過去以西半球為經濟主導的局面，在未來可能隨著中國經濟的進一步發展而面臨著改變。尤其是中國提出的「一帶一路」策略，很有可能成為引領未來世界經濟進步的「火車頭」。

中國的變化之大，讓人驚歎。尤其對於中亞、西亞等地的國家，中國是它們十分羨慕及模仿的對象。一帶一路就是一個機會，不但能把中國的經驗和產出分享給這些鄰國，促進地緣政治的友好發展，在帶動沿線地區發展的同時，更能夠發掘更多商機，使整體區域經濟都能共同發展。

一帶一路是一個橫跨亞歐大陸、在開初之時就涵蓋了多個國家地區的宏偉計劃，部署過程相應耗時甚長，目前，一帶一路仍在起步階段。因此，近幾年就是探索這些地區的最好時機，趁著這些地區尚未得到完全的開發，人為的破壞相對較少，可以讓我們記錄下不少保留了當地傳統的人文特色、地貌景觀，亦可在日後與得到發展的景象作對比。

# Foreword

In 2nd century BC, Emperor Wu of Han's envoy Zhang Qian was sent on a diplomatic mission to the Western Regions, which is the ancient locale for Xinjiang and Central Asia. He had spread the civilization of ancient China there and promoted goods trades with local countries. Since then, an official trading route between ancient China and foreign countries was formed, which later extended its way to Western Asia and the Mediterranean area and became an important passageway for the communication of Oriental and Western civilizations. This route, due to its original use of export of Chinese silk products, was named as the "Silk Road".

As fair trades further develop, the Silk Road gradually derived its seaway version. Although the maritime Silk Road could be traced back to the Qin and Han Dynasties, its peak period of prosperity was in the Song and Yuan Dynasties. During this period, china became the main goods of export; the maritime Silk Road thus had another name of the "maritime road of china". The Quanzhou city in the Fujian Province is universally considered as the starting point of the maritime Silk Road.

The Silk Road and the maritime Silk Road are important channels of trade and civilization communication in ancient times. With the two routes as historical background, in 2013, President Xi Jinping proposed the Silk Road Economic Belt (the Belt) and the 21st Century Maritime Silk Road (the Road) when he visited the Central Asia and Southeast Asia respectively. The proposal was brought into focus internationally. In 2015, the "Vision and Actions on Jointly Building Silk Road Economic Belt and 21st-Century Maritime Silk Road" was issued by the National Development and Reform Commission, Ministry of Foreign Affairs, and Ministry of Commerce.

After 40 years of economic reform, China has made its way to the second largest economy in the world. China is playing a more and more important role in the ever-changing world economy, which was predominantly led by Western countries in the past. In the future, the rise of China might, to some degree, change that tradition, especially with the Belt and Road Initiative being likely to steer the direction of global economic growth.

The progress of China is astonishing to the world, and to some of the countries in Central and Western Asia, China is even an object of envy and reference. The belt and road is the perfect chance for China to share our experience as well as excess capacity with our neighbors, facilitating a better geopolitical relationship. Moreover, when these areas become more developed in the future, more business opportunities will be available to boost the regional economy mutually.

The Belt and Road initiative is a great plan that crosses the Eurasia and covers multiple economies; its planning is time-consuming and currently it is still in the preliminary phase. Therefore, this is the perfect timing to explore these areas, before they are fully developed or affected, more or less, by manpower. This is a good time to take pictures of traditional lifestyles of local people and the uninfluenced natural landscape, which will be used as records and references for comparison in the future.

# 序言 - 林鄭月娥

香港是「一帶一路」建設的重要節點。在國家的大力支持下，我們將繼續發揮「一國兩制」的獨特優勢，在政策溝通、設施聯通、貿易暢通、資金融通、民心相通這五大領域下，致力作出貢獻。我們亦會把握當中的龐大機遇，進一步推動經濟和社會發展。

在建設「一帶一路」的過程中，政府積極擔當著促成者和推廣者的角色。此外，工商界和民間的參與亦不可或缺。在社會各界的共同努力下，香港在基建、經貿、金融、文化交流等方面，與「一帶一路」沿線地區的合作日益緊密，而香港中華廠商聯合會在李秀恒會長的帶領下，更是貢獻良多。我知道李會長早前率領了考察團前往中亞地區，協助業界開拓商機，收穫甚豐。廠商會又慷慨捐助設立了「一帶一路」獎學金，資助沿線國家青年來港升學，促進「一帶一路」的民心相通。

李會長一向愛好攝影，足迹遍及世界各地，而這本《帶路》攝影集便收錄了他在多個「一帶一路」國家拍攝的人文風光。我衷心祝賀這本《帶路》攝影集順利面世，讓我們一起透過李會長的鏡頭，見識「一帶一路」的多樣風采。

香港特別行政區
行政長官林鄭月娥
二零一七年十一月九日

# Preface– Carrie Lam

Hong Kong is a key link in the Belt and Road (B&R) Initiative. With the staunch support of our country, we will continue to make full use of its unique advantages under "One Country, Two Systems" and contribute to the success of the B&R Initiative's five major goals: policy co-ordination, facilities connectivity, unimpeded trade, financial integration, and people-to-people bonds. We will also seize the immense opportunities brought about by the Initiative, as we continue to go from strength to strength in economic and social development.

The Government is keen to play the roles of facilitator and promoter in the course of building the B&R. Meanwhile, the active participation of the business sector and the community is also indispensable. With the concerted efforts of various sectors of the community, we have seen closer co-operation between Hong Kong and territories along the B&R, in such areas as infrastructure, trade, finance and cultural exchange. In this regard, the Chinese Manufacturers' Association of Hong Kong (CMA), under the leadership of President Eddy Li, has been making exemplary contributions. I understand that a delegation led by President Li has paid a rewarding visit to Central Asia to explore business opportunities in the region. The CMA has also made a generous donation to establish the Hong Kong Scholarship for B&R Students, supporting young people from B&R countries to pursue studies in Hong Kong, promoting people-to-people exchanges.

President Li has always been an avid photographer and a keen traveller. This publication is a beautiful collection of his photographic work of peoples and landscapes in various B&R countries. I extend my hearty congratulations on the publication of this delightful piece of work, which allows us to embark on an eye-opening journey along the B&R through President Li's camera lens.

( Mrs Carrie Lam )
Chief Executive
Hong Kong Special Administrative Region
9 November 2017

# 自序

香港是個不足三千平方公里的彈丸之地，但卻是世界三大國際金融中心之一，地位僅次於紐約和倫敦，同時亦是重要航運中心及貿易中心。如此成就，除了因為地理上及制度上的優越，亦離不開港人勇於面對挑戰、刻苦開拓的精神。

從事鐘錶行業已經近 30 年的我，在上個世紀八、九十年代的創業期間，經常手持滿載手錶及零件樣板的行李箱，曾長途跋涉前往語言不通的非洲大陸開拓市場，也曾經歷重重關卡走進尚未開放的越南境內收取款項，曾到 40 多度如同烤爐一般的中東進行考察，亦曾在嚴寒的冬日踏上千里冰封的前蘇聯土地推廣產品……。

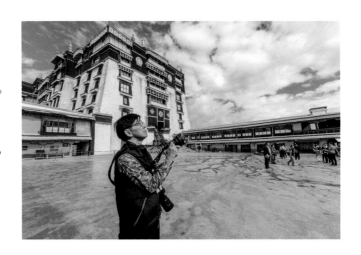

到了今時今日，科技及交通的進步，讓商業往來及通訊實現了電子化，當我遊歷這個世界擴寬視野的時候，亦不再需要再提著裝滿貨品的行李箱。取而代之的，則是我的數碼相機及鏡頭。

自「一帶一路」提出以來，沿線的國家及地區亦在很多時都被視為一個整體的新興市場。作為商人，同時亦作為攝影愛好者，我當然希望能夠趁著一帶一路這個新機遇，盡多進行實地考察，並透過鏡頭，去認識當地的風土人情。

希望這本攝影集能夠以一種藝術的記錄形式，呈現出近年一帶一路沿線國家的文化、生活、地貌及市場動態，給讀者作為參考之用。究竟在未來的十年、二十年乃至半個世紀之後，這些地方將發生怎樣的變化？希望能與大家一齊拭目以待！

# Author's Preface

Hong Kong is simply a small piece of land with an area of less than 3,000 square kilometers, yet it is one of the three international financial centers in the world, after New York and London. The city is also one of the world's most important shipping and trading hubs. These achievements are greatly attributed to Hong Kong's geographical and systemic advantages, and more importantly, the bravery, the assiduous and never-tiring spirit of the Hong Kong people.

I have now been in the watch industry for almost three decades. From time to time I would recall the days in the 1980s and 1990s when I was in the initial stage of starting up my own business. With a suitcase filled with sample watches and parts, I made arduous journeys to the land of Africa to explore the local markets. I overcame multiple challenges to get access to Vietnam to collect my receivables. I made field trips to the "oven-like" Middle East with temperature higher than 40 degrees Celsius, and also stepped on the territory of former Soviet Union to promote my products in the killing freeze…

Nowadays, improved technologies and convenient transportations have digitized commercial dealings and saved us from bringing along the heavy luggage of samples. When travelling around the world to broaden my horizon, I have now replaced the samples with my digital cameras and lenses.

Ever since the Belt and Road Initiative was proposed, the countries and areas along the belt and road are regarded as an emerging market on the whole. As a businessman and fan of photography, I naturally want to visit these places, so as to take records of the local customs and sceneries, as well as explore the business opportunities while the economic development plan starts off.

I hope this book can present to readers, through the form of art, the culture, lifestyle, landmarks and the markets of the belt and road countries in the past few years, as well as serving as a reference. How will changes take place in these areas in the future 10, 20 or even 50 years' time? I hope to witness it with you all.

# 中國

絲綢之路起始於古代中國，以長安（即今日的西安）為起點，經甘肅的河西四郡、敦煌，再經由新疆天山山脈一帶，踏出國門，到達中亞、中東，並連接地中海各國的陸路通道，以最初最具代表性的貨物絲綢命名。

其後這條貿易通道雖因民族衝突而一度中斷，但隨著成吉思汗建立的蒙古帝國擴大其版圖，絲綢之路得以復興，並讓東西方政治、經濟及文化的聯繫在元朝時期達到巔峰。正是元朝絲綢之路的再次暢通，讓意大利商人馬可·孛羅有機會通過絲綢之路來到中國，並把在中國的見聞傳回西方。與此同時，海上絲綢之路亦進入鼎盛時期。

其實，早在秦漢時期，海上絲綢之路就已初步形成，但基於宋元兩代的科技發展，才形成了較為成熟的航海技術，達到全盛，亦為後來明代鄭和下西洋的創舉打下基礎。鄭和船隊七次下西洋，途經數十個國家，最遠更曾抵東非地區。

到了 21 世紀的今天，中國提出了全新的「一帶一路」經濟戰略。全國多個省、市、自治區都積極參與，當中有香港、澳門、西安等為人熟知且經濟較為發達的城市，亦有如甘肅、新疆、內蒙古、西藏等相對未開發的地區——這些地區的本土特色尚未受到經濟進步帶來的徹底變化，較多地保有神秘感，而相信隨著一帶一路的推動發展，這些領域將會迎來新機遇，發生重大的轉變。

中國
China

The Silk Road originated in ancient China. Starting from Chang'an (now called Xi'an) and by way of the four counties to the west of the Yellow River, Dunhuang and Xinjiang, the Silk Road passes Central Asia and Middle East to reach the coastal countries along the Mediterranean Sea. It was named for the most representative goods along the trade route – silk.

Although this route was once interrupted by ethnic unrests, it was revitalized when Genghis Khan established the Mongol Empire. The expanded territory had facilitated the political, economic and cultural relations between the oriental and western worlds to reach the peak. It is during the Yuan Dynasty that the Italian merchant Marco Polo travelled to China through the silk route and shared the stories of China when he returned to Europe. The Maritime Silk Road was also in its heyday at this time.

The ancient Maritime Silk Road was formed preliminarily in Qin and Han dynasties. The development of scientific technology in Song and Yuan dynasties has further enabled a more advanced seamanship, embracing a floruit in navigation. Based on the mature navel technology, the seven treasure voyages led by Zheng He in the Ming Era had visited tens of countries and even made its way to East Africa.

At present in the 21st century, the brand new concept of belt and road is proposed by China. Multiple provinces, cities and autonomic areas are participating actively in the initiative, including developed cities that are familiar to public, such as Hong Kong, Macao, Xi'an, as well as areas that are relatively underdeveloped, such as Gansu, Xinjiang, Inner Mongolia and Tibet – economic development has not yet transformed the unique features of these places, and remain mysterious to outsiders. As the belt and road initiative progresses, new opportunities will occur in different domestic regions and bring unprecedented changes.

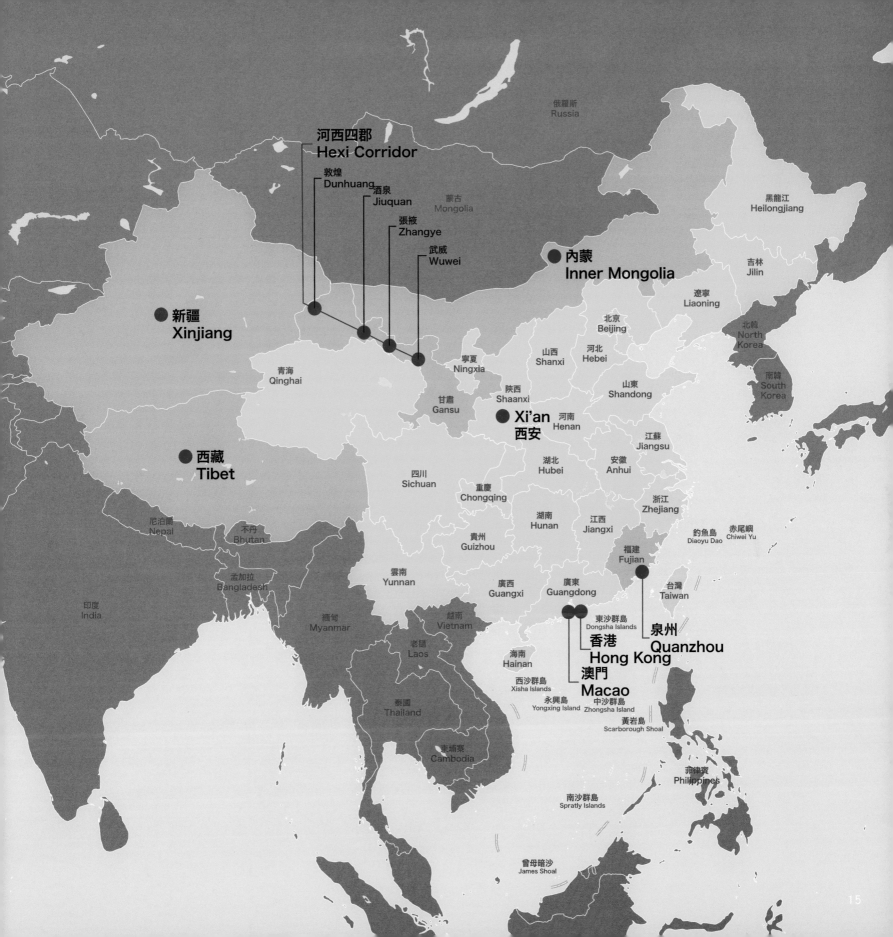

河西四郡
Hexi Corridor

敦煌
Dunhuang

酒泉
Jiuquan

張掖
Zhangye

武威
Wuwei

內蒙
Inner Mongolia

新疆
Xinjiang

西藏
Tibet

Xi'an
西安

俄羅斯
Russia

蒙古
Mongolia

黑龍江
Heilongjiang

吉林
Jilin

遼寧
Liaoning

北京
Beijing

北韓
North
Korea

南韓
South
Korea

山西
Shanxi

河北
Hebei

山東
Shandong

寧夏
Ningxia

陝西
Shaanxi

青海
Qinghai

甘肅
Gansu

河南
Henan

江蘇
Jiangsu

四川
Sichuan

湖北
Hubei

安徽
Anhui

尼泊爾
Nepal

不丹
Bhutan

重慶
Chongqing

湖南
Hunan

江西
Jiangxi

浙江
Zhejiang

釣魚島
Diaoyu Dao

赤尾嶼
Chiwei Yu

孟加拉
Bangladesh

貴州
Guizhou

福建
Fujian

台灣
Taiwan

印度
India

緬甸
Myanmar

雲南
Yunnan

廣西
Guangxi

廣東
Guangdong

東沙群島
Dongsha Islands

泉州
Quanzhou

越南
Vietnam

香港
Hong Kong

澳門
Macao

老撾
Laos

海南
Hainan

西沙群島
Xisha Islands

永興島
Yongxing Island

中沙群島
Zhongsha Island

黃岩島
Scarborough Shoal

泰國
Thailand

菲律賓
Philippines

柬埔寨
Cambodia

南沙群島
Spratly Islands

曾母暗沙
James Shoal

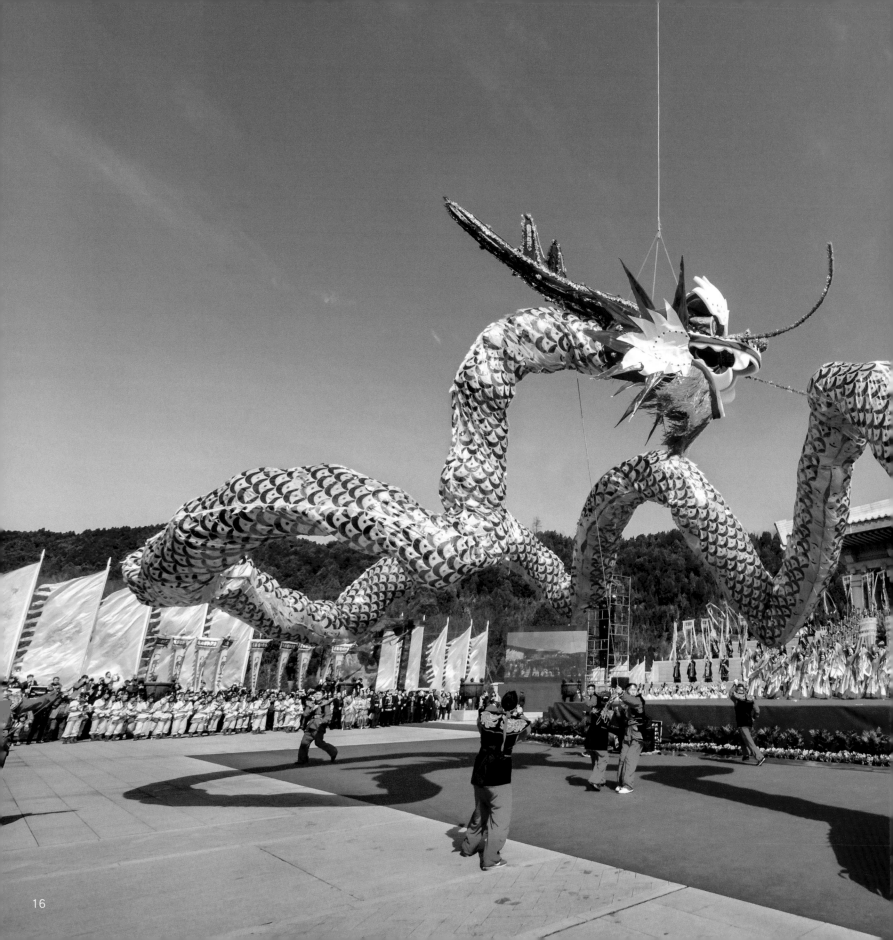

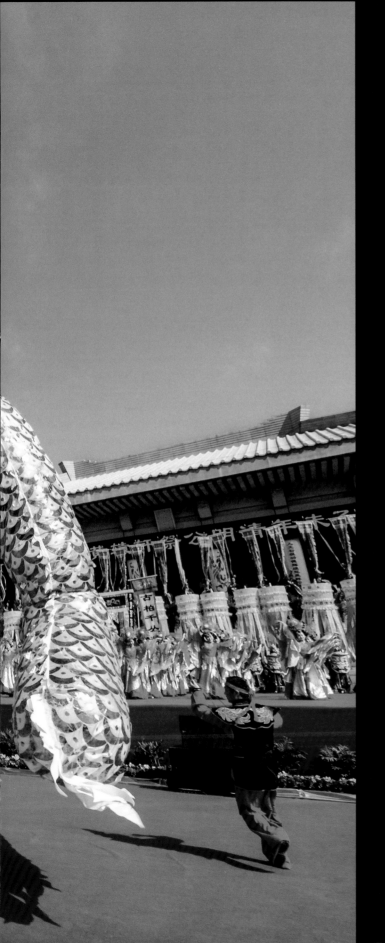

每年清明節，黃帝陵都會舉辦莊嚴而神聖的祭祀活動。（左）三皇五帝，是中國神話傳說中上古時期的八位帝王，如今被普遍視為中華民族及文化的始祖，其中黃帝的陵寢位於陝西省。（右）

Fete activities are held at the Mausoleum of the Yellow Emperor on the Tomb Sweeping Day every year. (Left) The three sovereigns and five emperors were a group of mythological emperors in prehistorical China. Today they are considered as the earliest ancestors of the Chinese nation and culture. Mausoleum of the Yellow Emperor, one of the eight emperors, is located in the Shanxi Province. (Right)

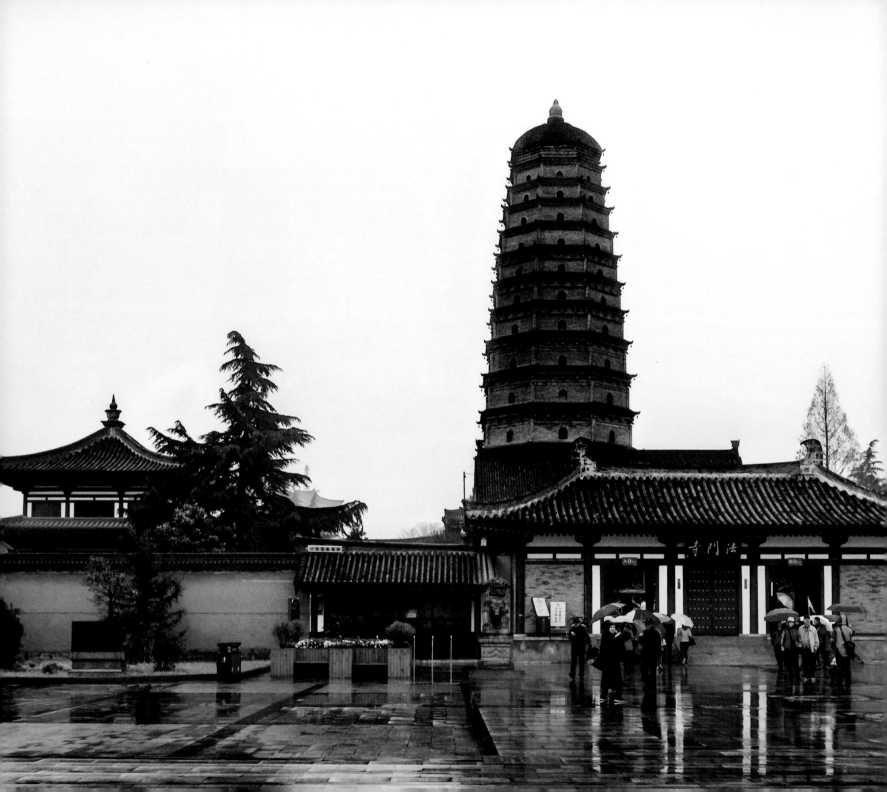

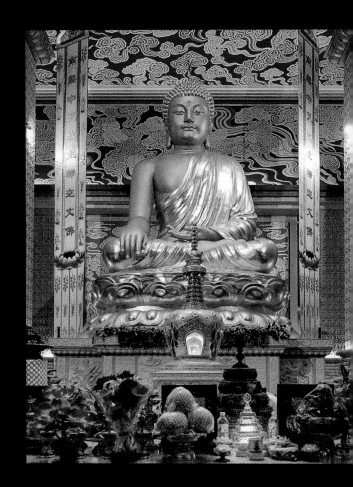

古代絲綢之路由古稱長安的西安為起點，經過甘肅河西四郡抵達現位於新疆的西域地區。西安法門寺在煙雨籠罩之下，讓人仿佛置身仙境。（左）法門寺因真身舍利的出土而成為佛教聖地。（右）

The ancient silk road, starting from the city of Xi'an, namely, the ancient Chang'an, led to the Western District which is now the Xinjiang Province through the four counties at the Hexi Corridor. In Xi'an, the Famen Temple draped in a veil of mist looks like a mystical paradise. (Left) The Temple is regarded as a sacred place in Buddhism for unearthing the true relic of Shakyamuni Buddha. (Right)

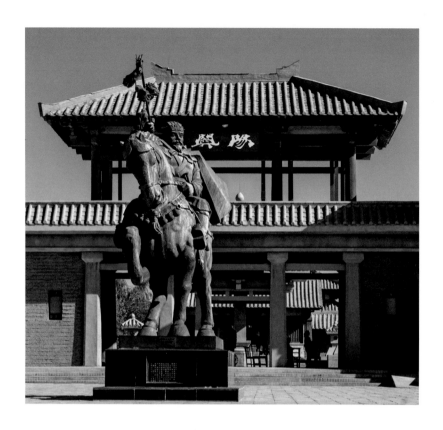

在古絲路交通要衝的陽關，設立了漢代使臣張騫的雕像。（左）
嘉峪關亦是古代中國使臣出使西域的必經之路。（右）

There is a statue of Zhang Qian, envoy of the Han Dynasty, at
the key waypoint on the ancient silk road - the Yang Pass. (Left)
Jiayu Pass is also on the only way for ancient Chinese envoys to
get to the Western District. (Right)

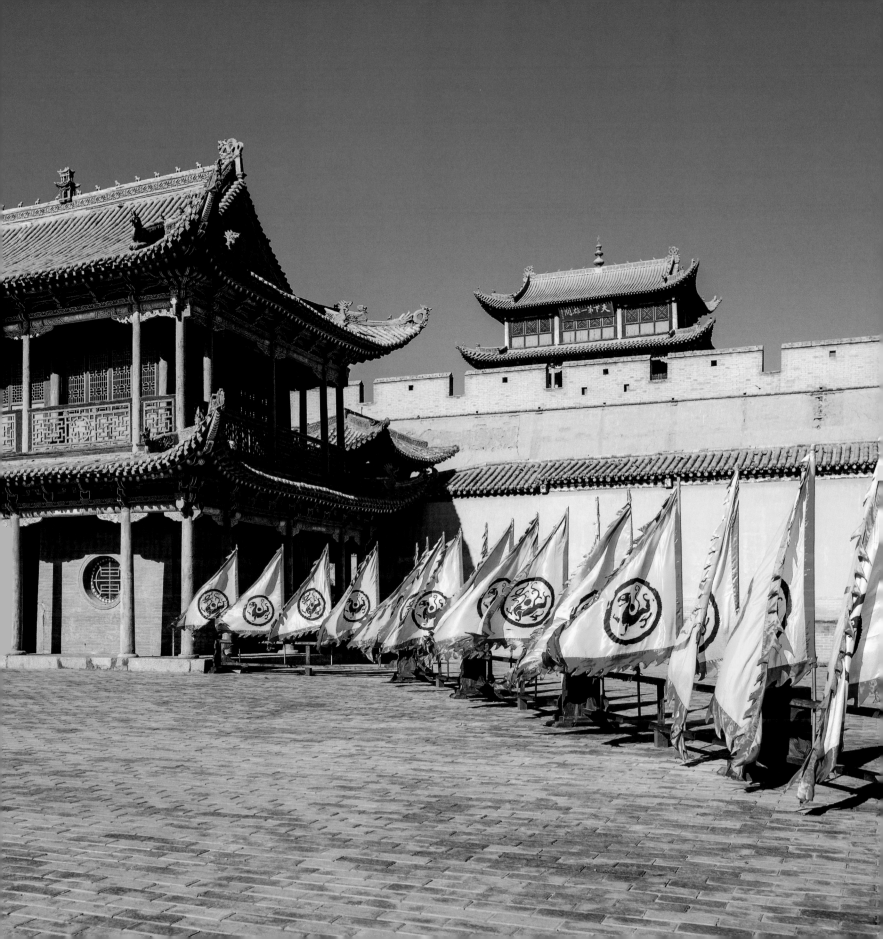

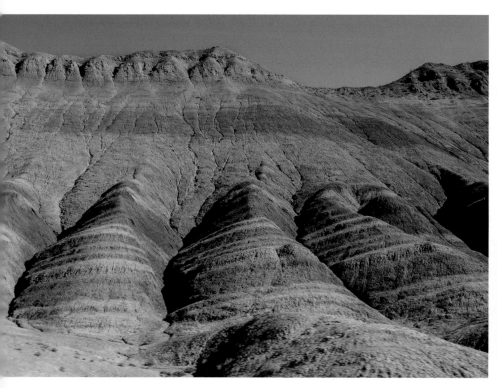

張掖丹霞地貌色彩斑斕，令人感歎大自然的鬼斧神工。（左）
甘肅張掖國家地質公園佔地三百餘平方公里，氣勢磅礴。（右）

Danxia landform in Zhangye consists of unusual layers of
colorful rocks. Viewers are easily astonished by the works
of God. (Left) The Zhangye National Geopark in Gansu is
a majestic park covering an area of more than 300 square
kilometers. (Right)

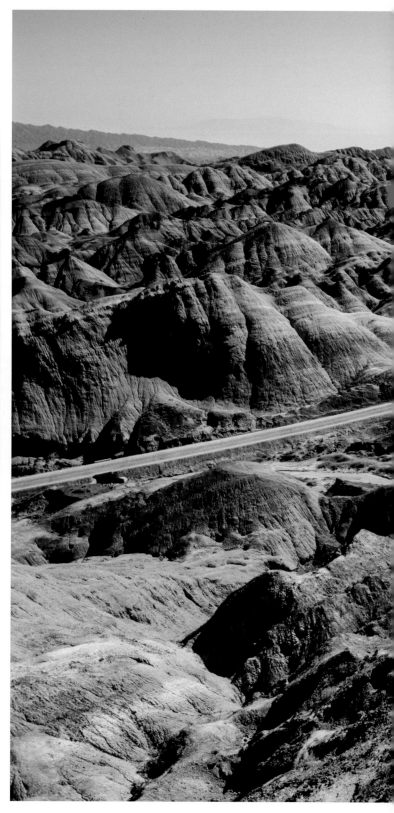

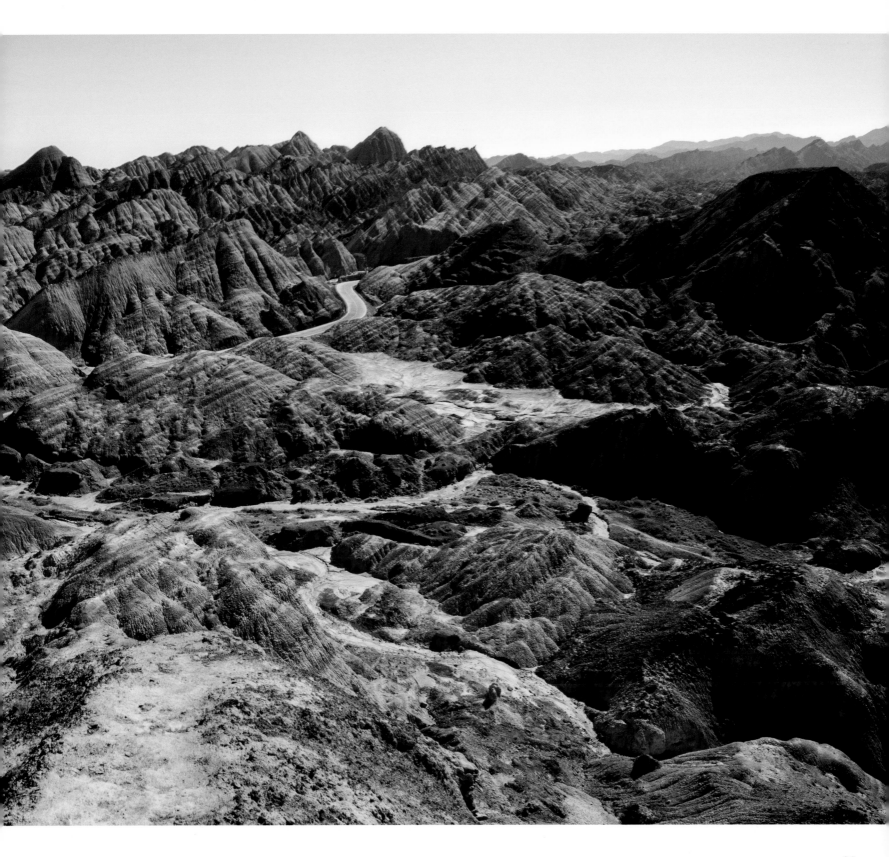

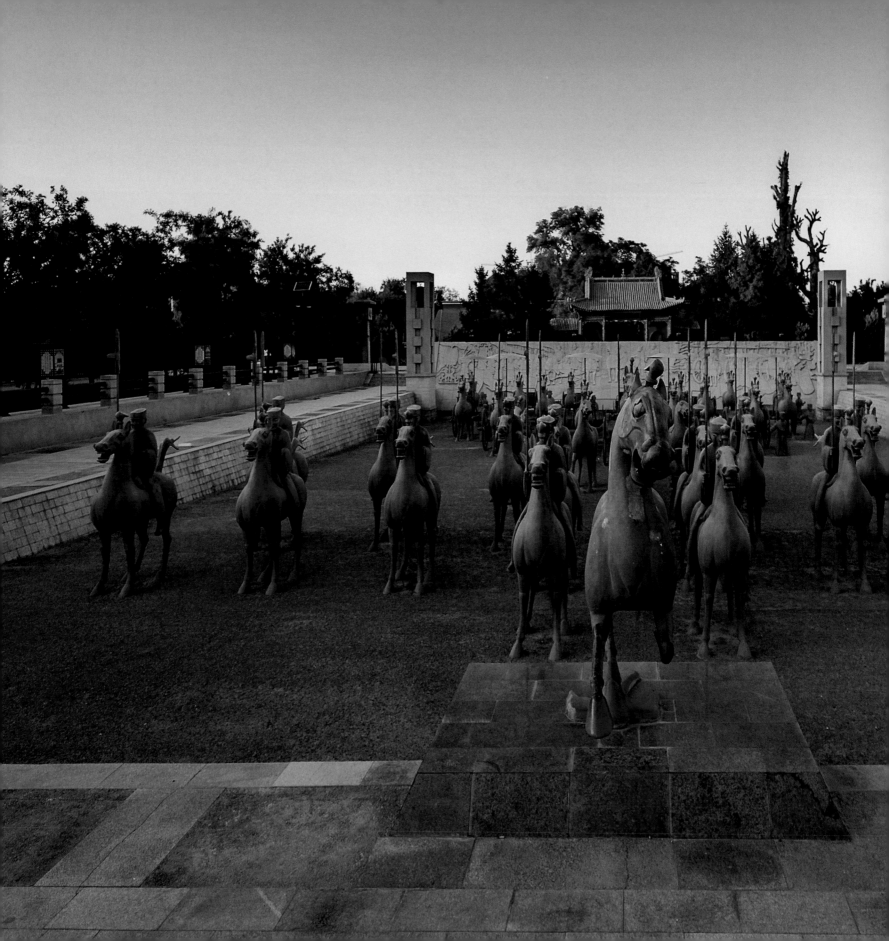

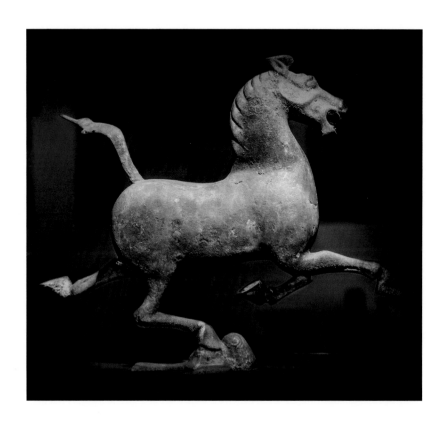

國家一級文物「銅奔馬」，又名「馬踏飛燕」，現藏於甘肅省博物館。（左）因其巧妙的構思及高超的鑄造技藝，被定為國家旅遊局及「中國優秀旅遊城市」的標誌。（右）

Grade-one cultural relics Bronze Running Horse, also known as the "Galloping Horse Treading on a Flying Swallow", is now at the Gansu Provincial Museum. (Left) Due to its ingenious design and excellent craftsmanship, the Bronze Horse is the symbol of China National Tourism Administration and China's Excellent Tourist Cities. (Right)

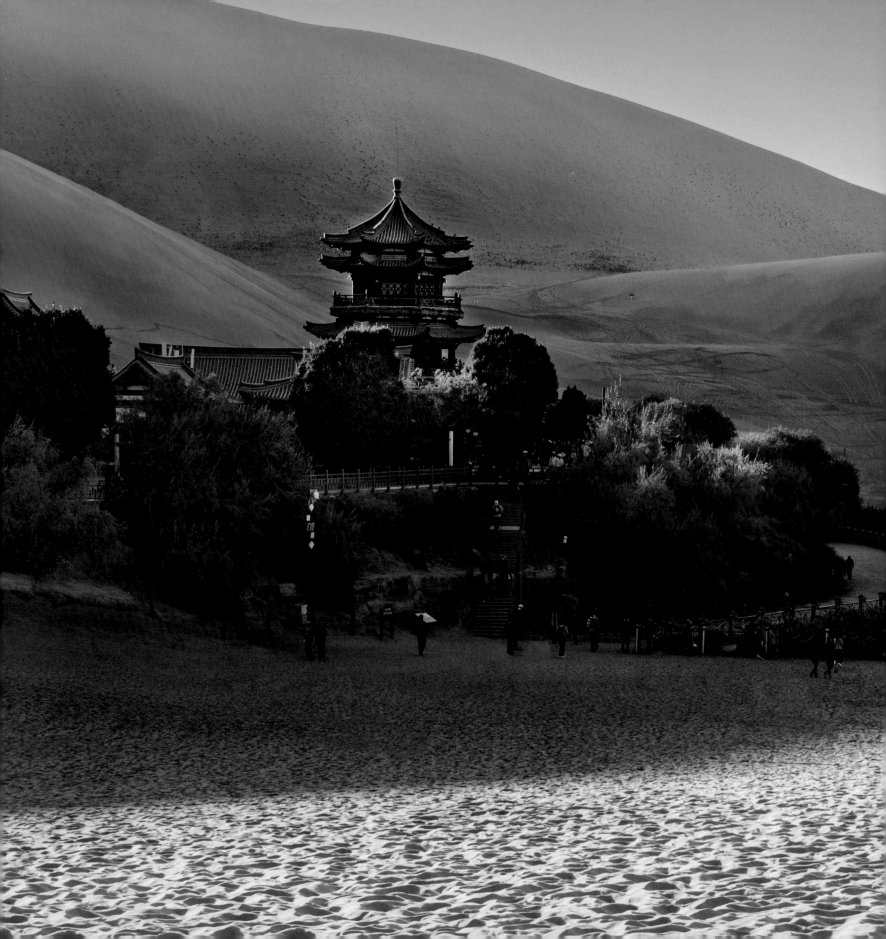

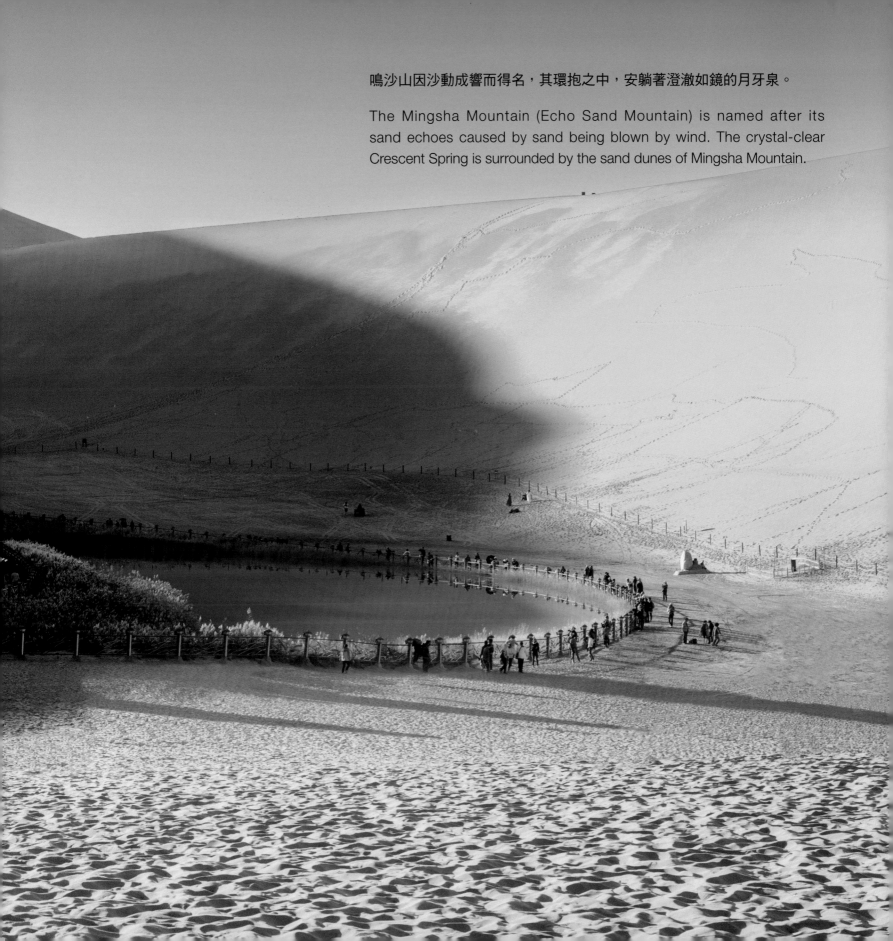

鳴沙山因沙動成響而得名，其環抱之中，安躺著澄澈如鏡的月牙泉。

The Mingsha Mountain (Echo Sand Mountain) is named after its sand echoes caused by sand being blown by wind. The crystal-clear Crescent Spring is surrounded by the sand dunes of Mingsha Mountain.

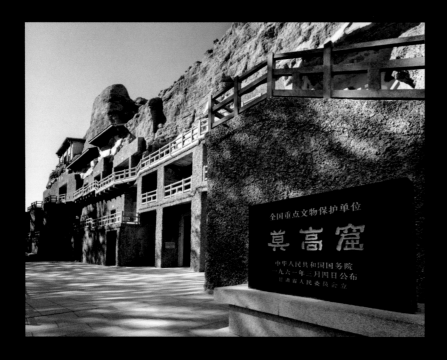

莫高窟俗稱千佛洞，歷經多個朝代長達千年的興建，匯聚了最上乘的佛教藝術。（右）1987 年，莫高窟被列為世界文化遺產。（左）

Mogao Caves, also known as the Caves of the Thousand Buddhas, contains the finest example of Buddhist art, with constructions in different dynasties spanning a period of 1,000 years in ancient China. (Right) The Mogao Caves became one of the UNESCO World Heritage Sites in 1987. (Left)

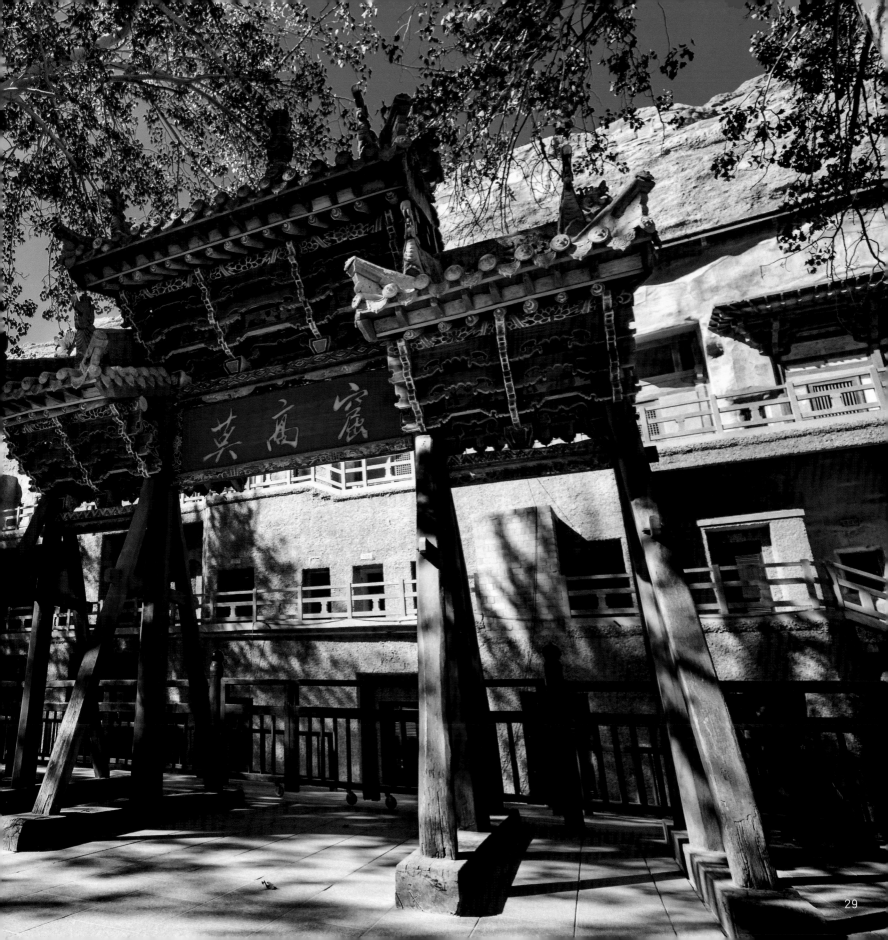

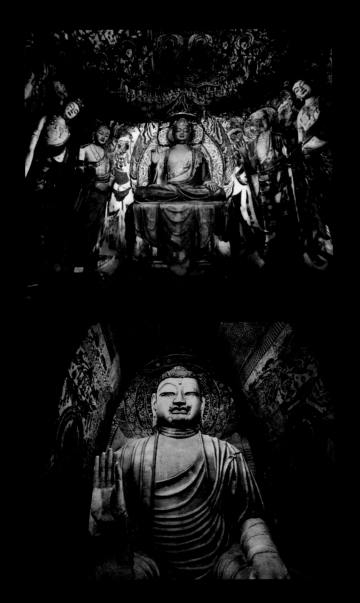

莫高窟以其精美的壁畫和塑像而聞名於世。（右）
圖為其中一個洞窟，照其風格推算應建於盛唐時
期。（左上）敦煌石窟內的群體塑像一般以佛居中，
兩側侍立著各種佛教人物。（左下）

The Mogao Caves is well-known for its exquisite
murals and sculptures. (Right) The picture shows
one of the caves, which is estimated to be created
in the peak era of Tang Dynasty according to its
style. (Upper Left) In Dunhuang's caves, Buddha is
generally shown as the central statue, attended by
other characters in Buddhism. (Lower Left)

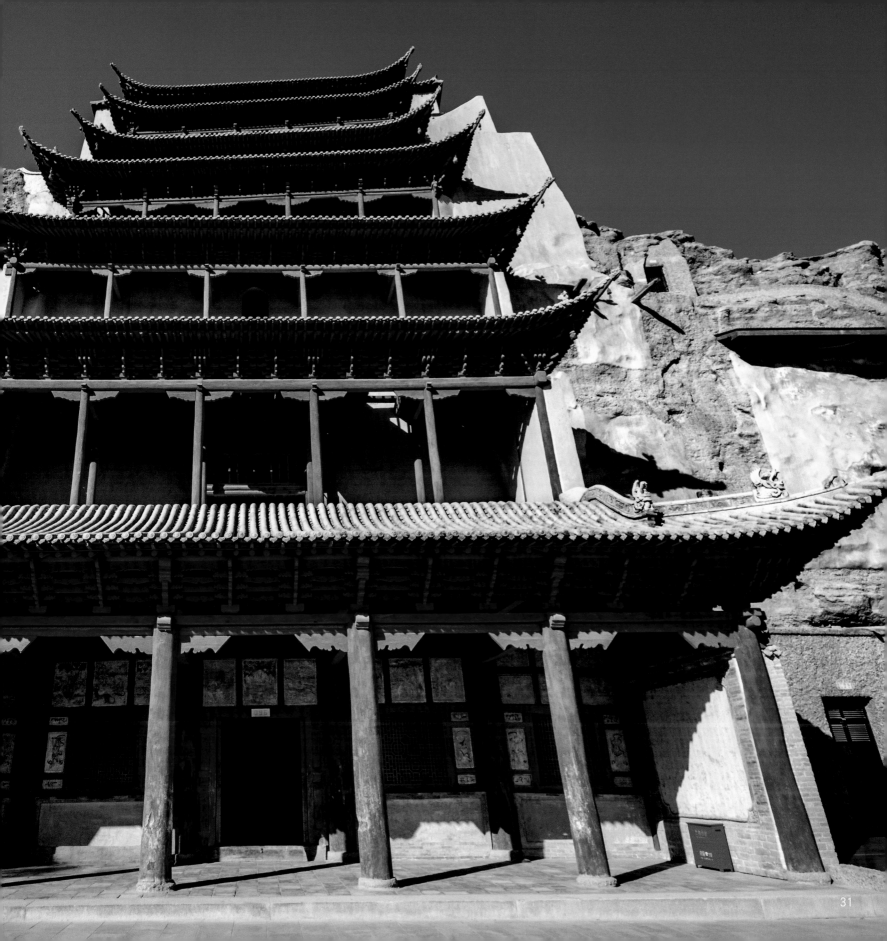

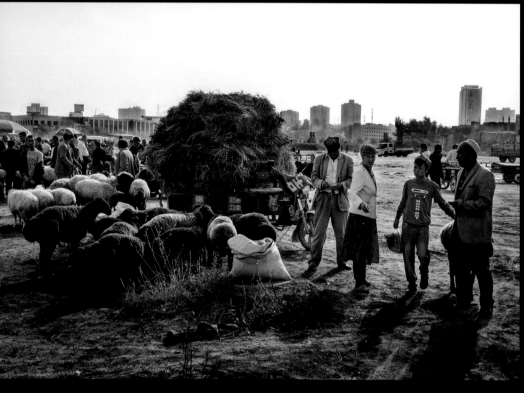

新疆是中國陸地面積最大的省級行政區，位於西北部，是近 20 個少數民族世代居住的地方，首府為烏魯木齊。在全國最西端的城市喀什，喀什噶爾古城擁有 2,100 多年歷史，是古絲路南北路線交匯之處。（右）露天市集上購買牲口的維吾爾族人，正在迎接節日的到來。（左）

Xinjiang is the largest provincial-level region of China in the northwest of the country, which is the traditional habitat for nearly 20 ethnic minorities. Urumqi is its provincial capital. In the westernmost city of Kashgar, the Old City, with more than 2,100 years of history, was the intersection of the northern and southern route of the ancient Silk Road. (Right) The Uyghurs are buying livestock from an outdoor market for the upcoming festival. (Left)

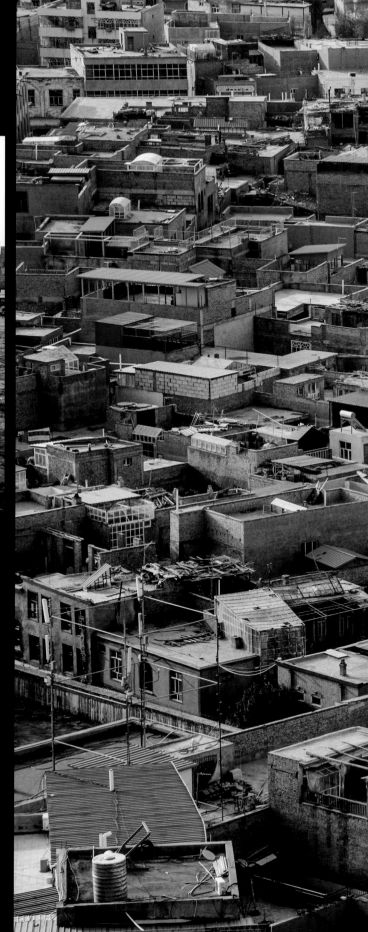

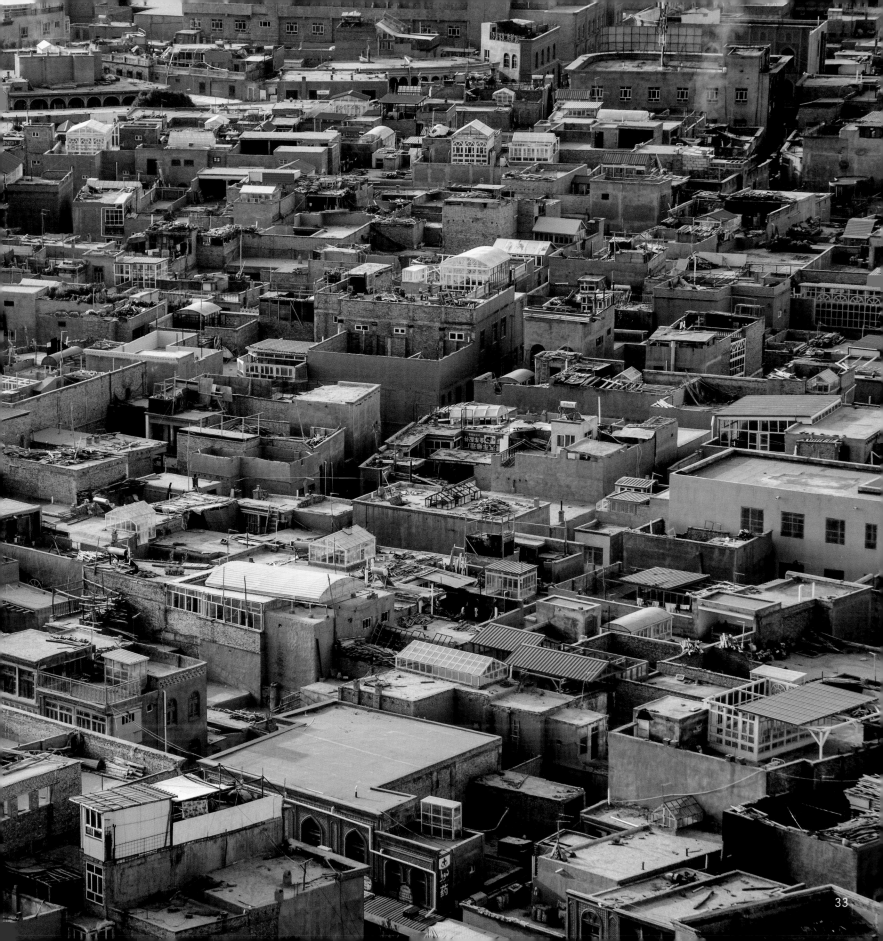

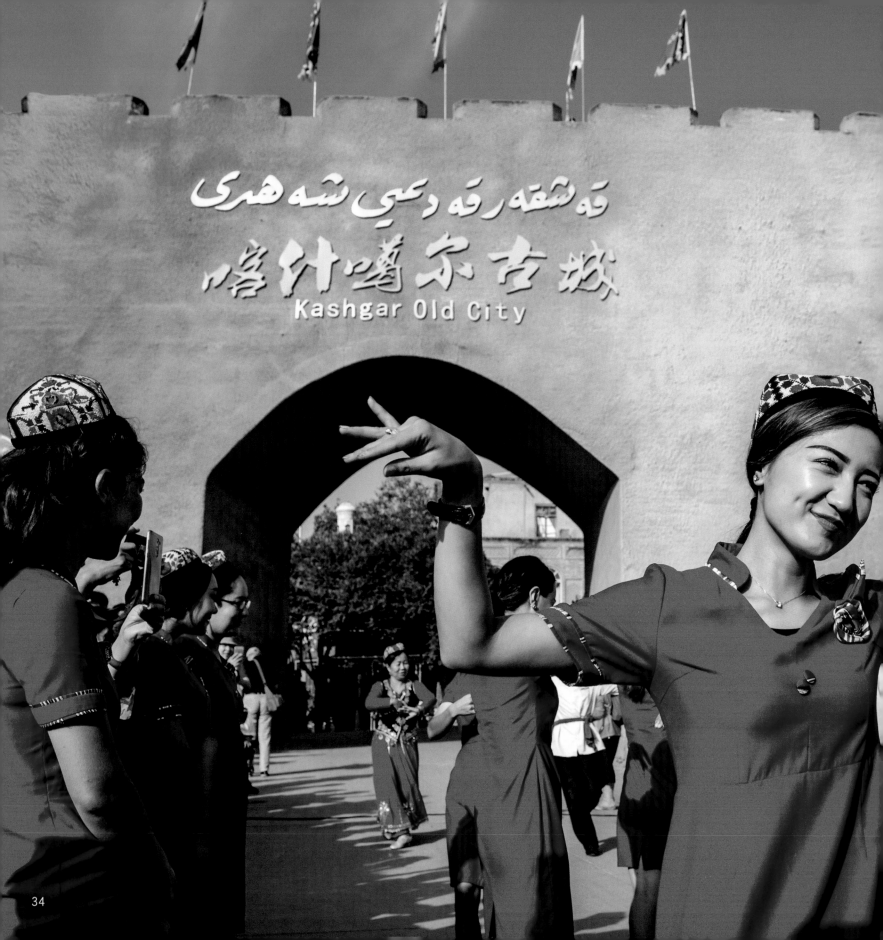

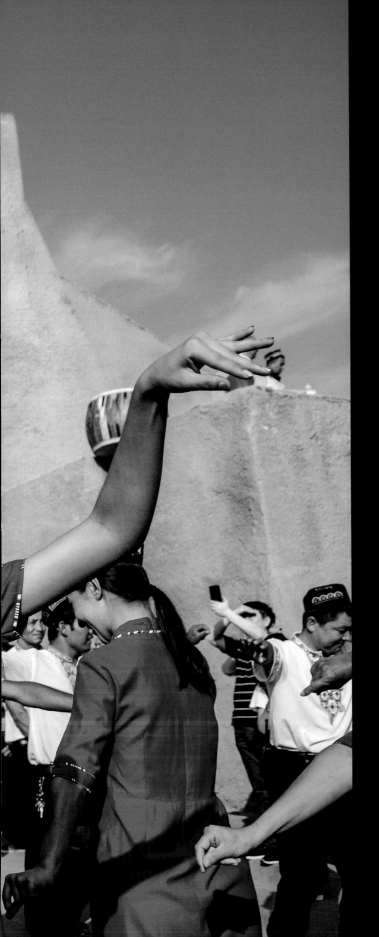

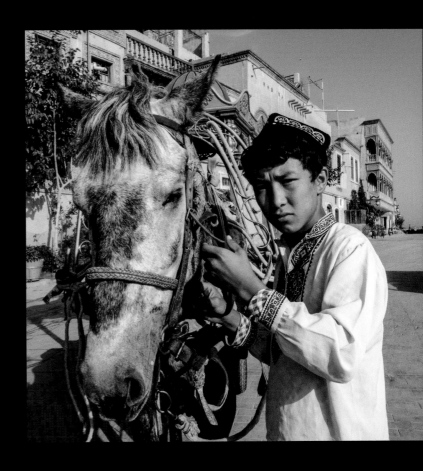

古爾邦節當天，穆斯林人們隨著廣場上歡快的音樂聲而翩翩起舞。（左）他們穿上新衣，齊聚喀什噶爾古城歡度節日。（右）

On the Eid al-Adha, Muslim people dance happily together to the music on the square. (Left) They would put on new clothes and gather at the Kashgar Old City to celebrate the festival. (Right)

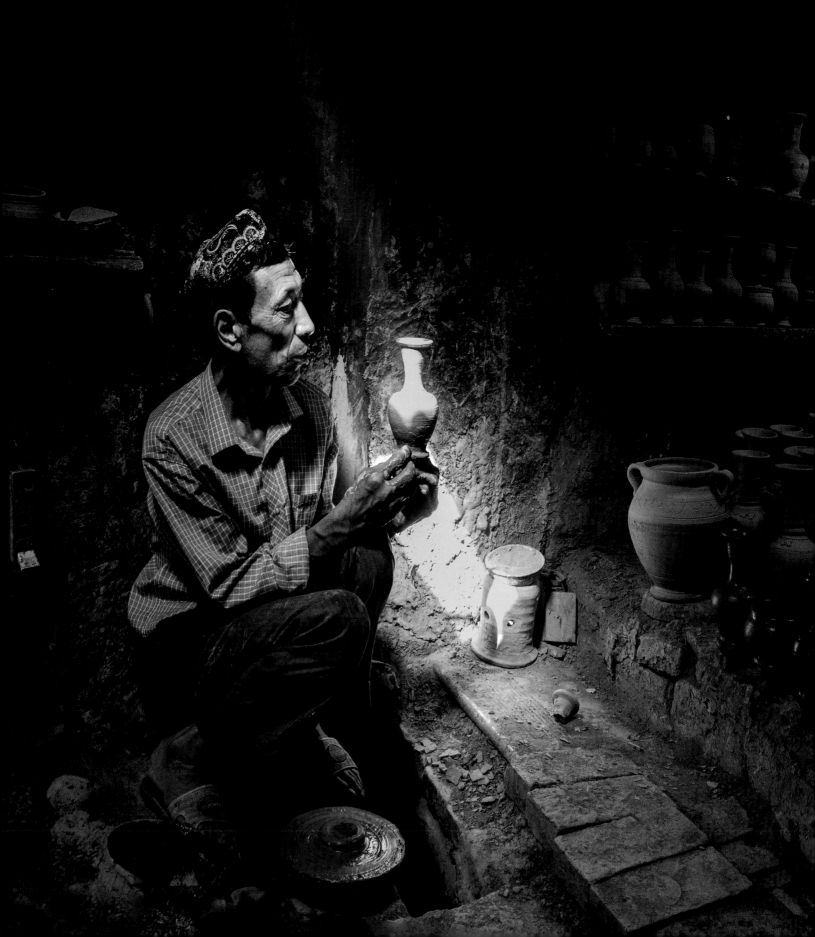

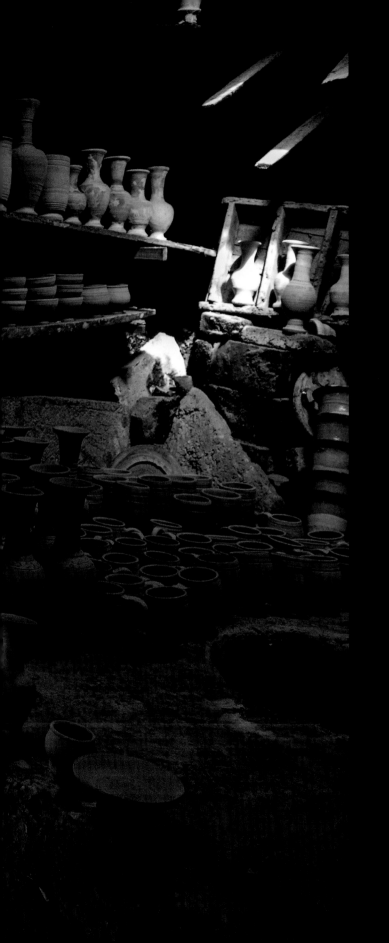

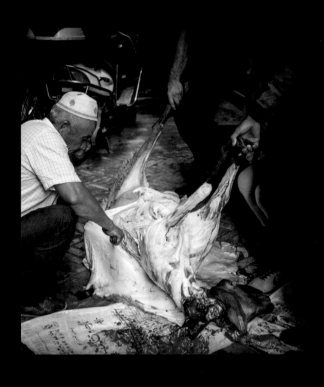

穆斯林人們會在宰牲節當天屠宰牲口。（右）在宰牲現場的附近有一個燒製土陶的窯洞。新疆的土陶燒製技藝已有兩千多年的歷史，隨著古代絲綢之路興起，期間不斷發展創新，一直流傳至今。（左）

Muslims would sacrifice livestock on the "Feast of the Sacrifice". (Right) There is a cave for firing potteries near the sacrifice location. With a history of more than 2,000 years, the firing technique of Xinjiang's earthenware has been continuously refined during the development of ancient silk road, and has been passed down to present time. (Left)

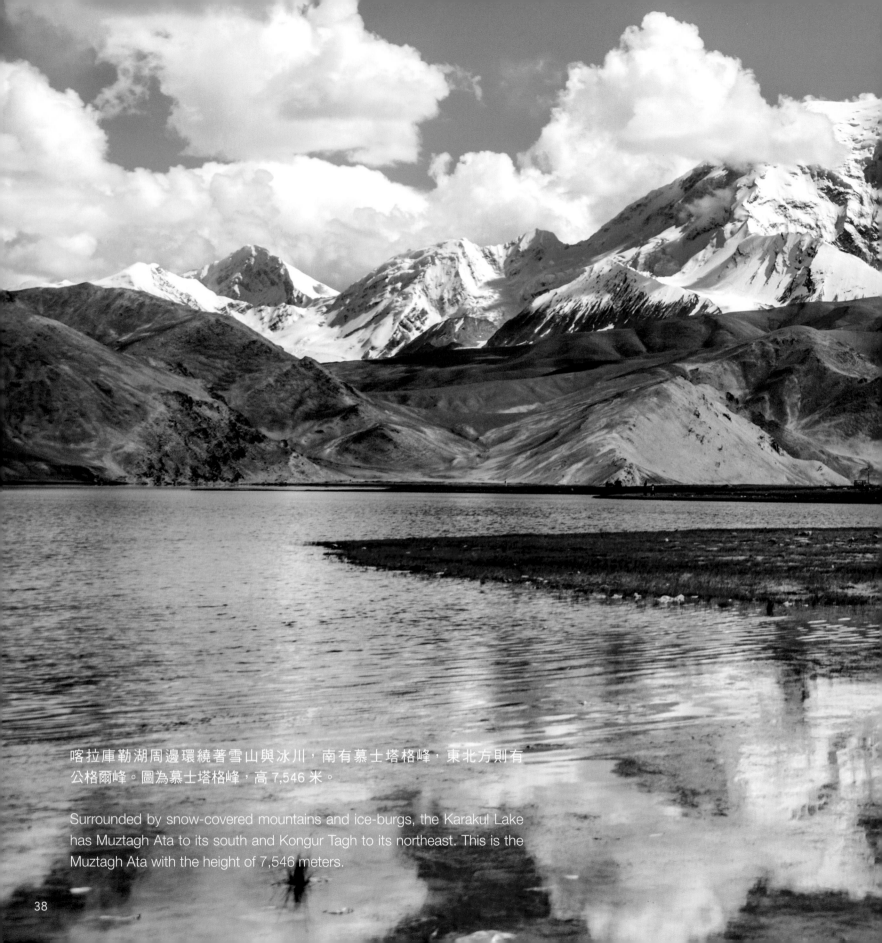

喀拉庫勒湖周邊環繞著雪山與冰川，南有慕士塔格峰，東北方則有
公格爾峰。圖為慕士塔格峰，高 7,546 米。

Surrounded by snow-covered mountains and ice-burgs, the Karakul Lake
has Muztagh Ata to its south and Kongur Tagh to its northeast. This is the
Muztagh Ata with the height of 7,546 meters.

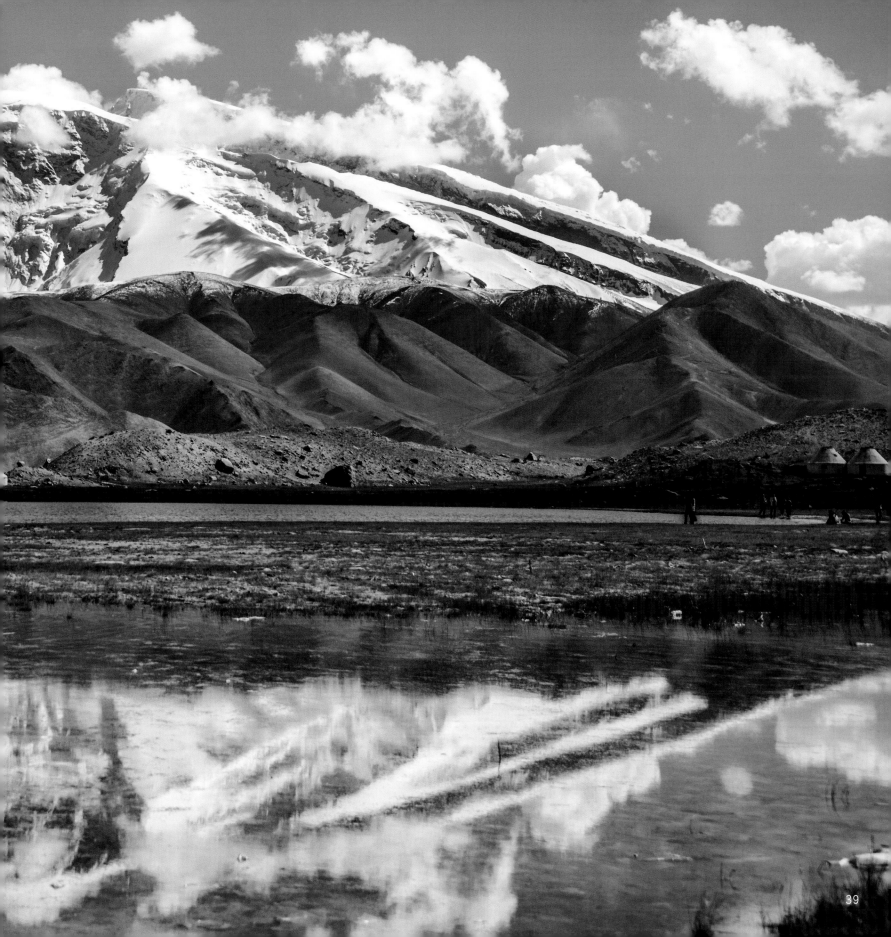

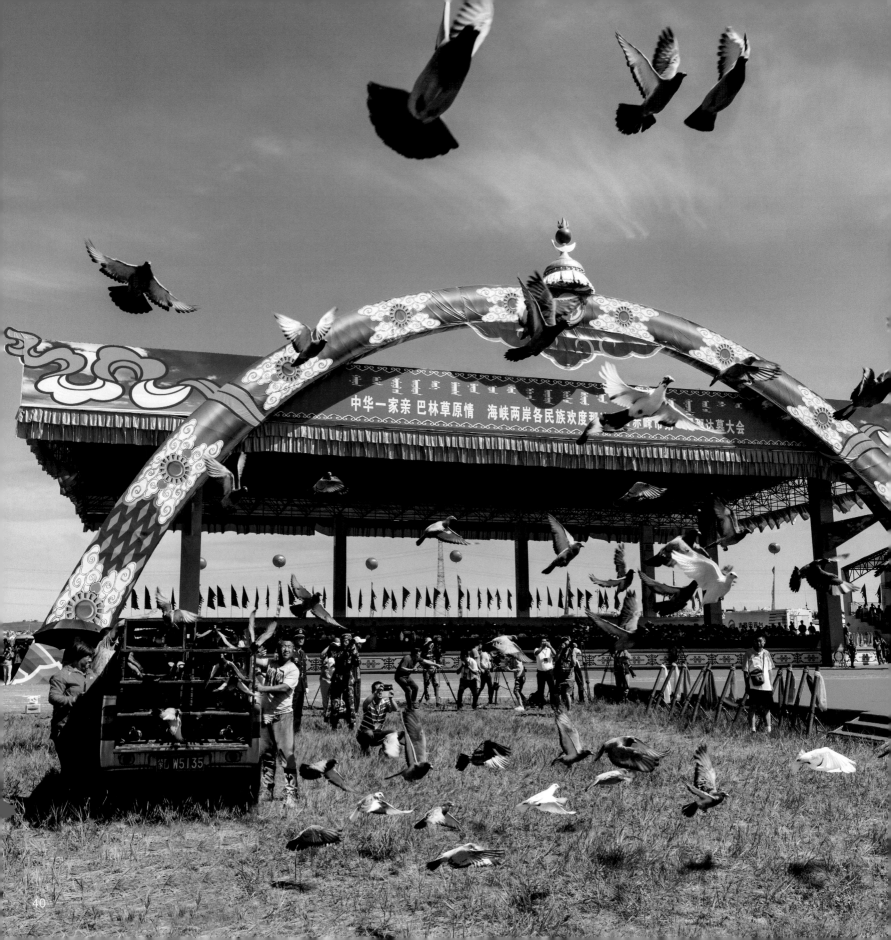

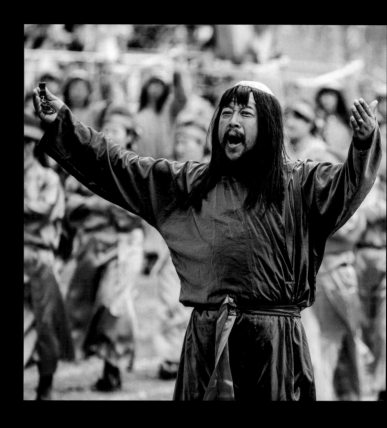

位於北部邊疆的內蒙古，地域遼闊，擁有豐富的自然資源。
在中國古代，草原絲綢之路亦是其中一條重要的貿易通道。
那達慕大會是蒙古族極具民族特色的活動。（左）在開幕
儀式上設有表演節目，其中蒙古長調是蒙古族傳統音樂，
不僅歌曲時間較長，每個字的音節亦會被延長。（右）

Inner Mongolia is in the north of China, with vast lands and
rich natural resources. In ancient China, the grassland silk
road was also an important trading route. The Naadam
festival is a featured Mongols activity. (Left) At the opening
ceremony, the performance of long drawn song is a
traditional music genre of this ethnic group – both the
length of the song and each syllable of text are extended to
longer duration. (Right)

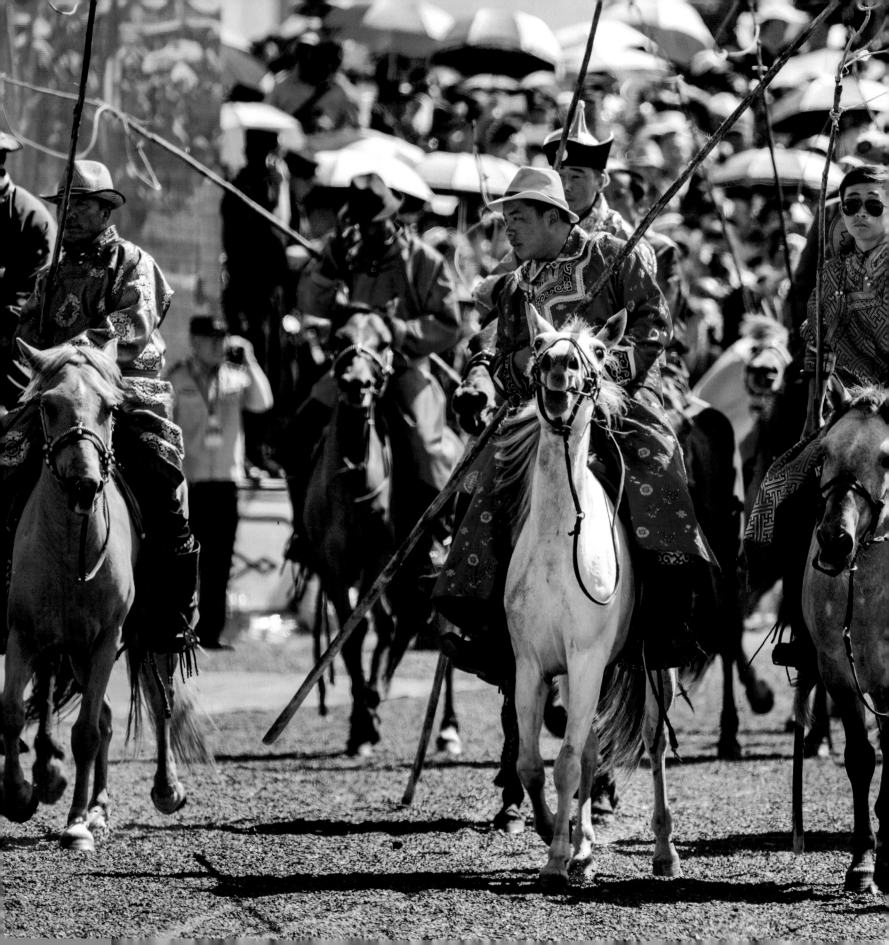

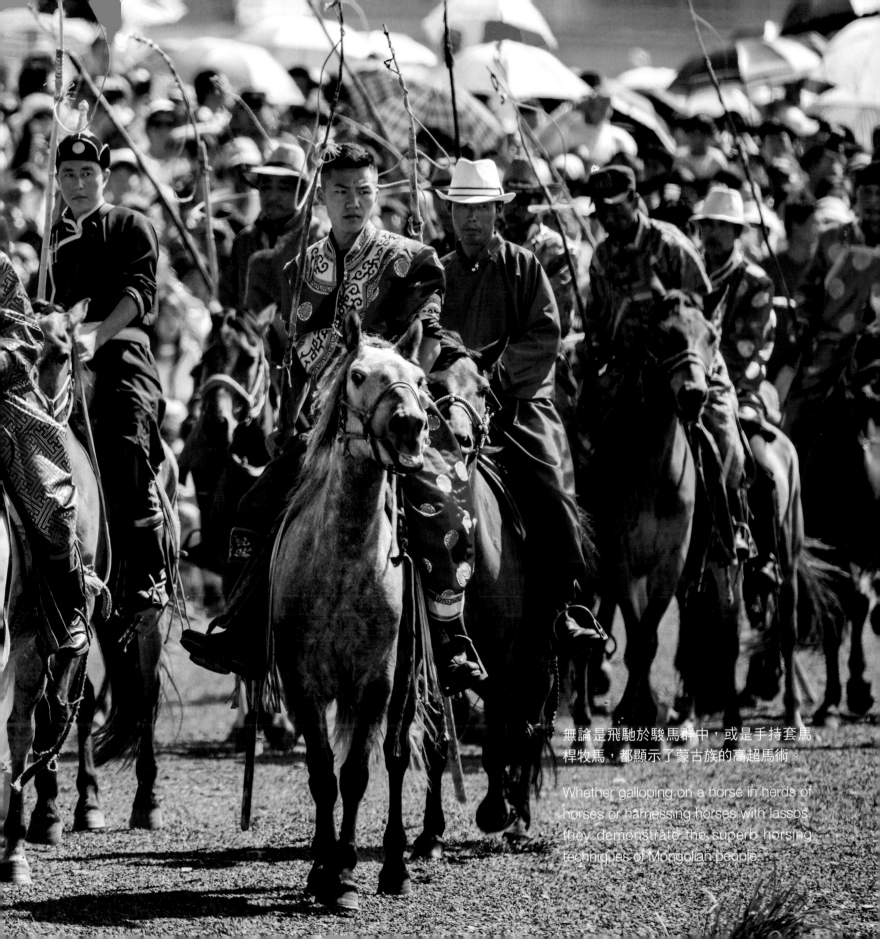

無論是飛馳於駿馬群中，或是手持套馬桿牧馬，都顯示了蒙古族的高超馬術。

Whether galloping on a horse in herds of horses or harnessing horses with lassos, they demonstrate the superb horsing techniques of Mongolian people.

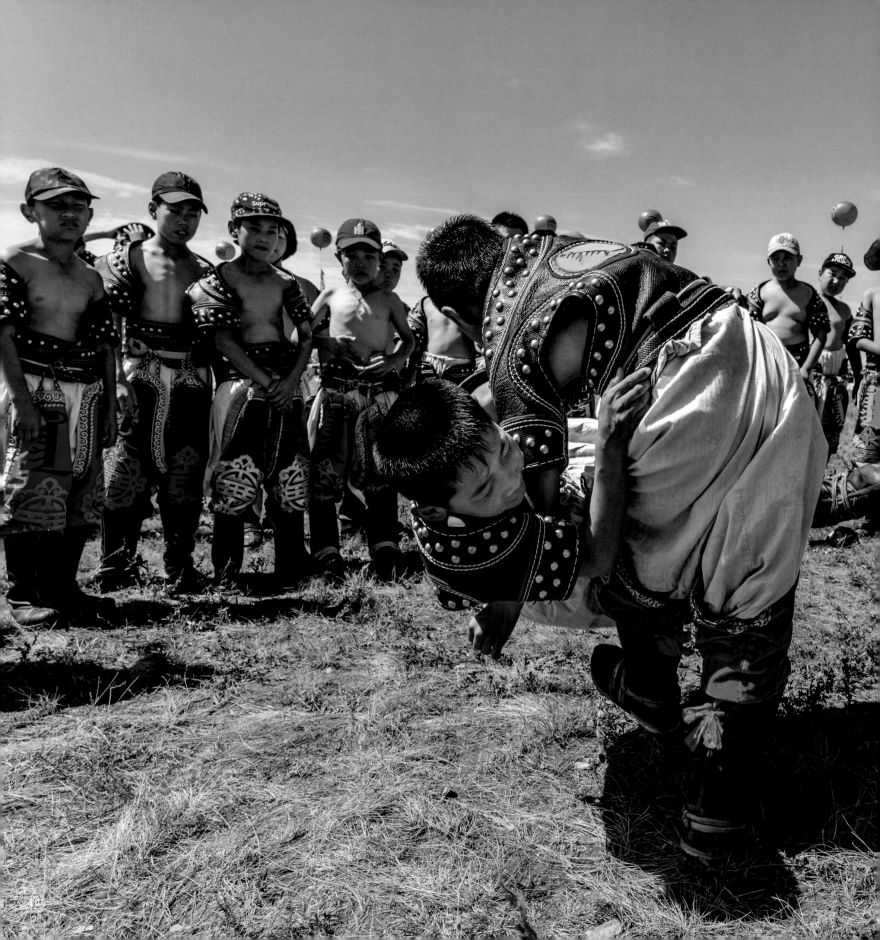

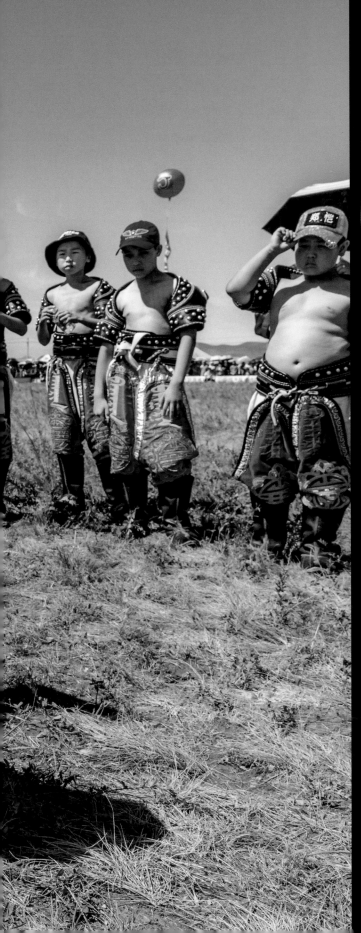

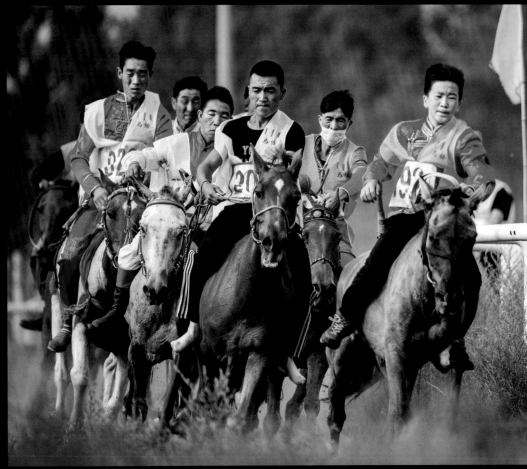

「男兒三藝」之一搏克，即蒙古式摔跤，象徵著勇敢和力量，蒙古族的孩童亦擅於搏克。（左）賽馬亦為蒙古族的「三藝」之一，那達慕大會上的賽馬比賽十分緊張刺激。（右）

Mongolian wrestling, one of the traditional "Three Manly Skills", represents courage and physical strength. In Inner Mongolia, even kids are good at it. (Left) Horse racing is also one of the traditional "Three Skills". This event is one of the most exciting and intense competitions in Naadam festival. (Right)

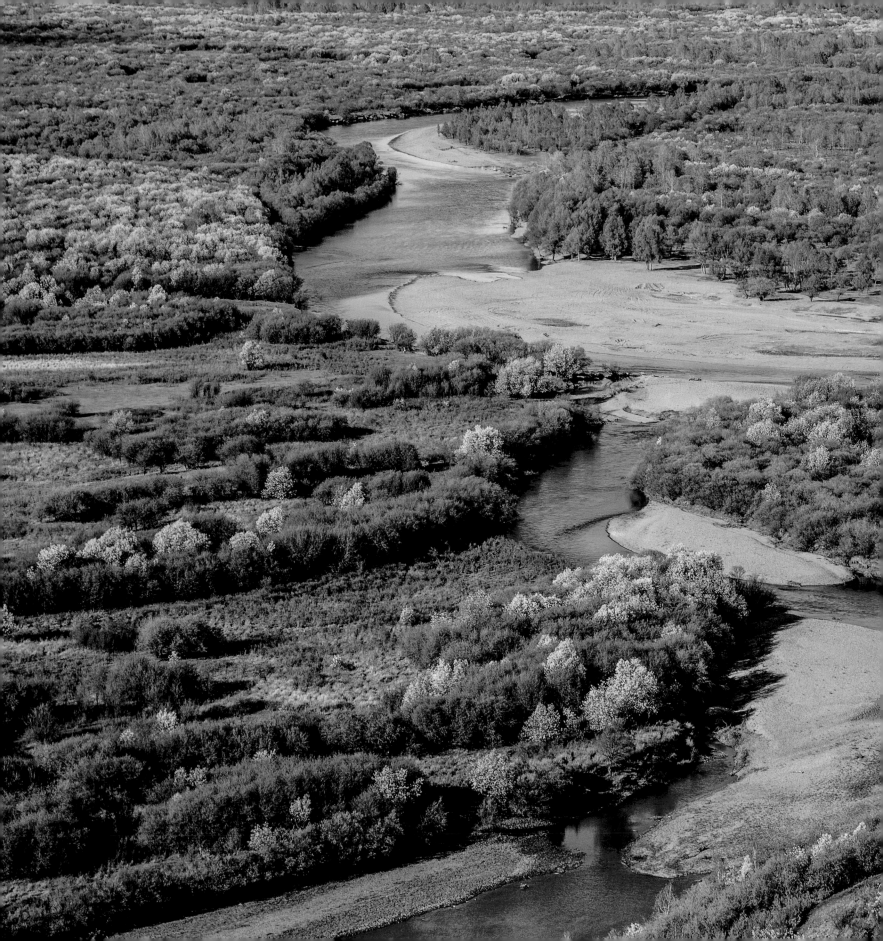

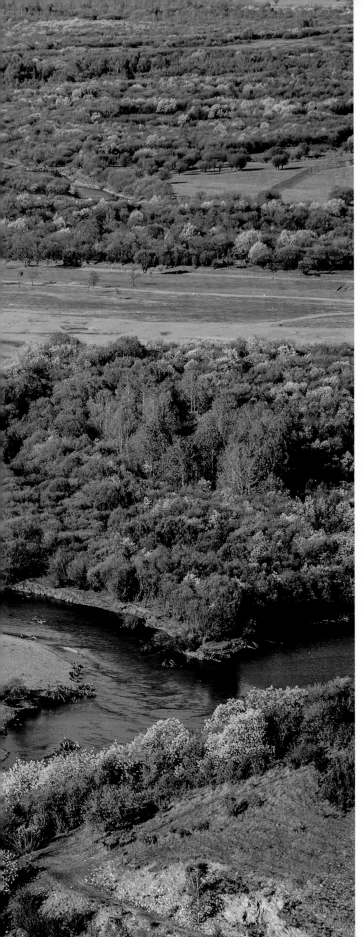

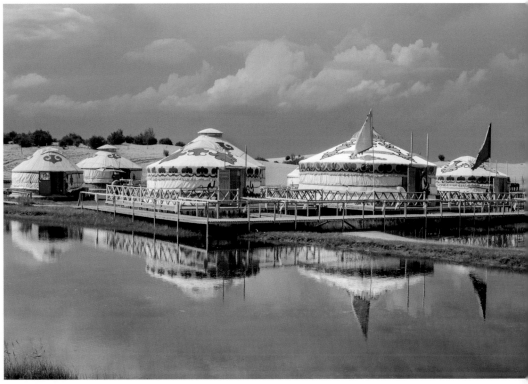

位於內蒙古額爾古納的根河濕地，是中國最原始、最廣闊的濕地，有「亞洲第一濕地」之稱。(左)蒙古包是草原上遊牧民族的傳統居所。(右)

Genhe Wetland in Eerguna, Inner Mongolia, is the most natural and largest in China, also known as "the first wetland in Asia". (Left) A Mongolian ger is a traditional dwelling by nomads on steppe. (Right)

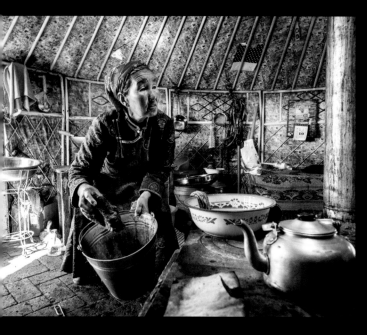

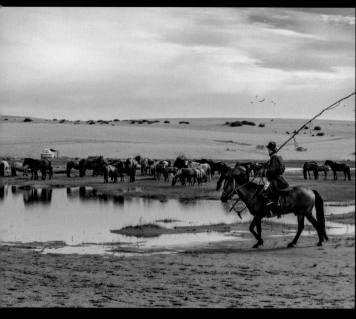

馬是蒙古族重要的夥伴、資產及家畜。（右）在此，連馬糞
也非常有用，是當地人重要的燃料。（左上）男子手持
套馬桿牧馬。（左下）

Horses are important partners, assets and livestock of
Mongolian families. (Right) Even dried horse dungs are
used as fuel for local people. (Upper Left) A man is herding
horses with a lasso. (Lower Left)

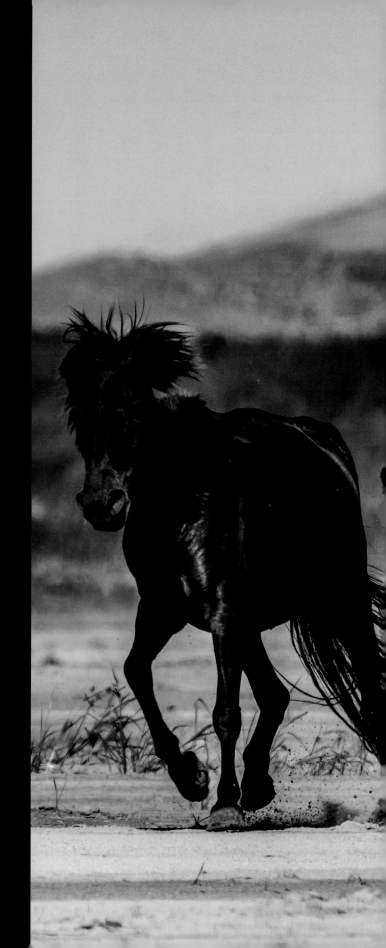

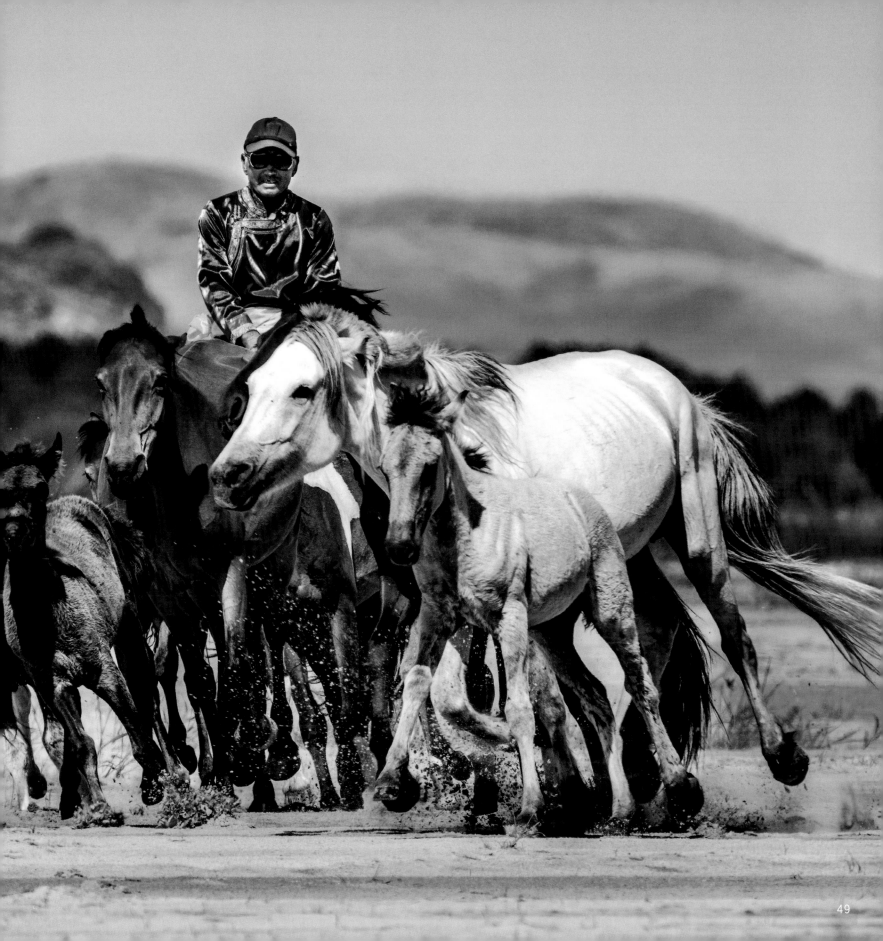

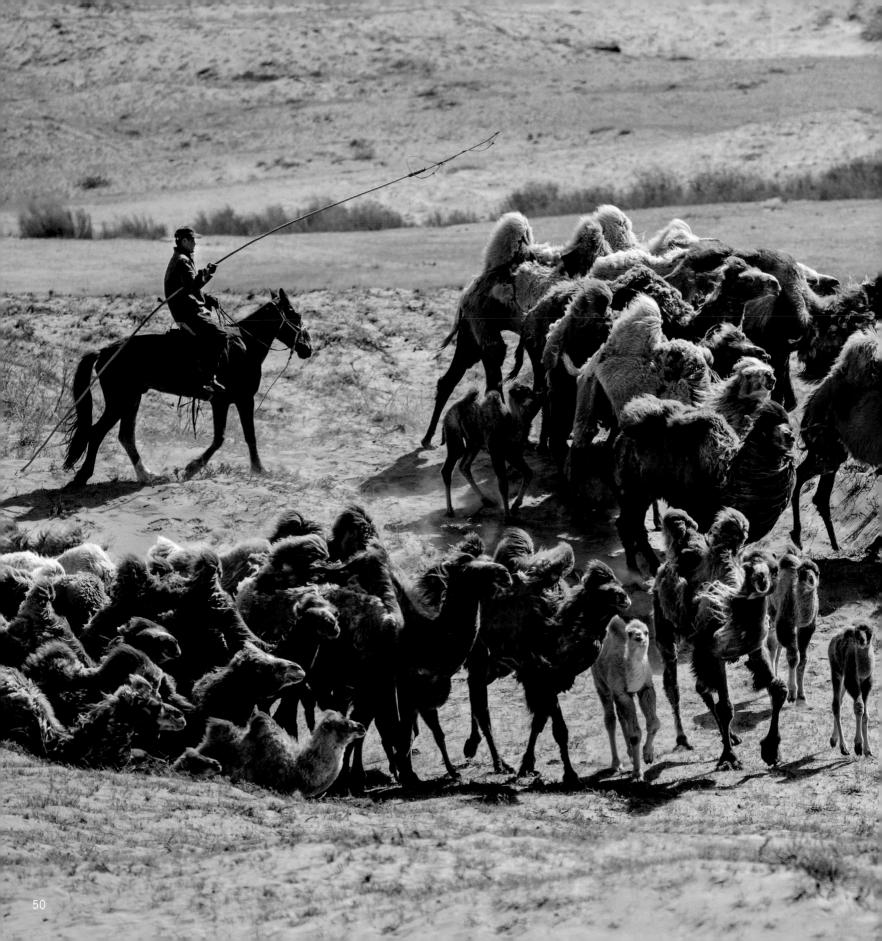

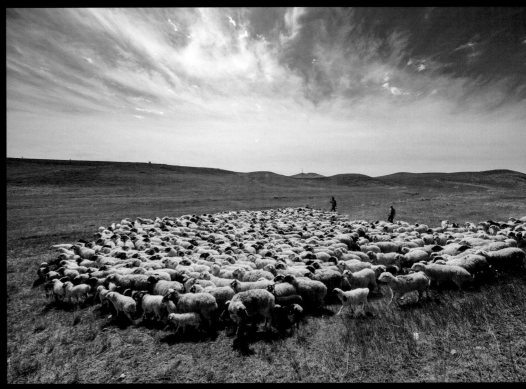

駱駝及羊都是生活在沙漠和戈壁地區的蒙古族家庭的重要家畜。（左）「天蒼蒼，野茫茫，風吹草低見牛羊。」（右）

Camels and sheep are important livestock for Mongolian families who live in the desert or Gobi areas. (Left) "Under the blue sky there lies the endless prairie; in the gentle breeze you can see the herds of animals." (Right)

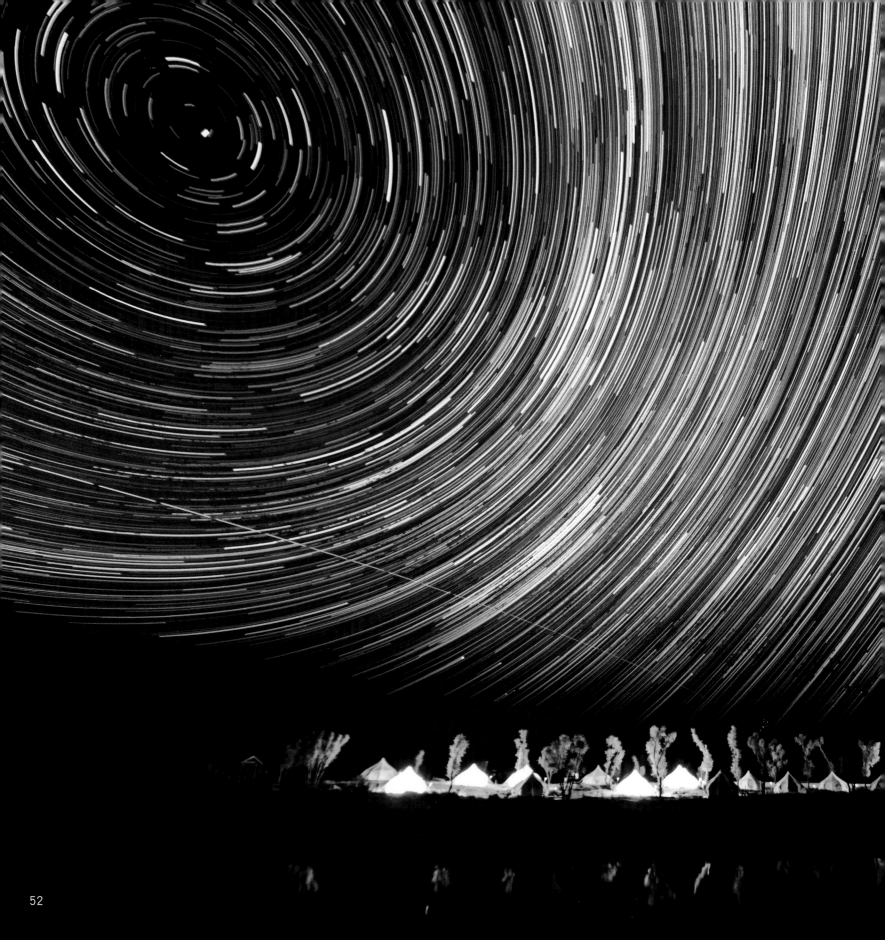

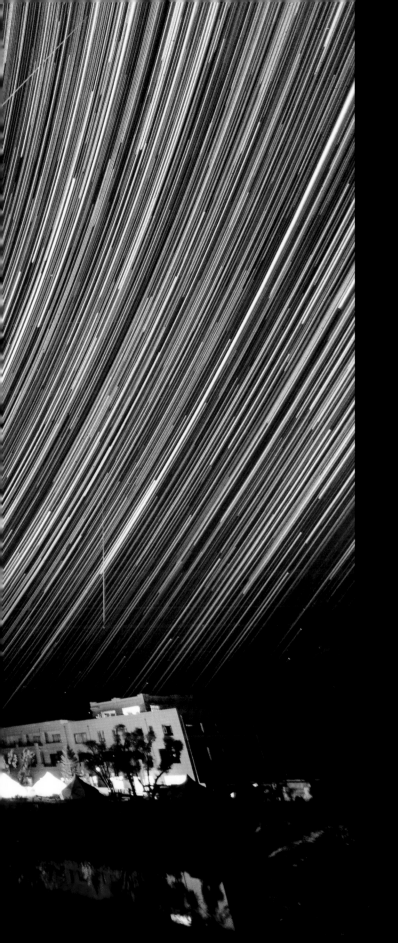

在一般的都市中，燈光非常充足，因此往往無法觀賞到夜空中的繁星。在玉龍沙湖，夜晚十分靜謐。（右）迷人的景色，在螺旋形星流跡的襯托之下，更加美不勝收。（左）

Stars are hard to perceive at nights in normal cities due to strong electronic lights. At Yulong Sand Lake, however, the night is extremely tranquil. (Right) It is fascinating to view the night scene under the clear and mesmerizing star trails in concentric circle. (Left)

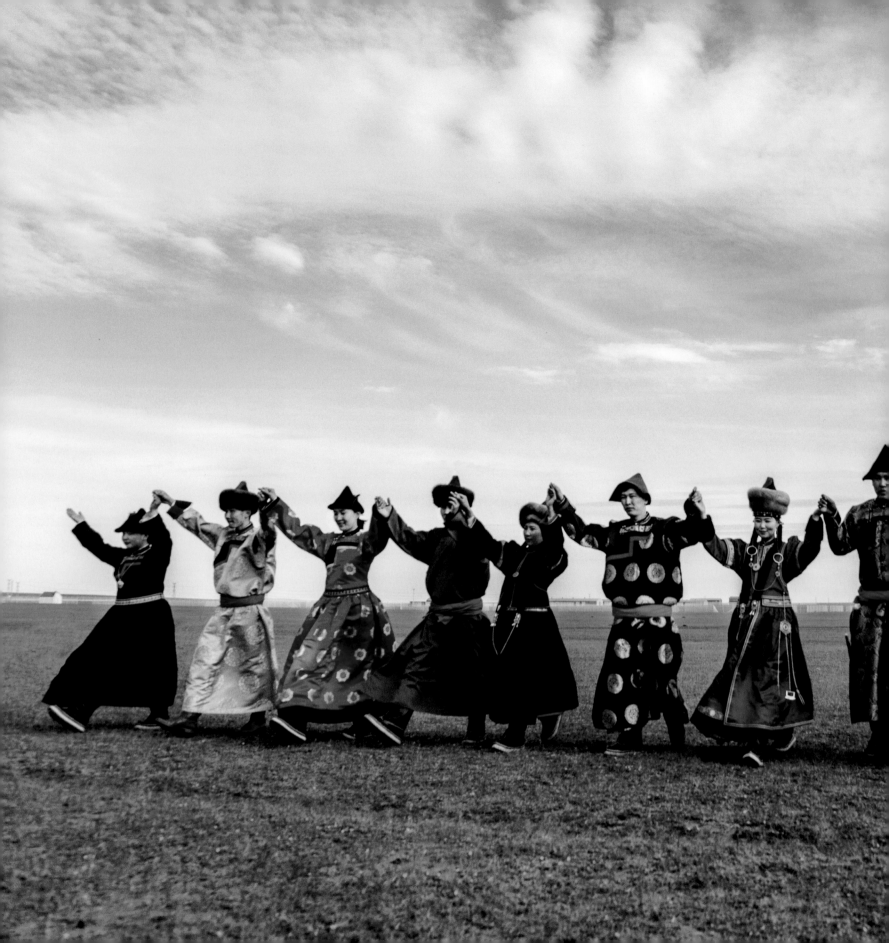

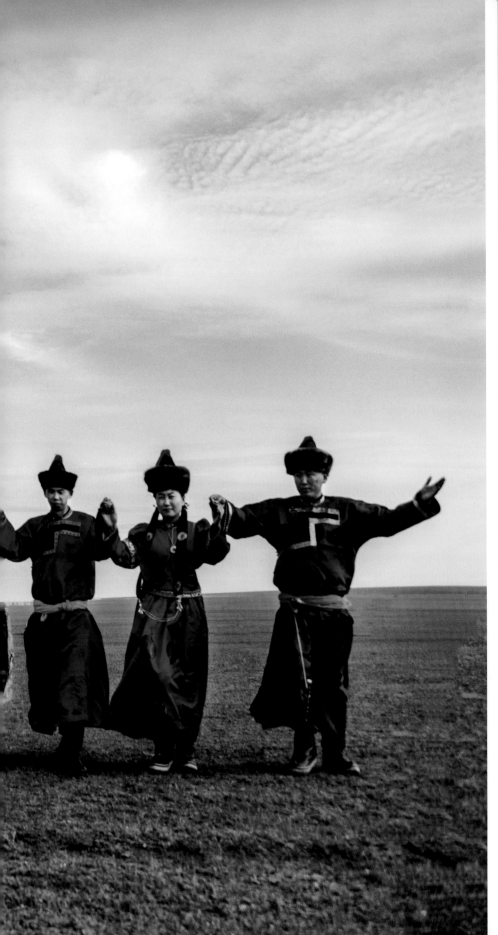

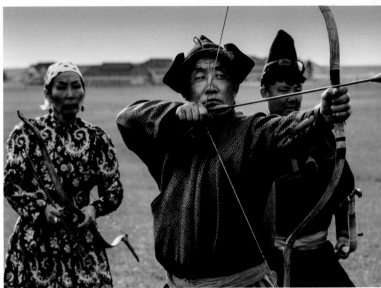

那達慕是蒙古族的重要節日，身穿傳統服飾的蒙古族人民齊聚。（左）蒙古族人大多能歌善舞。（右上）大會上更設有「男兒三藝」之一——射箭比賽。（右下）

Naadam is an important festival for Mongolian people, at which they would wear traditional clothes and get together. (Left) Most Mongolian people are good at singing and dancing. (Upper Right) There is archery (one of the "Three Manly Skills") competition in Naadam. (Lower Right)

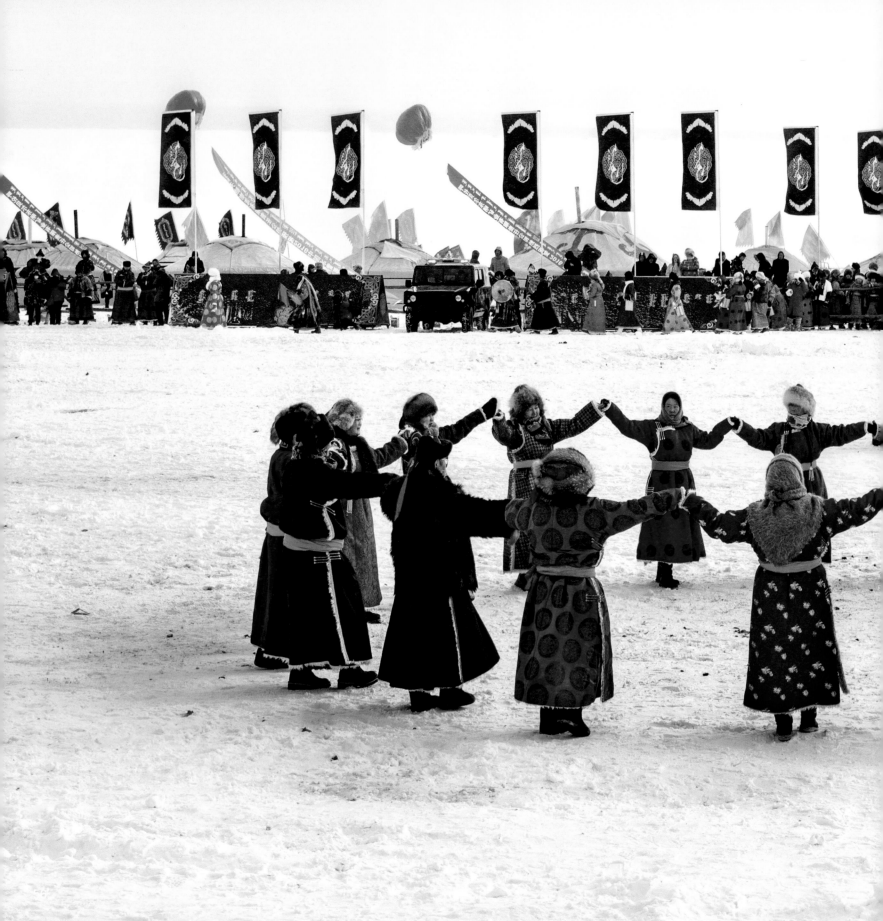

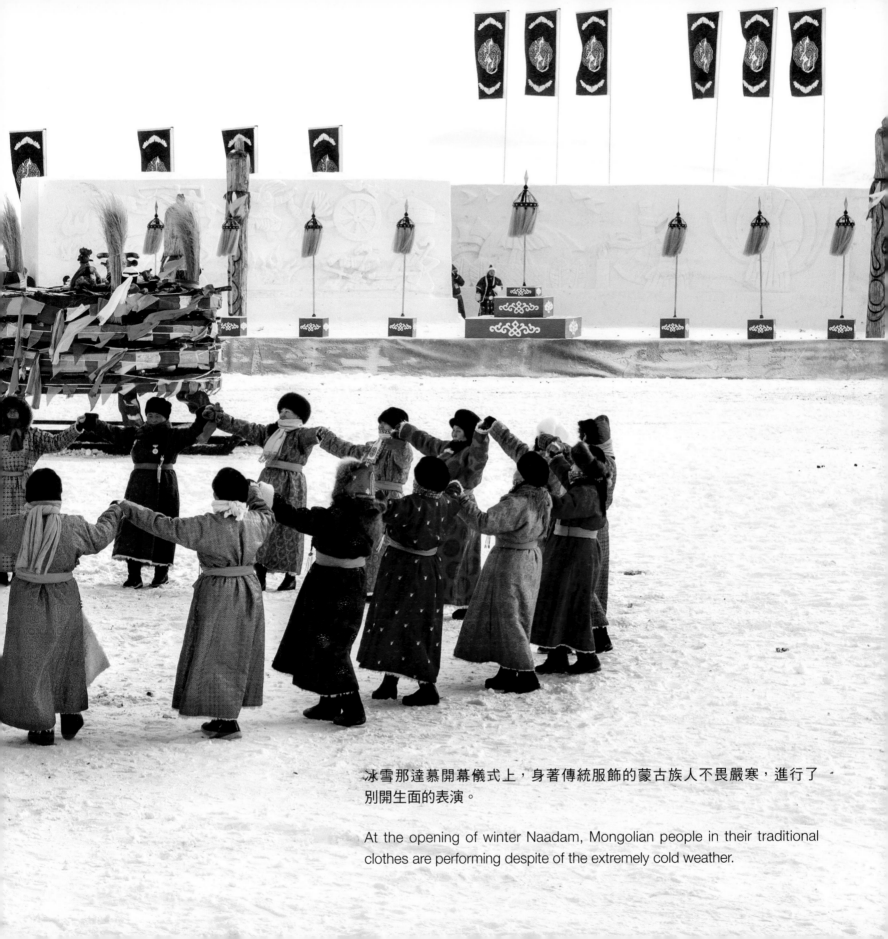

冰雪那達慕開幕儀式上，身著傳統服飾的蒙古族人不畏嚴寒，進行了別開生面的表演。

At the opening of winter Naadam, Mongolian people in their traditional clothes are performing despite of the extremely cold weather.

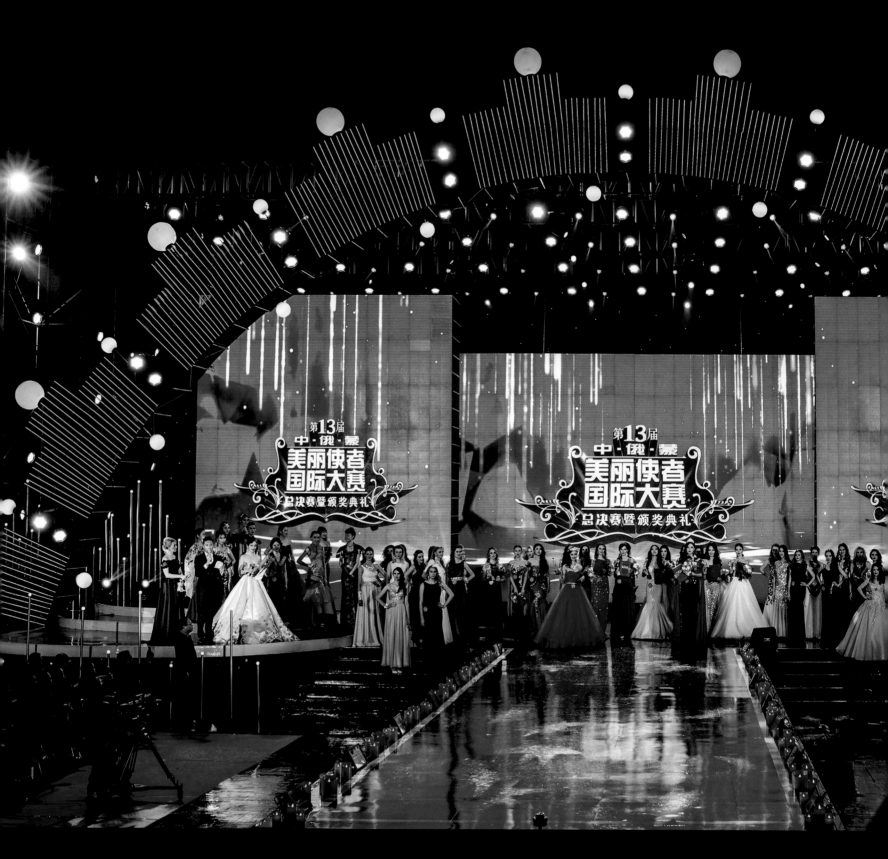

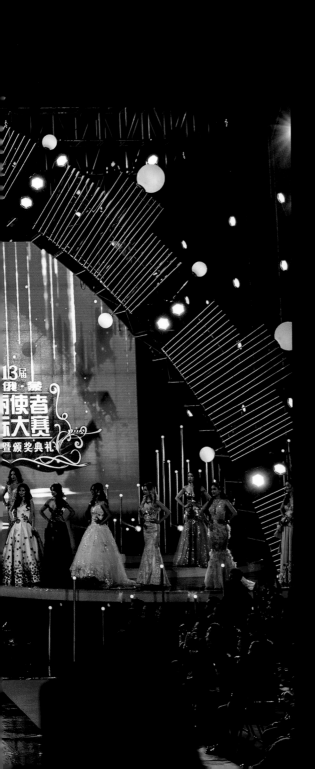

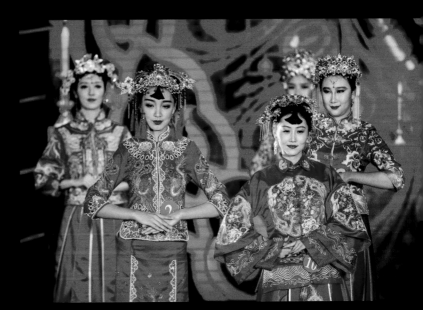

中俄蒙美麗使者國際大賽於滿洲里舉行。（左）佳麗展示各自的
民族服飾。（右上）鮮紅的中式嫁衣映襯出美麗的臉龐。（右下）

An international beauty pageant with contestants from
China, Russia and Mongolia was held in Manzhouli. (Left)
Contestants are presenting their national costumes. (Upper Right)
The beautiful faces are outstanding with the bright red light cast b
the Chinese style wedding dresses. (Lower Right)

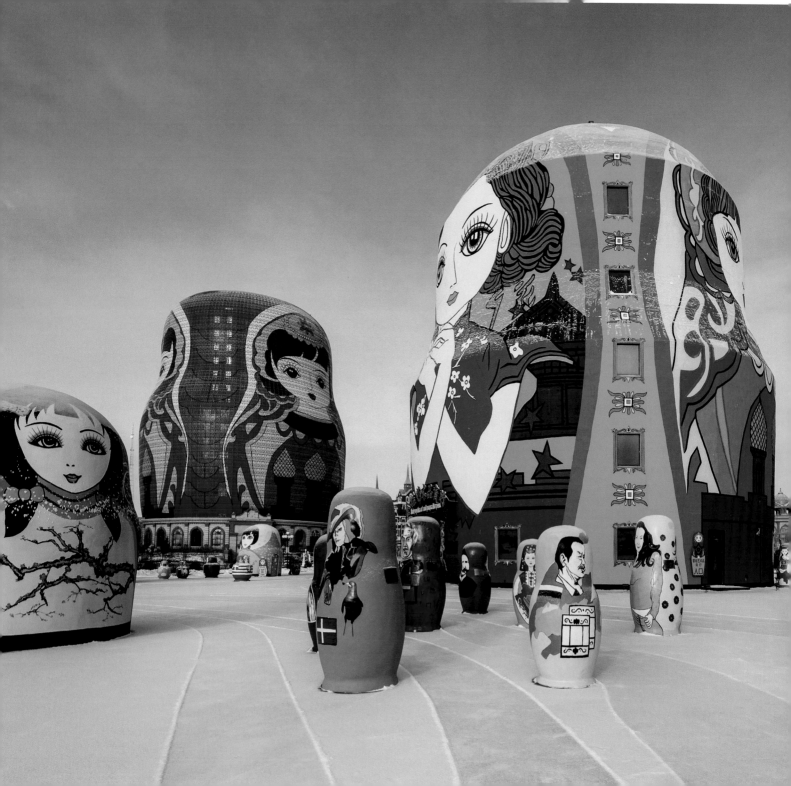

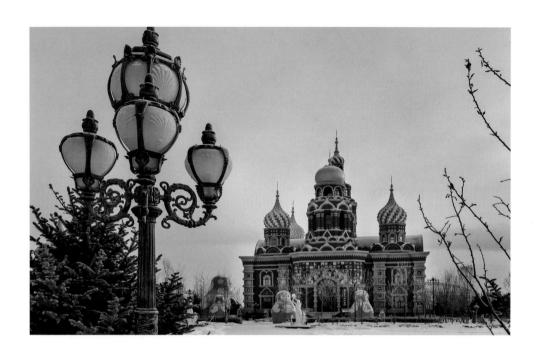

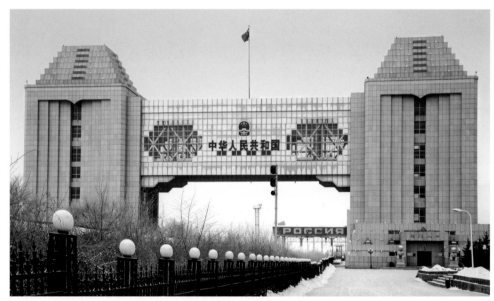

以俄羅斯傳統工藝為主題的套娃廣場。(左) 套娃主題酒店充滿了俄羅斯風情。(右上) 滿洲里位於中俄邊境,圖為滿洲里國門。(右下)

The Matryoshka Square is themed with the traditional Russian craftwork. (Left) The Matryoshka-theme hotel is filled with Russian flavor. (Upper Right) Manzhouli is located on the border of Russia. Picture shows the Manzhouli Nation Gate. (Lower Right)

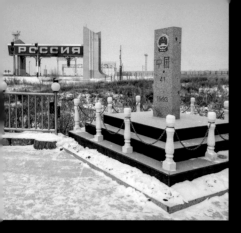

1994 年，中俄兩國勘界結束時，在邊境線上樹立起第 41 號界碑，象徵著國家領土的神聖不可侵。（左上）中俄蒙國際雪節在滿洲里舉行。（右）各類冰雕讓人目不暇接。（左下）

n 1994, China erected the No.41 Boundary Tablet at the borderline after the boundary survey with Russia, to emblem the inviolability of territory. (Upper Left) China-Russia-Mongolia ice and snow festival was held in Manzhouli. (Right) There are assorted dizzying ice sculptures at the festival (Lower Left).

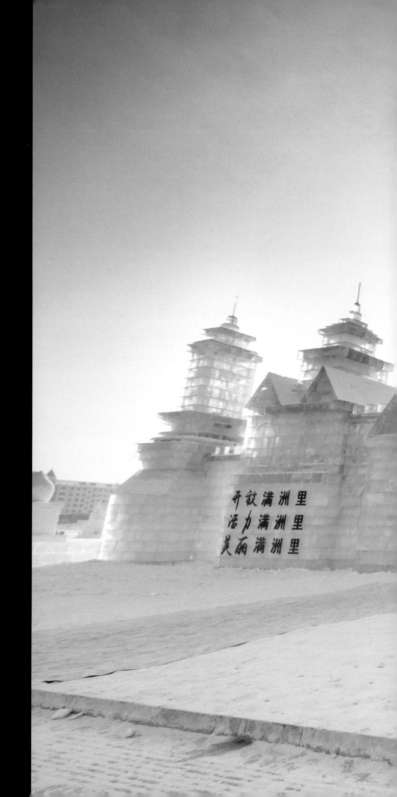

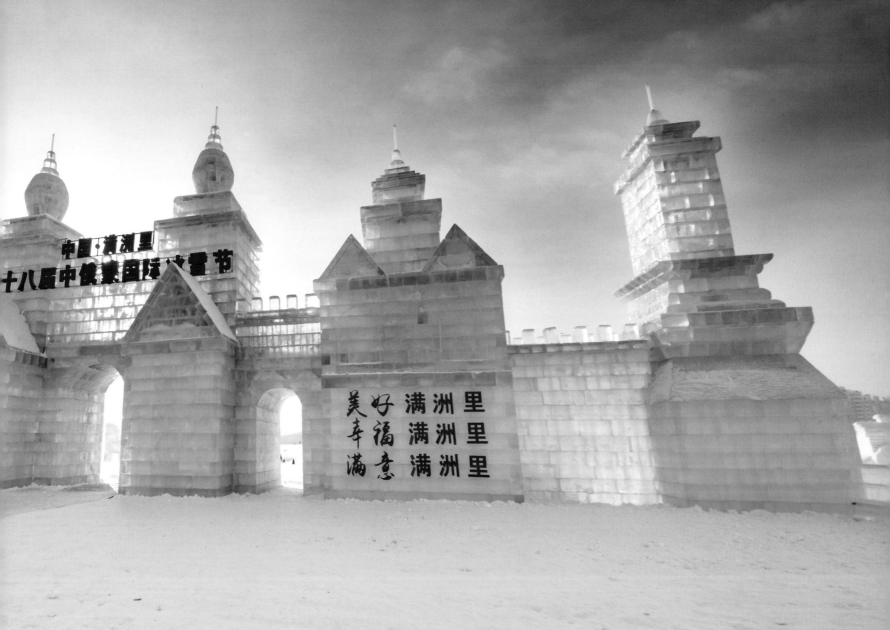

西藏位於有「世界屋脊」之稱的青藏高原之上，首府為拉薩。西藏是中國日照時間最長的地方，而拉薩的年平均日照時數更高達 3,000 小時，被稱為「日光城」。拉薩最具代表性的建築莫過於布達拉宮，氣勢恢宏的宮殿，充分體現了藏式建築的特色，是西藏政教合一的統治中心，於 1994 年被列為世界文化遺產。

Tibet is located on the "Roof of the World" Tibetan Plateau, and Lhasa is its capital. The region has the longest daytime in China. Lhasa, with an annual average duration of sunshine over 3,000 hours, is thus called the "sunlight city". The most representative construction in the city is the magnificent Potala Palace. The Tibetan-style palace is the political and religious core of Tibet, which was inscribed to the UNESCO World Heritage List in 1994.

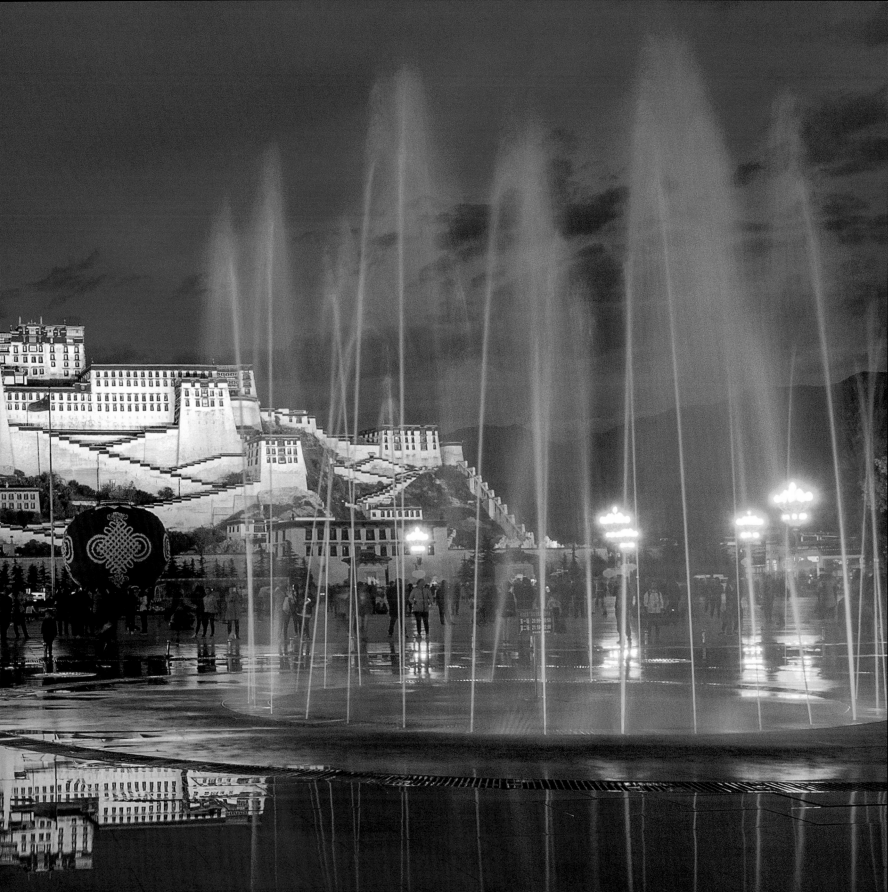

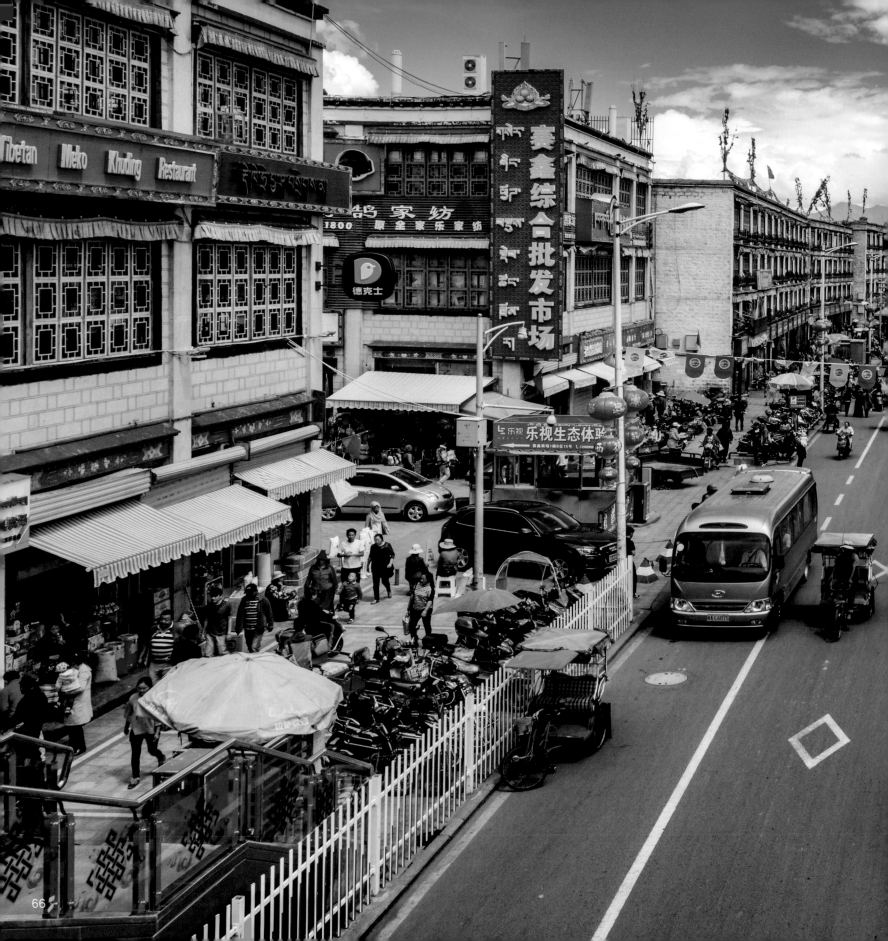

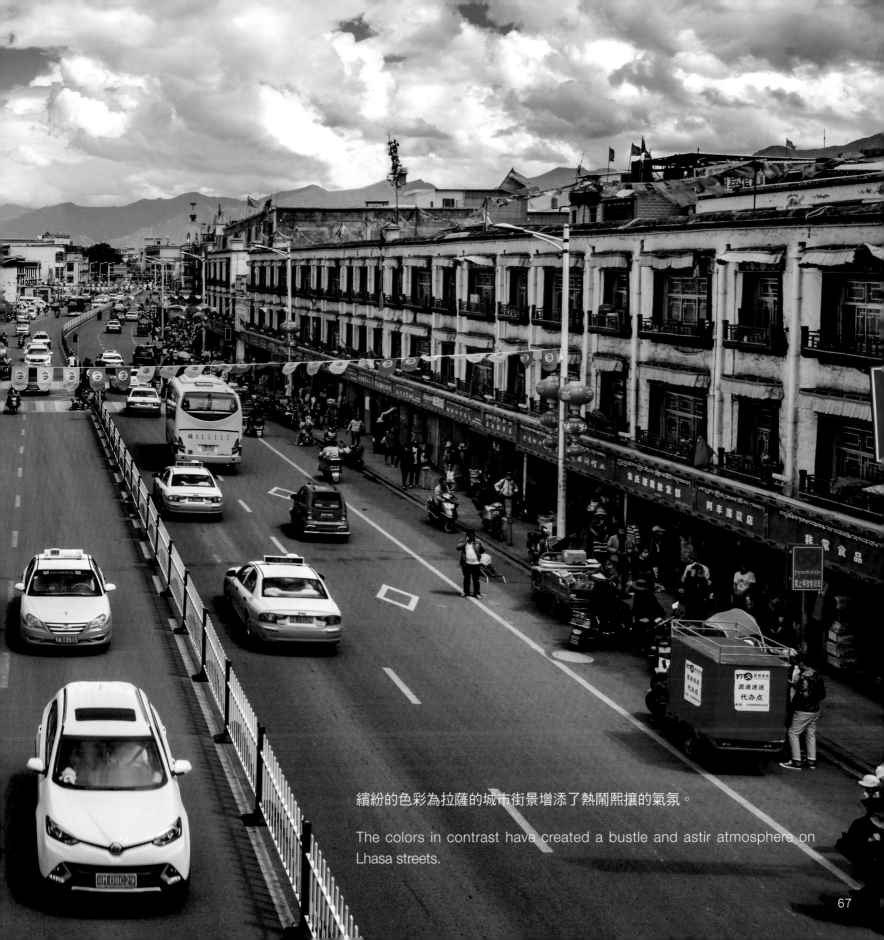

繽紛的色彩為拉薩的城市街景增添了熱鬧熙攘的氣氛。

The colors in contrast have created a bustle and astir atmosphere on Lhasa streets.

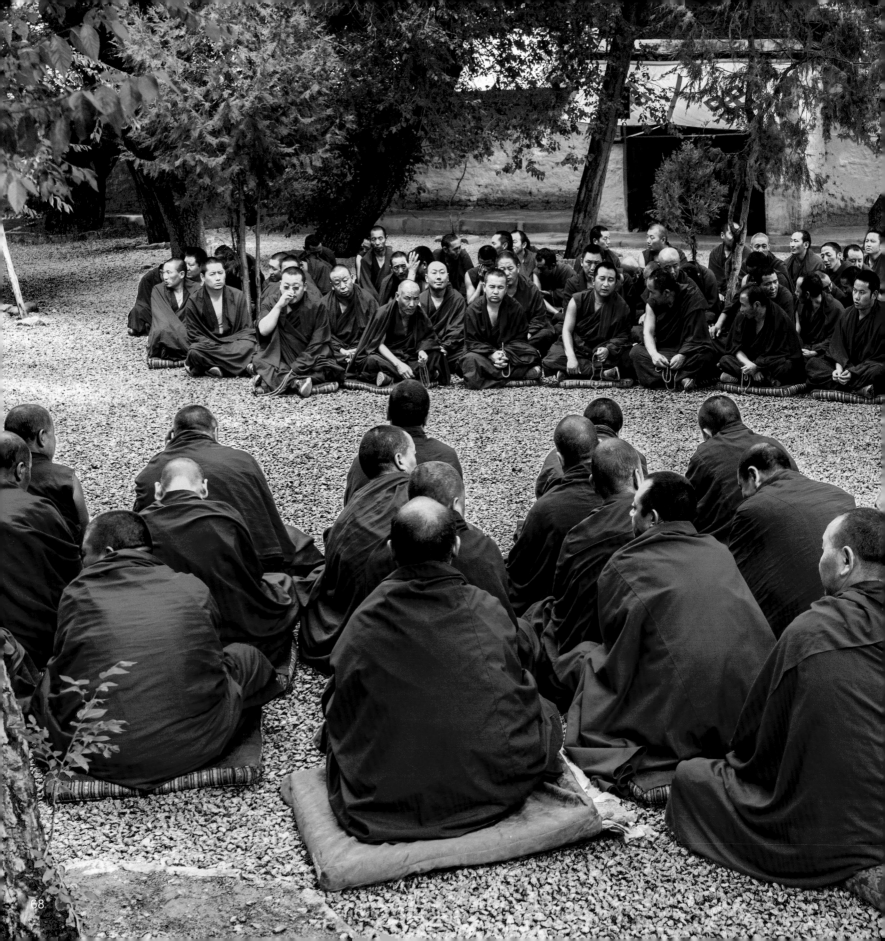

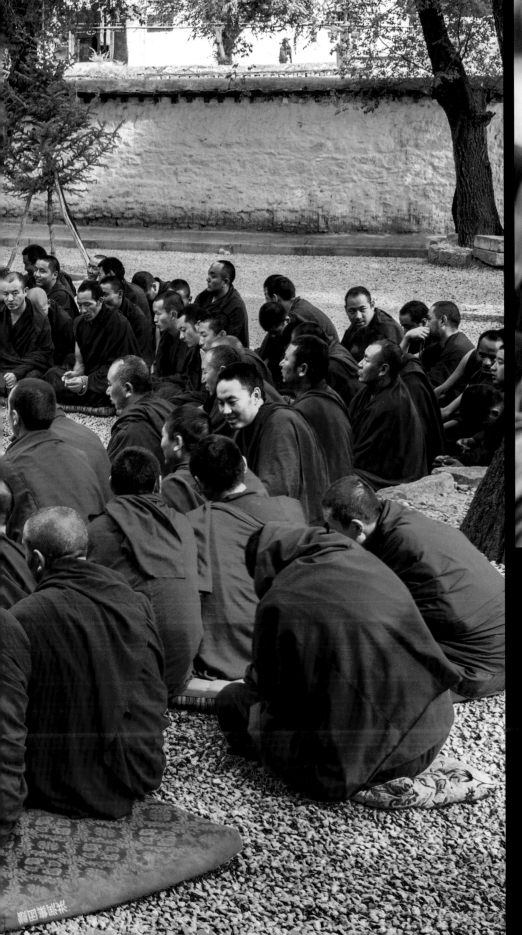

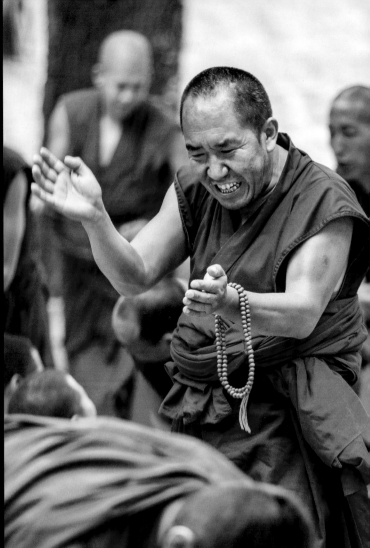

色拉寺最具特色的便是喇嘛的辯經環節。
激動之時往往聲音洪亮，配以辯經時的經典
雙手拍掌的動作，看起來十分有激情。（右）
激烈的辯論過後，眾人又能心平氣和地挨坐
誦經。一動一靜，讓人感悟特深。（左）

The featured scenery at Sera Monastery
is the daily debate session. Lamas would
use loud voices and clap their hands in
heated discussions. (Right) After the debate
they would sit down in circle to chant the
sutras together peacefully. The contrast of
emotional debate and peaceful chanting is
really impressive. (Left)

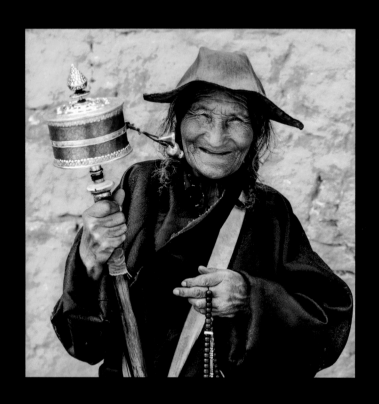

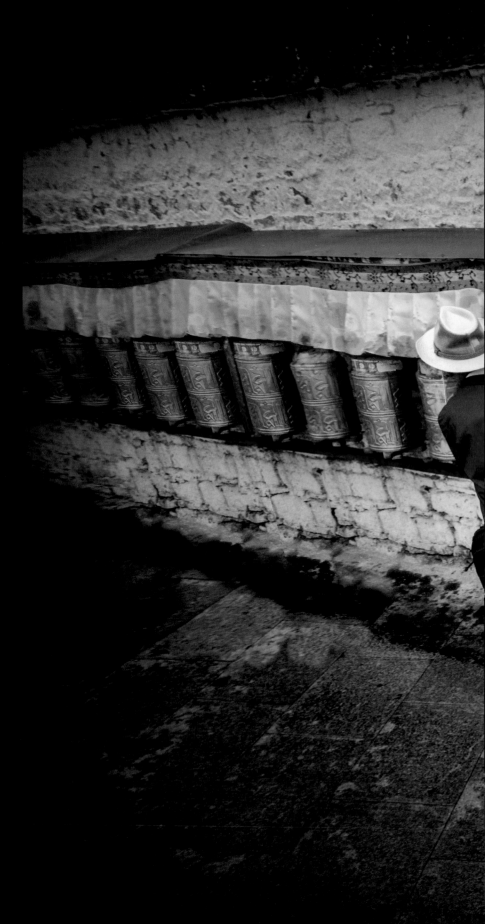

布達拉宮外設有長排延綿的大轉經筒，信徒輪番轉動，並在口中喃喃地念誦著六字真言「唵嘛尼叭咪吽」。（右）亦有虔誠的教徒經常手持小型轉經筒，以右手轉動。（左）

There is a long line of large prayer wheels outside the Potala Palace. Practitioners turn the wheels while chanting the 6-syllabel mantra "Om mani padme hum". (Right) There are also devotional practitioners who generally hold a small prayer wheel in their right hands to spin. (Left)

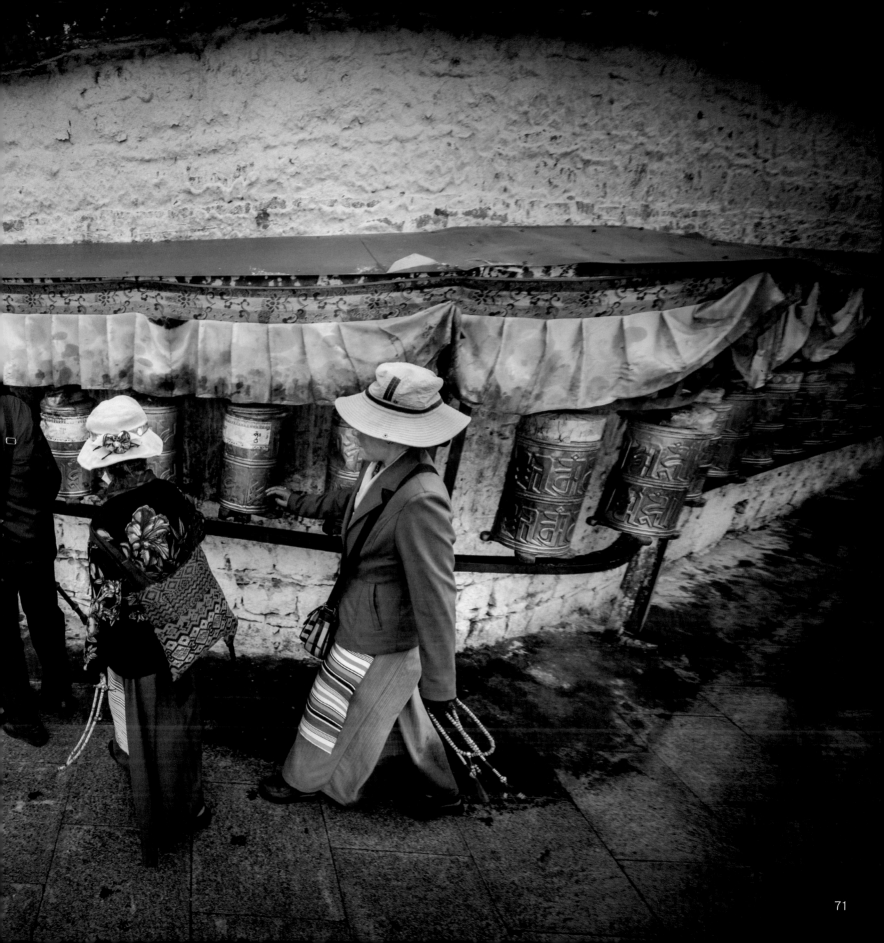

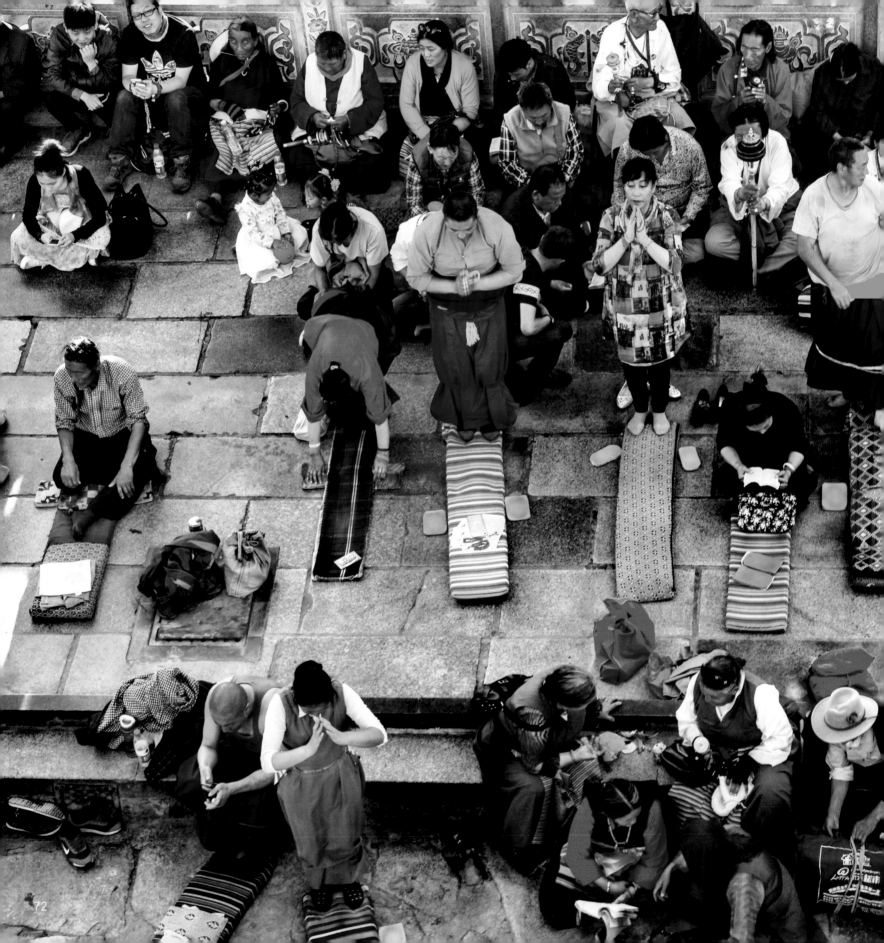

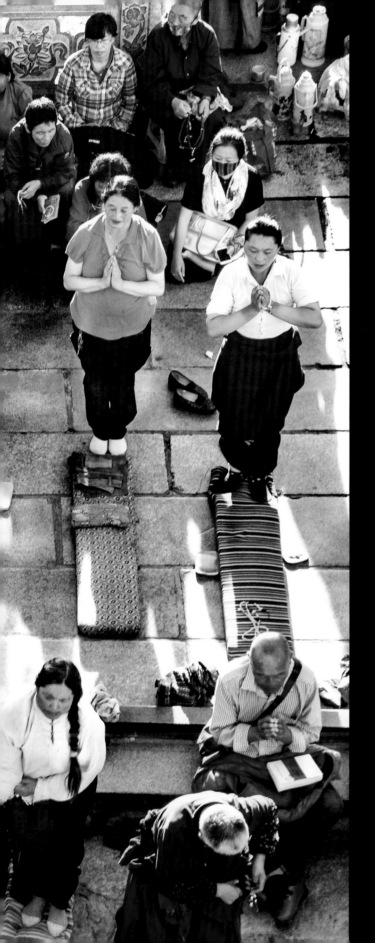

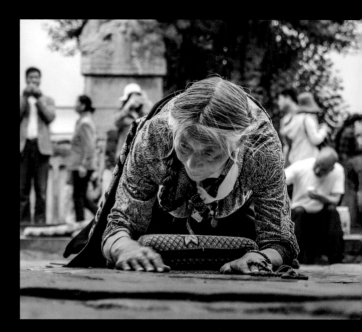

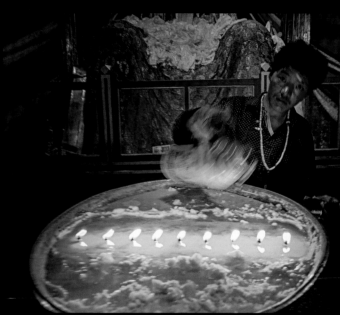

大昭寺外長期有藏傳佛教徒磕長頭禮佛。（左）
磕長頭可原地進行。（右上）寺廟之內，亦可見藏民手
持油壺添香油。（右下）

Practitioners are prostrating outside the Jokhang.(Left
Prostration can be done on the same site. (Upper Right
You can also see Tibetan man pouring oil to the tray with
burning candles in monasteries. (Lower Right)

街位於拉薩舊城區。（左）這裡如今已成為拉薩的宗教、觀
民俗、文化、商業和購物中心。（右）

hor Street is located at the old town of Lhasa. (Left)
s now become centers of religion, sightseeing, folk-custom,
re, business and shopping. (Right)

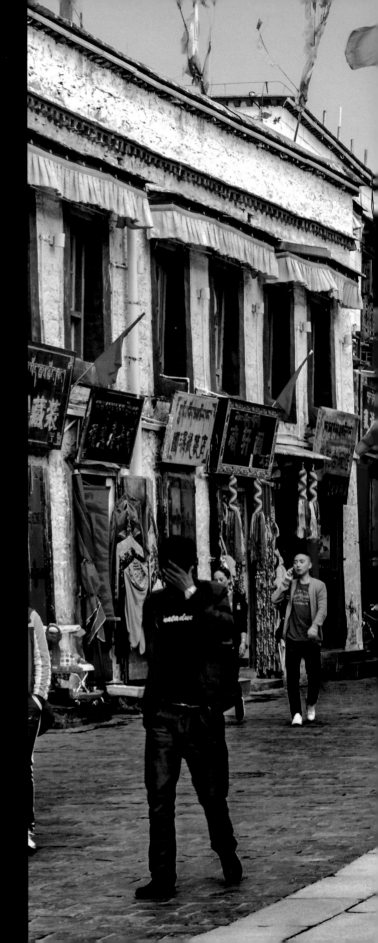

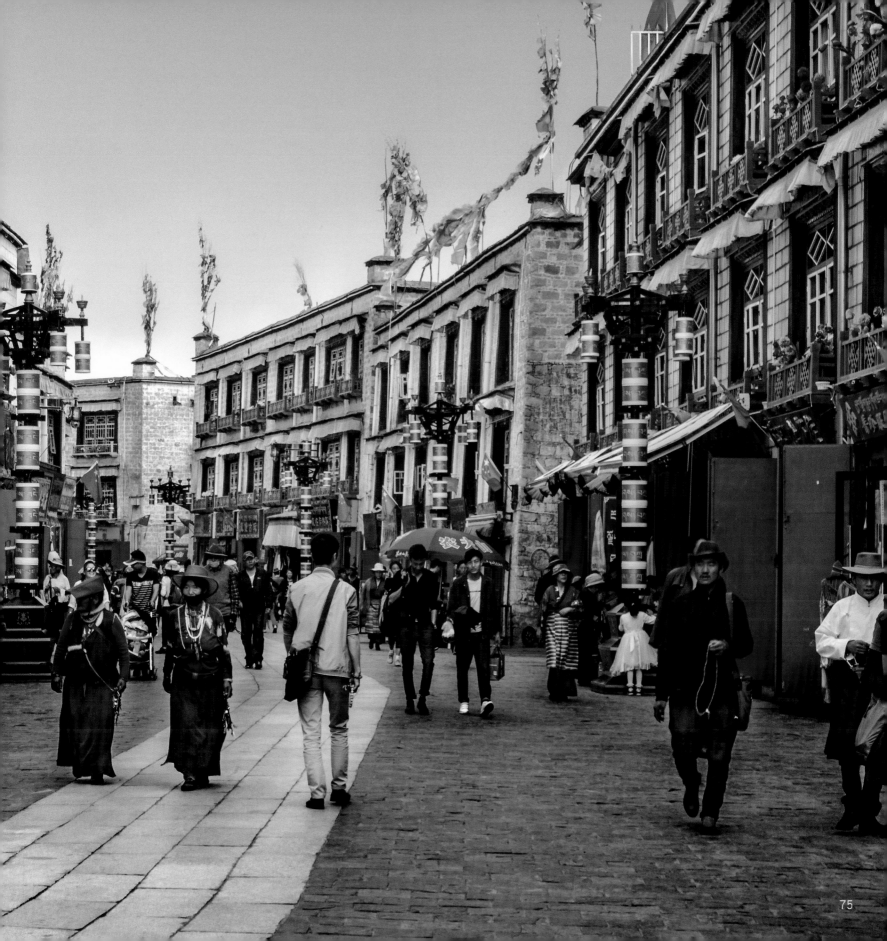

磕長頭是藏傳佛教的禮佛方式之一。（右）大昭寺附近，經常可見跋山涉水磕長頭而來的虔誠信徒。（左）

Prostration is a way of paying respect to Buddha in Tibetan Buddhism. (Right) In the surrounding area of Jokhang, one can often see prayers making arduous journeys to this place while performing prostration along the way. (Left)

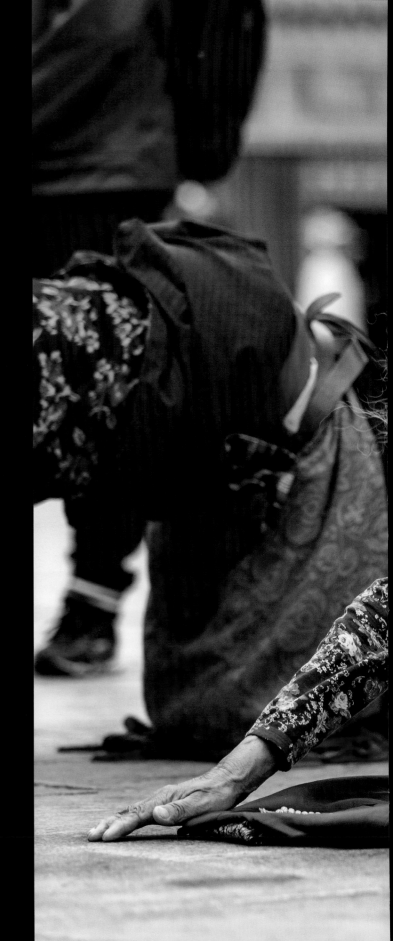

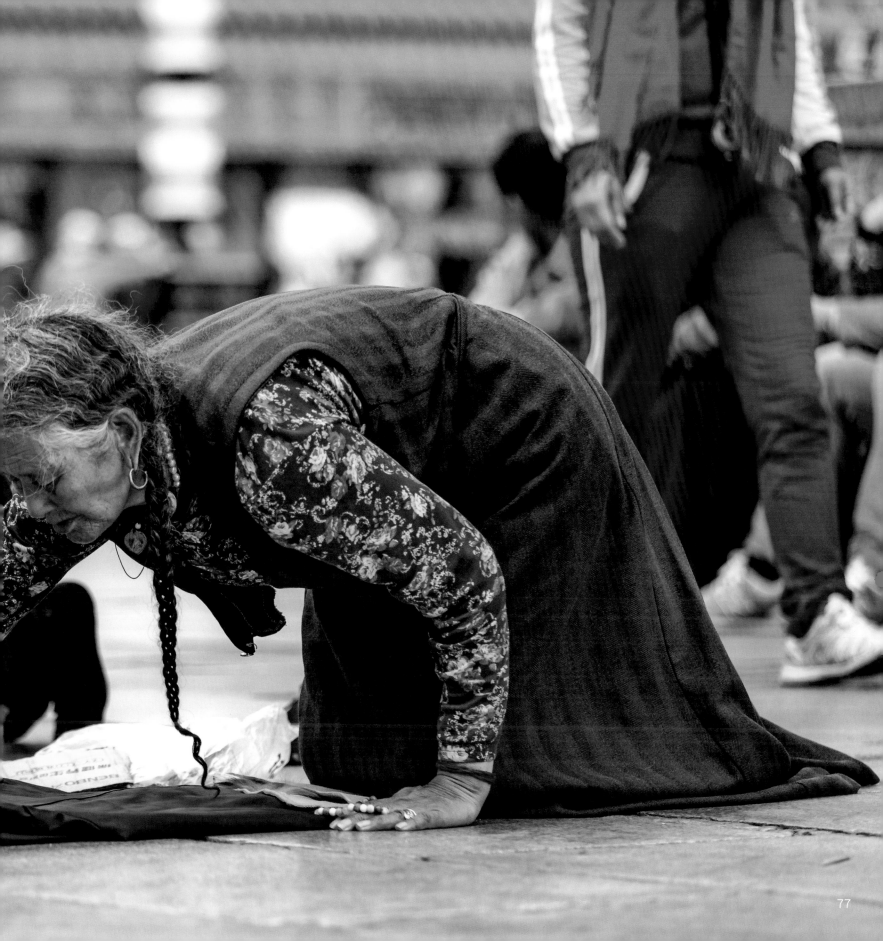

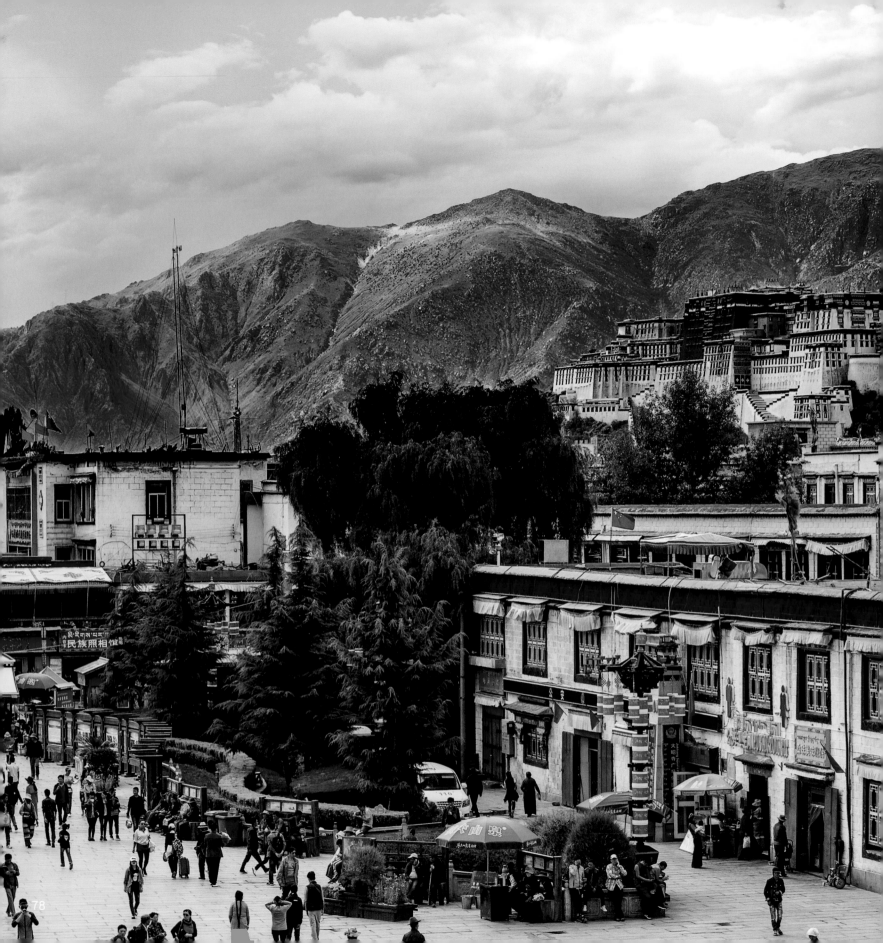

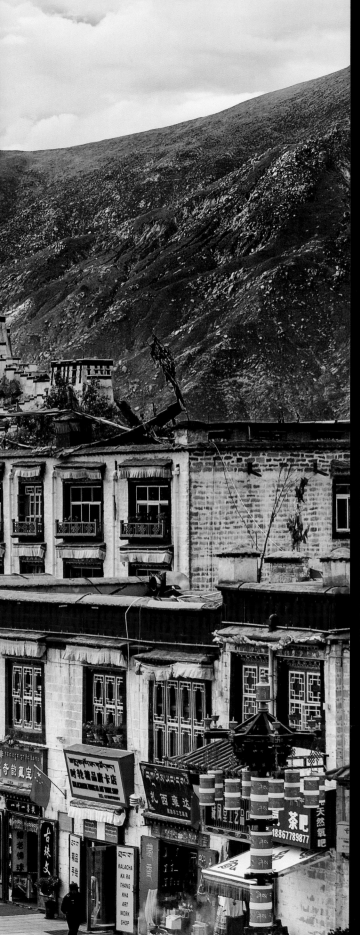

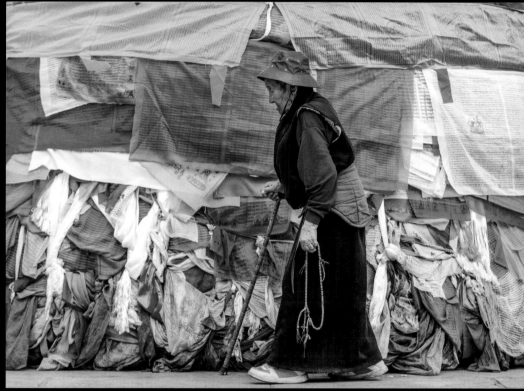

從八廓街可遠眺布達拉宮的景色。（左）五彩的經幡為街道增添了耀目的色彩。（右）

From Barkhor Street you can see the view of the Potala Palace in distance. (Left) The polychrome prayer flags have adorned the street with bright colors. (Right)

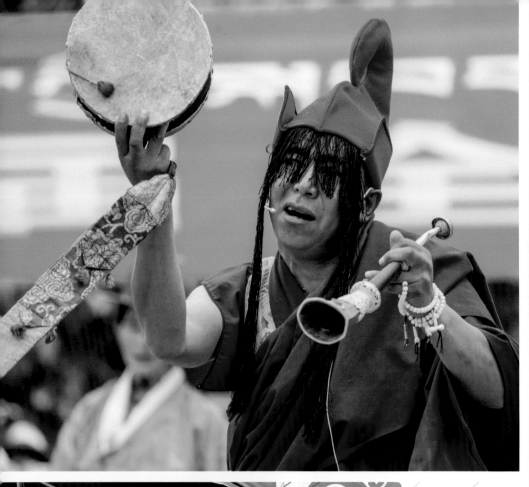

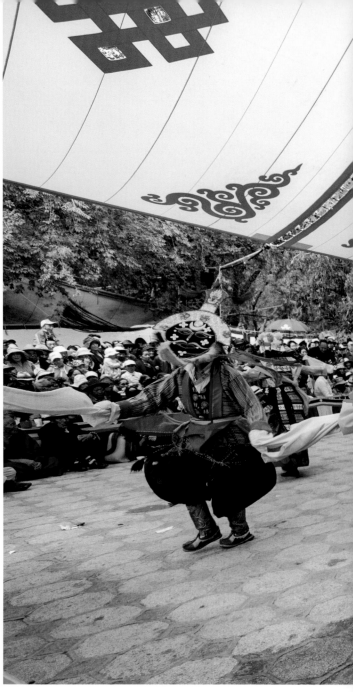

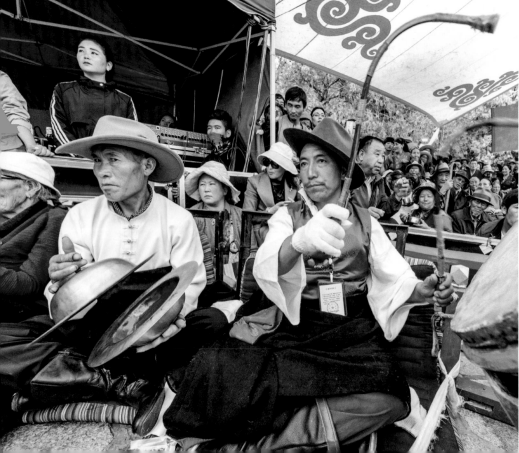

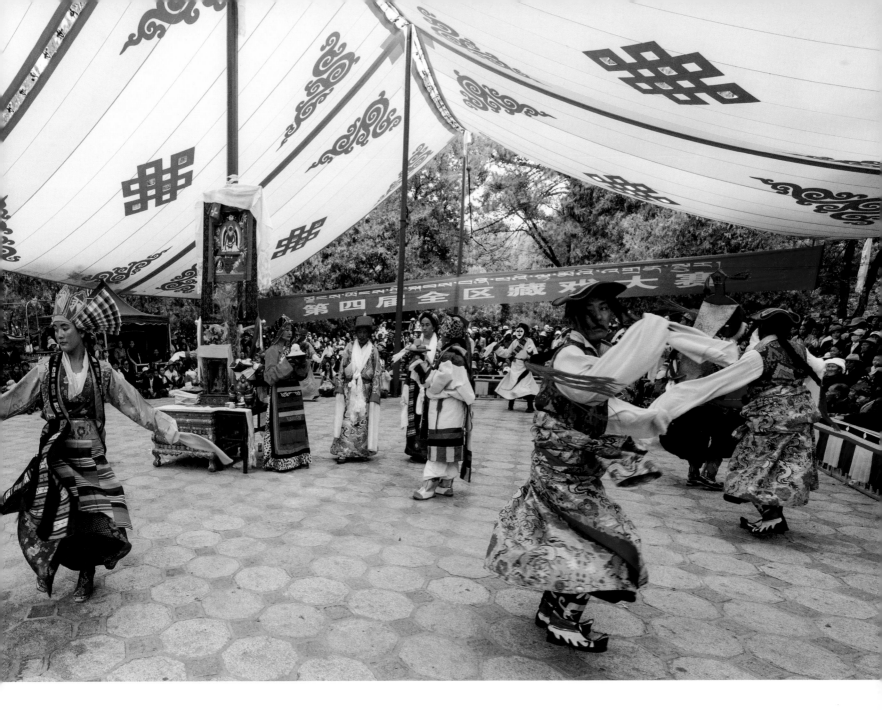

藏戲在藏語中叫作「阿吉拉姆」，廣泛流傳於藏族聚居地區。（左上）藏戲是集戲劇、音樂、文學、舞蹈為一體的綜合藝術。（左下）藏戲約起源於 14 世紀，在流傳過程中由於青藏高原各地的自然條件、習俗、文化、傳統的不同，擁有眾多的流派。（右）

Lhamo performance, also known as Ache Lhamo, is universally found in areas where Tibetan people gather. (Upper Left) It is a theatrical art that combines opera, music, literature and dance. (Lower Left) It is popularly believed to be started in the 14th century, and in the process of its handing down, Lhamo has generated assorted genres due to various natural conditions, conventions, culture and traditions in different parts of the Tibetan Plateau. (Right)

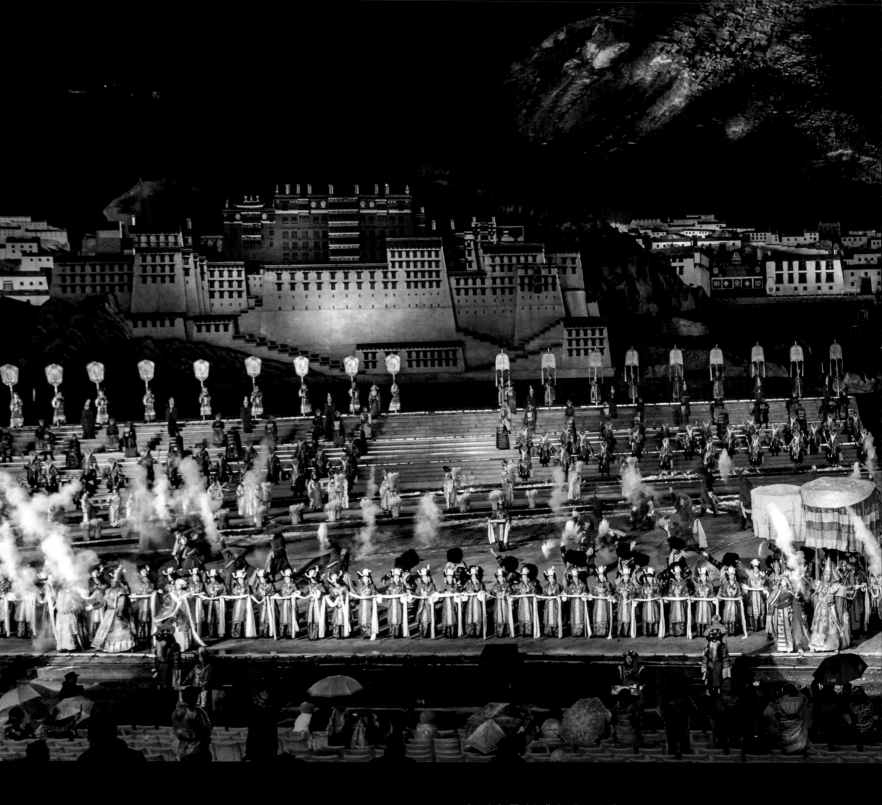

大型實景劇《文成公主》，以唐朝文成公主入藏事蹟作為故事主線的實景劇，800 多名演員參與演出 3,000 多個角色，將戲劇、音樂和舞蹈融為一爐，壯觀場面令人震撼。

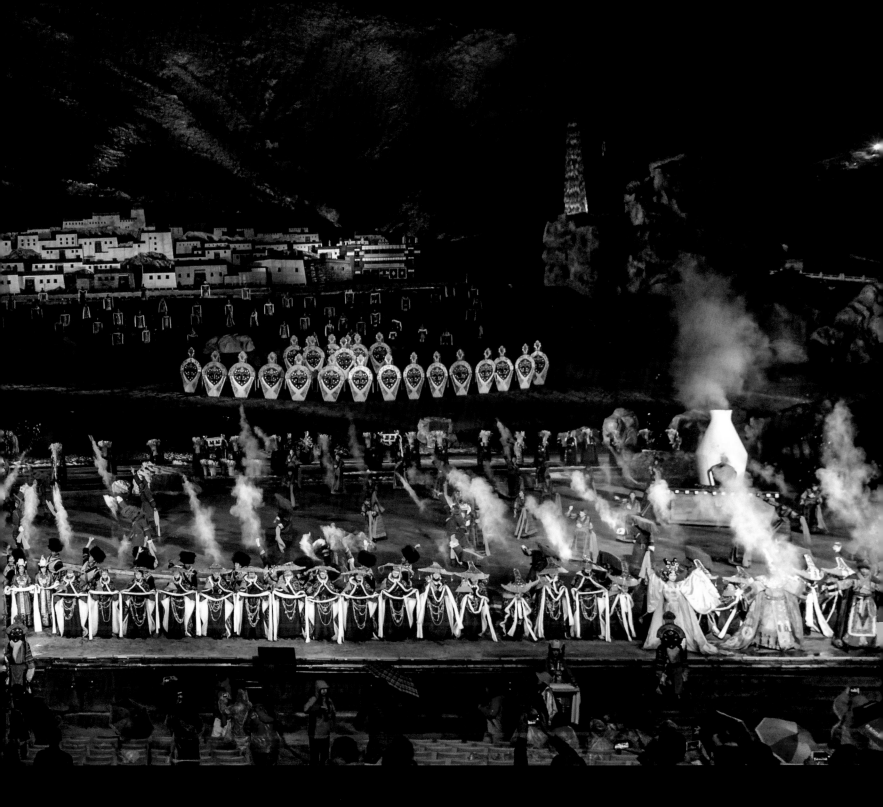

The large-scale live performance of "Princess Wencheng" is based on the history of Princess Wencheng of Tang Dynasty, who was granted by the emperor to King of Tibet for marriage. The show, integrating theatre, music and dancing, is spectacular to watch because there are more than 800 actors and actresses playing more than 3,000 roles.

泉州，位於福建南部，是多數人公認的海上絲綢之路起點。宋末至元代時，泉州超越廣州成為第一大港，在當時的世界上更與埃及亞歷山大港齊名。（右）在大坪山巔，民族英雄鄭成功的塑像以英勇之姿守護著泉州。（左上）開元寺是福建省內最大的佛教寺廟，東西兩側各有一塔。（左下）

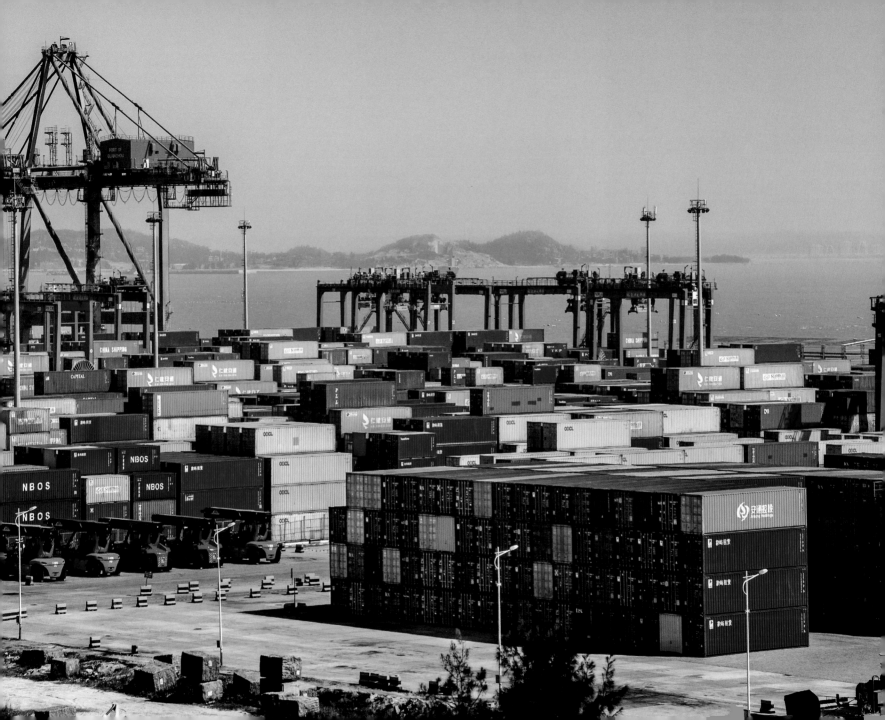

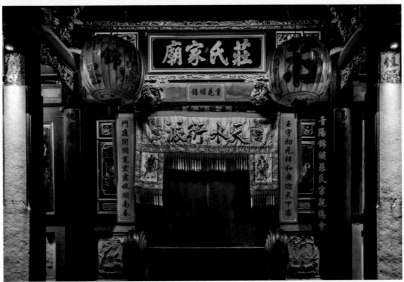

位於泉州市中心的鯉城區，擁有豐富的人文藝術瑰寶。（左）區內多個宗教的史蹟林立，更擁有中國現存最古老的阿拉伯風格伊斯蘭教建築——清淨寺。（右上）莊氏家廟建於明代，至今已有五百多年歷史。（右下）

Licheng District in central Quanzhou is rich in human art treasures. (Left) Of the many historical sites of different religions, there is the oldest standing Islamic architecture of Arabian style in China - the Qingjing Mosque. (Upper Right) The Zhuang Clan Ancestral Shrine was built in the Ming Dynasty, with a history of more than five centuries. (Lower Right)

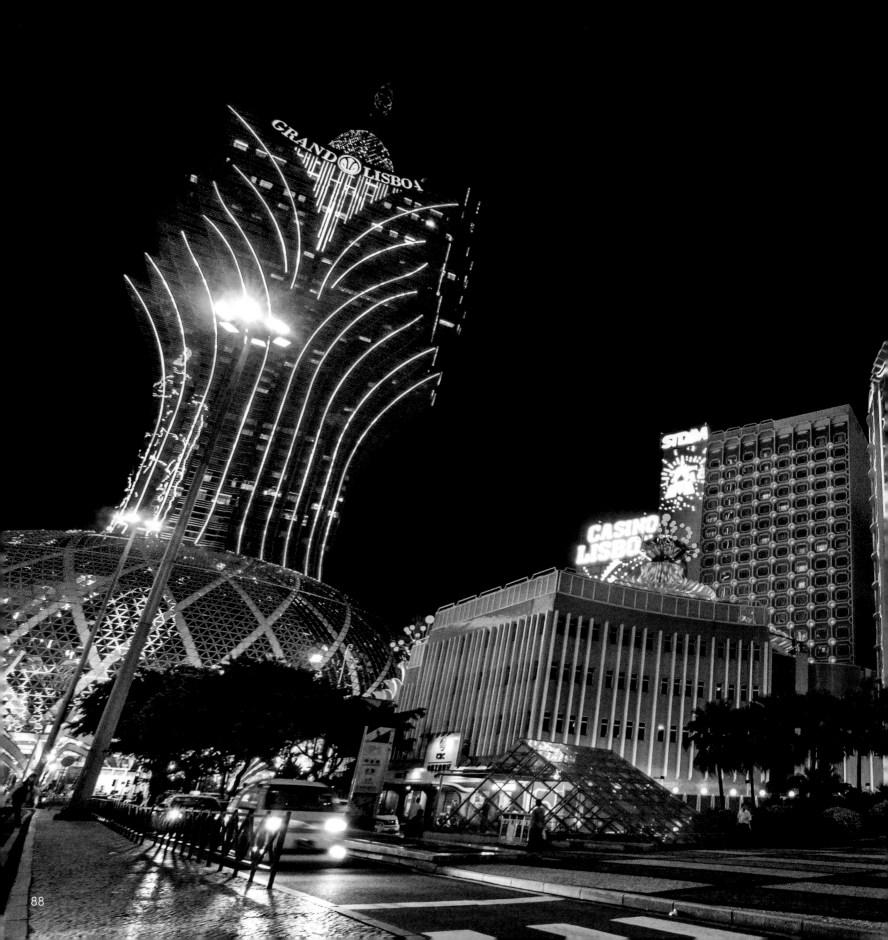

澳門特別行政區是中國面積最小的省級行政區，僅僅超過 115 平方公里。雖然面積十分有限，但澳門的旅遊業和博彩業都十分發達，因此這裡的人口密度為世界之最，每平方公里人口超過 20,000。澳門擁有「東方蒙地卡羅」或「東方拉斯維加斯」的美譽，在政府的大力推動之下，澳門已逐步成為世界第一大賭城。在夜色之下，一座座賭場散發著讓人迷醉的光彩。

The Macao Special Administrative Region is the smallest provincial district in China, with an area barely more than 115 square kilometers. Although with only limited lands, tourism and gambling industries are flourishing in Macao, which is probably why it is the most densely populated region the world, with a population density of more than 20,000 people per square kilometer. Macao is often esteemed as the "Monte Carlo/Las Vegas of the Orient". Under the support of the government, Macao has already become the gaming hub in the world. The casinos look fascinating under the dim light of night.

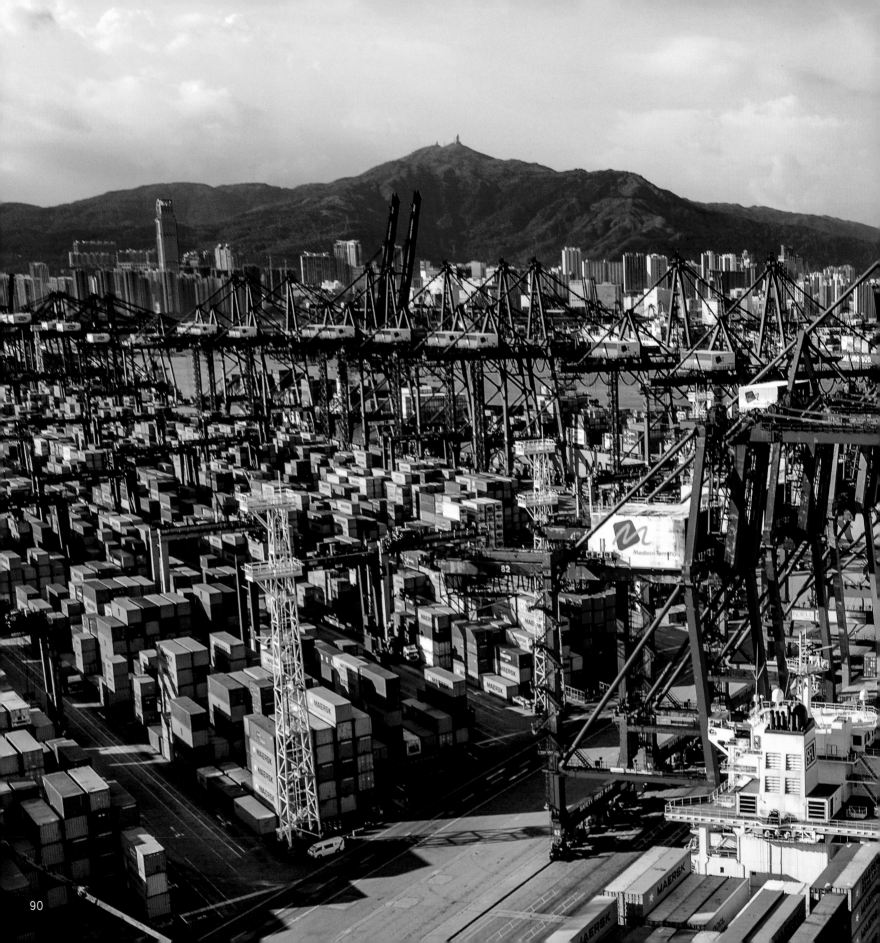

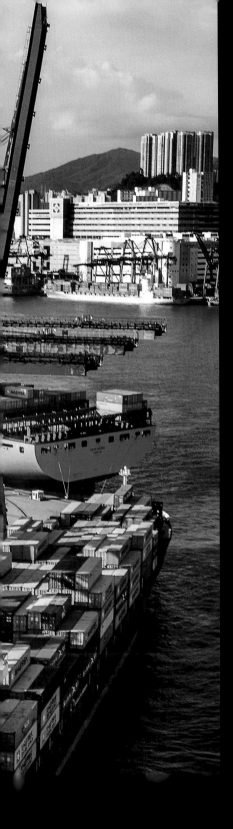

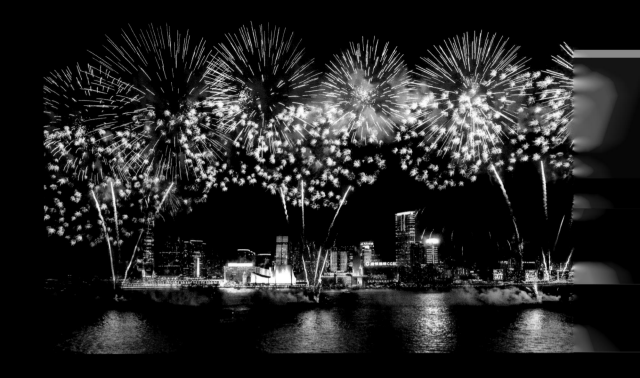

被譽為「東方之珠」的香港特別行政區，是中國、亞洲乃至全球的金融、服務業及航運中心。香港治安良好、社會廉潔、稅制簡單、法律健全、營商自由，擁有眾多優點。由於曾為英國的殖民地之一，多年以來都扮演著連接中國內地與國際市場的橋樑，更連續多年蟬聯全球最自由經濟體。在中國倡議的「一帶一路」跨國經濟帶的建設中，香港正在全力配合，發揮自身所長，期望能擔當好「超級聯繫人」的角色。（左）位於香港島及九龍半島之間的維多利亞港，是一個天然的優良港口，每逢重大節慶，都會有大批觀眾在此欣賞大型煙花匯演。（右）

With the reputation of "the Pearl of the Orient", Hong Kong is the center of finance, service industry and shipping hub in China, Asia, and the world. Hong Kong was once a colony of the United Kingdom. For years, the advantages of Hong Kong has enabled the city to serve as a connecting bridge between mainland China and the international markets and become the world's freest economy for consecutive years, including a sound public order, an incorruptible society, a simple taxation, an all-rounded legal system, freedom in doing business, and etc. In the Belt and Road Initiative proposed by the Chinese government, Hong Kong is sparing no effort in taking advantages of its superiorities, so as to be the "super-connector" between China and the world. (Left) The Victoria Harbour situated between the Hong Kong Island and the Kowloon is a naturally fine harbor, at where large-scale firework displays can be appreciated on

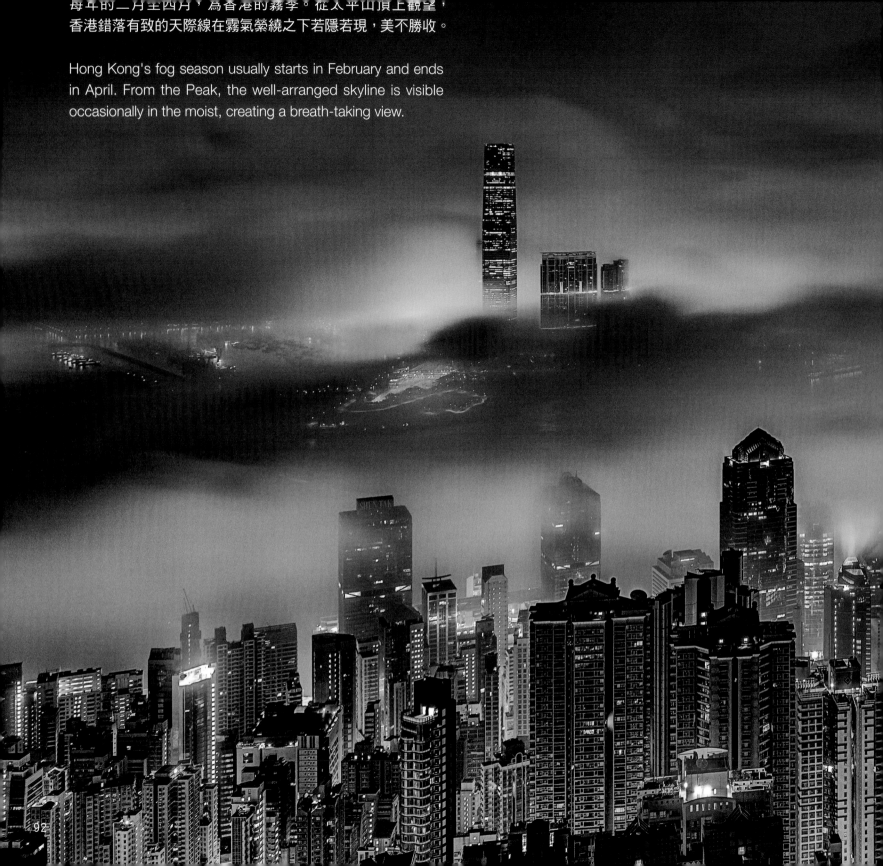

每年的二月至四月，為香港的霧季。從太平山頂上觀望，
香港錯落有致的天際線在霧氣縈繞之下若隱若現，美不勝收。

Hong Kong's fog season usually starts in February and ends
in April. From the Peak, the well-arranged skyline is visible
occasionally in the moist, creating a breath-taking view.

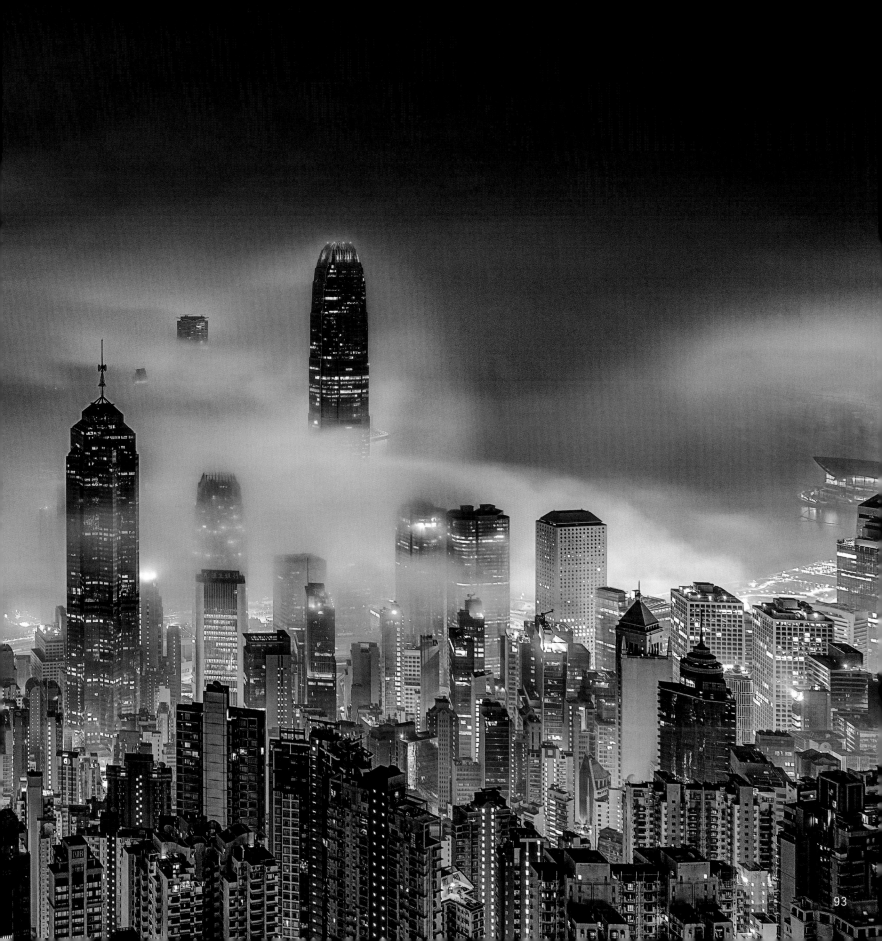

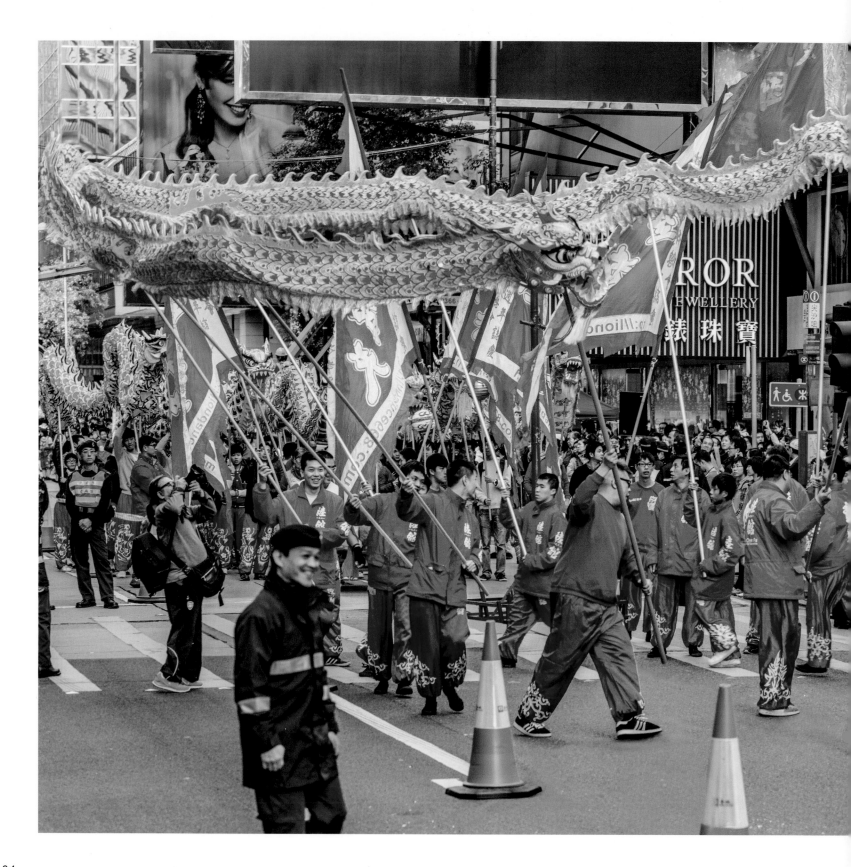

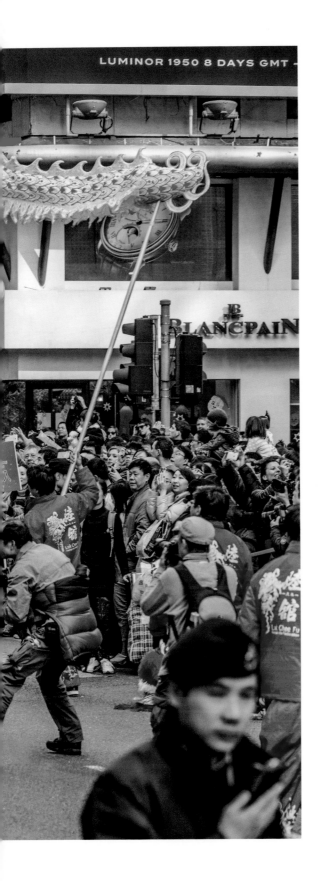

舞龍舞獅在中秋節等傳統節日上十分常見。（左）
鑼鼓喧天的場面往往會吸引眾多市民及
遊客同享歡樂的氣氛。（右）

Dragon or lion dance performances can be seen
during traditional Chinese festivals, such as Mid-
Autumn Festival. (Left) The resounding gongs
and drums are putting many citizens and visitors
in festive joy and laughter. (Right)

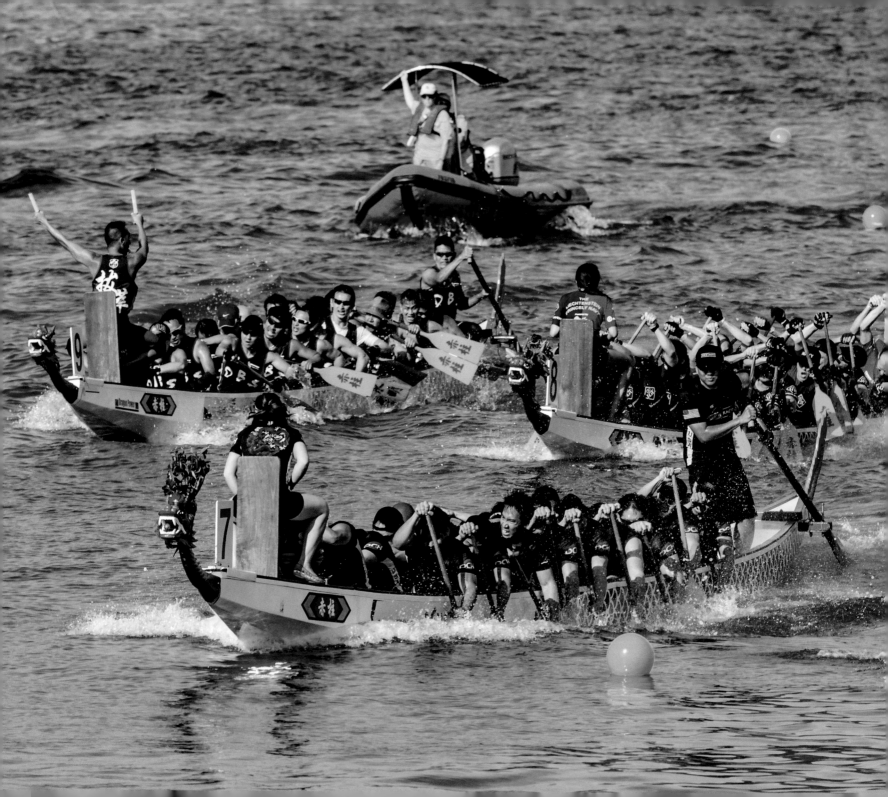

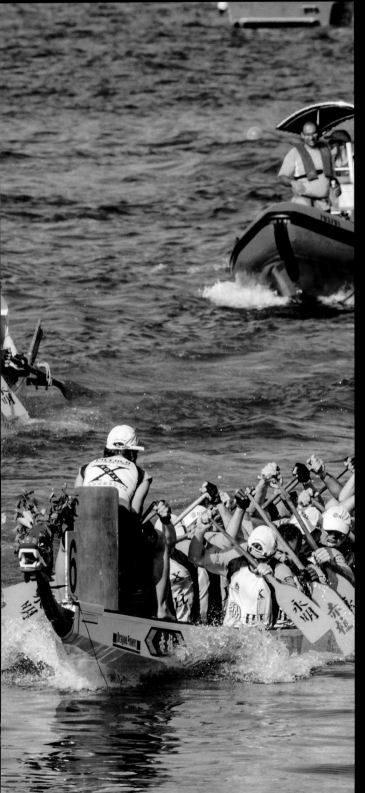

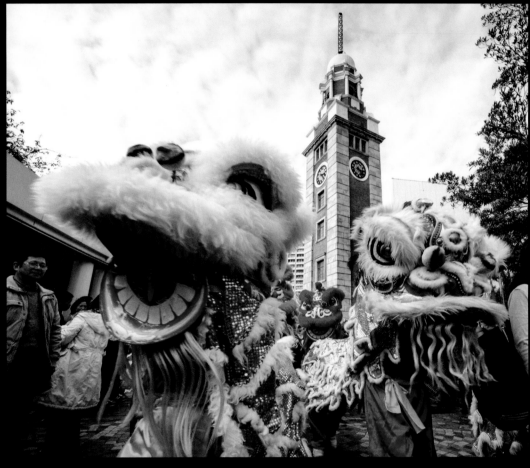

龍舟大賽為端午佳節點綴熱鬧的節日氣氛。（左）每年的新年期間，香港更會舉辦龍獅節，增添喜慶的氛圍。（右）

During the Dragon Boat Festival, the dragon boat matches bring liveliness and excitement to the city. (Left) Hong Kong Dragon and Lion Dance Festival is held annually around New Year to create a jubilant atmosphere. (Right)

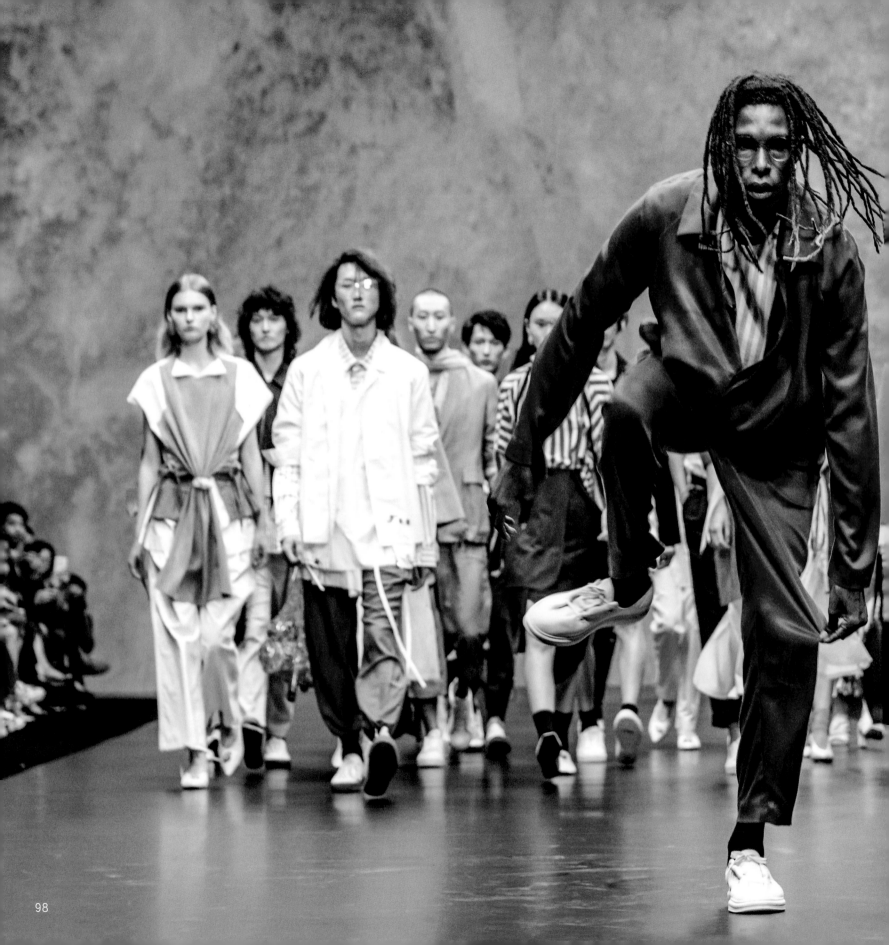

香港作為國際都會，經常舉辦各色各樣的文化表演活動，包括商會組織的公益活動。（右）國際知名品牌亦經常選擇香港作為時裝表演的城市。（左）

As an international metropolis, Hong Kong accommodates assorted cultural activities, including events for the sake of public welfare organized by different commercial chambers. (Right) Globally renowned brands would also choose Hong Kong as the city for holding fashion shows. (Left)

# 中亞

中亞，是「一帶一路」中陸上絲綢之路的十字路口，許多文化在此交匯碰撞。

過去提到中亞國家時，我們更多是透過史籍記載的片段，對這個地區加以認識，如今中亞國家已經獨立於蘇聯二十餘載，「絲路」心臟地帶的中亞仍仿佛縈繞著一股神秘的氣息，等著我們揭開這層面紗。

古代的絲綢之路，由長安出天山北麓或經帕米爾高原，再經中亞地區到達印度、伊朗和羅馬。在絲綢之路作為重要貿易通道而盛行的 1,700 多年間，中亞作為連接東西方的重要地區，在宗教、文化、藝術、科技的傳播過程中，發揮了不可或缺的作用。而中亞在擔當東西方「橋樑」的過程中，亦形成了兼容並蓄的文化氛圍。

中亞受到歷史因素影響，俄羅斯文化在區內十分流行，至今，許多地方仍以俄語為主要語言。目前，處於絲綢之路十字路口的中亞在不同程度上表現出對伊斯蘭文化和突厥文化的認同，同時西方文化大舉進入，對年輕人影響漸大，而東方文化也逐步滲入，各方文化都在共存於這片土地之上。

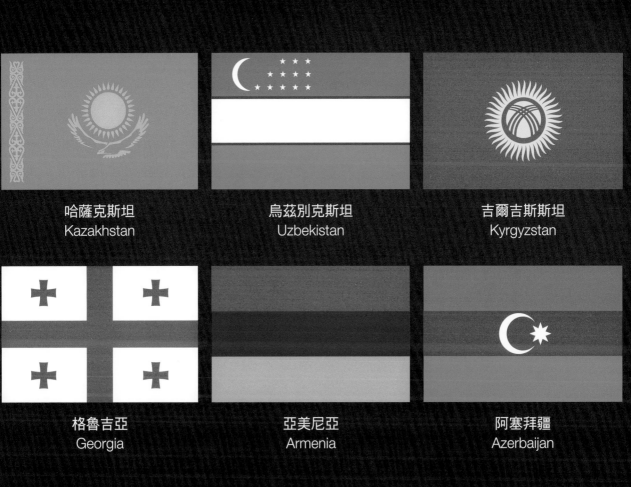

**哈薩克斯坦**
Kazakhstan

**烏茲別克斯坦**
Uzbekistan

**吉爾吉斯斯坦**
Kyrgyzstan

**格魯吉亞**
Georgia

**亞美尼亞**
Armenia

**阿塞拜疆**
Azerbaijan

# Central Asia

Central Asia is at the crossroad of ancient Silk Road, where different cultures converged.

In the past, we mainly rely on historical records to get to know these countries. Although they became independent around 20 years ago, the Central Asia – the heartland of the Silk Road – still seems mysterious to us, waiting to be unveiled.

The ancient Silk Road started from Chang'an, passing the north side of Tianshan Mountain and the Pamir high plateau, it then reaches the Central Asia and further its way to India, Iran and Rome. Silk Road was an important trading route for more than 1,700 years, during that time, the Central Asia plays an indispensable role of connector between the West and the orient, in terms of communications of religion, culture, art, and technology. As a connector, the silk role also created an atmosphere with high tolerant for cultural and artist difference.

Due to many historical factors, the Central Asia area is deeply influenced by Russian culture - Russian is still the main language in most places. At the moment, people at the crossroad of the Silk Road identify themselves more or less in the Islamic or Turkic ethnic culture. Meanwhile, western and oriental cultures are also permeating into the area, with the western having strong impact on the younger generation. Different cultural styles find their way of coexistence in Central Asia.

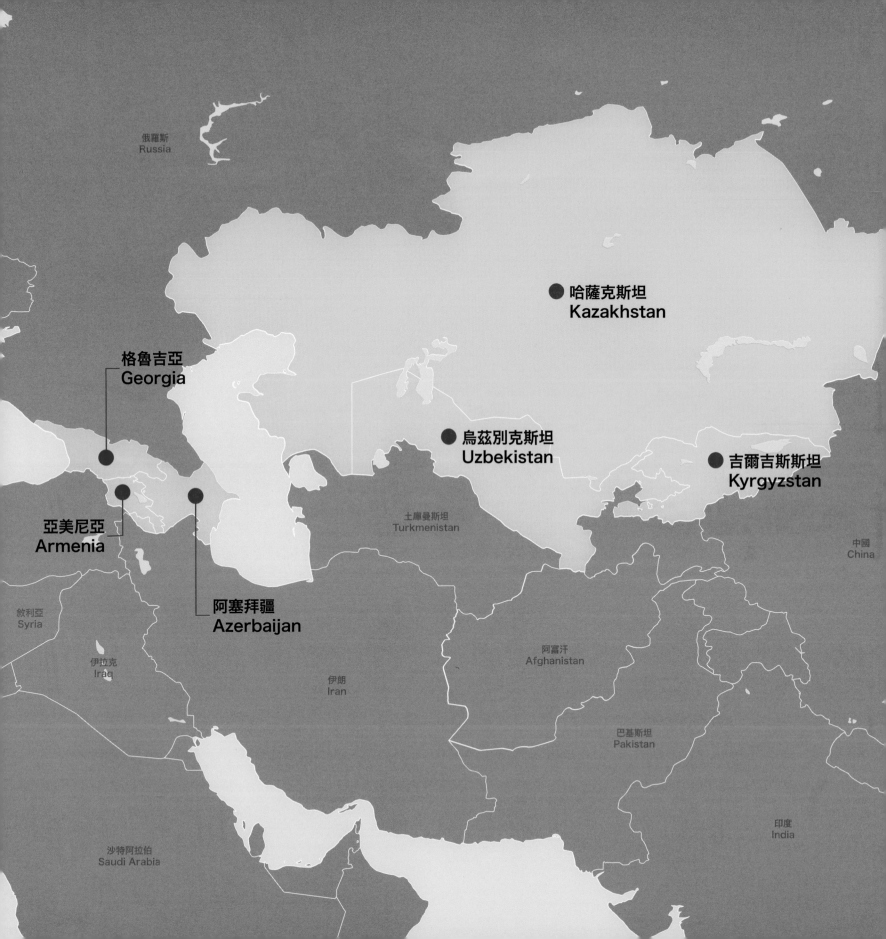

俄羅斯
Russia

格魯吉亞
Georgia

亞美尼亞
Armenia

阿塞拜疆
Azerbaijan

哈薩克斯坦
Kazakhstan

烏茲別克斯坦
Uzbekistan

吉爾吉斯斯坦
Kyrgyzstan

土庫曼斯坦
Turkmenistan

中國
China

敘利亞
Syria

伊拉克
Iraq

伊朗
Iran

阿富汗
Afghanistan

巴基斯坦
Pakistan

沙特阿拉伯
Saudi Arabia

印度
India

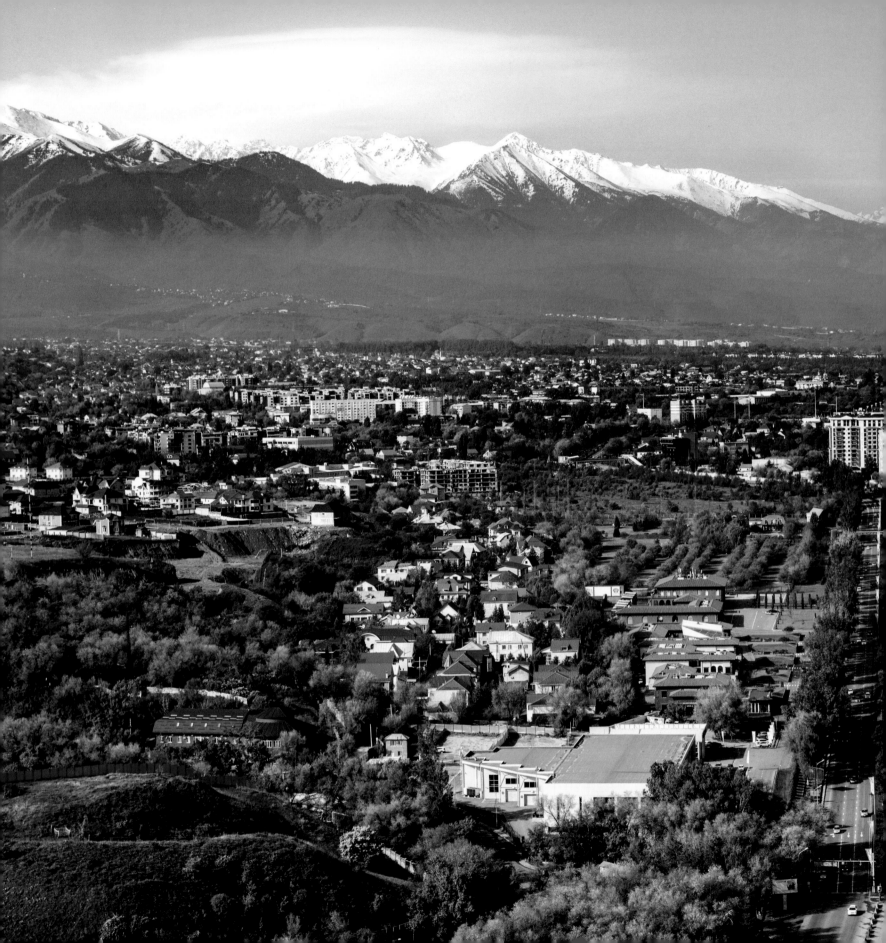

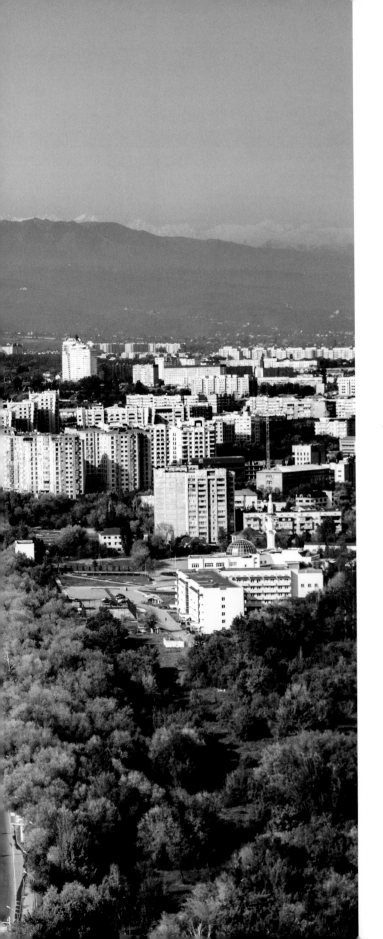

哈薩克斯坦是世界上最大的內陸國家，同時亦是中亞地區最大及世界第九大的國家。（左）其最大城市阿拉木圖是一座主要由俄羅斯人興建起來的城市，背靠白雪皚皚的外伊犁阿拉套山，三面環山，景色如畫。（右）

Kazakhstan is the largest landlocked country, and is also the largest and the ninth largest country in Central Asia and in the world respectively. (Left) Its largest city Almaty is a city originally built by Russians. Surrounded on three sides by mountains, including the snowcapped Trans-Ili Alatau, Almaty is picturesque. (Right)

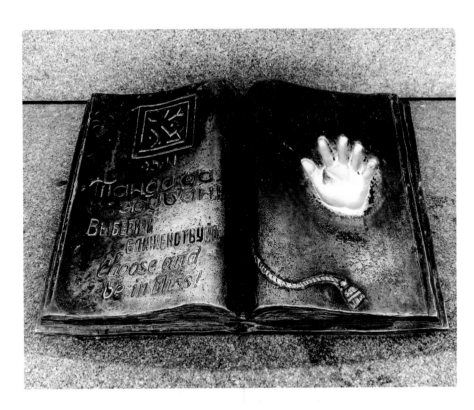

位於市中心的獨立廣場，其中央豎立了一座高 28 米的獨立紀念碑。
（左）碑下為一座翻開了的憲法書銅雕塑，右頁上有納紮爾巴耶夫總統
的右手手印，左頁刻有意為「人民的選擇得到福佑」的語句，以哈薩
克文、俄文及英文三語顯示。（右）

The Republic Square is located at the center of city, with the 28-meter-
high monument of Independence at its heart. (Left) There is also a
bronze statue of the open Constitution at the foot of the monument,
with President Nazarbayev's hand print on the right page and a trilingual
sentence on the left – "Choose and be in bliss" – in Kazakh, Russian
and English. and English. (Right)

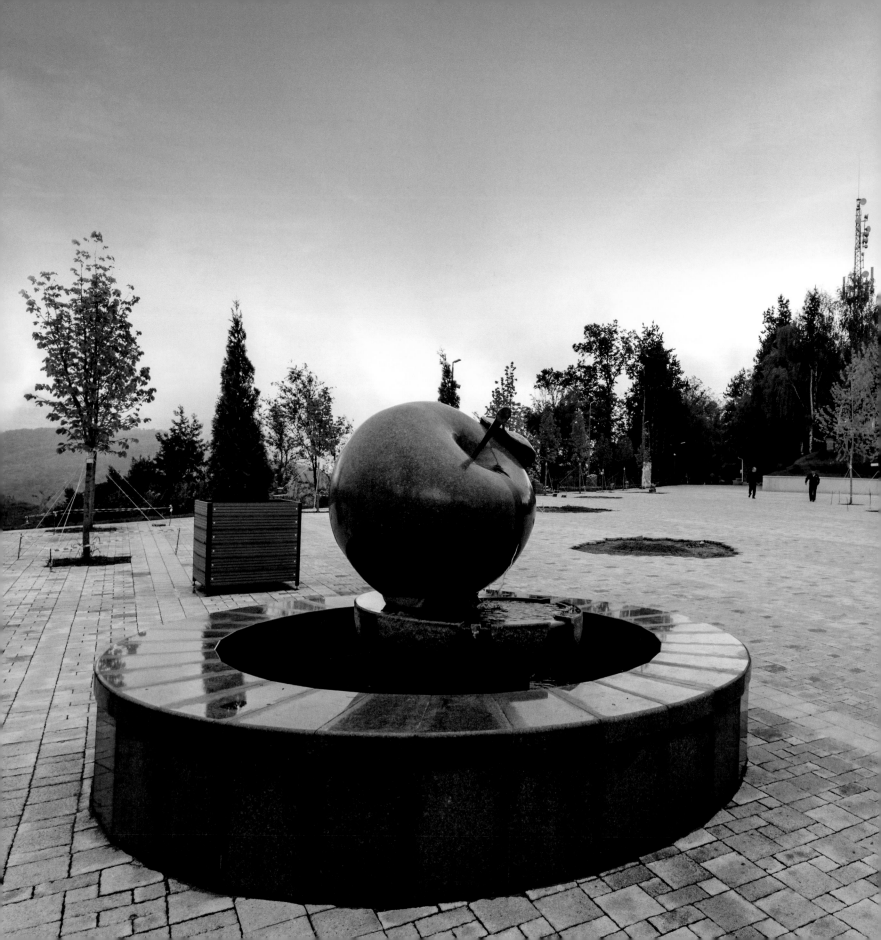

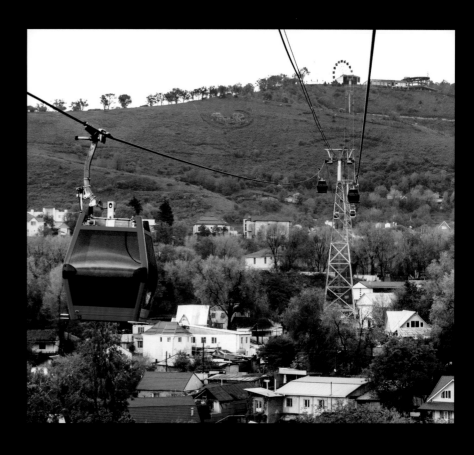

阿拉木圖盛產蘋果，被譽為「蘋果之城」，處處可見蘋果雕像。（左）
遊客可乘坐纜車俯瞰城市的景象。（右）

Almaty is known as "the city of apples" for it is abounded with the fruit; therefore, it's common to see apple statues everywhere. (Left) Tourists can take cable cars to overlook the view of the city. (Right)

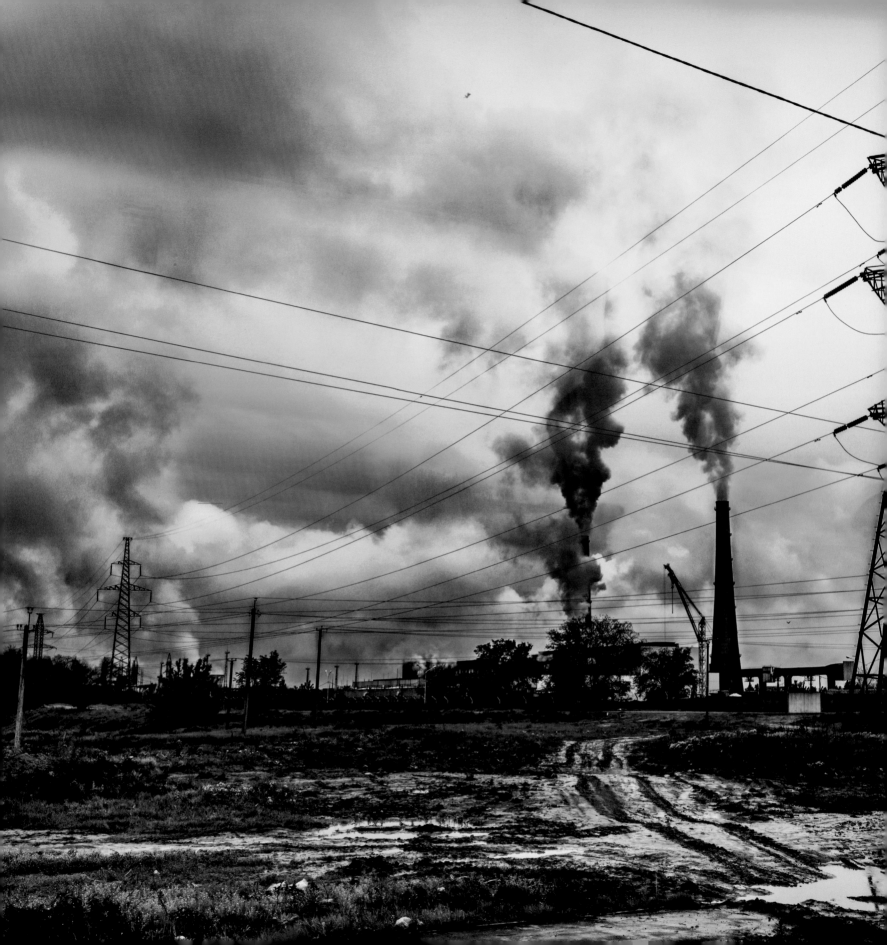

位於城市郊區的一個工業園，佔地 490 公頃。（左）此區正在
進行不斷的建設和開發。（右）

There is a 490-hectare industrial park in the
suburban area. (Left) It is under continuous construction and
development. (Right)

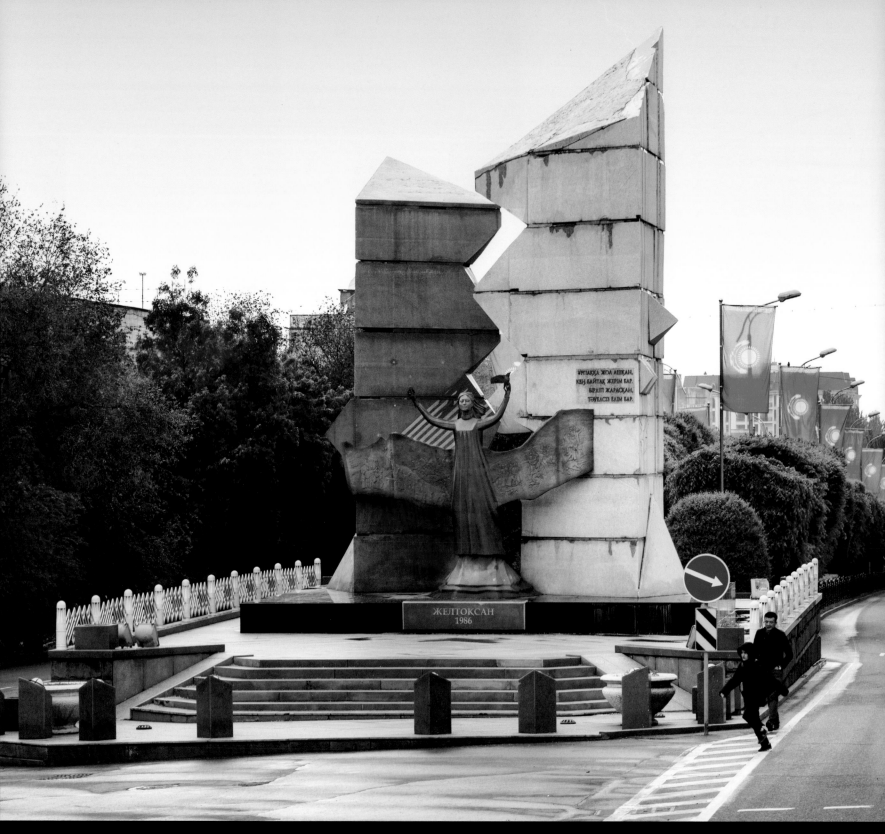

「黎明的自由女神」雕像豎立於 2006 年，紀念 1986 年發生的「傑勒托克桑事件」或「十二月事件」。（左）現在的市政府大樓原為總統府。（右上）圖為阿拉木圖的一家「五星級」酒店。（右下）

The "Dawn of Liberty" Monument was erected in 2006 to dedicate to the 20th anniversary of Jeltoqsan - or "December" o 1986 riots. (Left) The current city government building was originally the Kazakh President Office Building. (Upper Right) Image shows a luxury hotel in Almaty. (Lower Right)

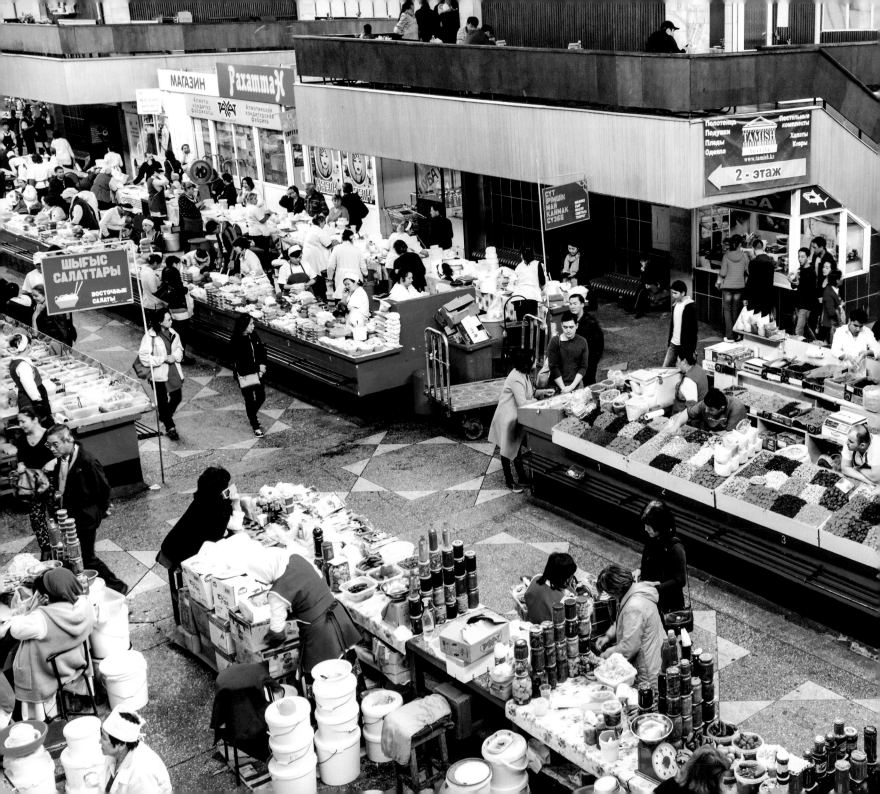

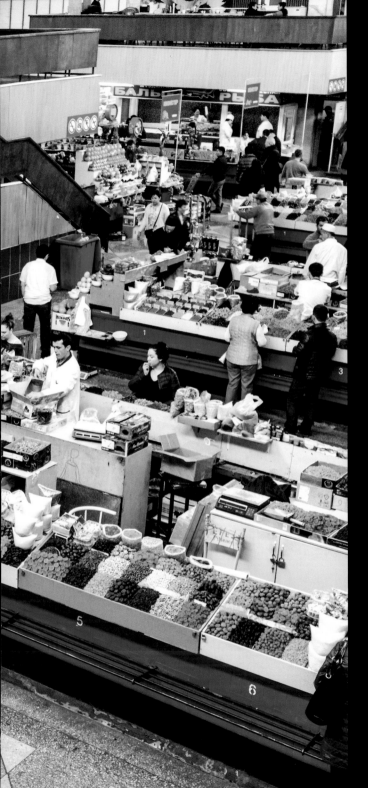

綠色市集是市內最大的市集。（左）這是體驗中亞真實生活氣氛的好去處。（右）

The Green Bazaar is the largest local market in the city. (Left) This is a great place for tourist to feel the real atmosphere of Central Asia. (Right)

現代哈薩克人經過多代的血統洗禮，面孔亦東亦西。（左上）餐廳的女侍應（左下）準備角色扮演的孩童（右）

After generations of miscegenation, the appearances of modern Kazakh are featured with both oriental and western characteristics. (Upper Left) A waitress at a restaurant (Lower Left) Children preparing for costume play (Right)

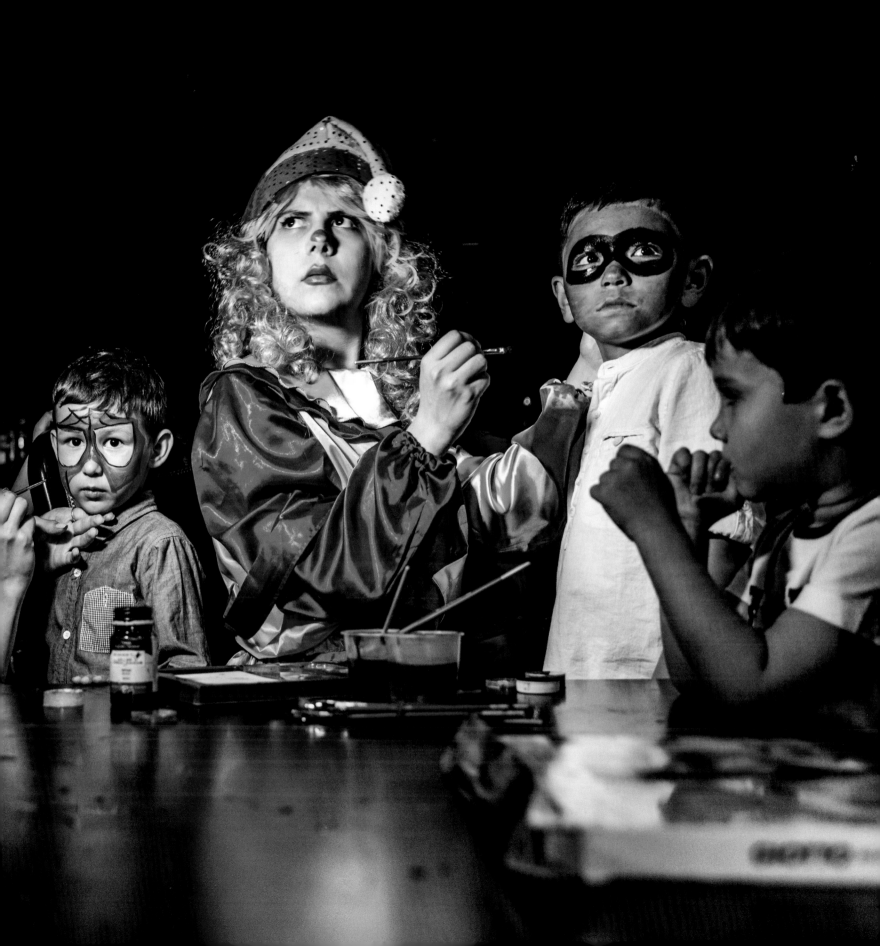

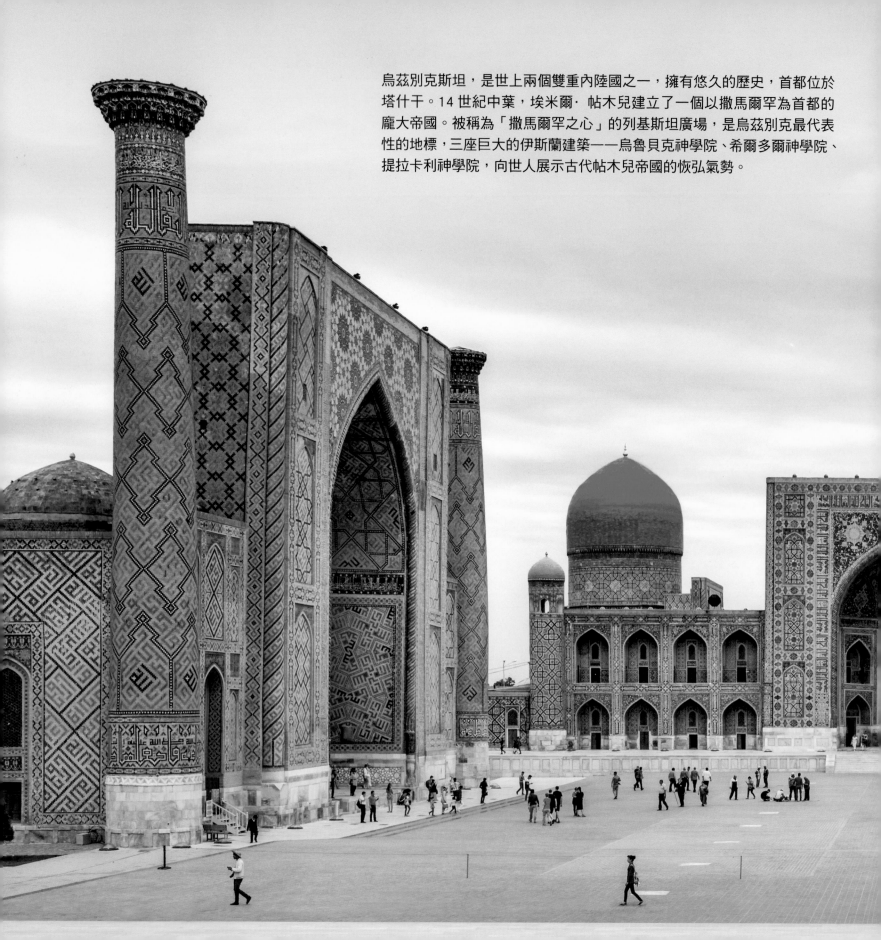

烏茲別克斯坦，是世上兩個雙重內陸國之一，擁有悠久的歷史，首都位於塔什干。14 世紀中葉，埃米爾‧帖木兒建立了一個以撒馬爾罕為首都的龐大帝國。被稱為「撒馬爾罕之心」的列基斯坦廣場，是烏茲別克最代表性的地標，三座巨大的伊斯蘭建築——烏魯貝克神學院、希爾多爾神學院、提拉卡利神學院，向世人展示古代帖木兒帝國的恢弘氣勢。

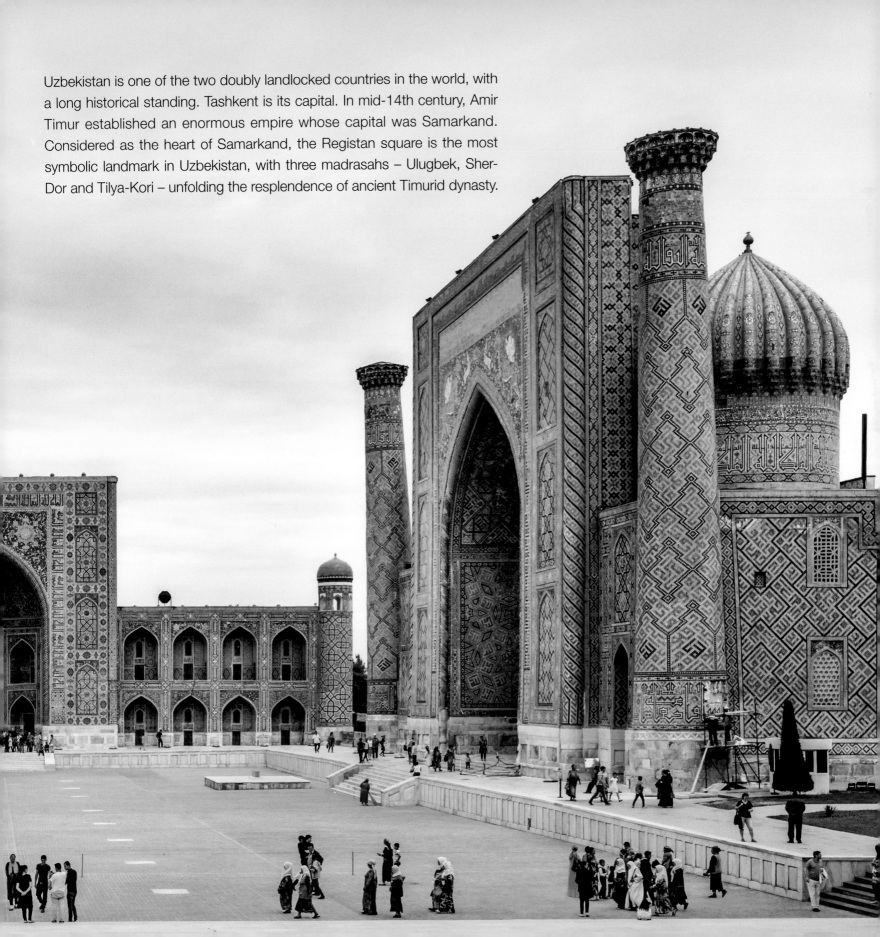

Uzbekistan is one of the two doubly landlocked countries in the world, with a long historical standing. Tashkent is its capital. In mid-14th century, Amir Timur established an enormous empire whose capital was Samarkand. Considered as the heart of Samarkand, the Registan square is the most symbolic landmark in Uzbekistan, with three madrasahs – Ulugbek, Sher-Dor and Tilya-Kori – unfolding the resplendence of ancient Timurid dynasty.

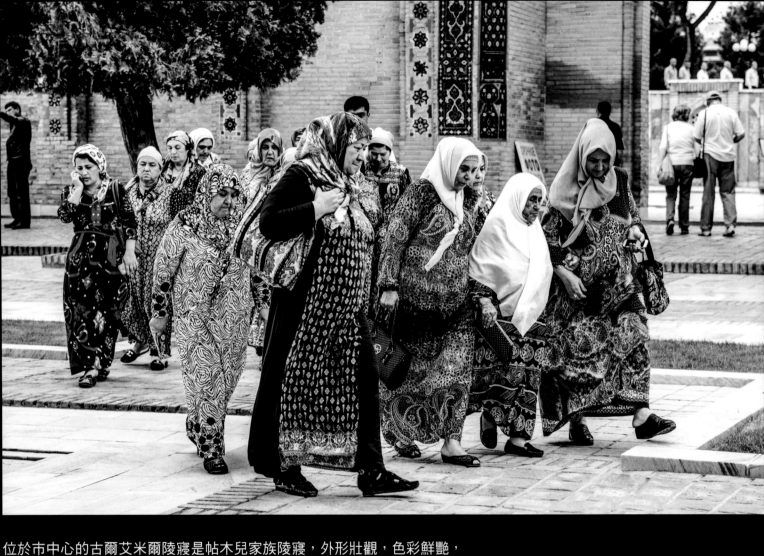

位於市中心的古爾艾米爾陵寢是帖木兒家族陵寢，外形壯觀，色彩鮮艷，
是中世紀東方建築的典範，也是帖木兒帝國最著名的古蹟之一。（右）
此處是本地人常去的地點。（左）

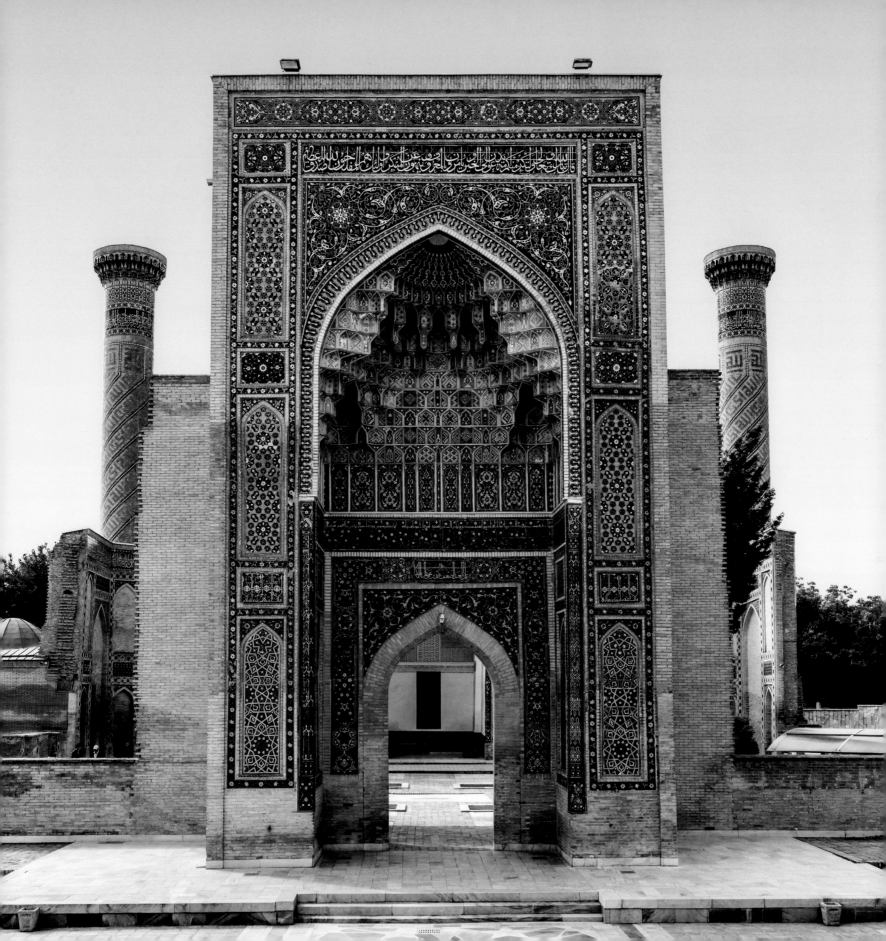

中亞當地的婦女喜歡穿著有雲彩般花紋的連身長裙。（左）
傳統服飾讓觀者仿佛瞬間置身於中世紀。（右上）年輕的女孩
們則偏好時裝。（右下）

In Central Asia, women adore one-piece long dresses with
flower patterns. (Left) The conventional costume would
instantly put us back to the Middle Ages. (Upper Right) Young
girls prefer fashionable dresses. (Lower Right)

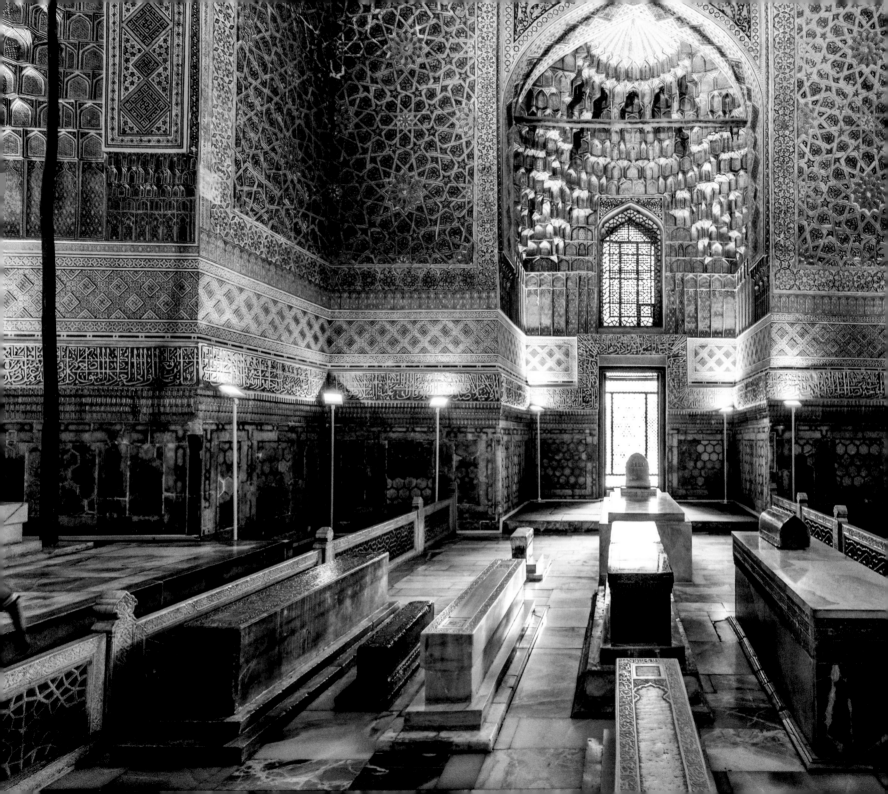

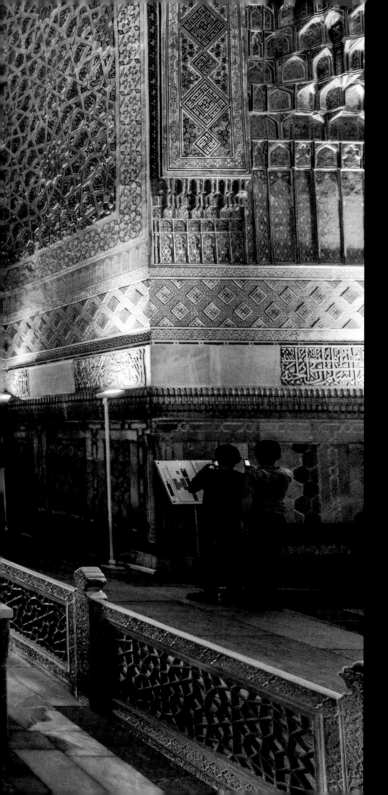

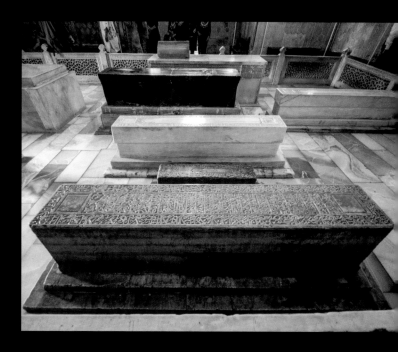

古爾艾米爾為帖木兒陵寢，其內氣氛肅穆，裝飾金碧
輝煌。（左）我們所見的九座石造棺槨，僅象徵性供人
祭拜，真正的遺體深埋地底。（右）

The resplendent interior of the Timur's mausoleum Gur-e-
Amir is filled with solemn and respectful atmosphere. (Left)
Today, the nine displayed coffins are symbolistic for worship
while the authentic bodies of the family are buried deep un-
derneath. (Right)

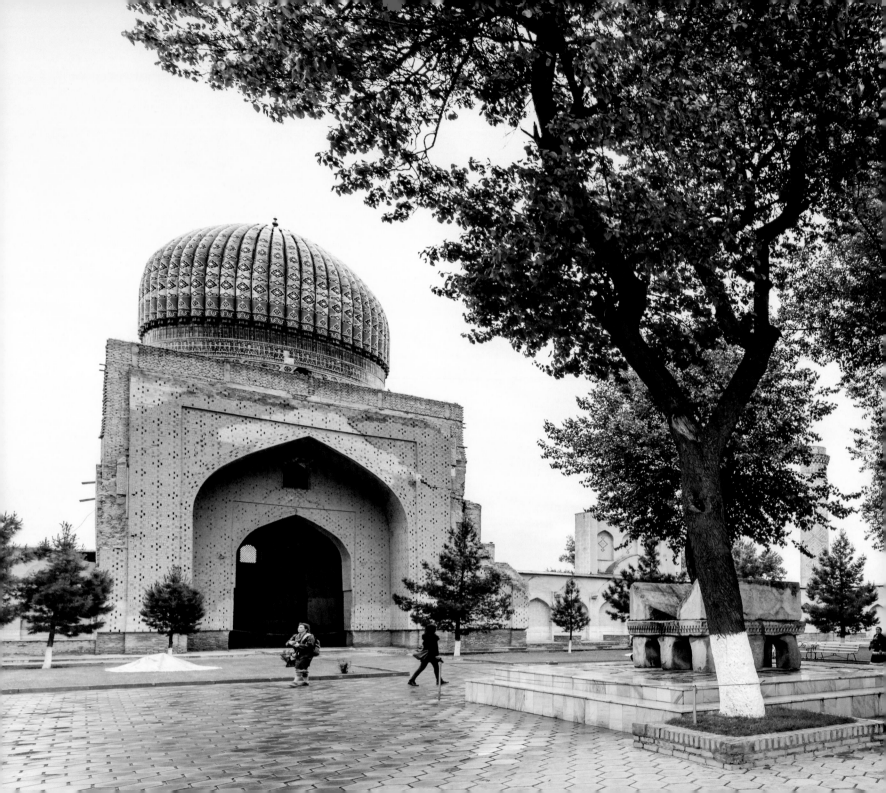

比比哈藍清真寺，以帝王最愛的妻子為名，曾
是中亞最大的清真寺。(左) 庭院中更設了
一座可放置可蘭經的巨石架。(右)

The Bibi-Khanym Mosque, named after the
most beloved wife of the emperor, was once
the largest mosque in Central Asia. (Left)
There is even a huge stone pedestal used as a
Quran stand in the middle of the courtyard. (Right)

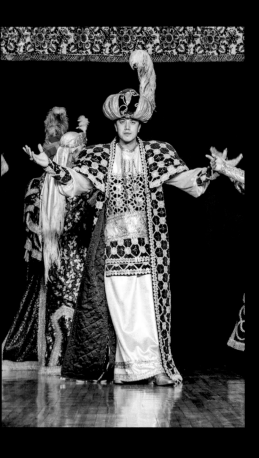

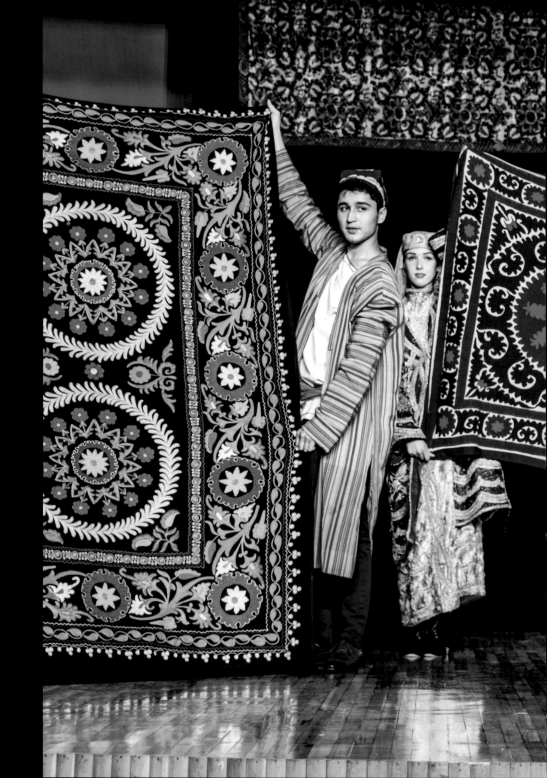

中亞當地的民族服飾多採用色彩豐富的
紋路。（左）布料常以傳統的刺繡方式
裝飾。（右）

The national costumes in Central Asia
tend to use colorful patterns. (Left)
Cloths are generally adorned with
traditional embroideries. (Right)

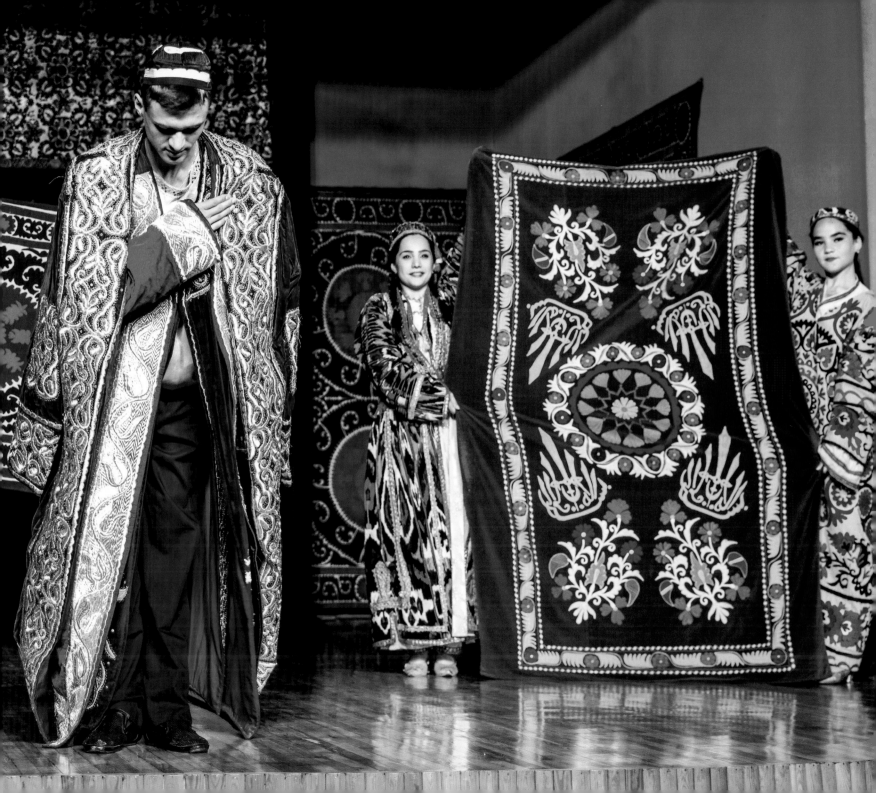

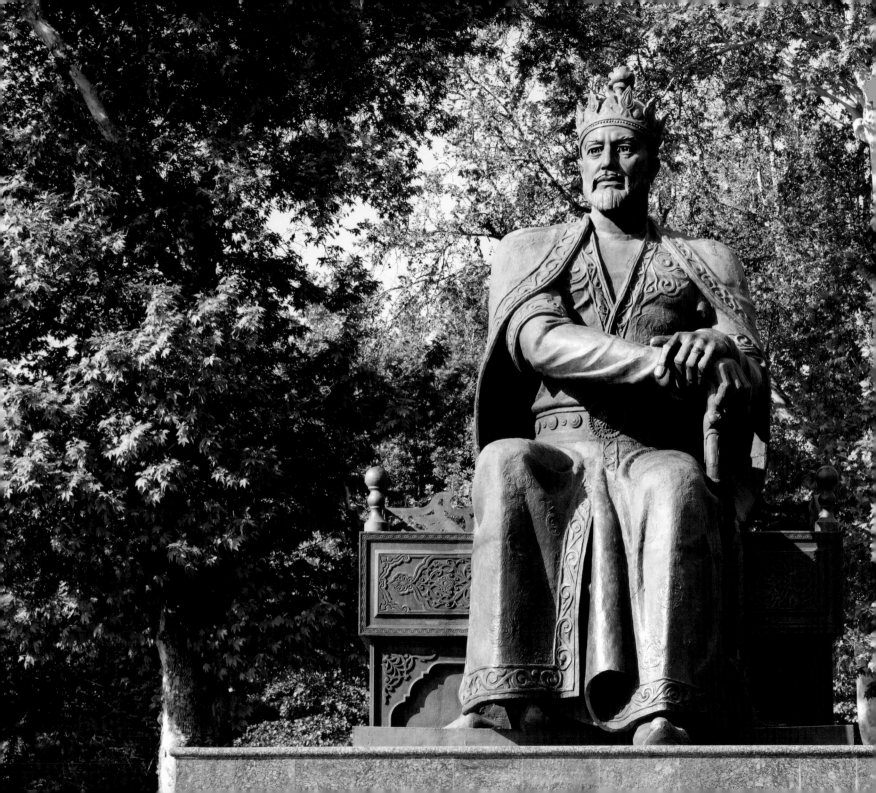

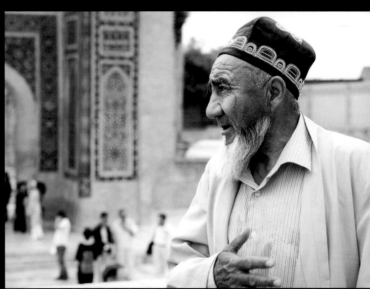

帖木兒是烏茲別克人心目中的民族英雄，備受敬重。（左）
雕像為其馬上英姿。（右上）一位老人到古爾艾米爾陵寢向
帖木兒致敬。（右下）

Timur is the national hero in the heart of Uzbekistan
people, which is highly respected by public. (Left)
The statue characterizes his heroic posture on horse. (Upper
Right) An old man visits the Gur-e-Amir to pay his respect
to Timur. (Lower Right)

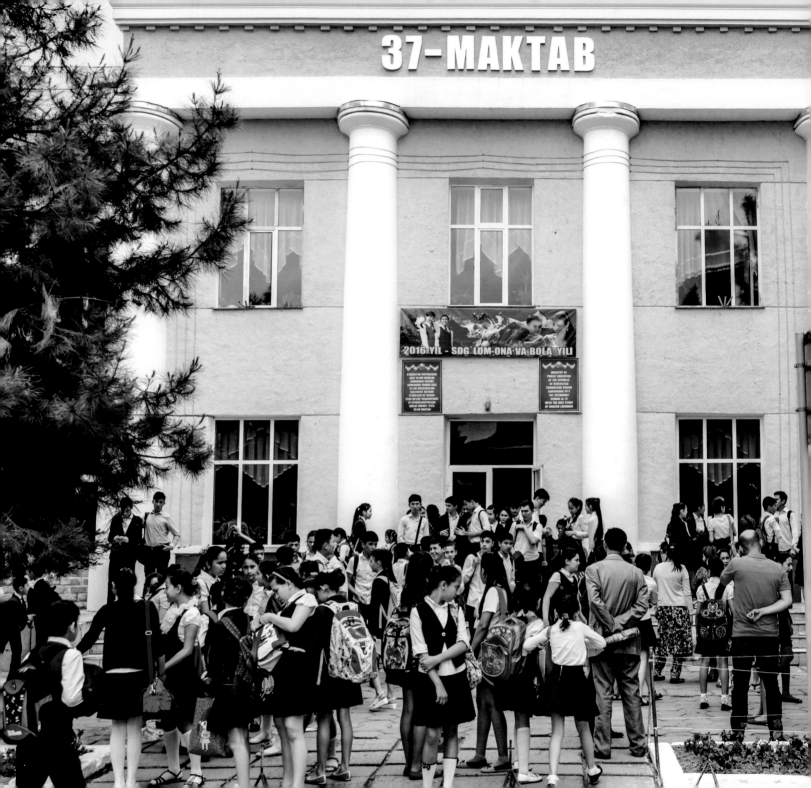

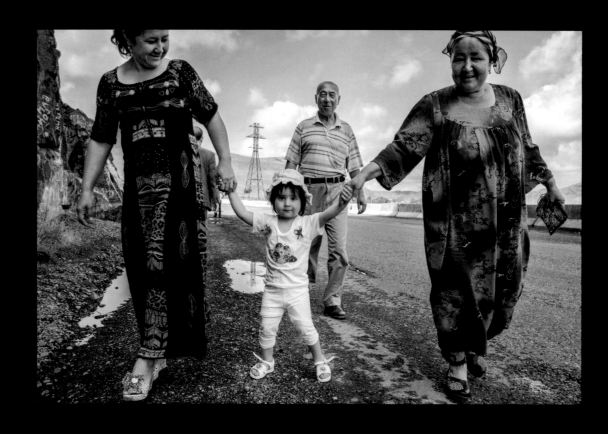

中亞各國信奉伊斯蘭教的人口眾多，幾乎佔 80% 左右。（右）當地的服裝、教育等多個方面都深受伊斯蘭文化的影響。（左）

Muslims take up a large proportion of population in Central Asia (around 80%). (Right) The local fashion, education, and other aspects are deeply influenced by Islamic cultures. (Left)

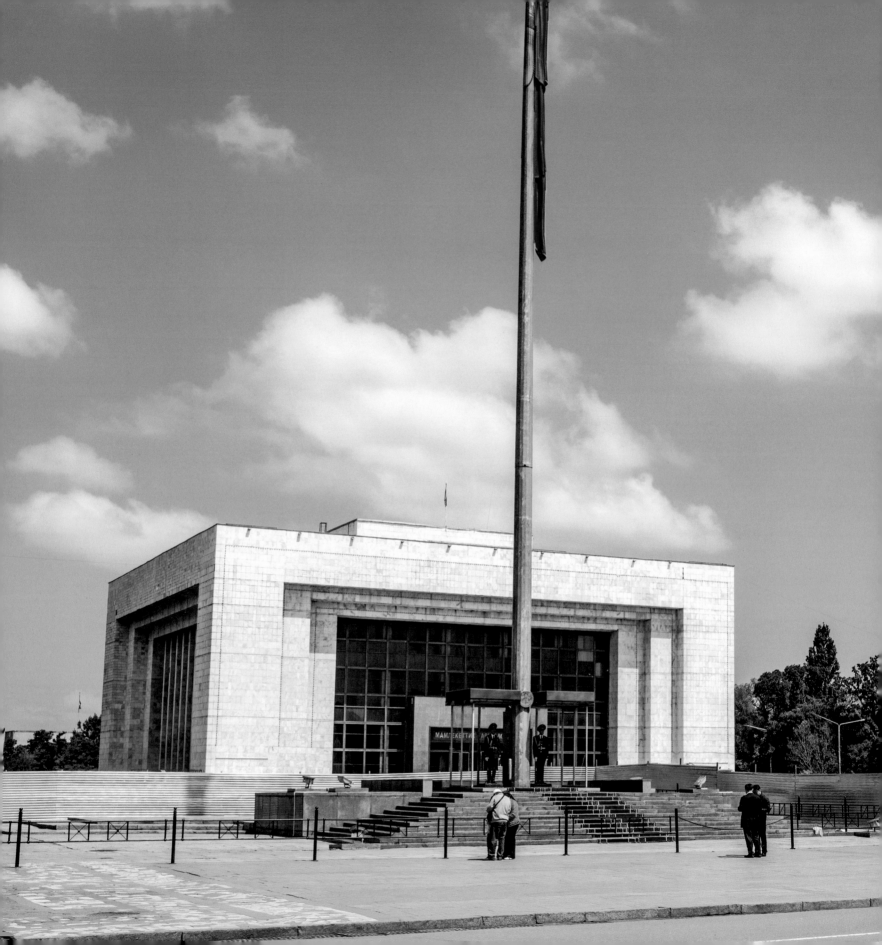

吉爾吉斯斯坦以中國、哈薩克斯坦、烏茲別克斯坦及塔吉克斯坦為鄰，定都於其最大城市比什凱克。相對周邊國家，吉爾吉斯的國土面積甚小，農業仍為其經濟的重要組成部分。

阿拉圖廣場是 1984 年為慶祝吉爾吉斯成立 60 周年而興建的。2005 年 3 月 24 日，該廣場成為鬱金香革命的最大活動現場。

Kyrgyzstan is the neighbor of China, Kazakhstan, Uzbekistan and Tajikistan, with its capital being its largest city Bishkek. Compared to its surrounding countries, Kyrgyzstan is relatively small in terms of territory. Agriculture is an important sector of its economy.

The Ala-Too Square was built in 1984 to celebrate the 60th anniversary of the Kyrgyz SSR. On March 24, 2005, the square was the site of the largest anti-government protest of Kyrgyzstan's Tulip Revolution.

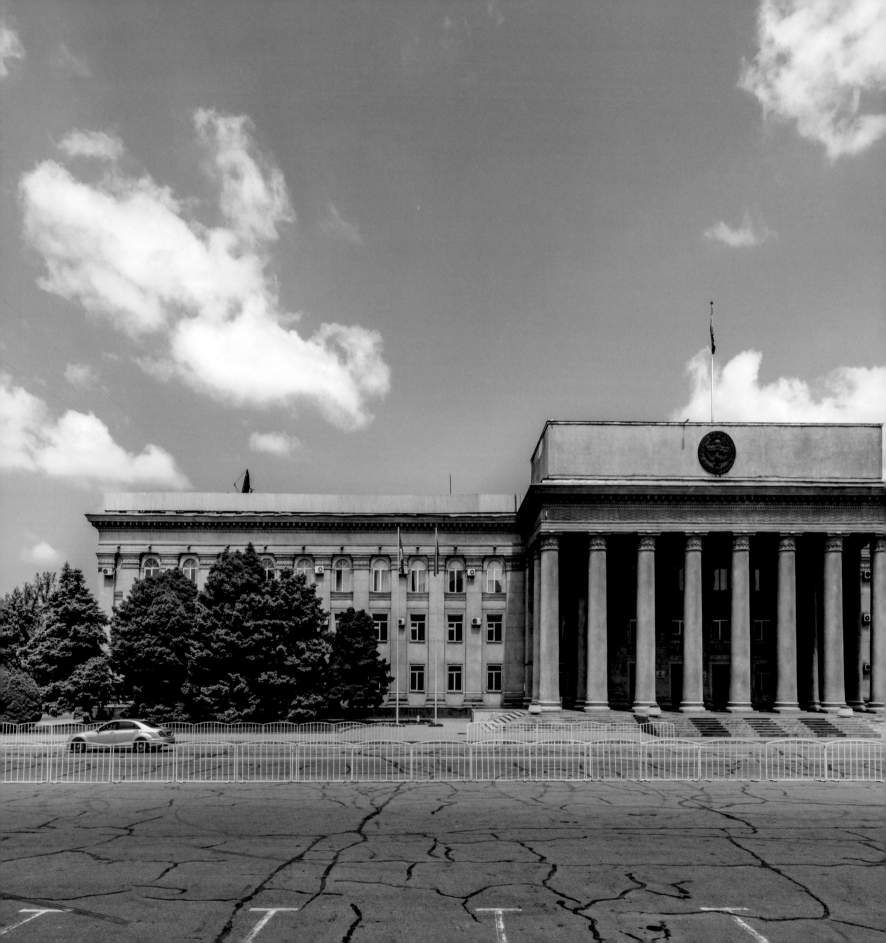

比什凱克市中心，坐落著吉爾吉斯的總統府邸白宮。（左）附近的公園內樹立著一座金光燦燦的潘菲洛夫紀念雕像。（右）

At the center of Bishkek, the White House is the presidential office building in Kyrgyzstan. (Left) There is a statue with golden glitter of Ivan Panfilov in the park nearby. (Right)

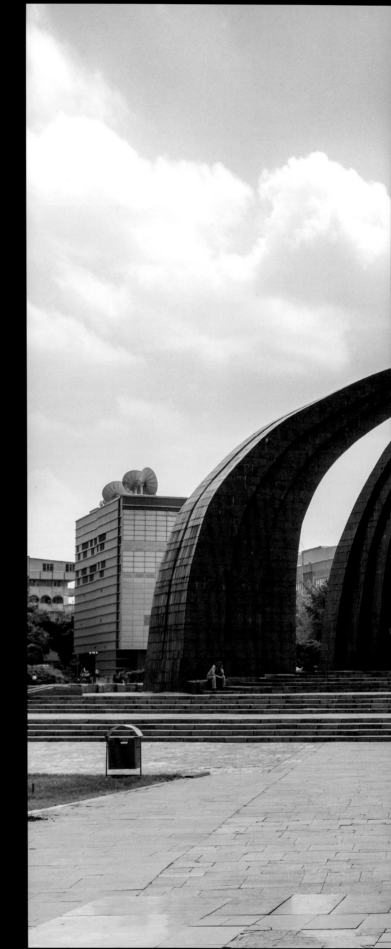

勝利廣場完成於 1984 年，紀念二戰戰勝納粹 40 周年，廣場中心的勝利雕塑由三個巨大花崗岩合併 形成了蒙古包的剪影。（右）中央燃著長明火。（左）

The Victory Square was finished in 1984 to commemorate the victory over Nazi in World War II. At the center of the square, the Monument of Victory consists of three giant granite arcs, resembling the shape of a yurt. (Right) The central area is filled with an eternal flame. (Left)

曾位於阿拉圖廣場上的列寧像已搬遷至其他地方。（左）比什凱克有一條「鄧小平大街」，其上矗立的紀念碑之上，以中文、吉爾吉斯文和俄文寫着：「此街以中國卓越的社會和政治活動家鄧小平的名字命名」。（右）

The massive statue of Lenin once placed in the Ala-Too Square has now been moved elsewhere. (Left) There is also a "Deng Xiaoping Avenue" in Bishkek, with a monument written in Chinese, Kyrgyz and Russian stating that "This street is named after Chinese outstanding sociologist and politico Deng Xiaoping." (Right)

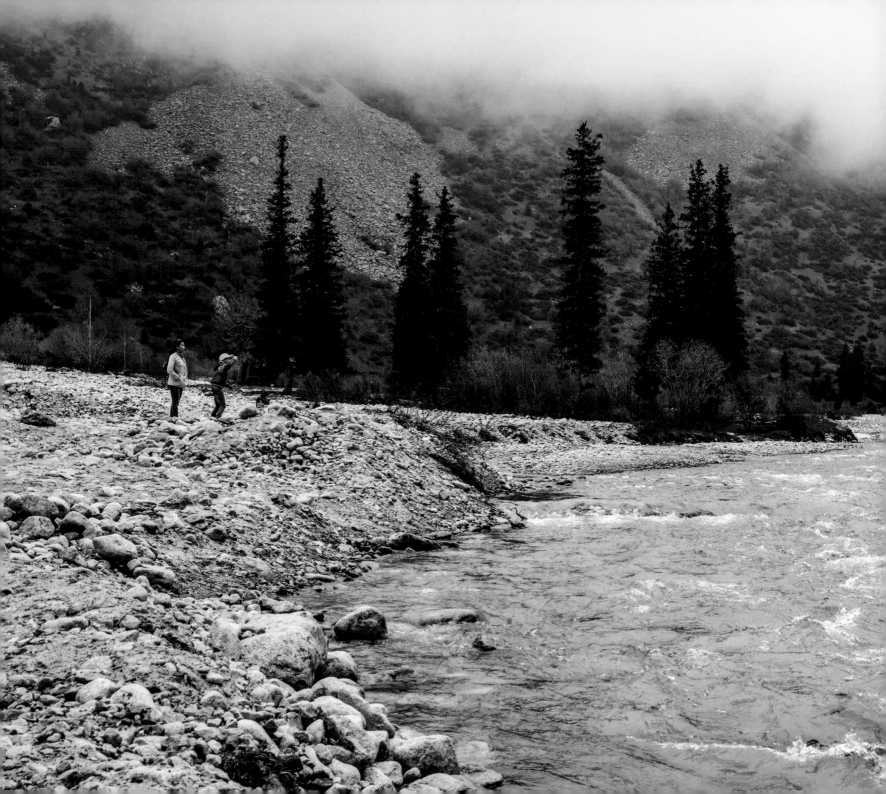

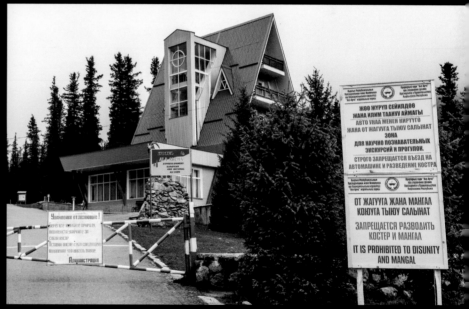

阿拉阿查國家公園可遠眺天山延綿雄偉的山脈。（左）
內部設有餐飲設施。（右上）更有一間阿拉阿查酒店，
可供遊客入住。（右下）

The view of Tian Shan range is spectacular at the Ala Archa National Park. (Left) It is well equipped with food and beverage facilities. (Upper Right) There is also an Ala Archa Hotel for visitors. (Lower Right)

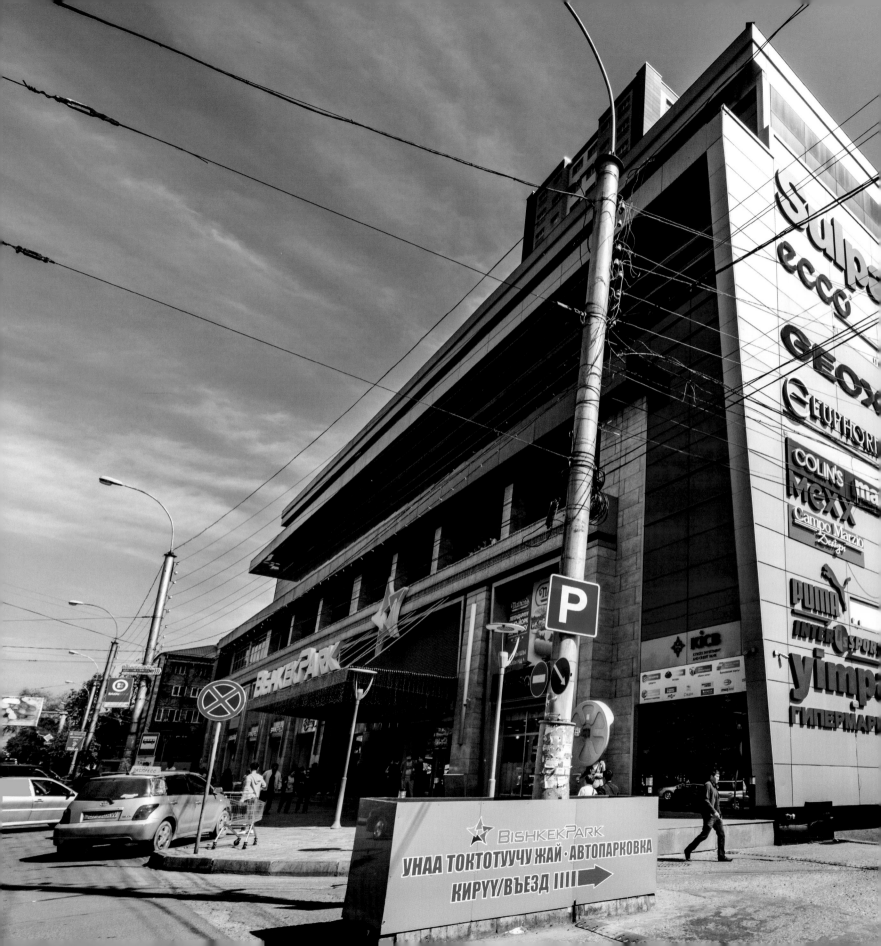

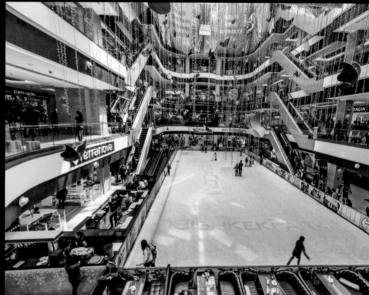

比什凱克公園購物中心屬於吉爾吉斯當地較為高檔次的商場。（左）商場內有一個大型的溜冰場。（右）

The Bishkek Park is a top-grade shopping mall in Kyrgyzstan. (Left) There is a large ice rink inside. (Right)

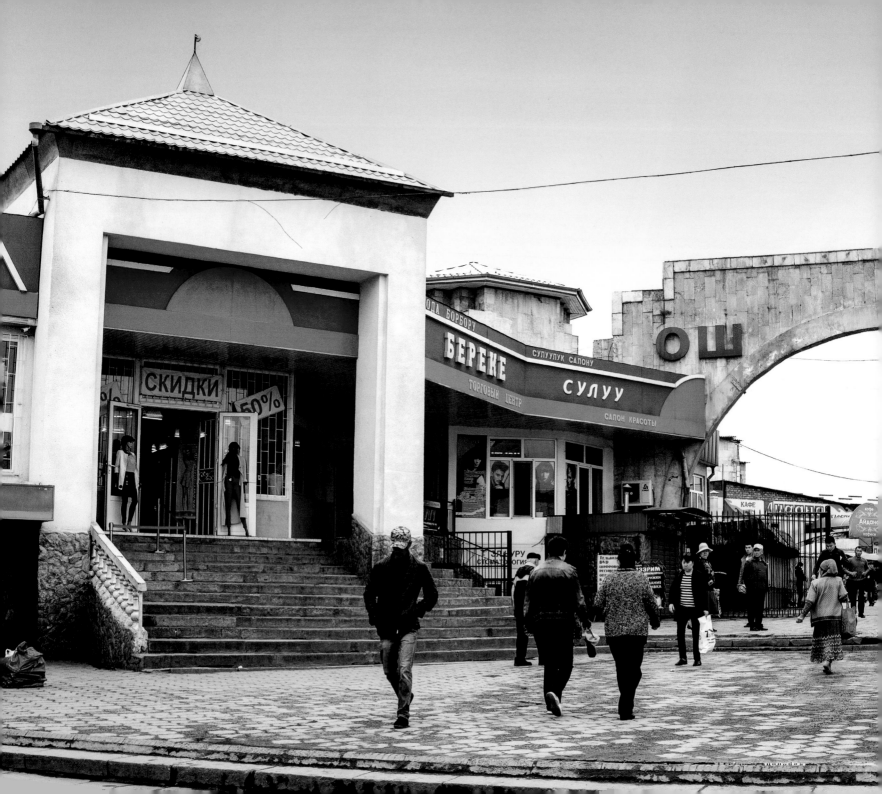

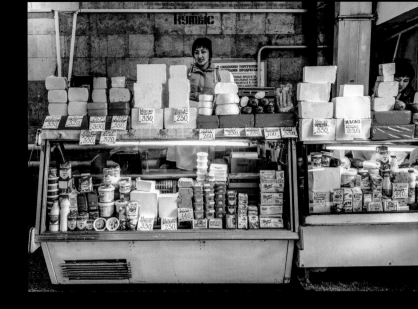

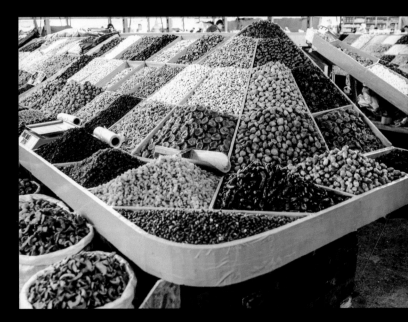

奧什露天市場是比什凱克較為平民化的市集。（左）遊牧民族
普遍喜愛奶製品。（右上）在此可買到各類香料乾貨。（右下）

The Osh Bazaar is a relatively plebeian market that
in Bishkek. (Left) Dairy foods are popular among nomadic
peoples. (Upper Right) Assorted spices and dried foods can be
found here. (Lower Right)

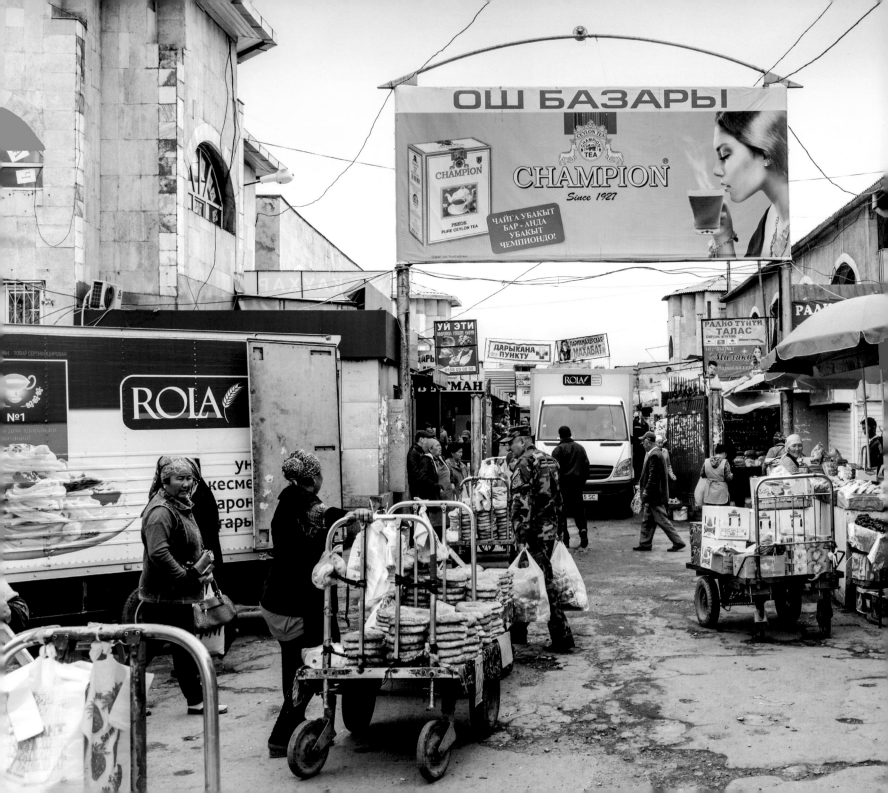

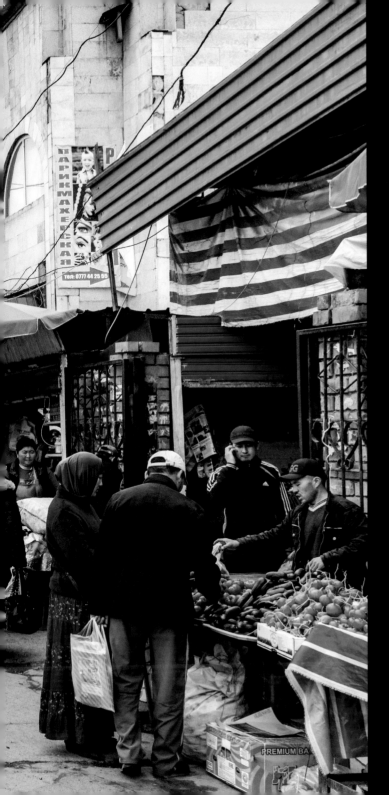

市場齊集各類農產品。（左）肉類為吉爾吉斯出口貨物的重要部分。（右上）當地最負盛名的特產當屬蜂蜜及堅果。（右下）

There are all kinds of primary products in the market. (Left) Meat is an important part of Kyrgyz exports. (Upper Right)Kyrgyzstan is known for its honey and nut products. (Lower Right)

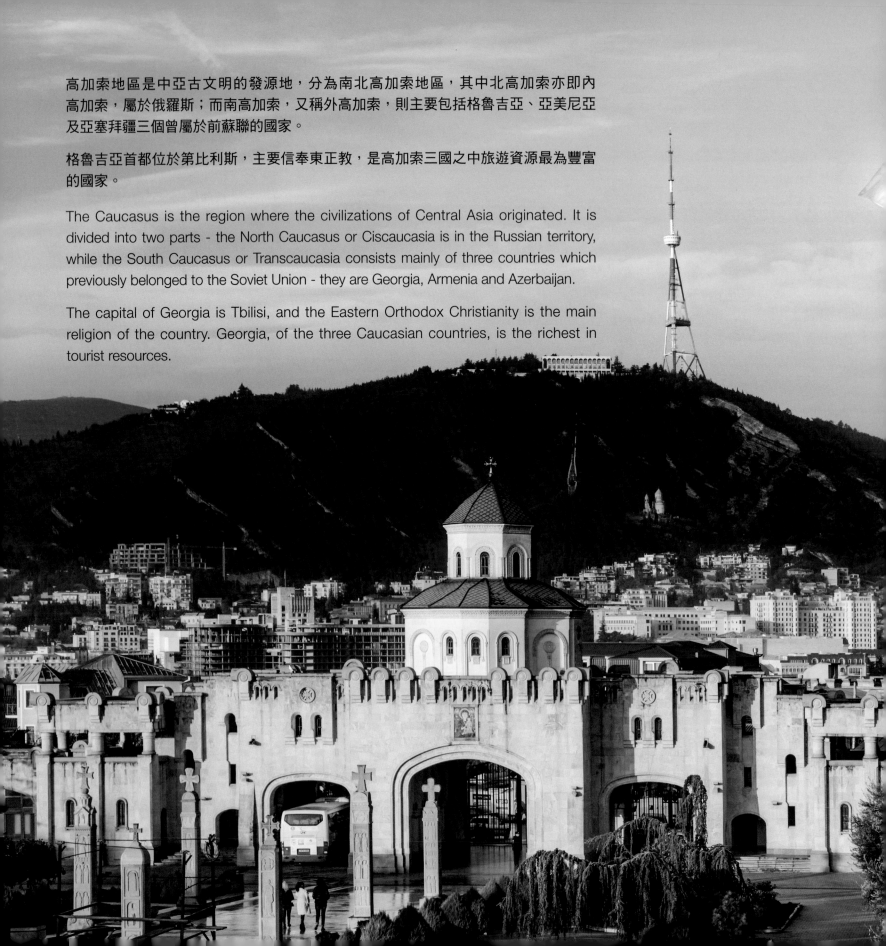

高加索地區是中亞古文明的發源地，分為南北高加索地區，其中北高加索亦即內高加索，屬於俄羅斯；而南高加索，又稱外高加索，則主要包括格魯吉亞、亞美尼亞及亞塞拜疆三個曾屬於前蘇聯的國家。

格魯吉亞首都位於第比利斯，主要信奉東正教，是高加索三國之中旅遊資源最為豐富的國家。

The Caucasus is the region where the civilizations of Central Asia originated. It is divided into two parts - the North Caucasus or Ciscaucasia is in the Russian territory, while the South Caucasus or Transcaucasia consists mainly of three countries which previously belonged to the Soviet Union - they are Georgia, Armenia and Azerbaijan.

The capital of Georgia is Tbilisi, and the Eastern Orthodox Christianity is the main religion of the country. Georgia, of the three Caucasian countries, is the richest in tourist resources.

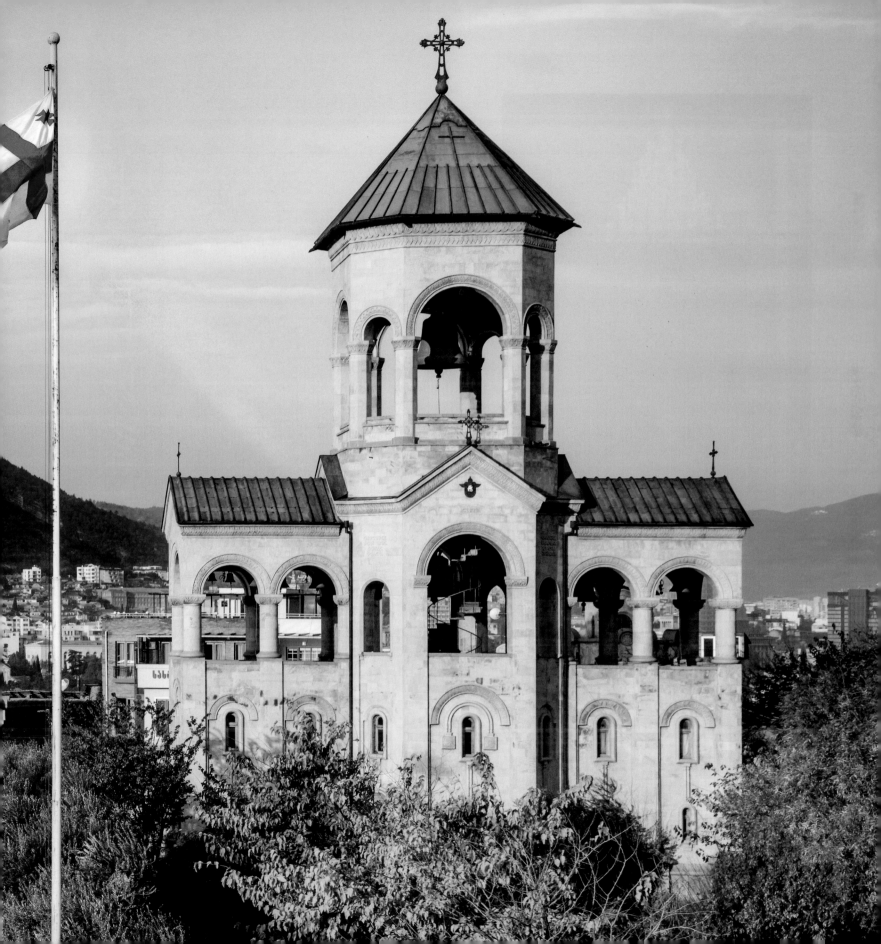

姆茨赫塔聖十字修道院所在之處，據說是在 4 世紀時，傳教士聖女尼諾第一次豎立起十字架的地方。（左）修道院的建立是為紀念基督教首次傳入格魯吉亞。（右）

It is said that in the 4th century, Saint Nino erected a large wooden cross on the site of Jvari Monastery. (Left) The monastery was established to commemorate Christianity's being introduced into Georgia for the first time. (Right)

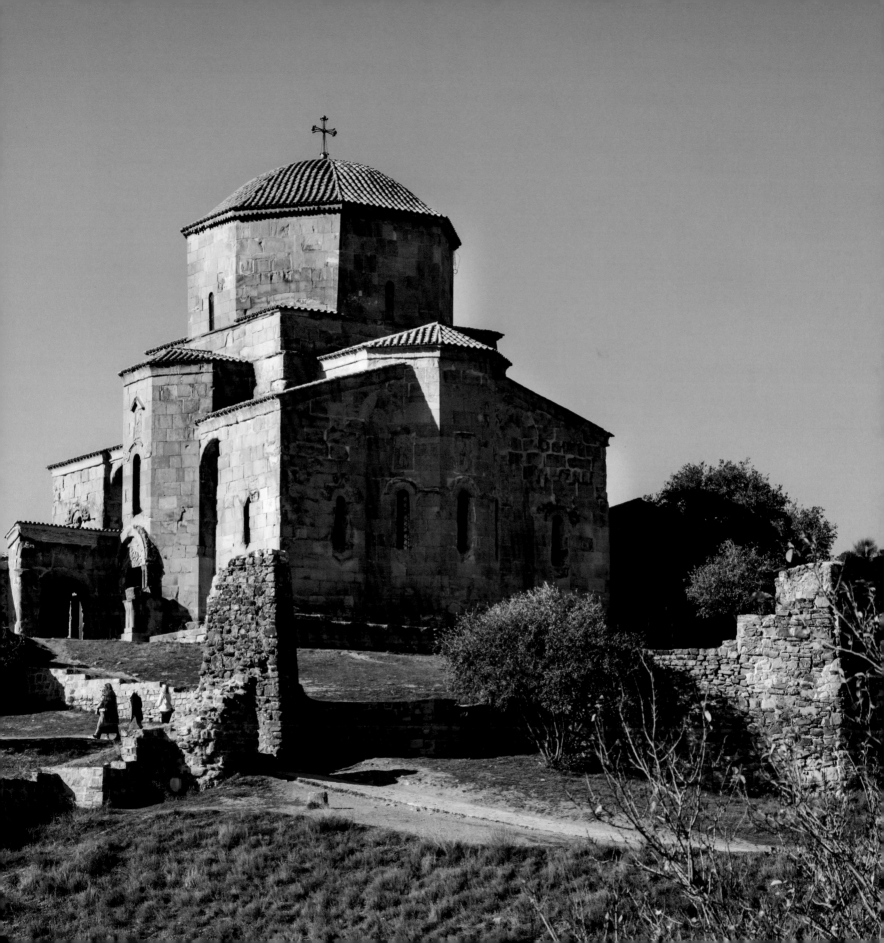

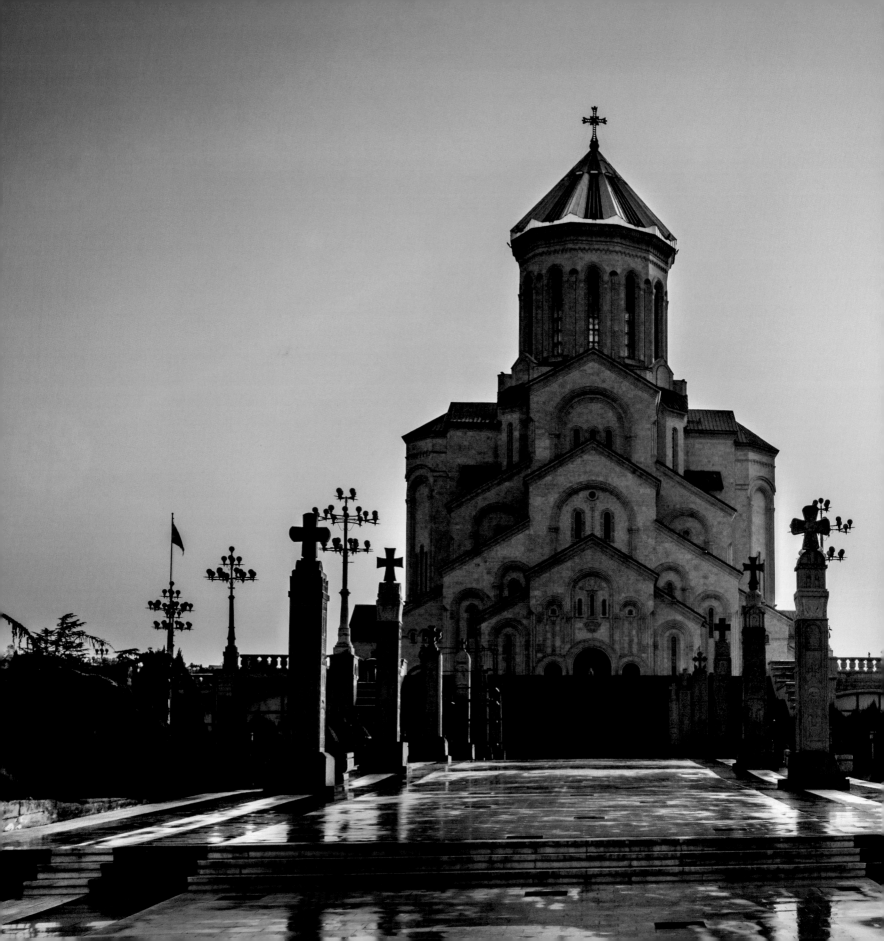

聖三一大教堂建築雄偉，是格魯吉亞最大、最高的教堂，從第比利斯的各個角度幾乎都能看到。

The Holy Trinity Cathedral of Tbilisi is the largest and tallest church in the whole country. It can be seen from almost everywhere in the city of Tbilisi.

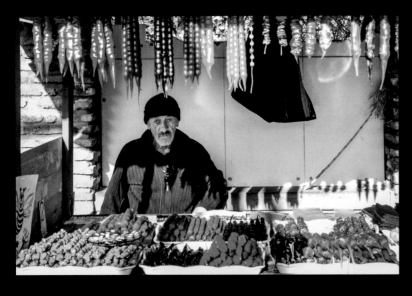

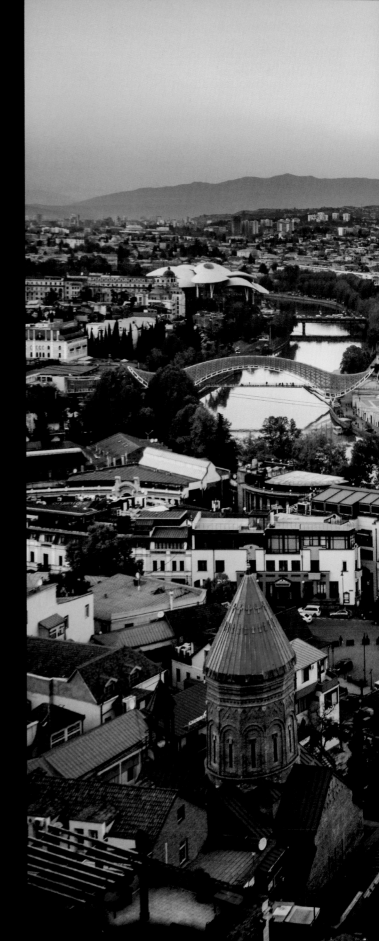

第比利斯是格魯吉亞多個朝代的首都。（右）這是該國最大城市，亦是政治、文化、經濟及教育中心，同時還是重要的交通樞紐。（左上）街角處經常可見小食店。（左下）

Tbilisi is the capital of Georgia for many dynasties. (Right) It is the country's largest city as well as the center of politics, culture, economy, education and transportation. (Upper Left) Snack vendors can be seen around street corners. (Lower Left)

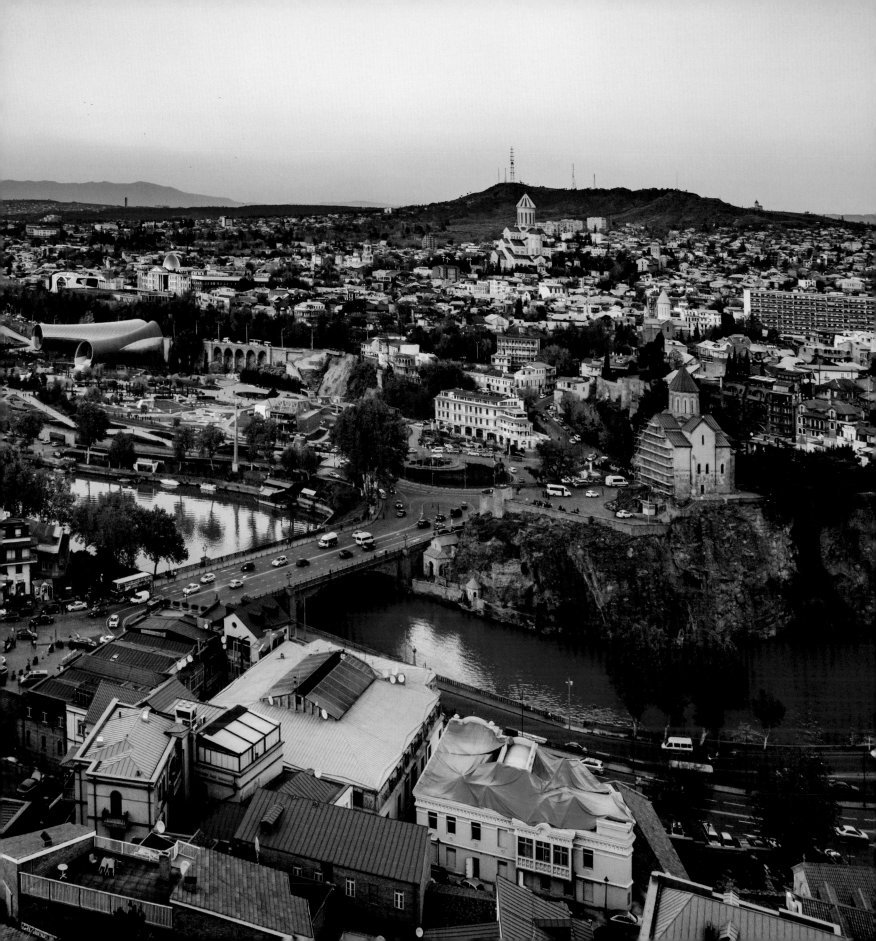

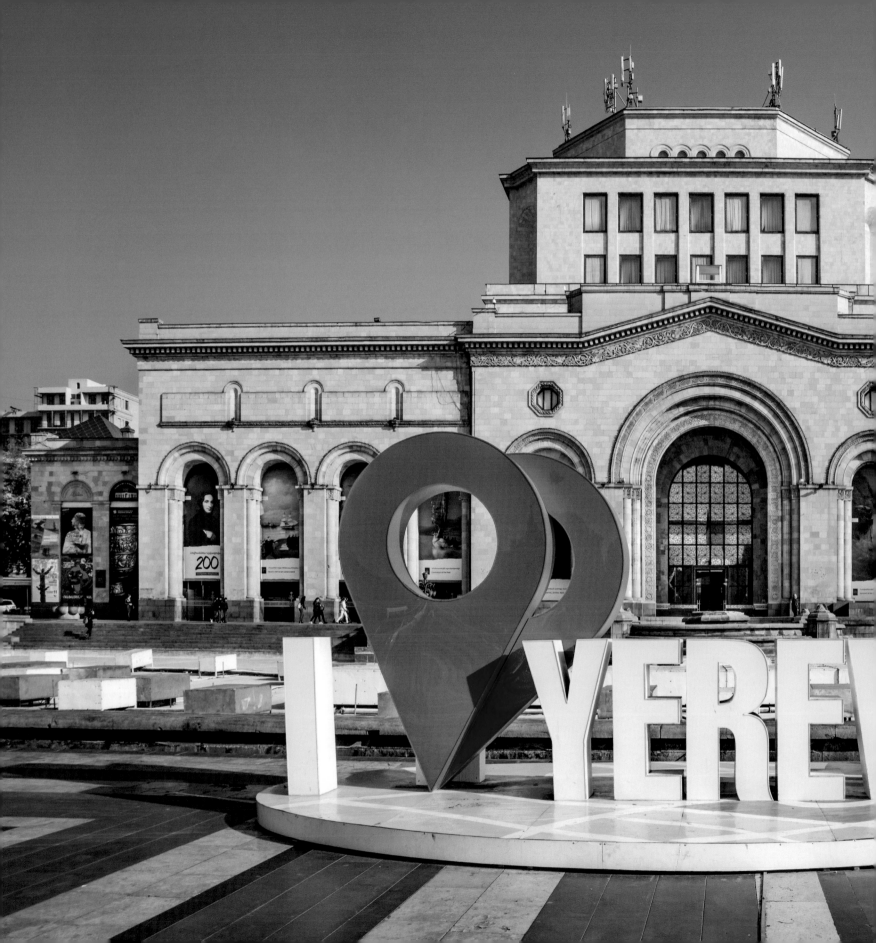

亞美尼亞是一個內陸國家，首都為埃里溫。早於 4 世紀初，亞美尼亞就已將基督教列為官方宗教，因此常被認為是「第一個基督教國家」。絕大部分的國民信奉基督教，因此與周邊信奉伊斯蘭教為主的國家有著宗教上或領土上的不穩定因素。亞美尼亞歷史博物館，是該國的國家博物館，坐落在共和廣場之上。在博物館前，更有「我愛埃里溫」的標識。

Armenia is an inland country whose capital is Yerevan. In the beginning of the 4th century, Armenia has already adopted Christianity as its official religion. The country is, therefore, considered to be "the first Christian country", with most of its nationals being Christians. Due to religious or territorial conflicts, instabilities exist between Armenia and its surrounding countries, which are mainly Islamic. The History Museum, also the National Museum of Armenia, is situated on the Republic Square. There is also an "I love Yerevan" sign in front of the museum.

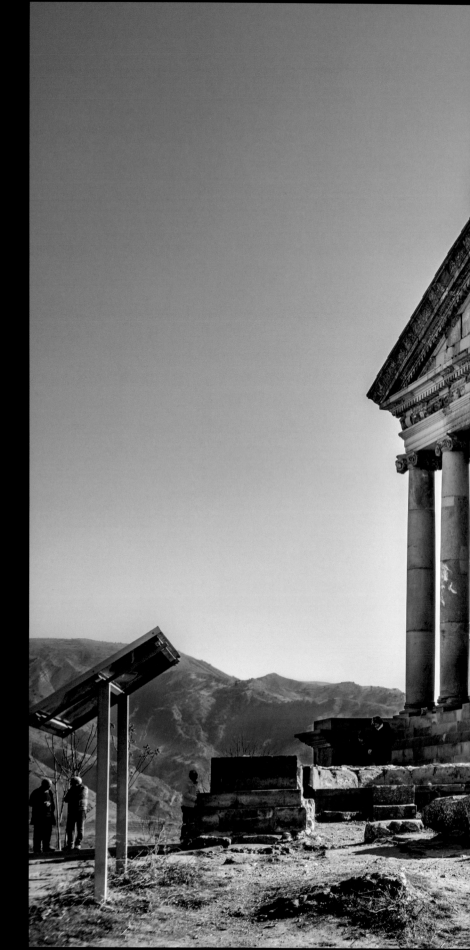

加爾尼希臘神殿的外形，讓人自然聯想起希臘的雅典衛城，但規模上彷如一個「迷你」版。（右）這座建於1世紀的神殿，是目前該國國內碩果僅存的希臘式列柱建築。（左）

The Temple of Garni naturally reminds us of the Acropolis of Athens in Greece, but in a much smaller scale. (Right) The temple, which was built in the 1st century, is now the only standing Greco-Roman colonnaded building in the country. (Left)

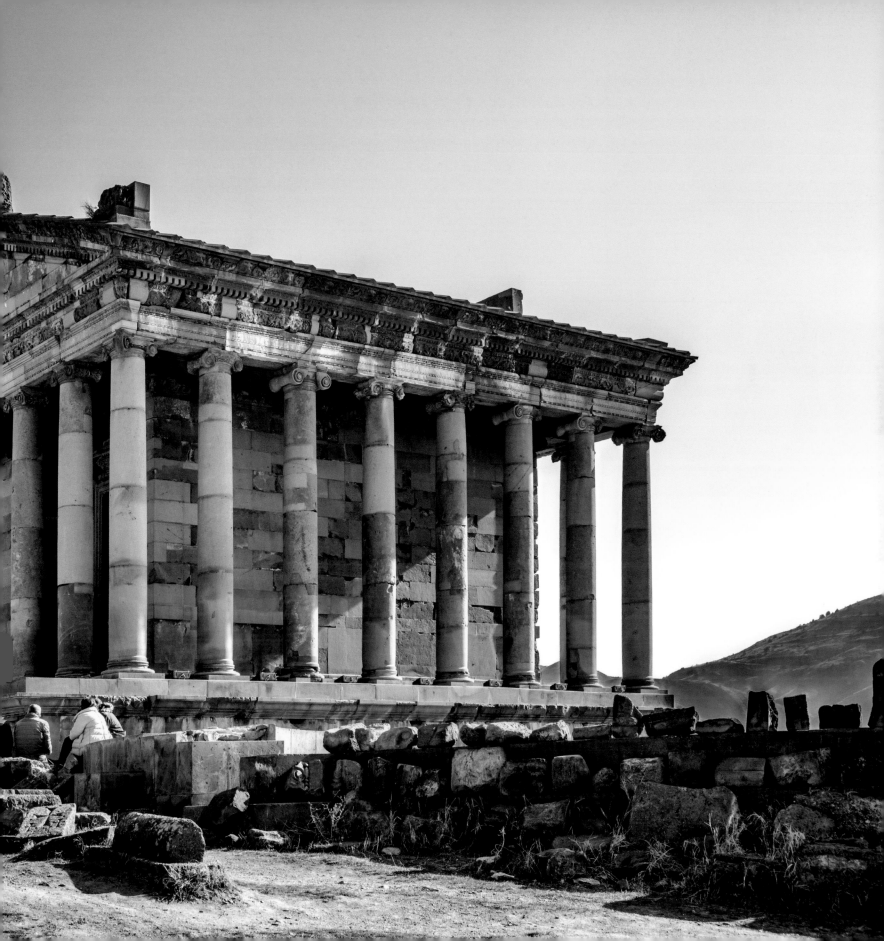

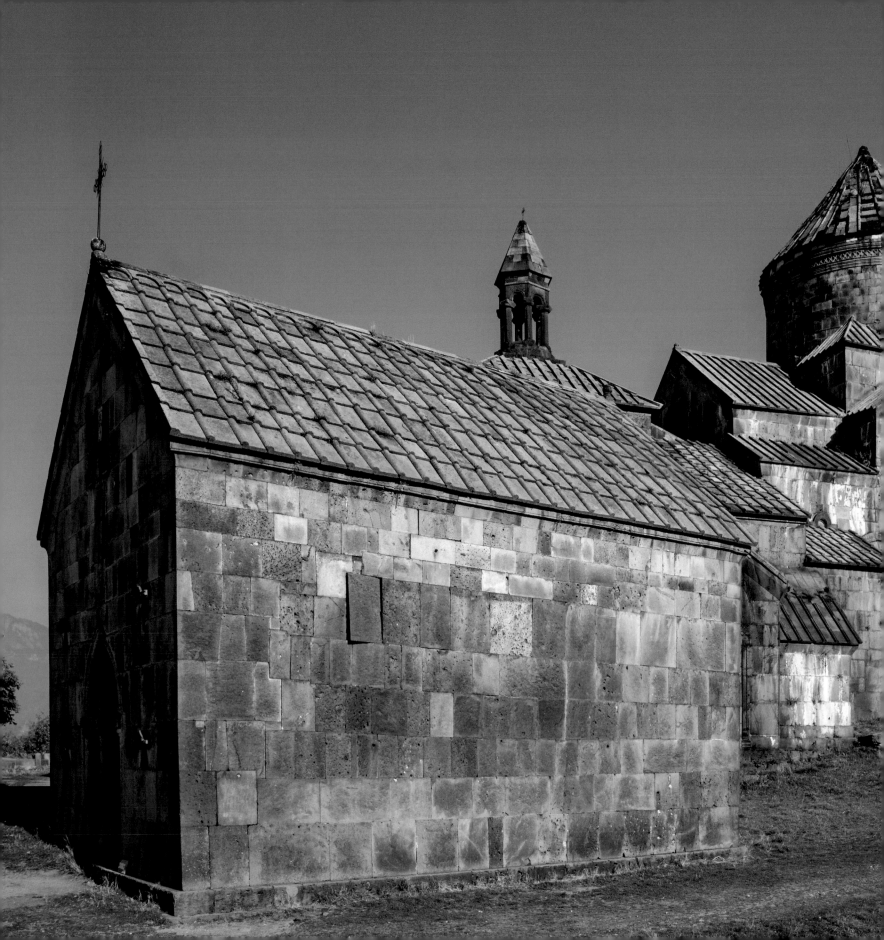

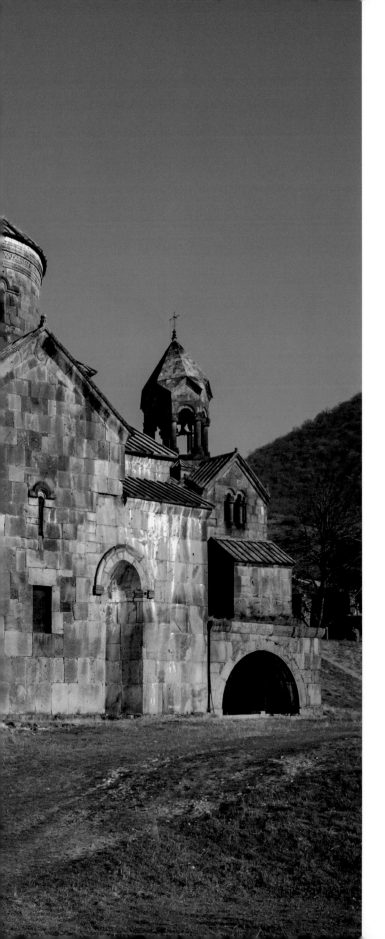

哈格帕特修道院於 1996 年被列為世界文化遺產。（左）
修道院結合了拜占庭風格及高加索本土建築元素，
是 10 至 13 世紀亞美尼亞宗教藝術的傑出典範。（右）

The Haghpat Monastery was placed on UNESCO's
World Heritage List in 1996. (Left) It is a representative
of outstanding religious art in Armenia from 10th to 13th
century, with its style combining Byzantine and Caucasus
architectural elements. (Right)

塞凡湖是高加索地區最大的湖泊，有傳得名於湖邊的塞凡納旺克修道院。修道院原本坐落於一個小島的南岸，但由於史太林時期的水利工程，塞凡湖水位顯著下降，現修道院所在之地已成為了一個半島。

Lake Sevan is the largest body of water in the Caucasus region, which is said to have got its name from the Sevanavank Monastery by the lake. The monastery was originally situated at the south end of a small island, but hydraulic construction during the Stalin period led to significant reduction in water level, which has turned the location of the monastery from an island into a peninsula.

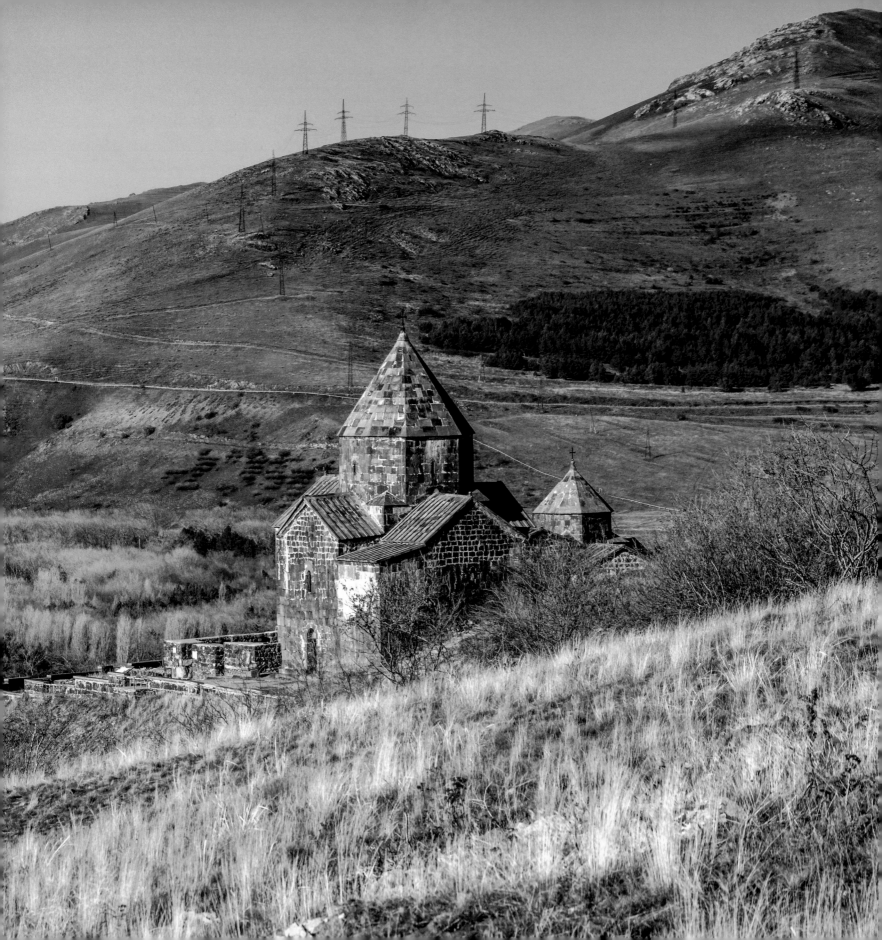

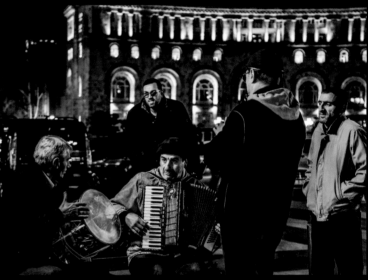

為了紀念設計了埃里溫現代都市計劃的
建築師亞歷山大・塔馬尼揚，在市中心
設有其紀念雕像。（左）饢是中亞國家的
主食。（右上）夜間的街頭表演呈現了輕鬆的
藝術氣息。（右下）

In order to pay respect to Alexander
Tamanian, the architect who designed
Yerevan's planning of a modern city, there
is a monument of him in the center of
the city. (Left) Naan is the staple food in
Central Asian countries. (Upper Right)
The street performances at night create a
relaxed artistic atmosphere. (Lower Right)

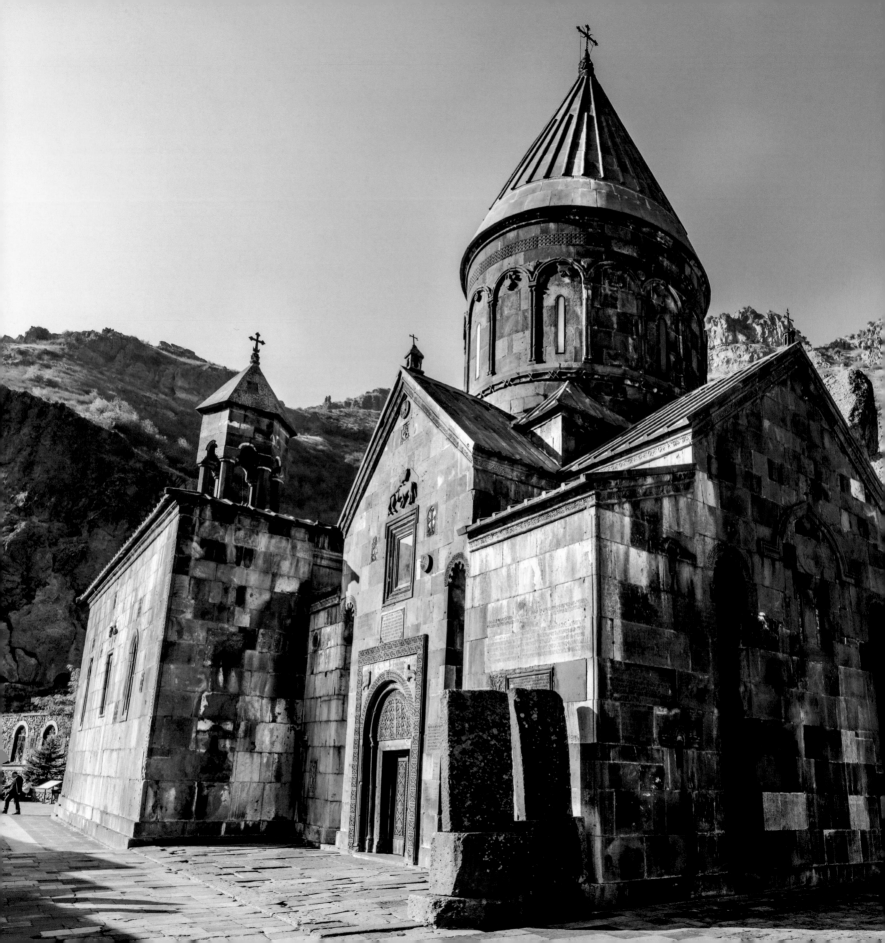

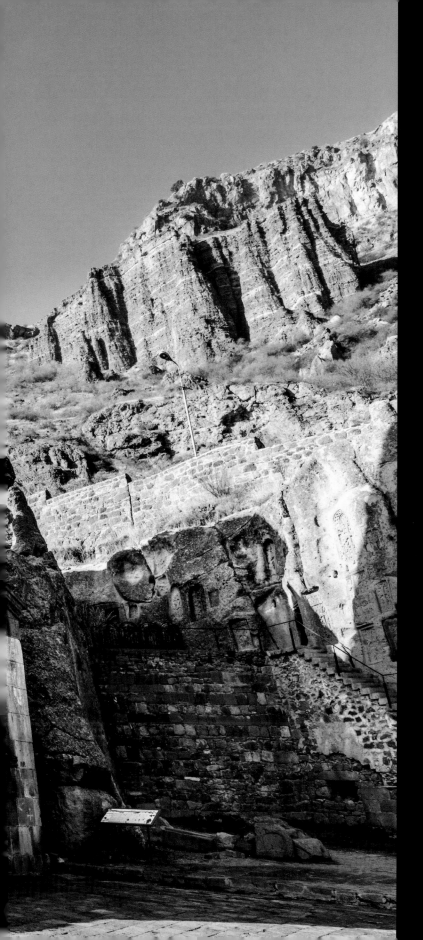

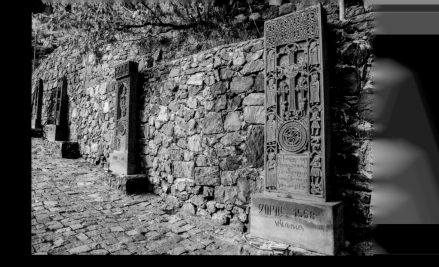

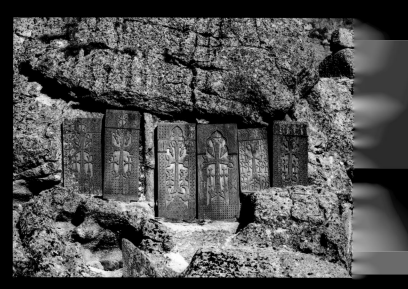

格加爾德修道院早於 2000 年就被列入聯合國世界文化遺產。（左）它曾被亞美尼亞人稱作「艾里凡克」，意為「岩洞教堂」。（右上）修道院的大部分建築都是從山岩之中開鑿出來的，巧妙利用空間，與壯麗的自然山景融合，可謂中世紀亞美尼亞建築的巔峰之作。（右下）

Geghard was listed as a UNESCO World Heritage Site in 2000. (Left) Its original name in Armenian is "Ayrivank", meaning "the Monastery of the Cave" (Upper Right) Most parts of the monastery were carved out of the adjacent mountain, taking advantage of the limited space ingeniously. Naturally integrated into the surrounding mountain view, Geghard typifies the best of Armenian architecture in Middle Ages. (Lower Right)

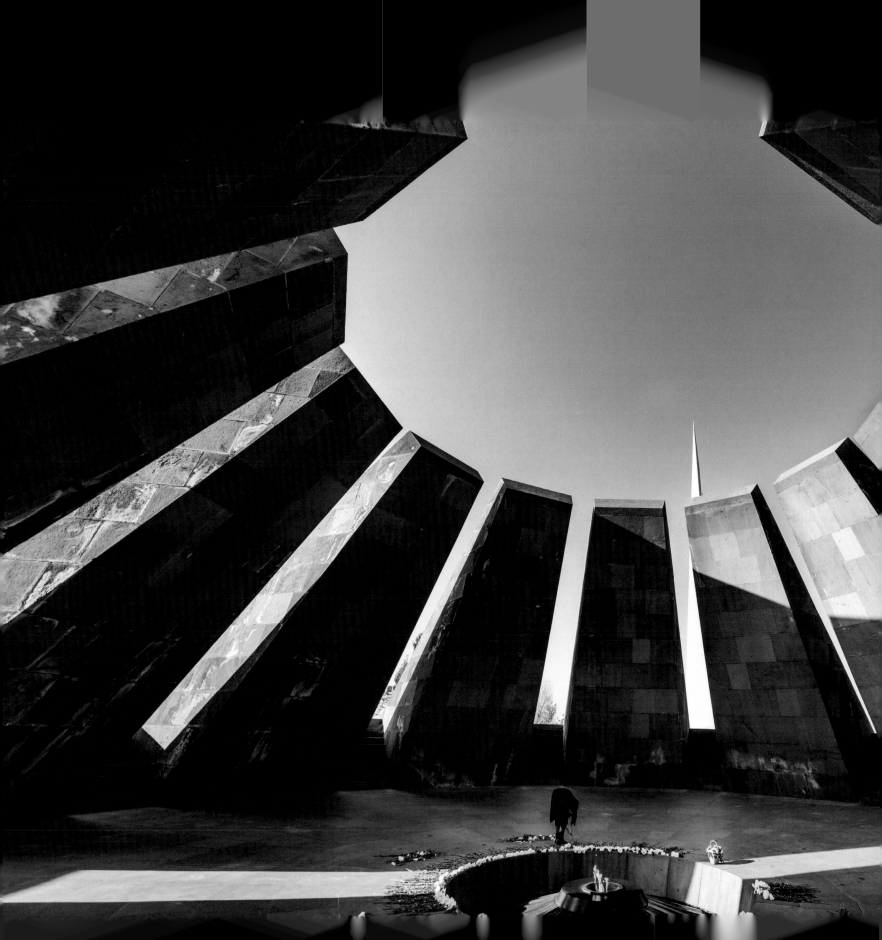

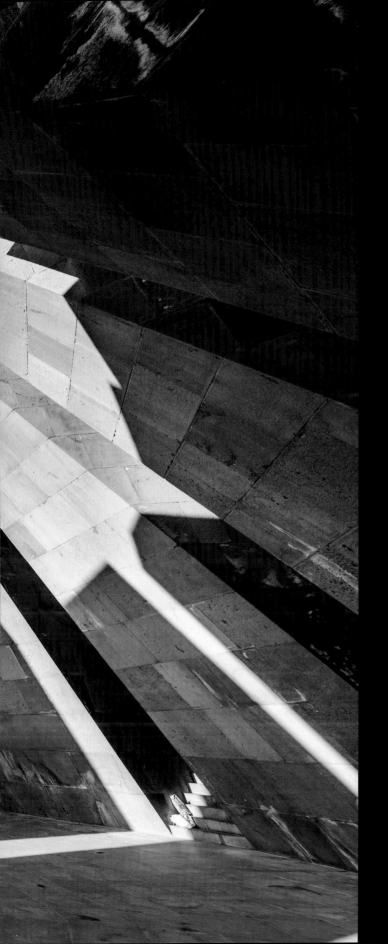

亞美尼亞種族滅絕紀念館建於 1967 年，外有一幅 100 米長牆壁，其上刻有大屠殺發生的村莊和城鎮的名字。（右）由 12 塊向中心傾斜的石板組成圓形紀念區，代表著大屠殺時期所喪失的 12 個省份，中央置有不滅之火，以向 150 萬死者致意。（左）

The Armenian Genocide memorial complex was established in 1967. A 100-meter-long wall is also built with names of towns and villages which suffered from massacres and deportations. (Right) The 12 slabs pointing to the center represent the twelve lost province - surrounded by these slabs, the eternal flame are sending regards to the 1.5 million victims. (Left)

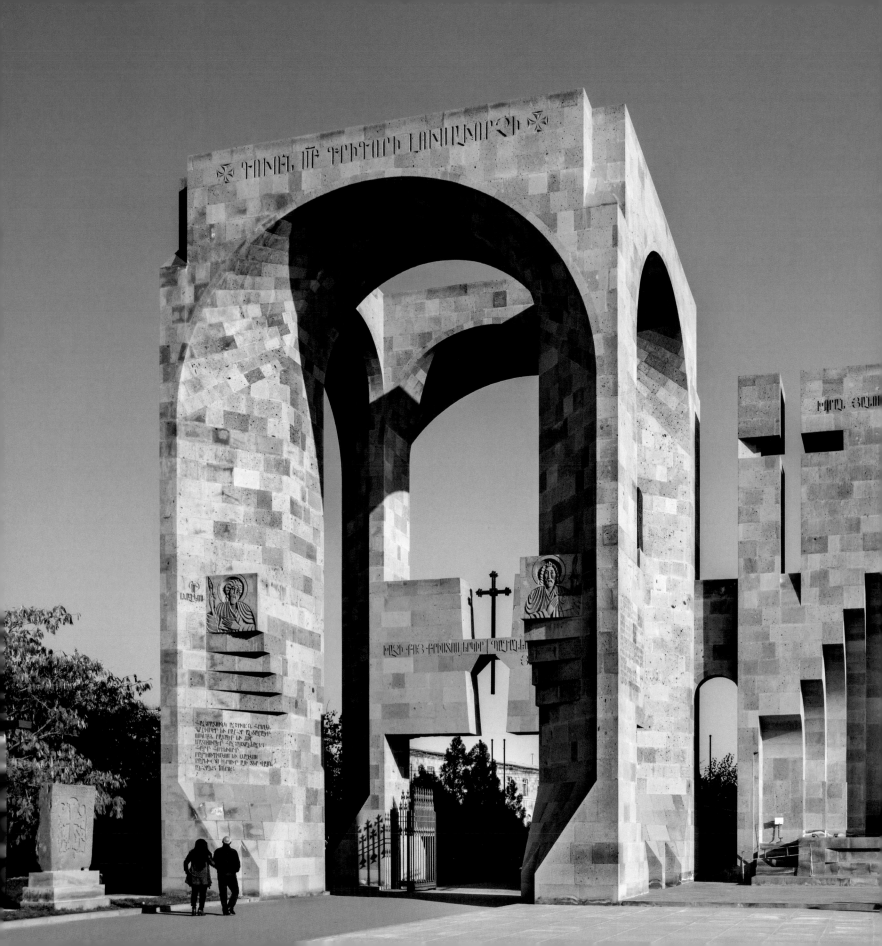

埃奇米艾津主教座堂被認為是世界上最古老的主教座堂。教堂對面設有神學院，其大門一旁為露天祭壇。（左）當地的孩童相聚到此遊覽。（右上）他們的臉上洋溢著溫暖的笑容。（右下）

Etchmiadzin Cathedral is considered to be the oldest cathedral in the world. There is an open-air altar next to the gate of the seminary standing opposite to the cathedral. (Left) Local children get together to visit the cathedral. (Upper Right) The smiling expression on their faces is heartwarming. (Lower Right)

阿塞拜疆處於中西亞與東歐的交界之處，因有可觀的石油產出，是一個比較富裕及高消費的國家。在波斯語中，「阿塞拜疆」解作「火的守護者」，因為「拜火教」曾在這片土地上盛極一時。而今，阿塞拜疆已演變成一個伊斯蘭國家。

阿利耶夫文化中心，建築以其外型的豐富線條感而在國際上擁有甚高的知名度，不遠處轟立著「我愛巴庫」標語。

Azerbaijan is at the connecting point of Central-and-Western Asia and East Europe. With abundant oil production, it is a wealthy country with high consumption level. Azerbaijan is a Persian word meaning "protector of the fire", for Zoroastrianism was once dominant in the country. But now, Azerbaijan has become an Islamic country.

The Heydar Aliyev Center is noted globally for its distinctive architecture, especially its affluent flowing on the exterior, with the "I love Baku" sign being not far away from the building.

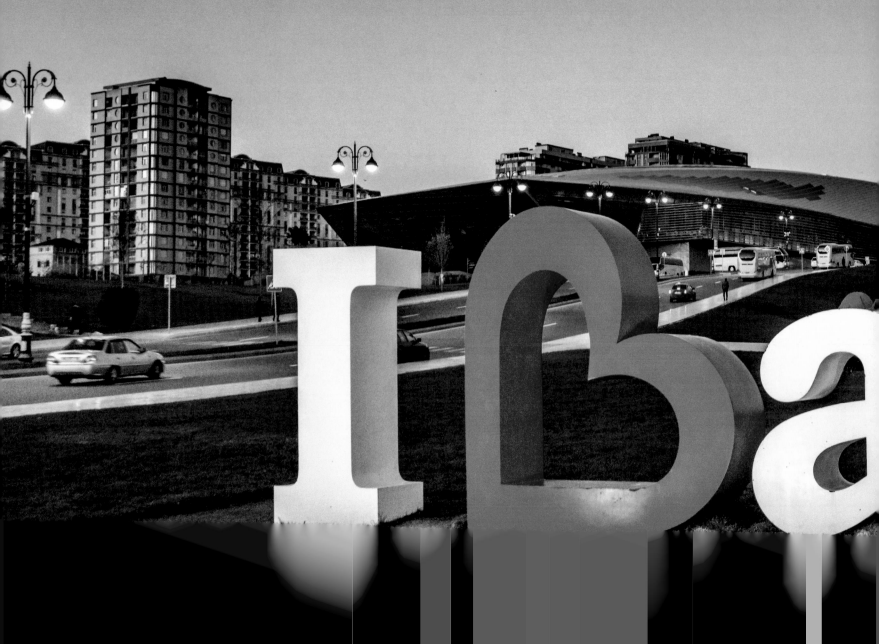

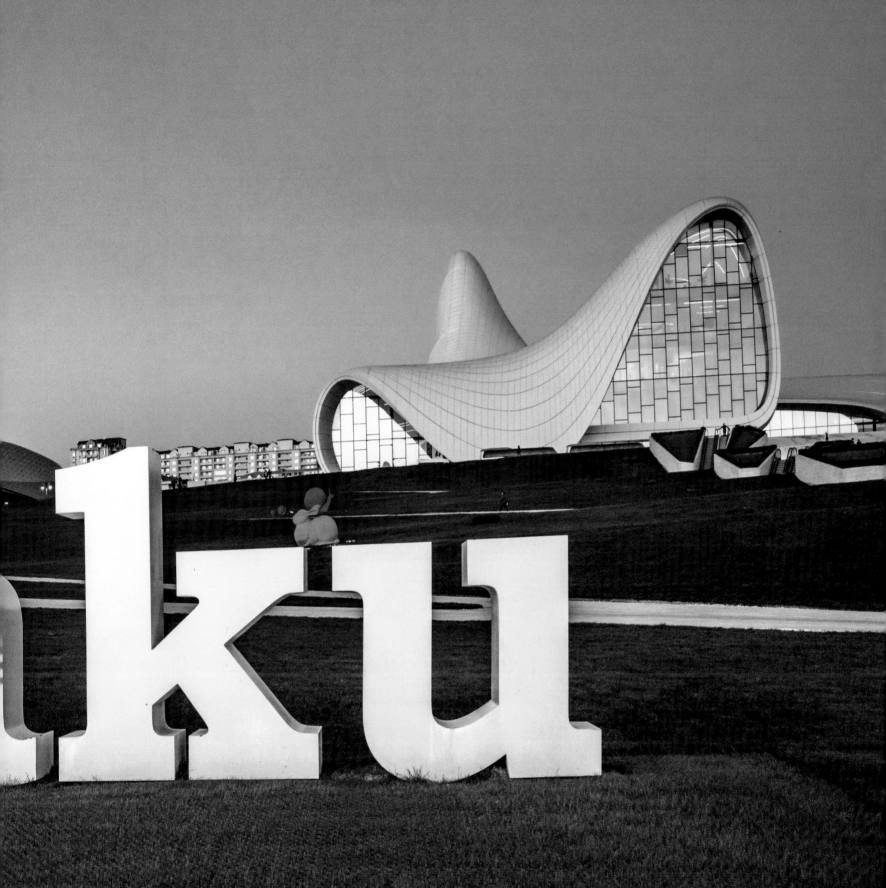

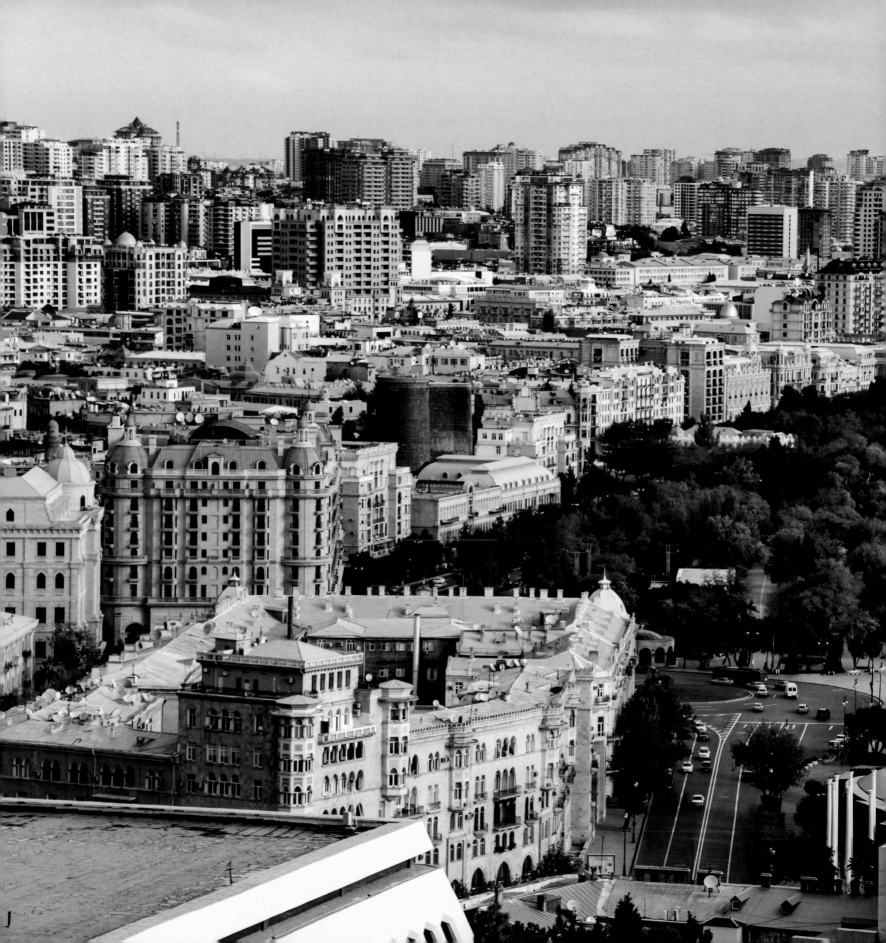

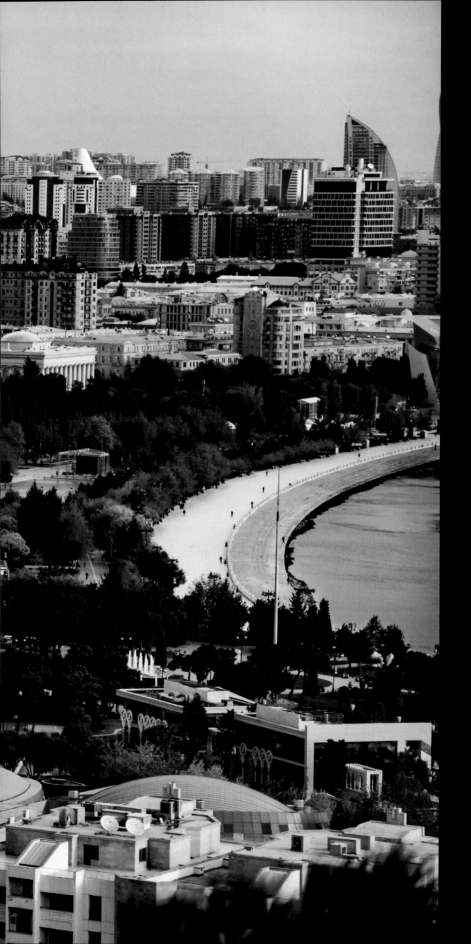

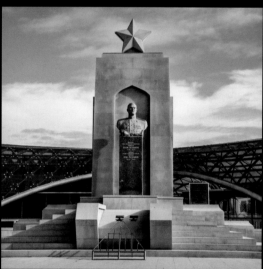

首都巴庫是該國的經濟文化中心，亦是外高加索的最大城市。（左）國旗上的藍、紅、綠三色分別代表著突厥、進步及伊斯蘭教。（右上）市內有一座前蘇聯阿斯拉諾夫少將的紀念碑。（右下）

Baku is the capital as well as the center of economy and culture of the country, and is also the largest city in Transcaucasia. (Left) The blue, red and green colors on the state flag of Azerbaijan symbolize, respectively, Turkic, Progress, and Islam. (Upper Right) There is a monument to major-general of the Soviet Aslanov in the city. (Lower Right)

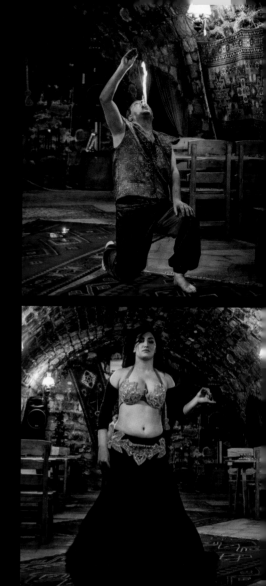

雖為伊斯蘭國度，阿塞拜疆卻並不排斥對世俗的追求。（左）城市的夜生活相當多彩。（右上）肚皮舞表演在餐廳內十分常見。（右下）

Although being an Islamic country Azerbaijan is tolerant of secularity. (Left The nightlife in the city is surprisingl varied and colorful. (Upper Right Belly dance is a common performance in restaurants. (Lower Right)

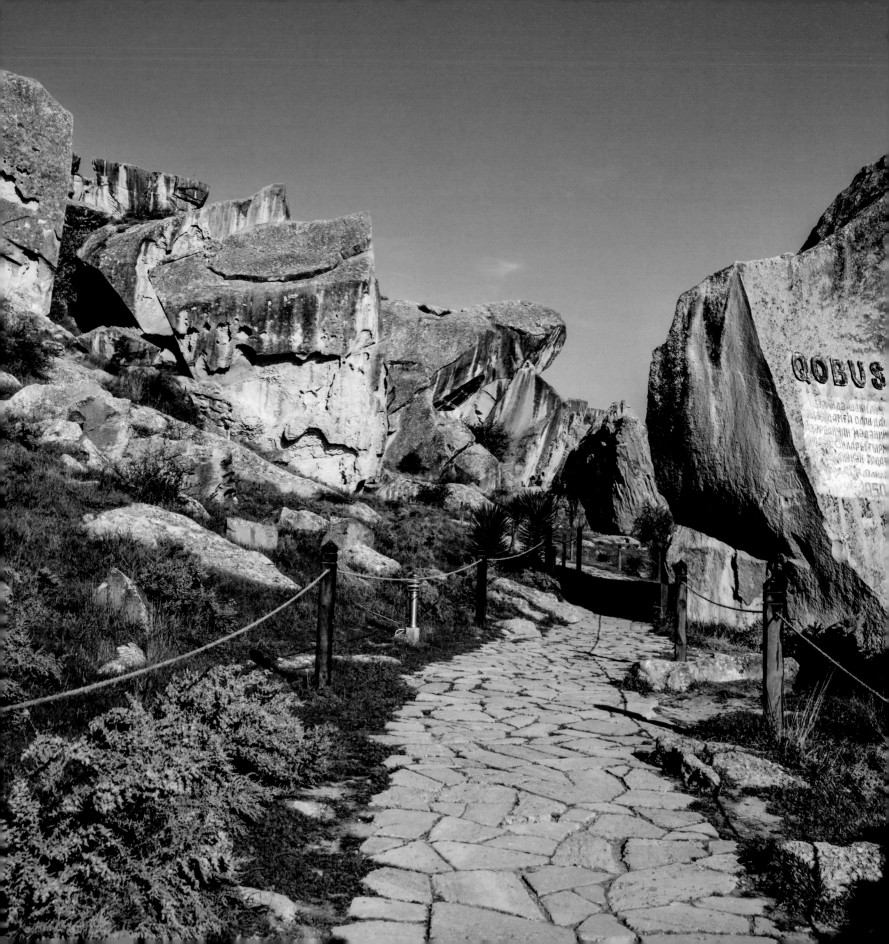

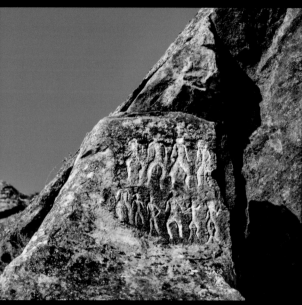

戈布斯坦岩石藝術文化景觀於 2007 年被列
世界文化遺產。（左）此地具有豐富的考古學
意義。（右上）其保存完好的岩石繪畫及雕刻，
向世人展示了史前人類的生活畫面。（右下）

Gobustan Rock Art Cultural Landscape was
declared a UNESCO World Heritage Site
in 2007. (Left) It is of great archeological
significance. (Upper Right) The well-preserved
rock arts are telling us the lifestyles of pre-historic
human beings. (Lower Right)

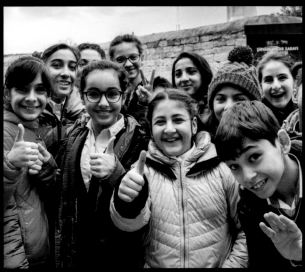

手工技藝在阿塞拜疆有著悠久的傳承歷史。（左）
無論是銅製品、布藝製品、木質工藝品等，都十
分精美，很適合遊客收藏或作為贈送給朋友的
紀念品。（右上）孩童對這些手工藝品尤其感
興趣。（右下）

Craftsmanship is well developed in Azerbaijan.
(Left) The copper products, fabric crafts, wooden
products and other craftworks are very exquisite,
as proper souvenirs for tourists. (Upper Right)
Children are especially interested in these
craftworks. (Lower Right)

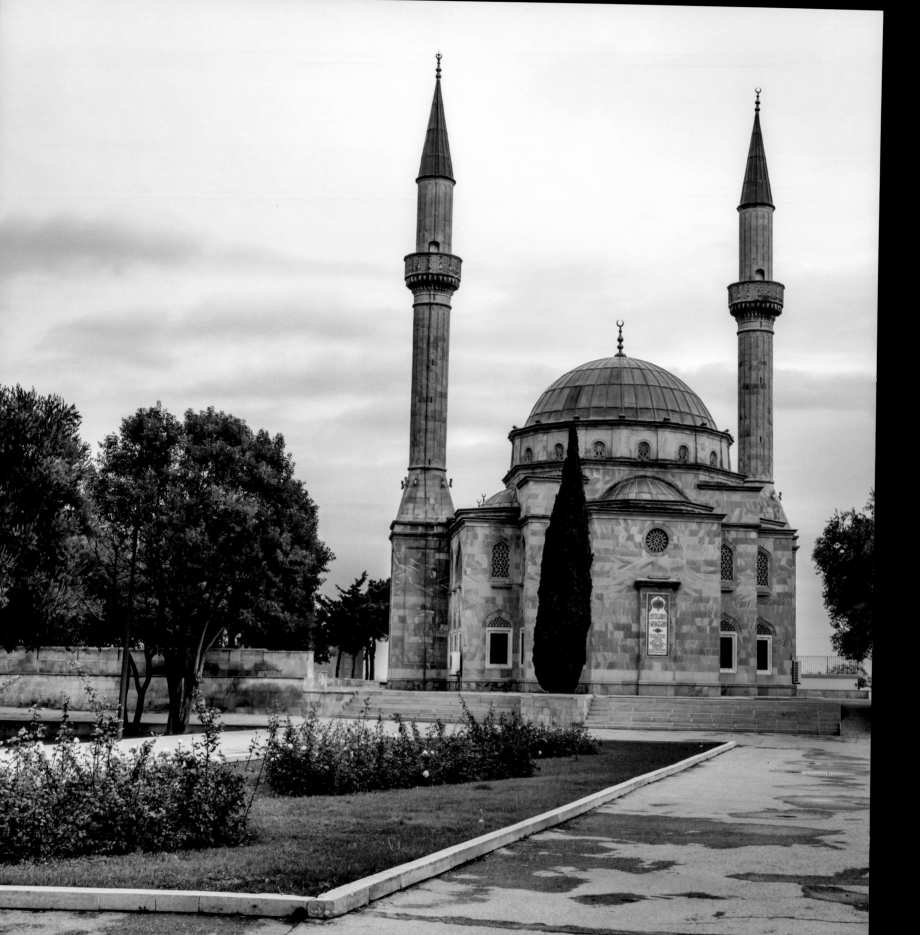

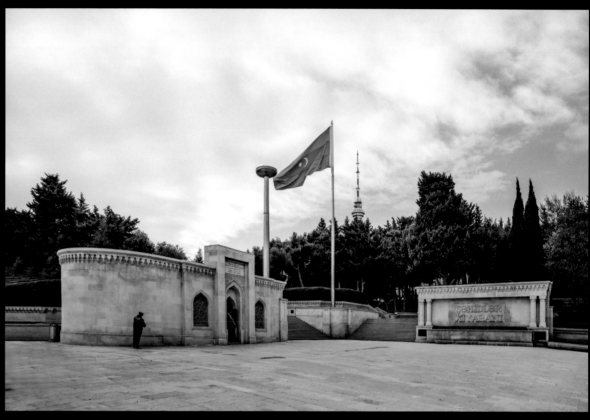

新城區的主要參觀景點集中在「烈士公園」附近，包括燃著永不熄滅之火焰的紀念碑、紀念與前蘇聯戰爭中殉難者的小徑等等，更可俯瞰整個巴庫城區的景色。（右）小徑的盡頭有一座清真寺。（左）

The Upland Park is the major place of interest for tourists in the new town district, where you can visit the monument with "Eternal Flame", the Martyr's Lane dedicated to those killed by the Soviet army, and so on. From the park you can also get wide eyesight to overlook the whole view of Baku city. (Right) The Mosque of the Martyrs is at the end of the Lane. (Left)

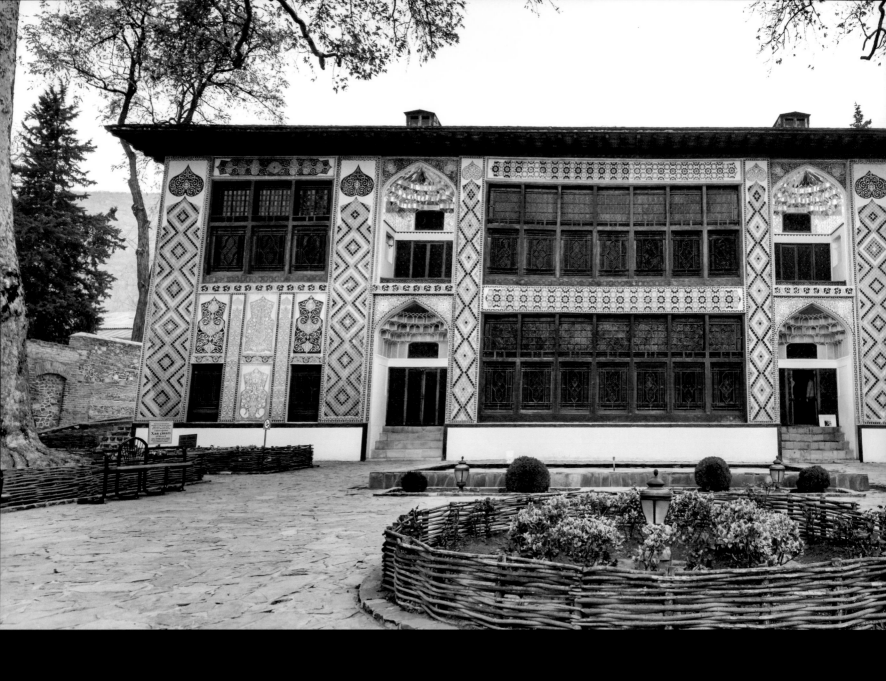

在保存歷史遺留下來的建築方面，阿塞拜疆下了不少的努力。（右上）國內多項歷史建築都被聯合國列入世界文化遺產的目錄，包括舍基汗國皇宮、巴庫舊城區及其內的希爾萬沙皇宮及少女塔等等。（右下）舍基汗國皇宮在外觀及內部，皆良好保存了 18 世紀的建造風貌，讓人驚豔。（左）

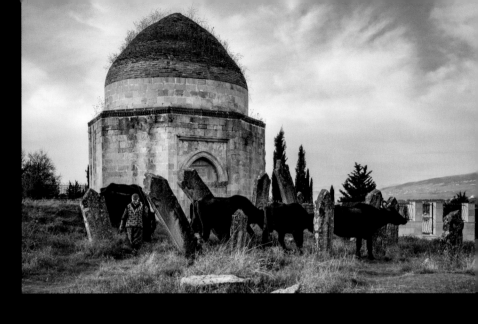
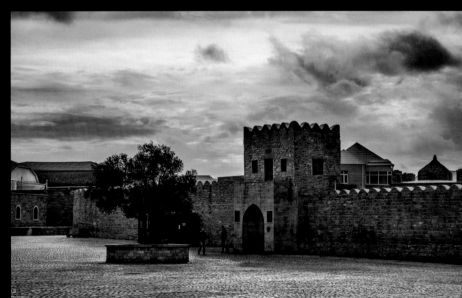

# 西亞

亞洲西部，處於聯繫亞洲、歐洲、非洲三大洲之地，介於地中海、黑海、裡海、紅海、阿拉伯海之間，自古以來就是重要的交通、文化與商業樞紐。古代的絲綢之路，就是通過中亞、西亞然後抵達歐洲。

西亞的歷史文化極其輝煌：美索不達米亞平原之上，古巴比倫人編著了《漢謨拉比法典》；在地中海東岸，希伯來人創立了一神信仰的猶太教；起始自伊朗高原，古波斯帝國的疆域曾橫亙歐、亞、非三大洲⋯⋯。

20 世紀，西亞發現了大量石油，整個地區的石油蘊藏量佔全球大約一半，因此被稱為「世界石油寶庫」。然而，豐富的石油資源為西亞帶來財富之餘，亦引起不少利益衝突，尤其列強的虎視耽耽。

中國倡導的「一帶一路」計劃，是一個和平、「雙贏」的經濟合作戰略，一方面可以為中國與當地建立相對穩定的能源合作，另一方面，有助西亞國家在經貿、金融和投資等領域走向國際，避免過度依賴石油出口。更重要的是，希望經濟的發展，能夠為西亞居民帶來更和睦、穩定的生活環境。

伊朗
Iran

以色列
Israel

巴勒斯坦
State of Palestine

阿拉伯聯合酋長國
United Arab Emirates

# Western Asia

Western Asia is a key location connecting Asia, Europe and Africa. The Mediterranean Sea, the Black Sea, the Caspian Sea, the Red Sea and the Arabian Sea have further made the area a traditional pivot of transportation, culture and commerce. It was by way of Central and Western Asia did the ancient Silk Road finally reach Europe.

At Mesopotamia, Babylonians compiled the Code of Hammurabi; at East Coast Mediterranean, Hebrews established the monotheistic religion of Judaism; starting from the Iranian Plateau, the territory of ancient Persian Empire strode across the continents of Europe, Asia and Africa. All of these have forged the splendor of the history and culture of Western Asia.

In the 20th century, abundant petroleum reserves were discovered in Western Asia, taking up about half of the world's reserve volume. Therefore, a name of "the world's treasure-house of oil" is granted to this area. However, the richness of petroleum has not only brought wealthy but also conflicts here.

The Belt and Road Initiative is a peaceful and mutually-beneficial strategy of economic cooperation. On one hand, a relatively stable trade of energy resources between China and Western Asia will be established, and on the other hand, it will assist the local countries to be less reliant on oil export, by enlarging the scale of international cooperation in trade, finance and investment. More importantly, the initiative will be able to boost the local economy, so as to bring about a more harmonious and stabilized living environment for

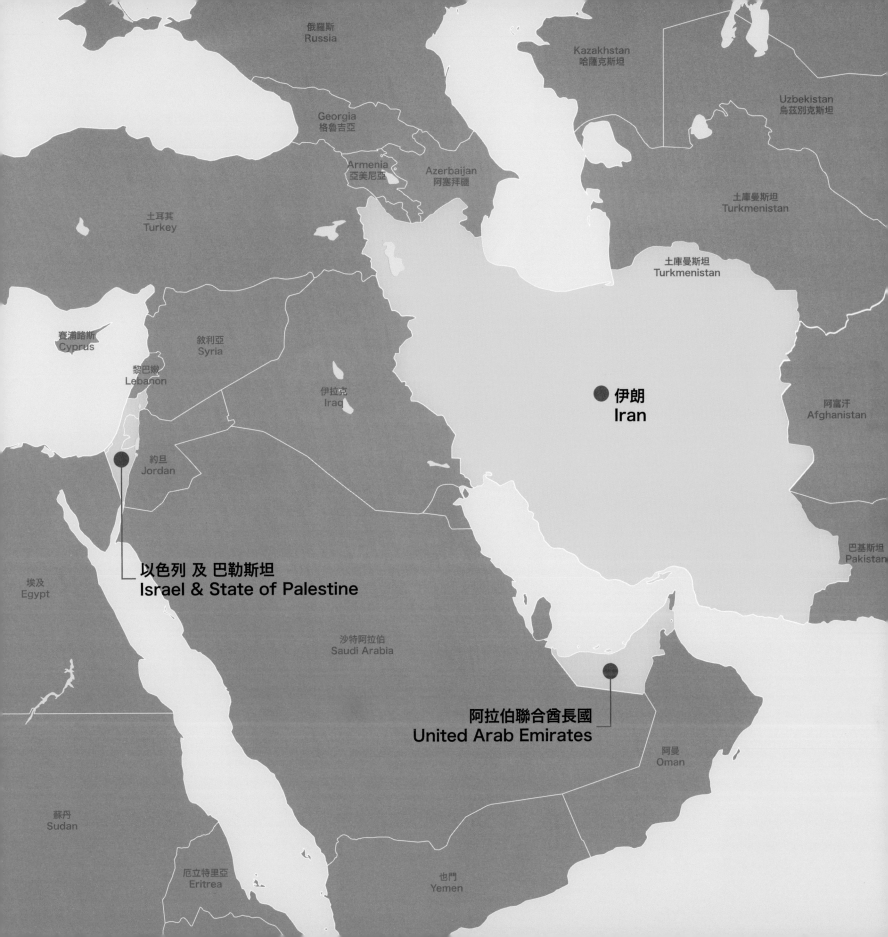

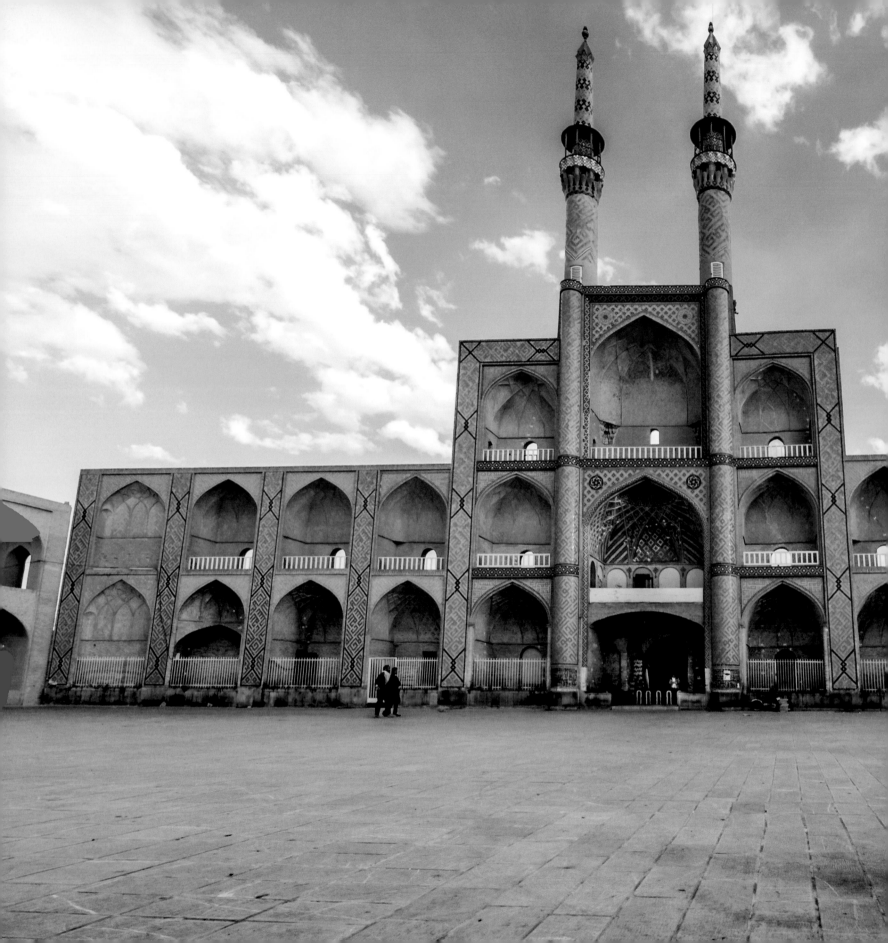

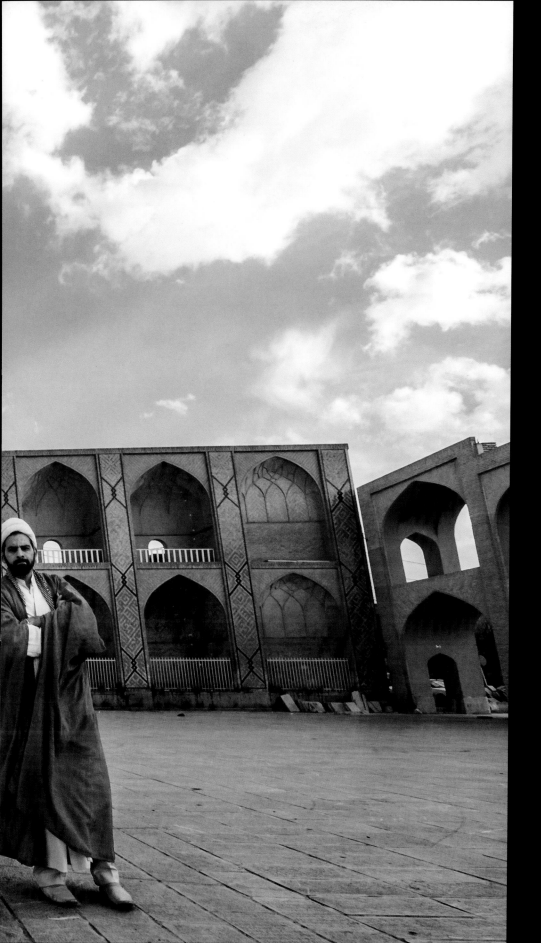

伊朗位於亞洲西南部，古稱波斯，首都為德黑蘭。伊朗歷代都在古絲綢之路上設立驛站，保護商隊免受侵擾，在東西方文化和貿易往來的通道中扮演重要的中間人及保護者角色。伊朗擁有悠久的歷史，在境內各地，包括德黑蘭、伊斯法罕、設拉子、亞茲德等城市，都散落分佈著眾多的珍貴古蹟。阿米爾‧喬赫馬克建築群，包括三層樓高的同名清真寺及同名廣場，建築構造十分罕見，是亞茲德標誌性建築物。

Iran is a southwestern Asian country which was known as Persia in ancient times, with its capital being Tehran. In the past dynasties, there were always staging posts established in Iran to protect trade caravans from being harassed. At that time, Iran was playing the role of intermediary and protector in the communication of culture and trade between the oriental and western worlds. With long-standing history, Iran possesses numerous historical sites of great value, which are scattered all over the country in cities such as Tehran, Isfahan, Shiraz, Yazd, and etc. The Amir Chakhmaq Complex, including a 3-storey mosque and a square which are both entitled with the same name, has very unique architectural structure, and has become a significant symbol of the city of Yazd.

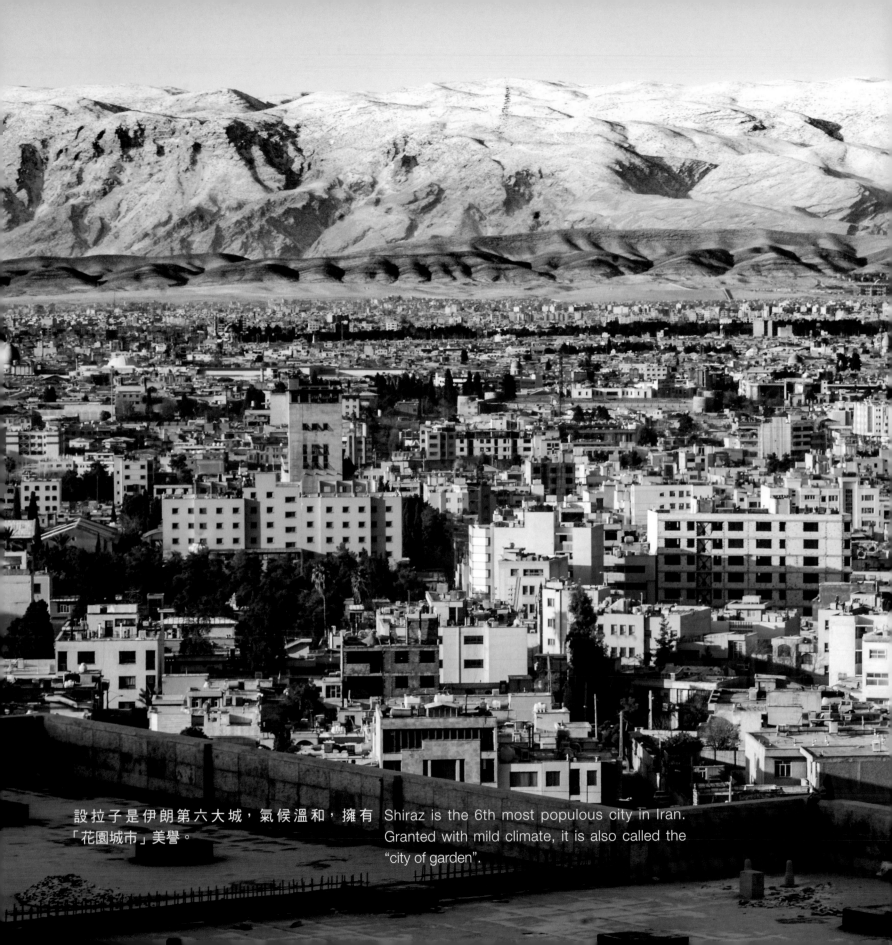

設拉子是伊朗第六大城，氣候溫和，擁有「花園城市」美譽。 Shiraz is the 6th most populous city in Iran. Granted with mild climate, it is also called the "city of garden".

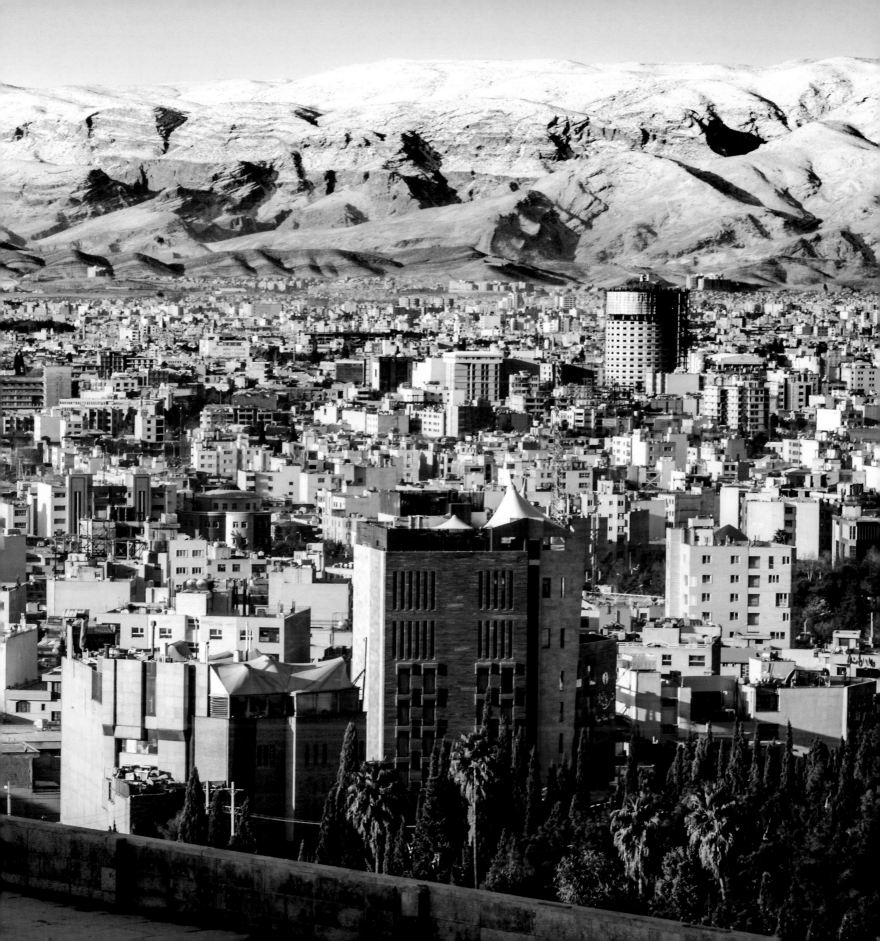

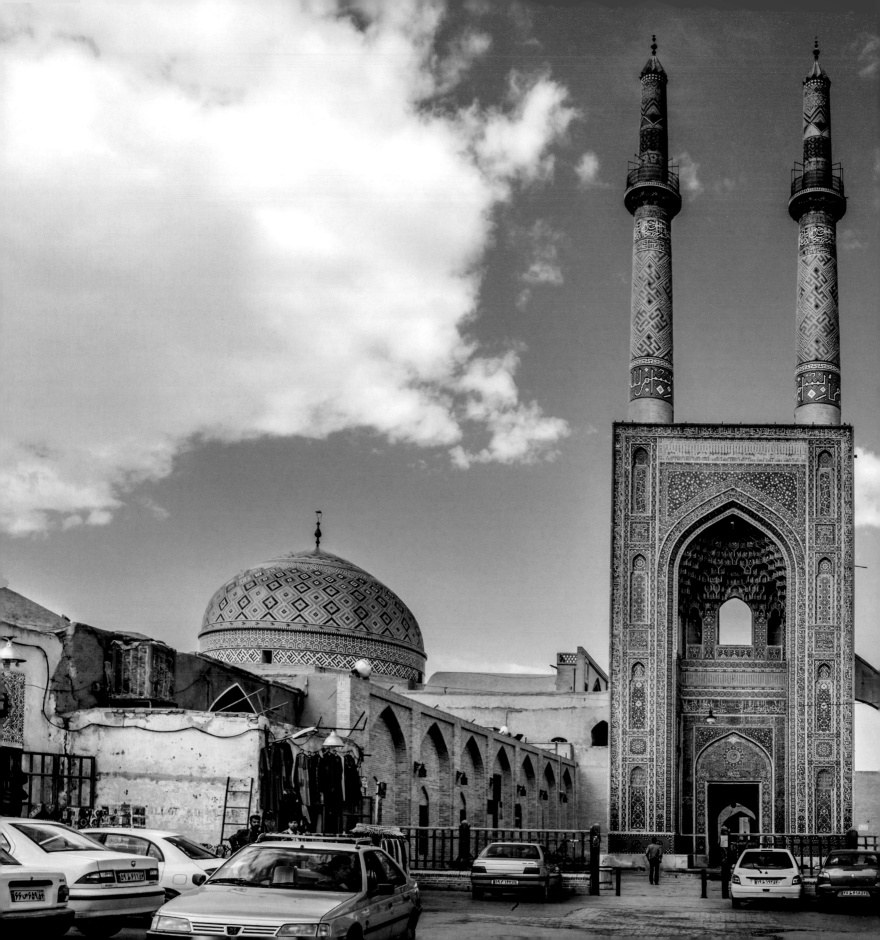

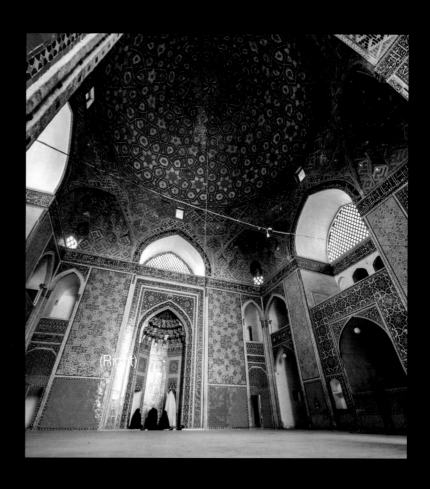

(Right)

亞茲德星期五清真寺由內而外都貼滿了美麗的馬賽克瓷磚。（左）每逢周五都可見眾多信徒聚集於此。（右）

Jameh Mosque of Yazd is a beautifully mosaicked mosque from interior to exterior. (Left) Lots of Muslims gather here (Right) on Fridays. (Right)

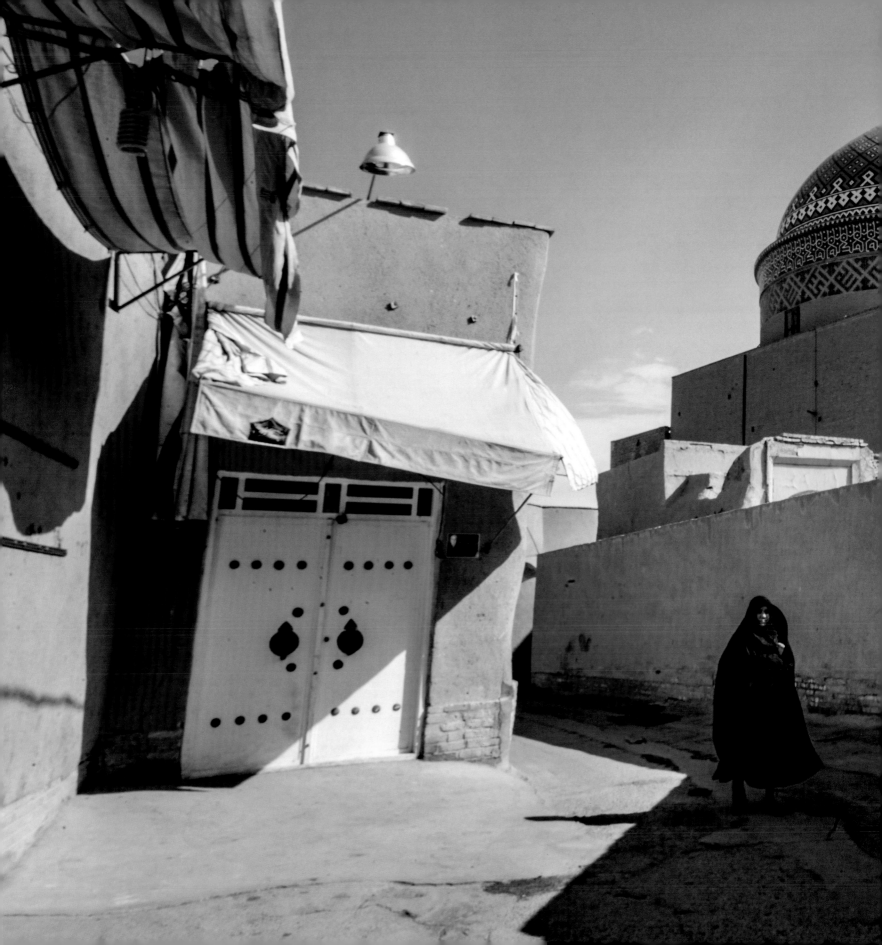

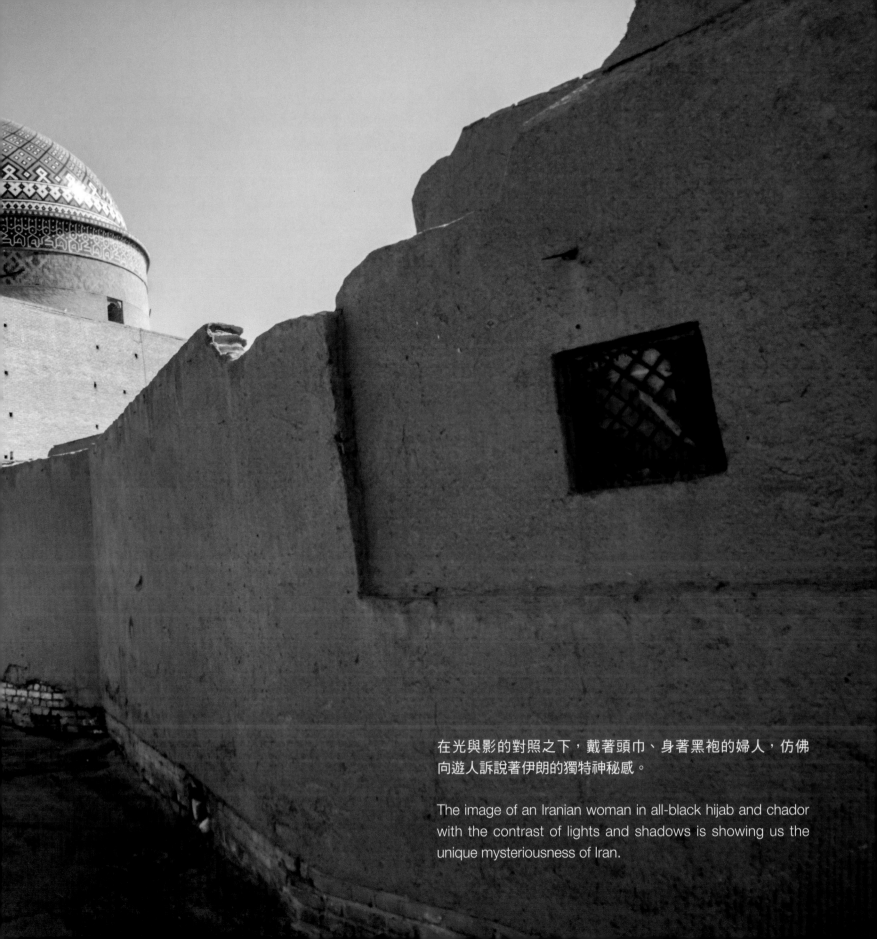

在光與影的對照之下，戴著頭巾、身著黑袍的婦人，仿佛向遊人訴說著伊朗的獨特神秘感。

The image of an Iranian woman in all-black hijab and chador with the contrast of lights and shadows is showing us the unique mysteriousness of Iran.

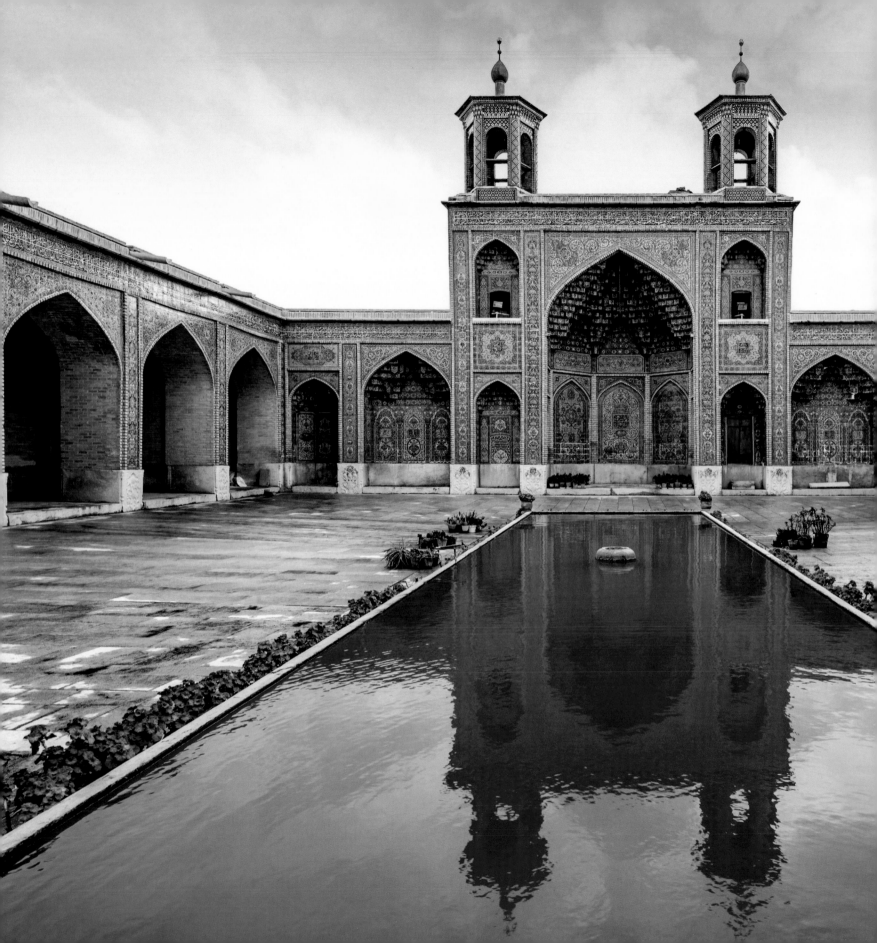

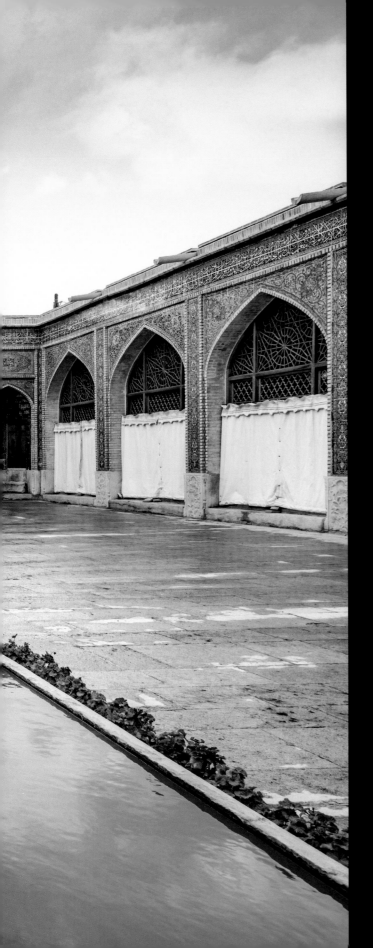

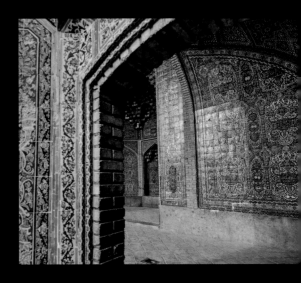

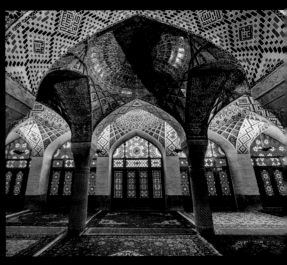

莫克清真寺，又可被稱為粉紅清真寺。（左）
清真寺採用了十分鮮豔大膽的用色。（右上）
從室內目睹陽光穿過彩色玻璃的時刻，猶如
置身萬花筒之中。（右下）

Nasir al-Mulk Mosque is also known as
the Pink Mosque. (Left) The construction
adopts bright colors. (Upper Right) The
view of sunlight passing through the colorful
window glass gives us an illusion of being in
a kaleidoscope. (Lower Right)

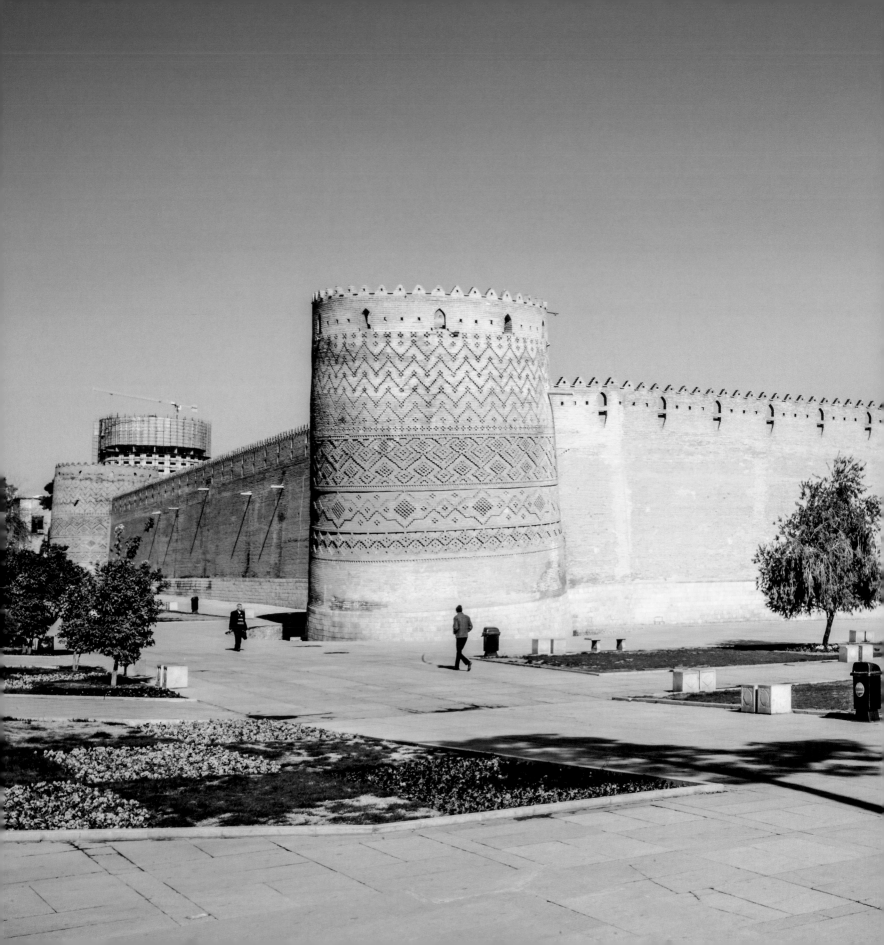

加謙汗城位於設拉子市中心，曾是皇城建築的一部分。曾經有一段時間，城堡是作監獄之用，從 1971 年開始，伊朗文化遺產組織接管建築，才改作為博物館。

Arg-e Karim Khan, located at the center of Shiraz, was once a part of the imperial city. At times, it was used as a prison. Since Iran's Cultural Heritage Organization started operating it in 1971, the use has been changed to a museum.

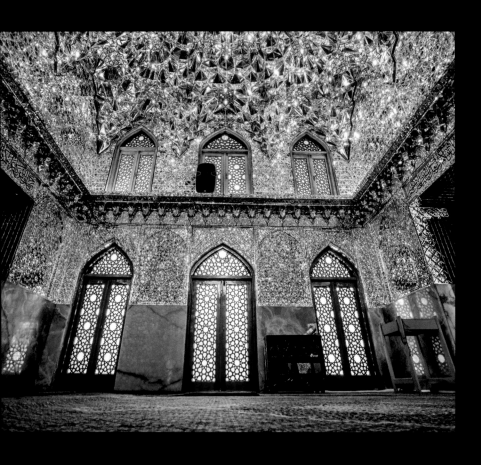

綠鏡清真寺坐落於設拉子，其內部佈滿綠色玻璃片，璀璨閃耀，讓人目眩神迷。（左）更難得的是，與其他清真寺不同，這裡歡迎遊客自由拍攝。（右）

The Ali Ibn Hamzeh Holly Shrine in Shiraz is fascinating and dazzling with its sparkling mirror tiles inside. (Left) What is rare about this shrine is that it welcomes photo-shooting by visitors. (Right)

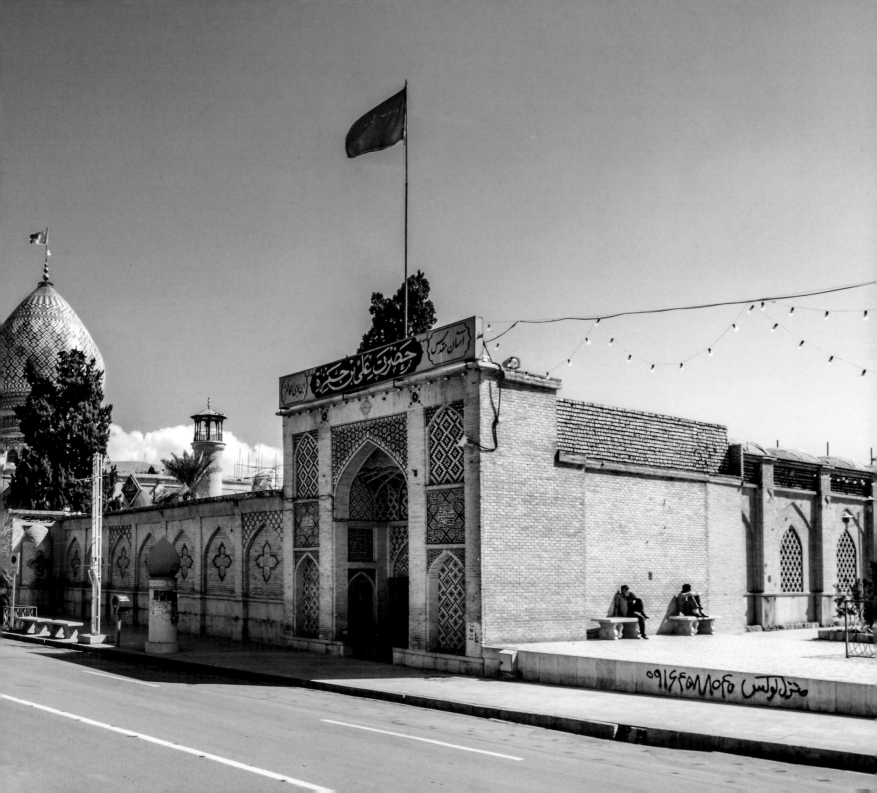

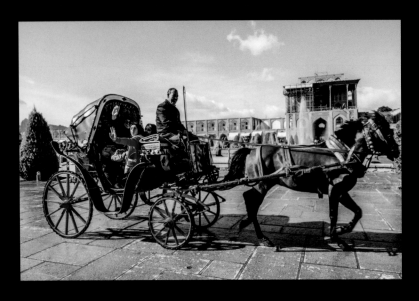

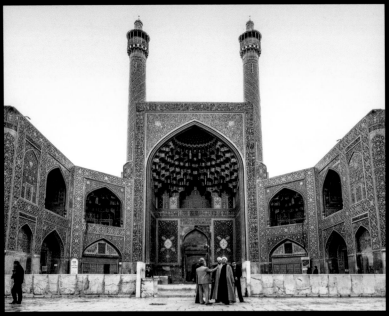

伊瑪目廣場原名皇家廣場。（右）廣場長 500 米，寬 160 米，是僅次於北京天安門廣場的世界第二大廣場。（左上）南端為伊瑪目清真寺。（左下）

Imam Square was previously named Naqsh-e Jahan Square. (Right) It is 160 meters wide by 560 meters long, and is the second largest square in the world after Beijing's Tiananmen Square. (Upper Left) Imam Mosque stands on the south side of the square. (Lower Left)

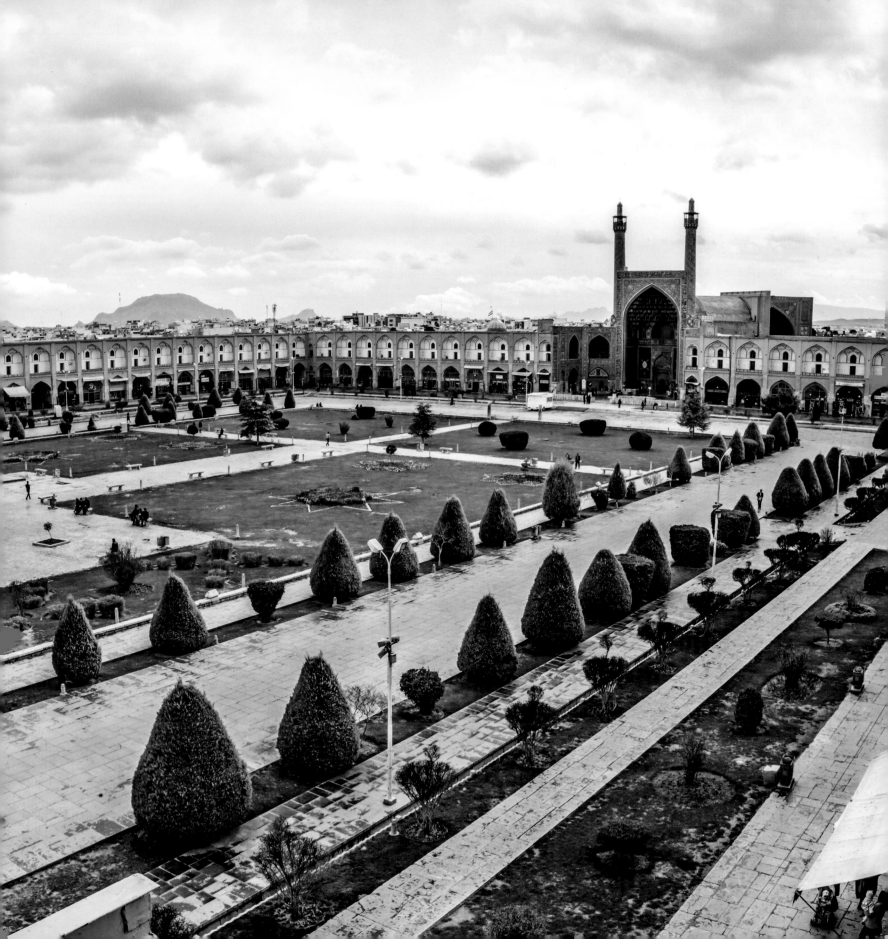

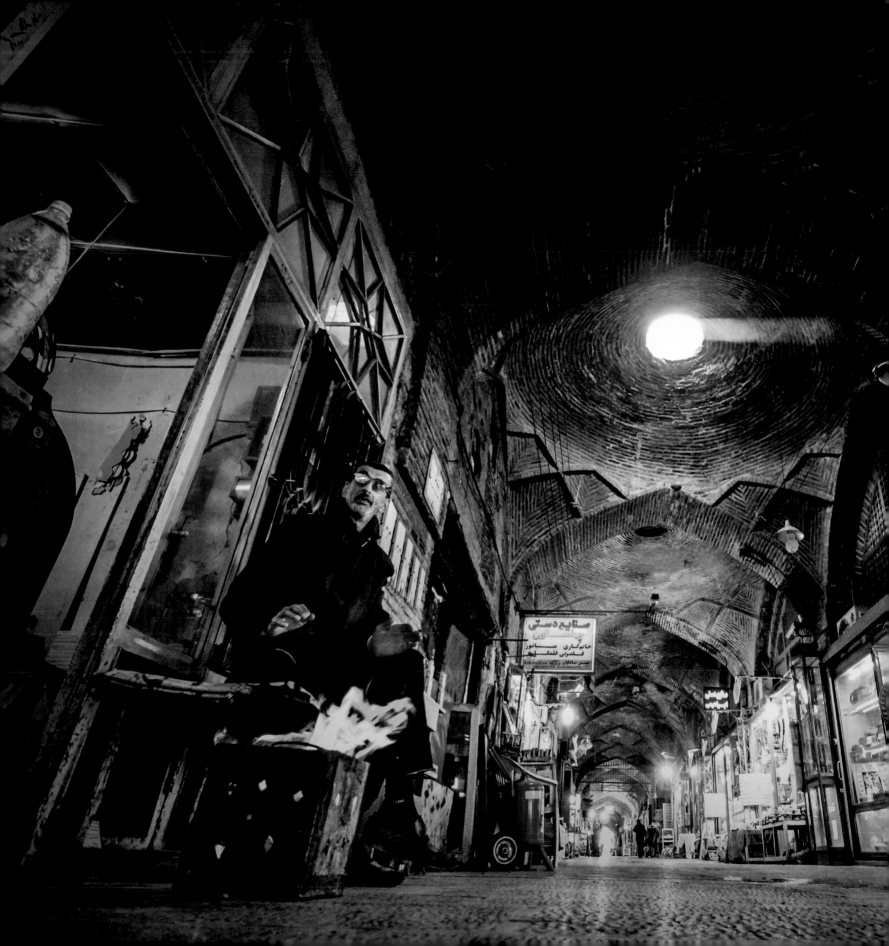

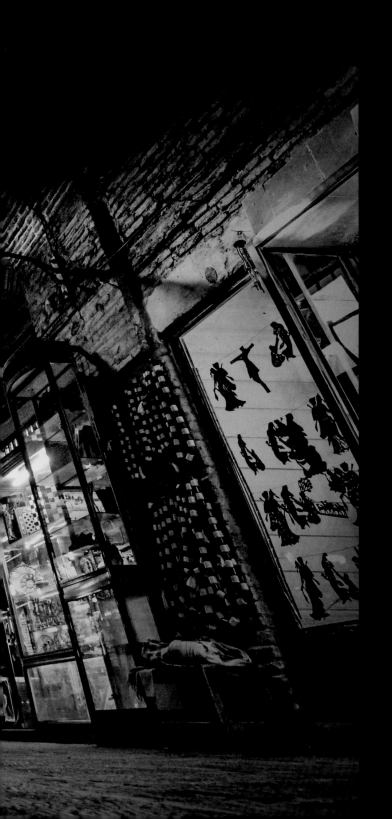

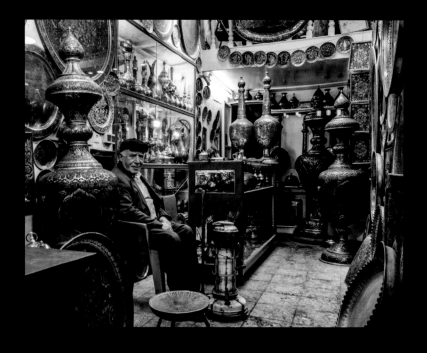

伊斯法罕大巴扎是中東地區最大、最古老的市集之一,歷史可追溯至 11 世紀。(左)這裡的商品,從手工藝品到家用電器等,應有盡有。(右)

The Grand Bazaar of Isfahan is one of the largest and oldest in the Middle East, which could be traced back to the 11th century. (Left) It has great variety of goods ranging from handicrafts to home appliances and to many others. (Right)

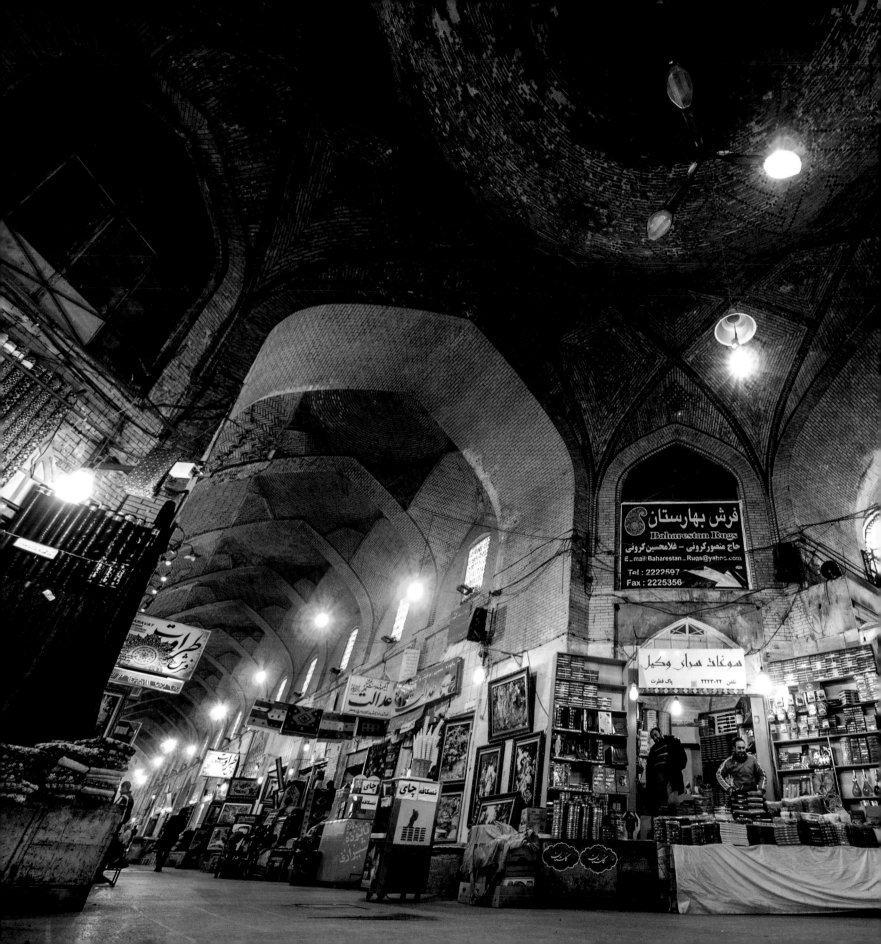

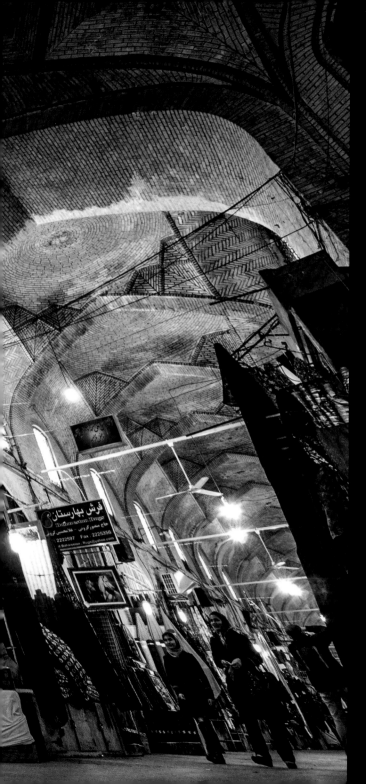

伊朗的市集之中，冷暖色調的燈光匯聚出特別的
景象。（左）色彩繽紛、琳瑯滿目的商品在燈光之下顯得
尤為吸引。（右）

The intertwining cold and warm light forms a unique view
in the bazaar. (Left) The assorted colorful goods appear
even more beautiful under the light. (Right)

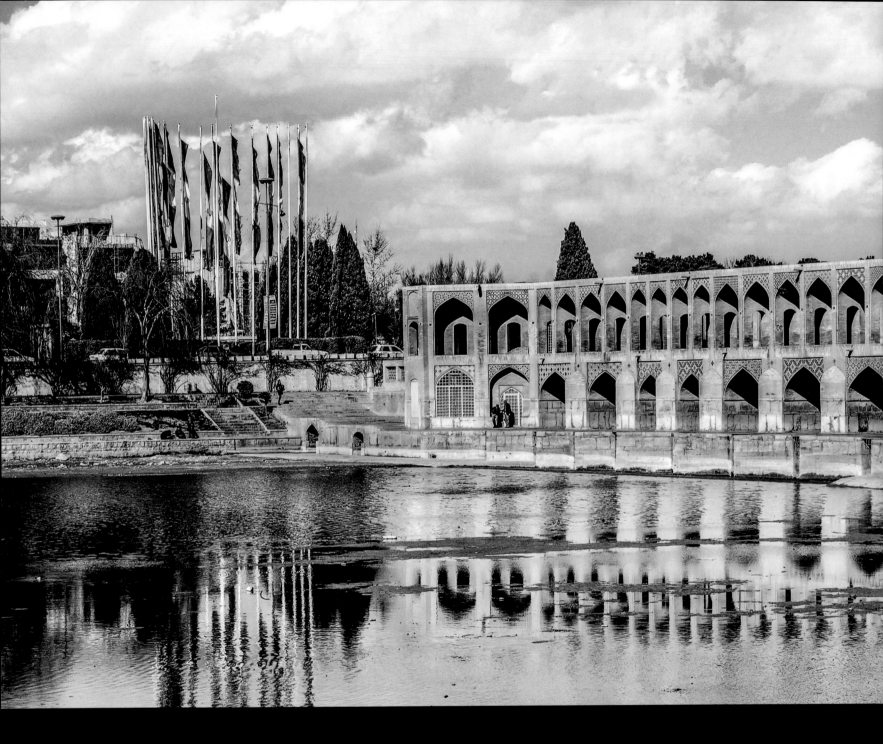

扎因代河之上，有 11 座美麗的橋樑。（左）
其中最著名的，便是同建於 17 世紀的三十三孔
橋及哈鳩橋。（右上）具有歷史的建築和澄澈的
湖水，吸引了眾多遊客前往。（右下）

Over the Zayandeh River, there span 11 beautiful
bridges. (Left) Of them the most renowned ones
are the Si-o-se-pol (Bridge of 33 Arches) and
the Khaju Bridge. (Upper Right) The historical
construction and the crystal-clear lake have
attracted numerous tourists. (Lower Right)

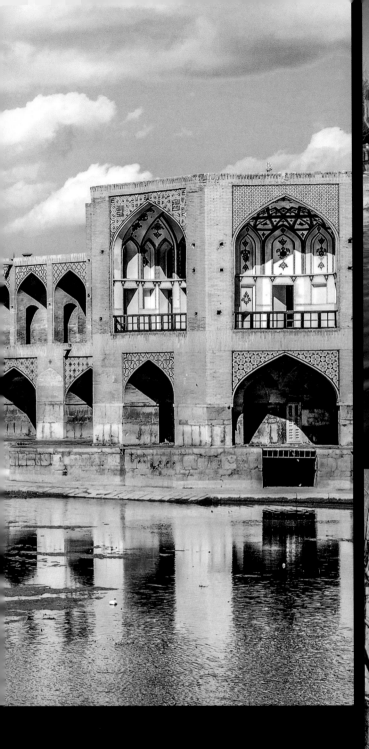

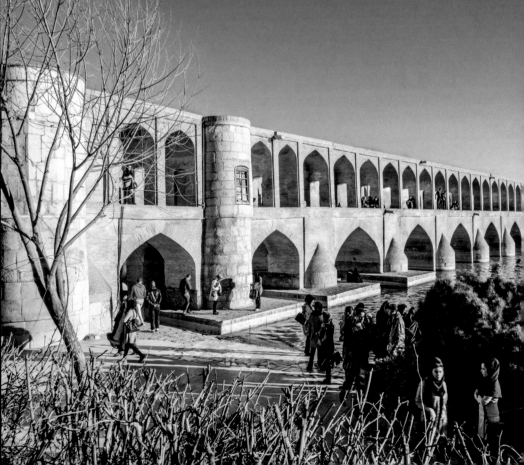

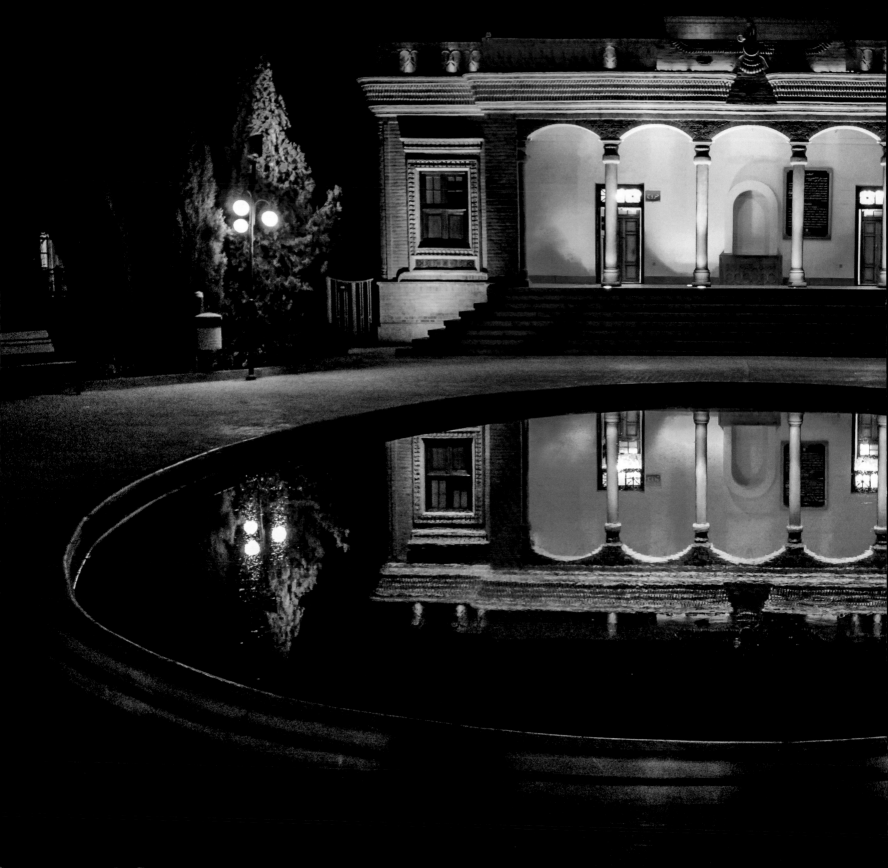

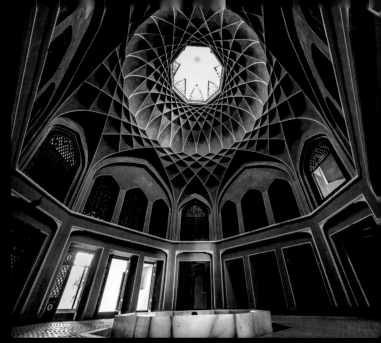

瑣羅亞斯德教又稱拜火教，在伊斯蘭教誕生之前，曾是中東地區最具影響力的宗教，因此直至今天仍可見傳統的拜火廟。（左）在亞茲德，亦可前往傳統波斯花園杜拉特阿巴德花園，園內幾何線條裝飾甚有特色。（右）

Zoroastrianism was once the most influential religion in Middle East before the appearance of Muslim. Zoroastrian Fire Temple can still be seen in Iran up to this date. (Left) In Yazd, there's also a traditional Persian garden - the Bagh-e Dolat Abad, whose interior design features geometrical figures. (Right)

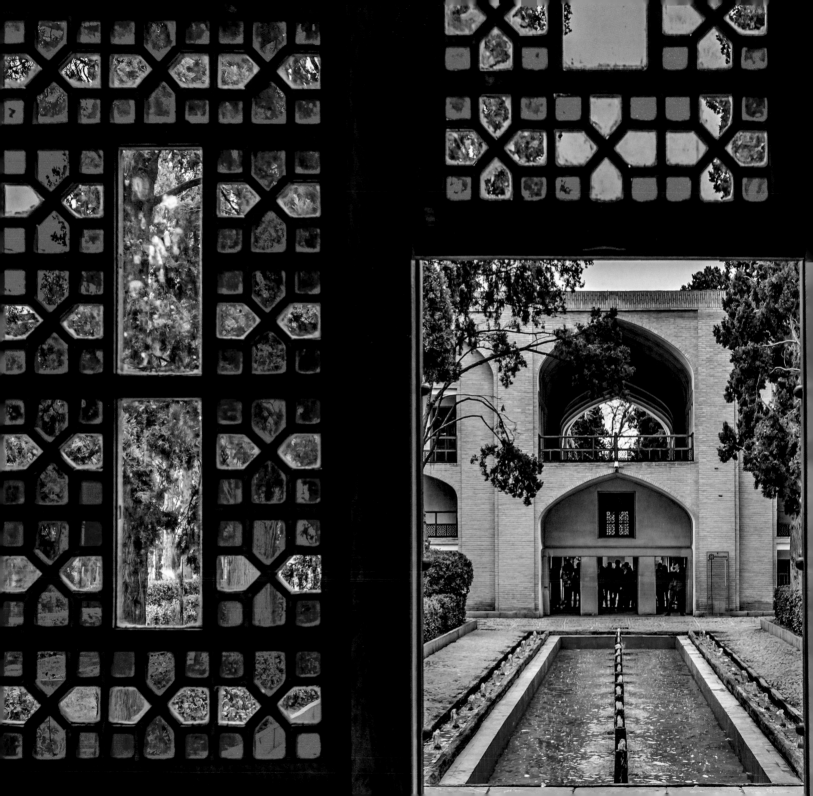

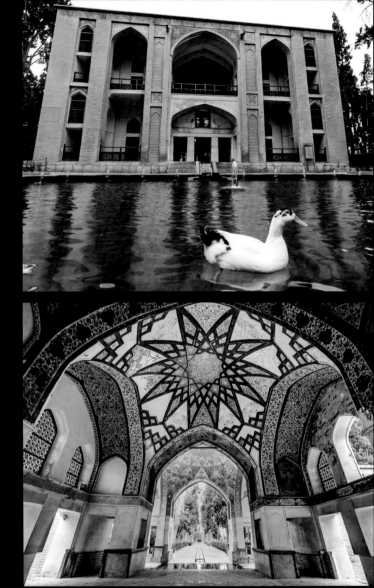

菲恩花園風景優美。（右上）這是伊朗現存最具古波斯風格的園林建築之一。（右下）透過彩色的玻璃窗欣賞園景，更添趣味。（左）

The Fin Garden is filled with magnificent sceneries. (Upper Right) It is one of the best representative gardens of ancient Persian style in Iran. (Lower Right) The garden's view is extraordinarily interesting through the colorful windows. (Left)

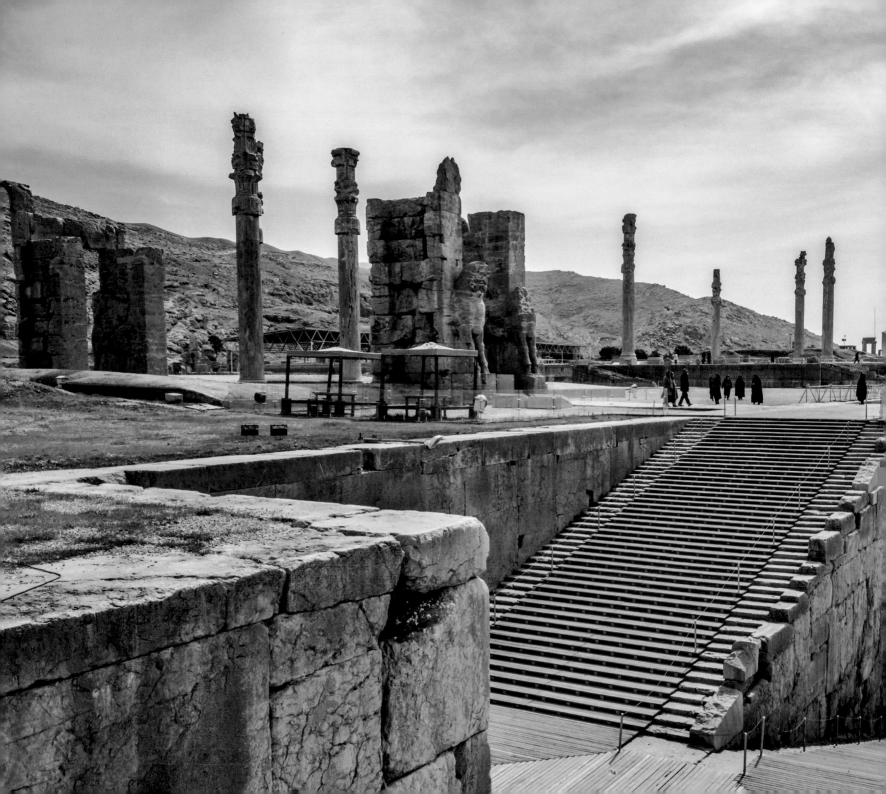

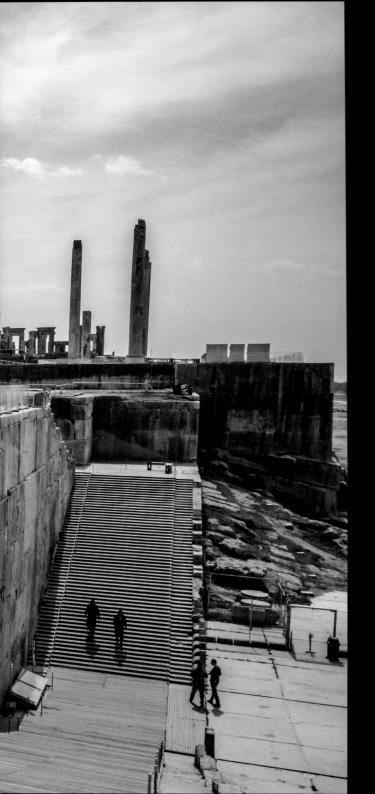

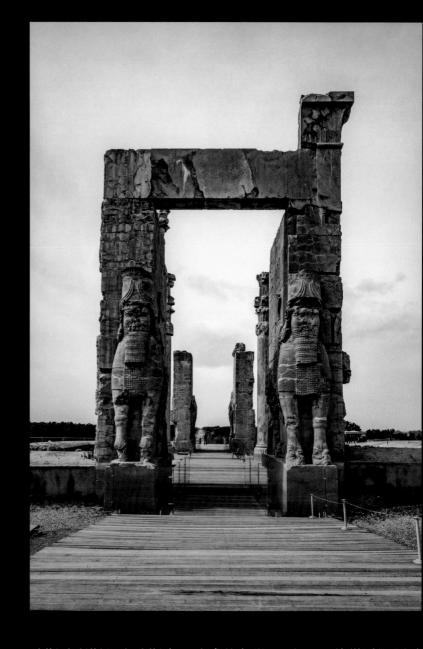

波斯波利斯是古波斯帝國強盛的象徵。（左）即使僅透過斷壁殘垣，亦不難感受到古波斯曾經的輝煌。（右）

Persepolis is the embodiment of the powerfulness of the Persian Empire. (Left) Even through the incomplete and broken relics, we can imagine the splendid past of ancient Persia. (Right)

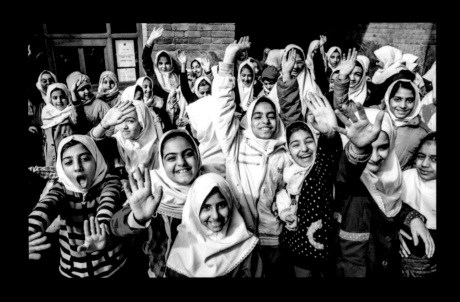

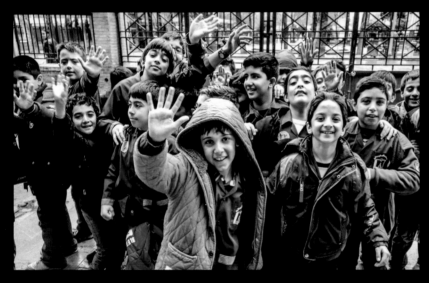

伊朗民風淳樸，對外來遊客非常友善。（右）在一所學校附近，
我遇見一群笑容燦爛的女童。（左上）男孩子們亦熱情地向遊客
打招呼。（左下）

Most Iranians are unsophisticated and hospitable to foreign
visitors. (Right) I encounter a group of girls with innocent and
bright smiles near a school. (Upper Left) The boys are fervently
greeting tourists. (Lower Left)

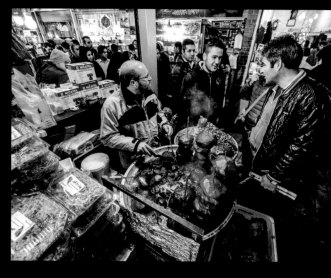

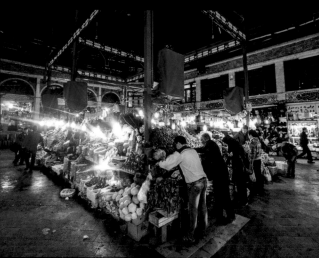

塔季里什市集是德黑蘭最古老的傳統市集之一。（左）
這裏聚集了眾多遊客及本地人，十分擁擠。（右上）
在此可以感受最本土的生活氣息。（右下）

Tajrish Bazaar is one of the oldest traditional
markets in Tehran. (Left) The is a very crowded
space for many tourists and local people would
choose to visit this bazaar. (Upper Right) You
can feel the most indigenous atmosphere of
local life here. (Lower Right)

令位於地中海和死海之間，同時是以色列
斯坦境內的城市，被猶太教、基督教和伊
三大宗教奉為聖地。

山可俯瞰整個耶路撒冷舊城區，黃昏之下，
真寺的黃金圓頂自然成為了焦點所在。

Jerusalem lies between the Mediterranean Sea and the Dead Sea, and is simultaneously an Israeli and Palestinian city. It is also regarded as a sacred land in Judaism, Christianity and Islamism.

Viewing from the Mount of Olives at dusk, you can see the breathtaking view of the old city of Jerusalem, where the golden Dome of the Rock is the absolute focus.

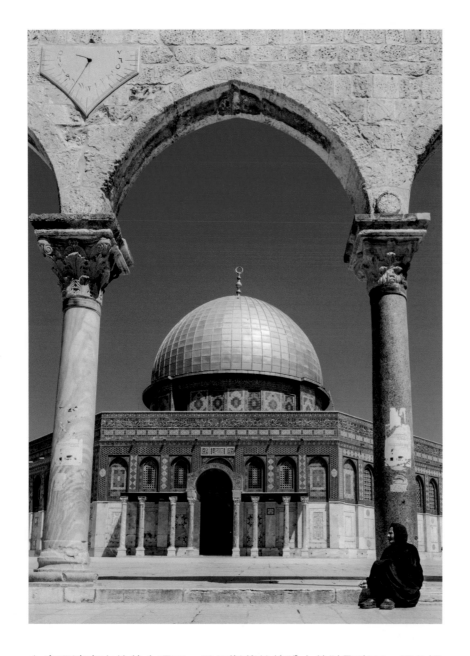

在奧瑪清真寺的黃金頂下，是伊斯蘭教傳說中的神聖岩石，因此這清真寺又名「岩石圓頂」。（左）在橄欖山之上，俄國東正教抹大拉的瑪利亞教堂亦十分奪目。（右）

The legendary sacred rock in Muslim is believed to be placed under the golden dome of the Qubbat As-Sakhrah; thus, the name of "Dome of the Rock" is granted. (Left) On the Mount of Olives, the Russian Orthodox Church of Mary Magdalene is also eye-catching. (Right)

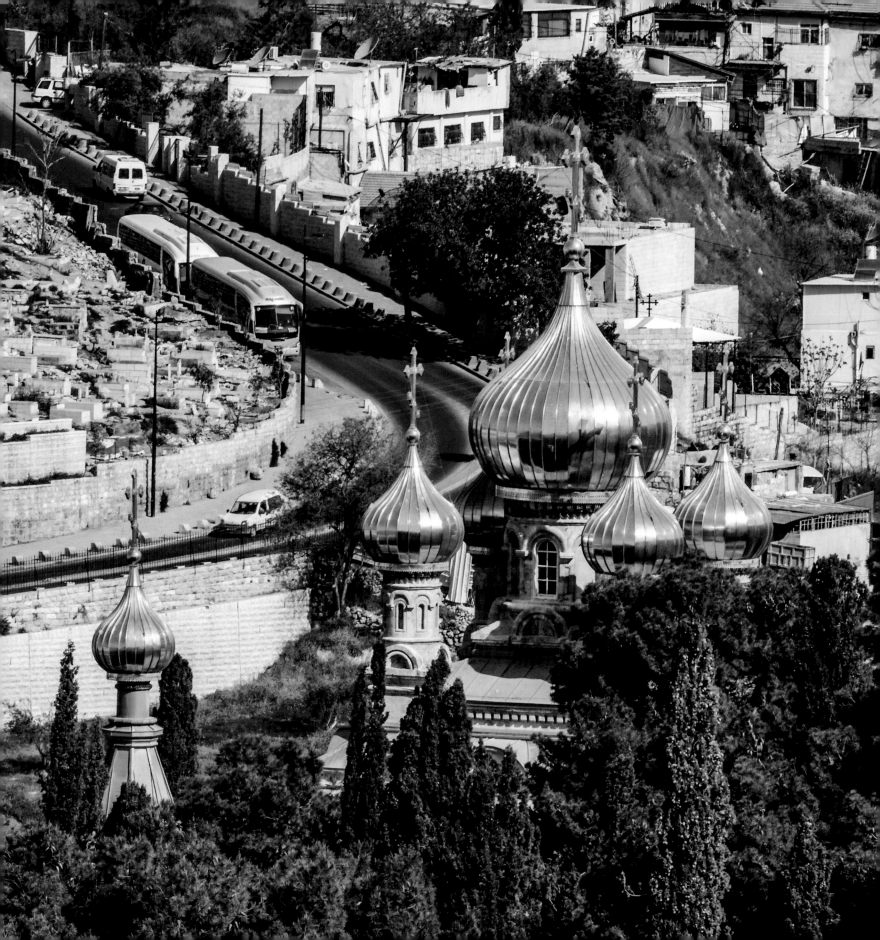

萬國教堂正式名稱為苦悶大教堂，位於橄欖山上，毗鄰客西馬尼園。（左上）聖墓教堂，則是苦路最後五站的地點。（左下）它是耶穌的墳墓所在地及復活之處，因此亦被稱為「復活教堂」。（右）

The Church of All Nations, whose official name is the Church of the Agony, is located on the Mount of Olives, next to the Garden of Gethsemane. (Upper Left) Church of Holy Sepulcher is where the last five stations of the "Way of the Cross" took place. (Lower Left) It is said to be where Jesus was buried and resurrected, also known as the Church of the Resurrection. (Right)

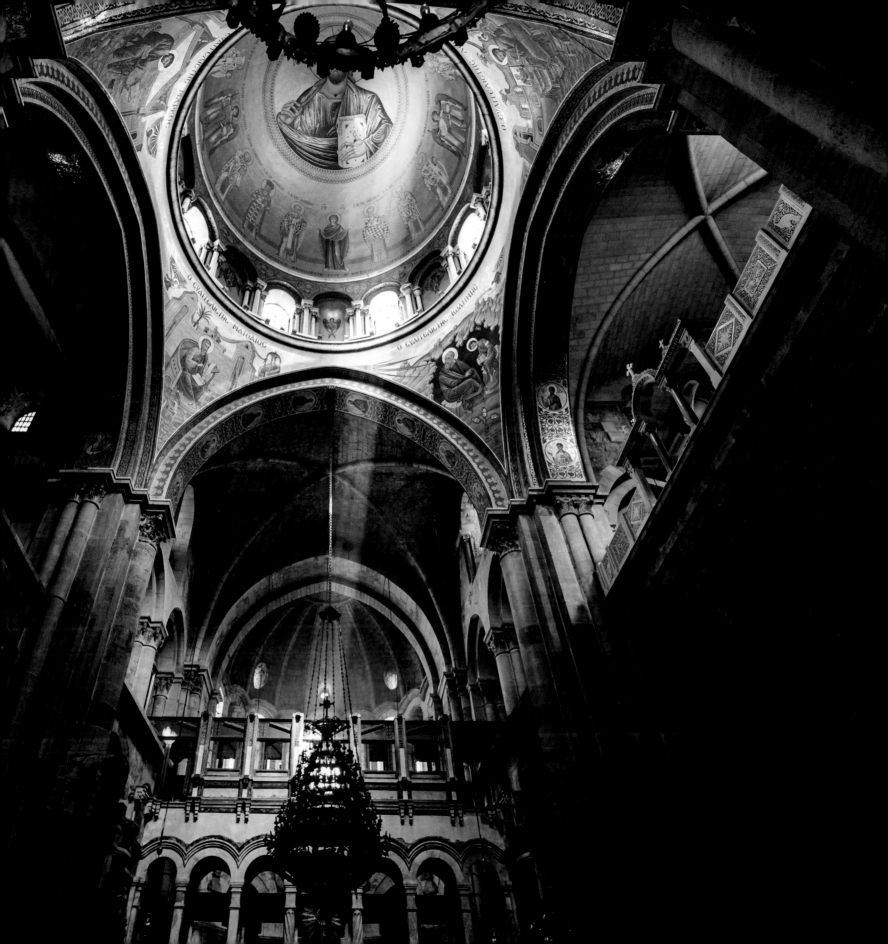

苦路第七站，為耶穌「再次跌倒」
之地。（左）第三及第四站，分別記錄
著耶穌「首次跌倒」及「路遇母親」的
地點。（右）

The seventh station of the "Way of
the Cross" is where "Jesus falls for
the second time". (Left) The third and
fourth stations are respectively the sites
of "Jesus falls for the first time" and
"Jesus meets His Mother". (Right)

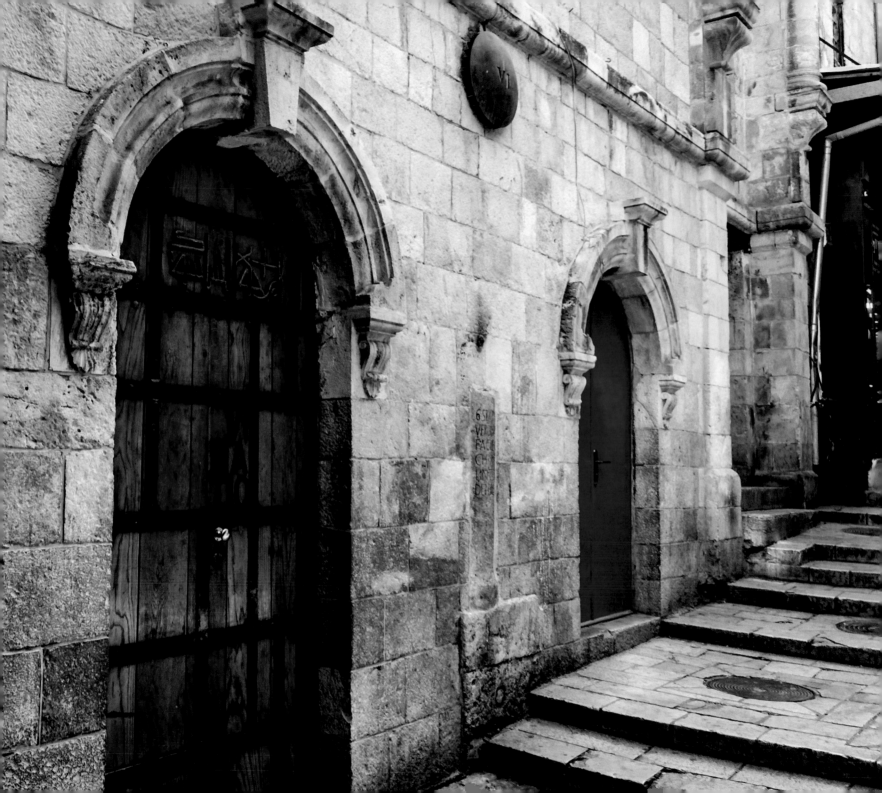

苦路第六站為「婦女拭面」的場所。（左）耶穌「三度跌倒」的地方則位於第九站。（右）

The sixth station represents the location of "Veronica wipes the face of Jesus". (Left) The place of "Jesus falls for the third time" is at the ninth station. (Right)

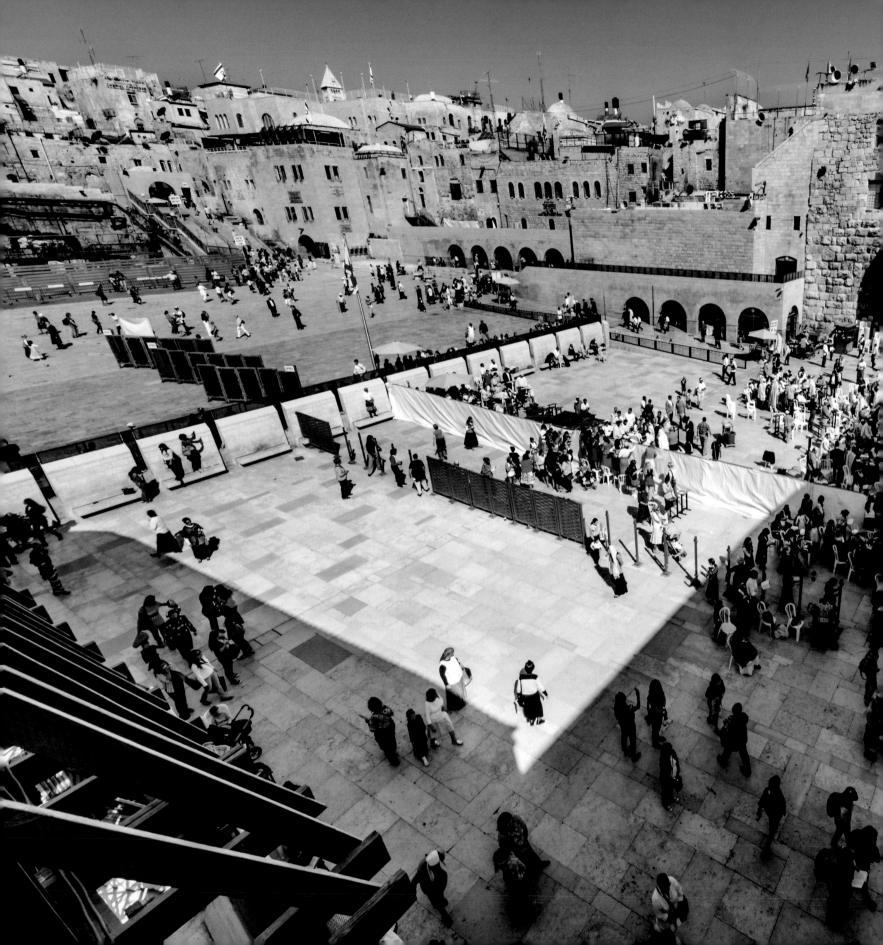

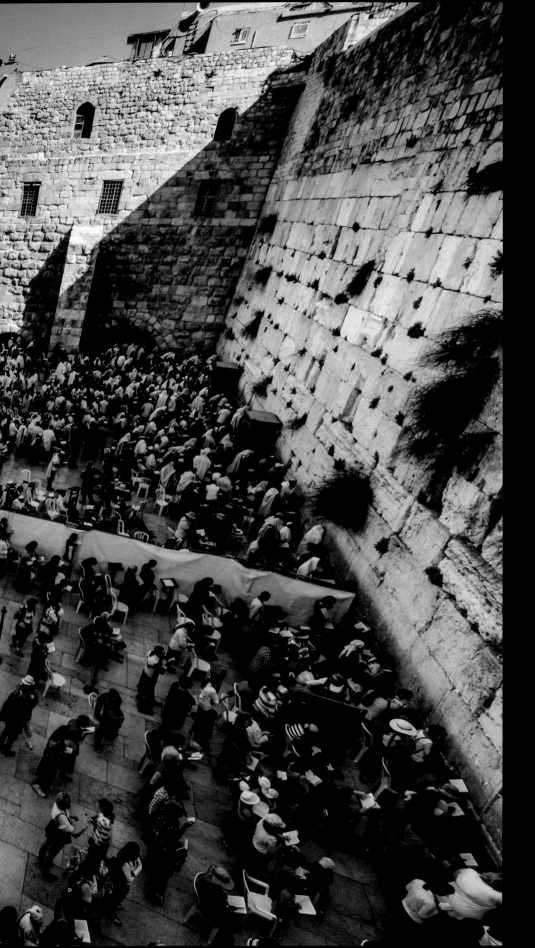

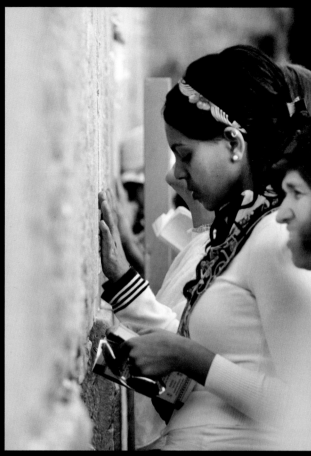

哭牆其實是古代猶太第二聖殿廢墟的西牆。（左）
因猶太人到此哭悼被毀的聖殿，它逐漸被人
稱為「哭牆」。（右）

The Wailing Wall is actually the Western Wall of
the Second Jewish Temple in ancient times. (Left)
It got its name by the practice of Jews weeping at
the site over the destruction of the Temples. (Right)

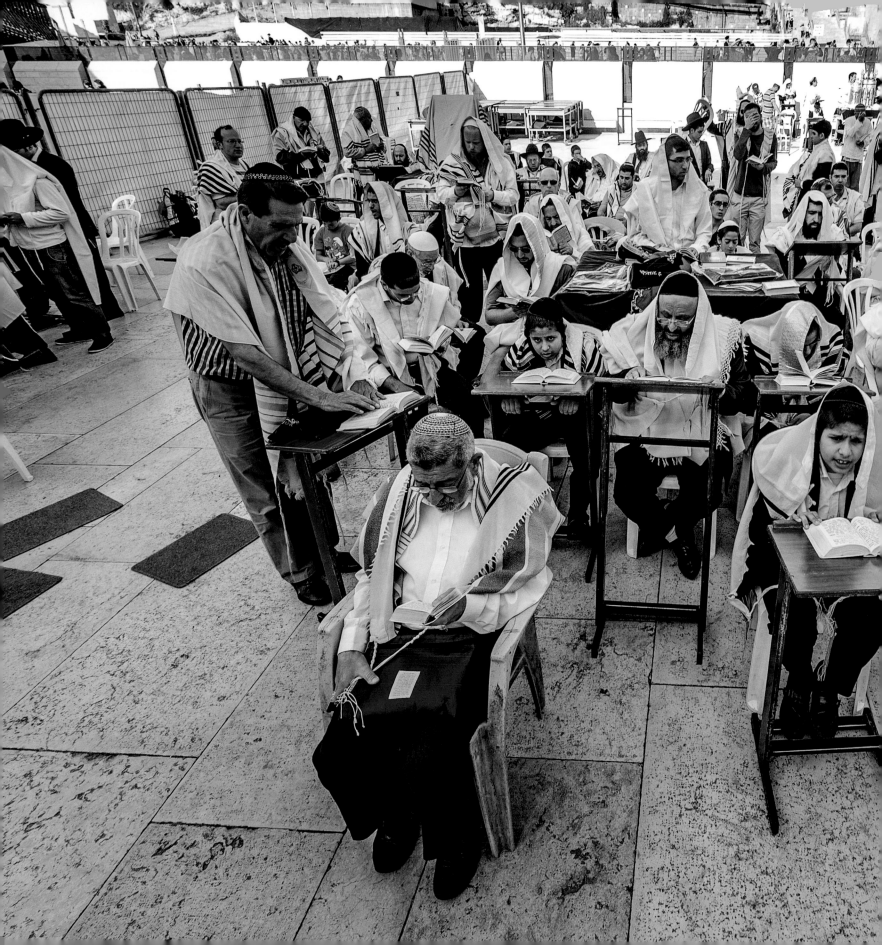

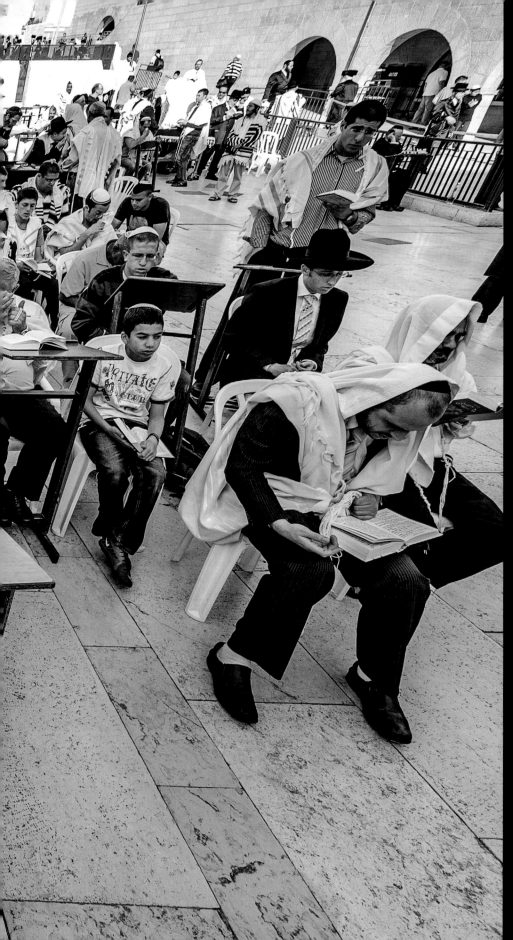

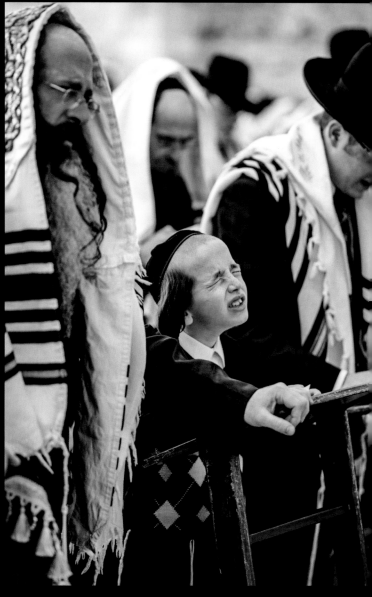

到如今，每天仍有眾多猶太教徒來到哭牆之前。（左）他們有的在誦經，或是在祈禱，亦有悲傷啜泣者。（右）

Today we can still witness thousands of Jews coming to the Wailing Wall. (Left) They are here either to chant the Torah, to pray, or even to weep sorrowfully. (Right)

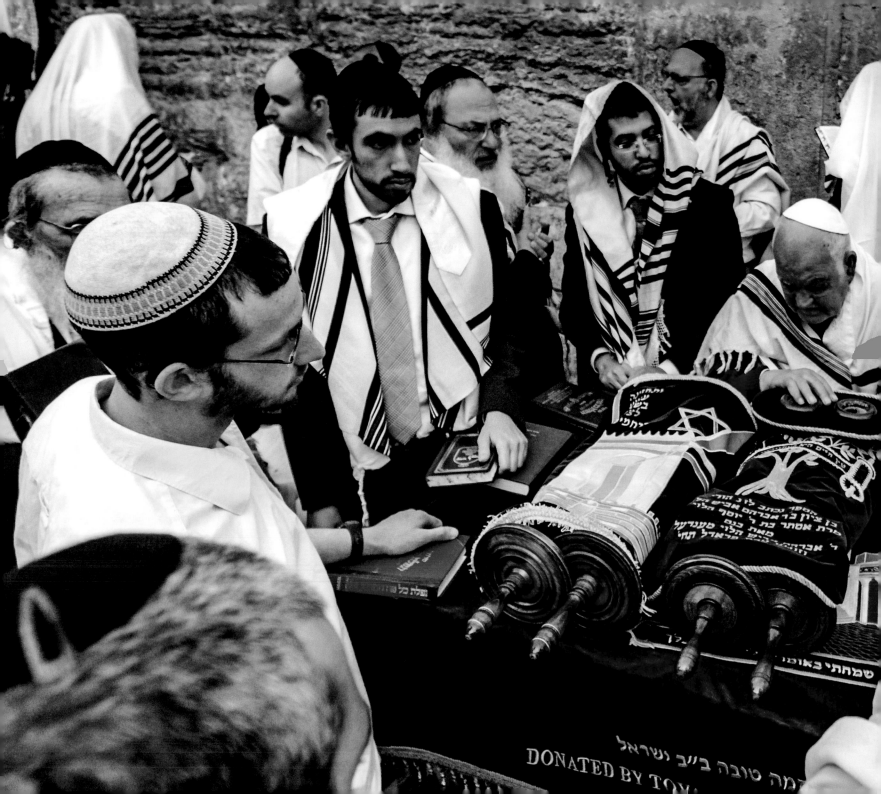

DONATED BY TO

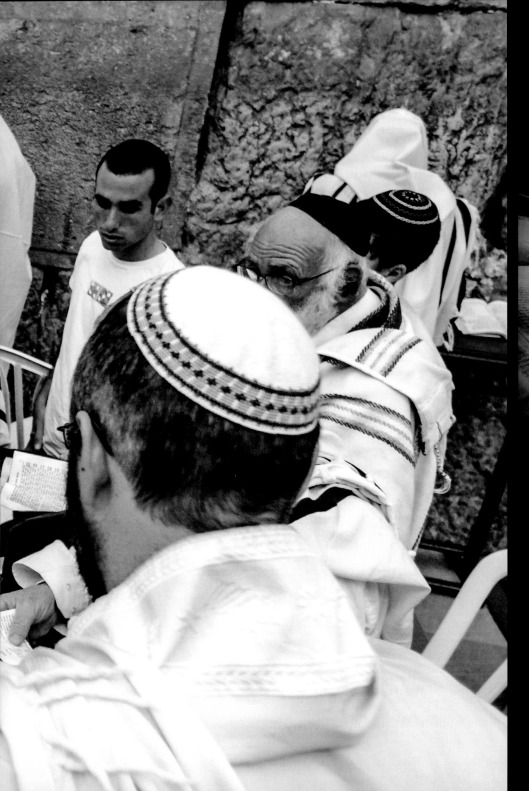

西牆被認為是當年最靠近聖殿的一面
牆。（左）因此在猶太教中被奉為除聖殿山
以外最神聖的地點。（右）

The Western Wall is considered to be closest
to the former Temple. (Left) It is therefore
regarded as the holiest site after the Temple
Mount in Judaism. (Right)

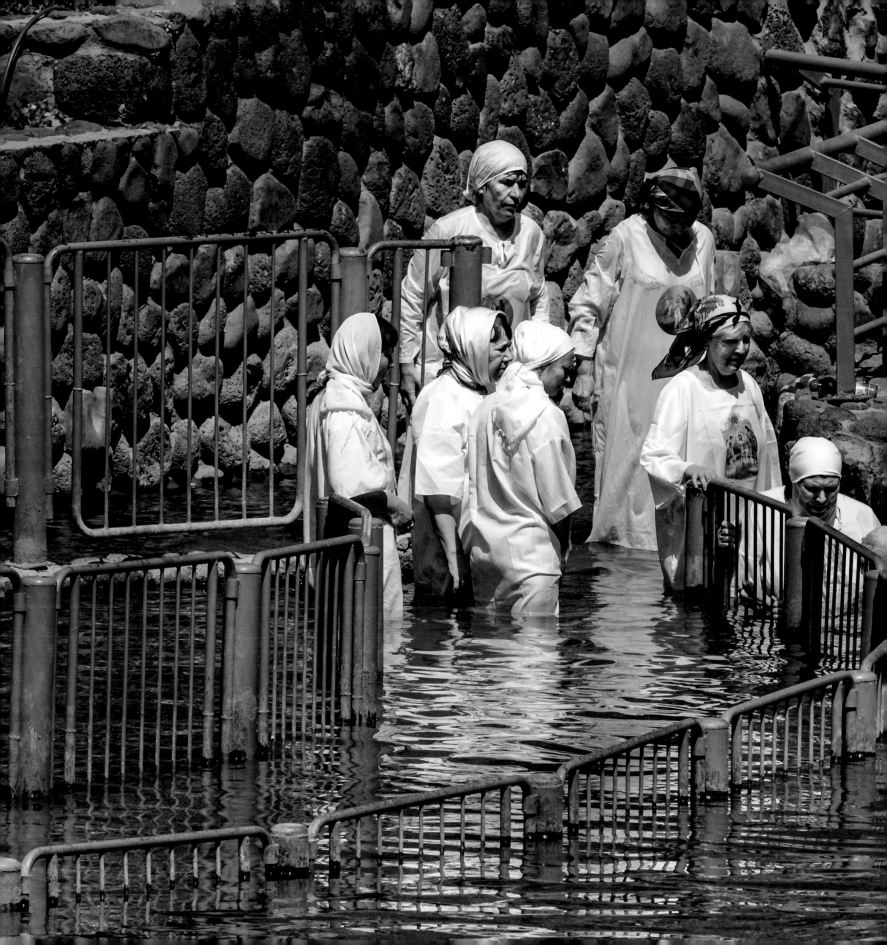

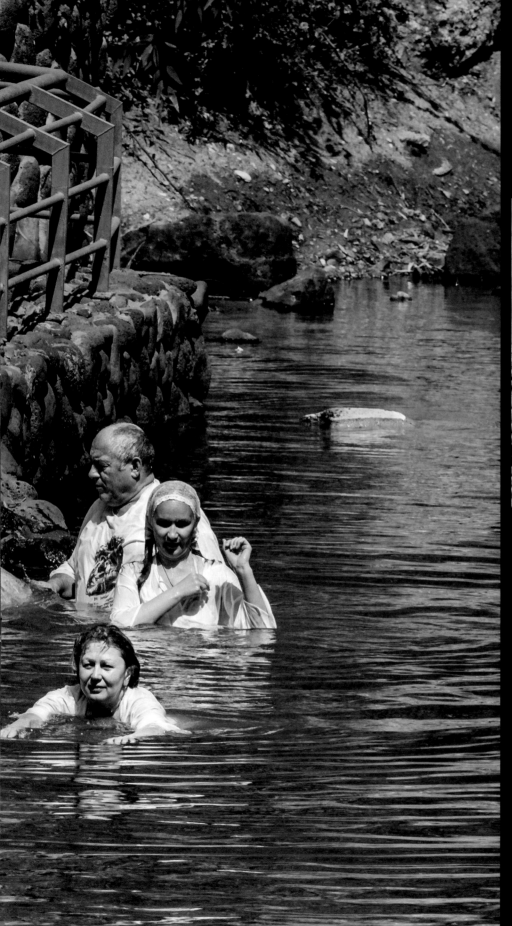

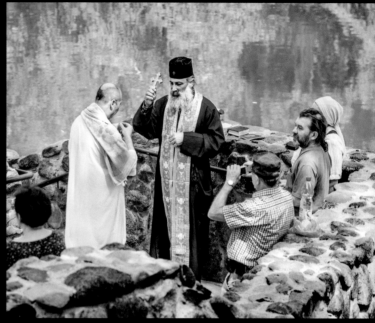

約旦河上的受浸處是當年耶穌受洗之地，如今被尊為聖地。（左）每年都會有大批信徒在此接受洗禮。（右）

The "Yardenit" on the Jordan River is regarded as a sacred place where Jesus was baptized. (Left) Every year, many believers would visit here to be baptized. (Right)

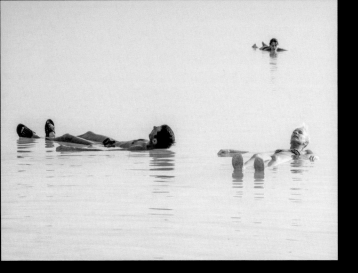

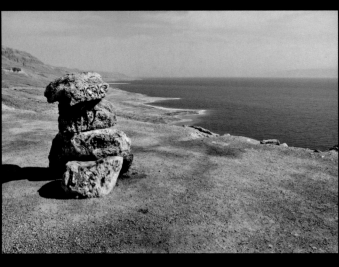

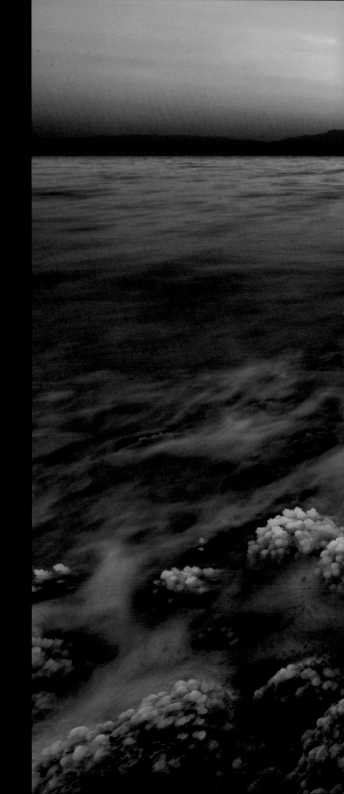

由於含鹽度極高,「死海漂浮」已經成為世界聞名的旅遊項目。(左上)除此之外,蔚藍的海水、奇異古怪的石頭,亦讓這裡極具觀賞價值。(左下)日出時分的死海美景,讓人彷彿置身仙境。(右)

Dead Sea floating has become a popular tourist activity due to its high salinity. (Upper Left) Besides floating, the blue ocean and bizarre rocks form a beautiful scenery that is worth the while. (Lower Left) The sunrise view at Dead Sea gives an illusion of being in the paradise. (Right)

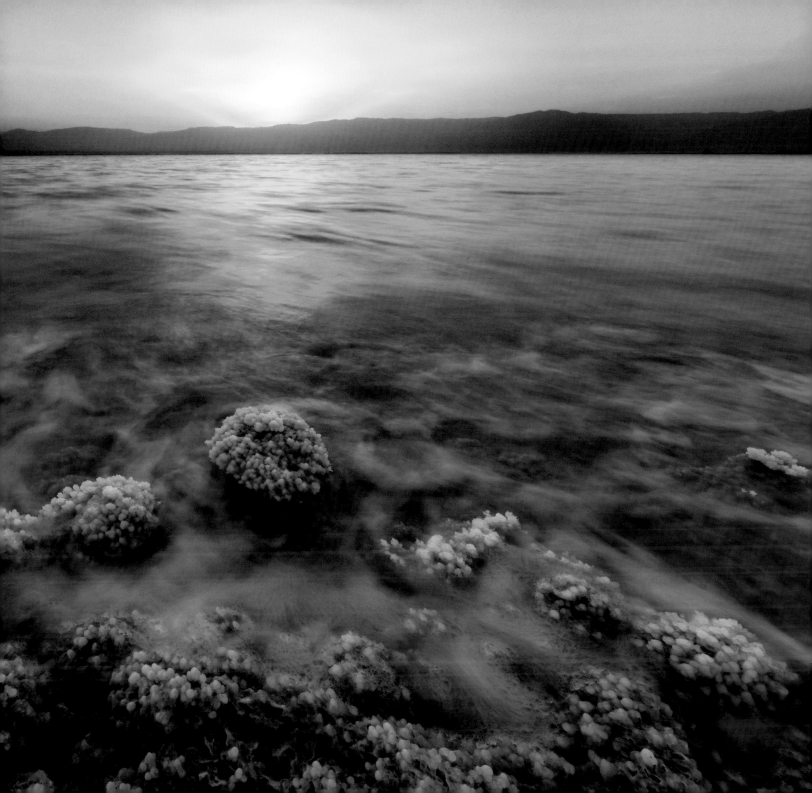

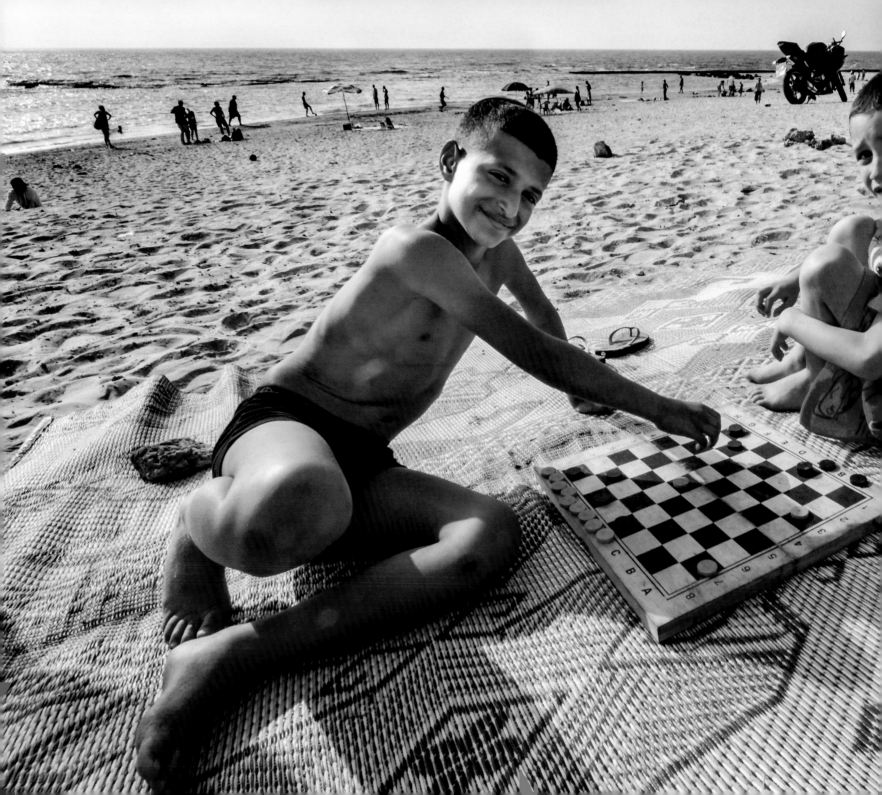

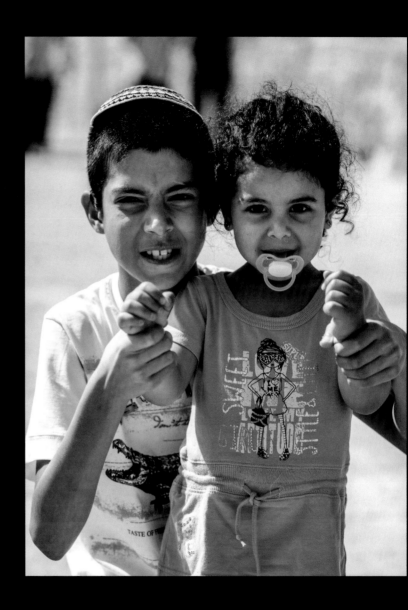

死海沙灘上有不少嬉戲的孩童。（左）一位男孩正陪著妹妹玩耍。（右）

Many children are having fun on the Dead Sea Beach. (Left)
A boy is playing with his younger sister. (Right)

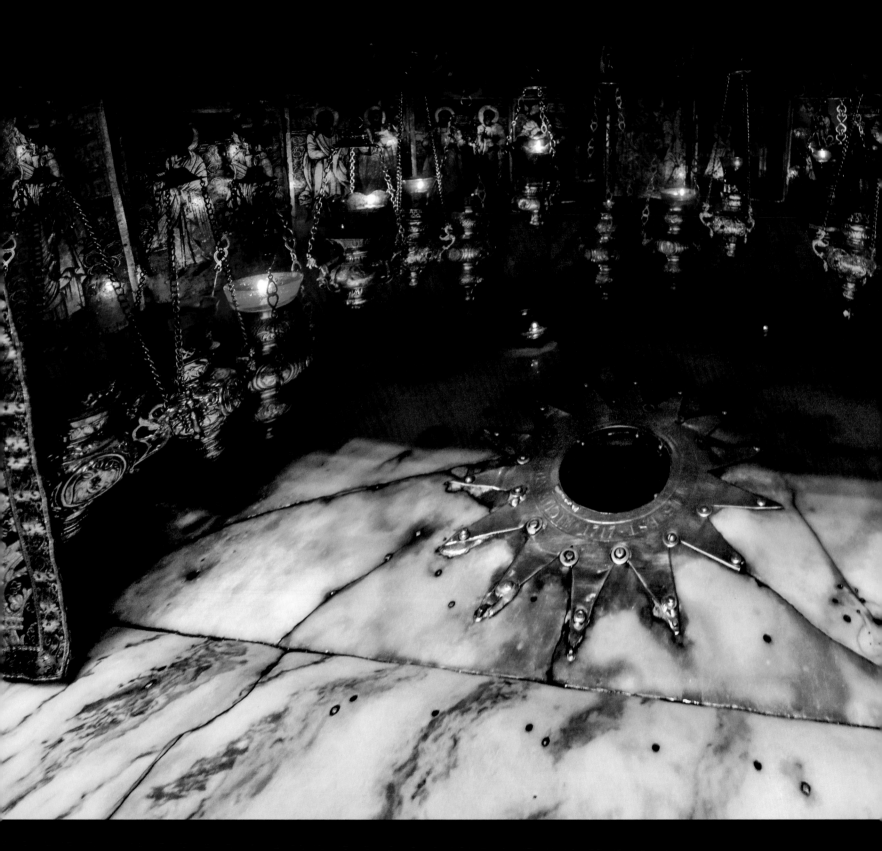

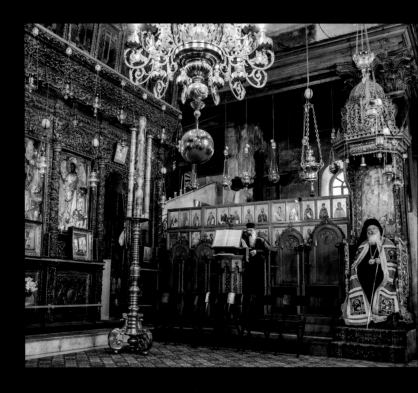

主誕堂是聖經記載耶穌出世的地方。（右）地下室的地上有十四芒星，被認為是耶穌出生之位置。（左）

In the Holy Bible, the Church of the Nativity is where Jesus was born. (Right) The fourteen-point silver star beneath the altar in the Grotto marks the traditional spot believed to be his birthplace. (Left)

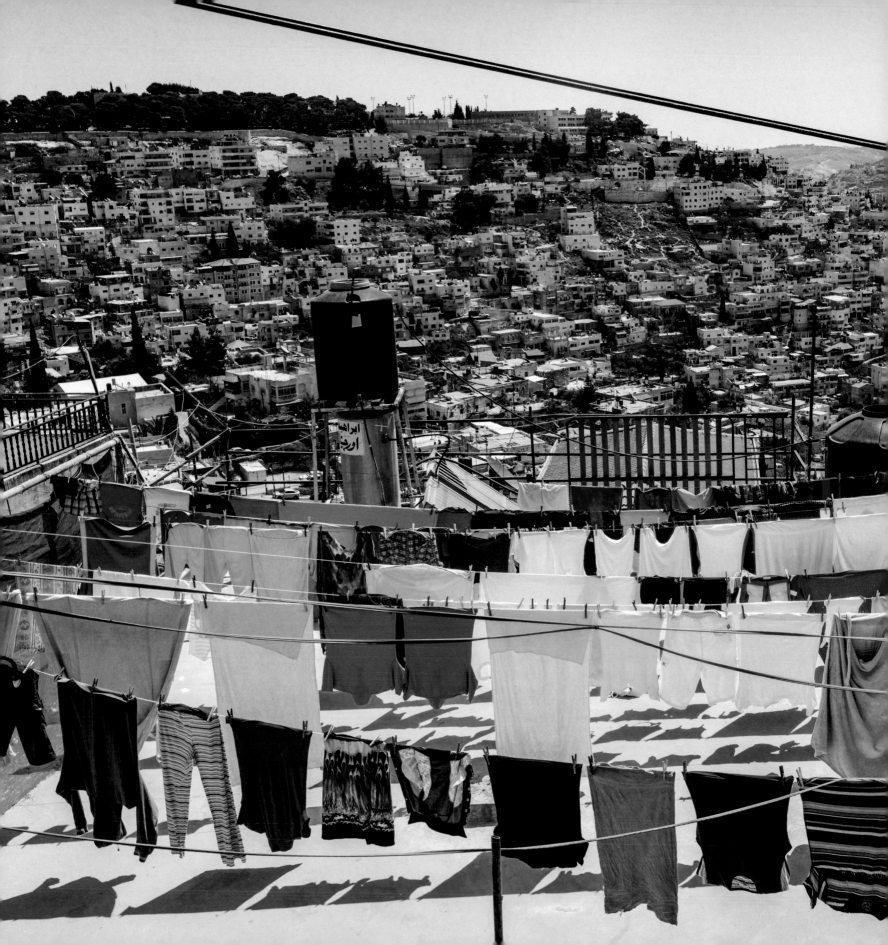

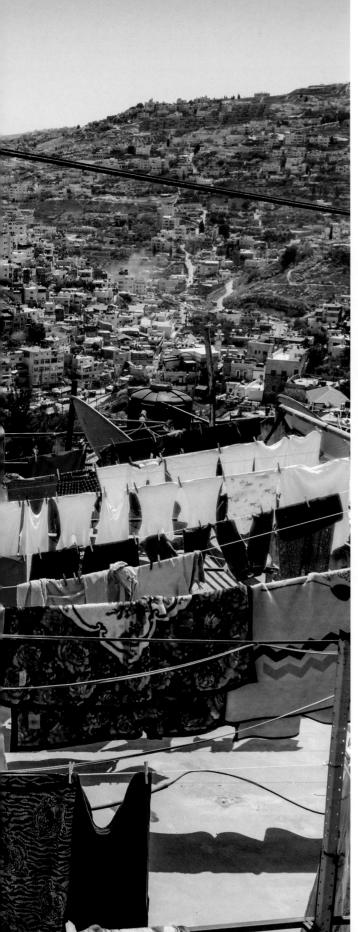

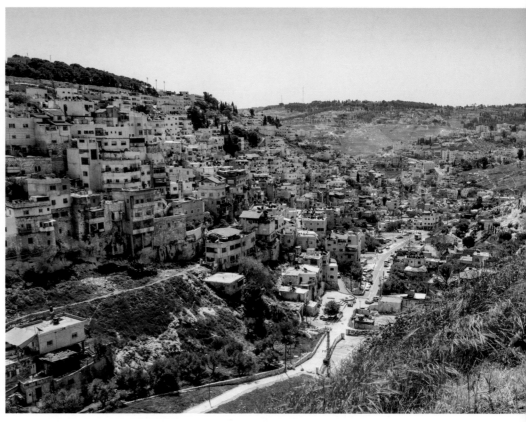

大衛城坐落於耶路撒冷城聖殿區古城牆以南的一個山頭。（左）
不少房屋興建於墳墓之上。（右）

The City of David is located to the south of the ancient wall
of Temple Mount in Jerusalem. (Left) Many houses are built
above graves. (Right)

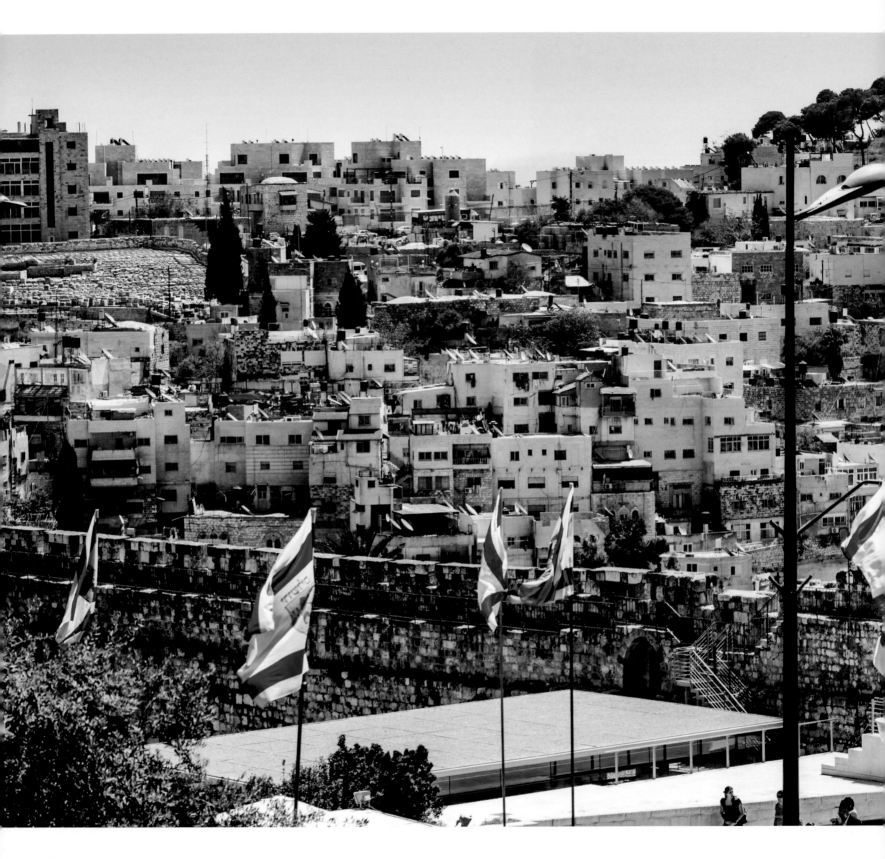

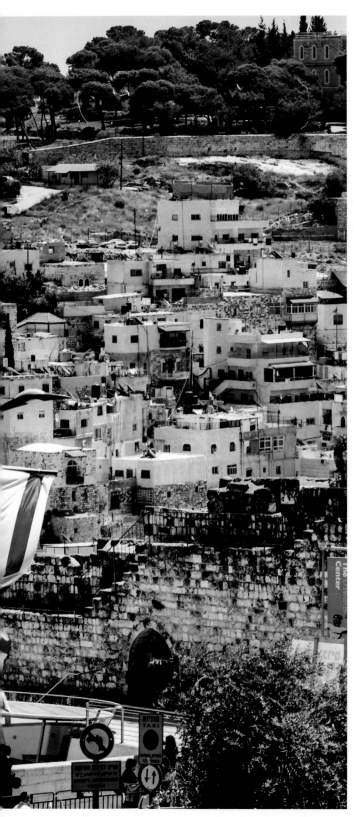

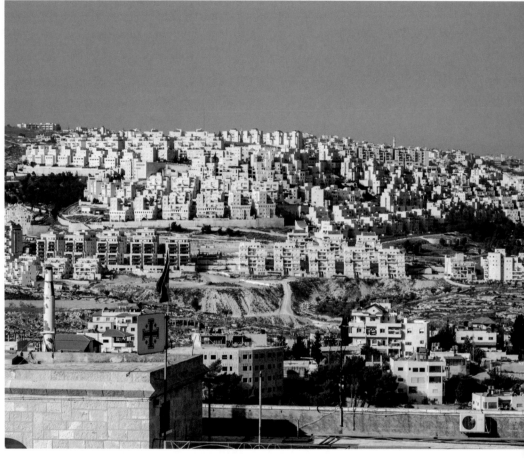

耶路撒冷的東部，被部分國家認定屬於巴勒斯坦境內。(左)
同在一個城市內，卻飄揚著不同的國旗。(右)

Certain parts of eastern Jerusalem are regarded by some nations
as Palestinian territory. (Left) A different state flag is hung up in
the same city. (Right)

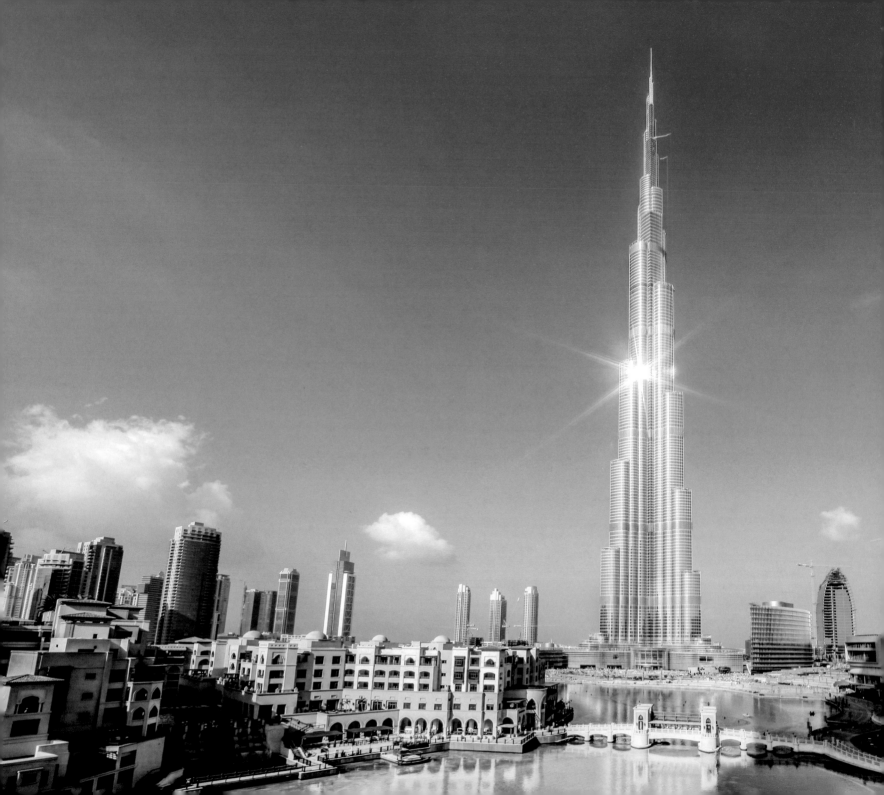

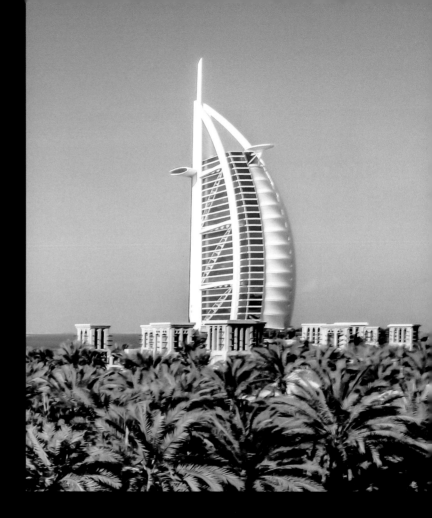

阿拉伯聯合酋長國簡稱阿聯酋，因其豐富的石油藏量，在荒蕪的沙漠之上建立起一個富饒的國家。其中 位於波斯灣東南岸的杜拜是阿聯酋乃至整個西亞地區的經濟及金融中心，擁有世界最高建築物——高 828 米的哈利法塔。（左）外形獨特仿似帆船的阿拉伯塔亦是當地知名地標。（右）

United Arab Emirates (UAE), thanks to its abundance in oil reserve has built a rich country on the deserted land. Located on the southeast coast of the Persian Gulf, Dubai is the economic and financial hub in UAE, as well as the whole of Western Asia. In the city, there is the highest building in the world - the 828-meter-high Burj Khalifa. (Left) Another famous local landmark is the uniquely shaped Burj Al Arab resembling the sail of a ship. (Right)

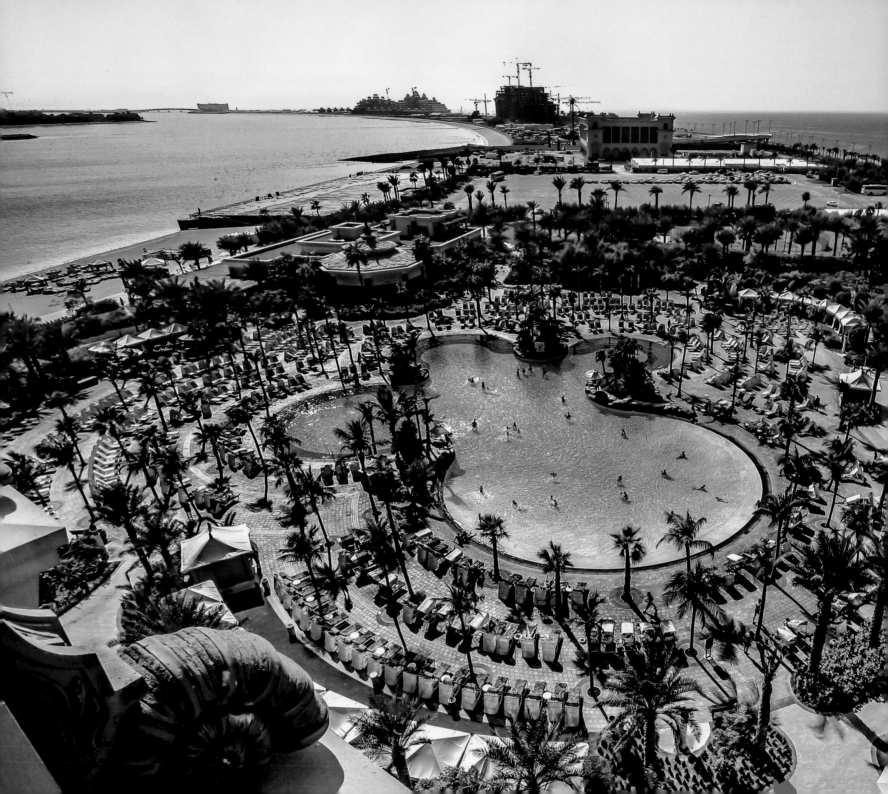

杜拜碼頭是全球最大的人工碼頭。（右上）碼頭集休閒娛樂、度假、商業於一體。（右下）鄰近的朱美拉棕櫚島則是世界上最大的人工島嶼之一，以其棕櫚樹地形舉世聞名，聚集了一眾知名的豪華酒店。（左）

Dubai Marina is the world's largest artificial marina. (Upper Right) This is a place for leisure, entertainment, vacation and commercial activities. (Lower Right) The adjacent Palm Jumeirah, which is famous for its landscape imitating the shape of a palm tree, is one of the largest man-made islands worldwide, accommodating the most renowned luxury hotels. (Left)

# 中歐及東歐

歐洲的中部包括德國、捷克、奧地利、瑞士等國，被視為經濟發達的區域。歐洲的東部地區，雖然沒有明確的範圍界定，但在文化方面，被視為一個整體區域，受到了希臘、拜占庭、東正教、俄羅斯及鄂圖曼文化的影響。正是因為受到了多元文化氛圍的薰陶，中歐與東歐地區對文化有著高度的包容能力和接受度。

順著古代絲綢之路的足蹟一路西行，過了西亞地區之後，就來到了歐洲的東部及中部，這是抵達絲綢之路最後終點西歐的最後一個區域。海上絲綢之路，亦是通過此處正式踏上歐洲的土地。

歐洲聯盟的成立，為歐洲國家的對外貿易及國際間經濟合作，提供了有效、便捷的平台。近年，西方國家經濟增長進入平緩期，加之債務危機帶來了不少阻礙，如何走出困境，得到進一步的發展，成為歐洲國家的首要課題。

另一邊廂，中國的經濟發展騰飛舉世有目共睹。中國提出的「一帶一路」為國際合作指出了新方向，其推進將會為歐洲中部和西部提供全新的發展機遇。

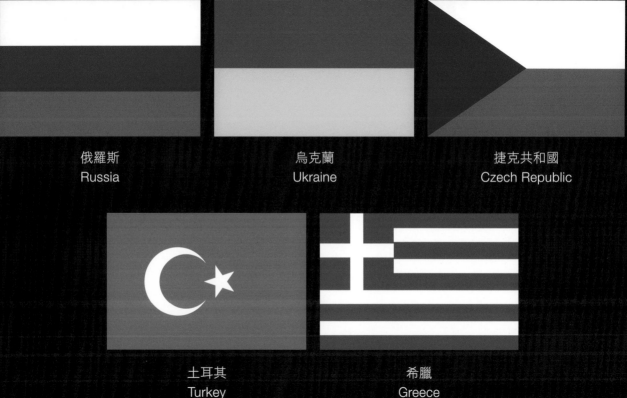

俄羅斯
Russia

烏克蘭
Ukraine

捷克共和國
Czech Republic

土耳其
Turkey

希臘
Greece

# Central and Eastern Europe

Central Europe is usually regarded as a developed area economically, including Germany, Czech Republic, Austria, Switzerland, and etc. Eastern Europe, although its scope not specifically defined, is generally seen as a cultural entity which is influenced by Greek, Byzantine, Eastern Orthodox, Russian and Ottoman cultures. The diversity in cultural characteristics has defined the high degree of tolerance and acceptance for other cultures in the Central and Eastern Europe.

The ancient Silk Road headed its way westward after the Western Asia to reach Central and Eastern Europe - the last station before reaching the final destination of Western Europe. At the same time, the maritime Silk Road also entered Europe by way of here.

The European Union has provided an effective and convenient platform for European countries to conduct foreign trade and international economic cooperation. However, as the Western world enters a phase of decelerated growth in recent years, and as debt crisis brings about even more obstacles, how to steer clear of the trouble and spur further economic development has become the top issues for Europe.

China, on the other hand, is universally recognized as a rapidly growing economy. The Belt and Road Initiative proposed by China has pointed out the direction for future international cooperation. Its progress will definitely bring brand new opportunities to Central and Eastern Europe.

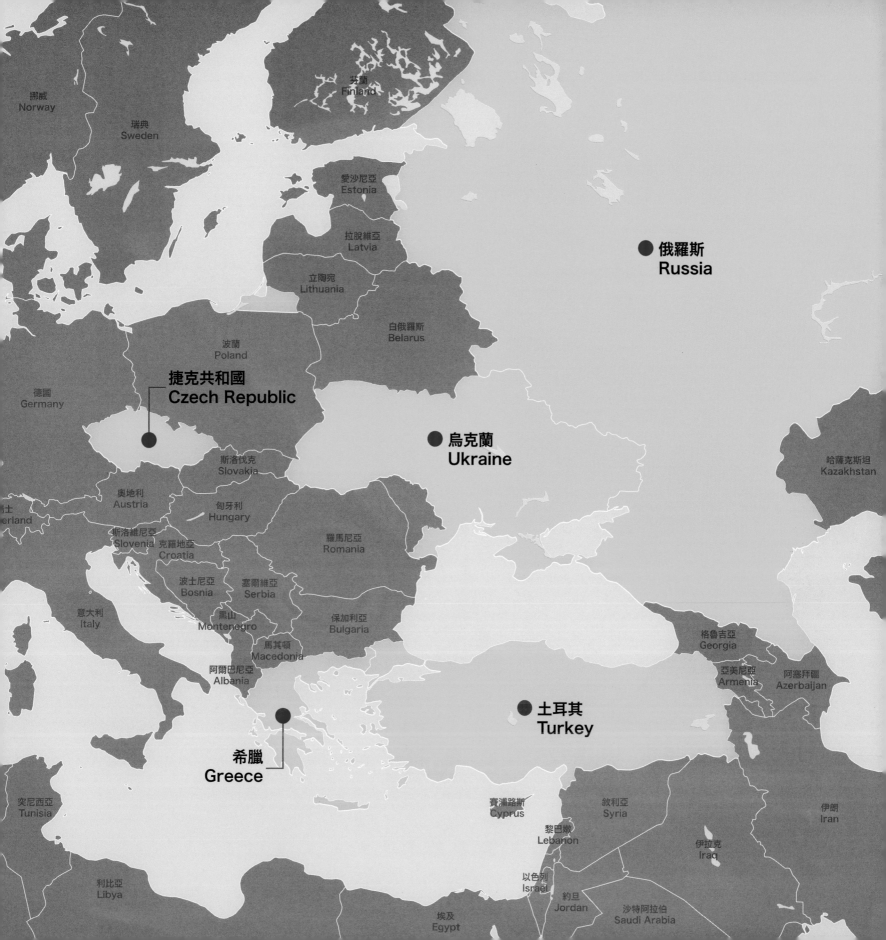

俄羅斯橫跨歐亞兩大洲，是世界上土地面積最大的國家。莫斯科是俄羅斯的首都，超過一千年的歷史，為這個城市留下了豐富的人文旅遊資源，不少都集中於紅場之上，當中就包括造型富有童話風格的聖巴素大教堂。

Russia is the largest country in the world by area, stretching over the continent of Eurasia. Moscow is the capital of Russia. With a history of more than 1,000 years, the city is abundant in cultural and tourism resources, many of which are located at the Red Square, including the fairytale-like St. Basil's Cathedral.

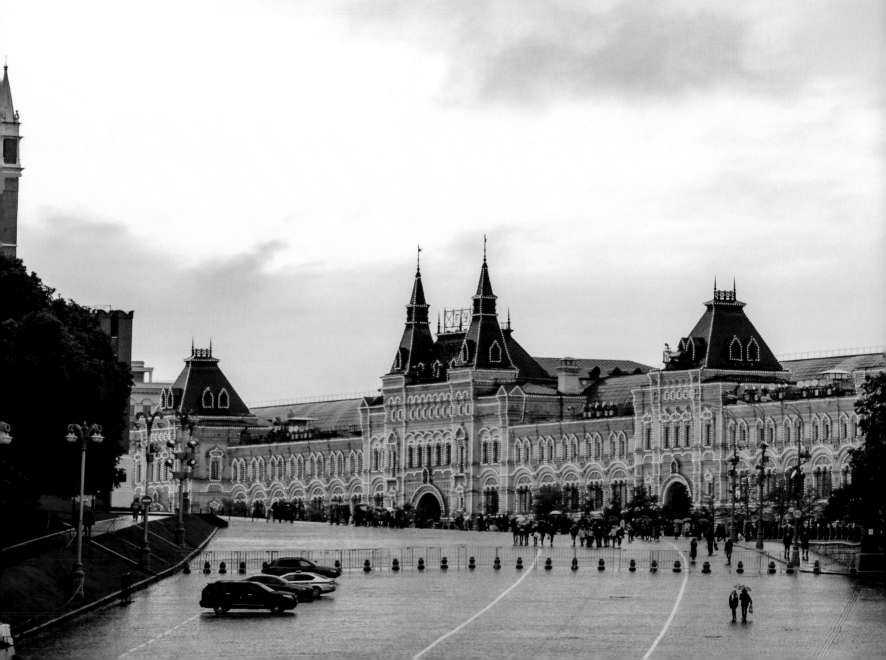

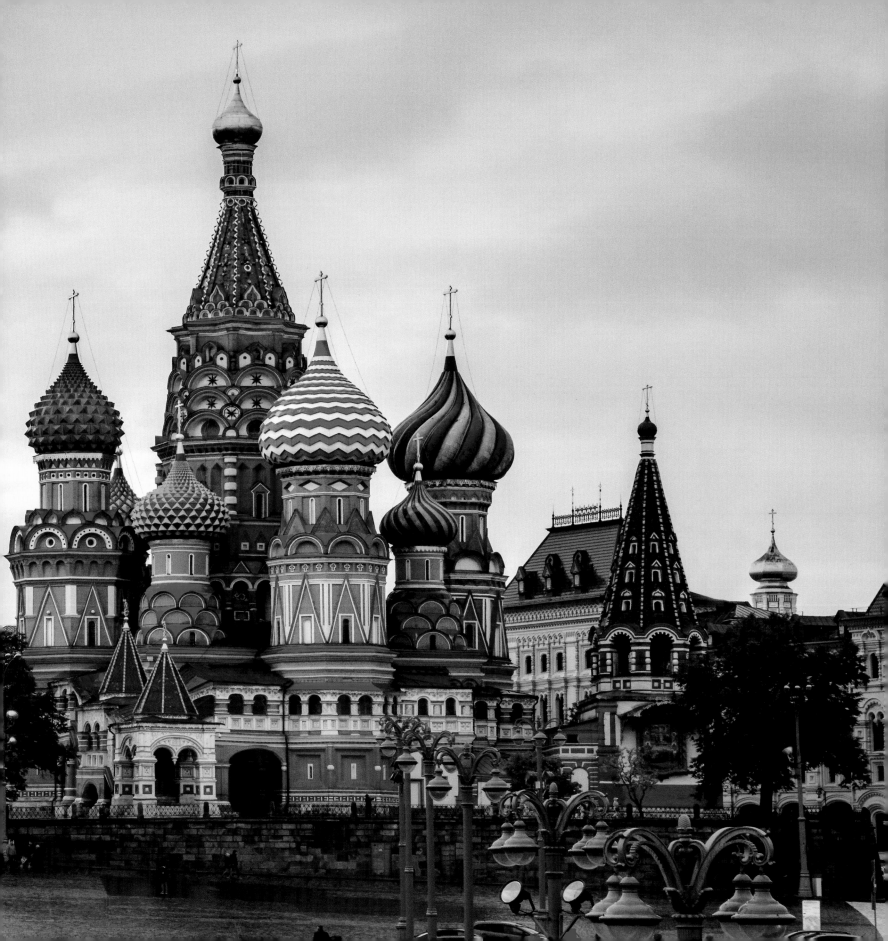

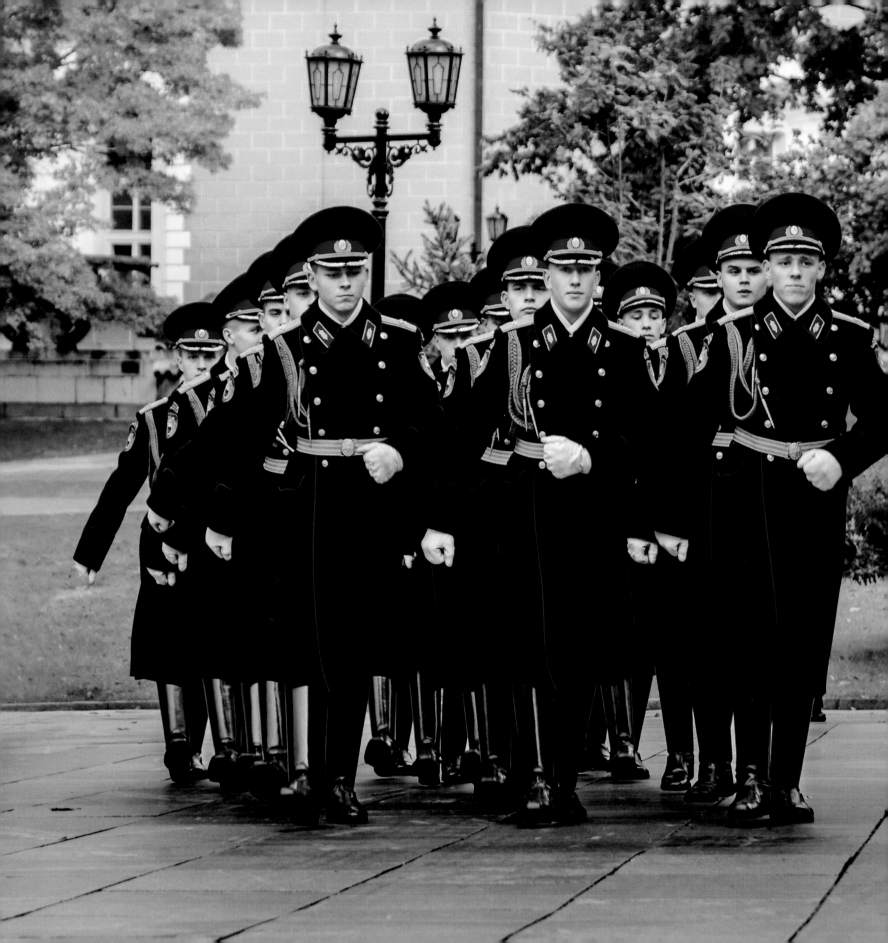

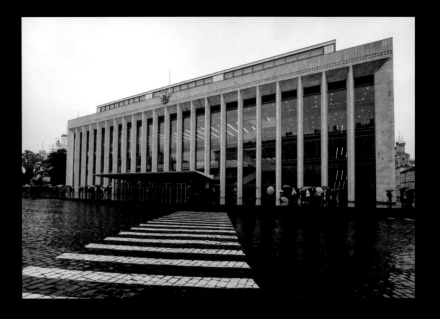

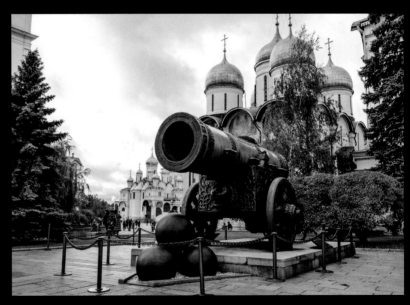

克里姆林宮為俄羅斯的行政中心。（右上）沙皇炮保衛著整個克里姆林宮。（右下）俄羅斯軍官儀表整潔，皆表情肅穆。（左）

The Kremlin is the administration center of Russia. (Upper Right) The Tsar Cannon guards the Kremlin. (Lower Right) Russian officers in neat uniforms share a solemn expression. (Left)

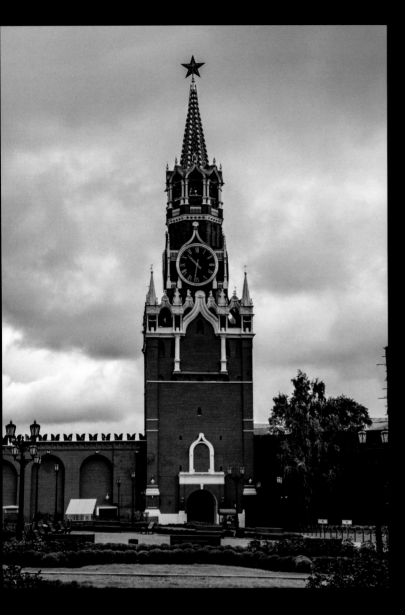

建有九個金色圓頂的天使報喜大教堂，外觀引人矚目。（右）
救世主塔是克里姆林宮的正門，在此可以俯瞰紅場。（左）

The Cathedral of the Annunciation stands out with its nine golden domes. (Right) The Spasskaya Tower (translated as the "Savior Tower") is the main entrance into the Kremlin, which overlooks the Red Square. (Left)

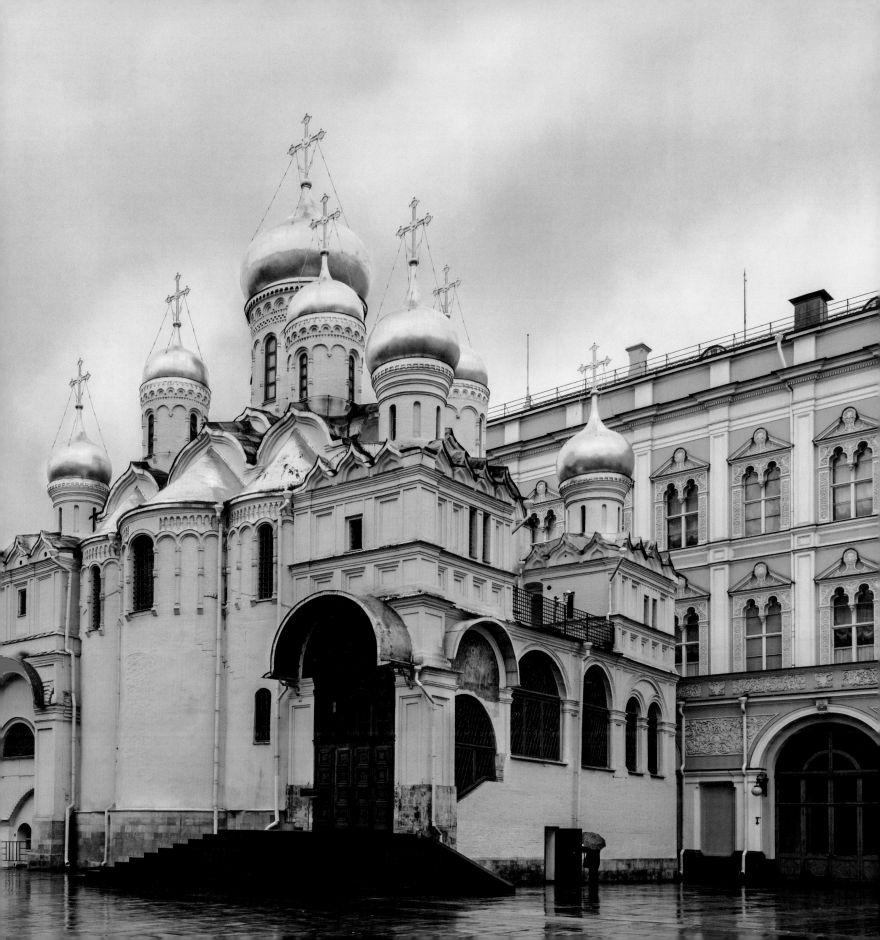

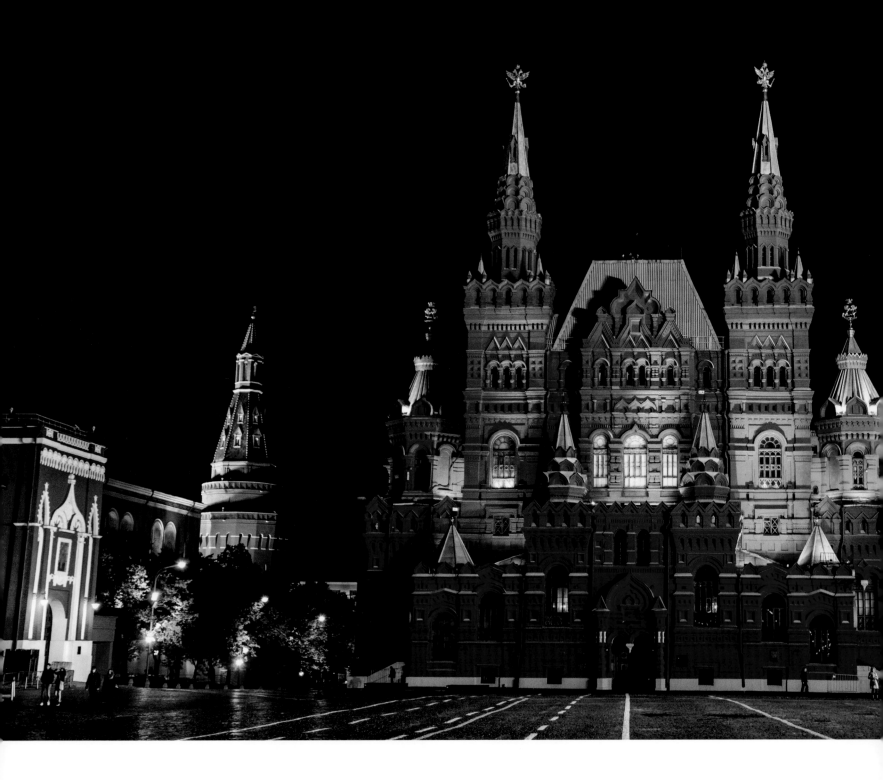

俄羅斯國家歷史博物館位於紅場附近，建於 1872 年，館藏展品多達百萬件。（左）從這裡可以遙望聖巴素大教堂夢幻般的夜色。（右）

The State Historical Museum of Russia was founded in 1872, with a total number of collections coming to millions. (Left) The dreamlike night view of St. Basil's Cathedral can be seen from here. (Right)

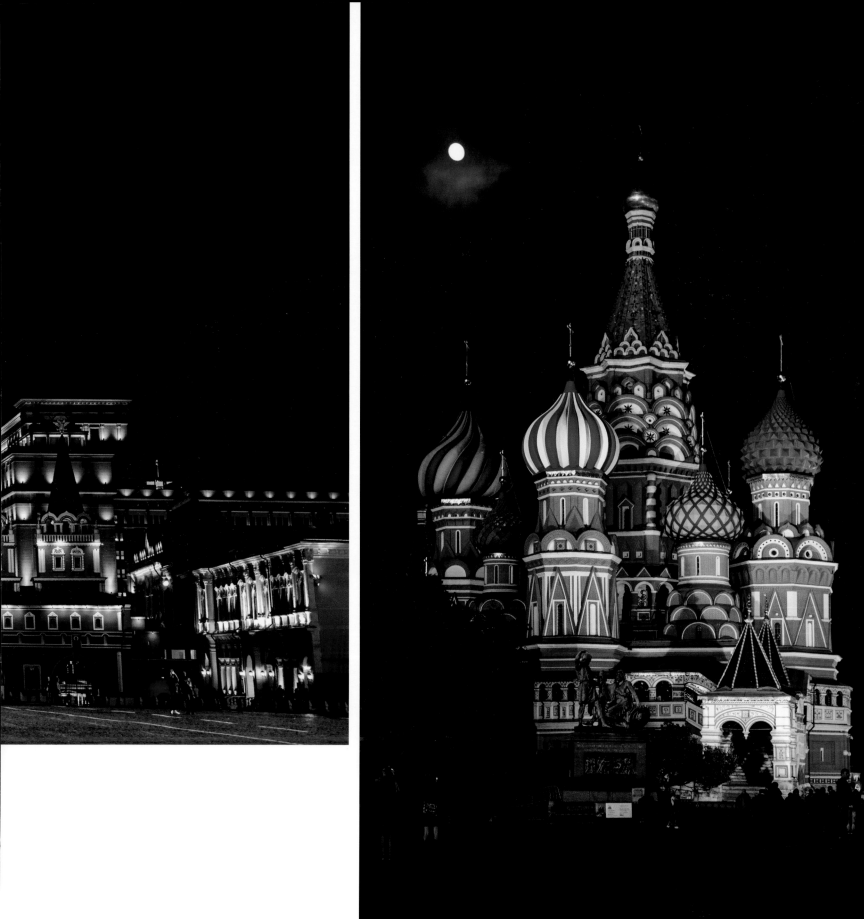

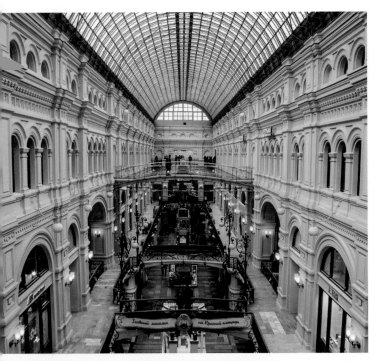

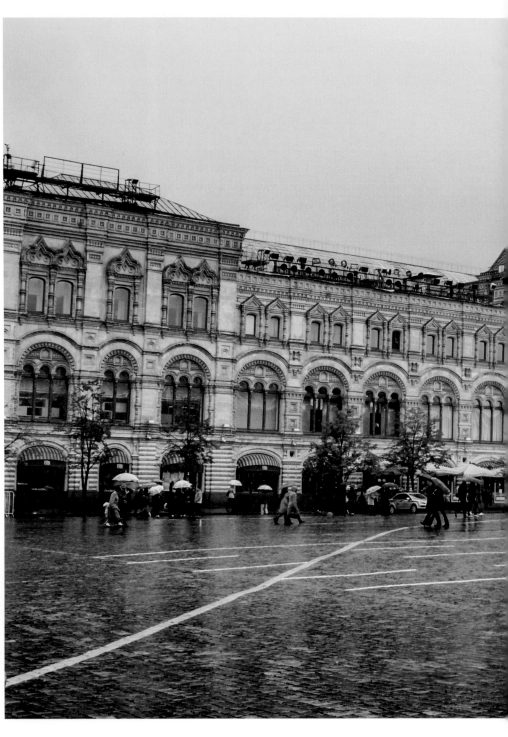

古姆百貨商場建於 1890 至 1893 年，為俄羅斯的國家百貨商場，位於紅場東面，三層高的建築延綿 242 米。（右）這是莫斯科最大的百貨公司，擁有逾千商舖。（左上）屋頂的鋼鐵框架及玻璃造型，讓人聯想到十九世紀的火車站。（左下）

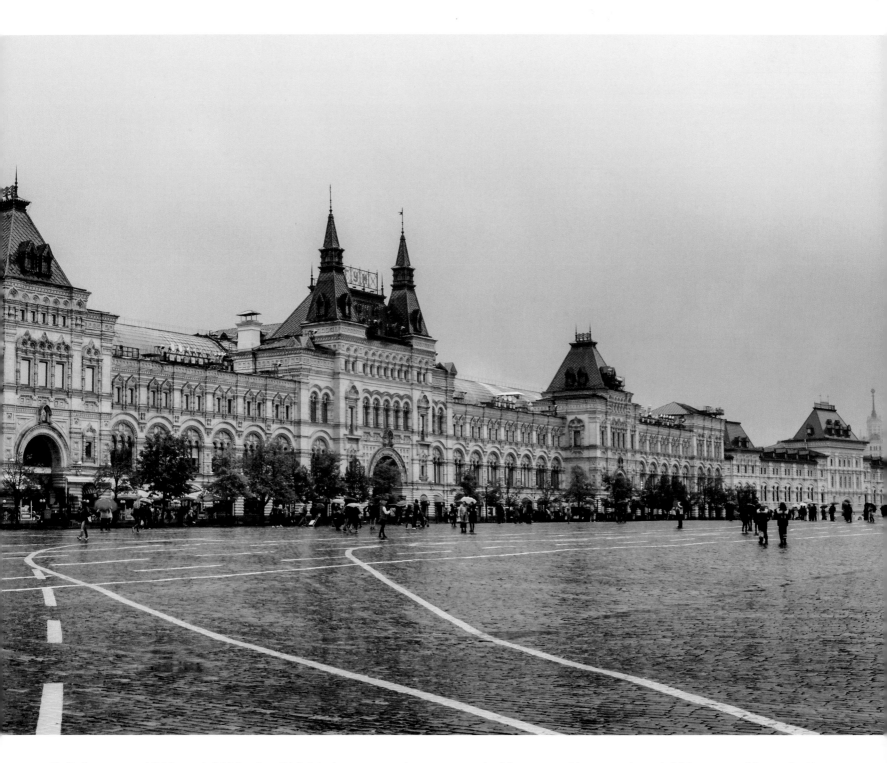

Built between 1890 and 1893, the GUM is known as the State Department Store of Russia, which is located at the eastern side of the Red Square. The 3-storey building stretches 242 meters. (Right) This is the largest department store in Moscow, with more than 1,000 stores. (Upper Left) Its steel framework and glass roof gives an impression of a railway station in the 19th century. (Lower Left)

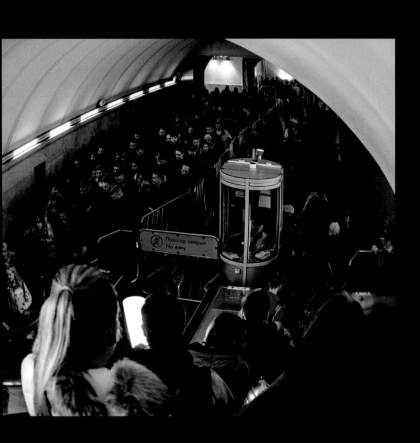

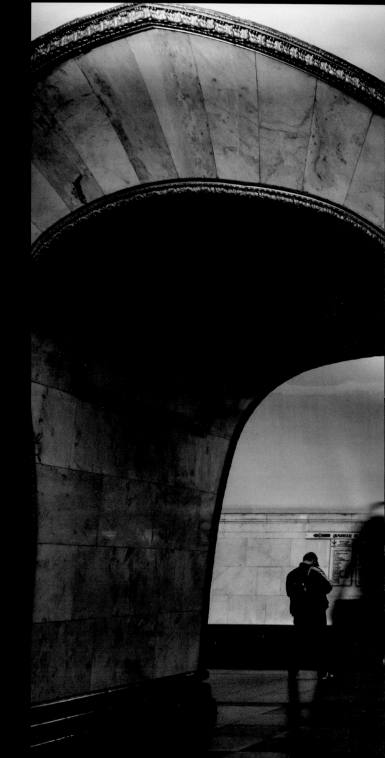

莫斯科地鐵，是全球最繁忙的地下鐵路之一。（左）站內充滿了藝術美感，處處點綴以大理石、彩色玻璃花紋、壁畫、浮雕等元素，讓乘客彷如置身一個個富麗堂皇的宮殿。（右）

The Moscow Metro is one of the most crowded subways in the world. (Left) The stations are artistically beautiful - the decorative factors of marble, colorized glass, murals and bas-reliefs seem to have transported passengers to magnificent palaces. (Right)

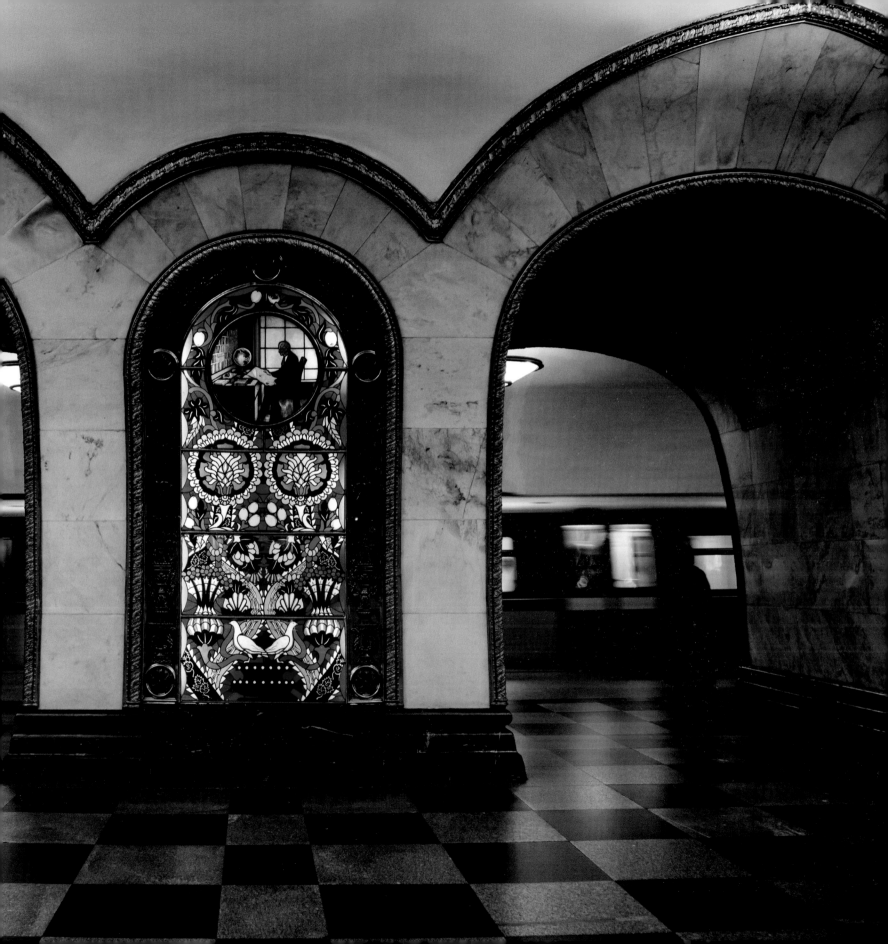

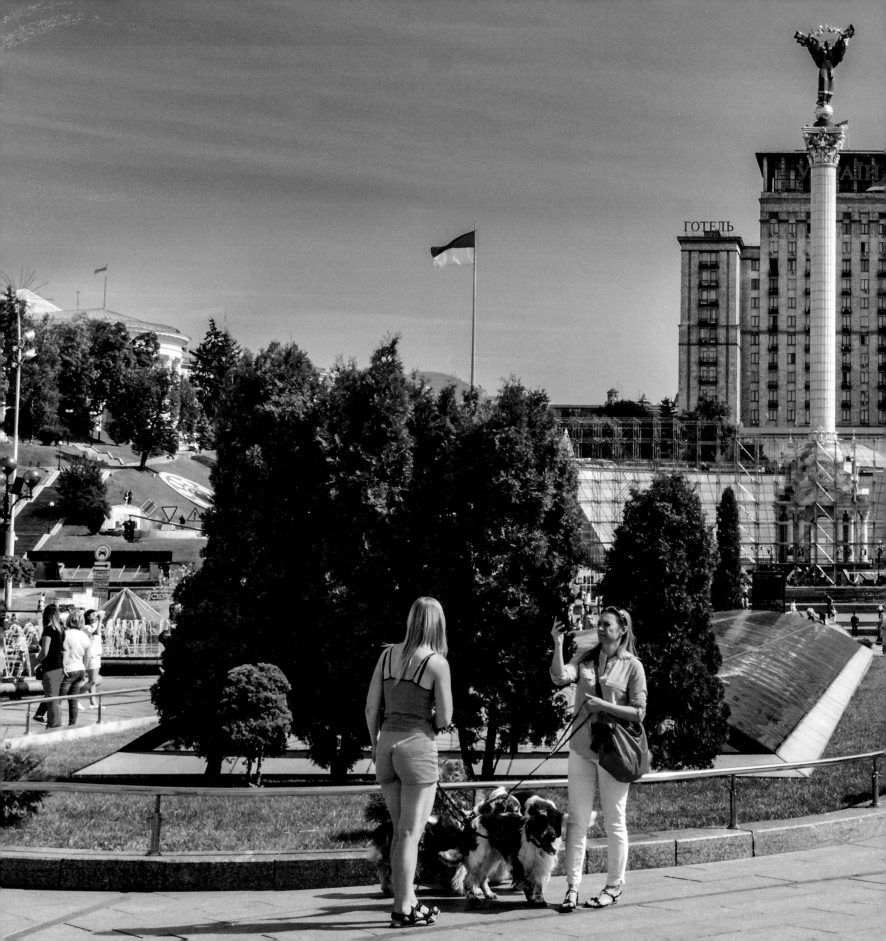

烏克蘭為歐洲面積第二大的國家，次於俄羅斯。於 1991 年正式宣佈脫離蘇聯獨立，定都基輔。烏克蘭擁有豐富的自然資源，文化歷史底蘊亦十分深厚，其文學、美術、音樂、戲劇、建築等方面都在國際上享負盛名。

Ukraine is the second largest country in Europe after Russia. With the proclamation of its independence in 1991, Ukraine separated itself from the Soviet Union and established its capital at Kiev. Ukraine is abundant in natural resources, and has a strong historical foundation for culture - its literature, art, music, theater, architecture and other fields enjoy high reputation in the world.

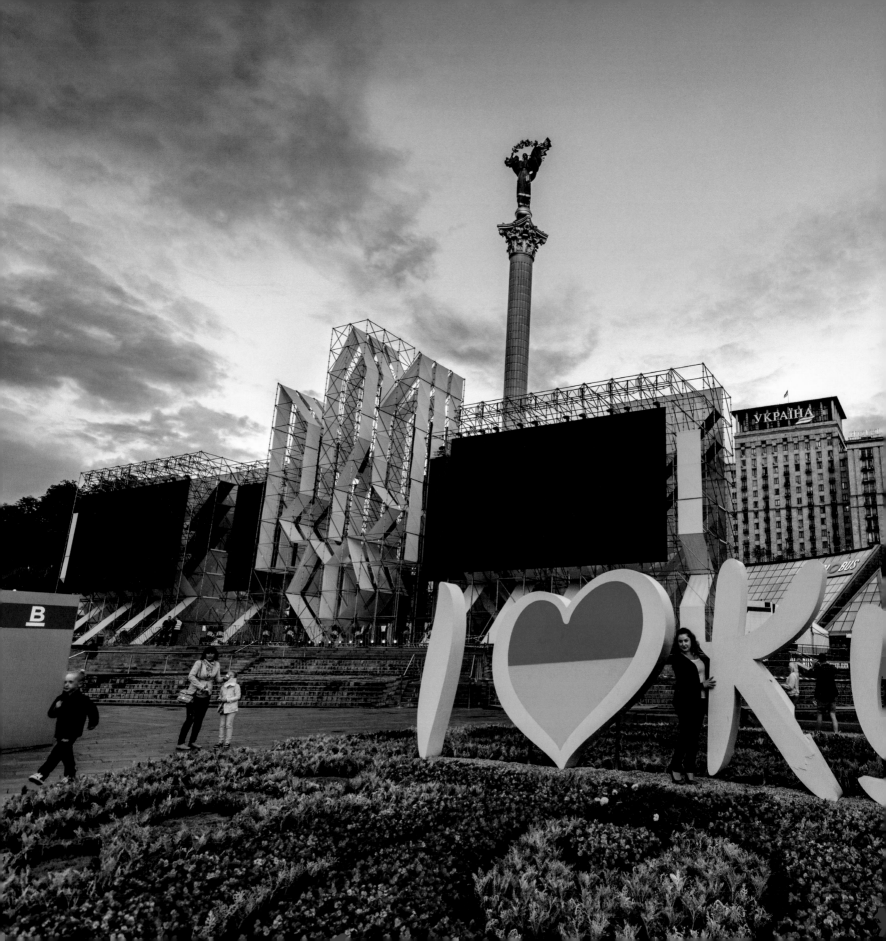

獨立廣場位於市中心，中央矗立著 40 米高的獨立紀念碑；廣場上隨處都有噴泉和雕塑，更有一個醒目的「我愛基輔」標語。（左）孩童在廣場上嬉戲。（右）

The Independence Square is at the center of the city, with a 40-meter high independence monument at its heart. Fountains and statues can be found everywhere on the square, and there's even a marked slogan of "I love Kyiv". (Left) Children are playing on the square. (Right)

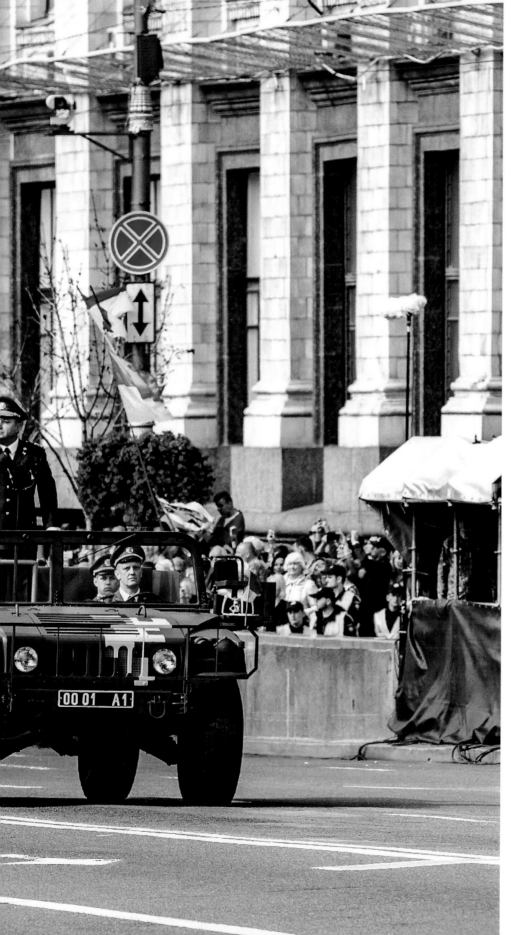

每年的 8 月 24 日，是烏克蘭獨立日。（左）
總統在閱兵儀式上向軍隊授旗。（右下）
烏克蘭女兵英姿颯爽。（右上）

August 24th is the annual Independence Day of Ukraine. (Left) The President presents the military with a flag at the military parade. (Lower Right) The Ukrainian female officer is mighty in spirit. (Upper Right)

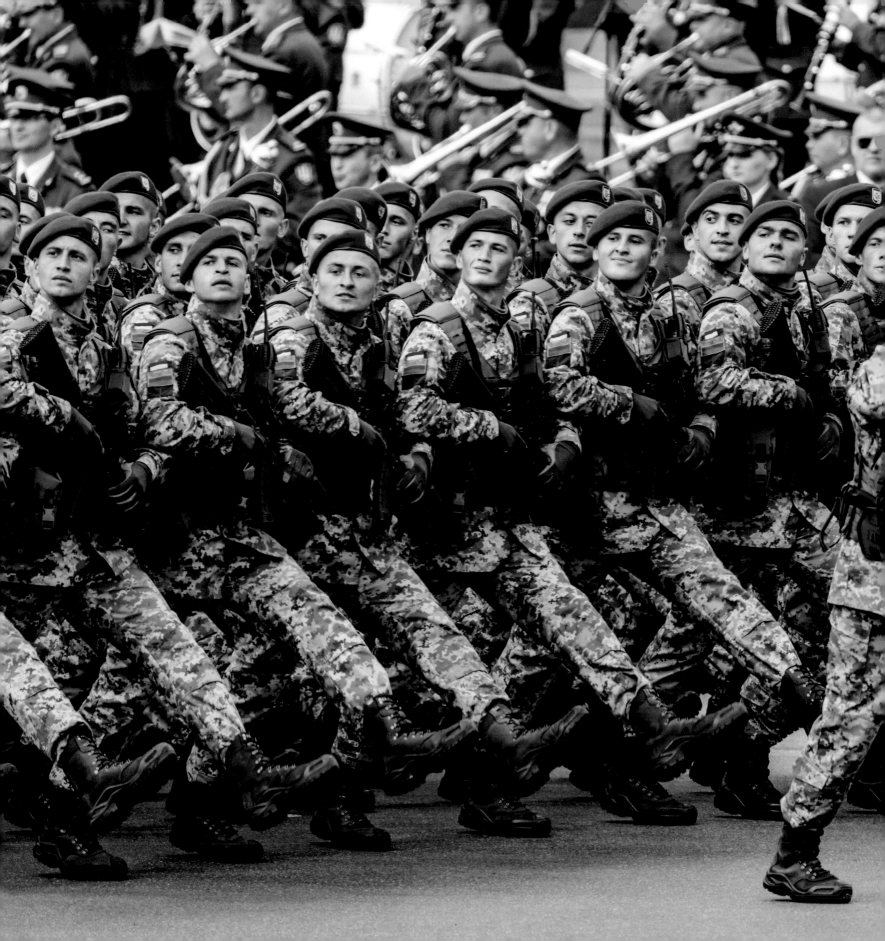

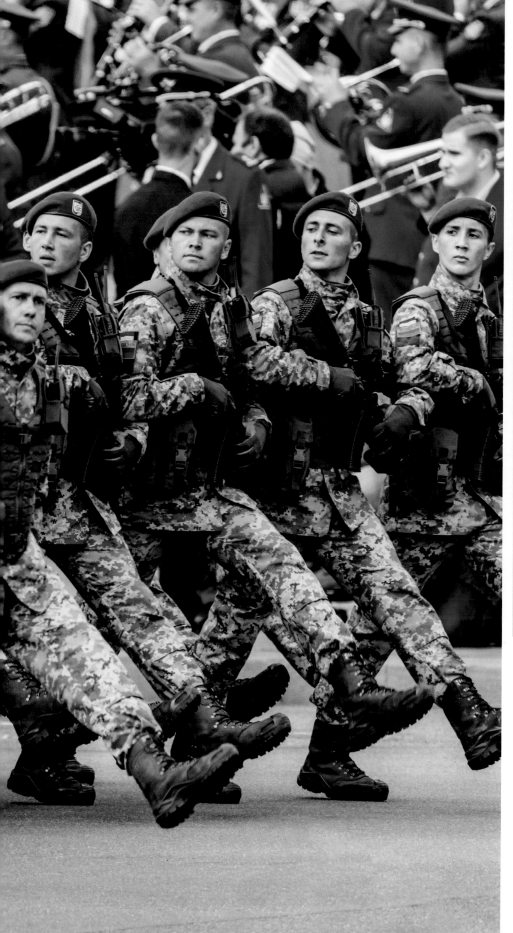

閱兵儀式約有 4,500 名軍人參加。（左）
他們以挺拔之姿展現了抖擻的軍容。（右）

About 4,500 soldiers participate in the parade. (Left) They keep their bodies tall and straight to show high spirits of the army. (Right)

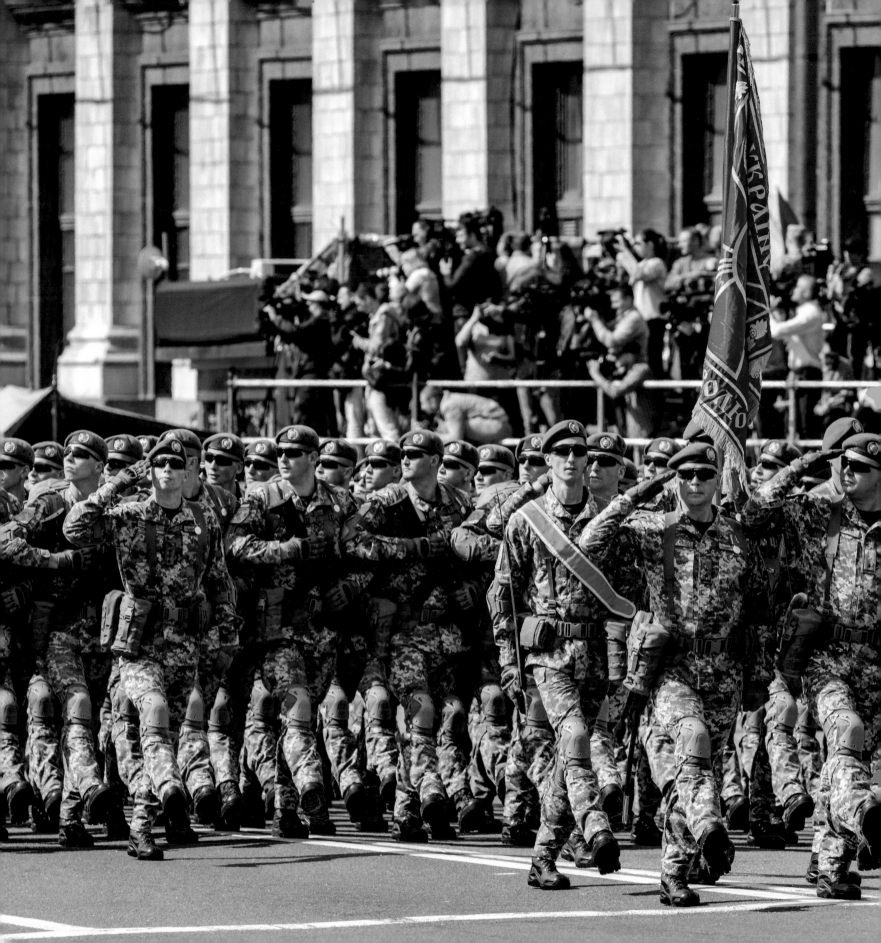

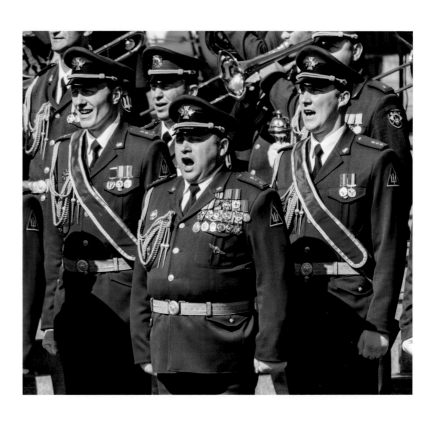

一年一度的大型閱兵儀式，聚集了各類兵種。（右）眾多國民及遊客前來獨立廣場觀賞儀式。（左）

The annual military parade has assembled assorted military branches. (Right) Legions of Ukrainians and visitors gather at the Independence Square to watch the ceremony. (Left)

聖米迦勒金頂修道院始建於中世紀。（左）
華麗的外表融合了拜占庭和巴洛克時期流行
的各種風格元素。（右上）祈禱者立於燭火
之前。（右下）

The St. Michael's Golden-Domed Monastery
was originally built in the Middle Ages. (Left)
Its resplendent exterior is a mixture of
popular features of byzantine and baroque
styles. (Upper Right) A prayer is standing in
front of the candles. (Lower Right)

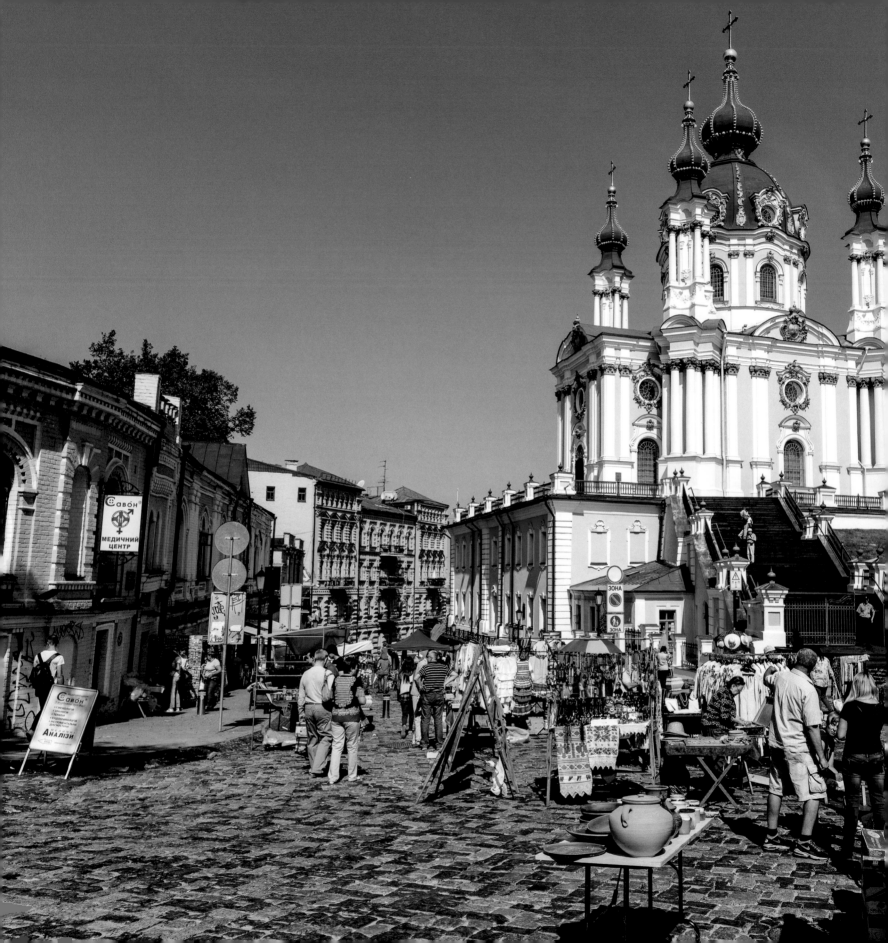

聖安德烈教堂位於安德烈斜坡之上。（左）附近有不少手工藝品攤檔，是遊客尋找及紀念品的好地方。（右）

The St Andrew's Church is located on the Andrew's slope. (Left) There are many stalls selling handicrafts in the surrounding area, making it a good place to buy souvenirs. (Right)

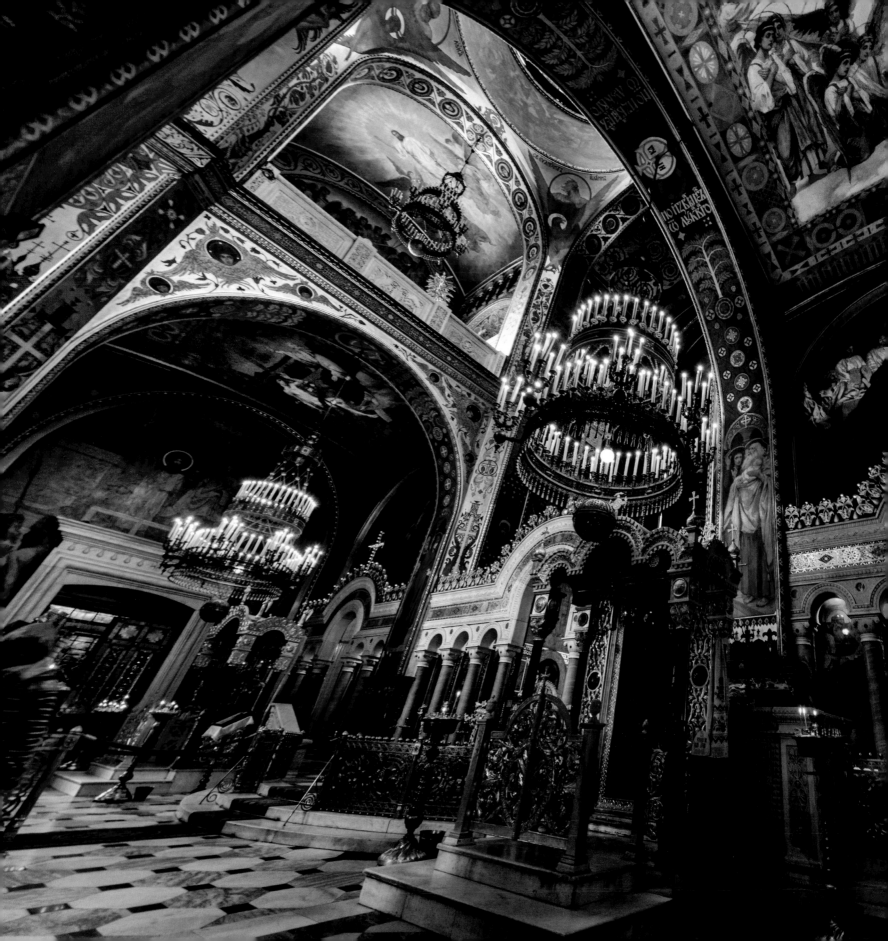

基輔洞穴修道院為東正教教堂，是當地重要的宗教場所。（右上）聖弗拉基米爾主教座堂則信奉烏克蘭正教。（右下）其內部裝飾精美華麗。（左）

The Kiev Monastery of the Caves of Eastern Orthodox is an important religious site in Kiev. (Upper Right) The St Volodymyr's Cathedral is a Ukrainian Orthodox church. (Lower Right) Its interior decoration is extremely exquisite and gorgeous. (Left)

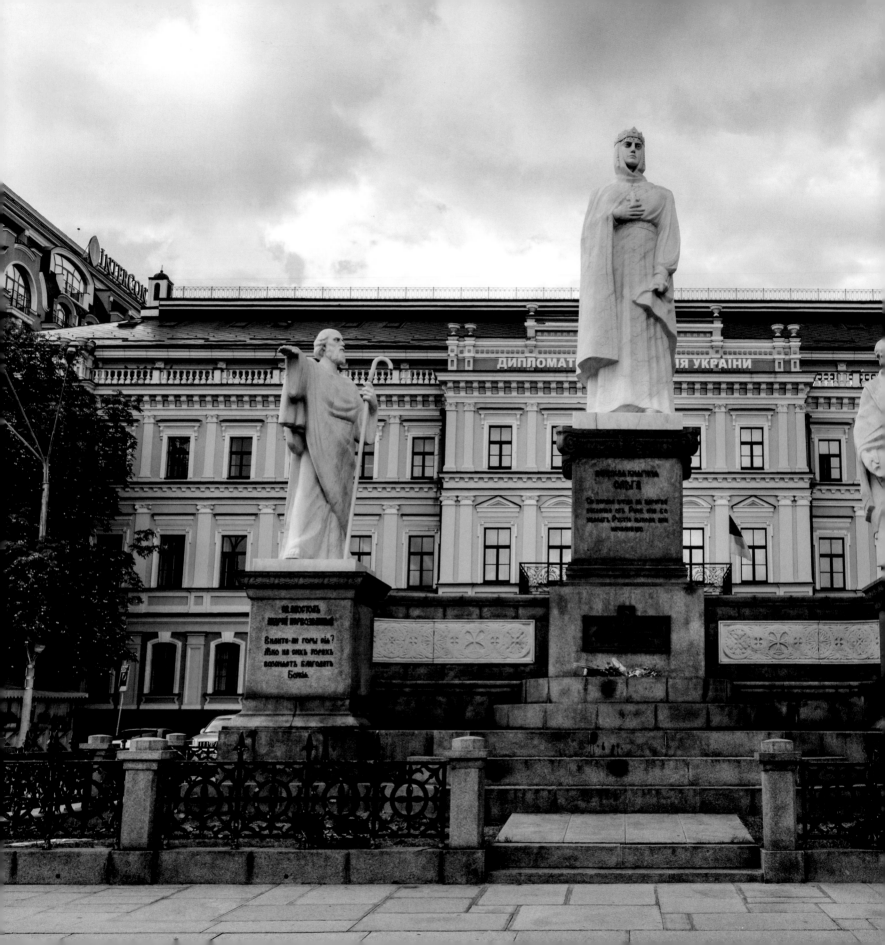

烏克蘭外交部及外交學院同處於聖米迦勒廣場之上，學院
前方矗立著古代基輔羅斯女政治家聖奧麗加的雕像。（左）
一位乞討者正坐在椅子上數著手中的錢。（右）

The Ministry of Foreign Affairs and the Diplomatic Academy
of Ukraine are both located at the St. Michael's square.
In front of the academy building, there is a statue of Saint
Olga, a female politician in ancient Kievan Rus'. (Left)
A beggar is counting her money on a chair. (Right)

烏克蘭國家歌劇院坐落於基輔市中心，
外觀典雅莊重。（右）歌劇院在國際上聲望
甚高。（左上）附近街頭的音樂表演聲中，
一個小女孩手舞足蹈。（左下）

The National Opera of Ukraine is at the center
of Kiev, with an elegance and grandiose
exterior. (Right) It has great international
reputation. (Upper Left) With the music of
street performance going near the opera,
a little girl is dancing with joy. (Lower Left)

黃金之門建於 11 世紀中葉，是基輔羅斯古城門。（右）這是現存不多、保留完好的雅羅斯拉夫大公時代的建築之一。（左）

Golden Gate was constructed in the mid-11th century as the gate to the city in ancient Kievan Rus'. (Right) This is one of few remaining intact constructions since the era of Yaroslav the Wise. (Left)

基輔衛國戰爭紀念館，館外高達62米的「祖國-母親」雕像左右手分別高舉盾與劍，是市內最知名的地標之一。

The National Museum of the History of Ukraine in the Second World War is one of the best known landmarks in Kiev, with a 62-meter tall monumental sculpture of the "Motherland" holding a shield and a sword in her left and right hand respectively.

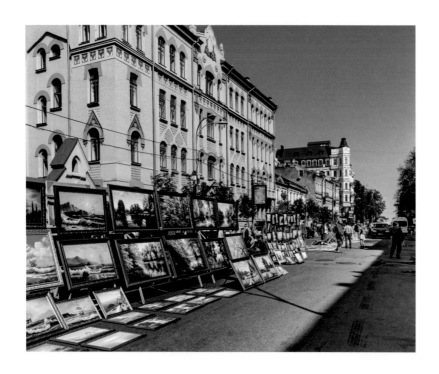

在烏克蘭的首都及最大城市，歷史、宗教建築與現代房屋在城中交錯融合，形成了獨特的城市景象。（左）安德烈斜坡是基輔一條文化街，被稱為「基輔的蒙馬特」。（右）

Apart from being the capital of Ukraine, Kiev is also the largest city in the country. The integrated styles of historical, religious and modern buildings have formed a unique city view. (Left) The Andrew's slope is a cultural street in Kiev, which is called the "Montmartre of Kiev". (Right)

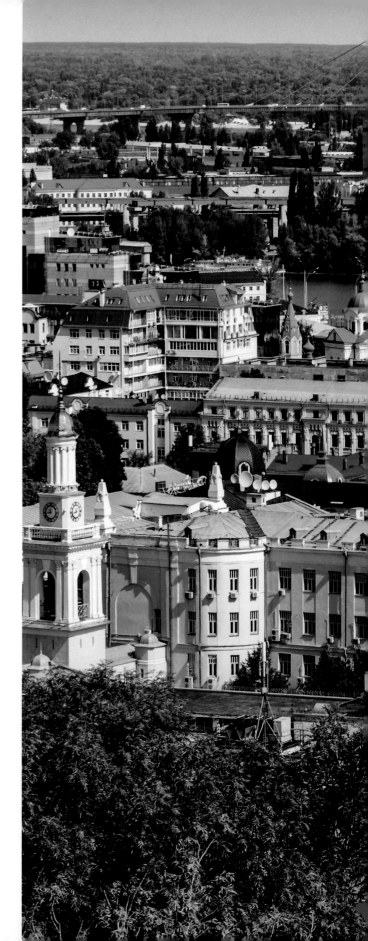

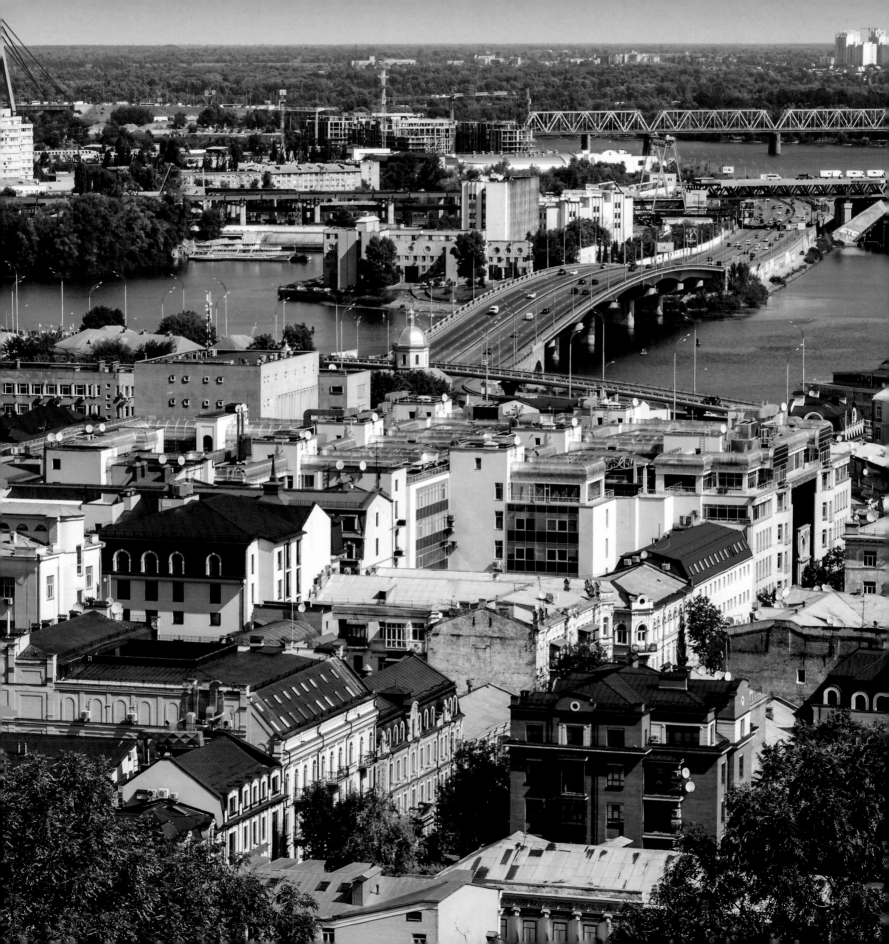

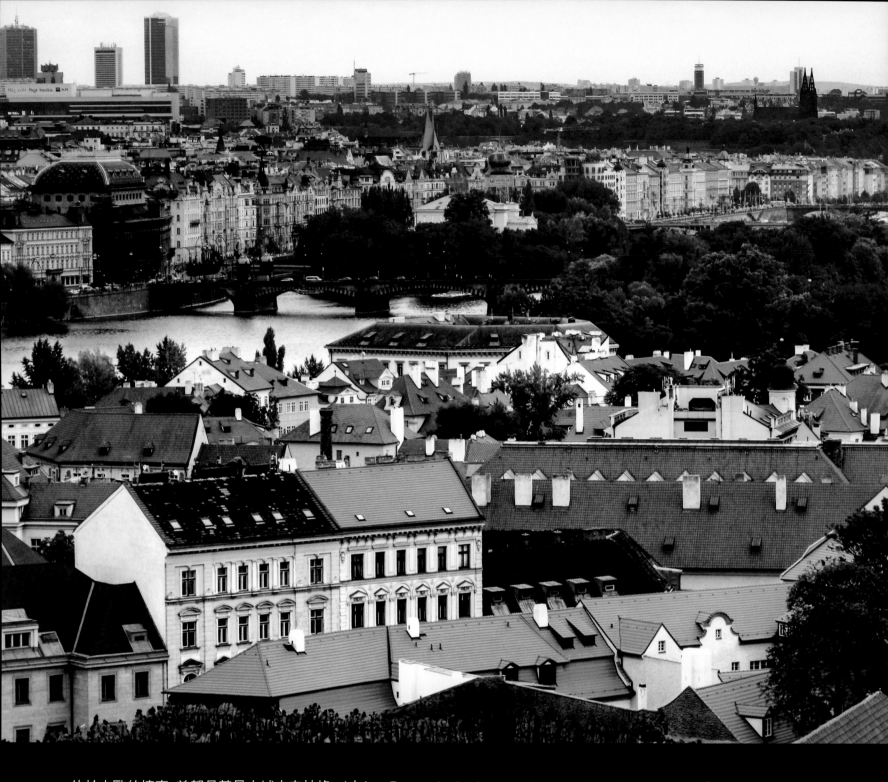

位於中歐的捷克 ,首都是其最大城市布拉格。(左)圖片拍攝於武器博物館。(右上)一個博物館內展示了古代歐洲的家居風格。(右下)

Prague is the largest city as well as the capital of Czech Republic, a country in Central Europe. (Left) The image is taken in a weapon museum. (Upper Right) This is a museum showing the home furnishing style in ancient Europe. (Lower Right)

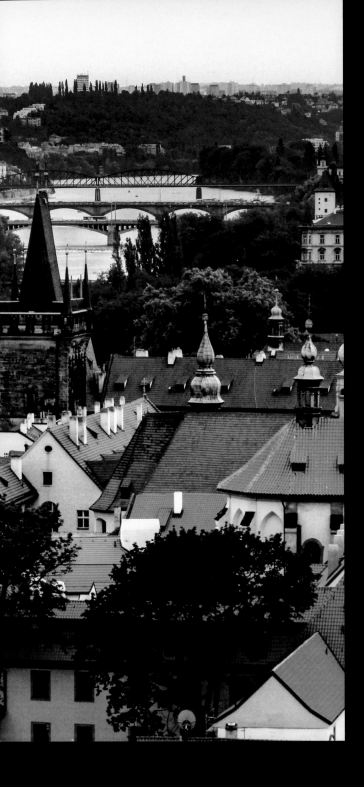
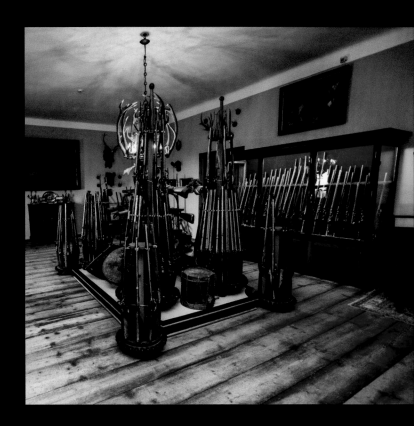

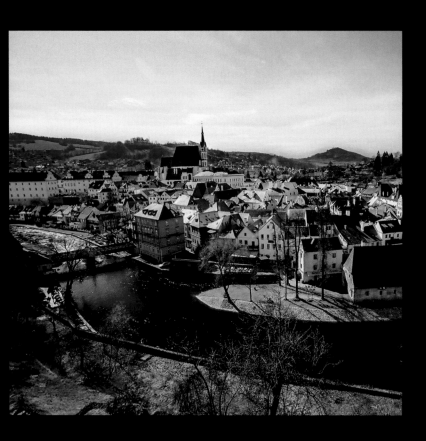

古姆洛夫是捷克重要的文化中心之一，其老城中心基本上保持
了中世紀的風貌。（左）古姆洛夫城堡是國內規模僅次於布拉格
城堡的古堡。（右）

Český Krumlov is a cultural center of Czech. The style of the
Middle Ages is well preserved in its old town. (Left) The Krumlov
Castle in the city is the second largest of its kind in the country,
following the Prague Castle. (Right)

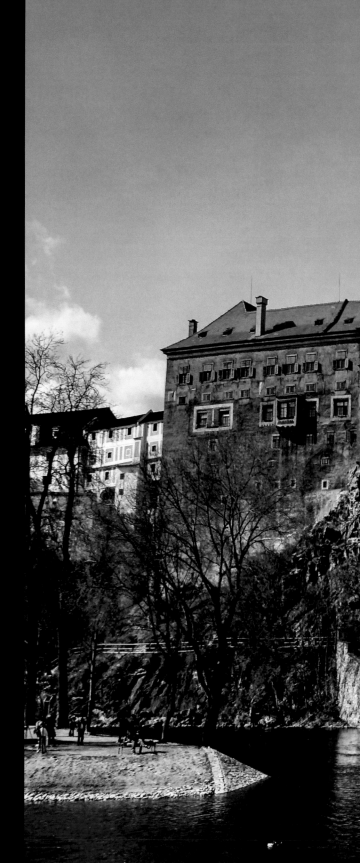

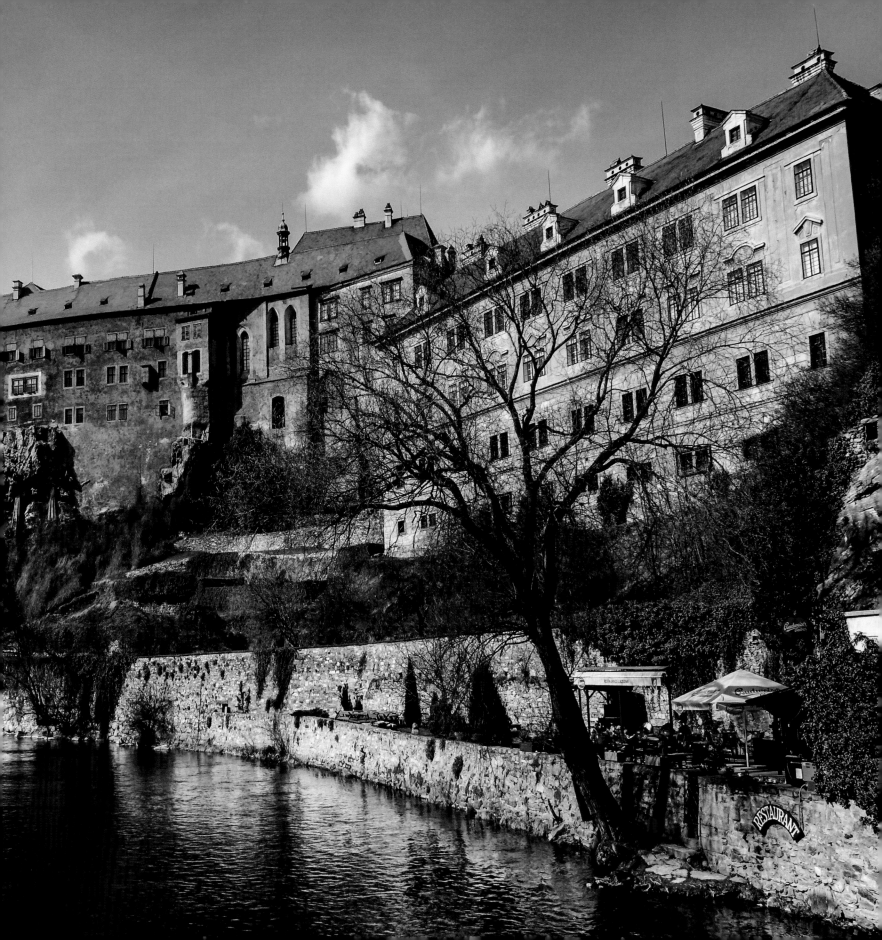

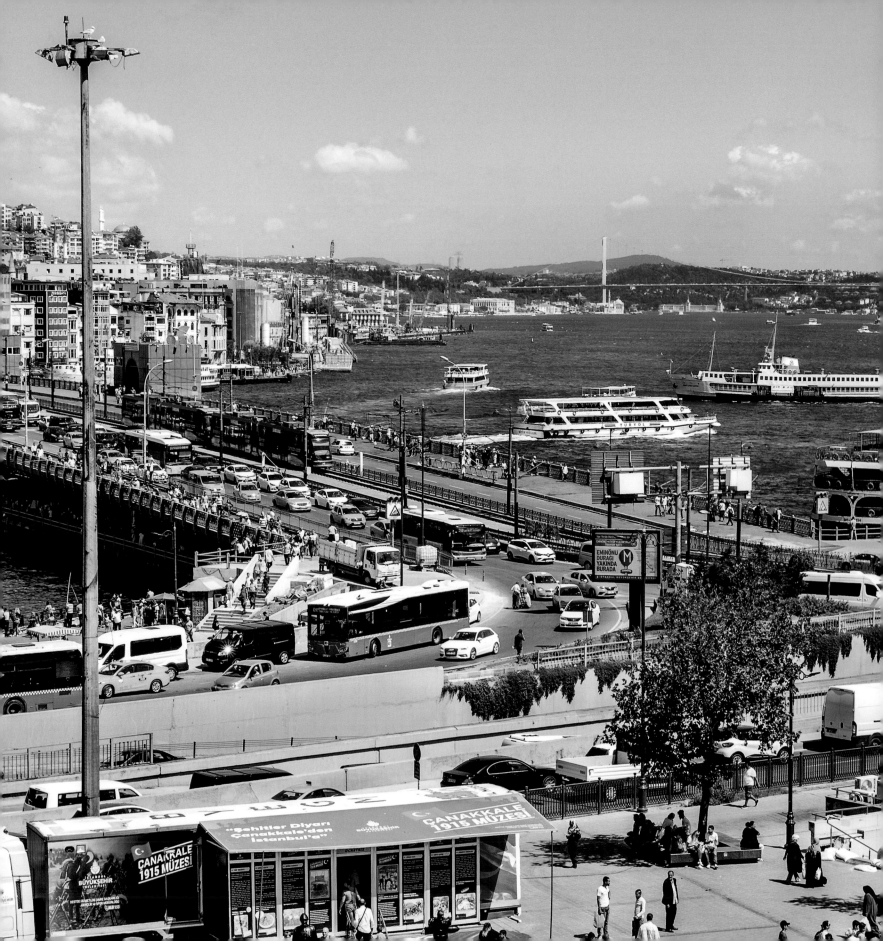

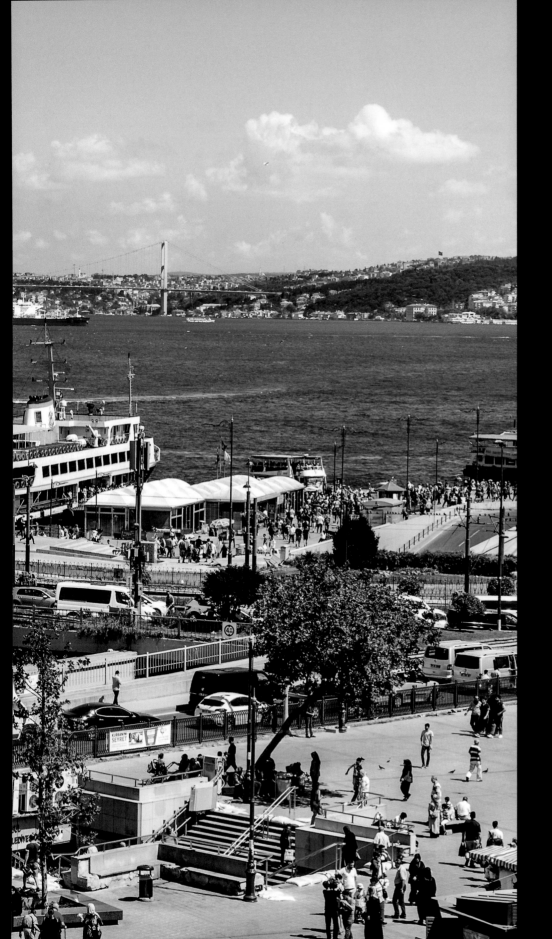

土耳其是一個橫跨歐亞兩洲的國家，最[大]
城市為伊斯坦堡，但首都卻是安卡拉。

伊斯坦堡，舊稱君士坦丁堡，它曾是羅[馬]
帝國、拜占庭帝國、拉丁帝國和鄂圖曼帝[國]
的首都。在歷史上，古代絲綢之路其中一[條]
分支路線的終點，就是君士坦丁堡，當時[由]
中國出口的絲綢、茶葉及瓷器等，成為鄂[圖]
曼帝國皇宮的珍品。

現代的伊斯坦堡城市景象繽紛多彩——清[澈]
藍天襯托著碧海，山林草木滿是綠意，建[築]
物及車輛以各種溫暖的顏色點綴出城市[的]
活力。

Turkey is a transcontinental countr[y in]
Eurasia. Whereas its largest city is Istan[bul,]
Turkey sets its capital in Ankara. Ista[nbul]
was known as Constantinople historic[ally,]
which was the capital city of the Rom[an,]
Byzantine, Latin and Ottoman empi[res.]
In history, Constantinople was also [the]
destination of one of the branch route[s of]
the ancient Silk Road. The Chinese-ex[ported]
silk, tea and china were favored treasu[res]
for the Ottoman royalty.Today, the c[ity]
view of Istanbul is colorful – with clear [sky]
mirroring the blue ocean, with trees [and]
forests dressing the vigorous green, [and]
with buildings and cars decorating the [city]
by assorted warm colors.

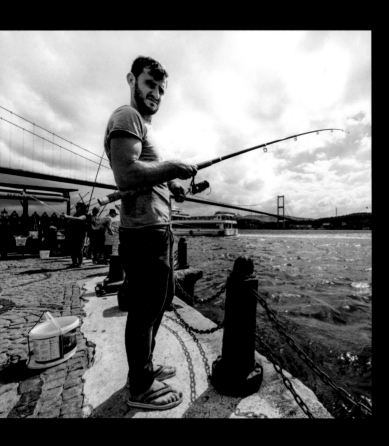

歐爾塔寇清真寺，座落於博斯普魯斯大橋橋頭。（右）
大橋之下，不少釣客聚集於此。（左）

Ortaköy Mosque is located at the bridgehead of the
Bosphorus Bridge. (Right) Under the bridge, many fishermen
gather and angle for fish. (Left)

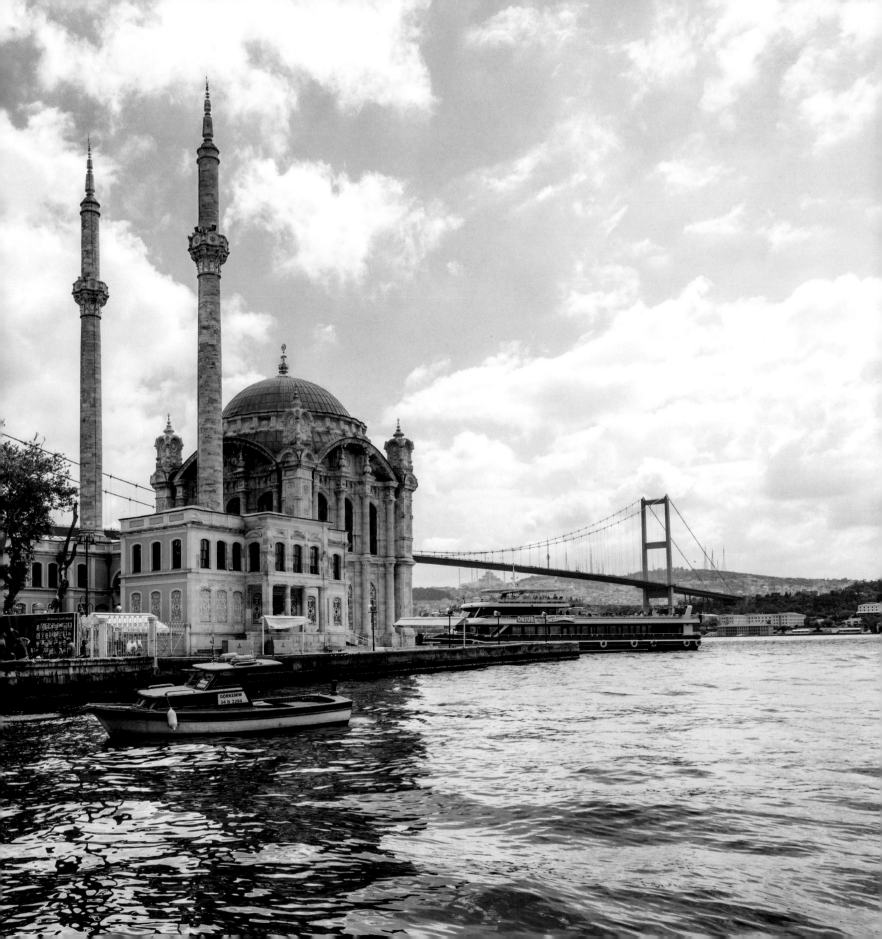

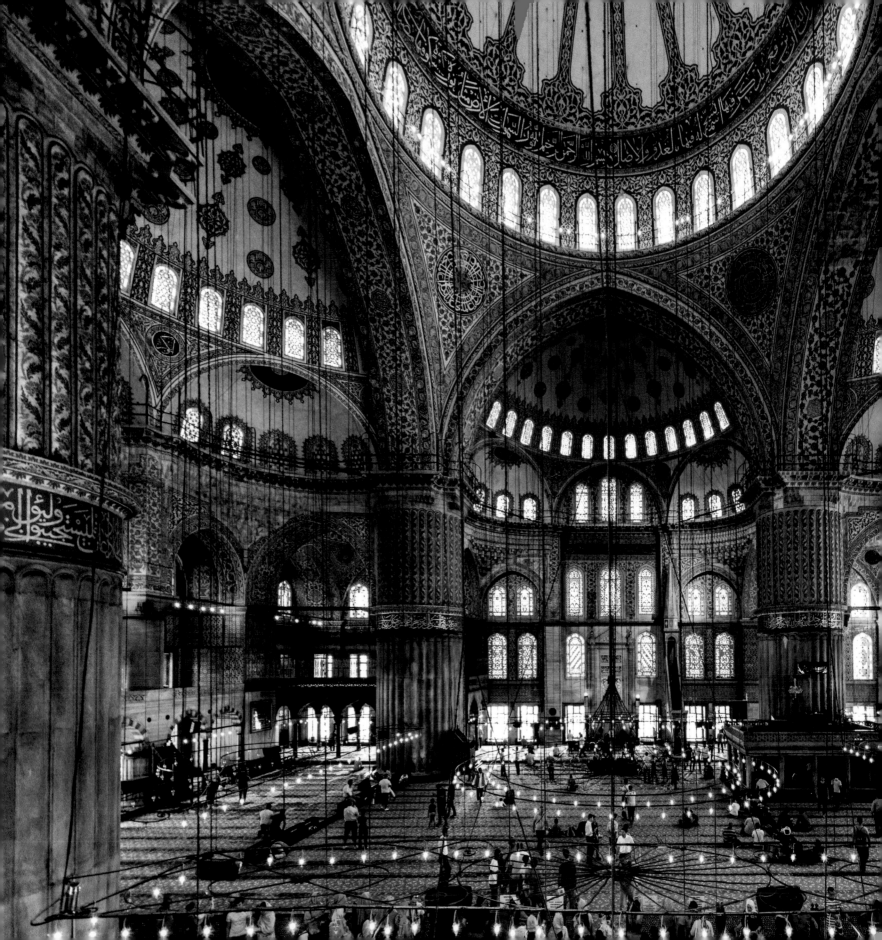

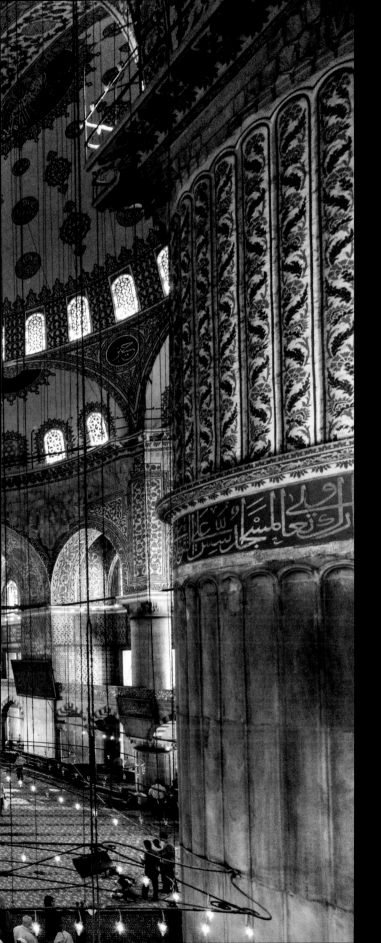

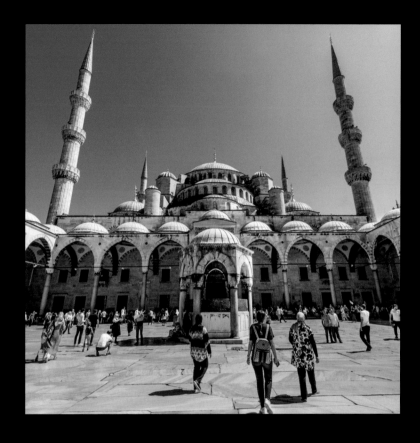

蘇丹艾哈邁德清真寺擁有六座高聳的拜塔。（右）因其內部的藍色磚塊，它又被稱為藍色清真寺或藍廟。（左）

The Sultan Ahmed Mosque has six towering minarets. (Right) It is popularly known as the Blue Mosque for its interior blue tiles. (Left)

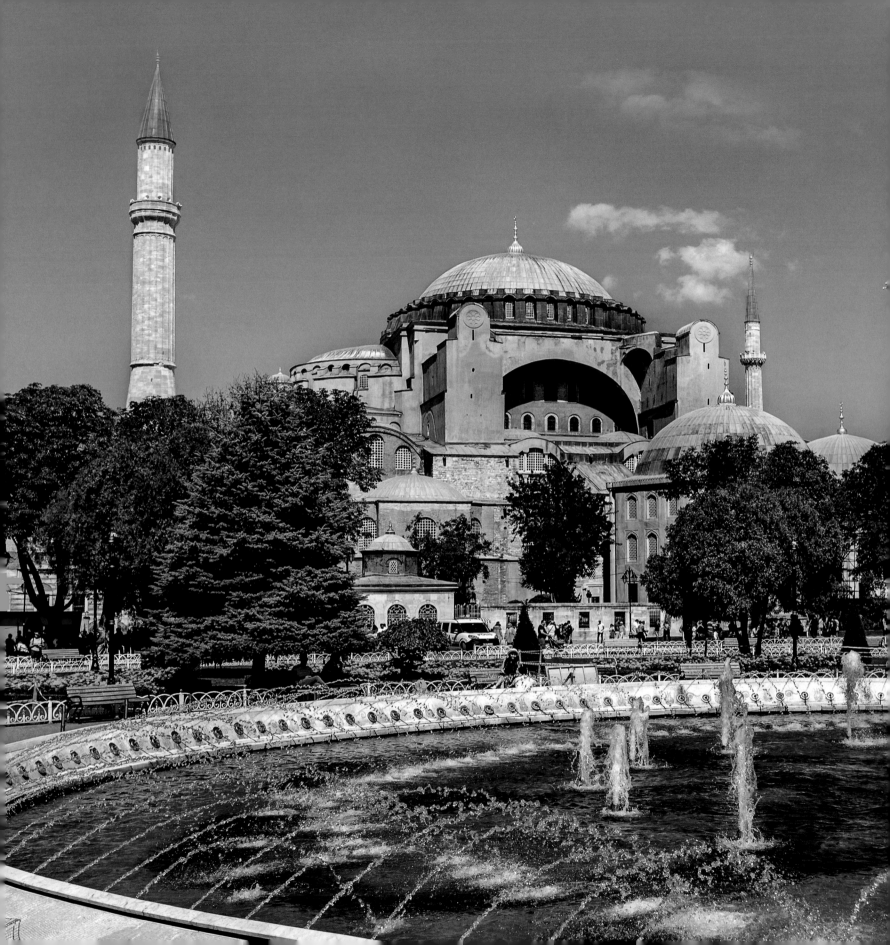

聖蘇菲亞大教堂是伊斯坦堡一座美麗優雅的拜占庭式宗教
建築，在宗教歷史及建築美學方面，都十分重要。現作博物館
使用。（左）教堂內有一隻可愛的小貓。（右）

The Hagia Sophia in Istanbul is a beautiful and elegant religious
building of Byzantine style, which is important both religiously
and architecturally. It is now used as a museum. (Left) There is
a cute kitten inside Hagia Sophia. (Right)

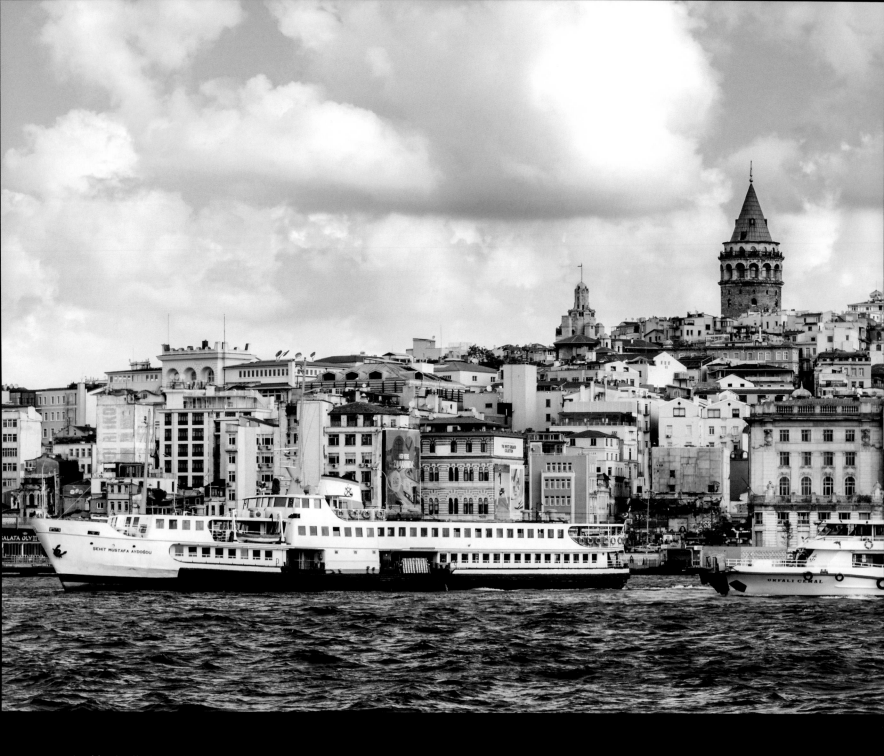

加拉達塔為伊斯坦堡觀景的絕佳位置，
可把金角灣、博斯普魯斯海峽盡收眼底。（左）
遠處的寺廟、宮殿也清晰可見。（右）

The Galata Tower commands a perfect view
of Istanbul. From there you can admire the
magnificent sight of the Golden Horn and the

加拉達塔坐落於伊斯坦堡的加拉達區，是鬧市內十分矚目的標誌性建築。（右）附近的咖啡廳內，不少遊客正愜意地享受著悠閒的時光。（左）

Located at the Galata quarter of Istanbul, the Galata Tower is an eye-catching landmark in the busy downtown area. (Right) In a nearby café, tourists are enjoying the carefree moments. (Left

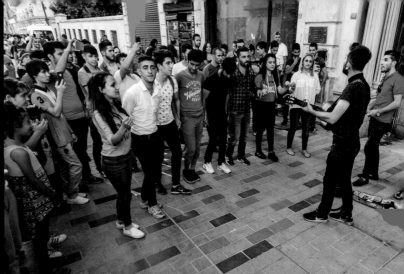

土耳其處於亞歐交界處，歷史悠久，吸引了來自世界各地的遊客。（左）當地人對所有外國遊客都十分熱情。（右上）土耳其烤肉在世界各地都可以品嘗到。（右下）

Located at the boundary of Europe and Asia, Turkey, a country with long history, has attracted numerous tourists from all over the world. (Left) Turkish people are extremely hospitable to all foreign tourists. (Upper Right) Doner kebap can be found in almost everywhere in the world. (Lower Right)

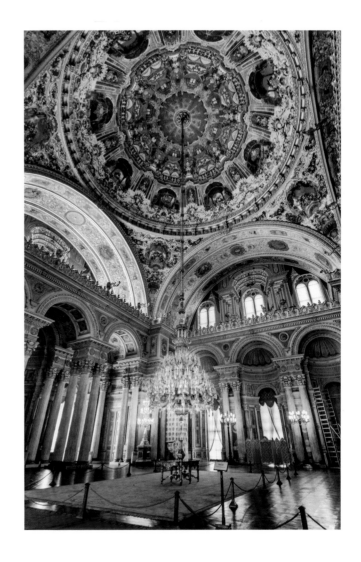

多瑪巴切皇宮是一座巴洛克式宮殿，位於博斯普魯斯海峽的海岸邊，曾是鄂圖曼帝國的主要行政中心。（左）殿內懸掛著一度是世界上最大的水晶燈，重 4.5 噸，華麗至極。（右）

The Dolmabahçe Palace is a baroque palace on the coast of the Bosphorus. It was once the main administrative center of the Ottoman Empire. (Left) Inside the palace is a magnificent 4.5-ton chandelier, which was once the biggest in the world. (Right)

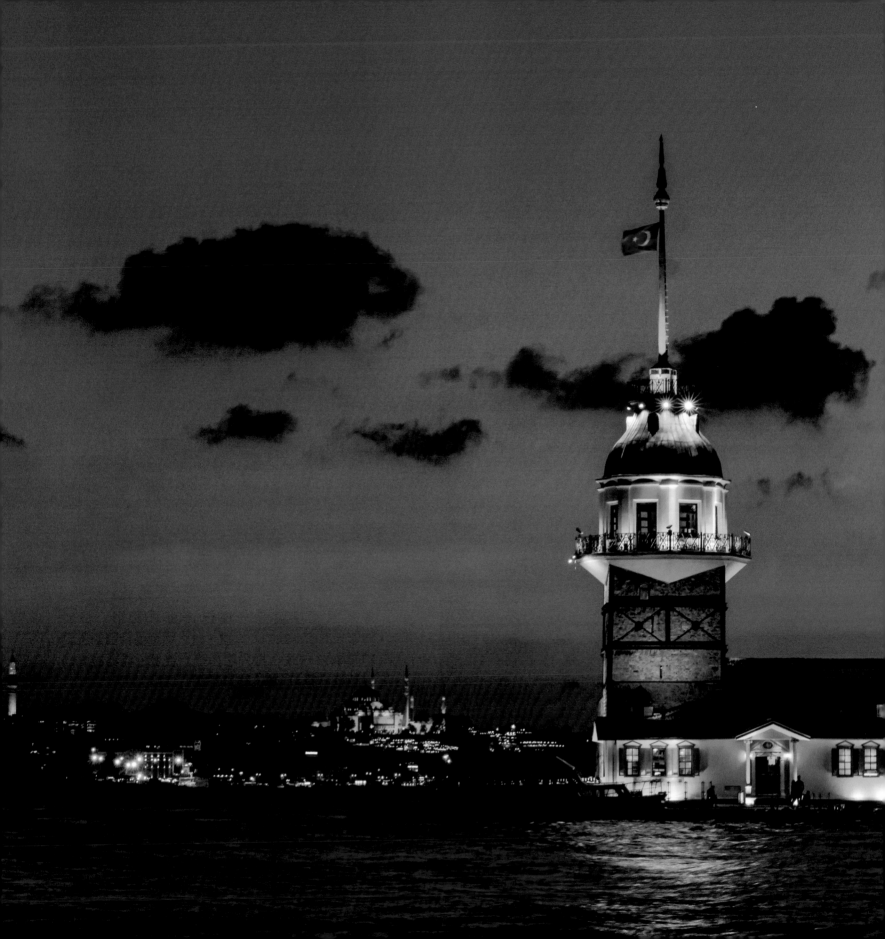

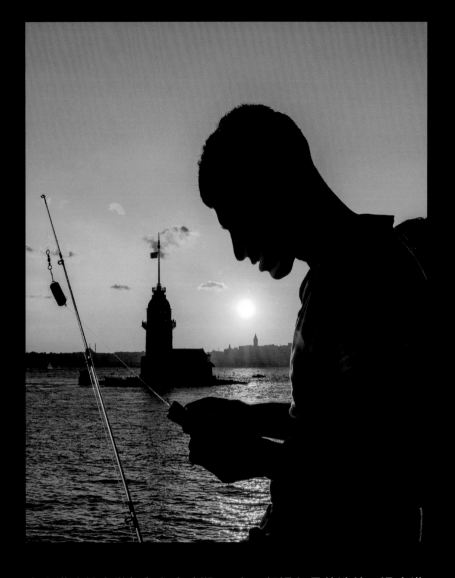

少女塔建於中世紀拜占庭時期。（左）經過年月的洗練，這座塔成為了伊斯坦堡與伊斯坦堡海峽的標誌。（右）

The Maiden's Tower was constructed in the medieval Byzantine period. (Left) It has become a symbol of Istanbul as well as the Bosphorus strait. (Right)

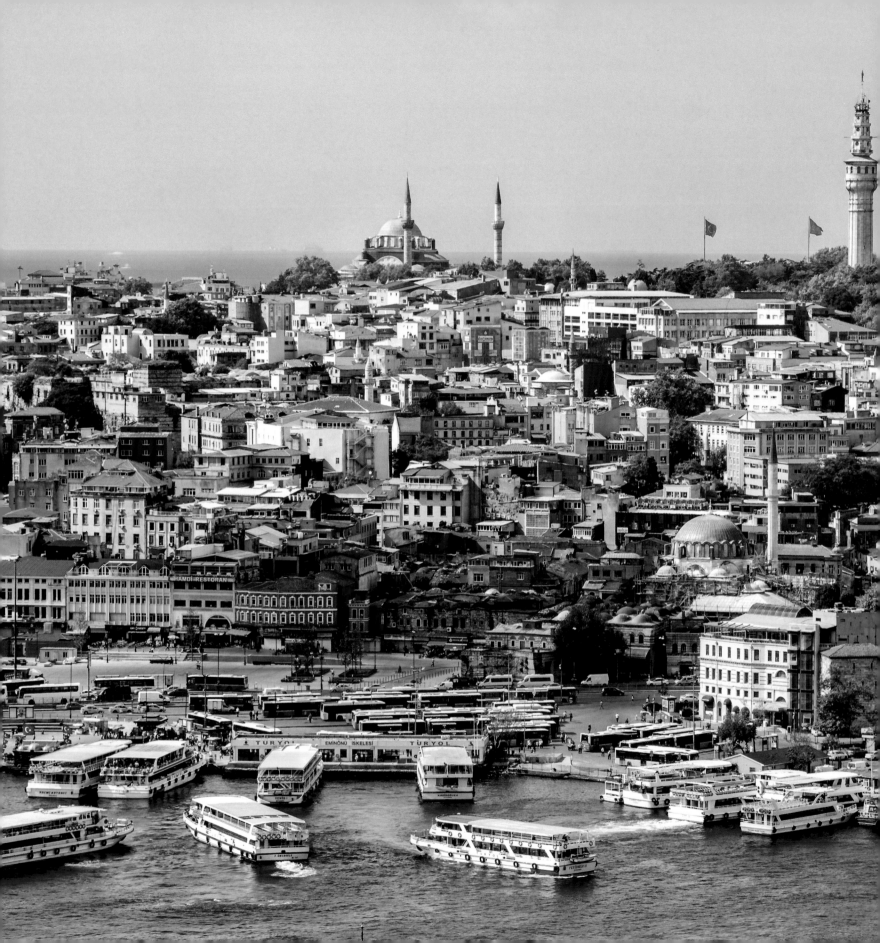

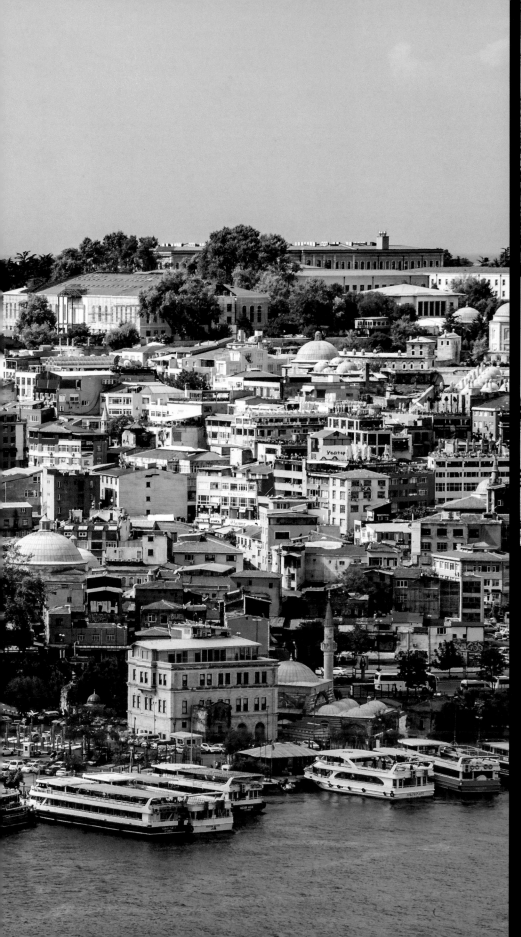

土耳其旅遊資源豐富，處處人潮熙來攘往。（右上）乘搭渡輪，可欣賞金角灣及博斯普魯斯海峽的景色。（右下）圓形的穹頂、高聳的塔尖、彩色的屋頂、湛藍的海水，都為伊斯坦堡增添了一分美感。（左）

Turkey is abundant in tourism resources, so huge crowds of people can be seen everywhere. (Upper Right) Visitors can take a ferryboat to enjoy the sceneries at the Golden Horn and the Bosphorus. (Lower Right) The round dome, the ascending tower, the colorful rooftops and the azure ocean, have all contributed to the glamour of Istanbul. (Left)

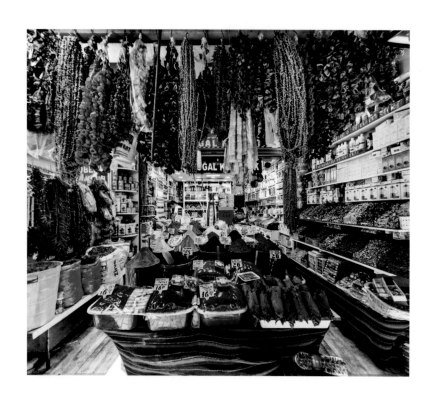

埃及市集是土耳其其中一個歷史最為悠久的市集，亦是在伊斯坦堡市內第二大的市集。（右）因有大量商店售賣香料，故亦有「香料市集」之稱。（左）

The Egyptian Bazaar is one of the oldest shopping complexes in Turkey, and is also the second largest bazaar in Istanbul. (Right) It is also named the "Spice Bazaar" for its large quantity of spice stores. (Left)

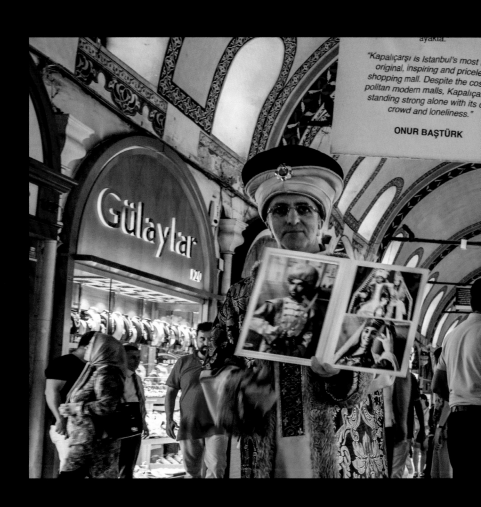

伊斯坦堡的「大巴扎」曾號稱是世界最大的室內市集。（左）其內有 61 條室內街道及超過 4,000 間商舖。（右）

The Grand Bazaar in Istanbul was once regarded as the largest covered bazaar in the world. (Left) There are 61 indoor streets and more than 4,000 shops. (Right)

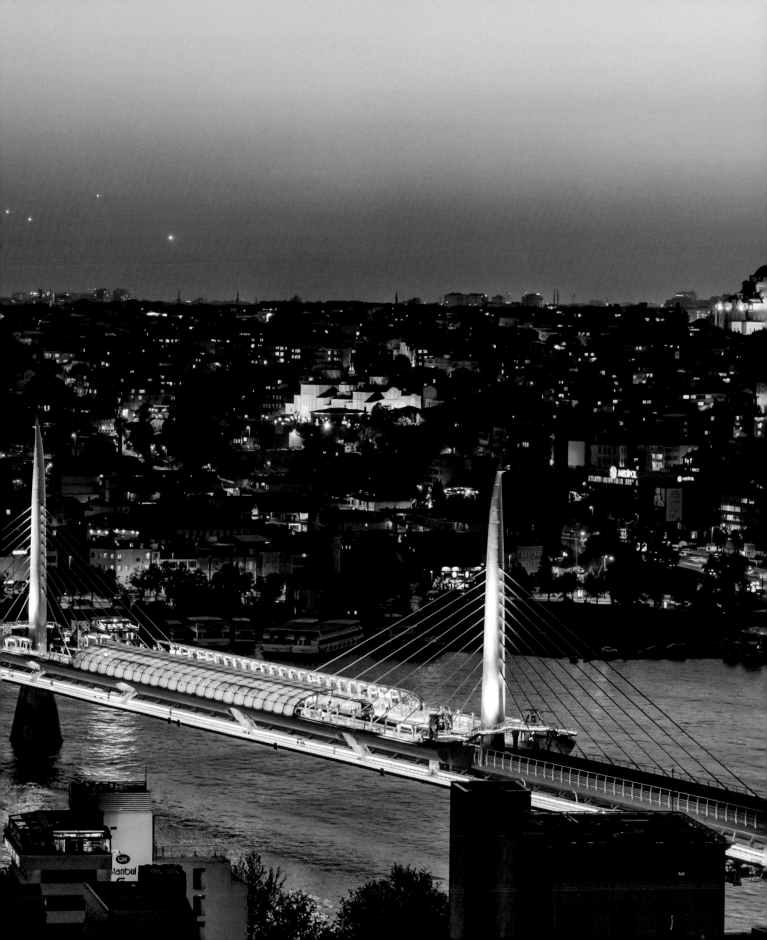

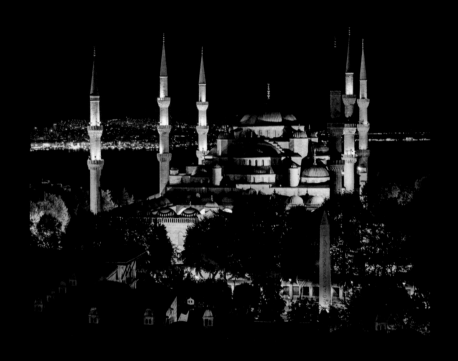

入夜之後，伊斯坦堡的城市景象，隨著不同時分的天色變化，散發著不同的迷人光彩。（左）圖為夜間的藍色清真寺。（右）

The appearance of Istanbul is charming in different ways as the color of the sky shades gradually in the evening. (Left) Picture shows the Blue Mosque at night. (Right)

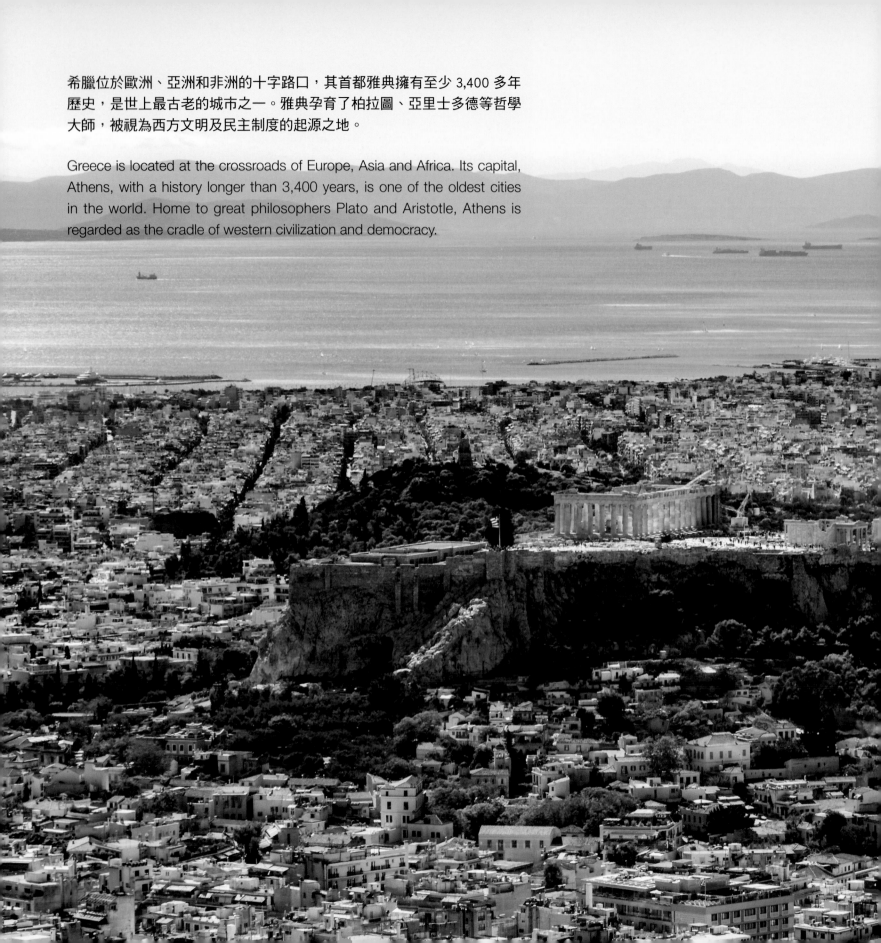

希臘位於歐洲、亞洲和非洲的十字路口，其首都雅典擁有至少 3,400 多年歷史，是世上最古老的城市之一。雅典孕育了柏拉圖、亞里士多德等哲學大師，被視為西方文明及民主制度的起源之地。

Greece is located at the crossroads of Europe, Asia and Africa. Its capital, Athens, with a history longer than 3,400 years, is one of the oldest cities in the world. Home to great philosophers Plato and Aristotle, Athens is regarded as the cradle of western civilization and democracy.

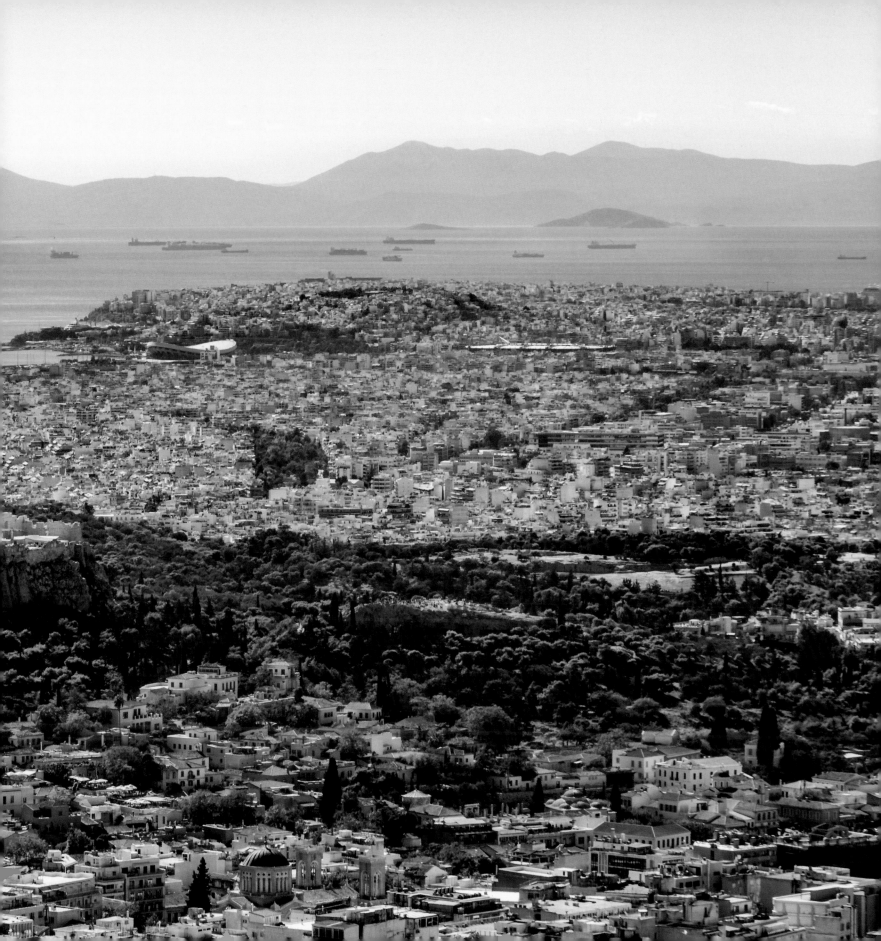

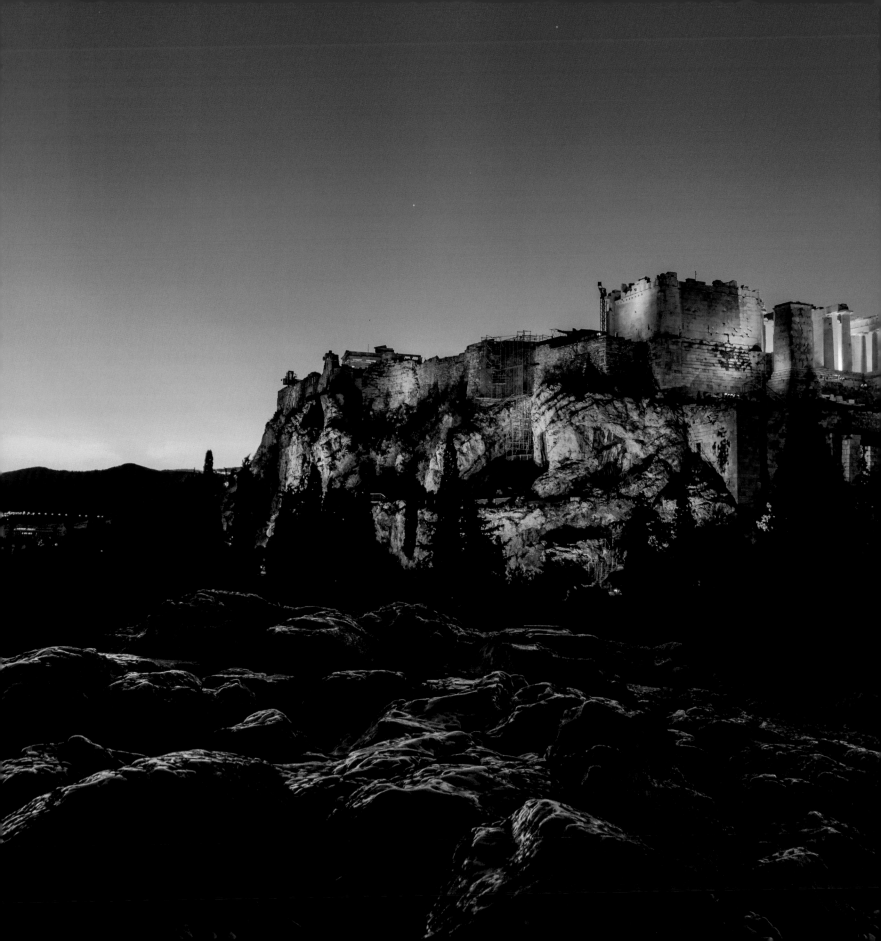

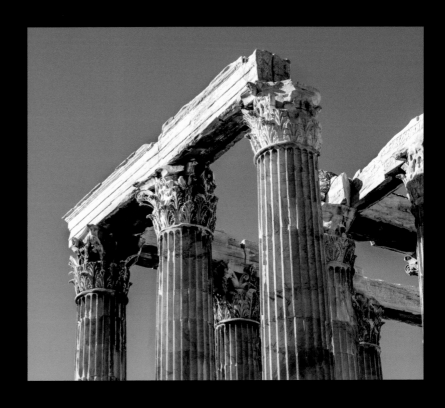

遊覽希臘必然要到雅典衛城。（左）其上有著舉世馳名的巴特農神殿，建築比例十分接近數學上的「黃金分割數」1.618，盡顯自然和諧之美。（右）

Acropolis of Athens is a "must-visit" site in Greece. (Left) The Parthenon on it is globally famous for its beauty of nature and harmony, which is embodied by adopting a proportion close to the golden ratio of 1.618 in mathematics. (Right)

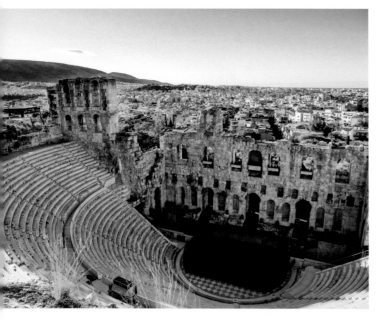

在巴特農神殿一旁，伊瑞克特奧神殿雖然規模較小，其南面有六尊少女雕像的女像柱門廊，充滿藝術的魅力。（右）狄俄尼索斯劇場又稱「酒神劇場」，可容納多達 17,000 名觀眾。（左）

Right next to the Parthenon, Erechtheum appears to be much smaller, but the Porch of the Caryatids containing draped female figures has also attracted many tourists. (Right) The Theatre of Dionysus, also known as "the theatre of the god of wine", can seat as many as 17,000 people. (Left)

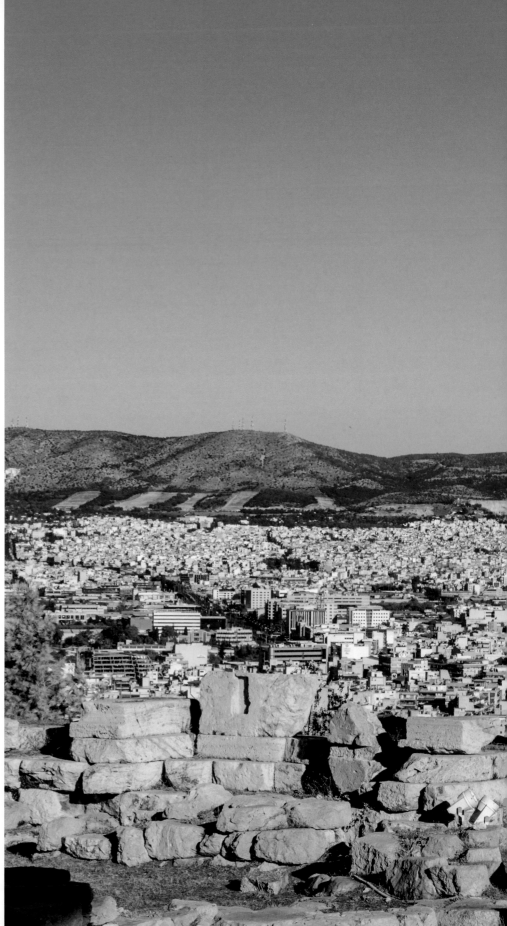

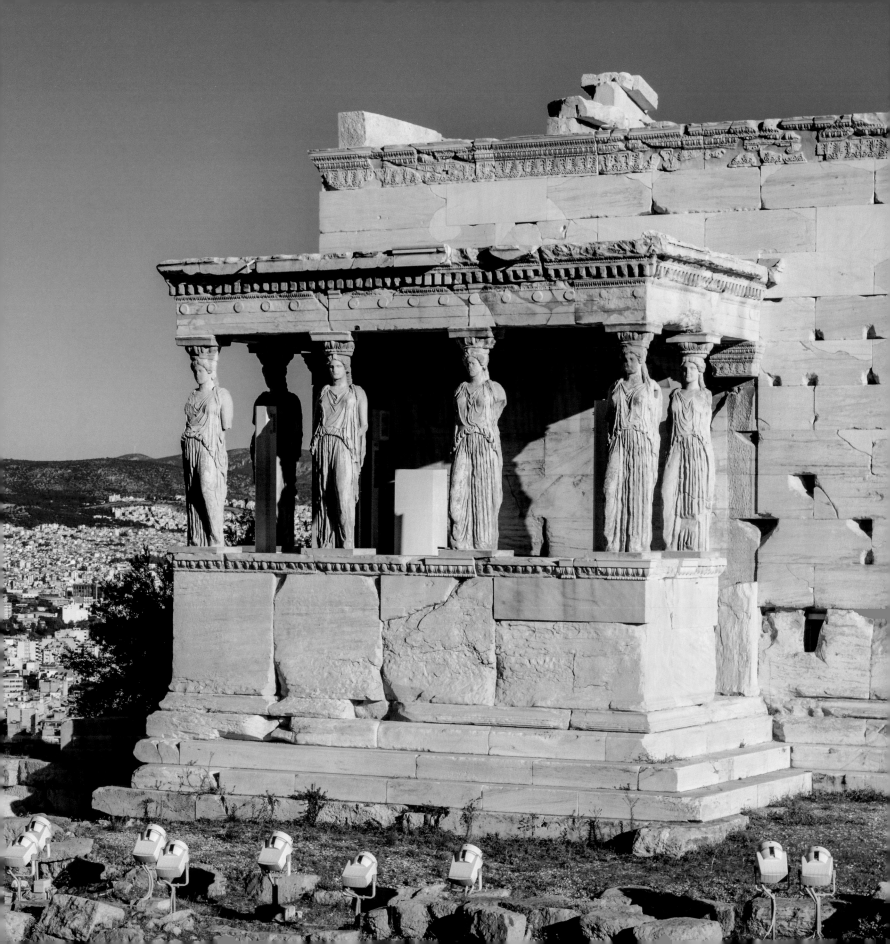

除了歷史悠久的文化遺產，雅典作為歐洲的商業中心之一，亦有現代化的一面。（右上）普拉卡是城中一個歷史悠久的區域，無論是本地人或是遊客，都鍾情到此購物、散步，享受休閒放鬆的時刻。（右下）奧林匹亞科斯足球俱樂部是國內頂級的體育俱樂部。（左）

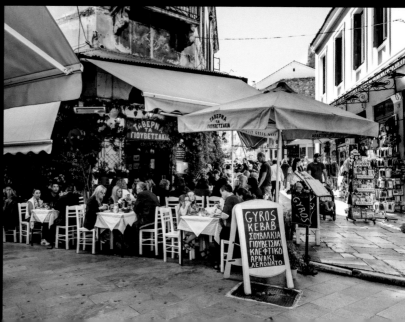

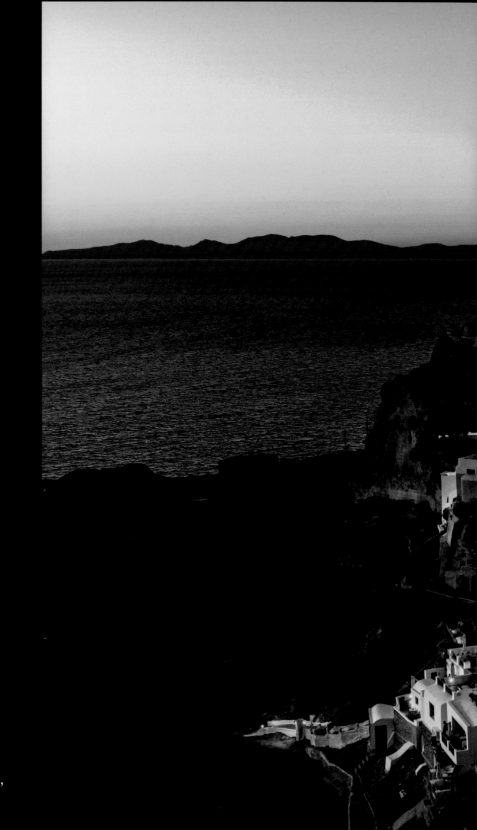

伊亞建於臨海的火山斷崖之上，此處的「日落愛琴海」，
是其標誌性的畫面。

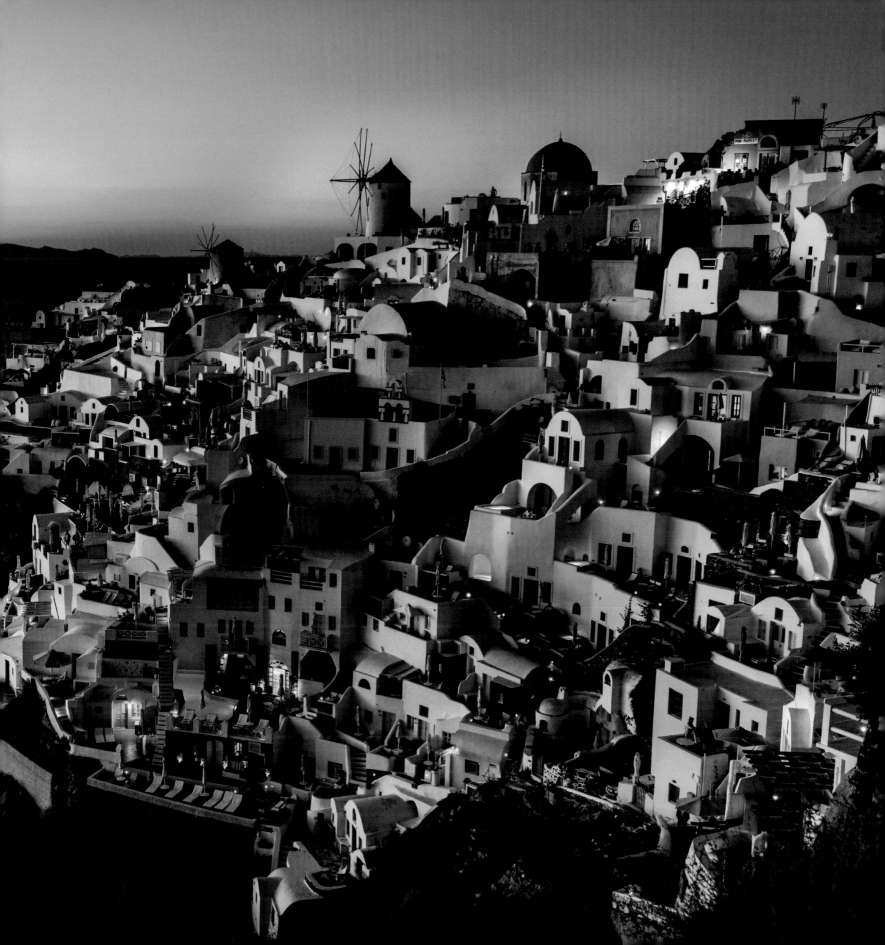

聖多里尼是希臘的熱門旅遊地。（左）經常出現在名信片上的藍色圓頂及雪白牆身的建築，在此隨處可見，與蔚藍的海水相映成趣。（右）

Santorini is a popular tourist destination in Greece. (Left) The image of blue dome and snow-white walls frequently appears on postcards. The scene can be seen everywhere here, forming a delightful contrast with the sea. (Right)

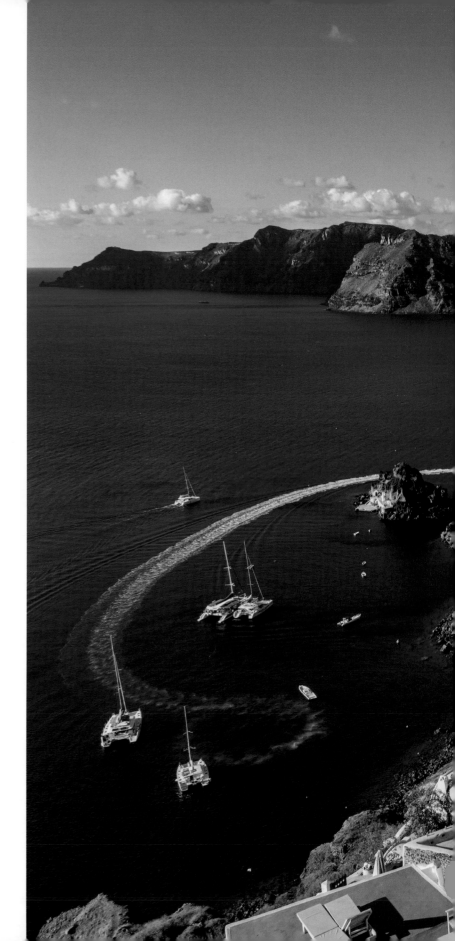

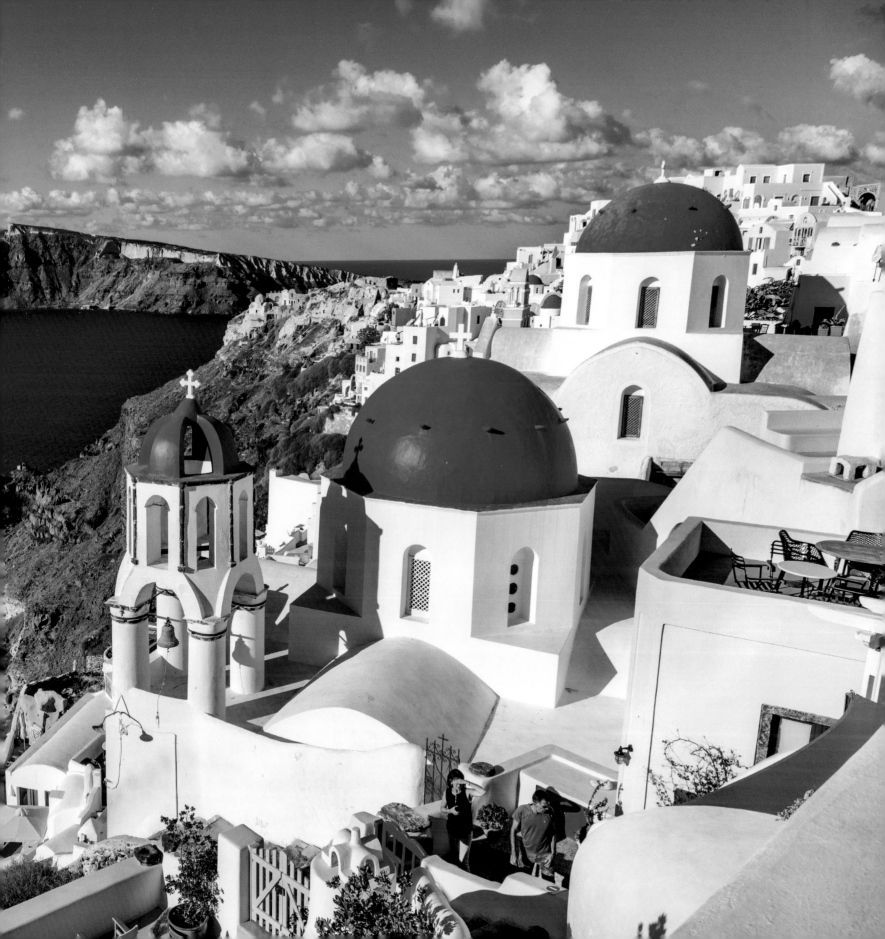

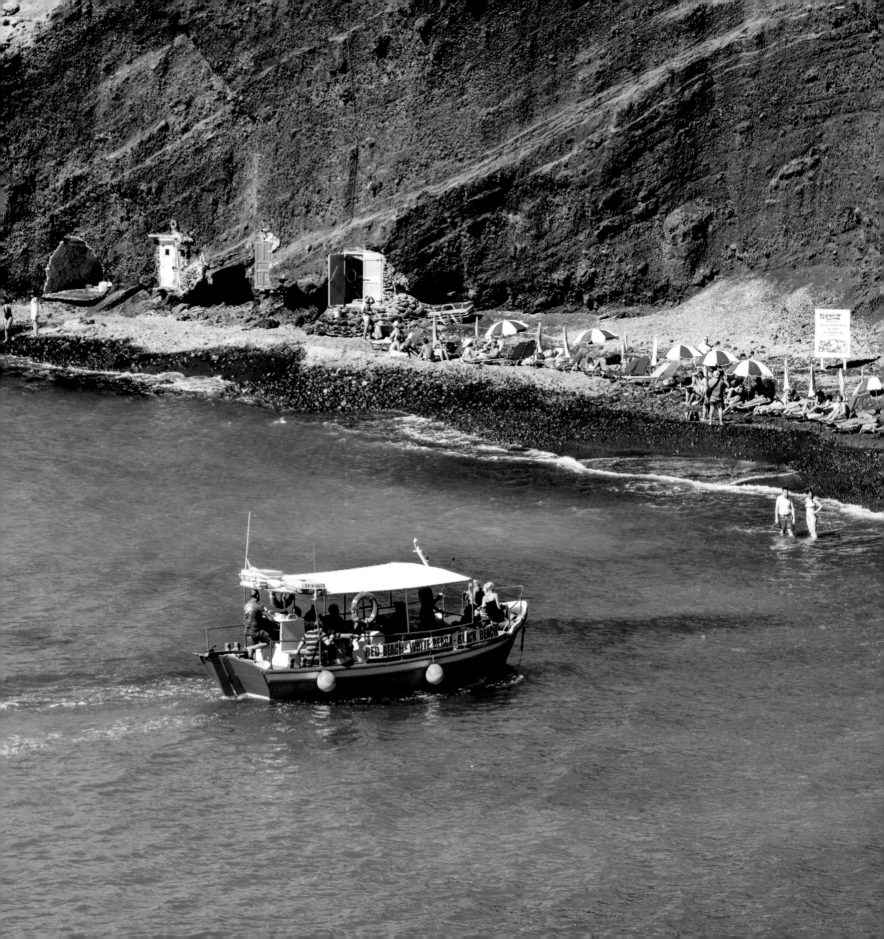

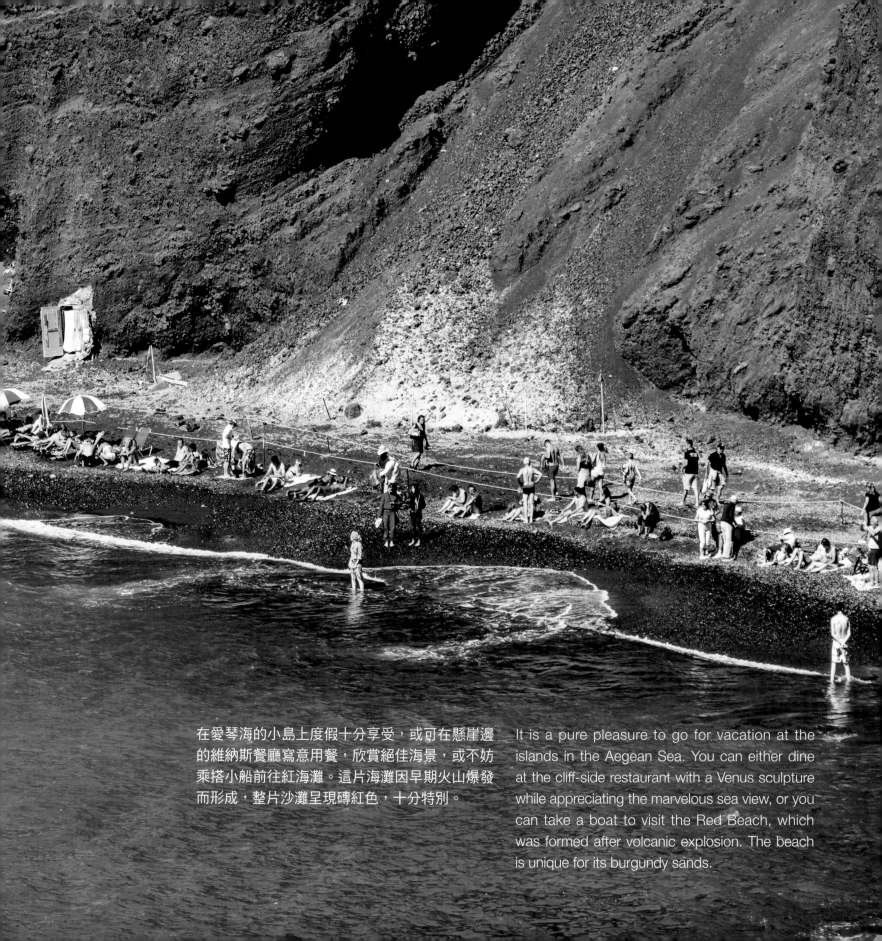

在愛琴海的小島上度假十分享受，或可在懸崖邊的維納斯餐廳寫意用餐，欣賞絕佳海景，或不妨乘搭小船前往紅海灘。這片海灘因早期火山爆發而形成，整片沙灘呈現磚紅色，十分特別。

It is a pure pleasure to go for vacation at the islands in the Aegean Sea. You can either dine at the cliff-side restaurant with a Venus sculpture while appreciating the marvelous sea view, or you can take a boat to visit the Red Beach, which was formed after volcanic explosion. The beach is unique for its burgundy sands.

# 西歐

西歐位於亞歐大陸的西部，由於氣候溫和、自然環境宜人，人口密度十分大。西歐孕育了燦爛輝煌的人文藝術作品，直到今天，羅馬、維也納、巴黎等著名城市，仍是世界上首屈一指的藝術之都。對商貿經濟發展的重視，加上縱橫分佈的水道，使西歐的對外貿易發展有了天然的有利條件。西歐更是兩次工業革命的發源之地。

公元 1 世紀，處於歐亞大陸兩端的漢朝以及羅馬帝國，憑藉陸上及海上的絲綢之路，使得中國古代的絲綢製品以及羅馬的玻璃器皿，能夠越過高山或重洋，抵達大陸的另一端。彼時，世界上最為強大的兩大帝國，越過重重阻隔交易著商品，交流著文化和科技，同時也惠及沿線諸多國家。

西歐是陸上及海上絲綢之路的最終目的地，與「一帶一路」戰略可謂密不可分。作為與「一帶一路」緊密相關的機構，「亞洲基礎設施投資銀行」（亞投行）吸引了眾多西歐國家的積極參與，可見西歐國家對中國市場及「一帶一路」機遇的高度重視。目前，往來於中國與歐洲的中歐班列，跨越萬里運送大宗貨物，班次正在逐步加密，被稱為「一帶一路」的「新引擎」。相信在未來，正在成形中的「中—歐亞腹地—西歐」經濟帶，將會成為世界經濟的新核心。

意大利                                         西班牙

# Western Europe

The Western Europe is a naturally blessed part in Europe with large population. It is the cradle for numerous masterpieces of humanity and arts – up to this date, Rome, Vienna, Paris, and other famous cities are still ranked top on the world's capital of arts list. The Western Europe attaches great importance to the development of commercial economy. With crisscrossing waterways, it had the advantages to develop foreign trade. It is also the birthplace of the two industrial revolutions.

In the 1st century AD, the Han Dynasty and the Roman Empire at both ends of the Eurasia managed to trade goods. Through the ancient Silk Road and Maritime Silk Road, Chinese silk products and Roman glass products made their ways to reach the other side of the continental landmass, across mountains and oceans. At that time, the world's two most powerful empires exchanged goods as well as culture and technologies; what's more, they spreaded out these valuable things to the countries along the way.

As the final destination of both land-route and maritime silk roads, Western Europe is an indispensable part of the belt and road. Many countries in this area actively joined the Asian Infrastructure Investment Bank (AIIB), which is closely related to the belt and road initiative, showing their interests to the Chinese market and the potential opportunities brought by the initiative. At the moment, known as "new engine" of the belt and road, the China-Europe Railway Express is travelling between China and Europe to transport mass freight, crossing more than ten thousand kilometers. The train frequency is gradually increasing, too. It is expected that in the future, the China-central Eurasia-Western Europe economic belt will take form, and become the new core for international economic growth.

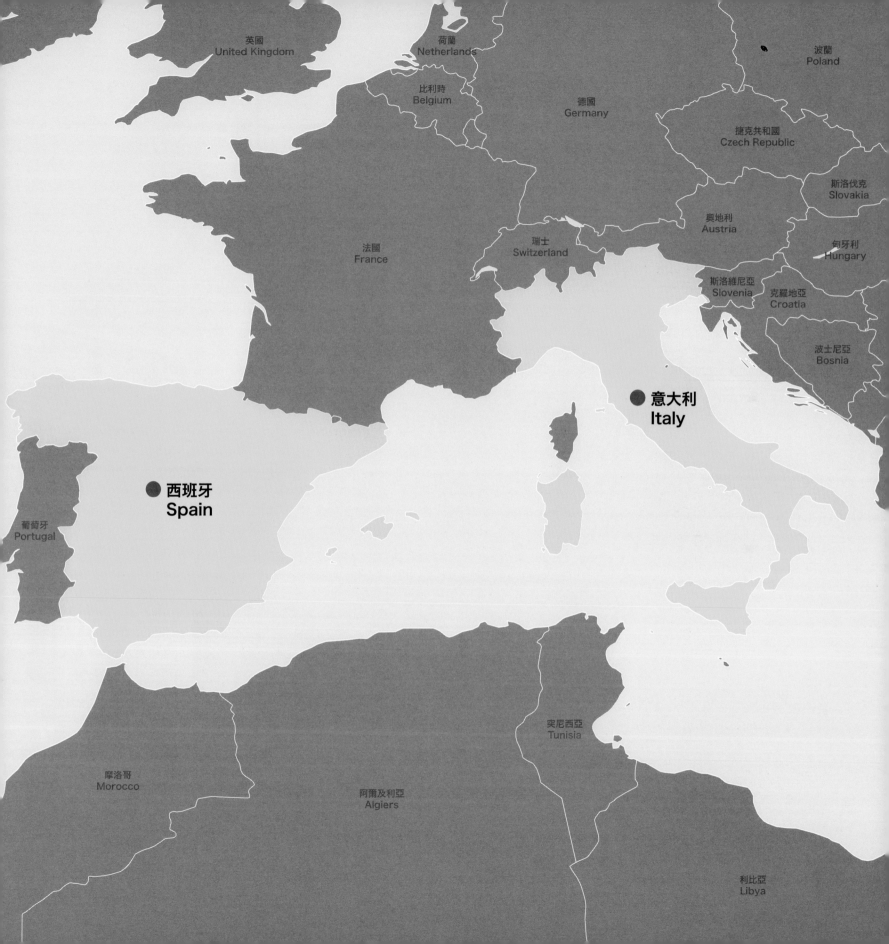

意大利位於地中海中心區域，首都羅馬，是一個發達國家，主要宗教為羅馬天主教。

自然風光優美、歷史文化深厚的意大利，被稱為「美麗的國度」。作為西方文明起源之一的古羅馬文明發祥地，意大利擁有西方世界的政治中心、被詩人提布魯斯譽為「永恆之城」的羅馬，文藝復興的發源地佛羅倫斯，世界時尚之都米蘭，「水上之都」威尼斯等等，在政治、文化、藝術、時尚、體育、宗教、電影、商業等多方面都有著舉足輕重的地位，曾誕生了達文西、米高安哲勞等著名藝術家。

特里維噴泉是羅馬最大的巴洛克風格噴泉，世界聞名，吸引了不少市民或遊客到此擲幣許願。

Italy is a developed country at the heart of the Mediterranean Sea, with Rome being its capital and Roman Catholic being the main religion of the country.

Italy has a poetical appellative "Belpaese", namely the "beautiful country", for its picturesque sceneries, profound historical and cultural depth. Italy is the cradle for Ancient Roman civilization – one of the origins of western civilization, and is also home to Rome, the "Eternal City" called by poet Tibullus, as well as the political center in the western world; to Florence, the birthplace to Renaissance; to Milan, the world's fashion capital; and to Venice, the "City of Water". In fields of politics, culture, arts, fashion, sports, religion, commerce, and etc., the country plays an important part internationally. It was home for numerous famous artists, including Leonardo da Vinci and Michelangelo.

The Trevi Fountain is the largest Baroque fountain in Rome. As one of the most famous fountains in the world, it has attracted numerous citizens and visitors to throw coins and make wishes.

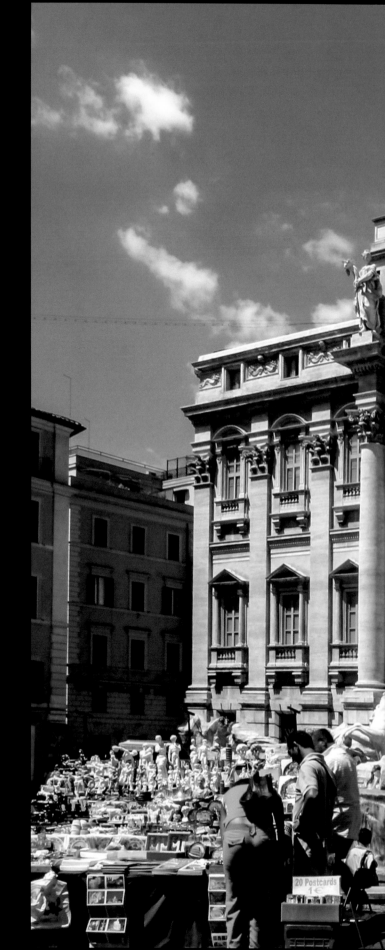

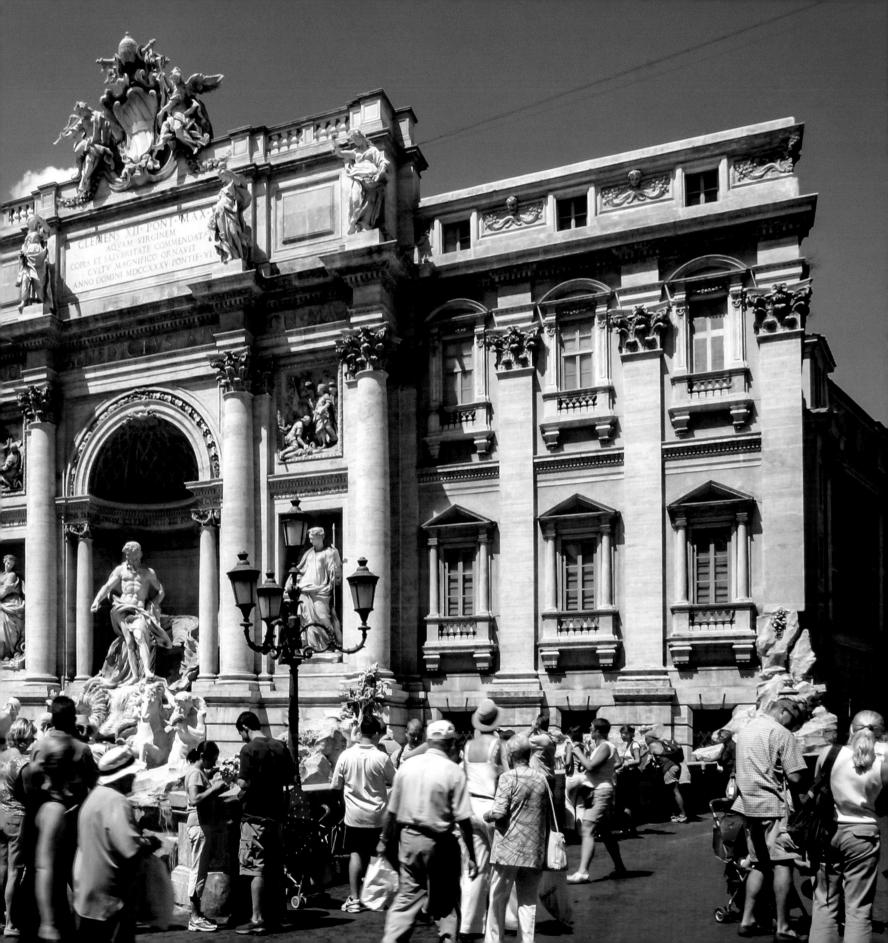

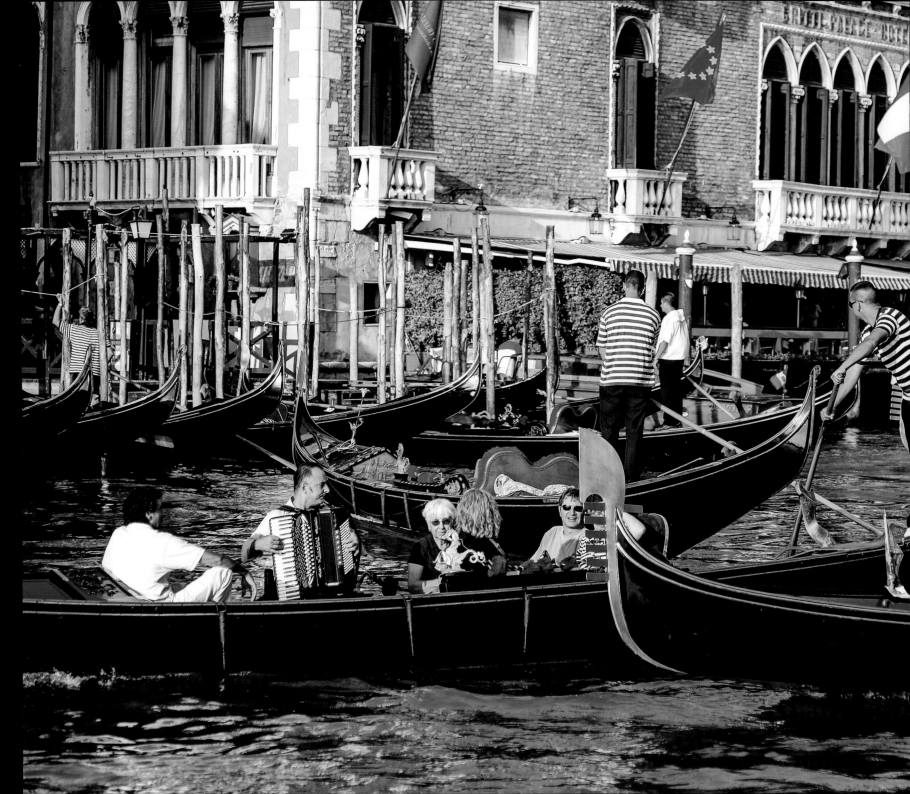

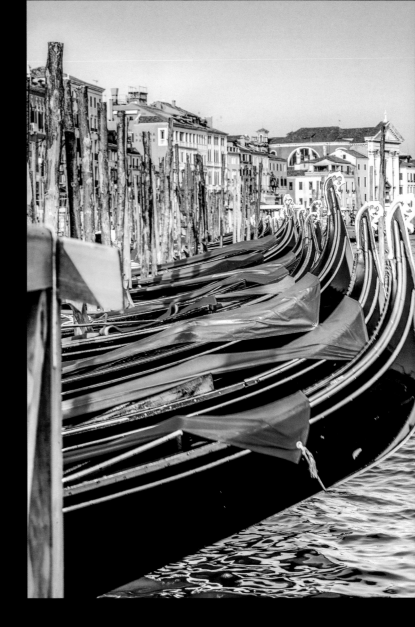

威尼斯被稱為「水上之都」，由 118 座小島組成，它們之間以運河分隔、由橋樑相連。（左）水上巴士是威尼斯最具代表性的交通工具。（右）

Venice – the "City of Water" – consists of 118 small islands that are separated by canals and linked by bridges. (Left) In Venice, the water-buses are the most representative vehicle of transportation. (Right)

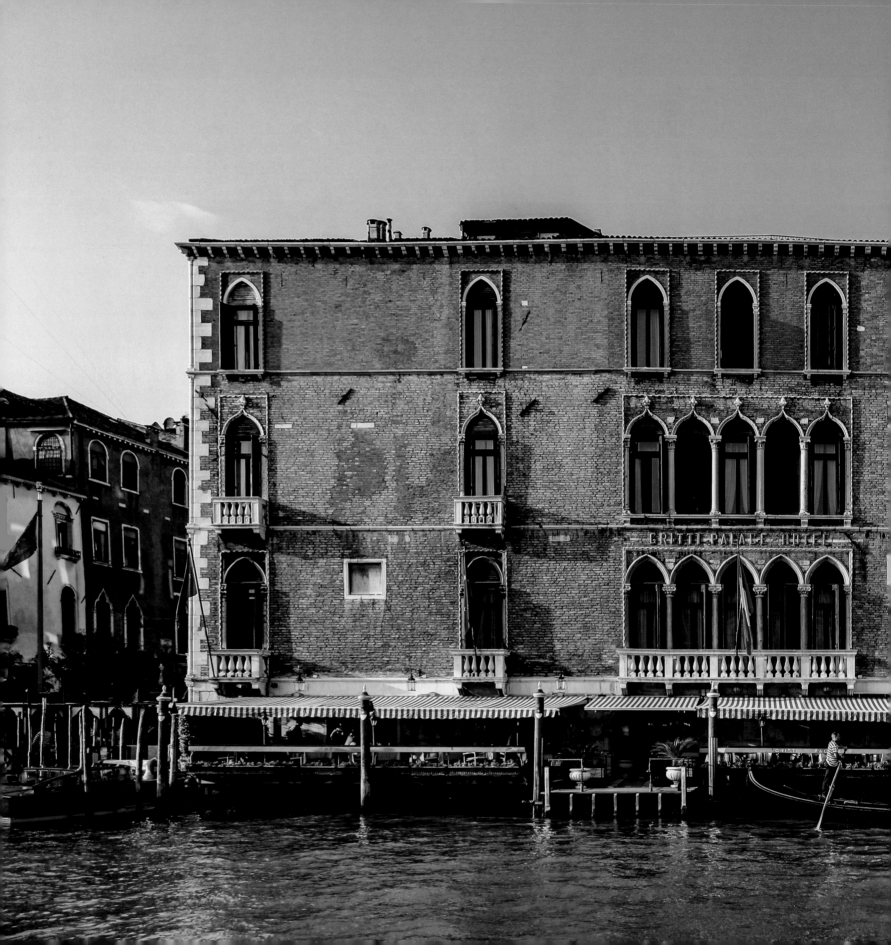

羅馬、威尼斯、佛羅倫斯等地，都是意大利最為人熟知的旅遊勝地。（左）這些城市以獨特的風情吸引著來自世界各地的遊客。（右）

Rome, Venice and Florence are well-known destinations of travelling in Italy. (Left) These cities are attracting tourists from all over the world with their unique Italian heritage. (Right)

351

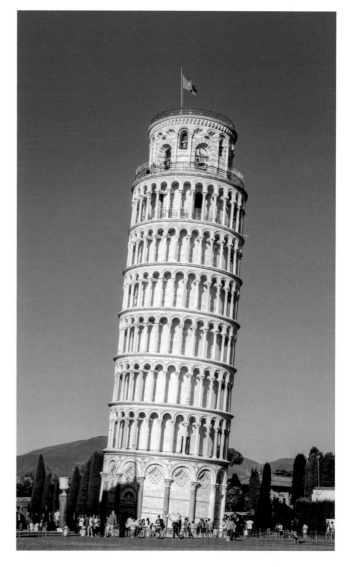

位於領主廣場上的舊宮，現為佛羅倫斯的市政廳。（左）僅需一個小時車程，就可以抵達比薩，參觀著名的景點比薩斜塔。（右）

Palazzo Vecchio - the Old Palace - on the Signoria Square is now the town hall of Florence. (Left) Only about a 1-hour ride away, you can also visit the famous Leaning Tower of Pisa in the city of Pisa. (Right)

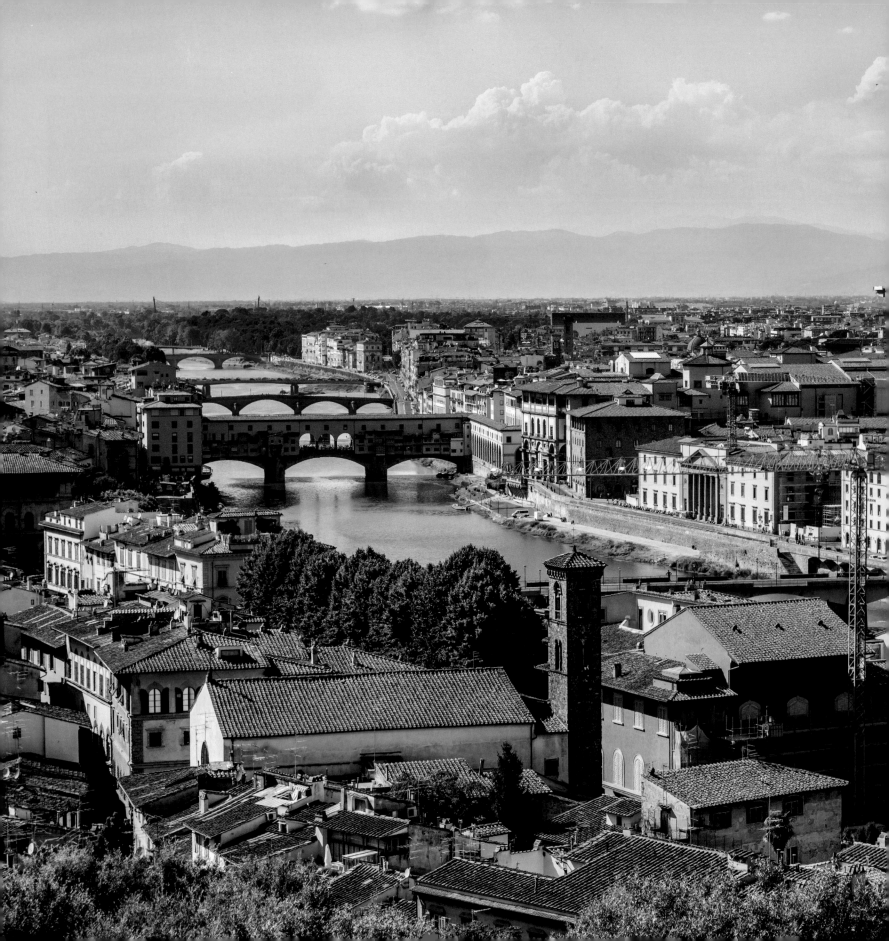

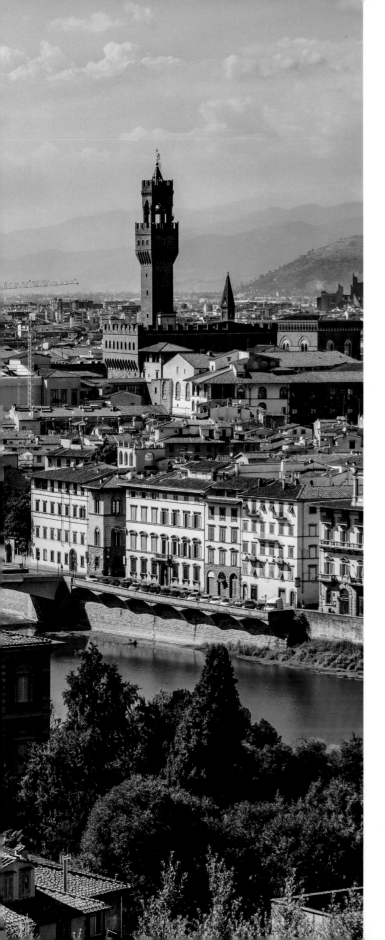

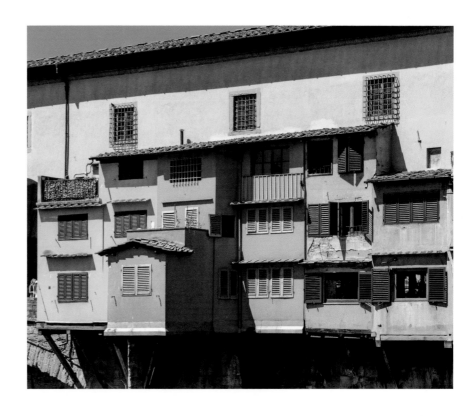

從阿爾諾河之南向北方眺望，可把佛羅倫斯的大部分景色納入眼簾，包括河上最有歷史的老橋。（左）橋兩側建有兩三層高的民宅，遠看就像掛在橋身上，仿如空中樓閣。（右）

Viewing from the south side of Arno, one can appreciate most parts of Florence, including the oldest bridge on Arno - the beautiful Old Bridge. (Left) The 2-to-3-storey houses built on both sides of the bridge are like castles in the air from a distance. (Right)

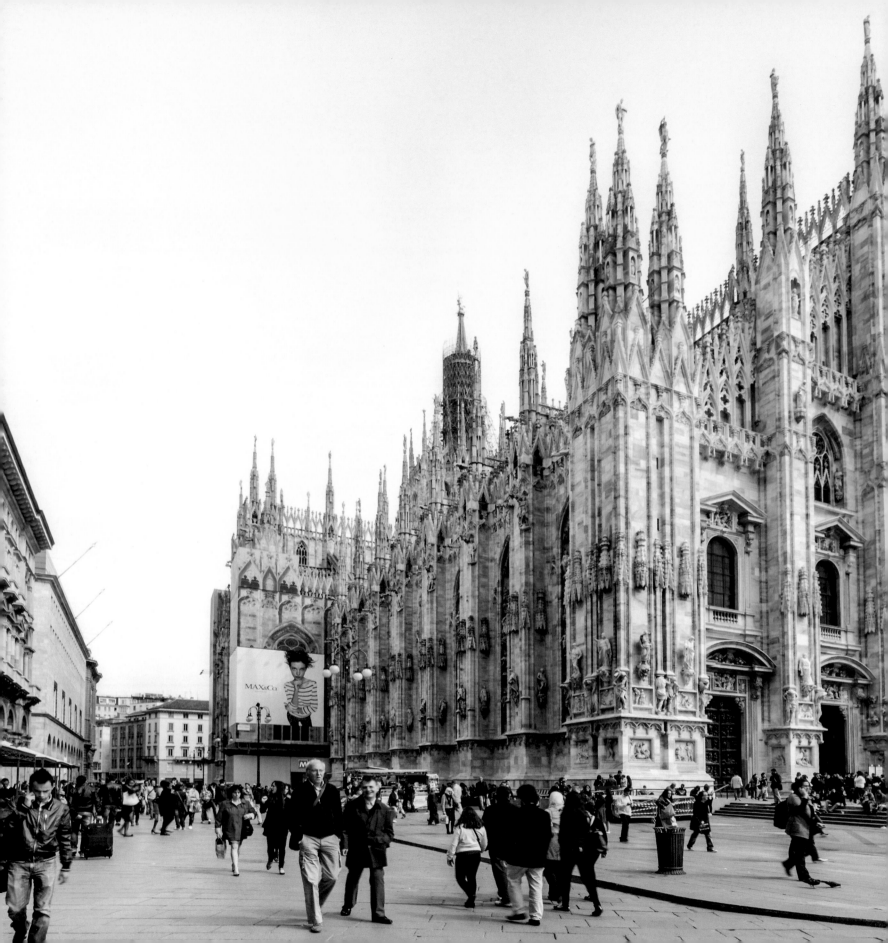

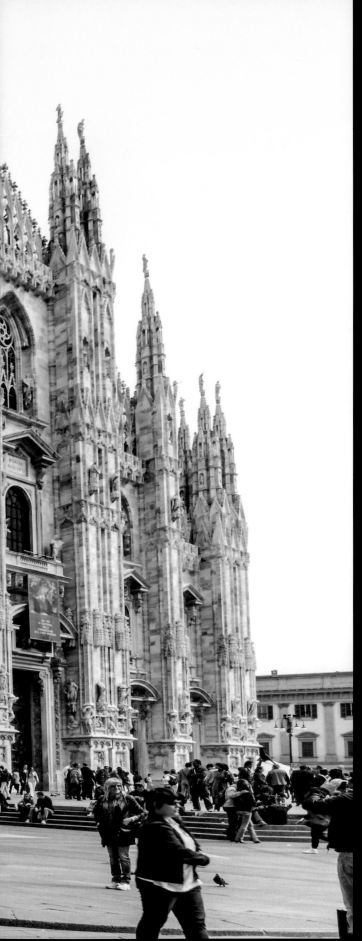

米蘭大教堂位於米蘭市中心，為國內最大、世界第三大教堂。（左）
這是文藝復興時期的代表作之一。（右）

The Milan Cathedral is the largest church in Italy and third largest in
the world. (Left) This is a Renaissance masterwork. (Right)

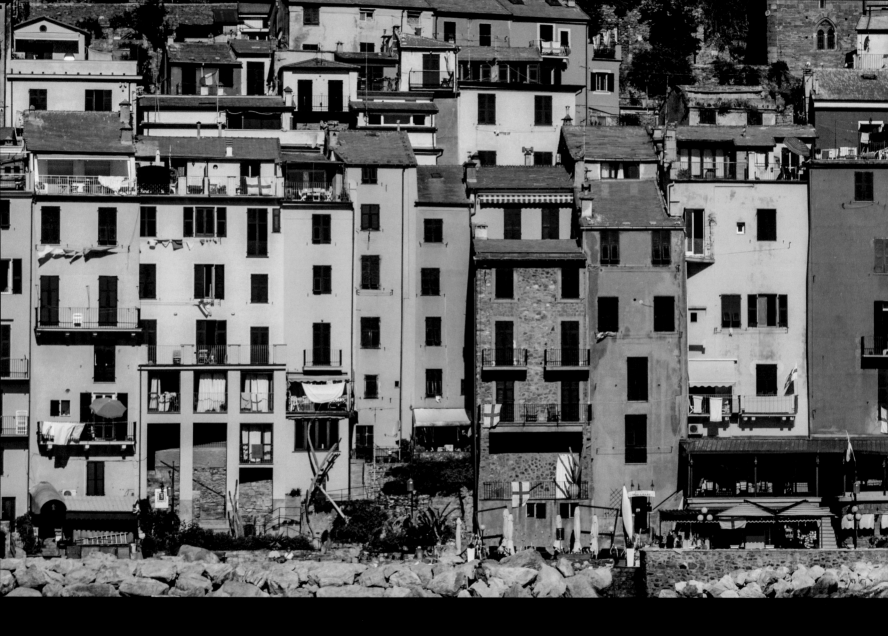

在意大利的利古里亞海岸線上，韋內雷港被稱為最浪漫的場所，深受知名英國

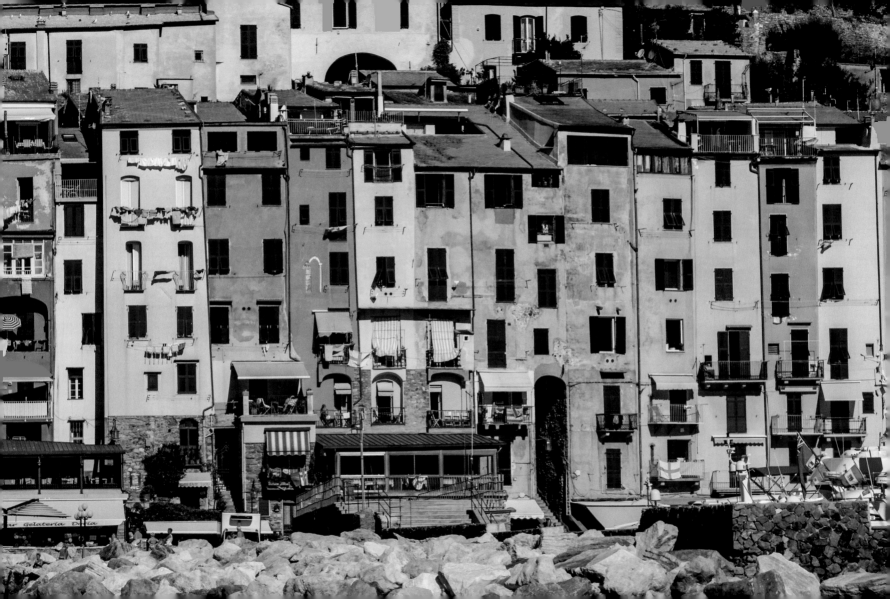

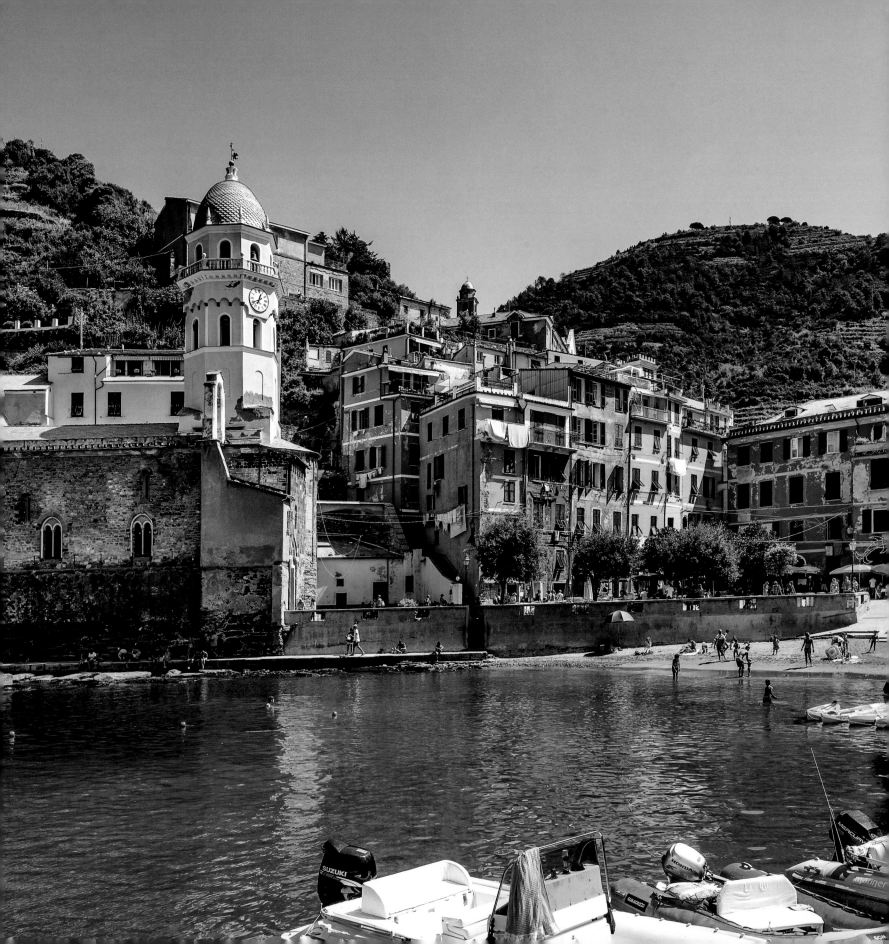

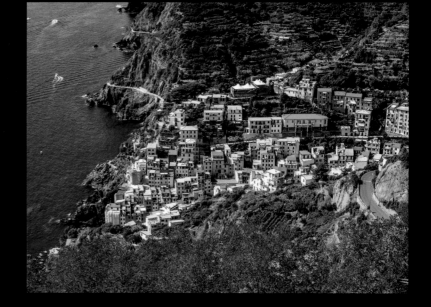

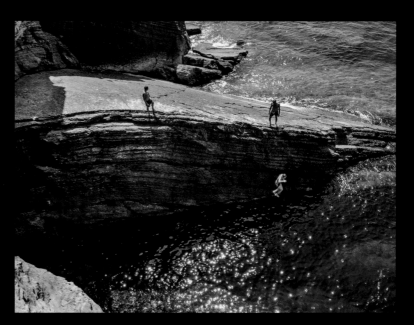

五漁村又稱為五鄉地，1997 年被列入世界文化遺產名錄，1999 年成為國家公園。（左）五個漁村處於背山面海的地勢之上。（右下）登高俯瞰，錯落有致的五彩房屋盡收眼底。（右上）

Cinque Terre means "five lands" in Italian. It became a UNESCO World Heritage Site in 1997. In 1999, a national park was established here. (Left) These five villages share a geographic similarity with hills setting a backdrop for the ocean in the front. (Lower Right) When overlooking from above, the colorful and irregular arrangements of houses have created a charming effect. (Upper Right)

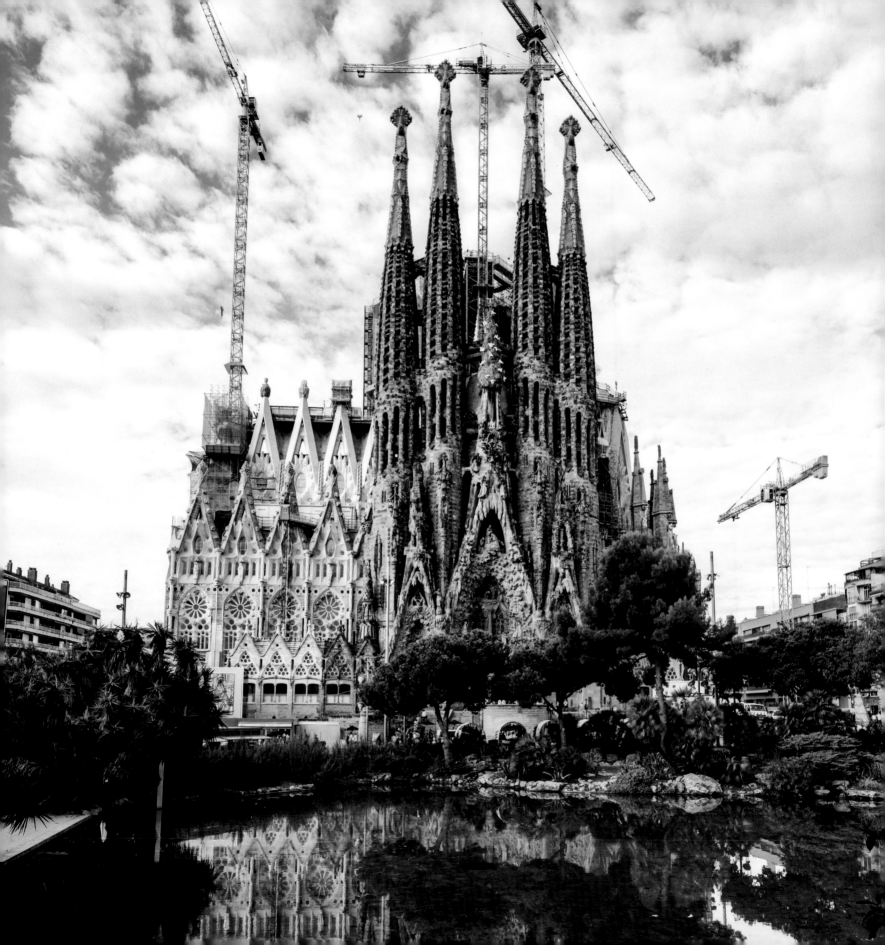

西班牙位於歐洲與非洲的交界處，首都馬德里。歷史上的西班牙帝國曾是全世界最大的帝國，被認為是世界上第一個「日不落帝國」，全盛時期的疆域甚至囊括了北美洲及南美洲的部分土地。

巴塞隆拿位於西班牙東北部的地中海沿岸，擁有超過 2,000 年歷史，一年四季皆氣候宜人，是舉世聞名的旅遊城市，多次被評為全球最具魅力的城市之一。這裡曾經誕生了建築大師安東尼‧高第，西班牙三大藝術巨匠畢加索、米羅與達利亦與這座城市有著深厚的淵源，造就了巴塞隆拿極具文藝氣質的城市風格。

要數當地最著名的建築，必定是高第所設計的聖家大教堂，這是世界上最高及施工時間最長的教堂。

Spain is a European country bounded on the south by Africa, with its capital established in the largest city Madrid. The Spanish Empire was once the largest empire in the world, crowned the first empire ever where "the sun never sets". At its peak, its territory reached parts of the lands of North and South America.

Barcelona is in northeastern Spain bordering the Mediterranean. As a universally renowned tourist city with delightful climate throughout the year, it has been selected as one of the world's most attractive cities for multiple times. Barcelona has a history of more than 2,000 years, and is home to the famous architect Antoni Gaudí. All three great masters of arts in Spain: Picasso, Miró and Dalí were closely connected to the city. Barcelona is, therefore, featured for its richness in literary and artistic temperament.

The most renowned building in Barcelona must be the Sagrada Família (Basilica and Expiatory Church of the Holy Family), which is designed by Gaudí. It is the tallest church in the world, also with the longest construction time.

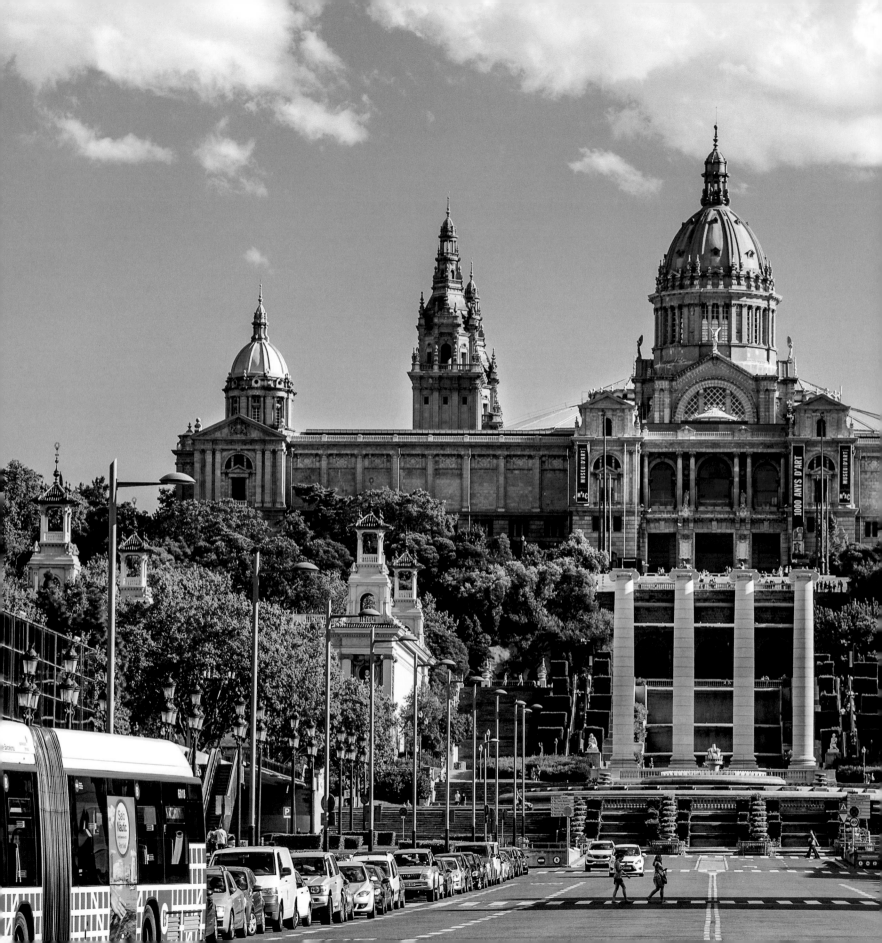

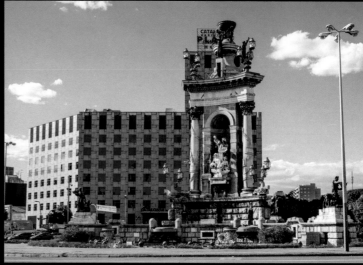

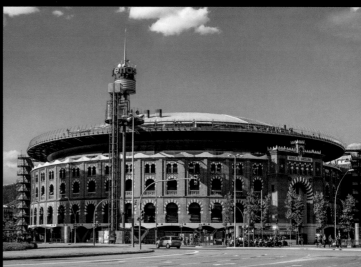

除了高第的作品之外，巴塞隆拿還有不少建築瑰寶。（右上）由鬥牛場改建而成的大型購物中心。（右下）為世界博覽會而興建的國家宮。（左）

Barcelona has multiple treasures of architecture besides the artworks of Gaudí. (Upper Right) The Centre Comercial Arenas de Barcelona re-constructed from the former bullfight arena. (Lower Right) The Palau Nacional built for the World Expo. (Left)

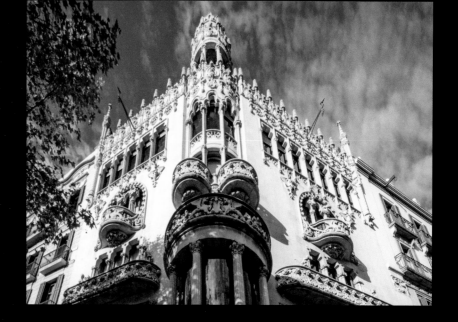

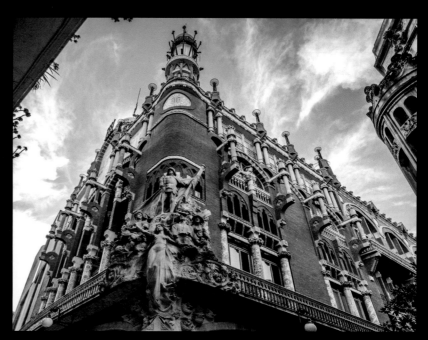

意大利至今仍保留了不少歌德式風格建築。（右上）哥德式建築興盛於歐洲中世紀高峰與末期。（右下）整體風格高聳瘦削，尖頂拱門亦是其特色之一。（左）

In today's Italy, there are still many existing Gothic architectures. (Upper Right) The style once flourished in Europe during the High and Late Middle Ages. (Lower Right) Gothic buildings are generally tall and slim, with ogives being on of its features. (Left)

伊比薩島位於地中海西部，是西班牙巴利亞利群島的第三大島。（右上）這裡是狂野派對的起源地，與夜生活、電音、派對等詞息息相關，是歐洲人乃至全世界派對狂人眼中的度假聖地。（右下）伊比薩的「夜店」文化始於上個世紀 60 年代，

當嬉皮士偶然發現了這個風光旖旎的小島，他們相約來到伊比薩，在這裏引吭高歌。時至今日，嬉皮士時代已經過去，但從伊比薩慵懶的生活態度和從不間歇的音樂，都仍滲透著曾經盛行一時的嬉皮風。（左）

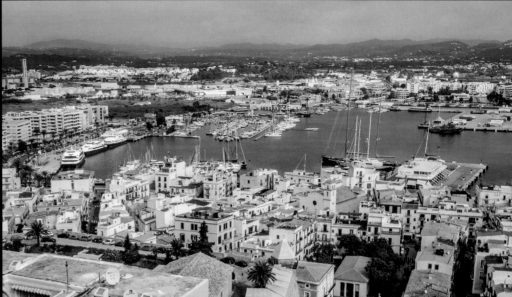

Ibiza in western Mediterranean is the third largest of the Balearic Islands in Spain. (Upper Right) Here is the cradle of Rave Party, and everything that has to do with nightlife, electronic dance music (EDM) and parties. It is the dream island for vacation in the eyes of Europeans and all party goers around the world. (Lower Right) The origin of the culture of clubbing in Ibiza can be traced back to the 1960s, when a group of hippies accidentally found this charming island. They gathered here and sang joyfully together. Although the hippie era has long past, its style can still be spotted in the laid-back lifestyle and non-stop music in Ibiza. (Left)

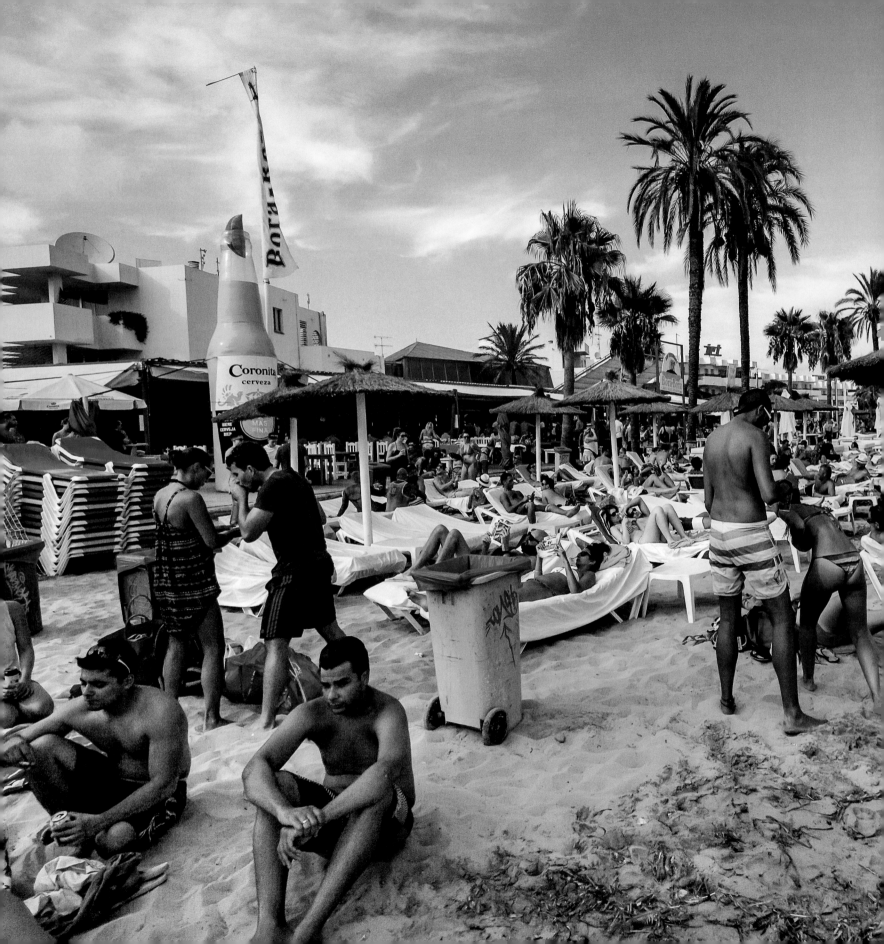

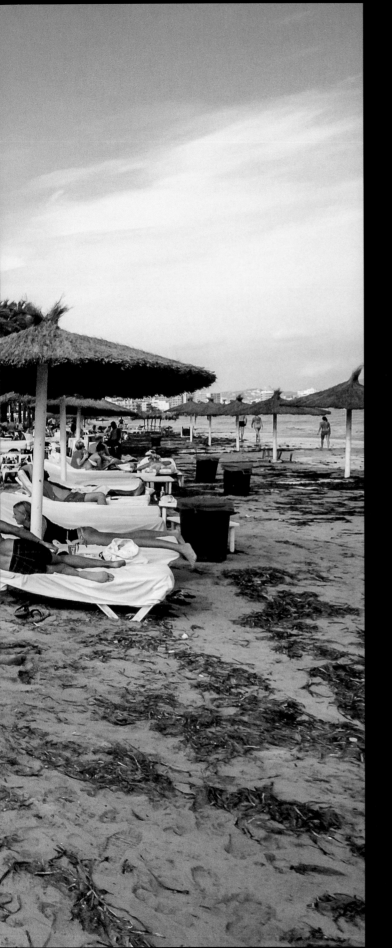

每年一到夏天，都會有眾多遊客到此，包括不少富豪及明星，或到酒吧內小酌，或在海灘上曬太陽，又或是在派對上徹夜狂歡。（左）他們喜愛到伊比薩享受悠閒的生活。（右）

Every Summer, plenty of tourists flock to Ibiza, many millionaires and superstars included, for some relaxed drinks in the bars, or to sunbathe on the beach, or even for parties throughout the night. (Left) They enjoy the leisure in Ibiza. (Right)

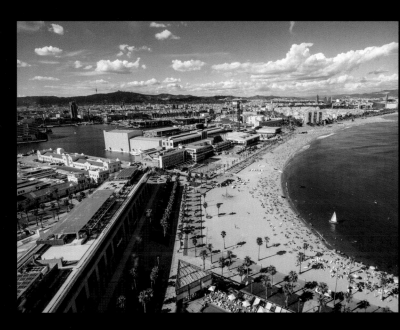

酒店內部可隨時舉辦泳池派對。（右上）海水在藍天的映照之下格外靜謐幽藍。（右下）港口邊停泊了不少富豪們的私人遊艇。（左）

Pool parties can be held anytime in hotels. (Upper Right) The sea looks fascinating under the blue sky. (Lower Right) At the harbor, there are numerous private yachts owned by the wealthy visitors. (Left)

# 東南亞

海上絲綢之路從中國東南沿海起始，經過南海諸國，穿過印度洋，進入紅海，抵達東非和歐洲。由於宋元兩代中國的造船技術和航海技術大幅提升，加以指南針的重大發明，海上絲綢之路進入了鼎盛時期。

海上絲綢之路離開中國之後的第一站，就是東南亞，而整條路線的其中一個重要節點，也在位於東南亞的馬六甲海峽。因此，東南亞對於整個古代海上網路乃至於21世紀海上絲綢之路，都舉足輕重。

在地理上，中國與東南亞有緊密的關係，不但與緬甸、越南和老撾在陸上接壤，柬埔寨、泰國、馬來西亞、印尼和菲律賓等更是南海沿岸的國家。因此，「一帶一路」中的「一路」若能穩步推進，不但在經濟上有極大發展潛力，在鄰國的和睦相處方面，亦能扮演重要的角色。

東南亞幾乎所有國家都有著漫長的海岸線，自然風光優美。在歷史上、文化上都有中華文明的影子，加之受到佛教、伊斯蘭教、印度教等宗教的影響，東南亞的文化氛圍呈現多元共存的景象。

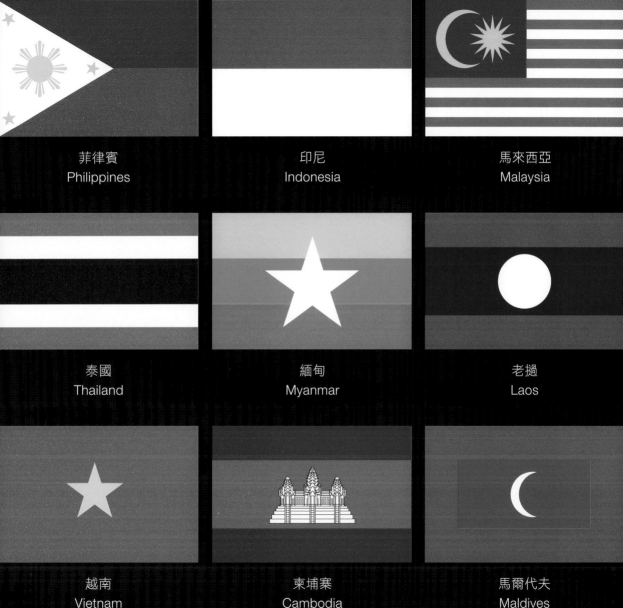

菲律賓
Philippines

印尼
Indonesia

馬來西亞
Malaysia

泰國
Thailand

緬甸
Myanmar

老撾
Laos

越南
Vietnam

柬埔寨
Cambodia

馬爾代夫
Maldives

# Southeast Asia

The maritime Silk Road starts from the coastal cities in Southeast China, by way of nations at the South Sea, the route passes the Indian Ocean to reach the Red Sea, and finally stretches itself to East Africa and Europe.

The very first station of the maritime Silk Road after the starting point in China is the Southeast Asia. The Strait of Malacca in this area is also a crucial node along the route. Therefore, for both ancient maritime Silk Road and the 21st Century Maritime Silk Route, Southeast Asia is always playing a decisive role.

Geographically, China is closely related to Southeast Asia: China is bounded by Myanmar, Vietnam and Laos, and Cambodia, Thailand, Malaysia, Indonesia and the Philippines are all the coastal states of the South Sea. If the "Road" in Belt and Road Initiative does truly progress, not only the economy, but also the peaceful coexistence among neighboring countries will benefit from it.

Almost every country in this area possesses extremely long coastline and beautiful sceneries. Historically and culturally, Chinese civilization has influenced these countries. In addition, the influences of Buddhism, Islamism and Hinduism have further created a culturally diverse atmosphere.

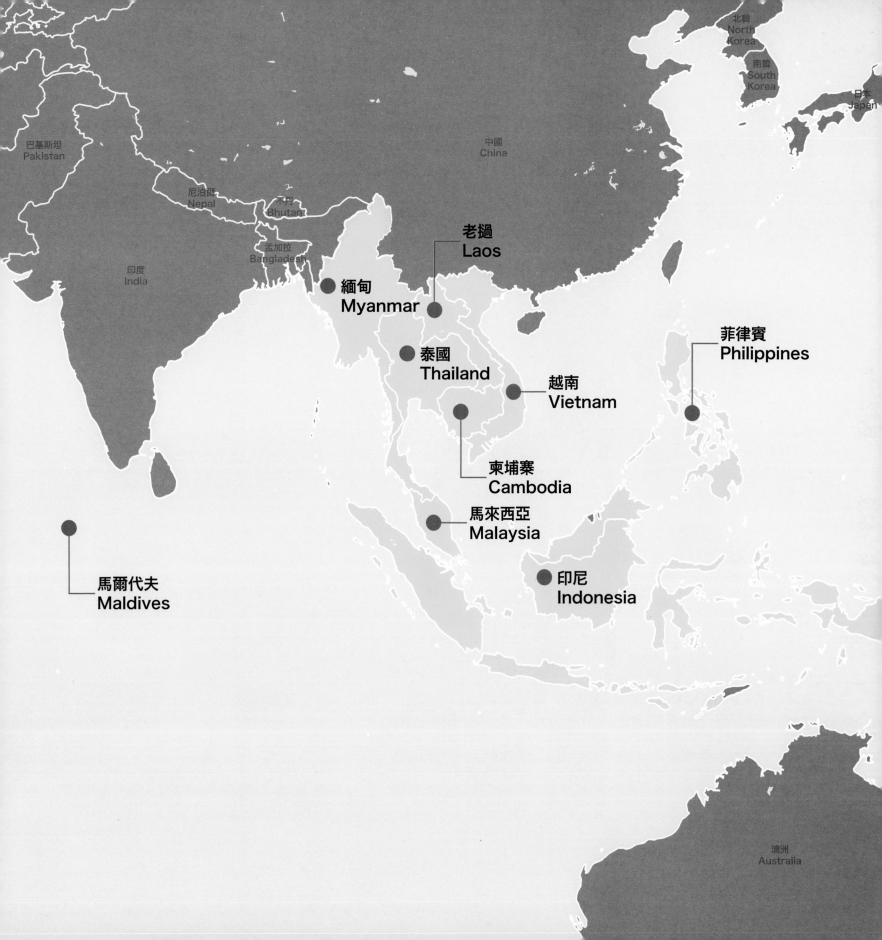

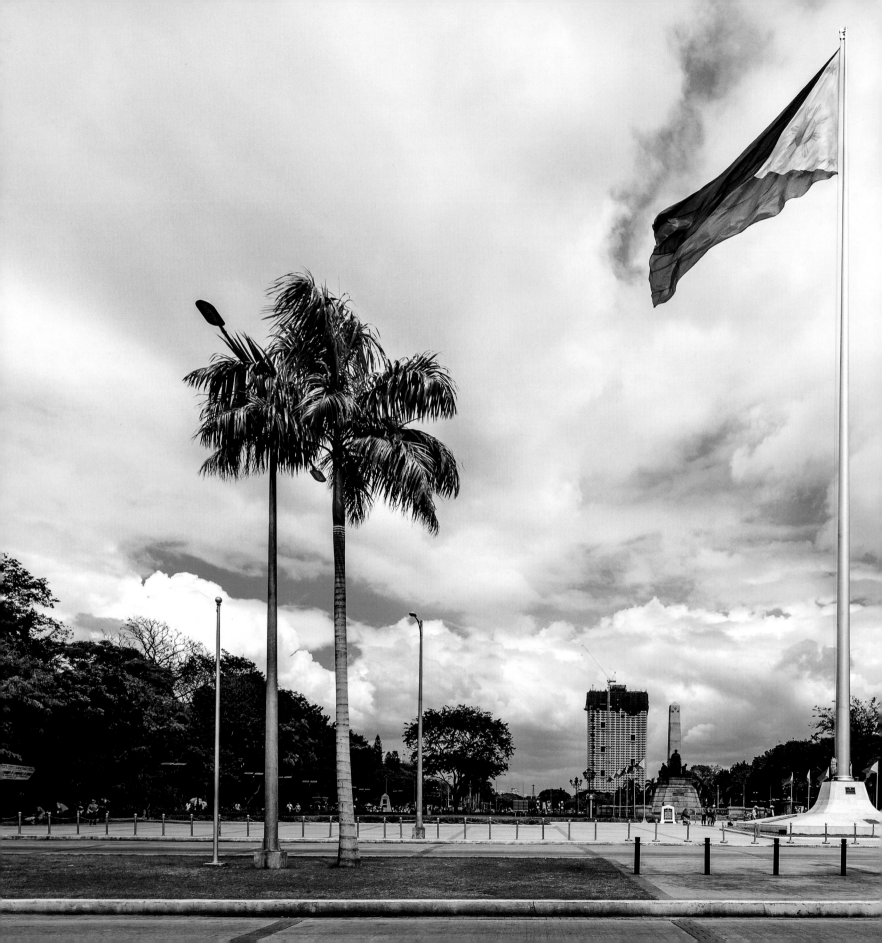

菲律賓是東南亞的一個群島國家，由超過 7,000 個島嶼組成，首都為馬尼拉。位於首都的黎剎紀念公園，是菲律賓舉行官方儀式的重要場地，遊客眾多。

The Philippines is a Southeast Asian country consisting of more than 7,000 islands, with Manila being its capital. The Rizal Park in the capital is an important venue for holding official ceremonies, attracting many tourists.

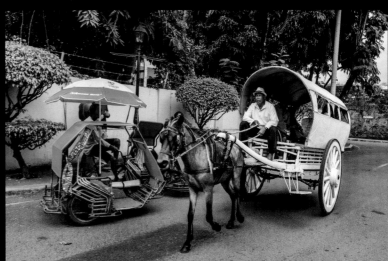

最初興建於 1581 年的馬尼拉大教堂，在歲月洗練中經過不斷重建，保留著濃厚的宗教氣息和古典韻味。（左）卡撒馬尼拉博物館，重現了西班牙殖民時期的家居風格。（右上）雙輪馬車從殖民時期一直沿用至今。（右下）

Manila Cathedral was first built in 1581. It has retained its deep religious atmosphere and classicality after several times of re-construction over the centuries. (Left) Casa Manila is a museum depicting the furnishing style during the Spanish colonization. (Upper Right) Kalesa has been used by the Philippine since the colonial period. (Lower Right)

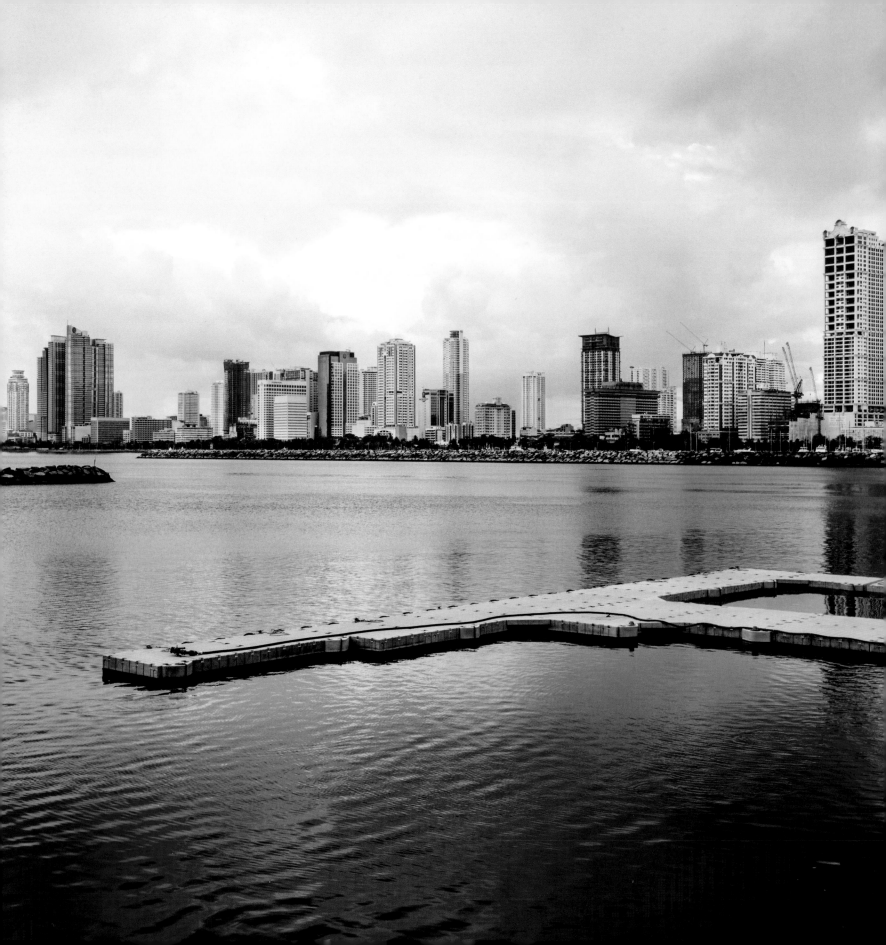

馬尼拉是一個國際大都會，融合了歷史遺留的風情與高樓大廈的現代感。（左）亞洲購物中心於 2006 年開業，當時是菲律賓最大的商場。（右上）在海邊，三名少年坐在堤岸之上，欣賞著沐浴在雲罅光之下的海面。（右下）

Manila is an international metropolis which integrates historical heritages and modern buildings. (Left) When Mall of Asia opened in 2006, it was the largest shopping mall in the Philippines then. (Upper Right) Three boys are sitting on the seaside embankment, viewing the sea surface illuminated by the crepuscular rays. (Lower Right)

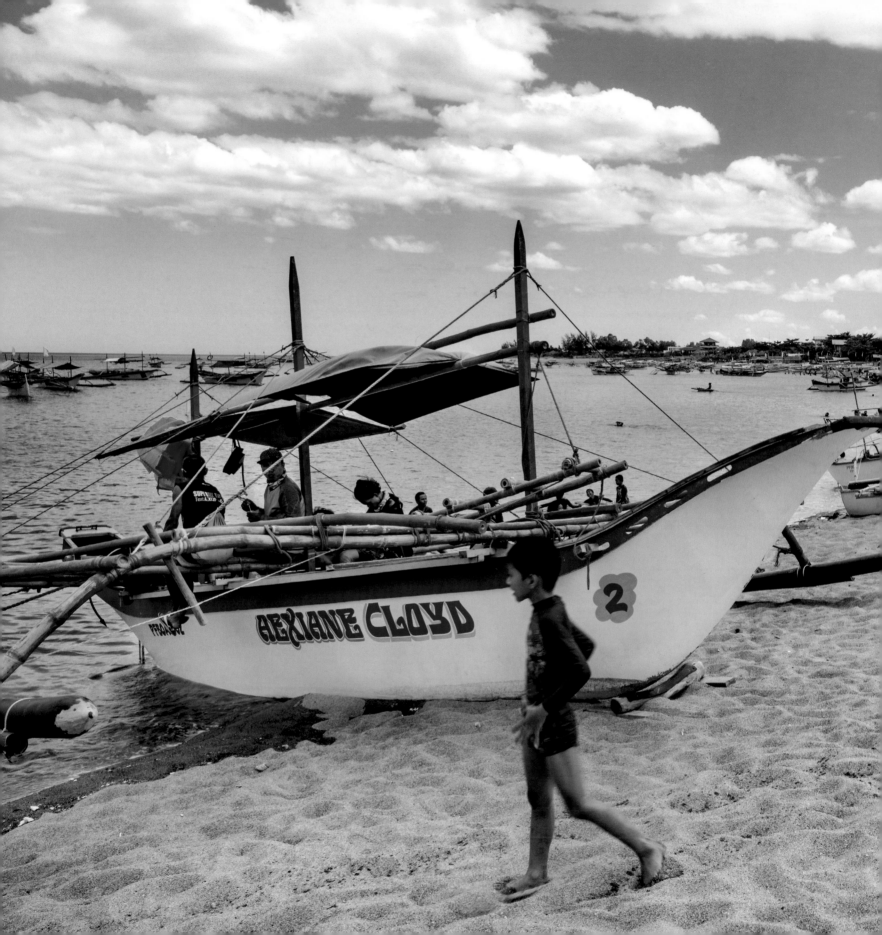

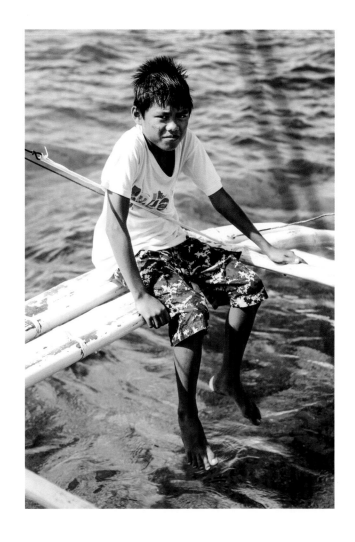

菲律賓的島嶼星羅密佈，造成了極長的海岸線，造就了豐富的海濱旅遊資源。（左）一個男孩正在海邊玩耍。（右）

With numerous islands and an extremely long coastline, the Philippines is in possession of abundant resources for coastal tourism. (Left) A boy is play at the sea. (Right)

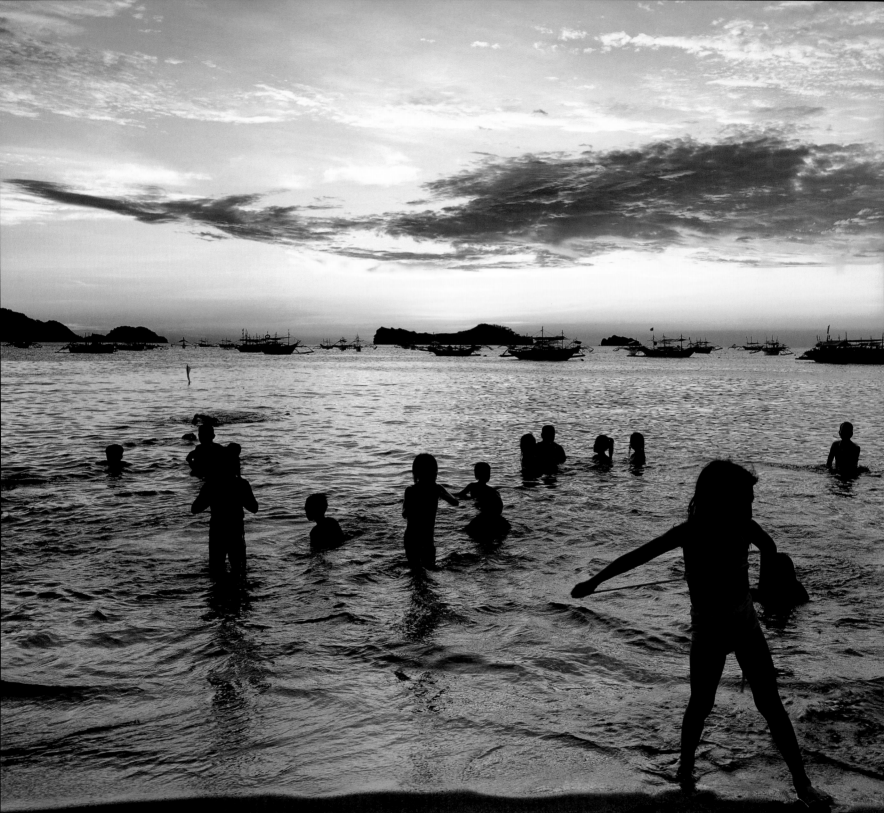

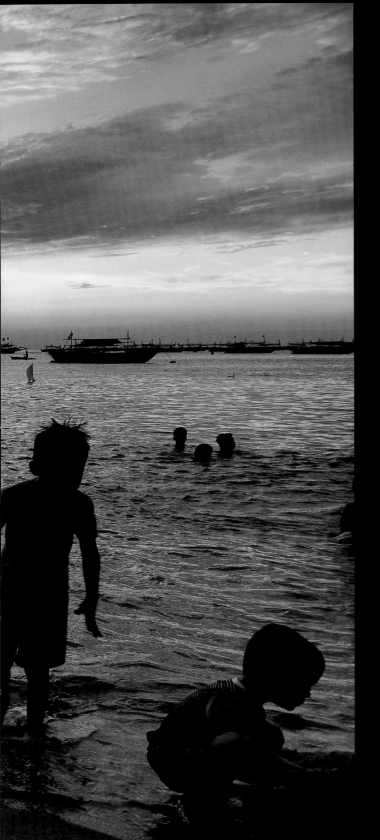

島民皆十分親善，令來自世界各地的遊客都感覺
無拘無束。（右）海灘邊，不時可見大群的孩童在一起
嬉鬧玩耍。（左）

The islanders live peacefully with tourist from all over
the world. (Right) Children are often found to be having
a good time on the beach. (Left)

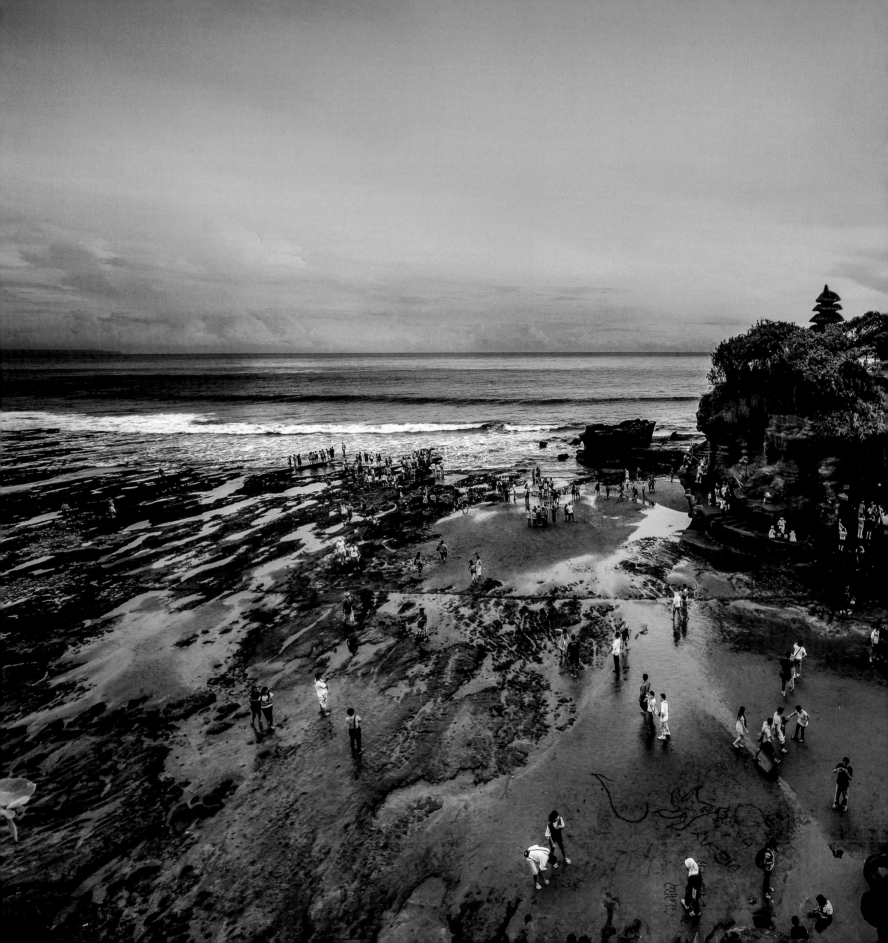

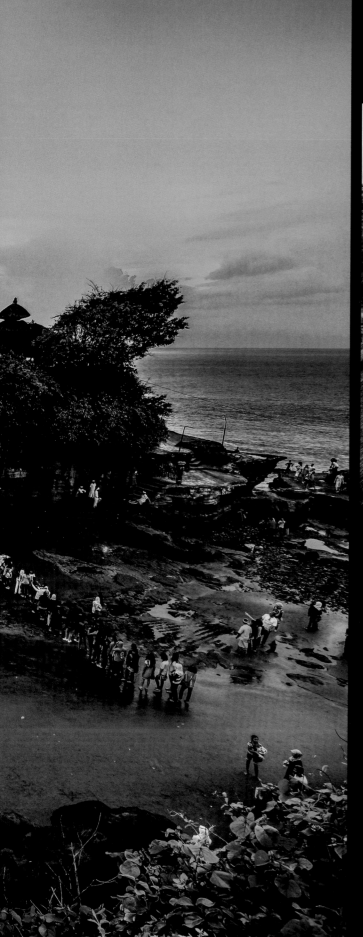

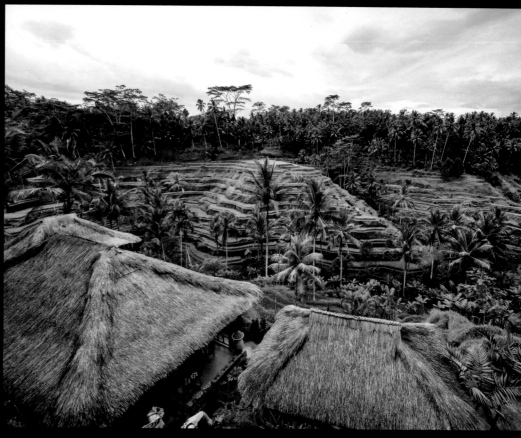

印度尼西亞簡稱印尼，疆域橫跨亞洲和大洋洲，主體位於東南亞地區，人口逾 2 億，為世界上人口第四多的國家，首都雅加達。印尼旅遊資源豐富，峇里島是其最受歡迎的旅遊目的地之一。（右）島上矗立著聲名顯赫的海神廟，漲潮時與陸地分割，是觀賞落日絕佳地點。（左）

Indonesia is a transcontinental country on the border of Asia and Oceania, with its main parts located in Southeast Asia. It is the fourth most populous country in the world, with Jakarta being its capital city. Indonesia is rich in tourist resources, and Bali is one of its most popular tourist destinations. (Right) On the island there lies the famous Tanah Lot temple, which is interestingly isolated from the land during times of high tide. This is a perfect sightseeing spot to appreciate the sunset view on the island. (Left)

馬來西亞是一個多元的國家，這一點在建築風格、宗教文化、美食文化等多方面都有所體現。以伊斯蘭為主要宗教的國情，讓馬來西亞有著伊斯蘭國家普遍可見的建築及衣著習慣；數量甚多的華僑，把中國傳統的習俗、美食及建築風格融入當地社會；為數不少的印度族裔，亦為馬國注入了印度的文化氣息；曾經的殖民地歷史為馬來西亞遺留下了一份歐式風情⋯⋯在以上種種元素的基礎之上，隨著世界經濟的發展，馬來西亞亦逐漸走向現代化、發展高科技，讓整個國家呈現一種多元文化共融的面貌。

位於吉隆坡的雙子塔是馬來西亞最有代表性的地標建築，以雙子塔為中心的吉隆坡夜景五光十色，璀璨醉人。

Malaysia is a pluralistic country in terms of architecture, religion, delicacies, and etc. The state's Islamic religion has made it similar to other Islamic countries in parts of the buildings and wearing habits. A large number of Malaysian Chinese have brought the traditional convention, cuisines and architectural styles into the local society. Besides, there are many people of Indian ethnic, too, injecting Indian factors into the country. What's more, the history of once being a colony has added some European atmosphere. Based on all these existing facts, Malaysia is also changing rapidly as the world's economy develops. The modernization and high technologies have made Malaysia a diverse and integrated country.

The Petronas Twin Towers in Kuala Lumpur is a landmark in Malaysia. The nightscape, with the towers at the center of the view, looks like a picture of twinkling stars scattered all around the city.

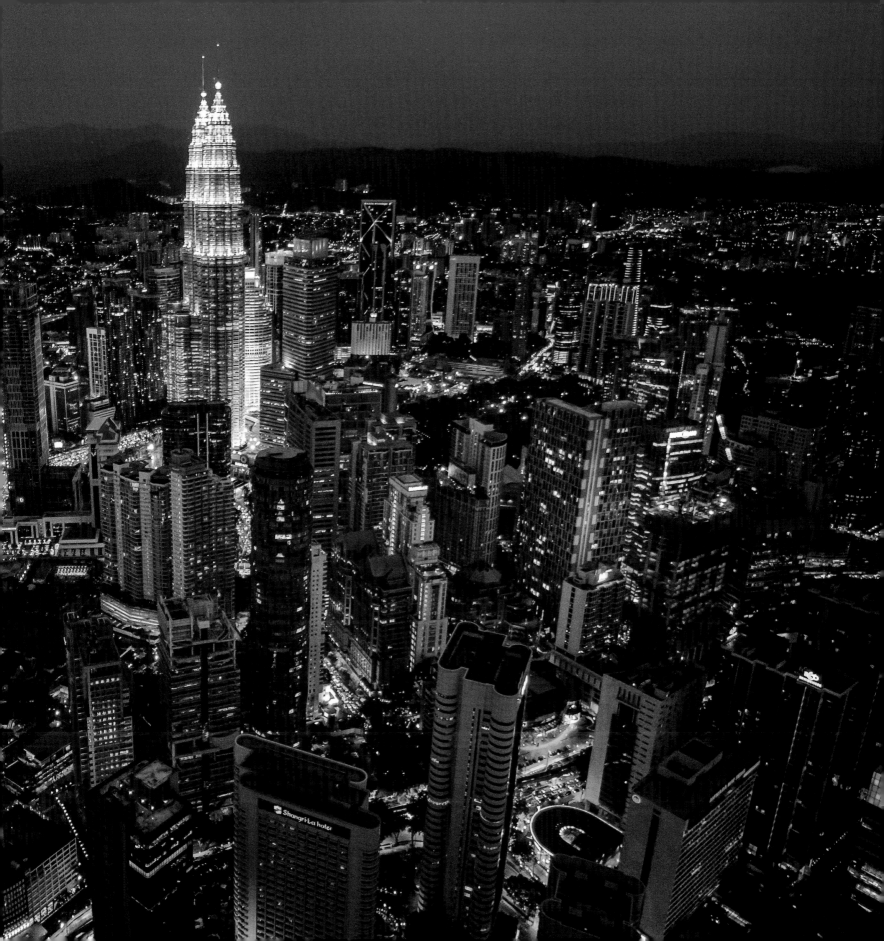

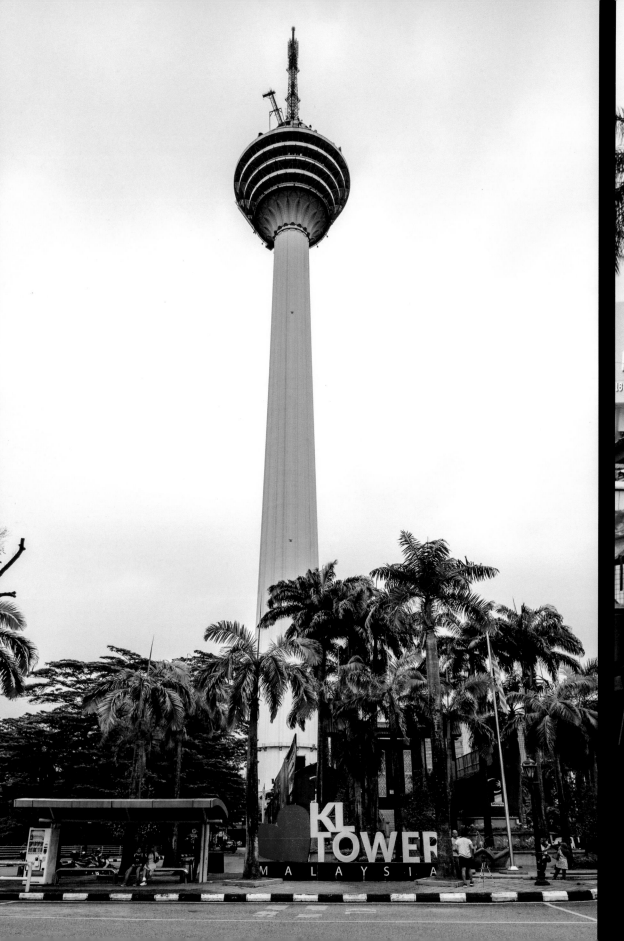

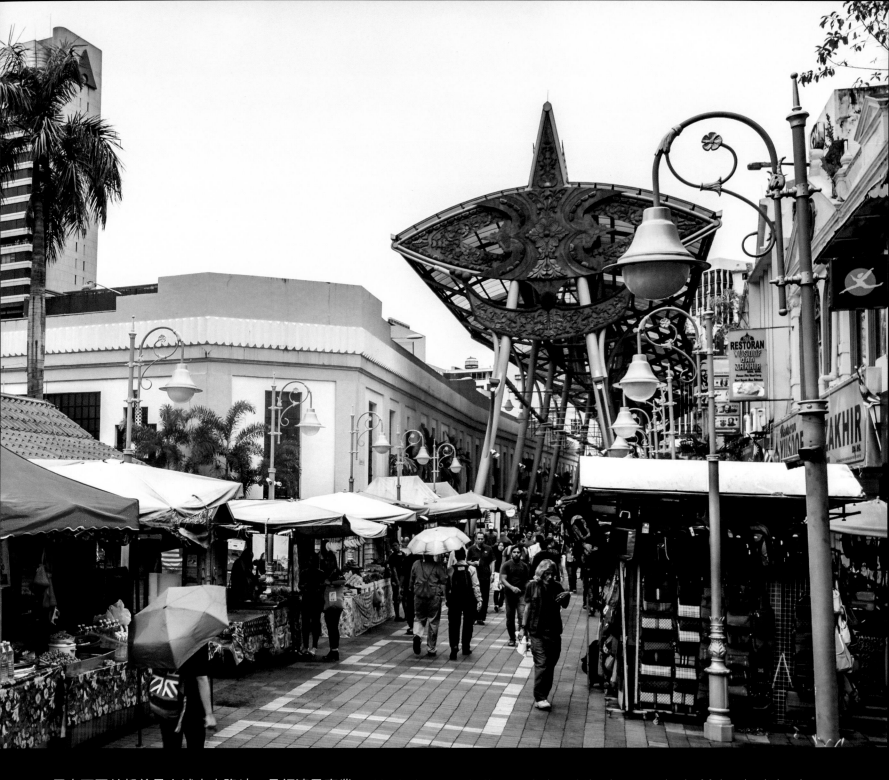

馬來西亞首都兼最大城市吉隆坡，是經濟及商業高度發展的國際大都會。（右）從吉隆坡塔之上可以俯瞰城市全景。（左）

Kuala Lumpur is the capital and the largest city in Malaysia; it is also an international metropolis with highly developed economy and commerce. (Right) From the upper area of the Kuala Lumpur Tower, a panoramic view of the city can be sighted. (Left)

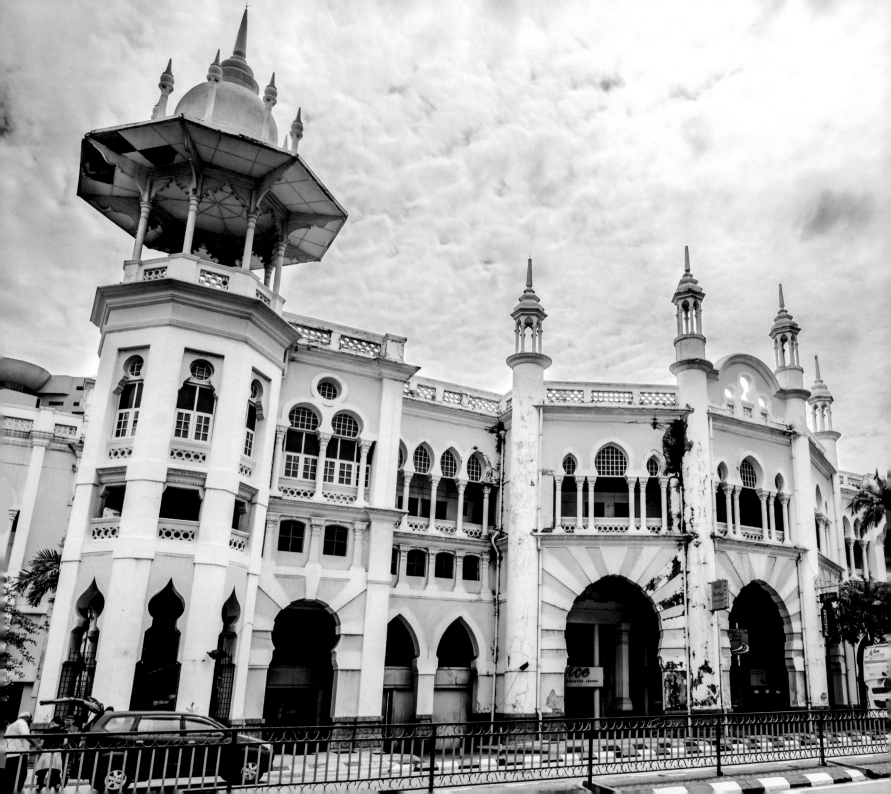

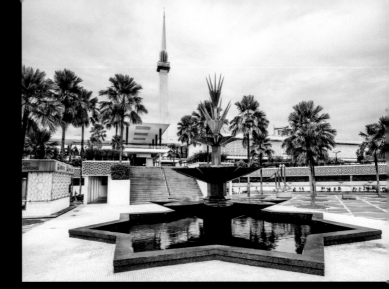

吉隆坡舊火車站落成於 1910 年，雪白的外表融合了東西方。（左）在當時，它被譽為世界上最美麗的火車站。（右上）附近設有「我愛吉隆坡」的裝置。（右下）

Completed in 1910, the Kuala Lumpur railway station is an all-white construction blending oriental and western designs. (Left) At that time, it was hailed as the most beautiful railway station in the world. (Upper Right) An installation of "I Love Kuala Lumpur" is erected nearby. (Lower Right)

國家皇宮是馬來西亞最高元首的官邸。建築糅合了馬來及伊斯蘭風格,許多大型慶典活動在此舉行。(左)在此可觀看皇宮守衛的換班儀式。(右)

The Istana Negara is the official residence of the monarch of Malaysia. The architecture mixes Malay and Islamic styles, and is the venue for many large-scale ceremonies and activities. (Left) The ceremony of changing of guards here has become a tourist attraction. (Right)

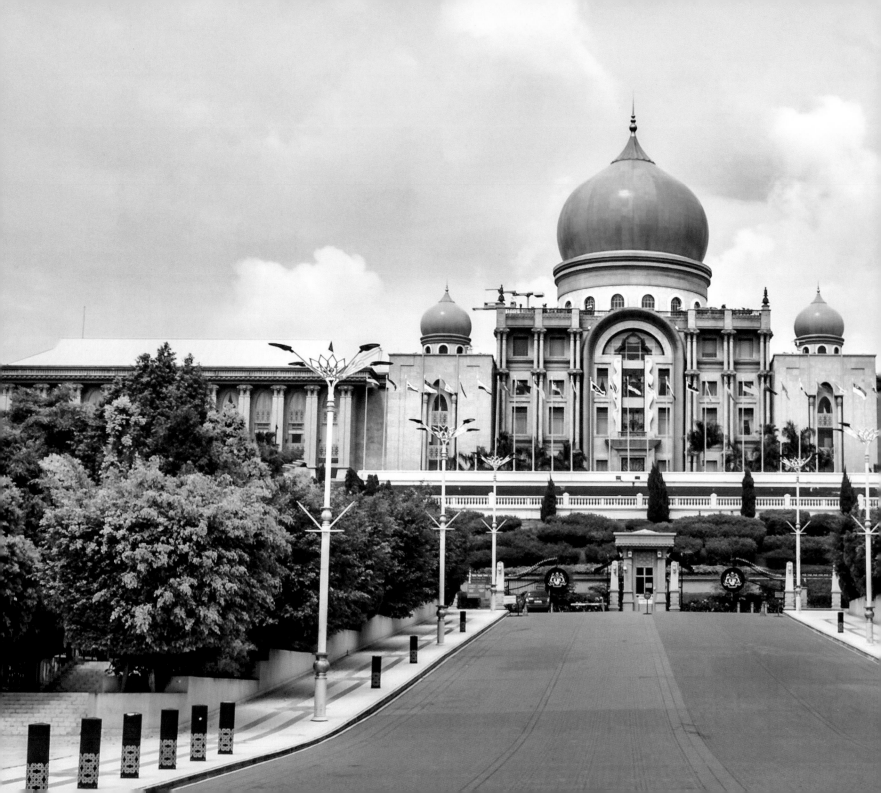

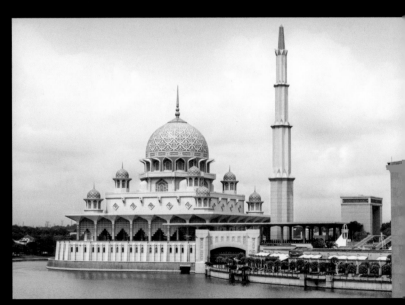

太子城距離吉隆坡市中心約 40 公里。（左）這是前首相馬哈蒂爾構思及開發出來的新城市。（右上）現時為馬來西亞的行政權力中心。（右下）

Putrajaya is forty kilometers away from downtown Kuala Lumpur. (Left) It was conceived and developed by former Prime Minister Mahathir Mohamad. (Upper Right) It now accommodates the federal administrative center of Malaysia. (Lower Right)

馬哈馬里安曼興都廟是吉隆坡最古老的印度廟，
初建於 1873 年。（左）1972 年，加建了五層廟塔，
突顯了印度南部的建築風格。（右）

Built in 1873, the Sri Mahamariamman Temple in
Kuala Lumpur is the oldest Hindu temple in the
city. (Left) The five-tiered gopuram added to the
temple in 1972 reflects the architectural style of
South India. (Right)

馬來西亞的美食可謂百花齊放。（右）有味道濃郁的馬來本土
圭餚，有色香味俱全的傳統中式美食，亦有以香料為特色的辛
辣印度菜色。（左上）更有融合了華人與馬來人的美食精華——
蜀一無二的峇峇或娘惹食品。（左下）

n Malaysia, you are able to have a taste of diverse cuisines. (Right)
There is the local cuisine with strong flavor, traditional Chinese
ood, spicy Indian dishes featured in spices, and so on. (Upper
.eft) And there is the Baba Nyonya or Peranakan combining the
essence of Chinese and Malaysian delicacies. (Lower Left)

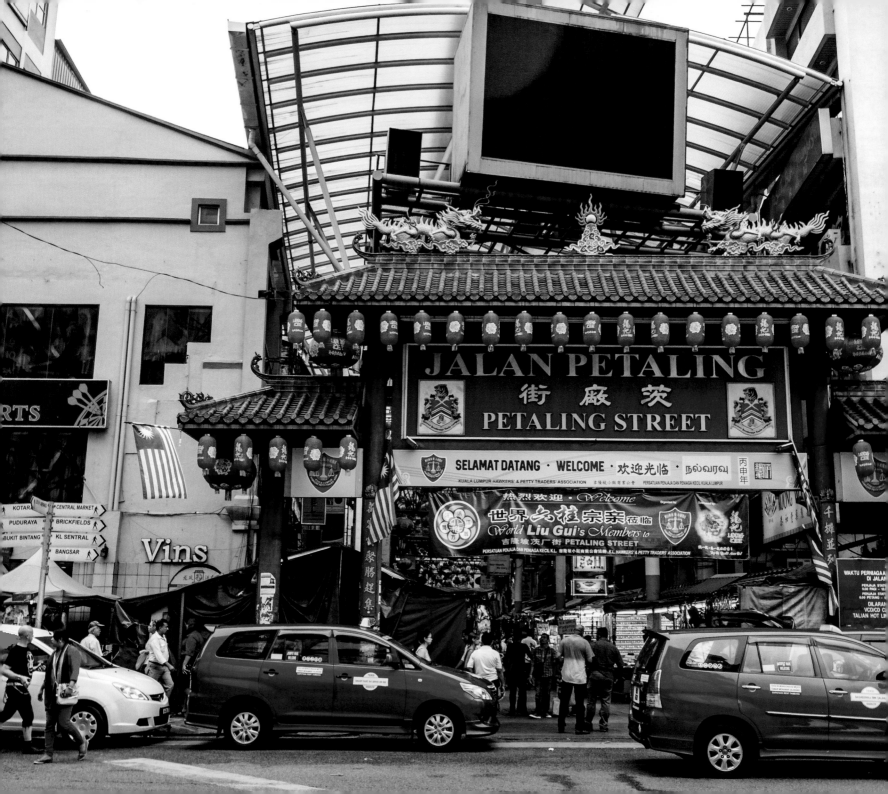

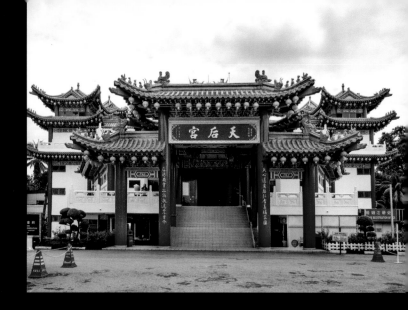

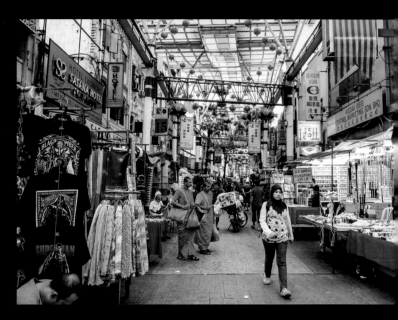

華人佔馬來西亞近四分之一人口。（左）茨廠街是吉隆坡著名的唐人街。（右下）天后宮亦極具中式建築風格。（右上）

Malaysian Chinese takes up nearly a quarter of its population. (Left) In Kuala Lumpur, the Petaling Street is a famous Chinatown. (Lower Right) The Thean Hou Temple in the city is in typical Chinese architectural style. (Upper Right)

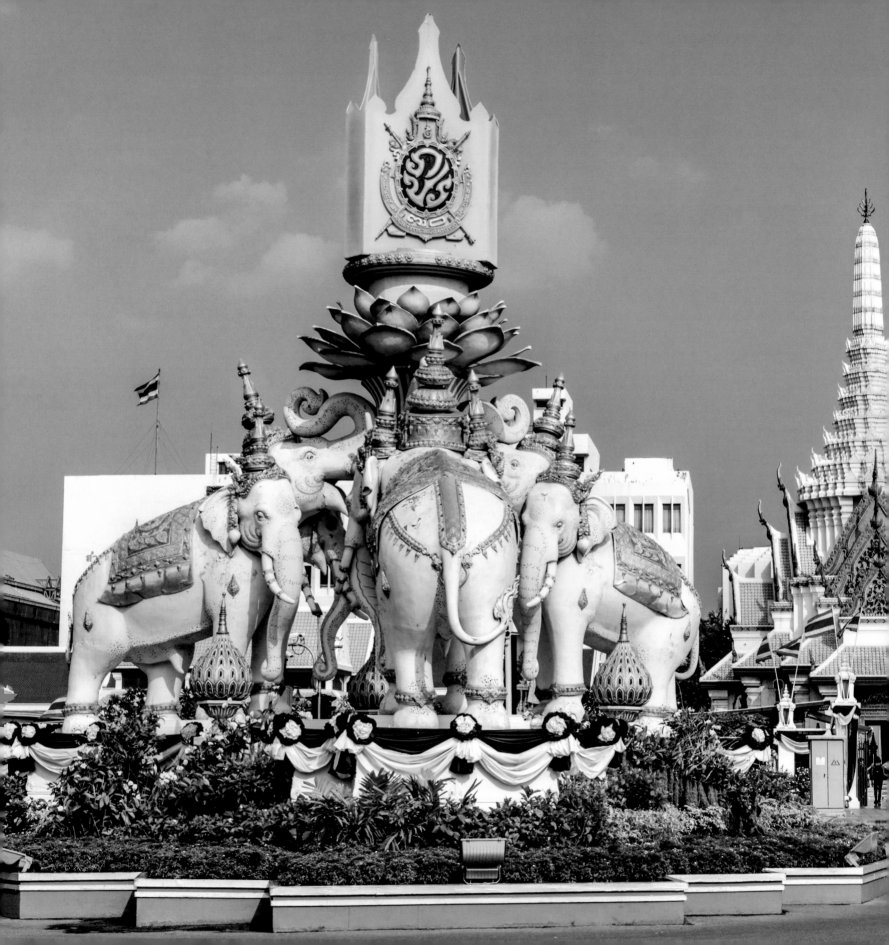

泰國古稱暹羅，首都為最大城市曼谷，以佛教為主要宗教。相傳佛祖釋迦牟尼是在其母親夢見白象後誕生的，因此泰國奉白象為聖物，象雕在多地可見。（左）前泰王蒲眉王，即拉瑪九世，備受國民尊敬。（右）

Thailand was formerly known as Siam, and Bangkok is its capital as well as the largest city. The majority of Thai people are Buddhists. It is said that Buddha Shakyamuni was born after his mother dreamed of a white elephant. This is why Thai people regard white elephants as holy creatures. Sculptures of elephants can be seen in many places in the country. (Left) Thailand's late King Bhumibol Adulyadej, also known as Rama IX, is highly respected among its people. (Right)

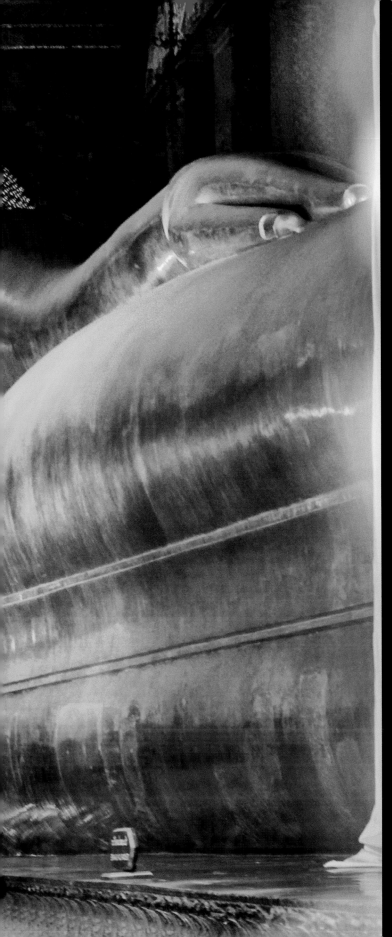

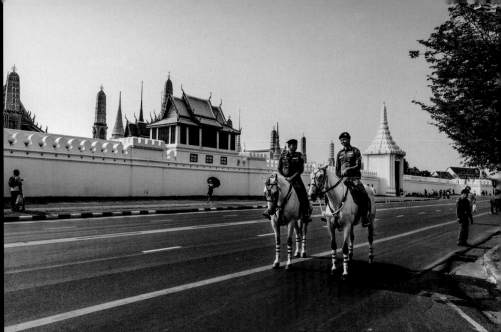

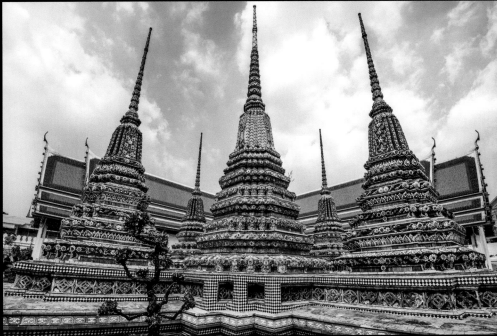

不少建築都融入了宗教元素，形成了獨特的建築風格。（右上）
臥佛寺是曼谷最古老、最遼闊的寺廟。（右下）其內，有一尊 46 米
長的臥佛像。（左）

Many buildings have integrated religious factors, creating a unique
style of architecture. (Upper Right) Wat Pho is the oldest and
largest temple in Bangkok. (Lower Right) Inside, there is a statue of
a reclining Buddha as long as 46 meters. (Left)

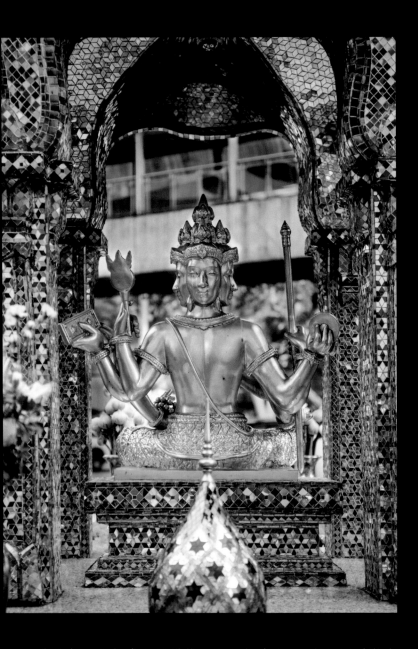

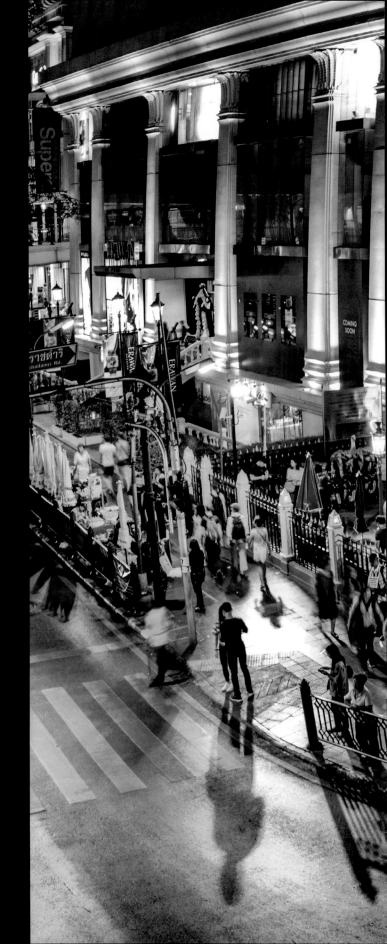

四面佛是泰國最負盛名的佛像，可謂無處在。（左）最受遊客
歡迎的一座，則位於曼谷市區心臟地帶的十字路口。（右）

The Phra Phrom is probably the most well-known and pervasive
Buddhist statue in Thailand. (Left) The one with most visitors is
off the crossroad at the center of downtown Bangkok. (Right)

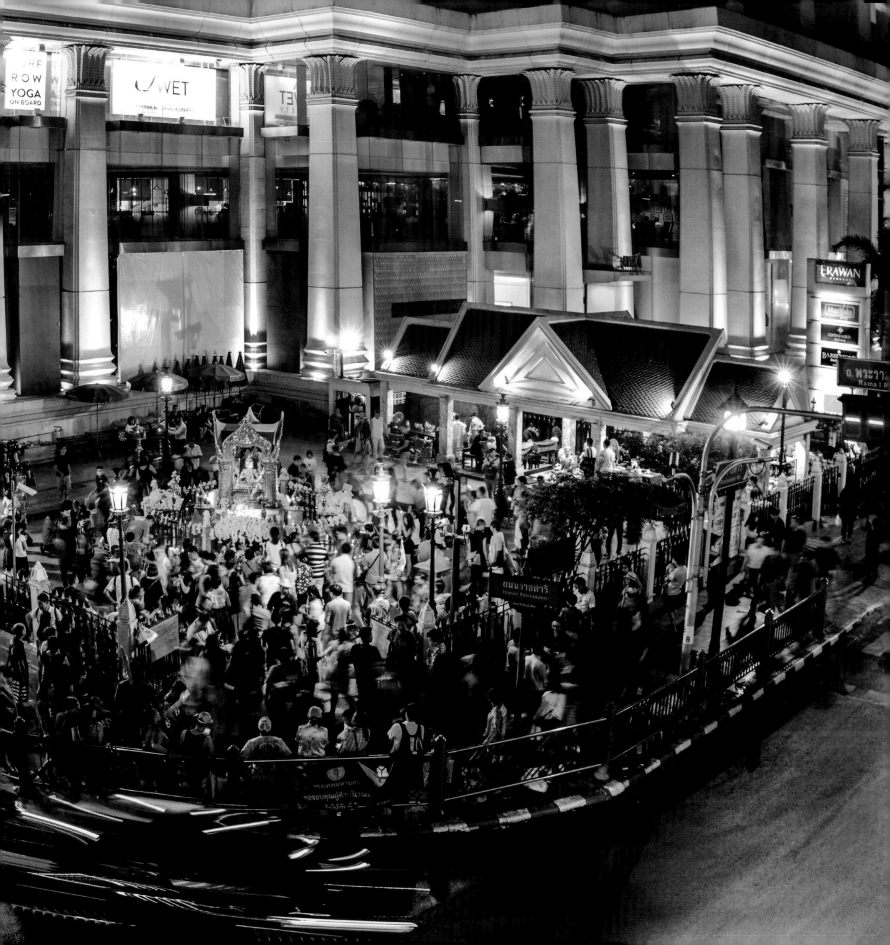

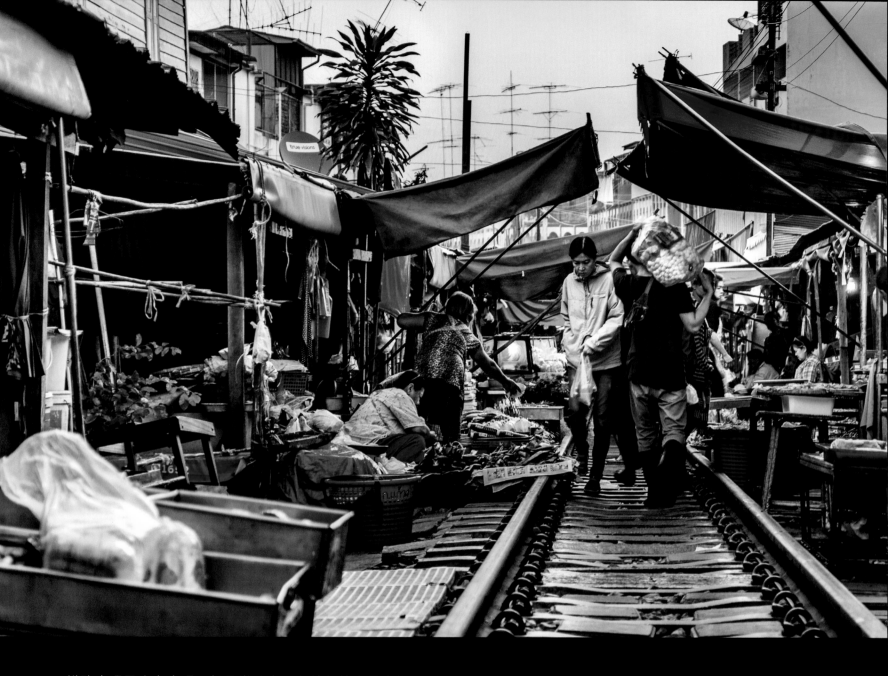

鐵路市場及水上市場，都是當地十分有特色的交易市集。（右）在美功鐵道市場之上，當每日僅有兩班的列車來臨之際，攤販會迅速在兩分鐘內收拾貨品，稍作閃避。（左）

Railway and water markets are both distinctive local markets. (Right) At Maeklong Railway Market, when the twice-daily trains come, stall keepers will rapidly pack their goods up within two minutes to dodge the train. (Left)

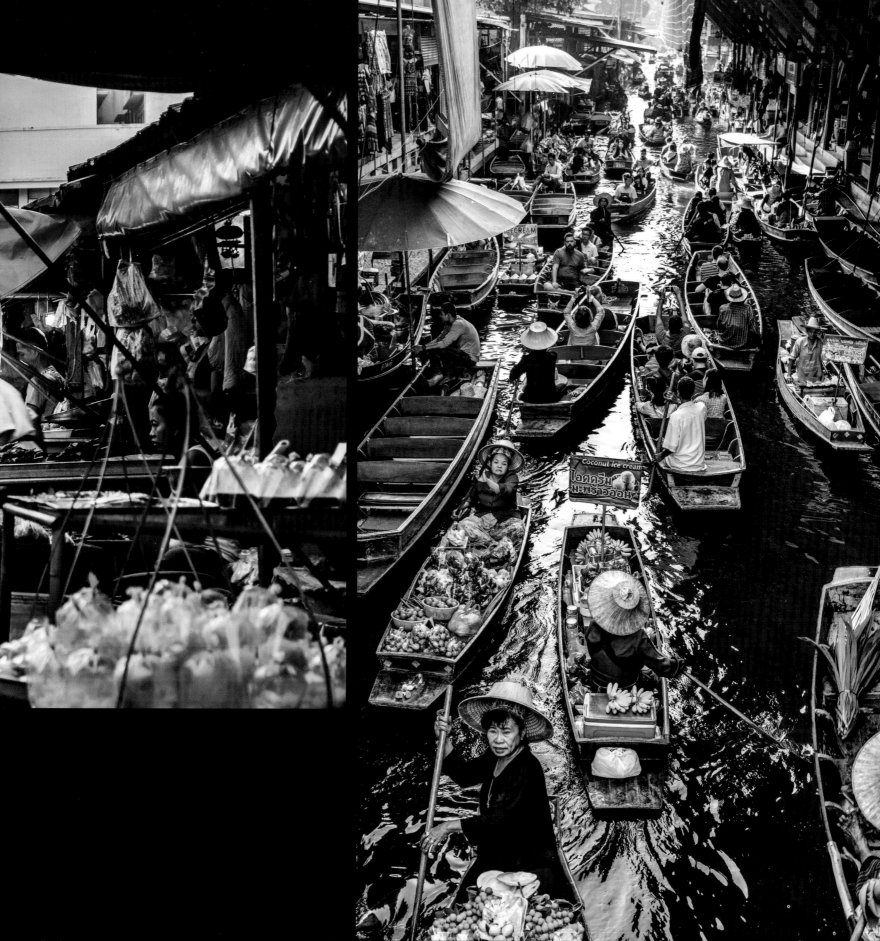

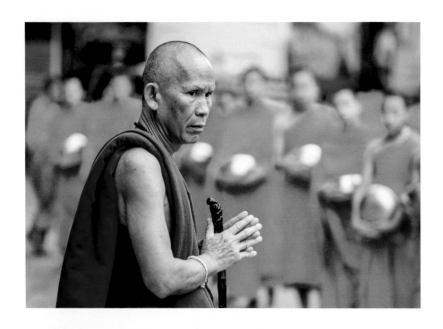

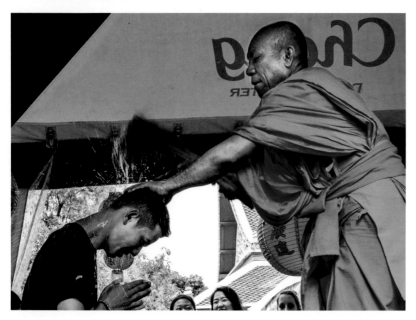

泰國僧侶眾多。（左上）虔誠的佛教徒對僧侶尊崇至極。（左下）有些信徒會以跪拜之禮以示對佛祖的敬意。（右）

In Thailand, there are a multitude of monks. (Upper Left) Devotional Buddhists pay utmost respect to them. (Lower Left) Some would worship on bended knees as a tribute to the Buddha. (Right)

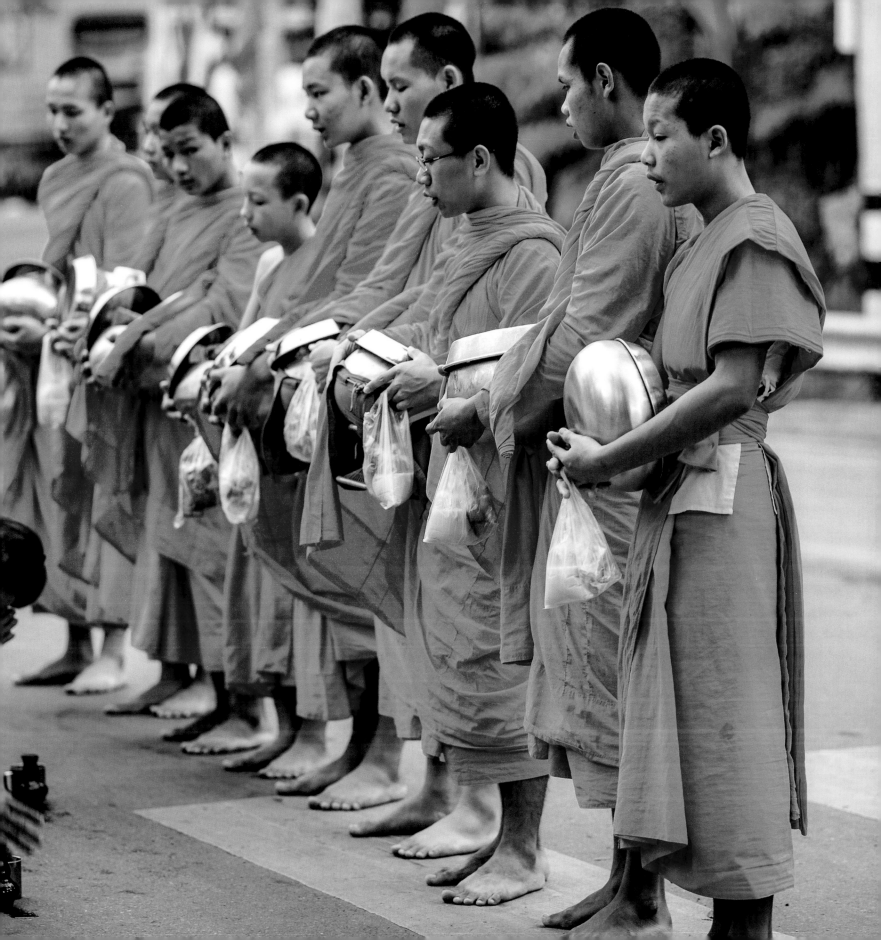

在泰北，可以感受更原始的泰國本土氣息。（左下）
遊客可在自然公園內體驗與大象互動。（左上）有機會
亦可前往神秘的「金三角」一遊。（右）

n Northern Thailand you are able to view Thai with less
sophistication. (Lower Left) The Elephant Nature Park
provides experiences of interacting with elephants. (Upper
Left) You can also travel to the "Golden Triangle" for
a glimpse at this secret area. (Right)

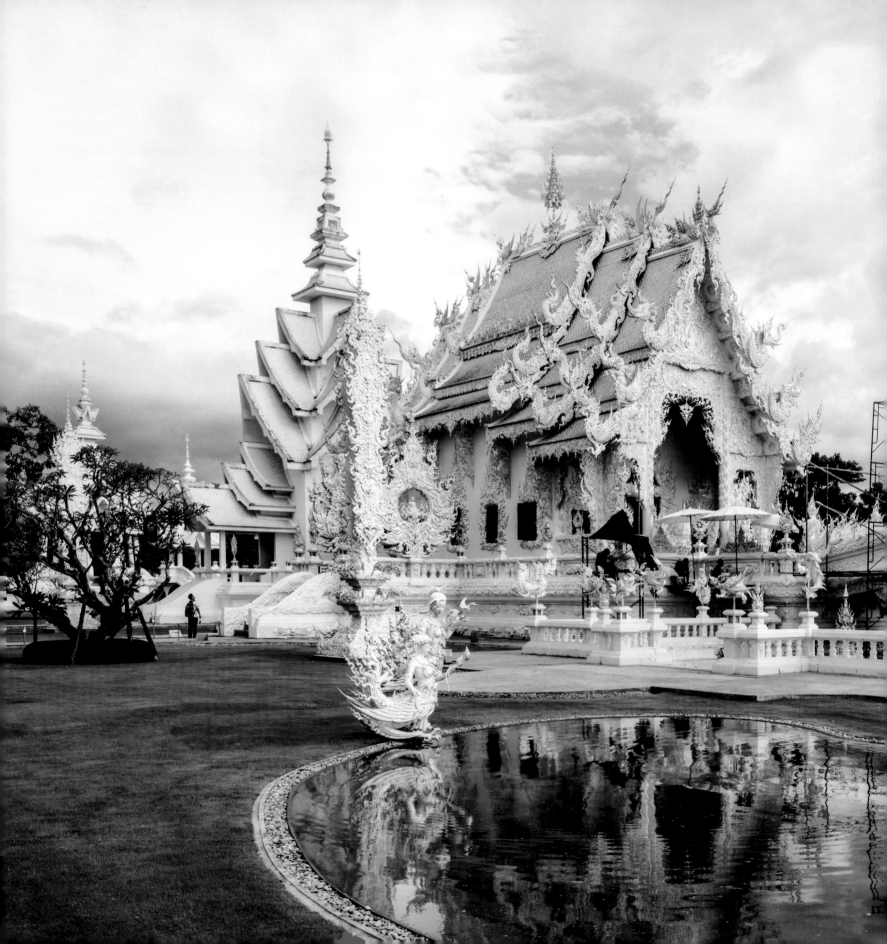

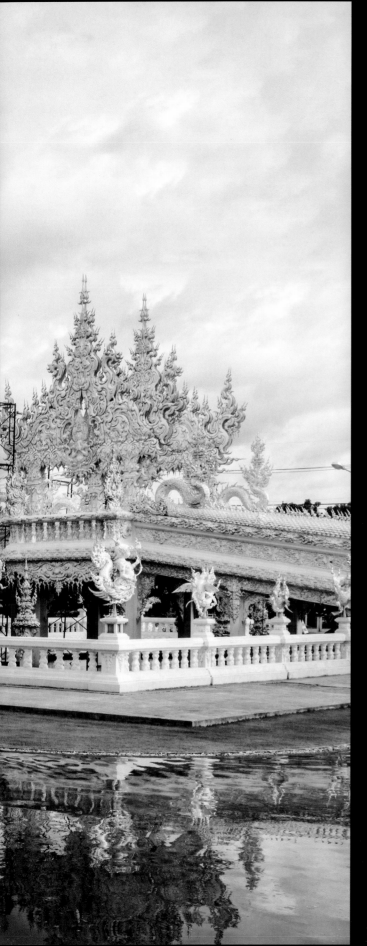

玻璃白廟又稱龍昆寺，與傳統佛寺的金碧輝煌截然不同，以純白為底，鏡面玻璃鑲邊，潔白無瑕，加以細膩的雕塑裝飾，完美融合了宗教及藝術元素。（左）泰國民族舞蹈服飾華麗，動作優雅，賞心悅目。（右）

The White Temple is also known as Wat Rong Khun. Being different from traditional golden-yellow Buddhist temples, this is a perfect combination of religious and artistic factors - an all-white building with embedded mirrored glass and ornate and exquisite carvings. (Left) Thai classical dance is pleasant to the eye, with resplendent clothing and elegant movements. (Right)

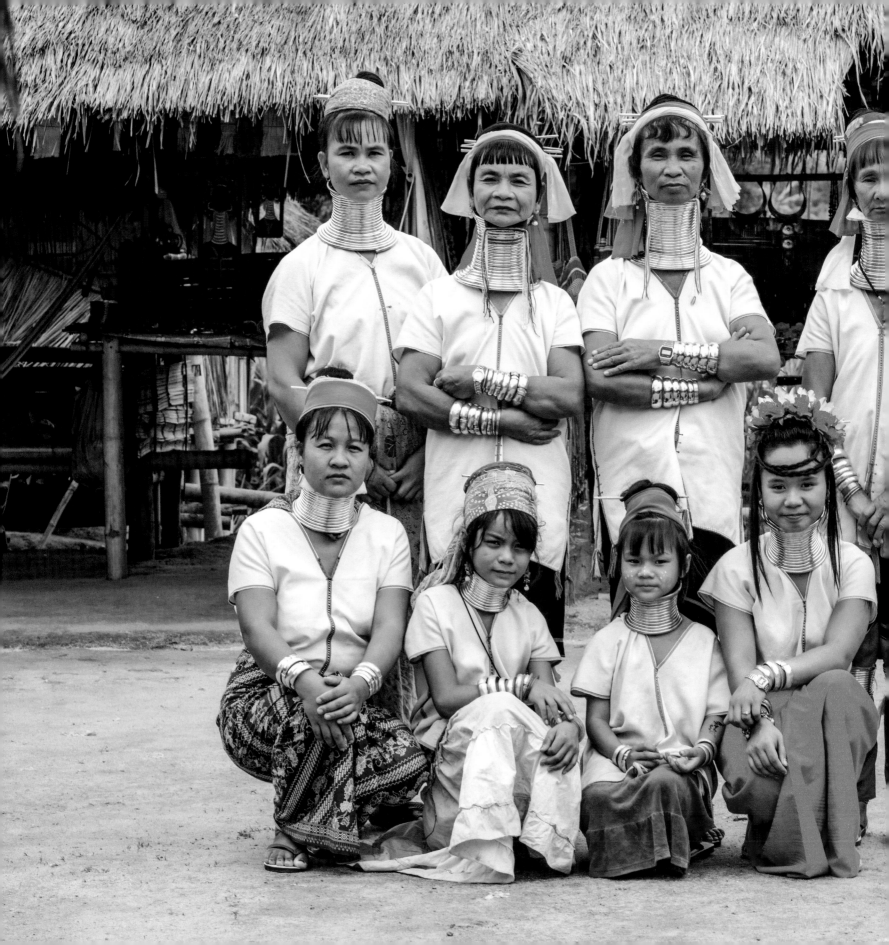

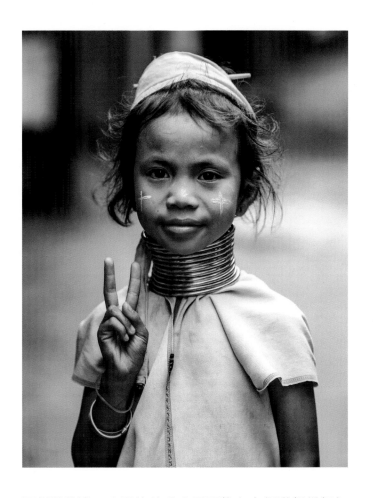

因躲避戰亂，克耶族的分支長頸族在上個世紀從緬甸遷徙到泰北定居。（左）在長頸族的傳統中，女性從五歲左右開始在脖頸上佩戴銅環，並隨著年齡漸長增加銅環數量。（右）

The Padaung tribe of the Kayan ethnic fled to the Thai border area due to conflict in Myanmar in the past century. (Left) Traditionally, Padaung women begin wearing copper neck coils from the age of five, and the coil number increases as they grow older. (Right)

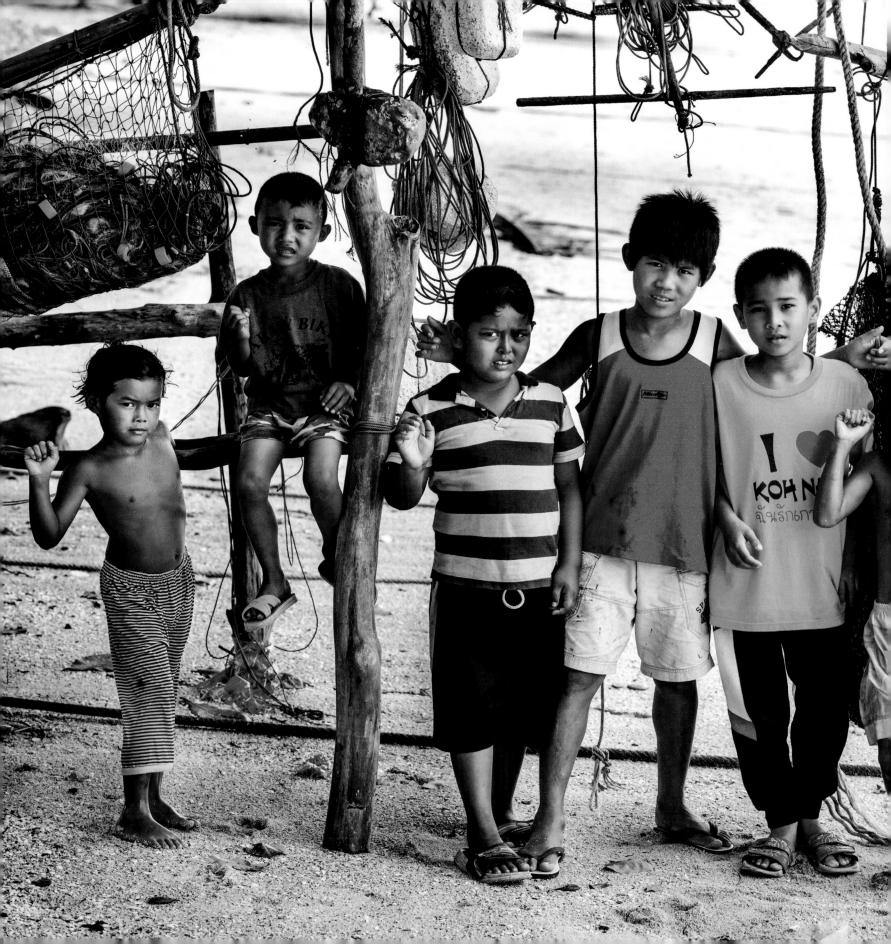

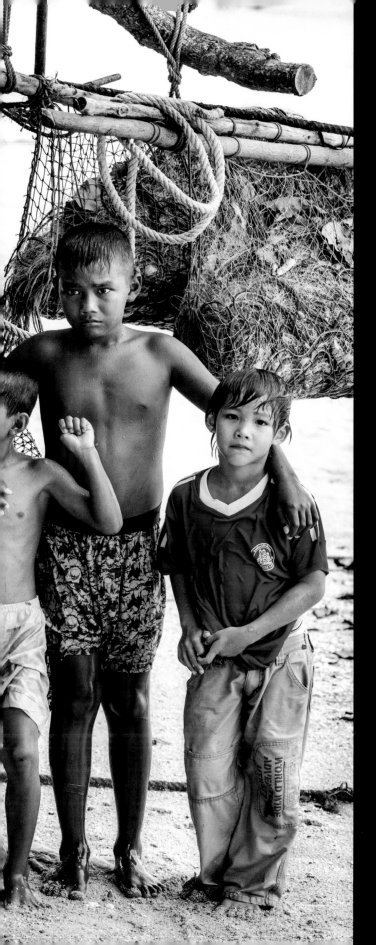

因長期生活在熱帶地區的海邊，當地的島民普遍皮膚黝黑，給人健康陽光之感。（左）在佛教盛行的泰國，練習瑜伽的民眾不在少數。（右）

Living in the seaside cities of the tropical area many islanders with tanned skins look healthy and bright. (Left) In Thailand where Buddhism is a predominant religion, yoga is popular among general public. (Right)

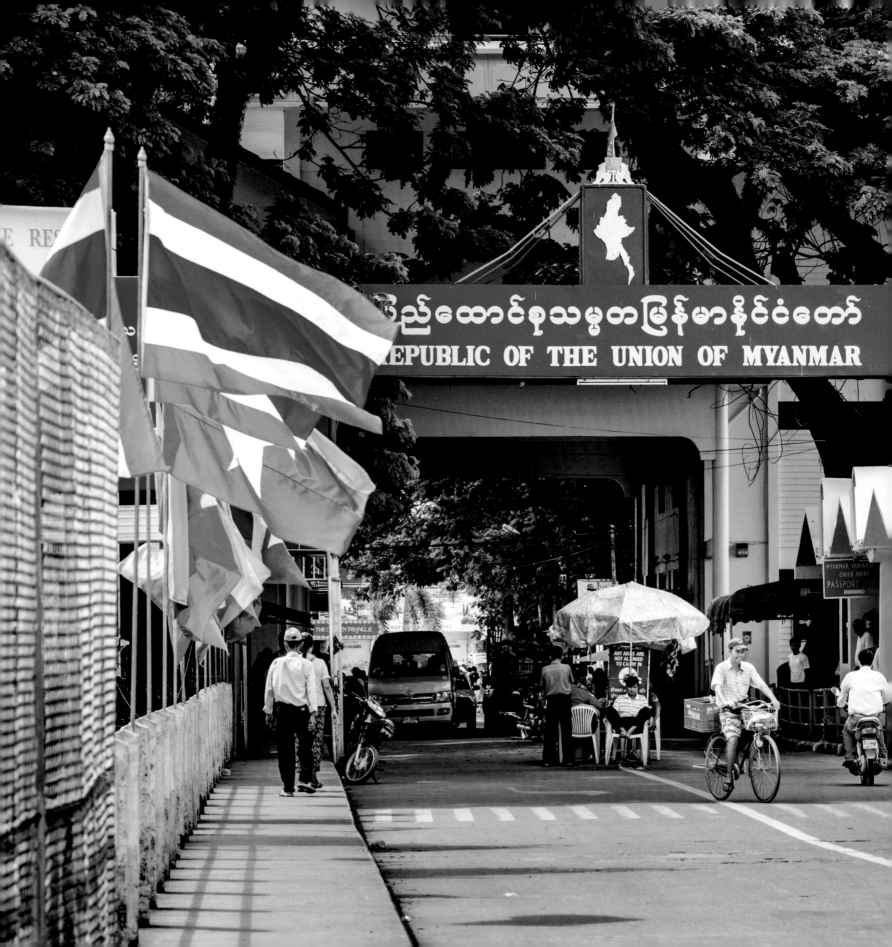

如果簽證齊全，不妨嘗試從泰國清邁經陸路入境緬甸。（左）緬甸境內，三輪車是十分普遍的交通工具。（右）

Travelers with proper visas can consider entering Myanmar overland from Chiang Mai, Thailand. (Left) In Myanmar, the three-wheeler is a popular transportation. (Right)

緬甸是東南亞國土面積第二大國，東北部與中國接壤，被聯合國認定為「最不發達國家」之一。2005 年，緬甸的首都由其最大城市仰光遷至內比都。

緬甸是世界上佛塔、寺廟最多的國度，被稱為「萬塔之邦」。緬甸人口當中，近九成為佛教徒，佛教佔據該國宗教的主導地位。在不少緬甸人的心目中，心靈信仰上的豐盛遠重要過物質生活，因此他們大多願意省吃儉用，把錢花在維修、興建佛塔或寺廟方面，從而造成了佛塔寺廟林立的景象。

在緬甸的街上，隨處可見穿著「籠基」的男人和穿著「特敏」的女人，色彩鮮艷的長裙成了緬甸一道道移動的風景線。

Myanmar is the second largest country in Southeast Asia in terms of total area, bounded by China at its northeastern lands. It is one of the "List Developed Countries" according to the United Nations. In 2005, the country's capital has been moved from its largest city Yangon to Naypyidaw.

Myanmar is regarded as the "Land of Golden Pagodas" due to its massive amount of Buddhist pagodas and temples. Buddhism is predominant in Myanmar, practiced by almost 90 percent of the country's population. In the minds of many Myanmar people, the richness of spirit and religion greatly outstrips that of material life. Therefore, many of them are willing to spend their money on maintaining or building pagodas and temples, instead of pursuing material pleasures. That's why there are so many Buddhist constructions nationwide.

On the streets of Myanmar, men in longyi and women in tamane can be seen everywhere. These colorful maxi skirts have created an exotic sight in the country.

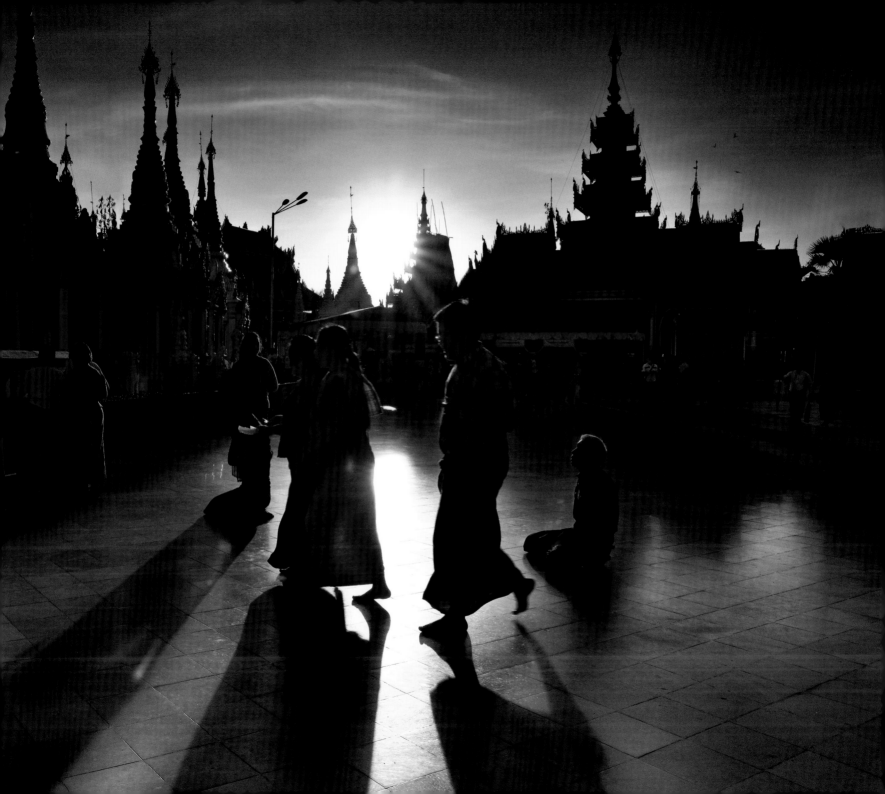

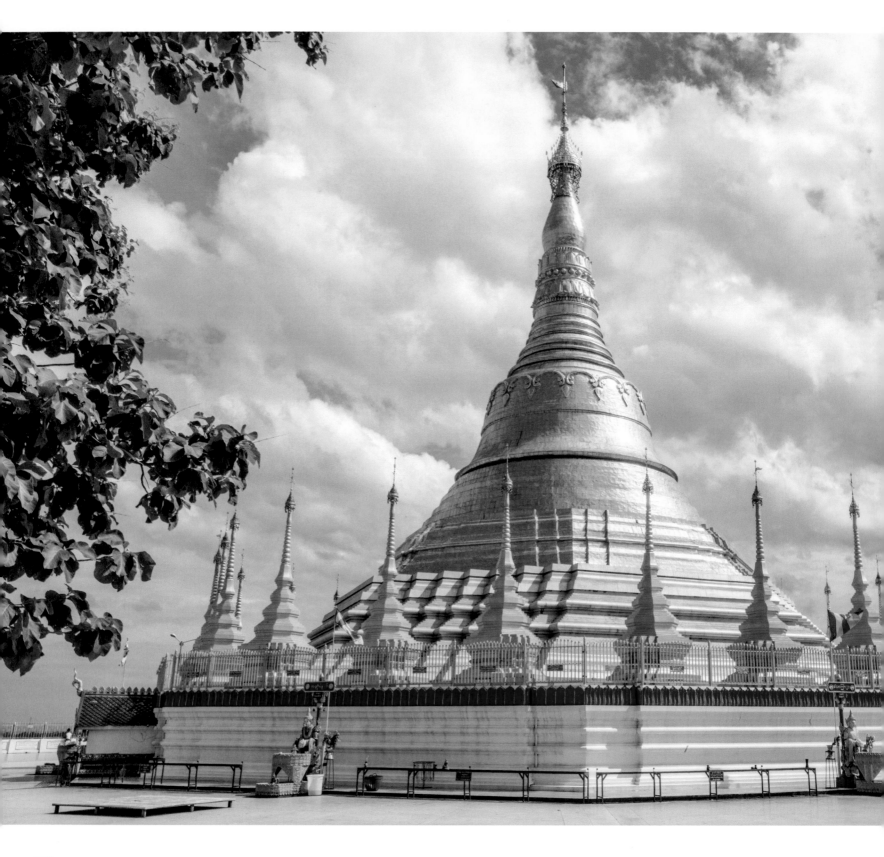

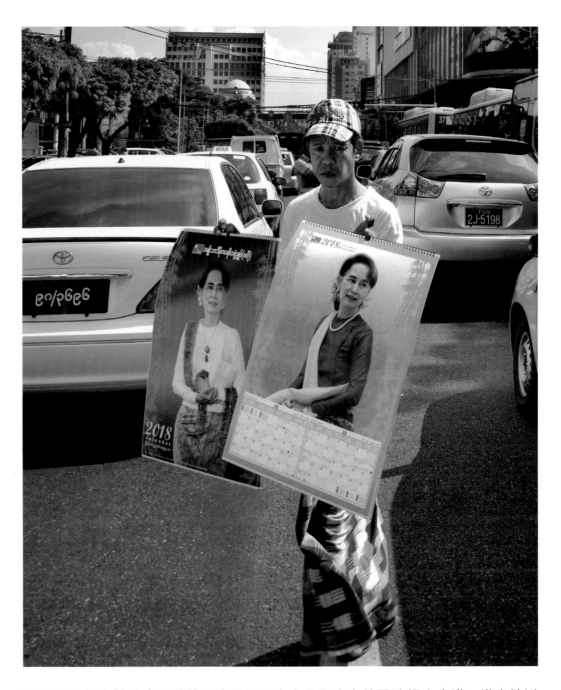

緬甸最具代表性的宗教建築，當屬仰光市中心聖山上的雪達根大金塔，塔高接近110米，極具氣勢。（左）街上可買到印有昂山素姬的掛曆。（右）

The Shwedagon Pagoda is considered the most representative religious constructions in Myanmar. Situated on the sacred Singuttara Hill at the center of Yangon, the pagoda is spectacular at almost 110 meters in height. (Left) Wall calendars with photos of Aung San Suu Kyi can be bought on streets. (Right)

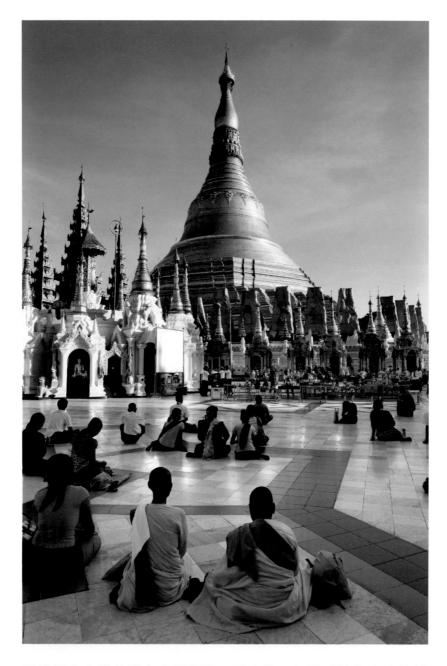

雪達根大金塔的塔身表面鋪著一層金箔，每日以神聖之姿迎接大批遊客及信徒。（左）緬甸的婦女兒童，經常在兩頰塗上有美容功效的檀娜卡。（右）

The magnificent Shwedagon Pagoda is rolled with gold, attracting large number of visitors and practitioners with its sacredness. (Left) Women and children in Myanmar apply cosmetic thanaka on their cheeks. (Right)

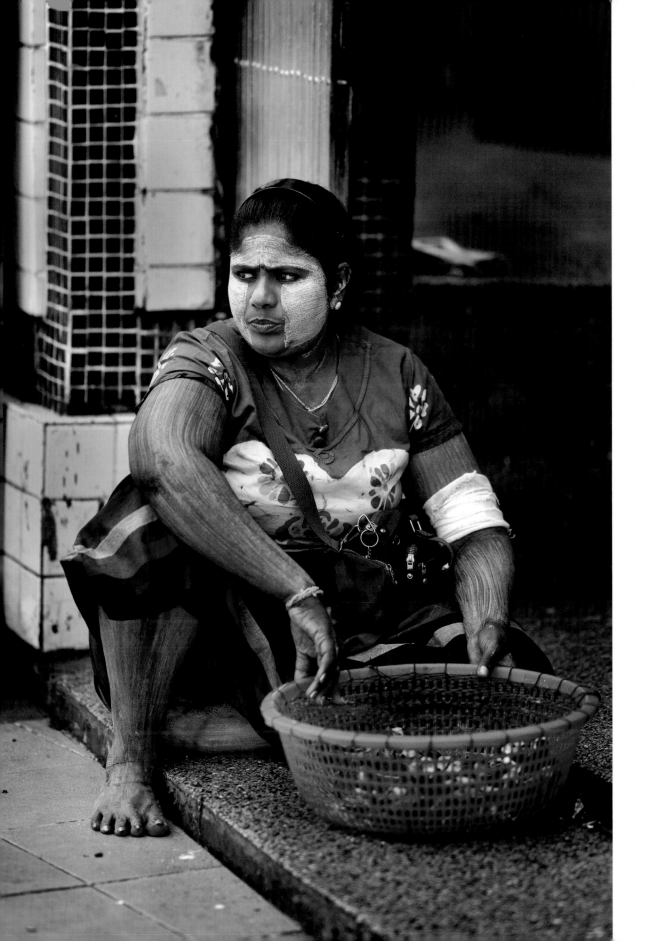

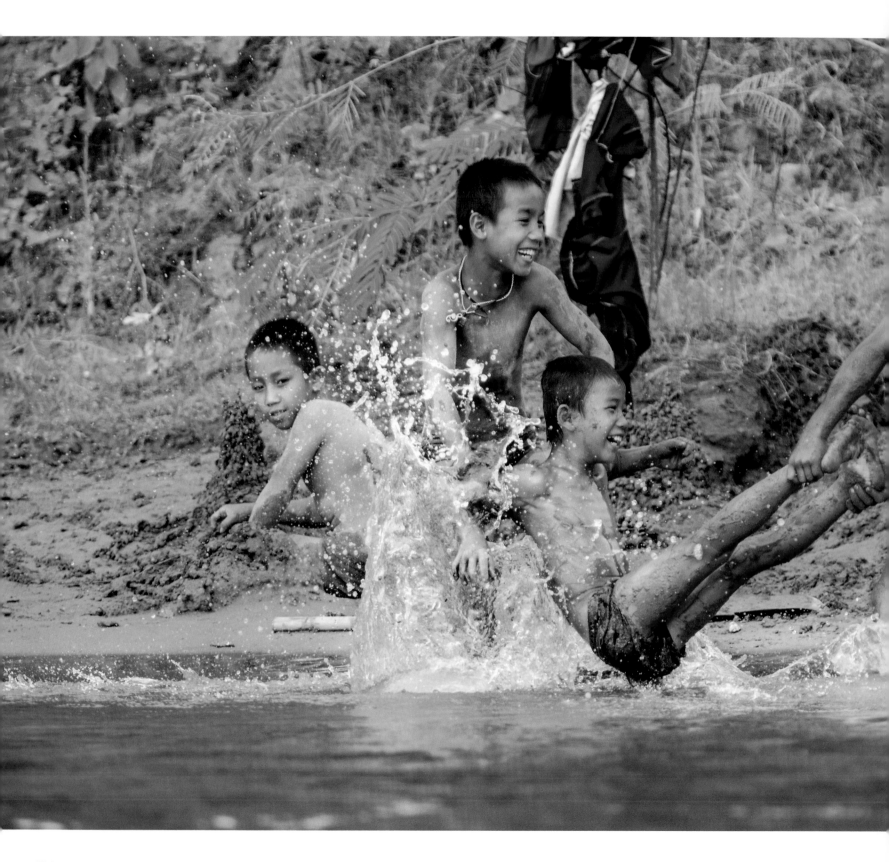

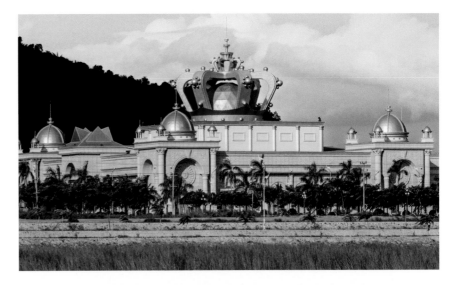

老撾是東南亞罕見的內陸國家，首都永珍。（左）2010 年，其政府成立了「金三角經濟特區」，開發豪華賭場、酒店、高爾夫球場等旅遊娛樂設施。（右上）目前該國正致力脫離最不發達國家行列。（右下）

Laos is, rarely, a landlocked country in Southeast Asia, with Vientiane being its capital. (Left) In 2010, the Lao government set up the Golden Triangle Special Economic Zone to develop tourism and entertainment facilities including luxury casinos, hotels, golf courses, and etc. (Upper Right) The country strives to graduate from the Least Developed Countries. (Lower Right)

越南地處東南亞的中南半島，曾是法國的殖民地，首都河內，最大城市為舊稱「西貢」的胡志民市。1986 年，越南開始推行「革新開放」，某程度上類似中國的「改革開放」。其後越南先後加入了東南亞國家聯盟（東盟）、亞洲太平洋經濟合作會議（亞太經合會）及世界貿易組織（世貿）。

Vietnam is on the Indochina Peninsula in Southeast Asia and was once colonized by French. Its capital and largest city are Hanoi and Ho Chi Minh City (formerly known as Saigon) respectively. In 1986, a policy called "Doi Moi" was implemented in the country, which was, more or less, similar to the economic reform of China. After that, Vietnam has joined the Association of Southeast Asian Nations (ASEAN), the Asia-Pacific Economic Cooperation (APEC) and the World Trade Organization (WTO).

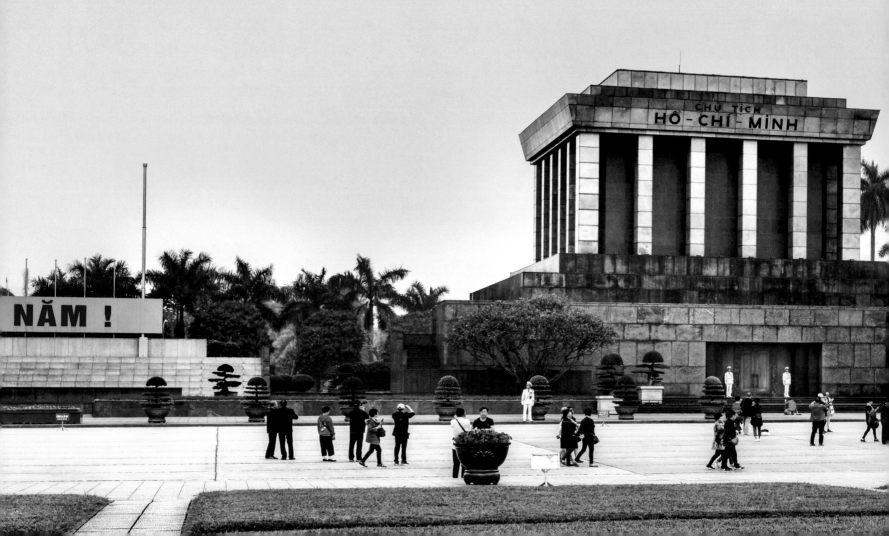

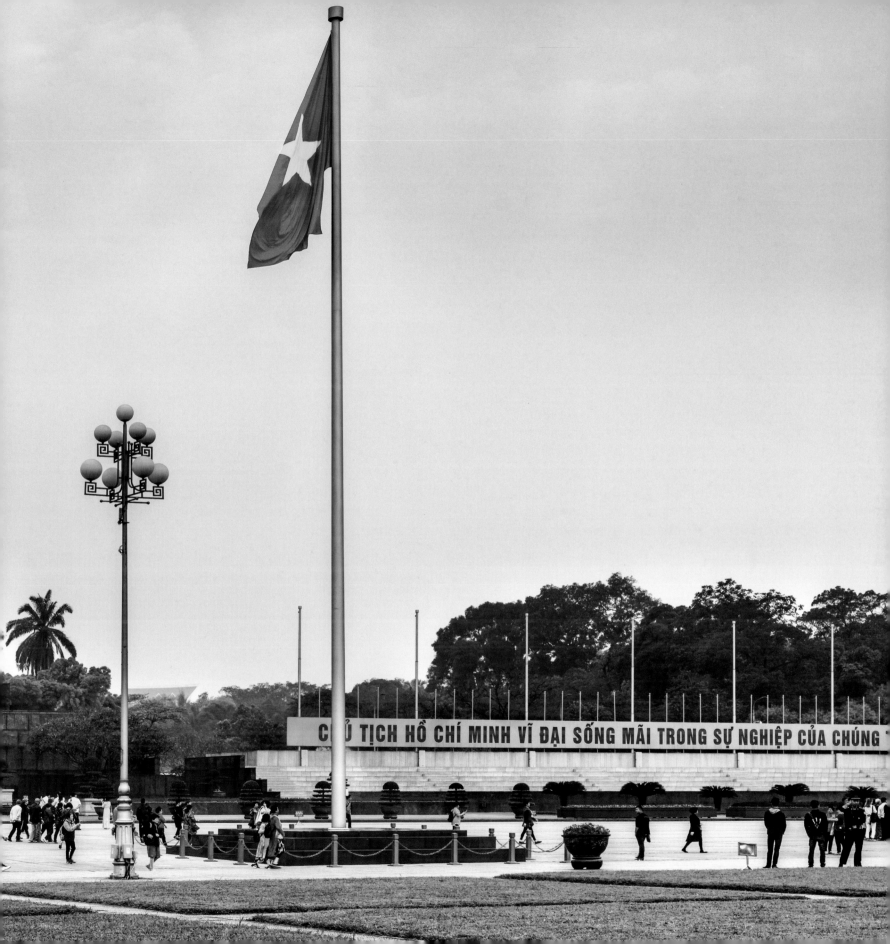

河內大劇院是新古典主義風格的典型建築，建於法國殖民期間。（左）鬧市中，各式各樣的汽車在身著淺棕色警服的交通警員指揮下，在街道上穿梭往來。（右）

Hanoi Opera House is of neoclassical architectural style, which was built during the French colonial period. (Left) On the busy streets, the traffic policewoman in tan-color uniform is commanding all sorts of vehicles, creating a never-stopping stream. (Right)

439

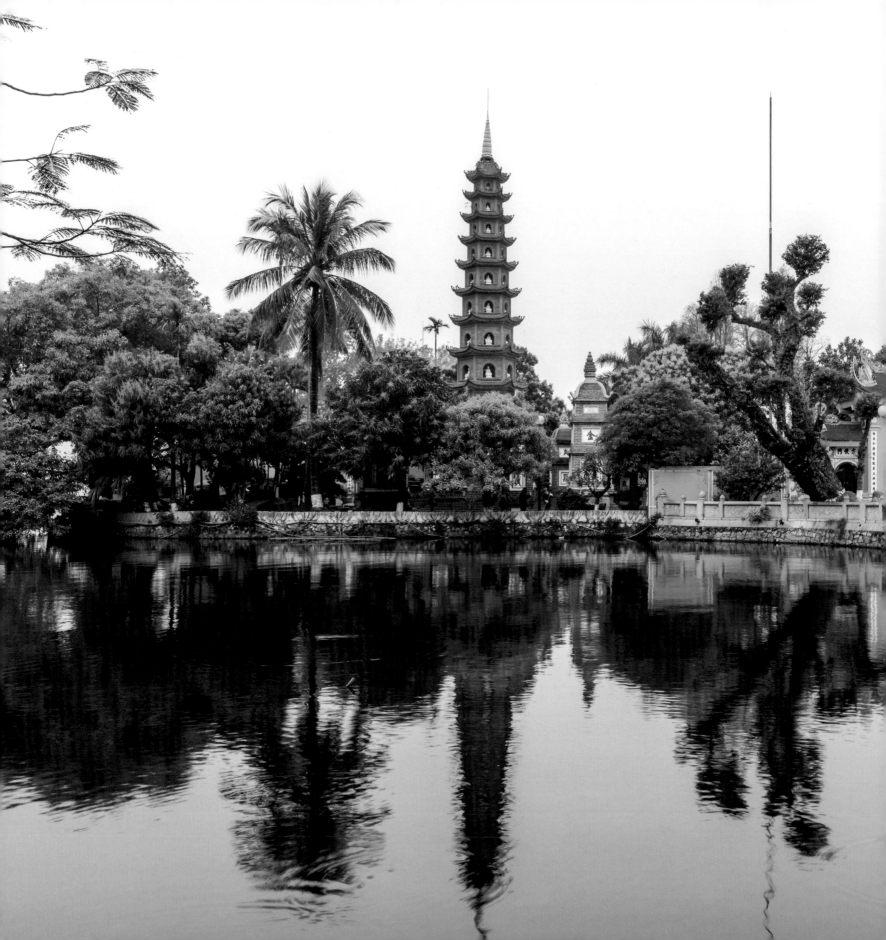

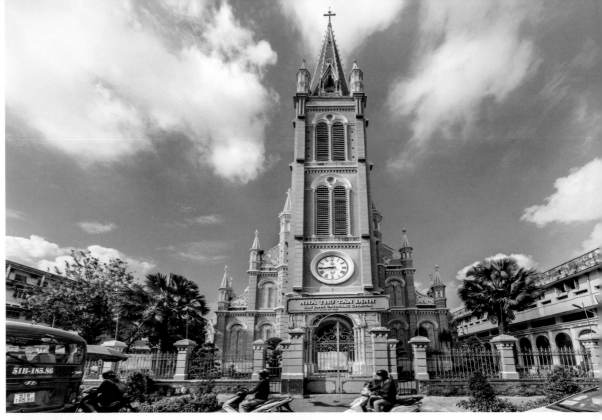

多宗教、多文化的環境，讓河內建築非常多元。耶穌聖心堂外表採用夢幻般的粉紅色。（右上）聖若瑟大教堂是傳統羅馬天主教的風格。（右下）鎮國寺是佛教寺院，具有中國古代建築風格。（左）

Diversity in religion and culture has created a versatile architectural style in Hanoi. The Church of the Sacred Heart of Jesus uses a dreamlike pink color on the exterior. (Upper Right) The St. Joseph's Cathedral is a traditional construction of the Roman Catholic. (Lower Right) The Buddhist temple Tran Quoc Pagoda is featured in ancient Chinese style. (Left)

441

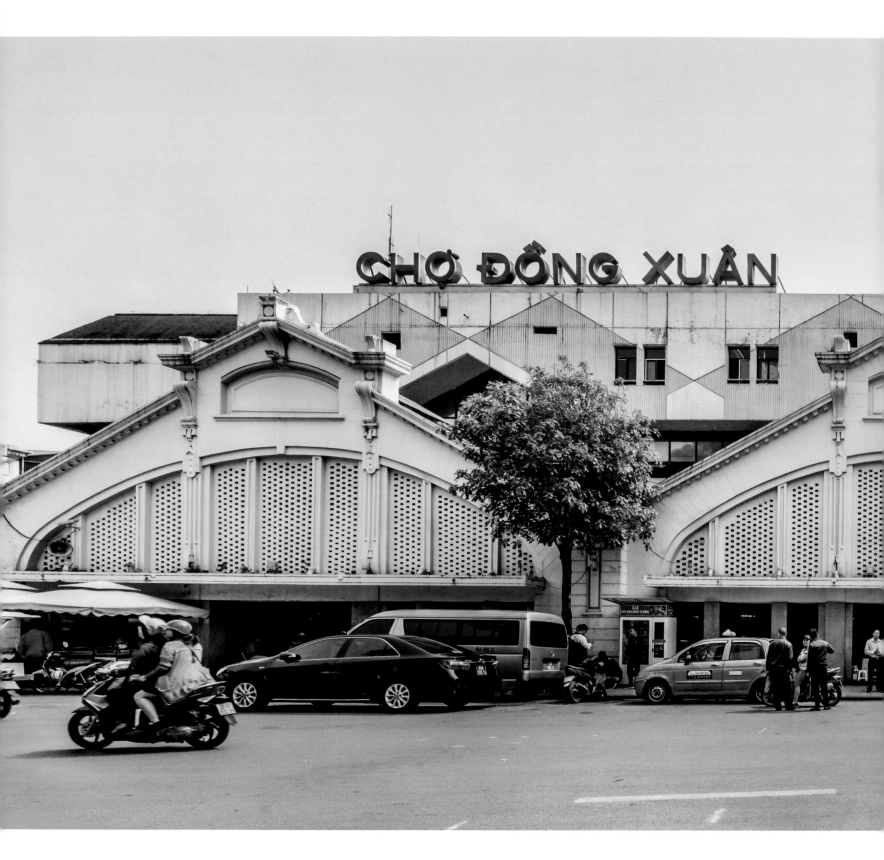

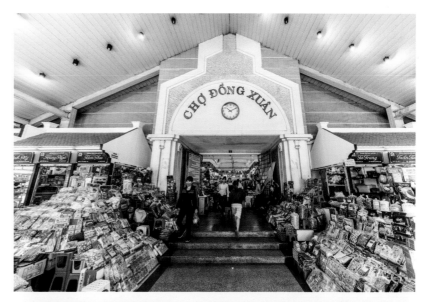

同春市場最初由法國殖民政府於 1889 年修建,現已發展為河內最大的室內市場。(左)因物美價廉吸引眾多本地人光顧,亦有不少遊客到此體驗當地特色。(右上)近年來河內亦湧現不少現代化百貨公司。(右下)

Hanoi's largest indoor market Dong Xuan Market was first built by the French colonial government in 1889. (Left) Its products, attractive in both price and quality, have drawn many local people, and its indigenous style is also appealing to tourists. (Upper Right) Many modern department stores sprang up in Hanoi in recent years. (Lower Right)

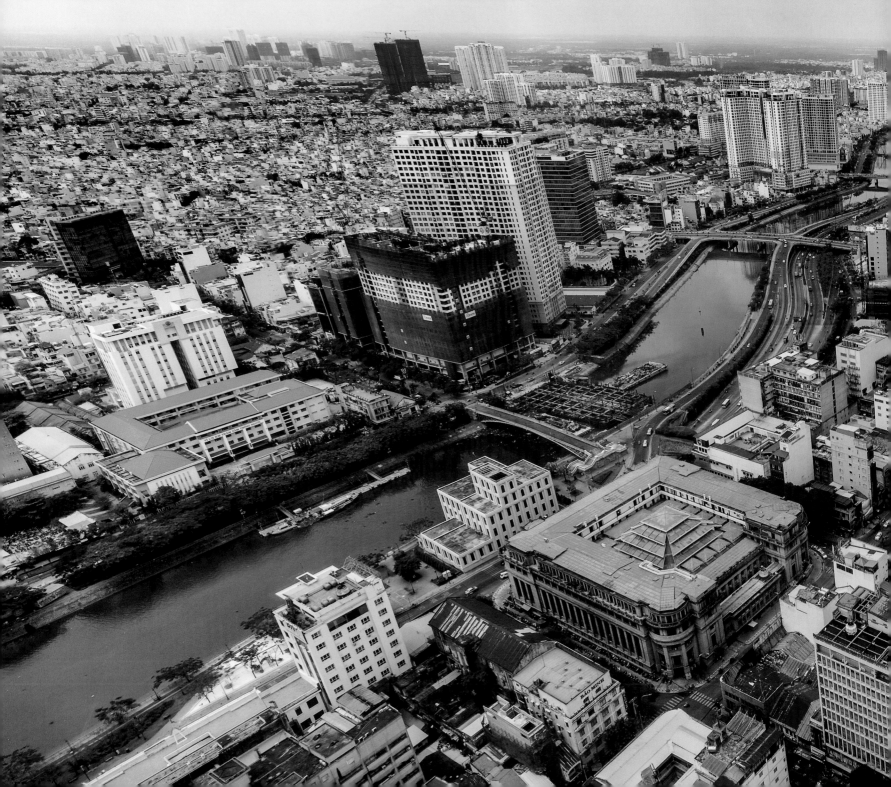

胡志明市素有「東方小巴黎」之稱，法國人為這座城市進行了城市規劃和現代化建設，形成如今車水馬龍的繁榮景象。

Ho Chi Minh City has always been granted as the "Paris of the Orient". The French had designed and modernized the city, and it is now a prosperous city crowded with people and vehicles.

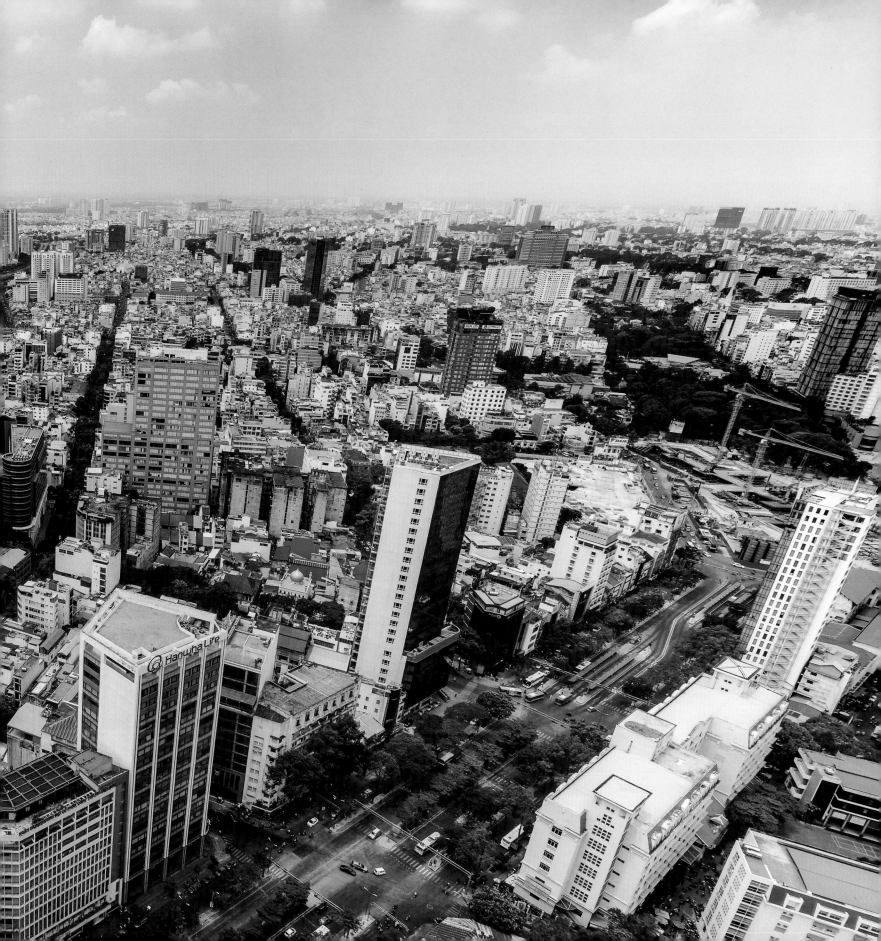

西貢中央郵局自 1892 年起正式啟用，建築風格充滿法式情調，與周遭環境相配合。（左）越南國民的身材普遍苗條，女士穿上傳統服飾奧黛，也是一條動人的風景線。（右）

Saigon Central Post Office opened officially since 1892, with a French architectural style echoing with its surrounding environment. (Left) Most Vietnamese are quite slim, making women in traditional Ao Dai appear to be beautiful and attractive. (Right)

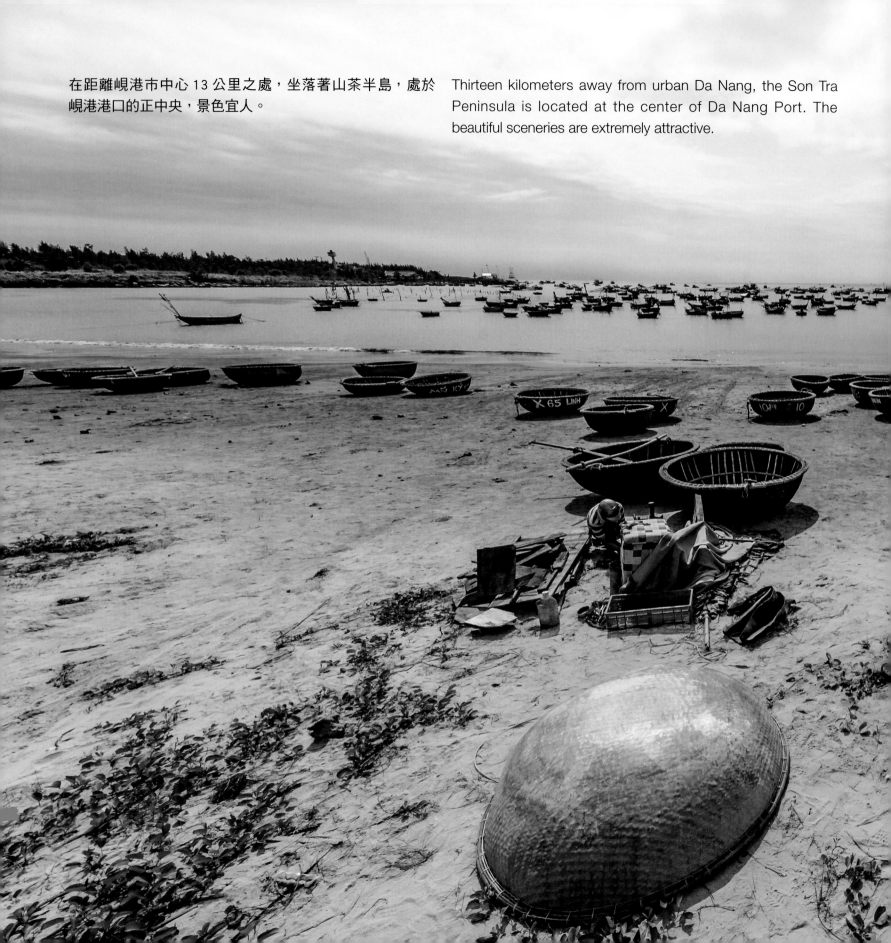

在距離峴港市中心 13 公里之處，坐落著山茶半島，處於峴港港口的正中央，景色宜人。

Thirteen kilometers away from urban Da Nang, the Son Tra Peninsula is located at the center of Da Nang Port. The beautiful sceneries are extremely attractive.

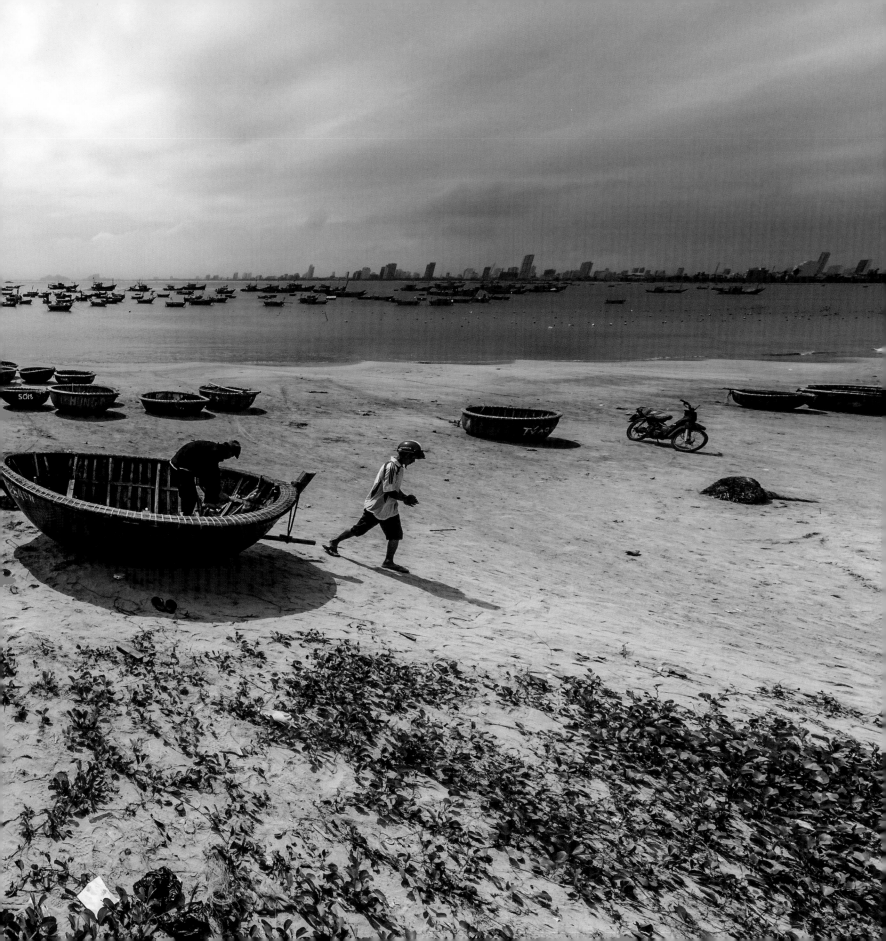

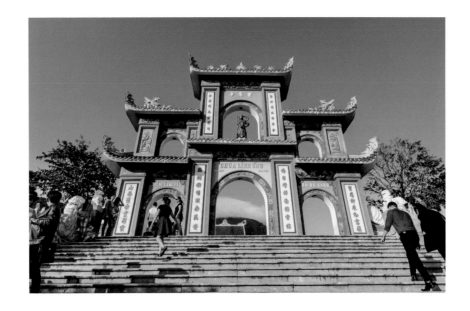

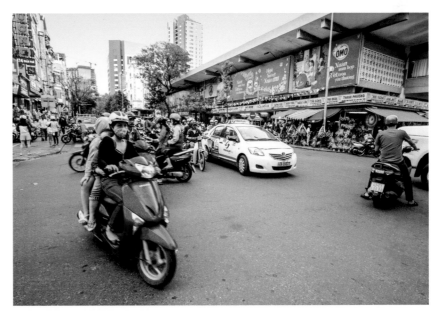

從城市化及經濟發展程度來看，峴港是越南第四大城市，僅次於胡志明市、河內市和海防市。（右下）靈應寺，位於峴港山茶半島之上。（右上）此處擁有東南亞最高的觀世音菩薩像，高67米。（左）

Da Nang is the fourth largest city in Vietnam after Ho Chi Minh city, Ha Noi and Hai Phong, in terms of urbanization and economy. (Lower Right) The Linh Ung Pagoda is located on the Son Tra Peninsula. (Upper Right) There sits the highest statue of Goddess of Mercy at 67 meters. (Left)

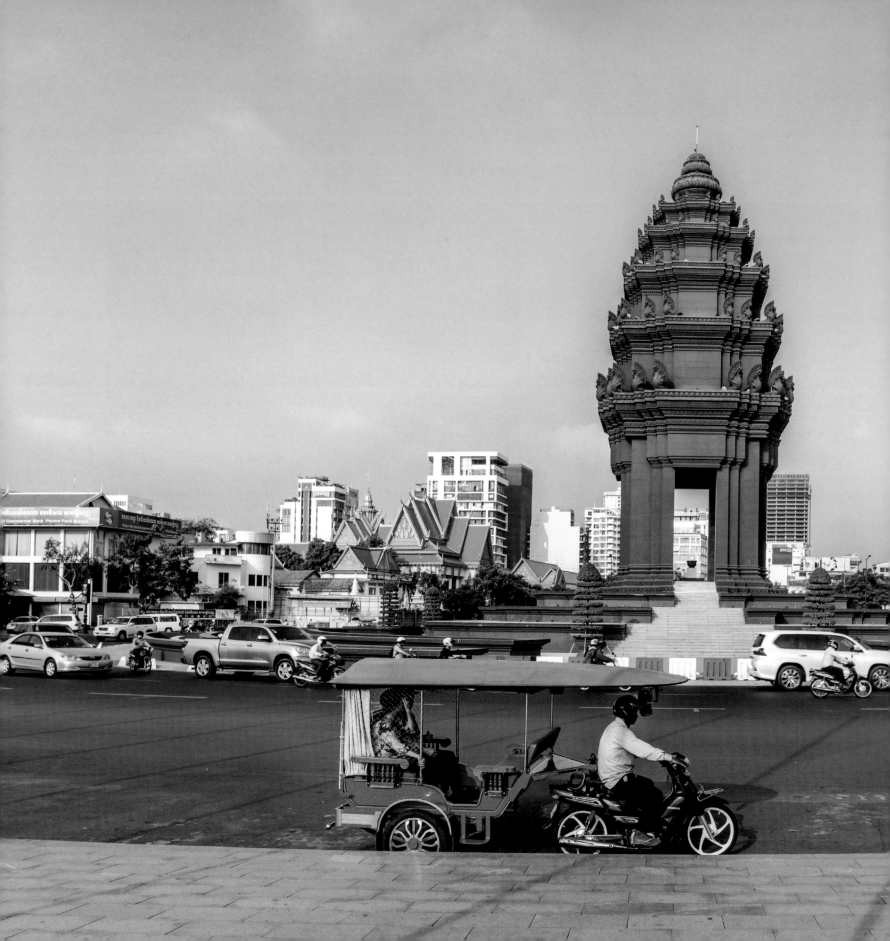

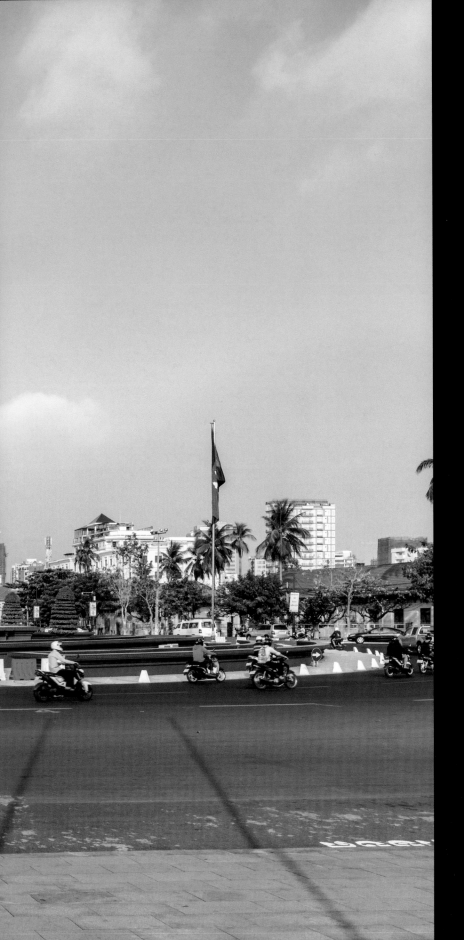

柬埔寨為東南亞中南半島之上一個歷史悠久的國家，早於公元 1 世紀已建立了統一的王國，舊稱高棉。

20 世紀 70 年代開始，該國經歷了長期的戰爭，直至 90 年代才進入穩定發展時期，工業基礎較為薄弱，被聯合國評定為最不發達國家之一。

金邊是柬埔寨首都，市內有一座獨立紀念碑，於 1958 年建成 紀念 1953 年 11 月 9 日該國擺脫法國殖民統治。

Cambodia is a country with long history on the Indochina Peninsula in Southeast Asia, with the historical Khmer Empire established in the first century. Phnom Penh is the capital as well as the largest city of the country.

Since the 1970s, the country went through a long duration of wartime. It was not until the 1990s did Cambodia enter a stable developing period. Therefore, the country has a relatively weak industrial base, and is listed as a Least Developed Country by the United Nations.

An Independence Monument was built in 1958 in Phnom Penh to memorialize Cambodia's independence from France in 1953.

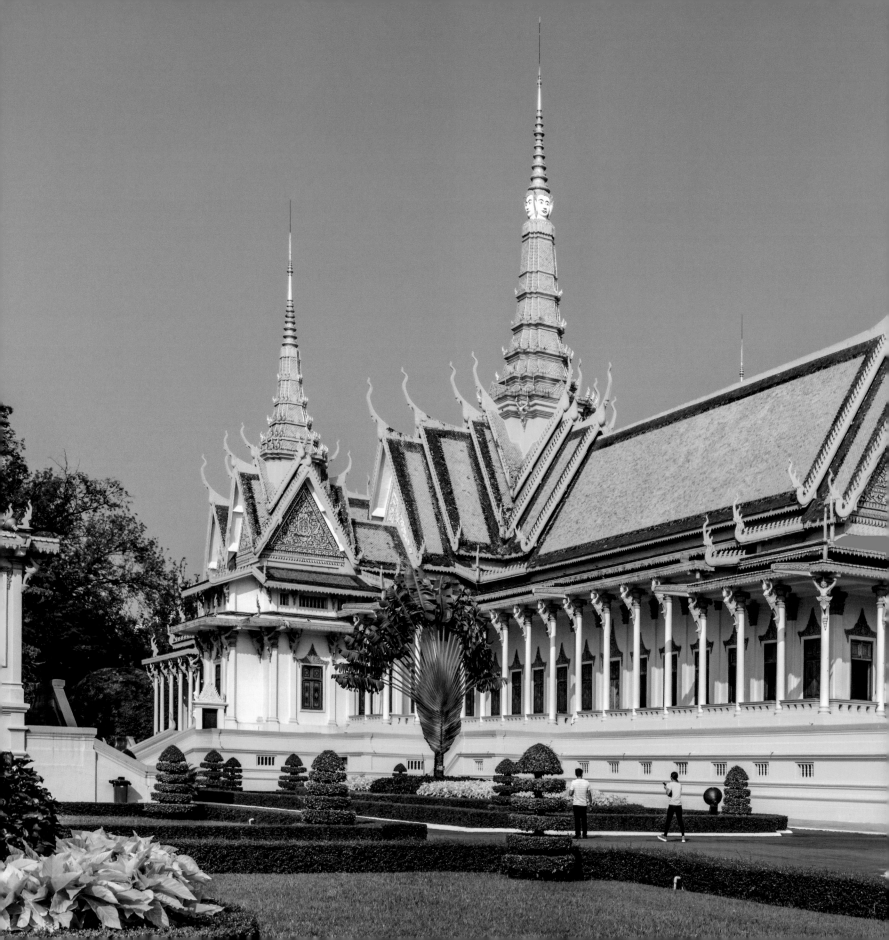

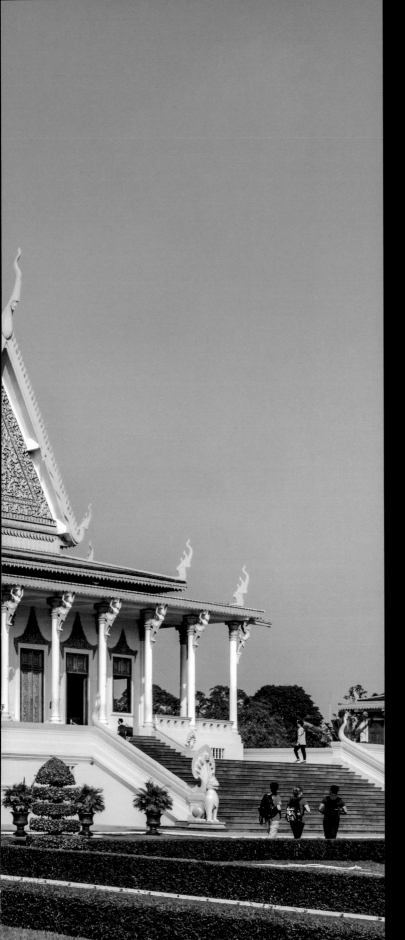

佛教是柬埔寨的國教，接近九成半國民為佛教徒。（右）
位於皇城南方的銀閣寺，亦稱玉佛寺，為王室寺廟。（左）

The official religion of Cambodia is Buddhism, practiced
by nearly 95 percent of its population. (Right) Located at
the south side of the Royal Palace, the Silver Pagoda,
also known as the Temple of the Emerald-Crystal
Buddha, is the temple of the royal family. (Left)

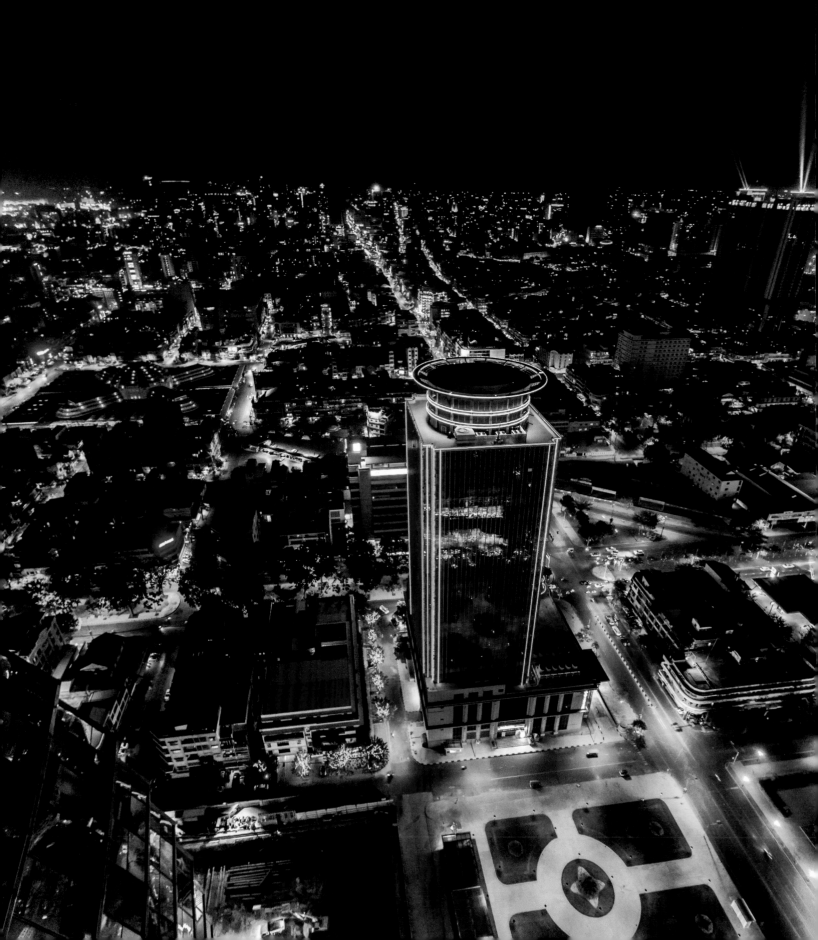

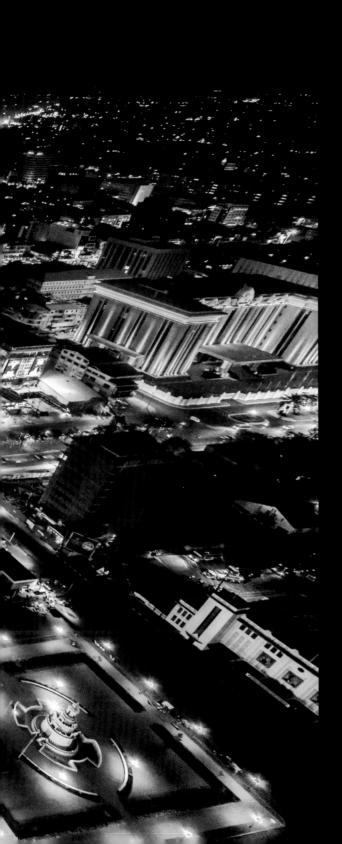

日間，遊客可前往金邊最大型的購物地——中央市場。（右上）此處建於 1935 年，由意大利人設計、法國人建造。（右下）當萬家燈火轉亮，夜景中的金邊亦美不勝收。（左）

In daytime, tourists can go shopping at the largest market in Phnom Penh – the Central Market. (Upper Right) It was designed by Italian and built by French in 1935. (Lower Right) When myriad twinkling lights sparkle in the evening, the night view of Phnom Penh is breathtaking. (Left)

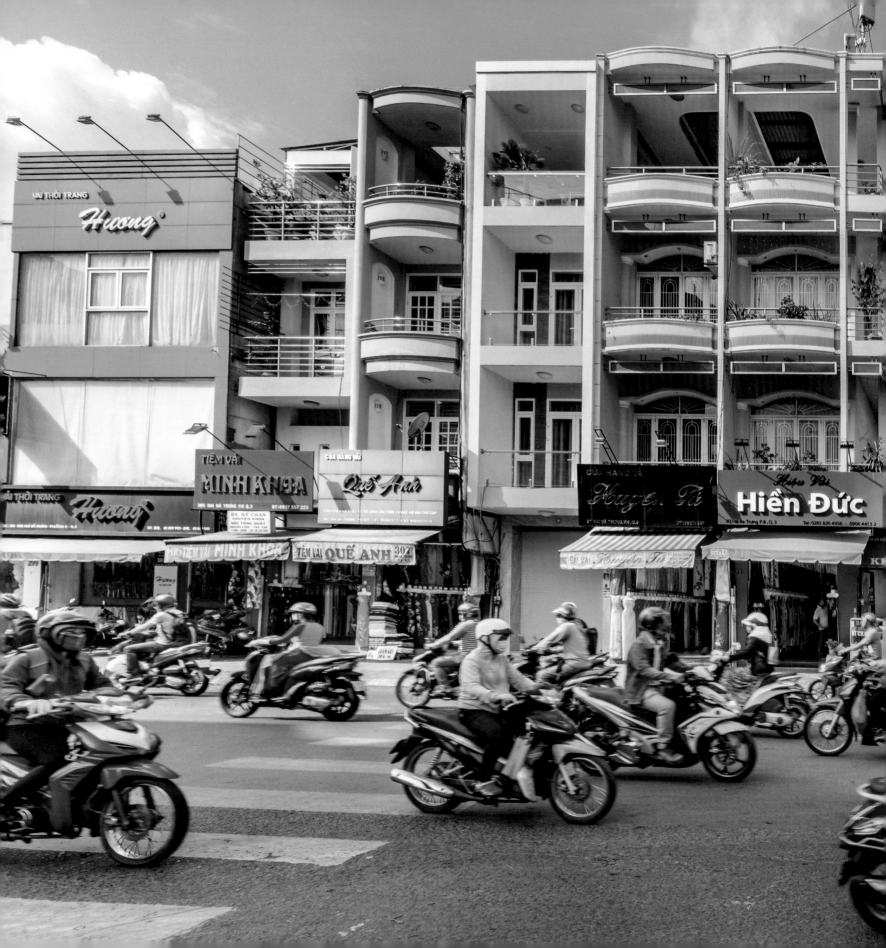

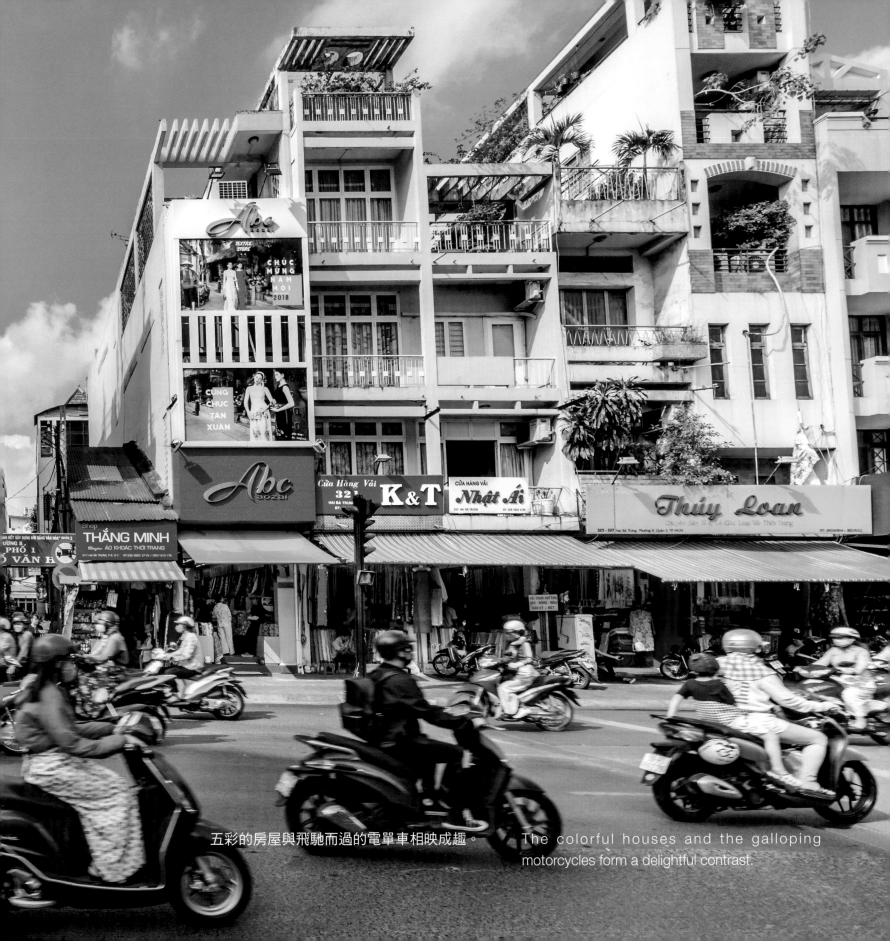

五彩的房屋與飛馳而過的電單車相映成趣。 The colorful houses and the galloping motorcycles form a delightful contrast.

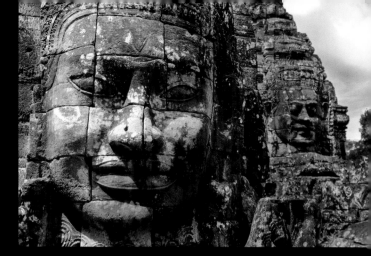

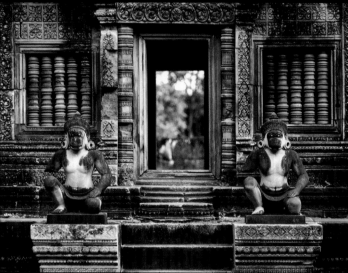

歷史上的吳哥王朝時期，高棉族人先後用了 400 餘年的時間，建造出超過 600 座大大小小的建築。吳哥窟是世界最大廟宇。（左）巴戎廟被稱為「高棉的微笑」。（右上）女皇廟的精美雕刻裝飾，顯示了古代高棉帝國的極高藝術造詣，讓人歎為觀止。（右下）

During the historical Angkorian period, the Khmer Empire used more than 400 years to build the Angkor with over 600 constructions. The Angkor Wat is the largest religious monument in the world. (Left) The Bayon temple is featured with its signature of "the smiling face of Khmer". (Upper Right) The elaborate decorative carvings on the walls of Banteay Srei are still exhibiting the highest accomplishment of the ancient Khmer Empire in arts. Visitors are easily lost in wonder by the extraordinariness of the relics. (Lower Right)

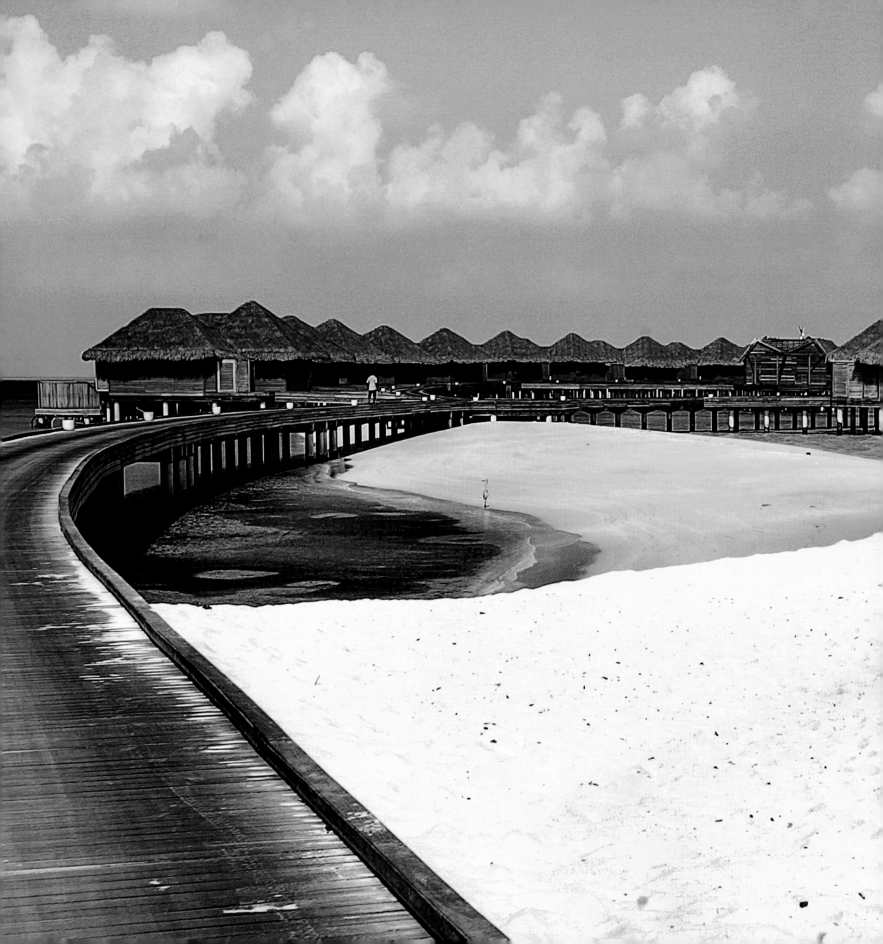

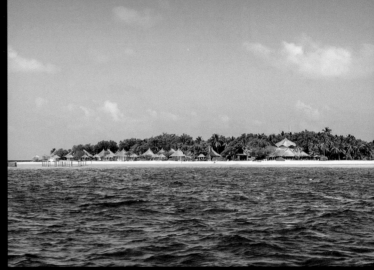

馬爾代夫是不少人心目中一生人總要去
一次的地方。（左）頭頂藍天白雲，腳踏細沙
綠水，被譽為人間天堂。（右）

Maldives, in the eyes of many people, is a
place to visit at least once in a lifetime. (Left)
With an azure sky and fleecy clouds, a blue
ocean adorned by soft sands, Maldives is
regarded as an earthly paradise. (Right)

# 非洲

無論從面積或是人口上來看，非洲都是世界第二大洲，僅次於亞洲。非洲是世界古人類和古文明的發源地之一，在此有著世界最大的浩瀚沙漠撒哈拉，有著廣袤無垠的熱帶草原，棲息著無數形態各異的野生動物。一直以來，非洲作為一片尚保留著原始自然氣息的土地，都給人以神秘的印象。

雖然非洲與中國的距離相去甚遠，然而出人意料地，在古代交通並不發達的情況下，海上絲綢之路的航線離開東南亞區域之後，一路經過印度洋，抵達了非洲東海岸。至此，這條貿易通道或是沿著海岸線南下，到達肯亞等國，或是穿過狹長的紅海，抵達地中海區域，並與陸上絲綢之路交匯於歐洲。

有了歷史的基礎和前提，現代中國提出的「一帶一路」倡議，自然延伸至非洲大陸，亦得到了不少非洲國家的支持及響應。中國政府近年積極協助非洲地區發展，投資逾千億美元幫助推動當地的鐵路、公路、橋樑、港口、電力、通信、工業園區等的興建，非洲可謂是「一帶一路」進度及成果最為顯著的地方。

在基礎建設得到逐步完善之後，相信非洲將會迎來嶄新的機遇，從而亦能推動「一帶一路」的整體規劃發展，迸發全新的經濟增長動力。

肯亞
Kenya

埃及
Egypt

Africa is the world's second largest continent after Asia in terms of land area and population. The continent is the one of the birth lands of prehistoric primitives and ancient civilizations. It is home to the world's largest hot desert and the boundless savanna where various species of wildlife accommodate. For quite a long time, this piece of land, with the raw style of nature, has been mysterious in people's mind.

Although being distant from China, Africa was by no means inaccessible. Despite the under-developed transport, the ancient Maritime Silk Road still made its way from the Southeast Asia to the Indian Ocean and finally to the east coast of Africa. From there, the trade route further divided into two directions: one went down along the coastline to Kenya and other countries, the other headed north and passed through the Red Sea to reach the Mediterranean and converge with the land way Silk Road at Europe.

With historical background, the current Chinese government has naturally included Africa into the Belt and Road Initiative. Many African countries respond actively to the proposal. In recent years, Chinese government has been constructive in helping the development of Africa. Investments worth more than tens of thousands of US dollars have been injected into local construction of railways, highways, bridges, ports, electric system, telecommunications, industrial parks, and etc. In a way, Africa embraces the most fruitful achievements brought by the Belt and Road.

It is believed that as the infrastructures gradually refine and improve, Africa is expecting numerous brand new opportunities. These opportunities will, in turn, push forward the progress of Belt and Road and create a power in economic growth.

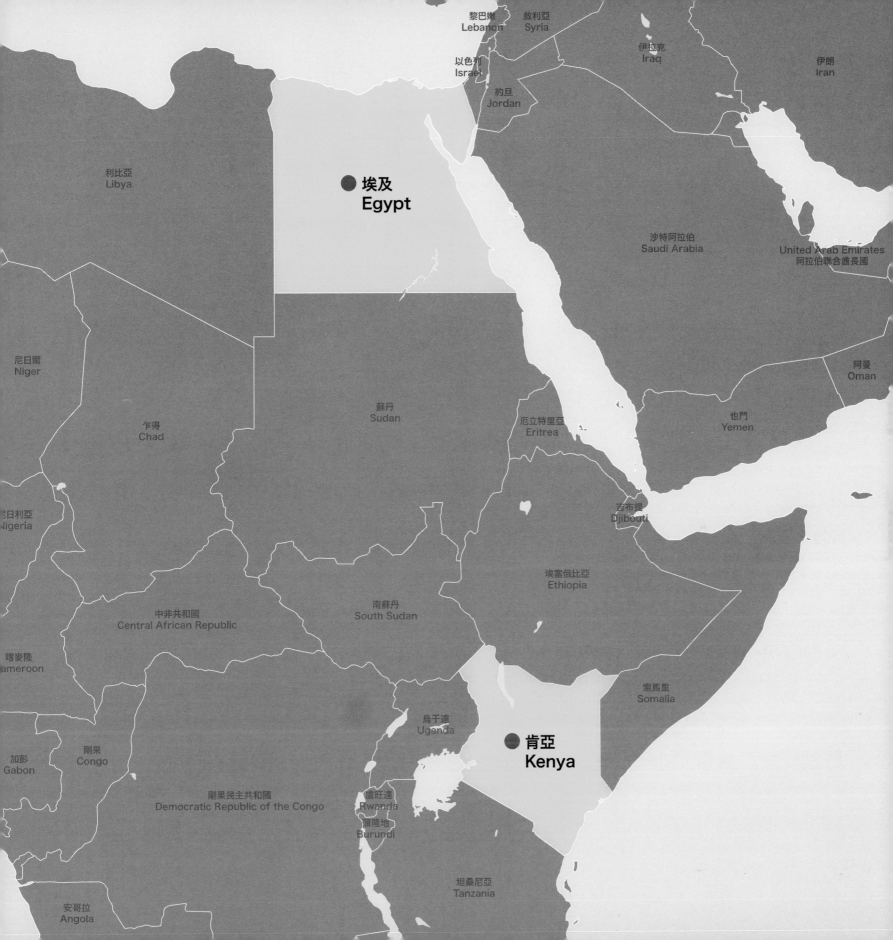

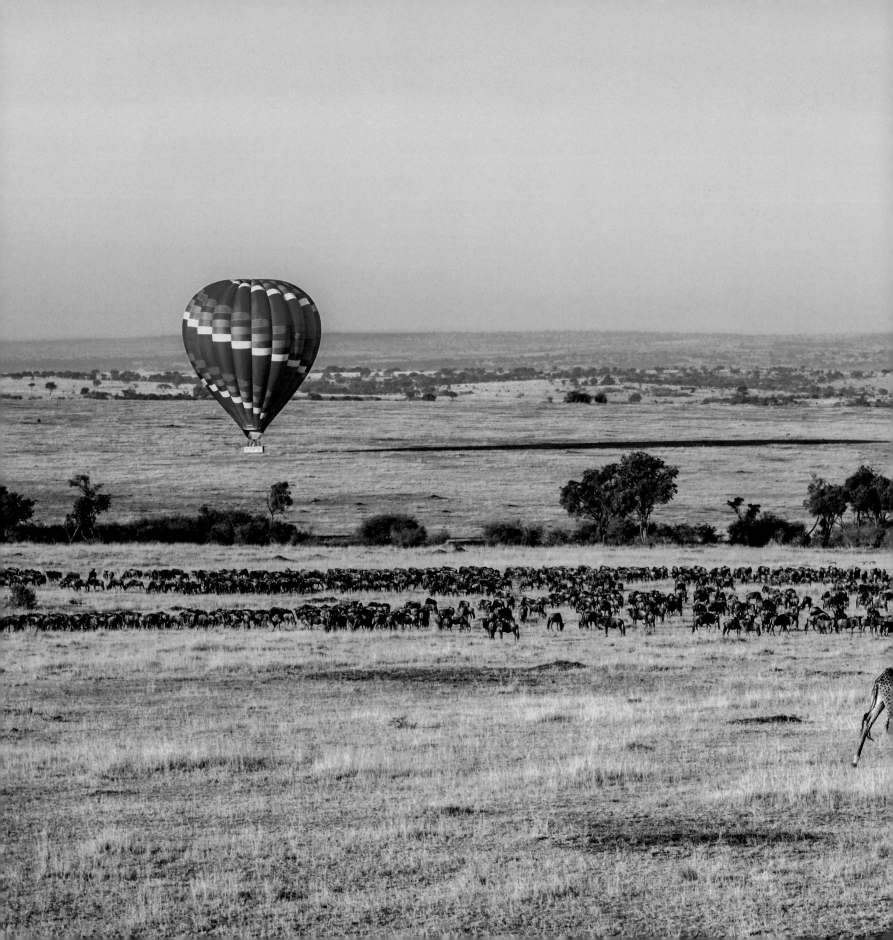

肯亞位於非洲東部，擁有廣袤的熱帶草原、綿延的山區以及迷人的海灘，首都為奈羅比。在高空之上，可以俯瞰廣闊無垠的大草原，因此不少旅客都會選擇登上熱氣球一覽景色。

Kenya is an Eastern African country with vast savannah, stretching and winding mountains and charming beaches. Nairobi is the capital of Kenya. The view of the boundless savannah is magnificent from above. This is why most visitors here would choose to take the hot air balloon to admire the superlative picture.

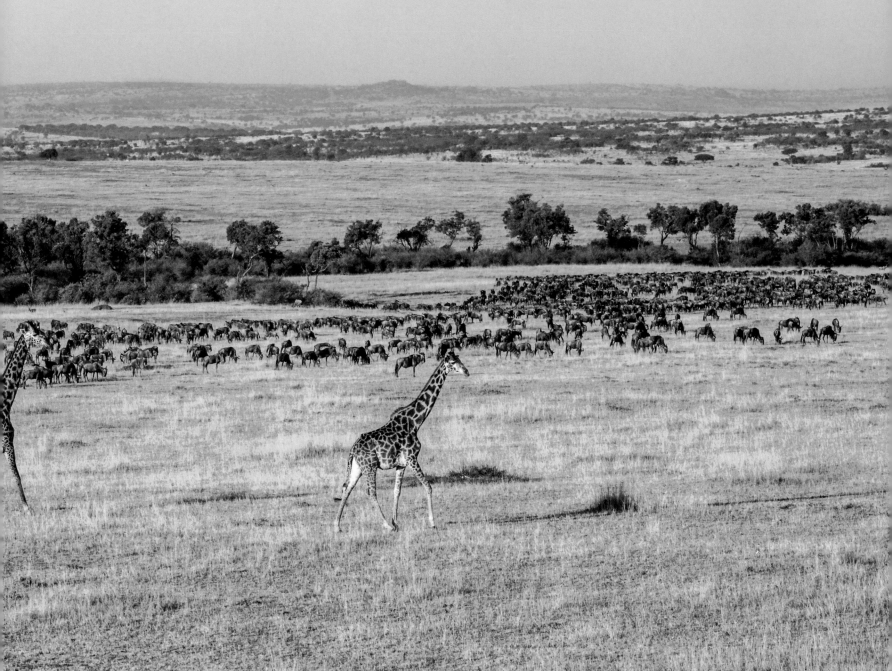

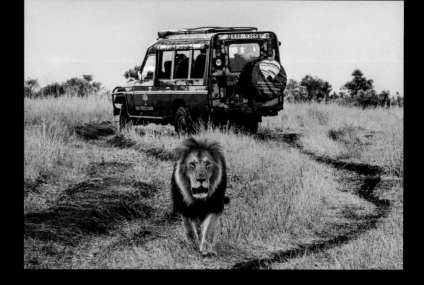

非洲狩獵旅行經過數十年的發展，成為熱門旅遊項目。（右上）保護區內餐飲設施正逐步完善中。（右下）在動物大遷徙期間，無數攝影愛好者都會前往一展身手。（左）

Safari in Africa, after decades of development, has become a popular tourist attraction. (Upper Right) The dining facilities within the reserve is getting better and better. (Lower Right) The savannahs are especially crowded during the period of great migrations, for thousands of photographers would gather and try to capture the precious moments. (Left)

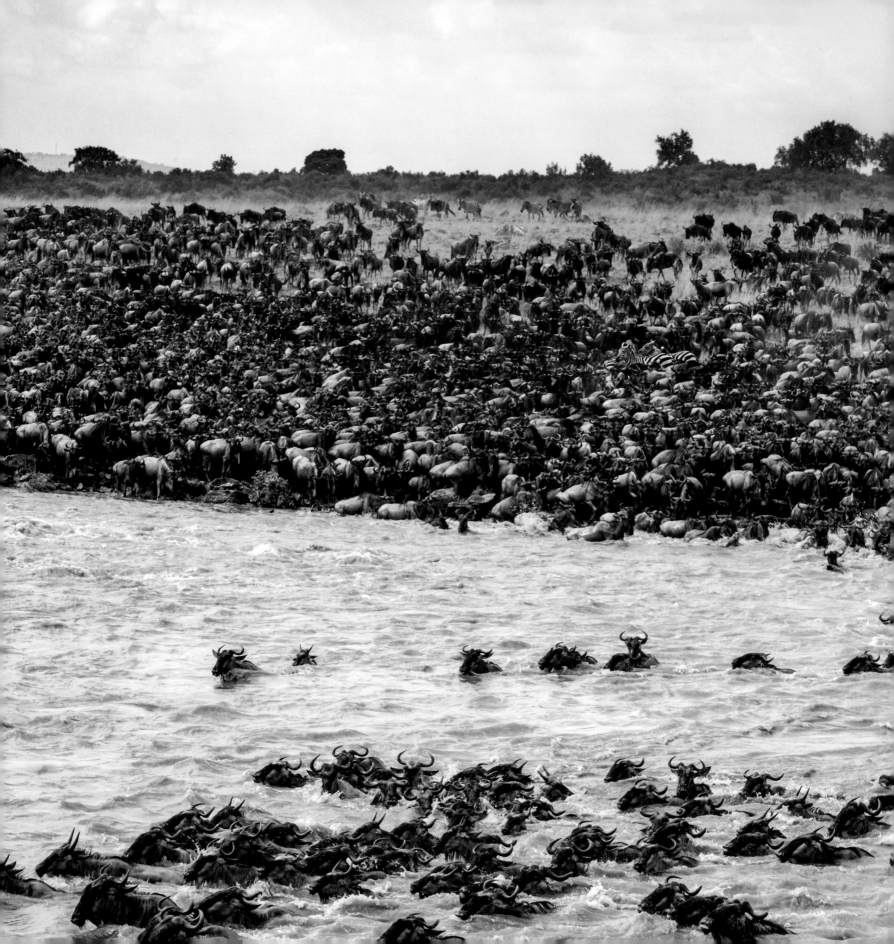

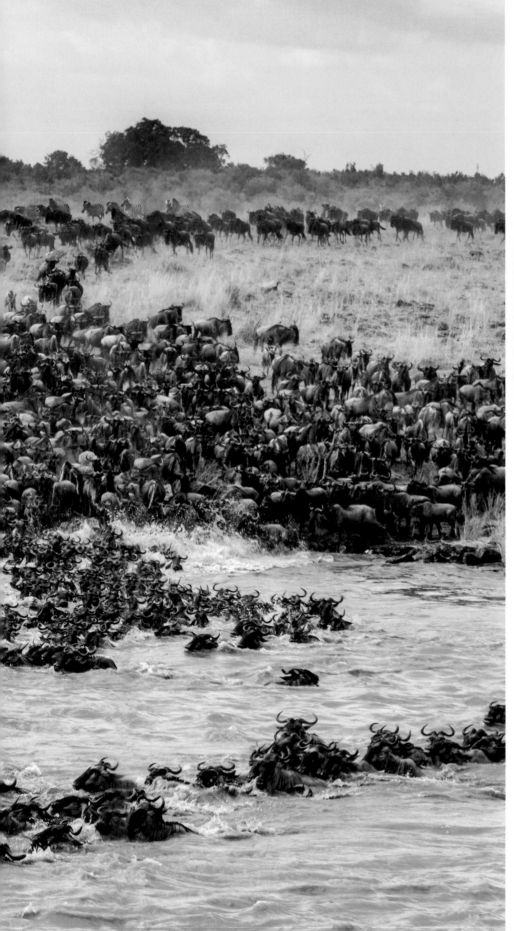

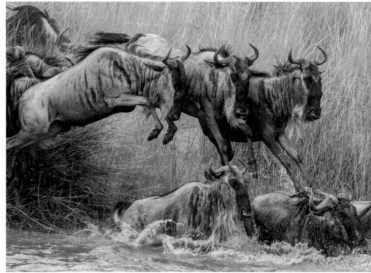

每年 7-9 月，馬賽馬拉草原都會上演百萬動物大遷徙的壯觀景象。(左)角馬在渡河時須對鱷魚保持警惕，但很有趣的是，河中的河馬擔當著渡河動物的保護者角色。(右)

Every year, from July to September, hundreds of thousands of animals will put on a spectacular performance of great migrations on the Maasai Mara. (Left) Interestingly, the wildebeests are strongly vigilant to the sudden attacks from the crocodiles when they cross the river, while the hippos act as the protectors of the migrating animals. (Right)

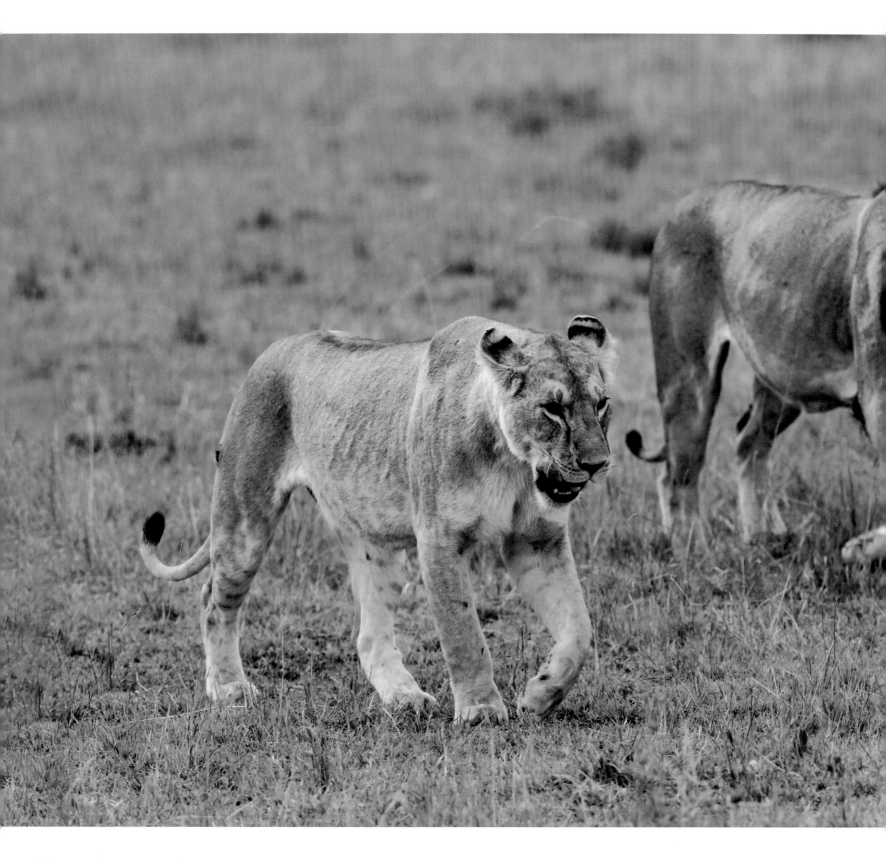

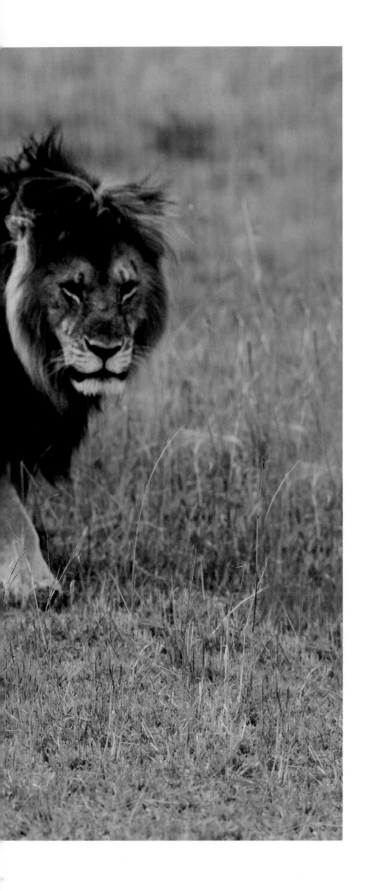

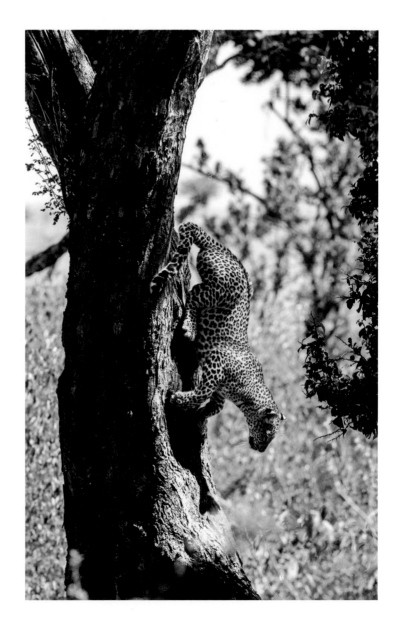

非洲「五大獸」指世界上最為危險、最難獵殺的五種動物，包括獅子、花豹、大象、犀牛和非洲野牛。（左）花豹慣於埋伏於樹上，伺機而動。（右）

Lions and leopards both belong to the "Big Five" - the five most dangerous and difficult-to-hunt animals in Africa, also on the list are rhinos, elephants and African buffalos. (Left) It is a habit of leopards to stay on trees and wait in ambush. (Right)

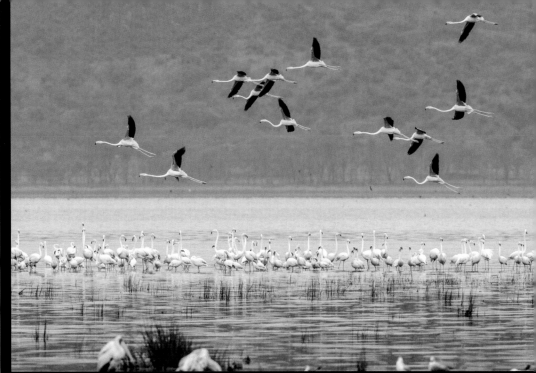

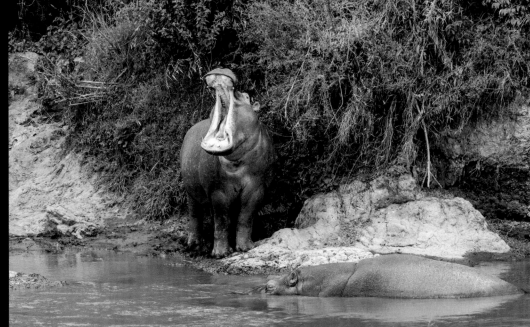

溫馴可愛的小鹿在森林中漫步。（左）優雅美麗的紅鶴展翅
於空中。（右上）作風粗獷的河馬棲息在水裡。（右下）

A tame fawn is wandering in the forest. (Left) The elegant flamingos
are flying in the sky. (Upper Right) The ferocious hippos are resting in
the river. (Lower Right)

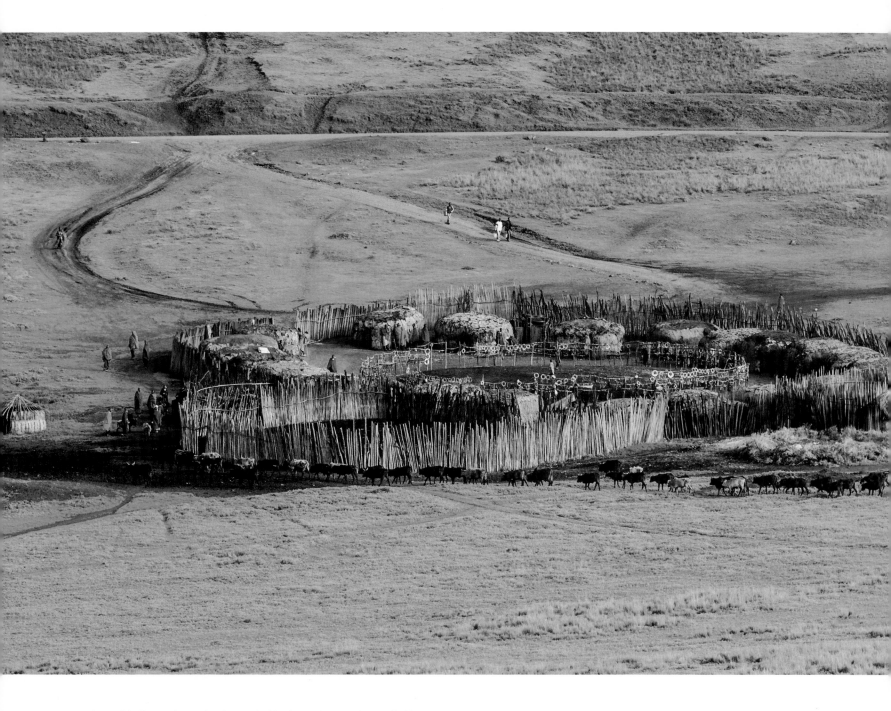

馬賽馬拉草原上現仍有馬賽族人居住。（左）雖然政府於 1977 頒布了禁獵令，讓他們無法再靠販賣獵物為生。（右上）但是，生態旅遊的興起為他們帶來了更為可觀的收入。（右下）

A number of Maasais are stilling living on the Maasai Mara. (Left) They were deprived of the income from selling preys after the government-issued preservation in 1977. (Upper Right) However, the emerging industry of ecotourism has compensated them even more. (Lower Right)

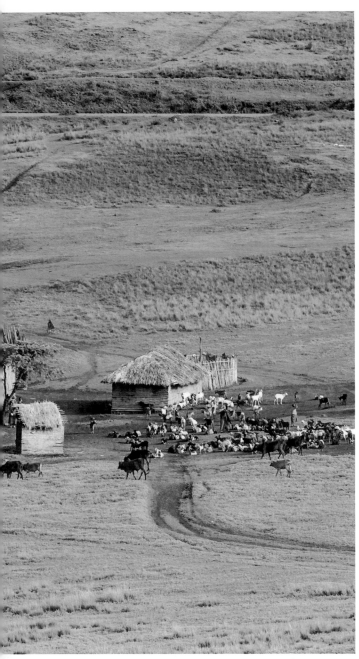

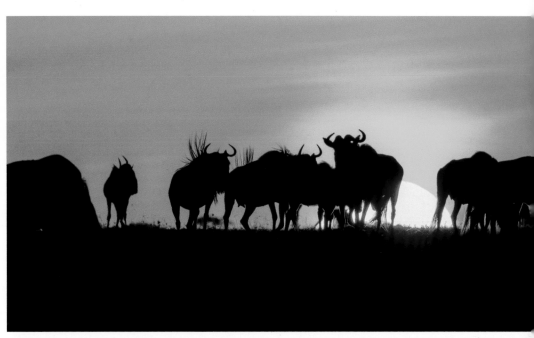

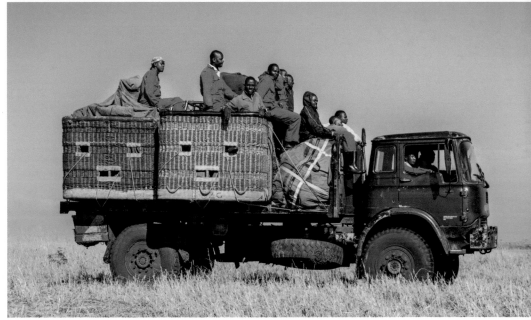

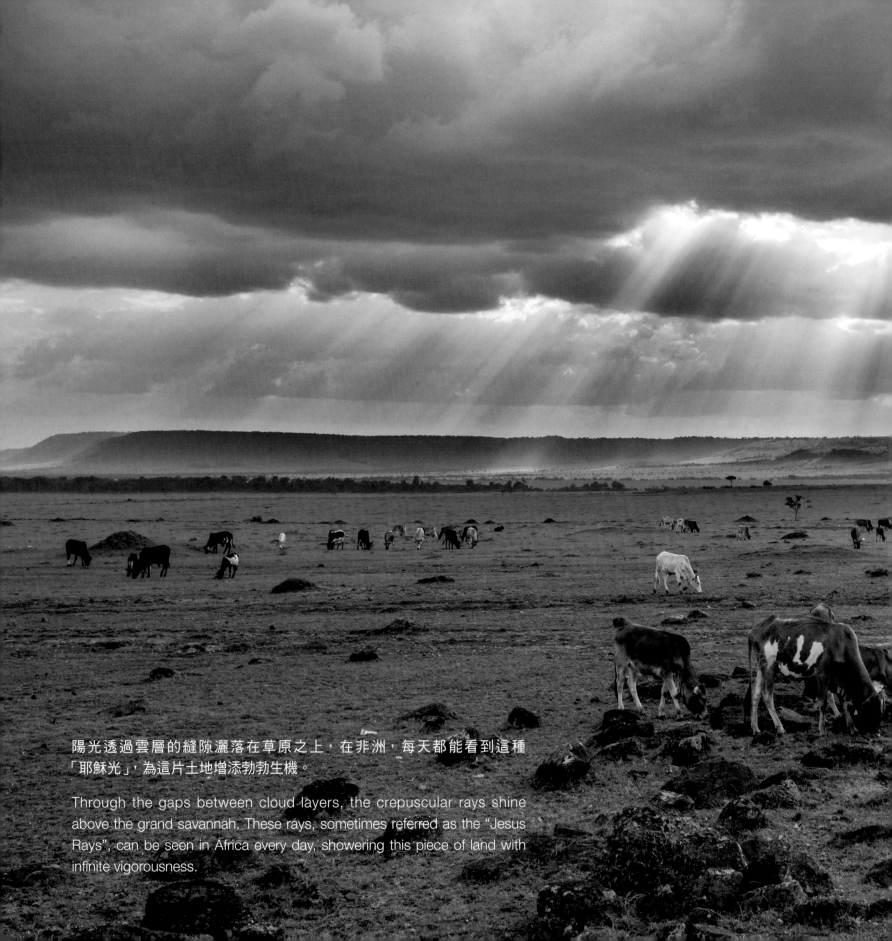

陽光透過雲層的縫隙灑落在草原之上，在非洲，每天都能看到這種「耶穌光」，為這片土地增添勃勃生機。

Through the gaps between cloud layers, the crepuscular rays shine above the grand savannah. These rays, sometimes referred as the "Jesus Rays", can be seen in Africa every day, showering this piece of land with infinite vigorousness.

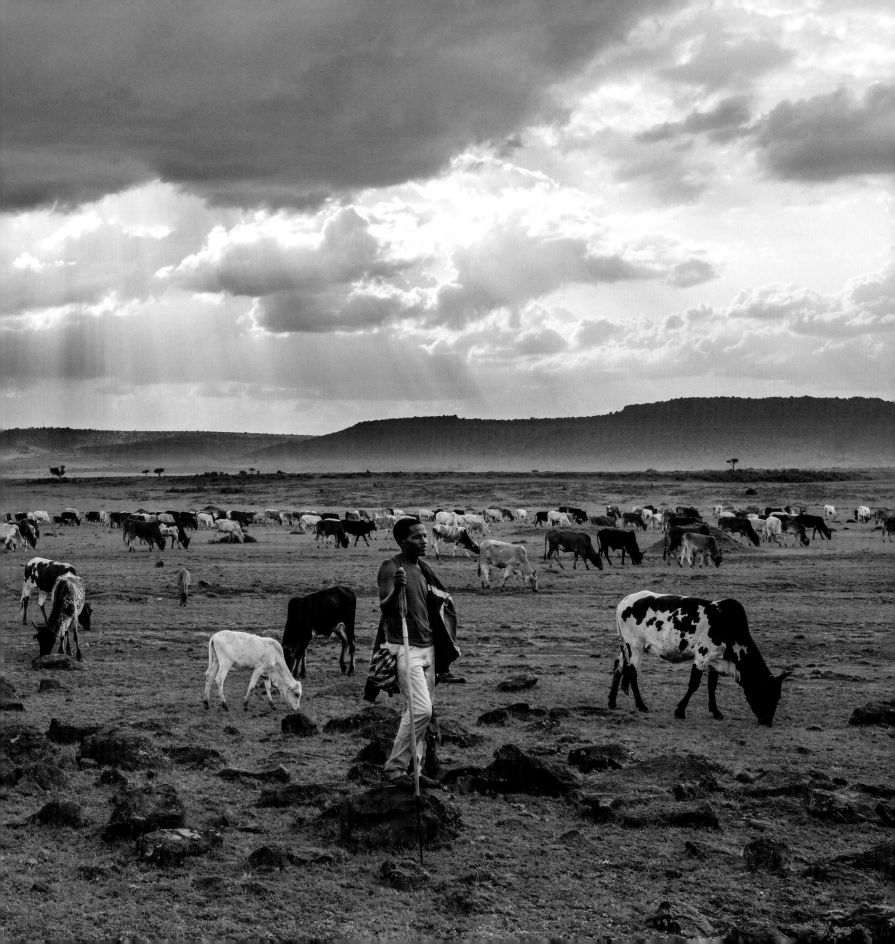

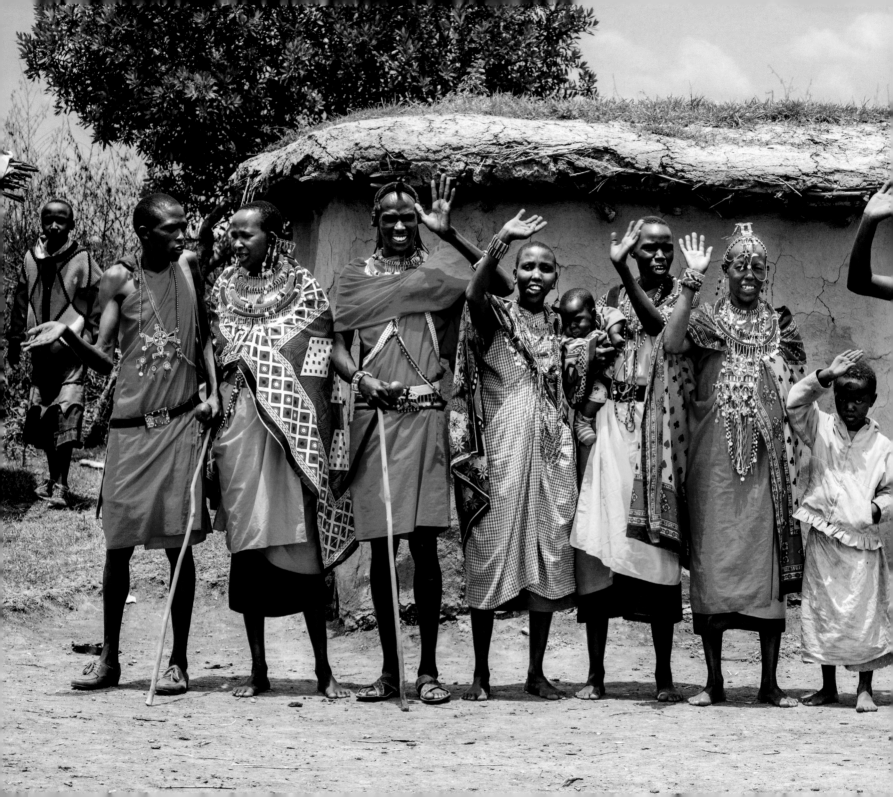

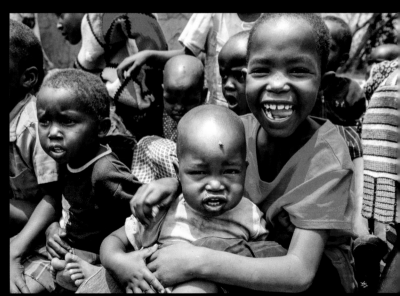

馬賽人現也成為馬賽馬拉草原上的「景點」之一。（右上）他們面上有著純樸而燦爛的笑容。（右下）隨意披在身上的紅藍布疋，是鏡頭下的絕佳畫面。（左）

The Maasais have become one of the attractions on the Maasai Mara. (Upper Right) They have simple but dazzling smiles on their faces. (Lower Right) The blue and red cloths they wear randomly have formed a perfect picture through the camera lenses. (Left)

古埃及是世界文明古國之一，擁有悠久的歷史。現代的埃及橫跨亞非兩洲，大部分位於非洲東北部，是東北非人口最多的國家，更是伊斯蘭信仰地區甚具影響力的國度之一。首都開羅。

Ancient Egypt is considered to be a cradle of civilization, with an extremely long history. The modern Egypt is a transcontinental country, sitting on the borders of Africa and Asia. The major parts of Egypt are located in the African continent, making it the most populous country in northeast Africa. Egypt has an influential power in the world of Islamic nations. Cairo is its capital.

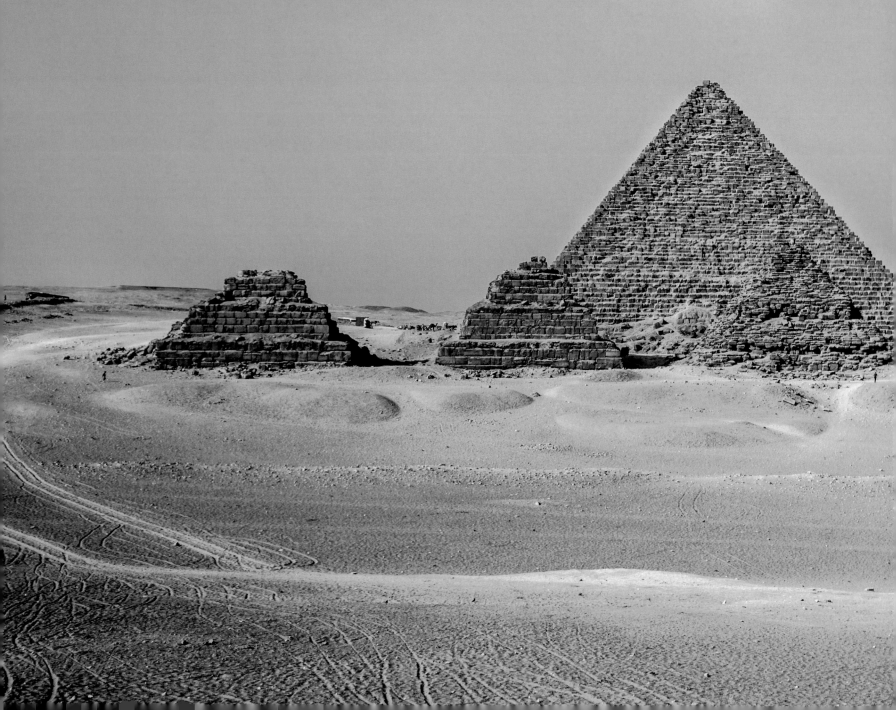

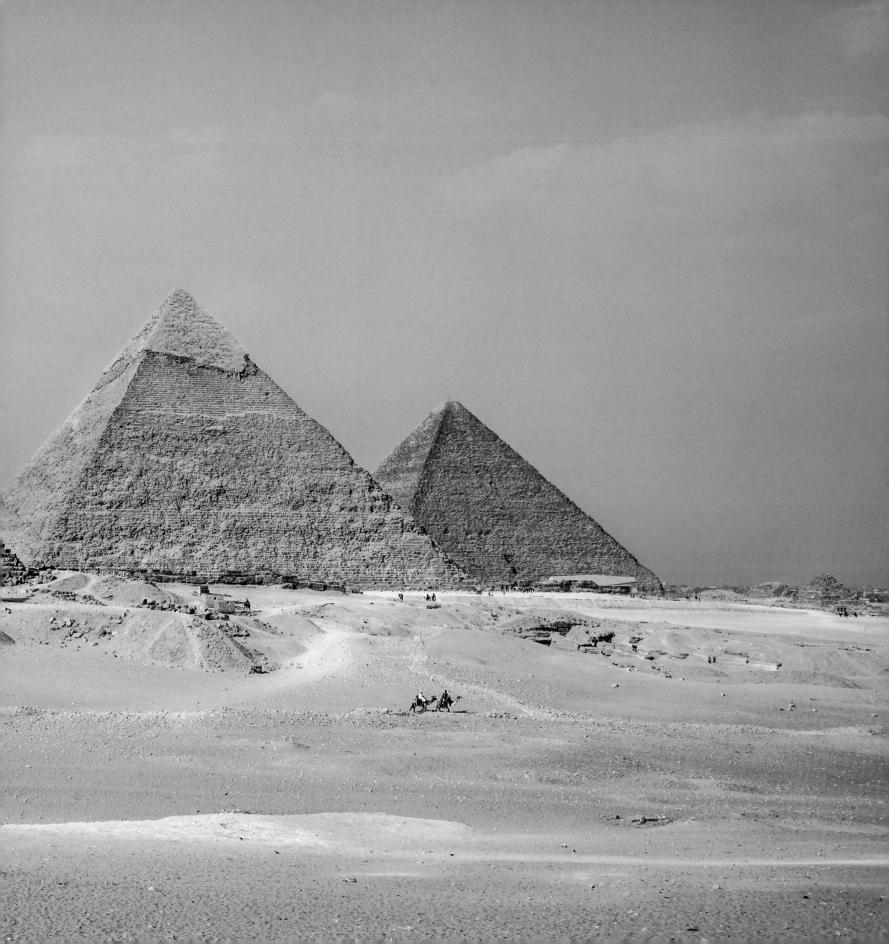

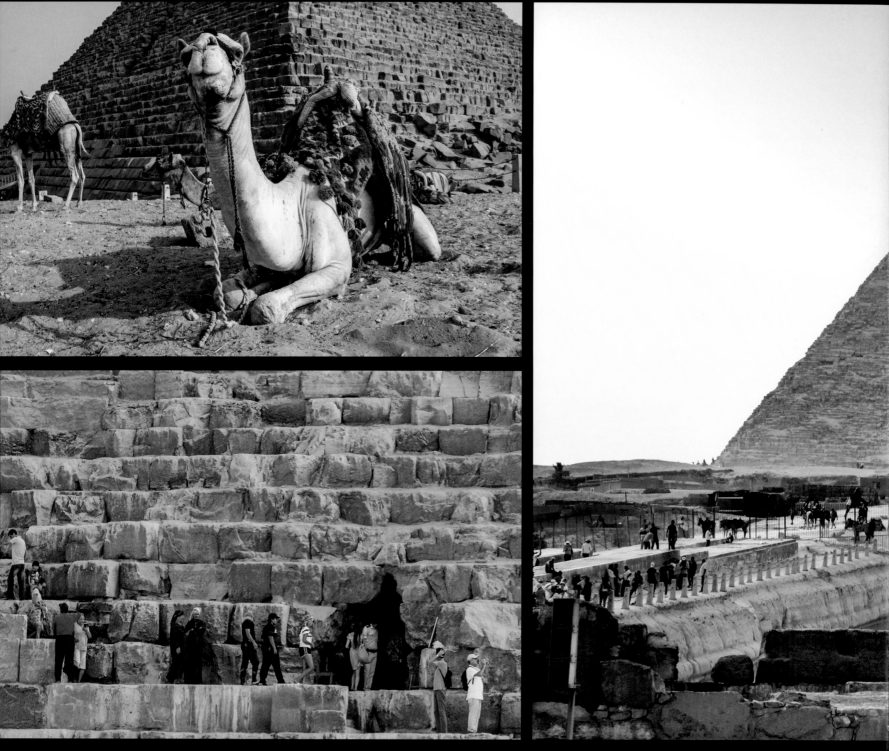

埃及金字塔，可謂古埃及文明遺留給現代人類的一大謎題。（左上）

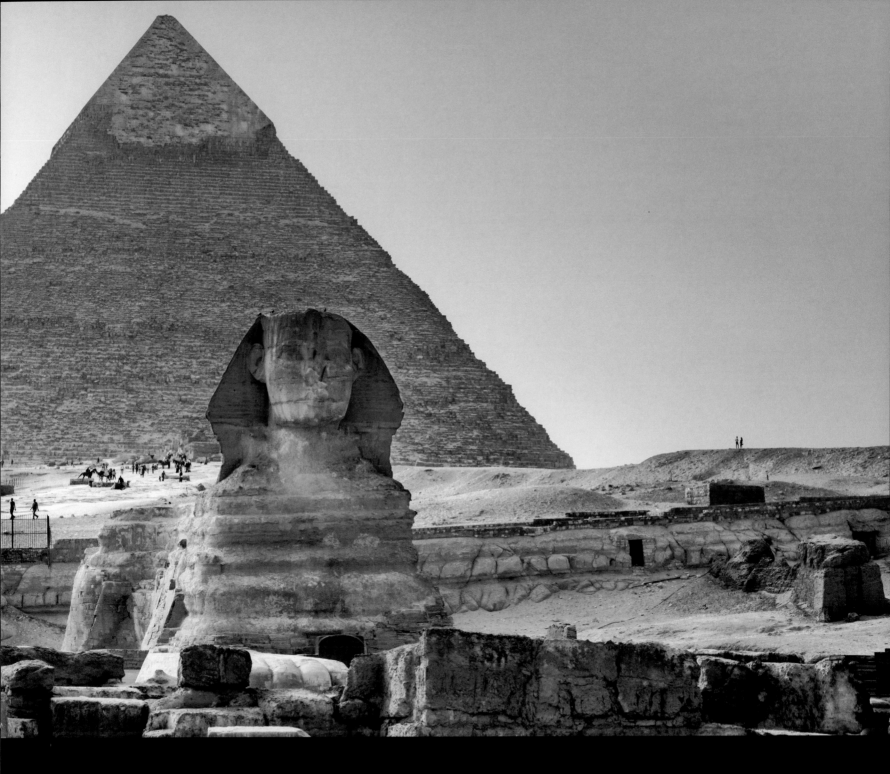

Egyptian pyramids are puzzles left by the ancient Egypt civilization. (Upper Left) In the Giza pyramid complex, the oldest and largest Pyramid of Khufu is regarded as the top of the Seven Wonders of the Ancient World, which is also the only one that is still standing today. (Lower Left) Right next to the Pyramid of Khafre, the second-largest pyramid after Khufu, there is the world's oldest known monumental sculpture the Great Sphinx of Giza. (Right)

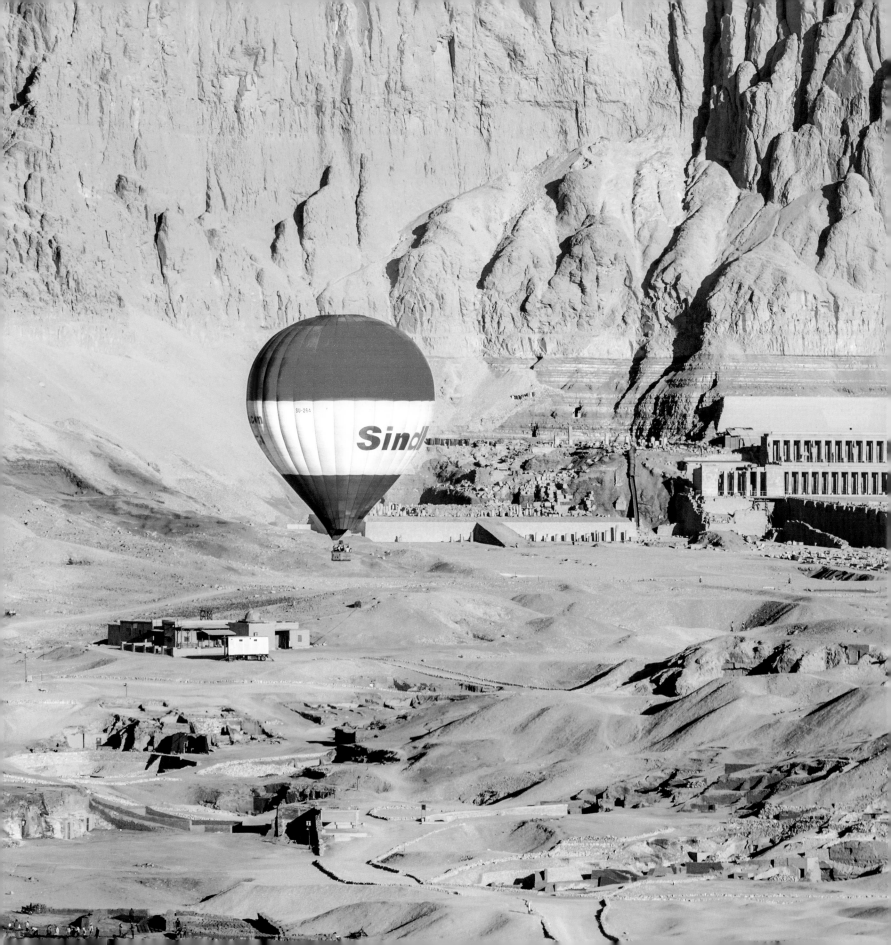

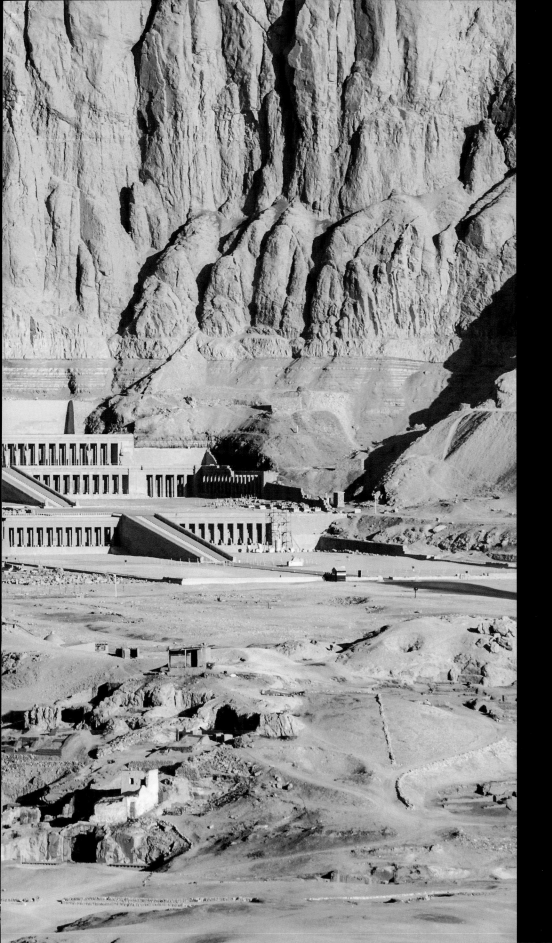

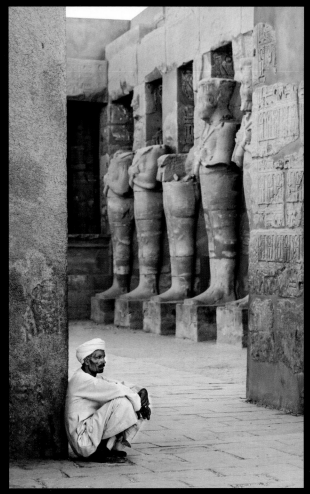

在尼羅河的西岸，帝王谷埋葬著古埃及新王國時期 18 至 20 王朝的法老和貴族，共有 60 多座陵墓。（左）女王神殿為第 18 王朝女法老王哈斯普蘇的陵墓，依山而建，非常宏偉。（右）

On the west bank of the Nile, there are more than 60 tombs lying beneath the surface of Valley of the Kings, which were built for the Pharaohs and nobles of the New Kingdom (the 18th to the 20th Dynasties of Ancient Egypt). (Left) The Mortuary Temple of Hatshepsut under the cliffs, tomb of the 18th Dynasty female Pharaoh, is a majestic construction. (Right)

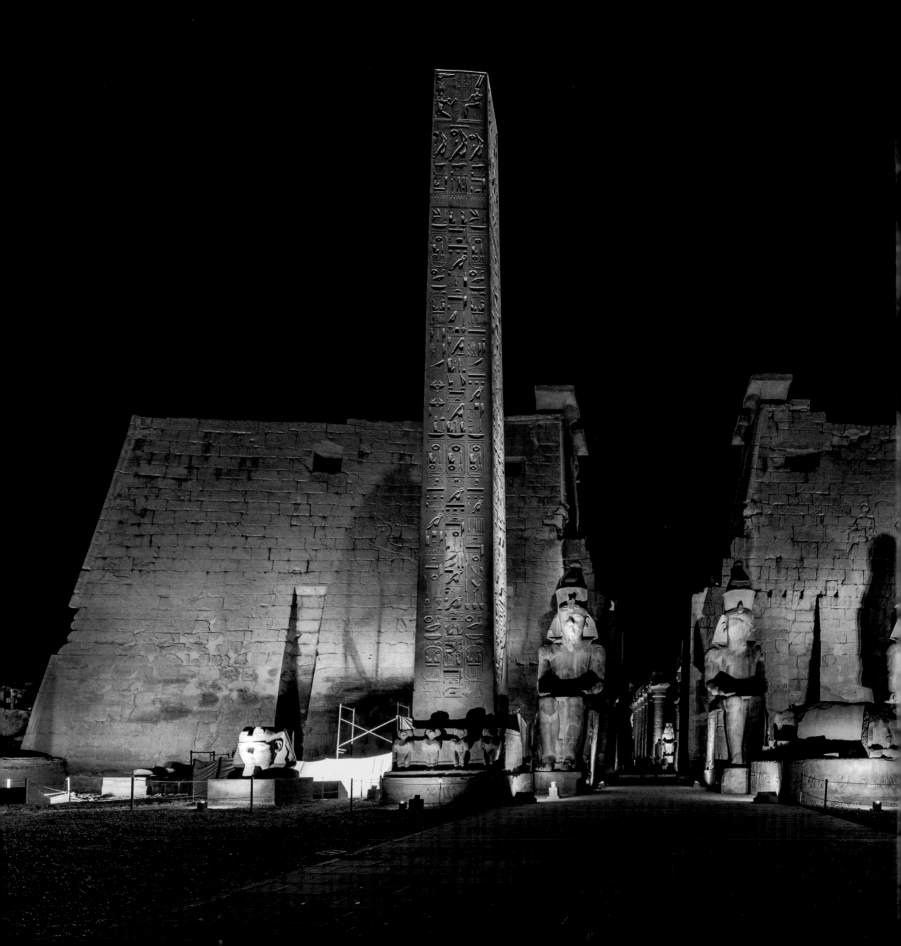

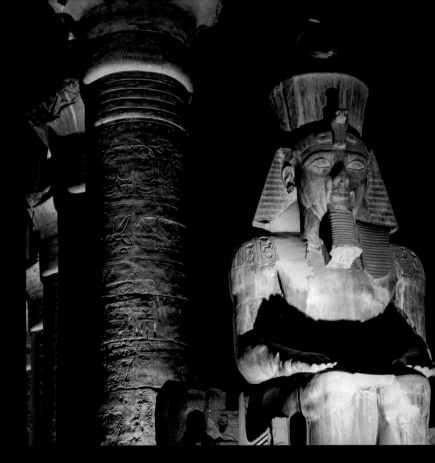

與帝王谷隔河對望的，是曾為古埃及首都的底比斯，現稱樂蜀。（右）樂蜀神殿經過歷代法老不斷加建，形成了如今世人眼中龐大宏偉的神廟。（左）

Thebes, as known as Luxor in nowadays, is at the opposite side against the Valley of the Kings, and was once the capital of ancient Egypt. (Right) The Luxor Temple, having been through several times of addition works by generations of Pharaohs, has become a large

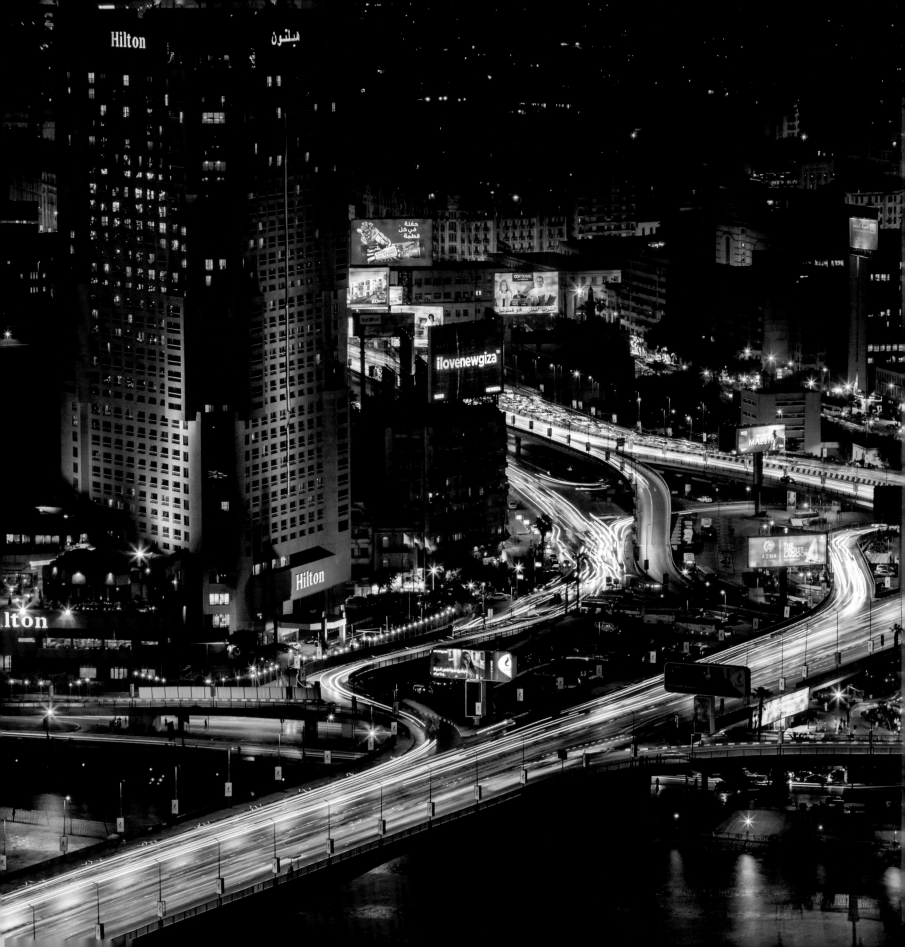

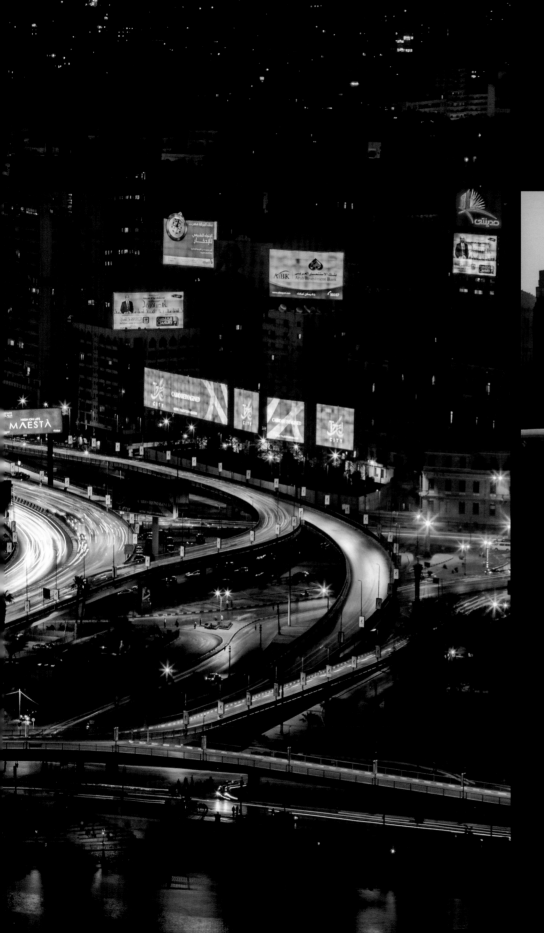

開羅曾被評為世界第一「不夜城」。（右）
其夜間的繁華程度絲毫不遜於紐約、倫敦
等國際大都市。（左）

Cairo once ranked as the "most 24-
hour" city in the world. (Right) It's
nightlife scene no less stunning than
international metropolises like New York
and London. (Left)

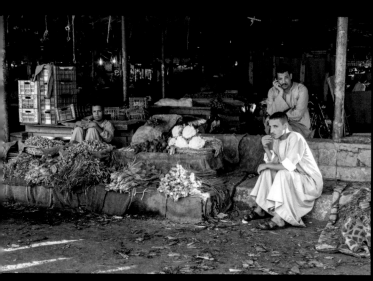

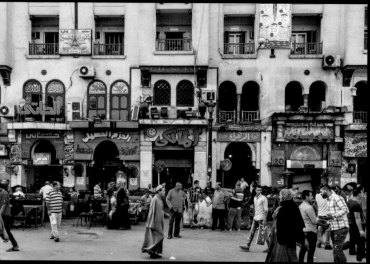

伊斯蘭教為埃及國教。（左上）約 90% 的埃及人口為伊斯蘭教徒。（左下）無論是建築風格、生活習慣，還是穿著打扮等方面，都有濃厚的宗教特色。（右）

Islam is the state religion of Egypt. (Upper Left) It is estimated that about 90 percent of its population are Muslims. (Lower Left) Islamic features can be found in the architectural styles, people's habits and customs as well as their ways of dressing. (Right)

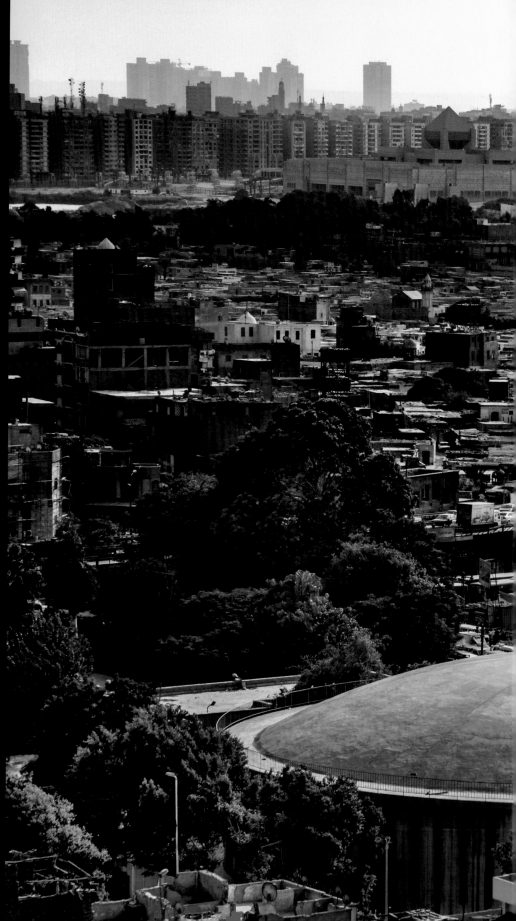

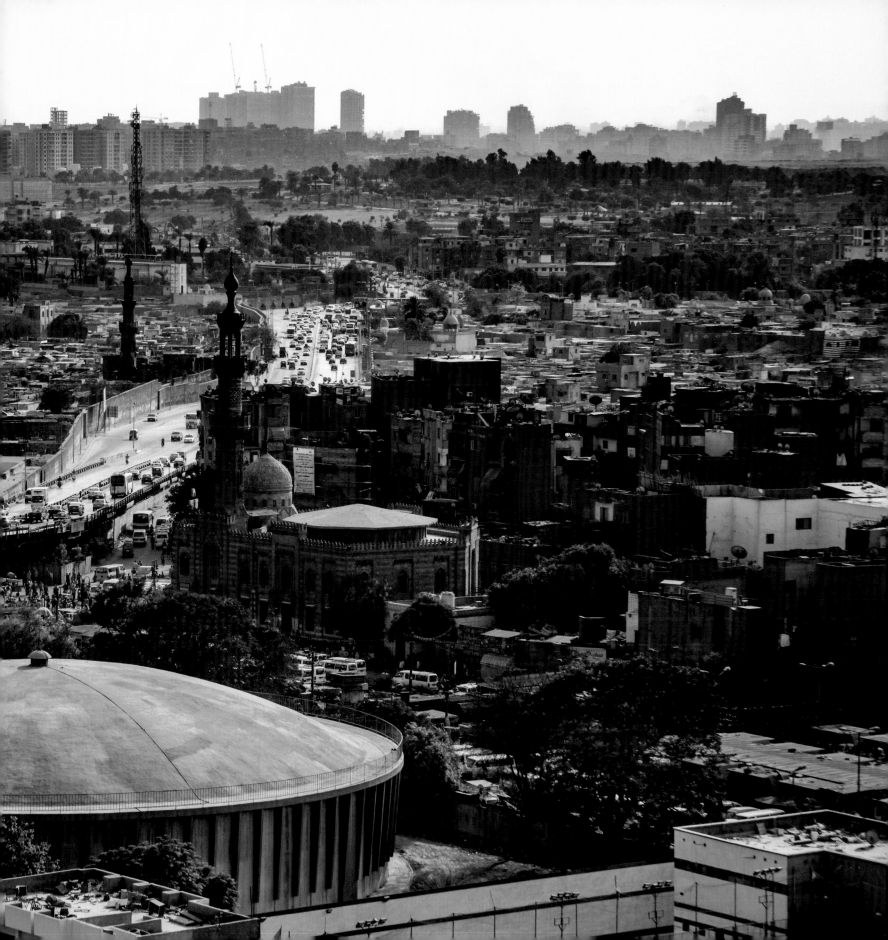

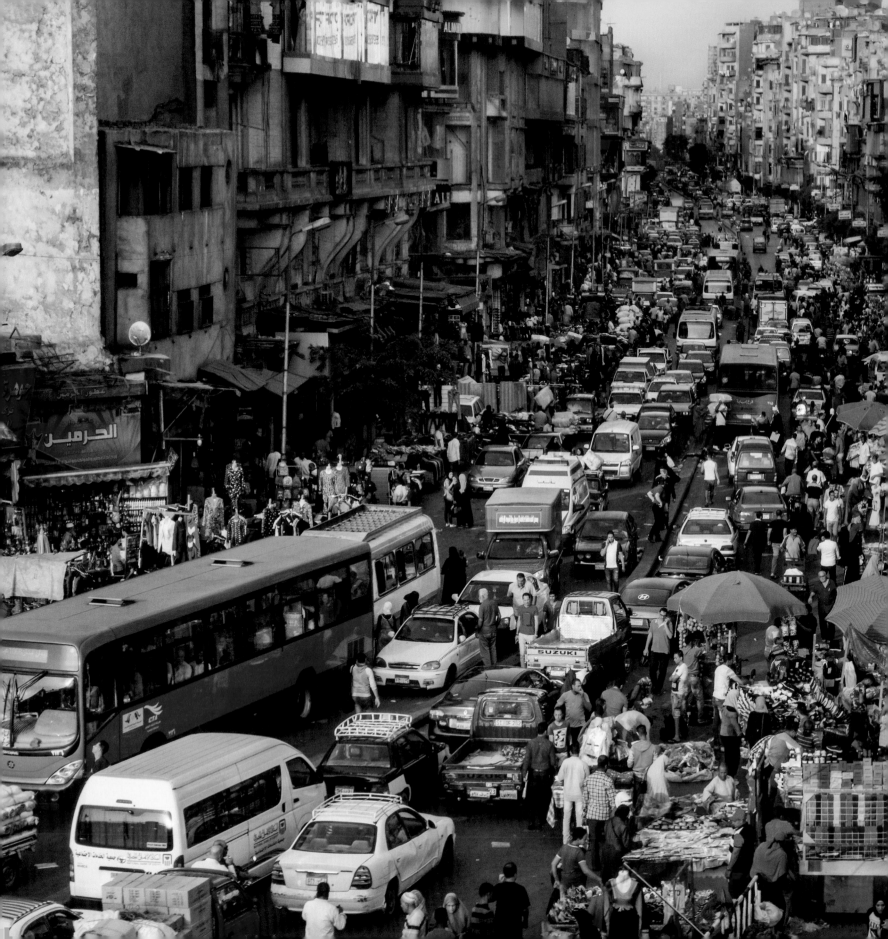

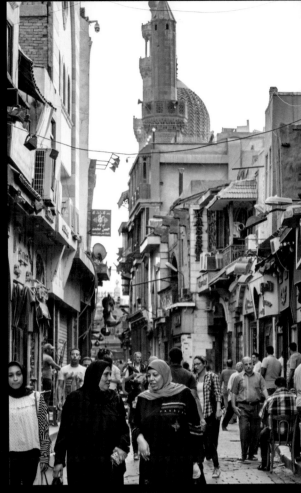

人流、車流的密集，使市中心的路面交通狀況讓
人不敢恭維。（右）塞車的情況在節日或假期更
是尤其嚴重，在重要旅途之前必須作好充分的時
間準備。（左）

The high flow-rate of people and vehicles is the
cause of major traffic in urban areas. (Right)
Traffic jam is especially severe during holidays.
A sufficient headspace of time is necessary for
any important journey. (Left)

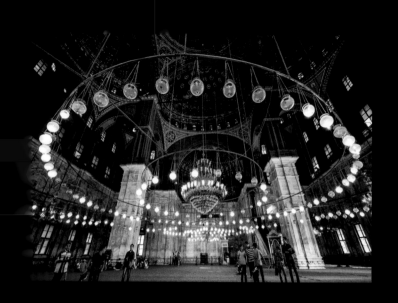

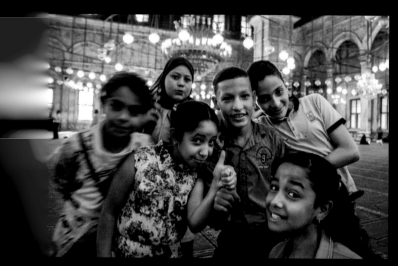

穆罕默德・阿里清真寺位於開羅大城堡區之內，又被稱為雪花石清真寺。（左上）到此參觀、禮拜的人眾多。（左下）清真寺由現代埃及的開創者穆罕默德・阿里下令興建，是市內十分醒目的地標。（右）

The Mosque of Muhammad Ali, or Alabaster Mosque, is situated in the Cairo Citadel. (Upper Left) A lot of people come here for visiting or Salat. (Lower Left) Commissioned by Muhammad Ali Pasha, who is regarded as the founder of modern Egypt, the mosque is an extremely visible landmark in the city. (Right)

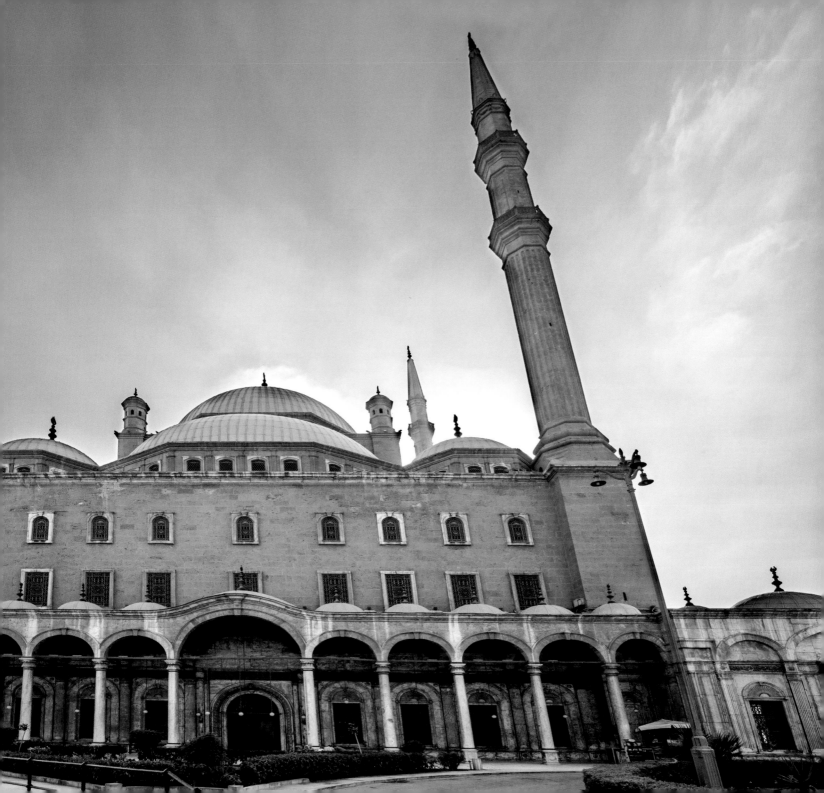

城郊村落中，仍有不少民眾依靠畜牧業為生。市區也同樣生活著牧民，但有趣的是，他們把養殖的牛羊群，安置在住房的屋頂。（右）一名農夫正趕著馬車。（左）

In the villages in suburban areas, many shepherds are still living on livestock-raising. Quite a few herdsmen can be found in downtown. Interestingly, they have chosen residential building rooftops as their farms for settling the cattle and goat herds. (Right) A farmer is driving a horse wagon. (Left)

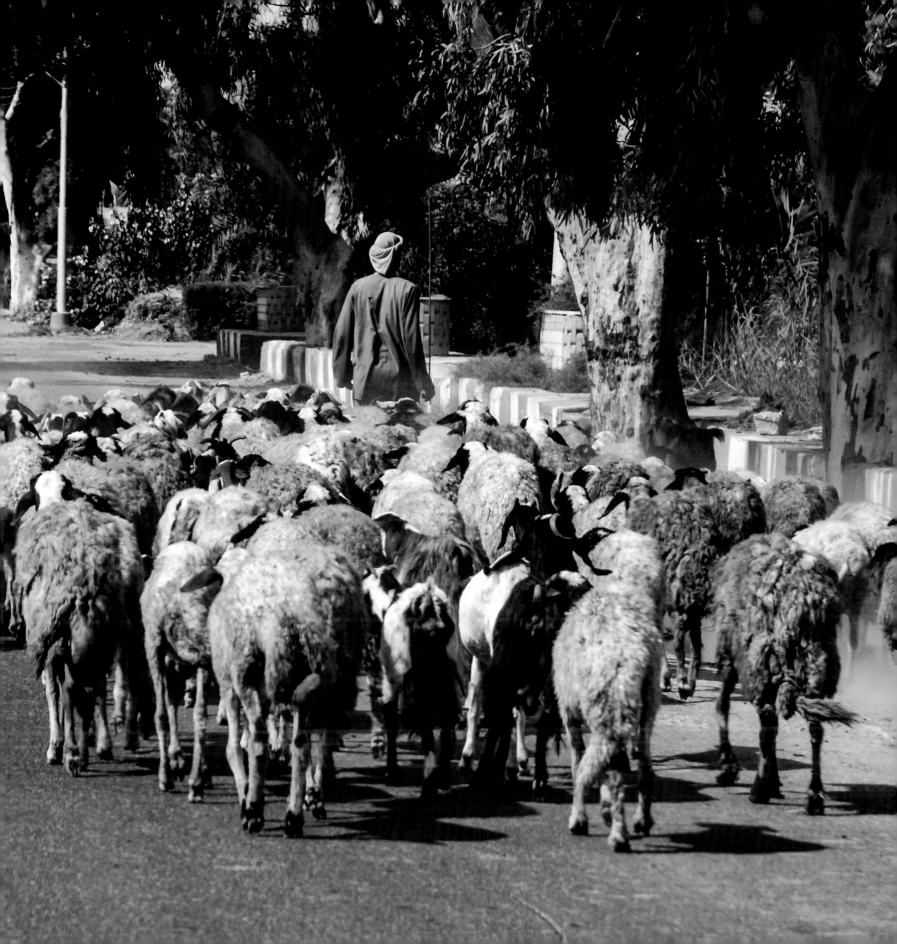

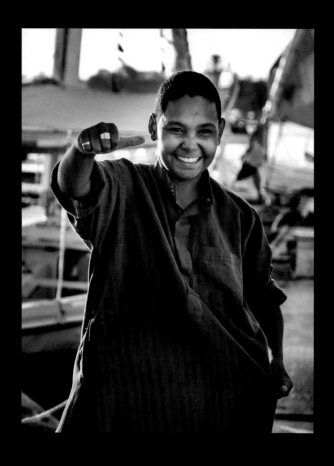

世界第一長河尼羅河，是埃及的母親河。（右）
在開羅的這一河段，不少遊客都會選擇夜遊
尼羅河，欣賞開羅的都市夜景。（左）

The world's longest river, the Nile, is the cradle
of Egypt. (Right) Many visitors choose to take a
night cruise at the Carol session to appreciate
the city's night view. (Left)

鳴謝 Acknowledgements

Peterpenn Poon, Joseph Lam, Zimman Shunji, Alvin Yau, Natalie Li, Connie Cheng, Ko Kin